The Alienation Effect

OWEN HATHERLEY

The Alienation Effect

*How Central European
Émigrés Transformed the
British Twentieth Century*

ALLEN LANE
an imprint of
PENGUIN BOOKS

ALLEN LANE

UK | USA | Canada | Ireland | Australia
India | New Zealand | South Africa

Penguin Books is part of the Penguin Random House group of companies whose addresses can be found at global.penguinrandomhouse.com.

Penguin Random House UK,
One Embassy Gardens, 8 Viaduct Gardens, London SW11 7BW

penguin.co.uk

Penguin Random House UK

First published in Great Britain by Allen Lane 2025
001

Copyright © Owen Hatherley, 2025

The moral right of the author has been asserted

Penguin Random House values and supports copyright. Copyright fuels creativity, encourages diverse voices, promotes freedom of expression and supports a vibrant culture. Thank you for purchasing an authorized edition of this book and for respecting intellectual property laws by not reproducing, scanning or distributing any part of it by any means without permission. You are supporting authors and enabling Penguin Random House to continue to publish books for everyone.
No part of this book may be used or reproduced in any manner for the purpose of training artificial intelligence technologies or systems. In accordance with Article 4(3) of the DSM Directive 2019/790, Penguin Random House expressly reserves this work from the text and data mining exception.

Set in 10.2/13.87pt Sabon LT Std
Typeset by Jouve (UK), Milton Keynes
Printed and bound in Great Britain by Clays Ltd, Elcograf S.p.A.

The authorized representative in the EEA is Penguin Random House Ireland, Morrison Chambers, 32 Nassau Street, Dublin D02 YH68

A CIP catalogue record for this book is available from the British Library

ISBN: 978-0-241-37820-5

Penguin Random House is committed to a sustainable future for our business, our readers and our planet. This book is made from Forest Stewardship Council® certified paper.

MIX
Paper | Supporting responsible forestry
FSC® C018179

For Carla, who knows where she's going.

KALLE: *In principle I think orderliness is a good thing. But I once saw a Charlie Chaplin film where he was packing a suitcase – or rather, chucking his stuff into a suitcase – and once he'd shut the lid he decided it was too messy because there were too many bits of cloth poking out. So he took out a pair of scissors and just cut off the sleeves and trouser legs and everything else. It astonished me. I can see you don't think much of orderliness either.*

ZIFFEL: *I'm just conscious of the enormous advantages of sloppiness. Sloppiness has saved thousands of lives. Often, in war, a man need only deviate very slightly from the course of action he's been ordered to take and he'll escape with his life ... I wouldn't want to stay in a country where order reigned supreme.*
Bertolt Brecht, *Refugee Conversations*, 1940–1[1]

Contents

INTRODUCTION
The Aliens

1	From the Palace of Pensions to the Palace of Westminster	3
2	Sanatorium for the Totalitarians	11
3	A Desert Island	22
4	Good-Day to Berlin	29
5	Luxury War for Aliens	34
6	A Question of Interest to Racists	47

PART ONE
Camera Eyes:
Film und Foto **from Budapest to Blackpool**

7	Stefan Lorant Dreams of England	59
8	Upstairs, Downstairs	81
9	Modern Antiquarians	94
10	The Shape of Things to Come	112
11	Whatever People Say I Am, That's What I'm Not	138

PART TWO
Books and *Buchkunst*:
Central Europeans Redesign the British Book

12	The Radical Autodidact's Bookshelf	149
13	Letters and Spaces	152
14	No Bosoms No Bottoms, No Brashness No Vulgarity	172
15	New Ways of Seeing Old Art	188
16	'Red Vienna' Goes to the Art School	212

CONTENTS

PART THREE
In and Out of Place:
'Degenerate Artists' in Ordinary Britain

17	How German Is It? – Three Exhibitions	239
18	'Finchleystrasse' and Other Londons	259
19	Central Europeans in the Celtic Fringe	282
20	New Figures in a New Landscape	303
21	A Mundane Calvary	323
22	Micro-Dada	344

PART FOUR
A Refuge Rebuilt:
Visions of Planning, Building and Reconstruction

23	Bringing the Gospel	369
24	Architects In Between	396
25	Lubetkin's Megaphone	406
26	Thoroughly Inlandish	423
27	Back to the Source	432
28	The Planners and the Anti-Planners	459

CONCLUSION
Weimar-on-Thames

29	Threepenny Operas	513
30	This Is What We Believe	523

Acknowledgements	533
Notes	535
Index	577

Introduction
The Aliens

i am definitely not bored, even though the initial period here is very difficult. the >feet<, the >pounds<, and the accursed language slow down the hard won pace of work many times over ... sensible heating is pretty much unknown in england, and chilly draughts, which supposedly kill germs, are virtually organized here; on the other hand, everybody lies in bed nursing colds, roasted by the fireplace on one side, while on the other a cold draught blows through the rooms. the thick fog makes sure you literally get to eat the unburned particles from the old-fashioned fireplaces. why do the english do absolutely nothing about this perpetually deplorable state of affairs? i think out of puritanical self-denial, for it is exactly the same with food; it is prepared almost to make sure it can give no one real pleasure. puritanical discipline has, to be sure, produced the most respectable and self-controlled of europeans, but in this neutralized air all imagination withers away. nevertheless i feel comfortable here in this sentiment-laden inartistic world, because people's humaneness here is so attractive and – because I am treated with a respect I cannot help liking.
<div align="right">Walter Gropius to Martin Wagner, 1934[1]</div>

I

From the Palace of Pensions to the Palace of Westminster

In 2004, I was admitted to St Thomas's Hospital, London, which stands directly opposite the Palace of Westminster across the River Thames. I'd spent a week with unbearable pains in my left eye, which had become red and inflamed. What I could see through became increasingly murky and unclear. After finding that I could no longer sleep through the searing pain in my eye, I made an appointment. A morning visit to my GP led to a patch being placed over the left eye and the strict instruction *not* to go back to work under any circumstances, but to immediately go to St Thomas's to see the emergency eye specialist. So I got on the bus from New Cross to Lambeth, and alighted at the hospital – barely glancing at it – and scurried into one of the hundreds of wards, receptions, laboratories and surgeries in this multi-storey, multi-level complex. I was complimented by the doctor for my speed in seeking attention – apparently, left just a little longer, I could have become blind in one eye – given some eye drops, and told two things. The first, that what I had was a curable inflammatory infection called Uveitis, sometimes called Iritis, because the iris, specifically, is attacked. The second was that I probably acquired the infection because I had the incurable Crohn's disease, which, it would soon transpire after a few tests, I did. Stumbling, dazed, out of the hospital, but with the eye drops already starting to do their soothing work, I used that inflamed iris to have a good look around.

Immediately, I noticed the Palace of Westminster across the river. There is probably no building that is more quintessentially, insufferably English. Mainly containing the Houses of Parliament, it was designed at the turn of the Victorian era by the establishment Anglican classicist Charles Barry, in a deliberately compromised alliance with the charismatic, Catholic goth Augustus Welby Pugin. The details, designed by

Pugin, are in the most flamboyantly ornamental Gothic, with no surface left uncovered. Statues, tracery, crockets and spires adorn the structure, particularly at the top of its several towers, the second largest of which is the clock tower nicknamed Big Ben; yet the massing, and accordingly, the facades of the building facing the river, are completely symmetrical and classical. It is the perfect English compromise. A pact between the two factions in the nineteenth century's style wars, a solution to the question of how to construct a building that would look both ancient and new, to project both immense wealth and puritan sobriety, to showcase both illogicality and rationality.

St Thomas's Hospital, out of which I had just emerged, is right on the south bank of the Thames – the eye clinic is in full view of Big Ben. The hospital consists of three buildings: two long, low pavilions, and a central tower, which deliberately does not compete with the building opposite, which we will come to presently. All of the buildings are clearly modernist, but not in the way such buildings are usually done in Britain. Unlike the National Theatre and the South Bank, east along the Thames from the hospital, St Thomas's is not Brutalist – that is, it is not aggressive, charismatic, or characterized by rough and raw concrete surfaces. Unlike the similarly close Royal Festival Hall, it is not light-hearted, decorative, pretty or 'typically English'. And unlike later modernist buildings, such as those in the City of London skyline visible from the hospital's higher levels, it is not high-tech, denoted by a slick skin of glass and an 'iconic', instantly recognizable and reproducible shape. It is a modernist's modernism, *classical modernism*.

One can list the negative virtues of St Thomas's Hospital, but most important is an attempt to create an image of order: of society as a seamlessly flowing and functioning machine, calm, clean, rational, sensible, and equal. Unlike the hospital's previous incarnation – a fussy, poorly planned collection of tawdry spires and turrets, a cluster of which still survive to the west of these buildings – it makes not the slightest effort to complement, impersonate or compete with the Houses of Parliament, despite the fact that their direct proximity, facing each other at all times, means you can never really contemplate one without the other. Perhaps because of this refusal to play a game of architectural tennis across the Thames, St Thomas's has usually been ignored. It is not listed, it is not famous, and unlike many buildings of its era, it never appears on a mug or a tea towel. It has also never been vehemently hated. Charles III very

probably doesn't like it, but he did not coin a particular epithet or insult to sum up his dislike. Rationality and order, St Thomas's suggests, is normal, and – why not? – a little boring. It is the least you should expect.

That, at least, is how you might see it on an average day. But this wasn't an average day, and I wasn't seeing things as I normally would. The experience of having a ferocious pain was suddenly salved, and given the time to linger – knowing I wouldn't be going back to work – I did so. I remembered, from a library book about public sculpture in London, that somewhere near here was a work by the Russian Constructivist Naum Gabo, and after a short wander – the sculpture wasn't signposted – I found it. It is in a sunken garden, on the Embankment. There is no building directly in front of it, so it is framed either by the insane spiked skyline of the Palace of Westminster over the river, or by the right angles of St Thomas's lower blocks. The sculpture is a thin, organic, curved form at the centre of a fountain. It is called *Revolving Torsion*, and like many of Gabo's sculptures it is 'kinetic' – that is, it moves and revolves, and water pours from it.[1] The way the water emerges makes the metal form look like a series of membranes, like tendons pulled over bone. If you can't quite see properly – and of course, on first seeing it, I couldn't – you might find the effect slightly unnerving, and ask yourself whether or not you're actually seeing what you're seeing. That feeling is exciting. But when you look closely at the sculpture, you see that the effect of motion is perfectly rational, and you can see the game that's being played. Gabo is sharing its rules with you.

Revolving Torsion is completely abstract – it doesn't represent or 'look like' anything, although an unimpressed observer might compare its stainless-steel components to a partially melted bottle opener. What is *not* abstract is the way the work relates to the buildings on either side of it. Look towards the hospital, and the sculpture's taut curves are in an obvious dialogue with, are framed by, the straight and pure lines. Look towards Big Ben, and it's more puzzling. This tiny work becomes monumental, and it seems to grip the Gothic turrets in a vice, as if wanting to freeze them, stop them, interrogate them – ask them what exactly it is they think they're doing, what the point is of all this silly gesticulation. Moving away from this intense little game, the green public square in which Gabo's sculpture sits, with its built-in concrete benches, feels exceptionally calm and restful, a difficult thing to be when you're just under Westminster Bridge Road. Sitting here, next to the white flowers

Naum Gabo's *Revolving Torsion* and Yorke Rosenberg Mardall's
St Thomas's Hospital.

growing in the specially made concrete boxes, I started to take in the white hospital buildings around. They're all clad in perfectly square white ceramic tiles, shiny and wipe-clean, as the surfaces of a hospital should be. The windows are large, and their painted steel frames are lightweight, designed so that as much as possible can be seen from inside them, and as much light and air can reach the patients and the staff. At the corners, the windows are slightly inset, as a way of revealing to the viewer the technology behind the building – that this is a frame construction, that it is not built from the ground up. The roofs are, of course, flat.

The space is very quietly beautiful – crystalline, soothing, pure. This is an impression I have tested when not putting eye drops into my eyes and found to be accurate. But I also remembered another building I had seen, in a far-away city better known for its Gothic and Baroque rather than its modern architecture – the Dům Radost or 'House of Joy', originally known as the Palace of Pensions, in Prague. It was built between 1932 and 1934 when the city was the capital of the new Central

A 1930s photograph of the Palace of Pensions in Prague, taken from J. M. Richards' Pelican *Modern Architecture*.

European state of Czechoslovakia. Unlike St Thomas's Hospital, the Palace of Pensions is quite famous in the histories of modern architecture, and features in many of them as an example of the Functionalism and Constructivism that briefly became the architectural mainstream in a handful of countries at the turn of the 1930s – the Netherlands, Czechoslovakia, Germany, the Soviet Union. While St Thomas's went looking for *me*, as it were, *I* went looking for the Palace of Pensions, on a visit to the Czech capital, on a pilgrimage to the great interwar modernist buildings that fill that city's inner suburbs, ignored by the tourists en route to the palaces and churches along the River Vltava. The Palace of Pensions consists of a long, tall slab and lower flanking blocks, just like St Thomas's. It is similarly clear in its design, an image of impeccable logicality and restraint, but at the same time quietly dramatic in its high-rise scale and confidence, its lack of qualms about ignoring the past. It is also clad in perfectly square tiles (here, more off-white). It is a public building for a welfare state, as of course is St Thomas's Hospital, the most prominent building of the National Health Service. The Palace of Pensions is also obviously the product of people who think Gothic architecture is a bit silly. What I didn't realize at the time was that there

was a reason why this influential, cultish edifice in Prague looked so much like the banal public building in London. It's because they were both substantially designed by Eugene Rosenberg.

In the early 1930s, when the Palace of Pensions was built, Eugene Rosenberg, born Evžen Rosenberg in 1907 in Topoľčany, Slovakia, was a partner at the firm of Josef Havlíček and Karel Honzík, a duo who were making their names as leading members of a Czechoslovak avant-garde of artists, architects and photographers. Czech and Slovak modernists were positioned at the heart of Europe, a midpoint, a bridge, between the capitalist, imperialist West and the fresh, new, socialist experiment in the East. At the Palace of Pensions, Rosenberg was the project architect, tasked with the day-to-day work of marrying the utopian design of the building to the practical possibilities of its builders on the site, and making any changes that might result. On the strength of this, Rosenberg struck out on his own, designing a series of similarly sharp and rational-looking office blocks, flats and shopping arcades on small sites in the Czech capital. Nazi Germany's piece-by-piece absorption of Czechoslovakia – first annexing the German-speaking Sudetenland, then invading the Czech heartland of Bohemia and Moravia, then turning Slovakia into a fascist puppet state – made Rosenberg, who was on the political left and had Jewish ancestry, decide to escape to Britain in 1939. Having arrived, he quickly made friends and contacts among a nascent modern architectural scene, helped by the fame of the Palace of Pensions. After the war, Rosenberg would found a firm with the English architect and writer F. R. S. Yorke and the Finnish designer Cyril Mardall – Yorke Rosenberg Mardall. 'YRM' still exists today, decades after the deaths of its founders, as a corporate architecture conglomerate.

Yorke Rosenberg Mardall designed all manner of buildings across Britain, and in a language which consistently and strongly recalls the vision of modern architecture that one finds at the Palace of Pensions, a graph-paper style of imperishable materials and unimpeachable logic. And always, those square white tiles, about which the company's founders would boast that the proportions of the buildings were so well calculated that they never had to cut a tile. Most of all, they were architects to the Welfare State, and especially to the most important, most loved aspect of the post-war British mixed economy, the National Health Service, whose staff were surely attracted by all those easily cleaned white tiles – the very image of public health. Yorke Rosenberg Mardall would

design big NHS hospitals in Crawley, Hull, Oxford, and this, the largest, St Thomas's Hospital in London. You didn't 'express yourself' if you were designing an NHS hospital, any more than you invited patients to 'consultations' about the design. You did the job, and you made it as clear, straightforward and sanitary as possible.[2] If you are, as I was on that day in 2004, scared and in pain, this can be comforting rather than alarming – a signal to you that everything is going to work just fine, that a machine designed around you is ready to cater to your needs.

It's telling that in designing this incredibly prominent building, Rosenberg employed another exile of the 1930s to design the public sculpture to stand at the heart of the public space opposite Parliament. Naum Gabo was born in the Russian provincial town of Bryansk in 1890 and educated in Moscow and St Petersburg; after the 1917 revolution, he became one of the first pioneers of the Constructivist movement with his *Realistic Manifesto*, written with his brother Antoine Pevsner. Gabo moved westwards across Europe as the interwar years went on; like Rosenberg, he was a Central-Eastern European Jew who had fled the rise of Nazism and come to London in the second half of the 1930s. He would not make his life there, unlike Rosenberg, but Gabo did live in Hampstead and St Ives for a decade between 1936 and 1946, and he had a huge effect in those ten years as a real, living emissary of the utopian fervour of the Soviet avant-garde, spurring on the courage of young sculptors and painters unsure how far they could take the break with the imperial consensus of their forebears. For Gabo, designing the sculpture for this NHS hospital was a gift, giving something back. In a note published as it was unveiled in 1976, he wrote of how he had 'lived in England through the most tragic years of her history and the most glorious period in the life of her people ... I never, in my heart, lost my attachment to England.'[3] And here they both were, at St Thomas's Hospital: Gabo and Rosenberg. These avant-garde experimenters managed to build their ideal right in the centre of the European capital that had once been the most hostile to their modernist ideology – although it had been comparatively forgiving, compared with the countries they had come from, as to their physical existence.

St Thomas's Hospital itself was built between 1966 and 1974; its construction exactly spanned the shift between the high-water mark of post-war modernism in Britain and the artistic movement's sudden and decisive plummeting of its public reputation. It is extreme in its lack of

extremity. The architectural historian Reyner Banham, writing a retrospective of Yorke Rosenberg Mardall at the start of the 1970s, pointed out how strange, how *un-English*, their commitment to clean, efficient public service actually was. 'The delivery of such a service offends both the extremes at which our island architecture tends to polarise: the highfalutin' cathedral-buildin' prima donna, and your humble servant the honest two-by-four craftsman.'[4] The Houses of Parliament were, of course, a combination of both, fusing the talents of the staid country-house builder Barry and the fanatic Pugin. But this is something else – it is hard to imagine that there was ever *any* period in British life where something so seemingly hostile to all 'British values' in design and everyday life could possibly have been built here. St Thomas's Hospital is like a Malevich painting photomontaged across the photographs on a London picture postcard; it is a giant three-dimensional work of propaganda against *making do* and *muddling through*. What on earth, I asked myself, as I squinted at the buildings and the sculpture with my one good eye, is this building doing here, right opposite Parliament? How did something that makes so little fuss of itself, and yet which so resolutely refuses to doff its cap, get built on the most symbolically important site in the country? I had no answers to these questions then, but as I walked off to take the bus home, my vision had been permanently realigned.

2

Sanatorium for the Totalitarians

This is a book about the intellectuals who migrated to Britain during the 1930s from the countries in Central and Eastern Europe that were overrun by fascism; it is a book about how these individuals shaped Britain, and how Britain shaped them. It begins in a period that in some ways resembles our own, dominated by a pervasive sense of crisis, the rise of the far right and the far left, and hyper-speed technological change, but the country at the heart of it is almost unrecognizable from the one we live in today. One of the reasons for this is the influence of that generation of migrants upon Britain, bringing to the country a more proudly urban, modernist and serious culture, which was at first ridiculed by many, but gradually became so accepted that we don't even realize how many aspects of quintessentially British twentieth-century culture, from *Picture Post* magazine to the conservation of Victorian architecture, from the classic design of Penguin Books to tourist pageants like Glyndebourne or the Edinburgh Festival, were the products of refugees fleeing either from Germany or those places Neville Chamberlain called 'small faraway countries of which we know nothing'. Some of these people would go on to become pillars of the British establishment, as could be seen by the amount of them who became Knights of the Realm: Sir Ernst Gombrich, Sir Nikolaus Pevsner, Sir Karl Popper and others.

Yet the cultures from which these people emerged has a reputation for being the most advanced and radical of the twentieth century in Europe.[1] The Central European movements in art, architecture, design, literature, theatre and much else, which are retrospectively summarized as 'the avant-garde', or as 'modernism', entirely revolutionized those disciplines, making them almost unrecognizable: those avant-garde movements included Expressionism, a trend in painting, sculpture and, briefly, architecture that shifted from the most angst-ridden and tortured form of

art into a crystalline utopianism; its nihilistic, parodic outgrowth, Dada; and Constructivism, a rationalist and socially reforming fusion of technocracy and creativity.

These movements weren't confined to the ateliers and art studios, but would affect theatre, for example the revolutionary, artificial, deliberately 'alienating' stagecraft of Meyerhold, Toller, Piscator, Brecht. It also influenced cinema, in the work of Expressionists like F. W. Murnau, Fritz Lang or G. W. Pabst, or Constructivists like Sergei Eisenstein and Dziga Vertov. Also literature, in the mix of matter-of-fact reportage related with a 'camera eye' in the work of Joseph Roth or Ilya Ehrenburg; and the covers of those books, which became Constructivist artworks in their own right under the design of László Moholy-Nagy, Karel Teige or Aleksandr Rodchenko, and their lettering, transformed by typographers such as Jan Tschichold or Paul Renner. There were also the magazine and newspaper designs and layouts, turned into agitational canvases through the Dadaist John Heartfield's work on the *Arbeiter Illustrierte Zeitung (Workers' Illustrated Newspaper)*. Finally, of course, architecture, where Expressionist and Constructivist ideas were translated into thousands of workers' houses by architects such as Bruno Taut in Berlin and Ernst May in the 'New Frankfurt'; and at the Weissenhof Estate in Stuttgart, planned by Ludwig Mies van der Rohe, various German architects and the Swiss designer Le Corbusier created what seemed for a time like a new, globally applicable model for housing and architecture. What unified all of these activities was an aspiration towards dissolving the boundaries between 'art' and 'life'. Painters were seldom content just to be painters, but imagined being able to serve some sort of new revolutionary society, which was imagined as being of the left in Germany and Russia – though the closely linked Italian Futurists put their work at the service of fascism.

Particularly after Dada's purgative retch of disgust, this was a period of 'constructive' movements, and the attempt to create new institutions and new rules for old forms of art. It was a great moment for the creation of new schools and institutes. To name the most famous and most relevant for this book, there was the Bauhaus school of design, architecture and art, which in its various homes in Weimar, Dessau and Berlin always maintained the belief that the built world could be transformed through some form of utopian thinking; the Warburg Institute in Hamburg, which pioneered a new form of art history that was both more

New Surfaces: an advertisement for Bauhaus Wallpaper, 1932.

New Cities: a still from Fritz Lang's *Metropolis*, 1927.

(*Left*) New Media: a 1930 issue of *A-I-Z*, covers by John Heartfield.
(*Right*) New Figures: Ernst Barlach's Expressionist sculpture, 1927.

'scientific' and rigorous, and also more esoteric and experimental, than anything that had gone before it; and the Frankfurt Institute for Social Research, which tried to fuse the ideas of Freud and Marx as a means to understand the apparently puzzling fact that capitalism did not die following the revolutions of 1917–19. Leaving aside a generally shared love of American cinema and technology, Ford factories and mechanization, this was not a period full of people who were pleased with the world as it was. All would have adhered to some version of Brecht's maxim, put to music in collaboration with Hanns Eisler: 'change the world – it needs it!'

All of this emerged under the influence of the seismic political changes in the aftermath of the First World War. In November 1918, Germany, on the verge of military humiliation, underwent an abortive socialist revolution, which wasn't wholly suppressed until 1923, after a five-year period of chaos, punctuated by invasions, Communist, military and fascist coup attempts, mass political violence and hyperinflation. In 1917, two revolutions in Russia overthrew first an age-old absolute monarchy, and then the centrist Provisional Government, instituting a regime in St Petersburg and Moscow committed to fomenting a World Revolution. Mass parties were under its substantial control in Germany, Czechoslovakia, France and elsewhere. In Hungary, for several months in 1919, a Communist Republic of Councils ruled from Budapest, enthusiastically supported by modern artists. New independent states were created by the treaties with the defeated powers of Germany and Austria-Hungary, and by the collapse of the Russian Empire. In Central Europe, these states included the newly separated Austria and Hungary, of course, but also the new union states of Czechoslovakia and Yugoslavia; straddling the historic centre and east of Europe were a reconstituted Poland and an expanded Romania, with the new states of Finland, Lithuania, Latvia and Estonia.

The epicentre of this 'new civilization', the Weimar Republic that ruled over most of Bismarck's recently unified German Reich, was unstable from the start; as early as the 1950s, the Polish avant-garde filmmaker, publisher and writer Stefan Themerson was having to correct the romantic ideas young people had of the Weimar Republic, those who 'think about the famous Twenties as if they were an Artistic Paradise, a kind of Glorious Technicolour where young poets were cushioned on soft pink sofas and asked to recite their abstract poems to immense, enthusiastic crowds, here and there gently sprinkled with a

war widow, a (perhaps temporarily unemployed) war hero, and a war orphan. Well it was not so.'² The Hungarian painter Imre Hofbauer, who lived in Berlin, Prague and Budapest before escaping to London, recalled the Weimar Republic in 1948 in a monograph on the Dadaist George Grosz:

> For the first time [Germans] had freedom. But they did not know how to be free. They did not know what to do with their new Constitution. They were like freed slaves, all at sea because they were free. Their civilisation had been shattered. Their literature, architecture, art, methods of manufacture, monetary system, in fact, their whole being was shaken to the core in consequence of the upheaval of war.³

These new freedoms might have been embraced by an avant-garde, but this was storing up a counter-reaction – which, after the Great Depression hit Germany at the end of the 1920s, became a flood of racism, ignorance and conspiracy theory, overwhelming this half-hearted attempt at a rational liberal republic. As the Stuttgart lawyer-turned-painter Fred Uhlman realized, the German modernists, liberals and social democrats 'had been living in a fool's paradise. I had not believed it possible that millions of Germans, who quoted Goethe and Schiller and so proudly described their nation as *ein Volk von Dichtern und Denkern*, a nation of poets and thinkers, could fall for such a farrago of nonsense, the "diarrhoea of undigested ideas", of a Hitler.'⁴

But this wave of reaction spread well beyond Germany. In the early 1930s, the Soviet Union first slowly, then harshly repudiated the artistic avant-garde it had incubated, ironically mirroring the way in which the National Socialists loathed these 'Judeo-Bolshevik' movements, repressing them as they came to power in January 1933.⁵ Although these were the most dramatic clampdowns, a similar process happened across Central and Eastern Europe. After brief democratic experiments, all of the new states – except for Czechoslovakia and Finland – had become right-wing, antisemitic dictatorships by the mid-1930s, as of course had Germany. Britain had its upheavals – the Irish War of Independence, 1919–21, the General Strike of 1926, two brief Labour governments undone first by the secret services and then by the Great Depression – but compared with the social and political avalanches happening between Cologne and Moscow, it was untouched.

Each of the wars, revolutions and coups in this zone created thousands of refugees, and the political crises would often follow on from each other. It wasn't at all unusual for an artist living in Britain in 1939 to have lived during the previous decades in Budapest, Berlin, Vienna, Prague, Paris and then Amsterdam, before making their way to London. Conservative and liberal 'White' Russians fled between 1917 and 1921 to Paris, Berlin, Belgrade, Sofia, Harbin and Shanghai. Socialist Hungarians fled the violent suppression of the 1919 Republic of Workers' Councils, usually to Vienna or Berlin. But these were followed by much larger migrations in the face of, first, the Nazi seizure of power in Berlin in 1933 – the concentration camps were opened within days, and were first filled with Communists – then the bloody overthrow in 1934 of the enlightened Social Democratic local government of 'Red Vienna' by the Catholic Fascist central state. This led to people who had escaped from Berlin to Vienna fleeing in turn to Paris or Prague. In 1938, Prague was also no longer safe, as Nazi Germany first chopped away at and then fully absorbed Czechoslovakia, mere months after liberal, conservative and apolitical Jewish Austrians who had remained after the coup of 1934 fled the *Anschluss*, the annexation by Germany. Those who thought it was possible to stay in Nazi Germany and hope for the best were horrified by the events of 1938, particularly the state-orchestrated pogrom of *Kristallnacht* in November. Relatively few refugees from Italian Fascism or from the Spanish Civil War of 1936–9 made it to Britain, but the Second World War itself, particularly with the fall of Warsaw in 1939 and the fall of Paris in 1940, brought many anti-Nazi Czechs, Slovaks and Poles to this country, many of whom went on to fight in Allied armies.

Overall, around 100,000 Central European refugees made their way to the United Kingdom between 1933 and 1940. This was a smaller number than many other countries had taken, and the United States was always the preferred destination for most refugees. Very few would have considered Britain their first choice. For Fred Uhlman, travelling further and further away from the obscurantist Reich that ruled over his home country, Britain was simply an unknown zone, 'a happy isle of lotus eaters'[6] which had somehow sat out the twentieth century. The ignorance was mutual: 'I arrived in England on the 3rd September, 1936, but if it had been China I could not have known less about the country which was now my second home.'[7] Because of this huge cultural, if not geographical distance, it has been argued that the people who

came to Britain were disproportionately conservative, and unrepresentative of the more radical strains of interwar Central European culture. Whether this was really true we'll explore over the course of this book, but one inescapable fact is that fairly few figures of the first rank from the Berlin-Budapest-Vienna-Prague-Warsaw culture of the 1920s and 1930s – often summarized, not wholly accurately, as 'Weimar Culture' – made it to Britain or, even less, stayed long-term. An extreme example is Sigmund Freud, who came to London in June 1939 when he was already dying, and who with his architect son Ernst transformed a Hampstead house into a replica of his Vienna apartment. Some refugees were in England for just a few months, like the brilliant playwright, poet and ideologue Bertolt Brecht, or weeks, like the luxury-modernist architect Mies van der Rohe. Some stayed for a few years before leaving for the United States just before the war began: this category included major figures in the Bauhaus school such as Walter Gropius, László Moholy-Nagy and Marcel Breuer, and the philosopher and main figure of the Frankfurt School, Theodor Wiesengrund Adorno. Many remained in Britain during the war, but left afterwards, for East or West Germany or America, such as Naum Gabo, the photomontage artist John Heartfield, or the radically opposed economic historians Karl Polanyi and Friedrich Hayek. Some lived in England for many years without attracting much attention, and died in poverty, like the Dadaist Kurt Schwitters.

Of the truly globally important cultural figures of the time, one can make a very short list of those who genuinely *settled* for the rest of their lives in Britain: this would include the novelist Arthur Koestler; the historian Isaac Deutscher; the novelist and critic Elias Canetti; the philosopher Ludwig Wittgenstein; the psychoanalyst Melanie Klein. Previous fame was irrelevant – the famous critic Alfred Kerr, once so feared that the Viennese journalist Hilde Spiel recalled an actor spontaneously vomiting when spying him in the audience, struggled in England; but Alfred's teenage daughter Judith became one of the best-loved children's book authors in the English language. The Czech architect Jacques Groag never designed a single permanent building during over two decades in Britain; but his younger, previously unknown wife Jacqueline (born Hilde Pick) became a very successful textile designer, creating modernist fabrics for the fashion industry and maquettes for London Transport. Then there are those who arrived as youths and went on to become major figures as adults, like the painters Lucian Freud and

Frank Auerbach, or the historians Eric Hobsbawm and Ernest Gellner. Perhaps the most important were those who arrived as adults with some reputation, but whose major work was created in Britain. This category includes the majority of those whose work is most appreciated over here, such as the art historian Ernst Gombrich, the architects Ernő Goldfinger, Walter Segal and Berthold Lubetkin, the photographers Bill Brandt and Edith Tudor-Hart, the art and architecture historian Nikolaus Pevsner, the filmmaker Emeric Pressburger, the muralists Feliks Topolski and Hans Feibusch, the urbanist Ruth Glass, the novelist and travel writer Sybille Bedford, and the philosopher Karl Popper.

Many of these people became so integrated into British life that their foreignness, their avant-gardeness, completely disappeared, or seemed to.[8] Wittgenstein, most likely unintentionally, effectively founded British analytic philosophy, with its hostility to abstraction, politics and generalization. Nikolaus Pevsner spent the 1930s and 1940s lobbying for modern architecture and modern design in the face of widespread official indifference and hostility, but he is known to most people as the author of 'The Buildings of England' series, the architectural guides to each county that will tell you everything you need to know about medieval parish churches and Victorian town halls. Generations of British people received their artistic self-education through a copy of Gombrich's *The Story of Art*, a work that effectively stops short just before the avant-garde emerges. More to the point, in many cases the radicalism of the source was often hidden – how many people who have ever picked up one of Thames & Hudson's black 'World of Art' paperbacks will be aware of the roots of its founders, Walter and Eva Neurath, in the interwar experiments in socialist culture of 'Red Vienna'?

For some, this combined prominence and disappearance could be explained by something quite simple. Britain was unappealing for a radical intellectual in the 1930s and 1940s, a combination of smug imperial hegemon and wealthy backwater; this meant that the refugees who remained were those who had some sort of affinity with British quietness and restraint. This was, indeed, the argument of some of the emigrants themselves: in his 1954 autobiography *The Invisible Writing*, Arthur Koestler related that:

> I have found the human climate of England particularly congenial and soothing – a kind of Davos for internally bruised veterans of the

totalitarian age. Its atmosphere contains fewer germs of aggression and brutality per cubic foot in a crowded bus, pub, queue or street than in any other country in which I have lived.[9]

Accordingly, Koestler decisively 'chose' Britain:

> Up to this turning point, my life had been a phantom-chase after the arrow in the blue, the perfect cause, the blueprint of a streamlined Utopia. Now, with unintentional irony, I adopted as my home a country where arrows are only used on dart-boards, suspicious of all causes, contemptuous of systems, bored by ideologies, sceptical about Utopias, rejecting all blueprints . . . enamoured of its leisurely muddle, incurious about the future, devoted to its past . . . I was even more intrigued by the English attitude to the outside world, which I summed up in a maxim: 'Be kind to the foreigner, the poor chap can't help it.'[10]

But the near-seamless assimilation that accounts like these represent was the basis for an influential attack on almost the entire generation of exiles by the young Marxist historian Perry Anderson, published in the *New Left Review* in the mythic year of 1968. In 'Components of the National Culture', Anderson lamented the 'mediocre and inert' culture of 'the most conservative major society in Europe'. This hidebound environment had been changed to some degree by the 1960s, because 'in this intensely provincial society, foreigners suddenly became omnipresent'.[11] Yet if those who went from Berlin to New York, Moscow, Shanghai, Ankara or Tel Aviv brought their revolutionary culture with them, this wasn't the case for London. 'The wave of emigrants who came to England in this century were by and large seeking refuge from the instability of their societies,' wrote Anderson, and 'England epitomised the opposite of all this: tradition, continuity and orderly empire', with a 'culture [which] was consonant with this special history'. As a result, 'a process of natural selection occurred, in which those intellectuals who had some elective affinity to English modes of thought and political outlook gravitated here. Those refugees who did not went elsewhere.'[12]

Not everything in this stands up to scrutiny so many decades later. Anderson deliberately excised the arts from his survey; and while he correctly noted the large number of 'Austrians among those who chose Britain', his dismissal of Vienna – the centre between 1919 and 1934

of the most developed socialist culture in Europe – as a heartland of 'parish-pump positivism' was unfair. Follow the Austrian tradition in another direction and you end up not at the exam-question trivialities of Oxbridge analytic philosophy but at the radical internationalism of the Isotype pictorial language devised by Otto and Marie Neurath.[13] But the question remains. Why is it that, say, Ernst Gombrich and Karl Popper, self-proclaimed defenders of bourgeois culture, came to embrace British life, whereas aesthetic and political revolutionaries such as Bertolt Brecht (a lifelong Anglophile who loved Samuel Johnson and Jacobean drama) and Theodor Adorno (who lived in Oxford for several years) did not? According to Anderson, it was because for the likes of Gombrich or Popper, 'England was not an accidental landing-stage on which these intellectuals found themselves unwittingly stranded ... it was a conscious choice, as the antithesis of everything they rejected.'

These figures were especially hostile to grand ideologies and 'general ideas', something that could be seen in Popper's vehement rejection of all systematic political philosophy from Plato to Hegel to Marx, and in Friedrich Hayek's elevation of nineteenth-century British free-trade capitalism into a trans-historical model, precisely *because* it was based on accident. 'Established English culture,' wrote Anderson, 'naturally welcomed these unexpected allies.' Not only did they '[reinforce] the existing orthodoxy', they also 'exploited its weakness'[14] – they told the British establishment what it wanted to hear. But these minds, sharpened by the universities of Berlin, Vienna and Prague, were intellectually much more formidable than the flabby existing cadre of Oxbridge.

These successes rested on the failures of other, more radical refugees. Anderson's major example was the Polish-Jewish biographer of Trotsky and Stalin, Isaac Deutscher, 'the greatest Marxist historian of his time' anywhere in the world, who had lived in Britain since the 1930s but had 'never secured the smallest university post'.[15] What we now know, and Anderson didn't, is that this was because of the specific lobbying of Sir Isaiah Berlin, the quintessential liberal exile, raised in Riga and St Petersburg, who had fled at a young age with his parents from the Russian Revolution; Berlin felt an obsessive hatred of Deutscher and his unrepentant Marxism, and blocked his projected appointment at the new University of Sussex in the 1960s, something Anderson could not have known at the time.[16] Another example he cited was the Hungarian Marxist art historian Frederick Antal, who was similarly 'kept outside

the university world'[17] due to his politics. Even those places where Britain didn't seem at all backward were deceptive, according to Anderson. He explained that the Freudian psychoanalytic establishment moved almost in toto from Vienna to London at the end of the 1930s and stayed there – with Anna Freud and Melanie Klein leading rival schools of analysis from different corners of Hampstead – because psychoanalysis was successfully 'sealed off as an esoteric enclave, a specialised pursuit unrelated to mainstream "humanistic" concerns'.[18] The familiar narrative that Britain was made more international and less parochial by Central European intellectuals was totally reversed by Anderson – for him, the emigration into Britain had actually made the country *more* parochial, not less, by giving its 'eccentric' conservatism the seal of continental intellectual approval.

However, expanding out from Anderson's 'humanistic' disciplines of philosophy, economics and history, into art, architecture, theatre or literature (let alone the natural sciences), it's easy to see that a 'red' rather than a 'white' emigration made the most significant impact. British modern architecture, for instance, roots itself in two émigré founding fathers: Berthold Lubetkin, born in Tbilisi to Polish Jewish parents and educated in Moscow at the 'Soviet Bauhaus', VKhUTEMAS, the state art and technical school founded in 1920, and the Budapest-born-and-raised, Paris-educated Ernő Goldfinger. Both were very public Marxists who were extensively employed by governmental bodies. But Anderson's critique pointed to something real: the complex romance between these continental migrants and the island they were washed up upon. If you found the place unappealing, you naturally would move on somewhere else, whether to the United States, Palestine or what was left of 'home' after the war. But if you felt an affinity, what kind of country was it you were admiring?

3
A Desert Island

Great Britain, as seen through the eyes of these newly arrived refugees, is as alien to us now as it was to them at the time. Irrational but clean and pleasant, with everything in its place and everything working smoothly; insular and monocultural; cold and emotionless. The only thing in their accounts that hasn't changed (rather, has intensified) is the poor housing and the constant damp.

Fred Uhlman's comparison of Britain to 'China' for a visitor from Stuttgart notwithstanding, there have been numerous times in which Britain and the countries of Central Europe have had a close, interrelated dialogue. It could be traced as far back as the mid-Victorian era, with a German Prince Consort decreeing the creation of an 'Albertopolis' of artistic and scientific institutions in South Kensington to emulate the centralized public patronage of a Munich or a Berlin; the innovative turn-of-the-century Glasgow architect Charles Rennie Mackintosh had an eager appreciation society in Vienna; and by 1900 there was a widespread English ruling-class fear – now reckoned by economic historians to have been largely needless[1] – that Germany was overtaking Britain in technological and industrial expertise. But curiously, the Germany that is now probably most mythologized and celebrated, the country's cultural explosion between 1918 and 1933, was probably the Germany in which there was *least* British interest at the time.

John Willett, the British art historian and translator who did more than most to explain this German culture to British readers during the 1960s and 1970s, recalled in the 1980s that 'scarcely anybody in England' was interested in Expressionism during the 1930s and 1940s, while 'the socially advanced wing of *Neue Sachlichkeit* seemed positively detestable'.[2] In his great study of the radical side of Weimar Culture, *The New Sobriety*, Willett ascribes this to British Francophilia,

and to something specific to that culture in the first instance – the fact it was collective and deeply politicized, with no room for 'art for art's sake', and with less role for the individual 'genius'. Weimar had dozens of brilliant artistic groups, institutions and publications, but it produced no Picasso. Willett is categorical that when he first became aware of this culture at the end of the 1930s – in both Germany and his initial enthusiasm, Czechoslovakia – it was considered an eccentric, puzzling thing to care about.

Revisionist historians have snipped at the familiar notion of interwar Britain as a culturally conservative enclave distant in mind from continental Europe and implacably hostile to avant-garde ideas, but they have never quite managed to destroy it.[3] One reason for this is the overwhelming evidence, in nearly every account by a European visitor, of what it was like to arrive here from the rest of Europe in the 1920s and 1930s. For artists, the change was particularly alarming. The photomonteur and sound poet Kurt Schwitters, who eventually found his last home in a barn at Elterwater in the Lake District, declared 'nobody in London cares about good art'[4] – though the genial Dadaist made an exception for the Anarchist art historian and polymath Herbert Read. In his 1932 book *The Spirit of London*, the Austrian artist and travel writer Paul Cohen-Portheim, who understood Britain better than most, warned aesthete visitors to expect 'faultless but conservative taste'. In the West End, they'd discover that:

> St. James's is a centre of art, but of old, well-established, and recognised art only. You will see magnificent Chippendale chairs and cabinets, Chelsea china, and perfect mezzotints, Queen Anne silver, and Chinese porcelain; you will see pictures by the great painters of Italy and Holland, by Reynolds and Gainsborough – but you will look in vain for a Picasso or the products of the Bauhaus Dessau.[5]

On his arrival in Britain in 1934, the Bauhaus director Walter Gropius was appalled by the weather and the tasteless food. Yet he was also relieved when what he took to be something familiar from Nazi Germany turned out to be innocuous – as when he discovered that what he had feared was propaganda ('TAKE COURAGE', 'WELCOME TO THE STRONG COUNTRY') on the roads and streets was merely beer advertising.[6] Art historians keen today to stress the importance of

their pet eccentric English enthusiasms, be they the woodcuts of Eric Ravilious or the buildings of Edwin Lutyens, must grapple with the fact that the European artists, designers and architects of the first half of the twentieth century found these parochial and puzzling, if they noticed them at all. The engineer Ove Arup, born in Newcastle to Scandinavian parents, had studied in Denmark and worked in Hamburg before he returned to England in 1923. He would proceed to work on many of the most important buildings of the twentieth century, but he found that 'In London I had to adjust to a completely different intellectual climate – it was like stepping 50 years back in time.'[7]

The exiles were primed for this by several books published on 'the continent' during the 1920s and 1930s, which stressed just how alien Britain was to conventional European sensibilities. For Cohen-Portheim, the title of his 1930 book, *England, The Unknown Isle*, was significant; the Dutch historian Gustaaf Johannes Renier published a widely read book in 1931, *The English: Are They Human?* The sensibility of the Central European avant-garde was similarly struck by English oddness and insularity. The great science-fiction writer and sponsor of abstract art Karel Čapek, very approximately a kind of Czech H. G. Wells, published his *Letters from England* in Prague a few years earlier, in 1924. In it, you can see all the tropes of Exotic England analysis, which combines paradoxical extreme modernity with great conservatism, uniformity with individualism. As his boat-train passes through the towns and suburbs of Kent:

> At last the train bores its way between houses of a curious sort; there are a hundred of them entirely alike; then a whole streetful alike; and again, and again ... the train flies past a whole town which is beset by some terrible curse; inexorable Fate has decreed that each house shall have two pillars at the door. For another huge block she has decreed iron balconies. The following block she has perpetually condemned to grey bricks. On another mournful street she has relentlessly imposed blue verandahs. Then there is a whole quarter doing penance for some unknown wrong by placing five steps before every front door. I should be enormously relieved if even one house had only three; but for some reason that is not possible. And another street is entirely red ... I thank Heaven that I did not have fifty dreams alike, one after the other. I thank Heaven that dreams at least are not turned out wholesale.[8]

Much of the alienation derives from the way that these uniform streets are not where social life appears to be taking place. Čapek looks constantly in vain for any signs of urbanism, for people living some kind of identifiably urban existence out on the streets, and does not find it:

> The London streets are just a gulley through which life flows to get home. In the streets people do not live, stare, talk, stand or sit; they merely rush through the streets . . . in Italy, in France, the street is a sort of large tavern or public garden, a village green, a meeting-place, a playground and theatre, an extension of home and doorstep; here it is something which belongs to nobody, and which does not bring anyone closer to his fellows.[9]

There is in fact a pervasive fear of a 'continental' urbanism, and despite – or because of – the terrifying uniformity of English streets, no sort of modernist 'ballet of the street' will be found in them. 'In our country a man thrusts his head out of the window, and he is right in the street. But the English home is separated from the street not merely by a curtain in the window, but also by a garden and a railing, ivy, a patch of grass, a door-knocker and age-old tradition'.[10] For Čapek, the alienation also extends to the strange way in which the city interacts with its countryside – not a place of production, as it is in his native Czechoslovakia, but something ornamental, just like the useless patches of green in front of each of those unnervingly identical houses. Cohen-Portheim makes similar observations about London, but knowing it much better than Čapek, he points out that a very real street life does emerge on the weekends in certain places, in the then largely Jewish district of Whitechapel and in the large towns and cities of the North, where 'promenading' was a distinct activity.

London is also an imperial city, and one in which it is unclear exactly where all the immense wealth of plunder has actually gone, outside of the museums and a few luxury districts. Čapek visits the 'Empire Exhibition' held in Wembley that year, 1924, and is as puzzled by it as by everything else: 'there are four hundred million coloured people in the British Empire, and the only trace of them at the British Empire Exhibition consists of a few advertisement supers, one or two yellow or brown huxters and a few old relics which have been brought here for curiosity and amusement . . . Everything is here, including the stuffed lion and the extinct emu; only the spirit of the four hundred million is

missing.'[11] And yet, while 'if you search in the London collections for ivory carvings or embroidered tobacco-pouches, you will find them; if you search for the perfection of human work, you will find it in the Indian museum and the Babylonian gallery, in the Daumiers, Turners, and Watteaus, or in the Elgin marbles'. Little of this wealth or beauty can be found on those endless, miserable streets. 'You can ride for hours and miles on the top of a bus from Ealing to East Ham, and from Clapham to Bethnal Green; and you will scarcely find a place where your eye could derive pleasure from the beauty and lavishness of human work.'[12] The Frankfurt musician and experimental radio pioneer Ernst Schoen put it all rather more pithily a few years later, in a poem:

A fascinating old woman: England,
London: Millions of tightly compressed
Identical little houses built quickly out of dirt.[13]

So England is not a country much concerned with beauty, especially not in the built environment – but it is one where a sense of order pertained, which was deeply strange to those raised in Central Europe. This difference was obvious even – or especially – to children. Two decades before he would flee Vienna as an anti-fascist intellectual, Elias Canetti, who grew up in Ruschuk (now Ruse), Bulgaria, briefly lived in Manchester as a child between 1911 and 1913, due to the textile-business connections of his upper-middle-class Sephardic family. 'Everything I witnessed in England at that time fascinated me with its order,' he remembered in the 1970s. 'Life in Ruschuk had been loud and fierce, and rich in painful accidents', but going to school in suburban Manchester was quiet, predictable and rigid.[14]

Perhaps the most vivid description of a sudden change from the interwar continental environment to that of 1930s England comes in the autobiography of a British historian raised in Alexandria via Vienna and Berlin, Eric Hobsbawm. In *Interesting Times*, Hobsbawm gives us first the breathless rush of his last memories of pre-Nazi Berlin, when, as a teenage Communist, he took part in the last legal demonstrations of the German Communist Party (KPD) and hid the printing press of the Communist School Students League in the family home (as he and his family had British citizenship, he was not at risk). 'Next to sex, the activity combining bodily experience and intense emotion to the

highest degree is the participation in a mass demonstration at a time of great public exaltation . . . the occasion has remained unforgettable.' He sketches out his memories of Weimar Culture – not, he is keen to point out, a 'youth culture', for all its modernism, but something communal, cross-generational and to an extent cross-class. But most of all, Hobsbawm wanted to stress the shattering event of proudly being in the Communist crowd for the last days of Weimar Germany. 'What I can remember,' he writes, 'is singing, with intervals of heavy silence'. The songs ranged from the 'Internationale' to 'Red Wedding' by the great Communist composer and Brecht collaborator Hanns Eisler, a song named after the most strongly Communist Berlin district. 'When, in British isolation two years later,' Hobsbawm continues:

> I reflected on the basis of my communism, this sense of 'mass ecstasy' (*Massenekstase*, for I wrote my diary in German) was one of the five components of it – together with pity for the exploited, the aesthetic appeal of a perfect and comprehensive intellectual system, 'dialectical materialism', a little bit of the Blakean vision of the new Jerusalem and a good deal of intellectual anti-philistinism. But in January 1933 I did not analyse my convictions.[15]

What followed was like a cold shower. He was now in an immense, apparently endless suburban city, the capital of what was 'in 1933 still a self-contained island where life was lived by unwritten but compelling rules, rituals and invented traditions'.[16] Some distance now from the marching workers of Berlin, believing (tragically, utterly wrongheadedly) that they were on the verge of power in 1932 and 1933, the teenage Hobsbawm's encounters with the British working class were 'disappointing, but also puzzling'.[17] Europe's most advanced and oldest capitalism had created not an insurgent class 'for itself', but a proletariat that was both intensely class conscious and far from revolutionary. Ultimately, 'by 1932 Berlin standards, London seemed a relapse into immaturity',[18] both for Hobsbawm himself, who went from being an aspiring revolutionary cadre in a city in ferment to just another middle-class English-school student; and more generally, the country came across as culturally, if not technologically, *backward*.

When émigrés began to arrive in larger numbers, they were amazed by London's vastness, alternately alarmed and comforted by its placidity

and ignorance – and frequently appalled by its weather. The Viennese Social Democrat, journalist and novelist Hilde Spiel wrote of her excitement on arrival at how genuinely international London seemed compared to anywhere in Central Europe – this was the hub of a global empire, and looked it, especially in 'Piccadilly Circus with its statue of Eros, from which invisible threads appeared to radiate in all directions as far as the Antipodes ... and everywhere the milling crowd of exotic figures, splendidly dressed Indians and African tribal chieftains'. She was simply 'overwhelmed by the sheer size and diversity of the city',[19] but had an absolute horror of the weather, in her first December in London, 1938:

> A winter without snow. And yet I feel the cold more than I ever did in Vienna. Fog, drizzle, rain, gales. The damp cold penetrates through all the cracks, through all our pores; the sliding windows let in a draft; a skylight in the bathroom stays immovably open; the radiant heaters in the fireplaces formerly used for coal hardly warm the rooms; there is a musty smell throughout the house.[20]

That smell recurs in the memoirs of Stefan Zweig, a popular middlebrow novelist who was forced out of Vienna to London at the end of the 1930s: 'that curiously acrid, dense, damp atmosphere that wraps itself around you when you come close', which hit him as he disembarked from Victoria Station.[21] The feeling was not always negative, by any means. The Danzig-born, Berlin-based socialist psychologist Charlotte Wolff, a close friend of Walter Benjamin, arrived in 1935: landing 'on a misty October day', she recalled decades later:

> The feeling which got hold of me after I had set foot in Dover can only be described as a sense of enchanted unreality. On boarding the train to London, I had a feeling of liberation redolent of my flight from Berlin after we had left the German frontier at Aachen. The comfort of the compartment, the quiet voice of the waiter, acted like a tranquillizer. His courtesy was enhanced by the quietness of the passengers, who seemed to be engrossed in reading newspapers, or just sat still. No noise, no unnecessary words or movements disturbed the peace of this English train. Silence is bliss to strained nerves.[22]

4
Good-Day to Berlin

A picture of mutual uninterest between 'Weimar Culture' and Britain is largely accurate during its actual lifespan. One can list in a couple of paragraphs most of the British people and institutions between 1918 and 1933 who took a great interest in Central European culture. Leonard and Virginia Woolf's Hogarth Press were early adopters of Viennese psychoanalysis and translators of it. In 1926, the Northampton toy-maker and industrialist W. Bassett-Lowke had the German proto-modernist Peter Behrens replace his earlier house by Charles Rennie Mackintosh with a very modest white-walled villa; this house influenced a small estate of modern houses by the Scottish architect Thomas Tait for the workers of the Crittall Windows factory in Silver End, Essex. *The Studio* magazine maintained a passing interest, and commissioned the Expressionist utopian turned housing architect Bruno Taut to write a series of articles, published in 1930 as a book, *Modern Architecture*, the first of its kind in English. British enlightened planners were aware of the monumental housing schemes of 'Red Vienna', and occasionally commissioned reduced versions of them such as the Ossulston Estate in Somers Town, north-west London.

When it came to art, the Dutch bookseller Zwemmer's, in Charing Cross Road, would stock volumes from the *Bauhausbook* series. London Transport under Frank Pick, various state propaganda boards under the enlightened imperial bureaucrat Stephen Tallents, and the advertising agency Crawford's all kept an eye on German, Dutch, Czechoslovak and Soviet developments in design. British cinema wasn't wholly uninterested in German Expressionism, with the director E. A. Dupont being hired to make the film *Piccadilly* in 1929. The more politically risky Soviet cinema was heavily censored in England but found supporters in the new London Film Society, run by the producer Sidney

Bernstein and the aristocratic Communist, critic and screenwriter Ivor Montagu – which counted the young Michael Powell and Carol Reed among its members. Among critics, Herbert Read did not share in the conventional dismissal of German art, and even the francophile Bloomsbury critic Roger Fry was aware something was happening in art history out there, having attempted to publish the Munich-based Swiss aesthetician Heinrich Wölfflin. Evelyn Waugh knew enough about Weimar modernism to include a caricature Teutonic functionalist architect in his first novel, *Decline and Fall*, in 1928. Much earlier, in 1914, Wyndham Lewis and his Vorticist group had some awareness of Expressionism and early Constructivism, and part of *On the Spiritual in Art* by the future *Bauhausler* Wassily Kandinsky was translated in their journal *BLAST*. During the 1920s, Lewis's solo journal *The Enemy* was the only British publication that even approximately resembled the continental avant-garde 'small magazines' of the time like *G*, *Merz*, *ReD*, *Zenit*, *Litterature* or *LEF* – but Lewis himself, who spent a long sojourn in Germany in 1931, was in his infinite wisdom inspired to publish a book in praise of Hitler, who himself was soon to do his best to eradicate this culture. So, while there was not an *absolute* disconnection, there was remarkably little engagement given the geographical proximity.

This changed in the 1930s, at least partly in consequence of the emigration, but also because people had come of age who were aware something had been happening on the continent, east of Paris. In terms of publishing, the new Left Book Club published many German and Austrian exiles, while the similarly newly established Penguin Books both borrowed shamelessly from Weimar book design and publicized Central European struggles through its series of Penguin Specials on current affairs. From the early 1930s on, London-based architects such as the Canadian Wells Coates and the New Zealanders Amyas Connell and Basil Ward began to develop a truly modern type of architecture. The circle around the *Architectural Review* formed a welcoming party for Weimar émigrés, with an enthusiasm for their work that for the moment even touched vehemently parochial Little Englanders such as the poet John Betjeman and the cartoonist Osbert Lancaster. The creation of the Courtauld Institute of Art in London by the bequest of a Manchester industrialist in 1932 created Britain's first centre for art history, which would welcome many Weimar scholars. In the second half of the 1930s, émigré abstract artists and sculptors like Gabo and

Piet Mondrian would be embraced by a Hampstead scene that now included both highly original abstractionists such as Barbara Hepworth and Henry Moore, and something new: English modernist epigones, like Ben Nicholson, who had changed his style almost overnight from Bloomsbury daubings to a derivative style redolent of a minor Constructivist painter from Łódź. A similar process of lightning conversion happened to young Neo-Georgian architects like Maxwell Fry.

Certainly, the situation was at its worst for writers. British developments in modernist fiction were well in advance of those in the visual arts – at least if one puts aside the fact that the famed 'Men of 1914' such as Joyce, Yeats, Eliot, Pound and Lewis were either Irish or North American – and this work enthused many Central European avant-gardists. The subtly experimental prose of Virginia Woolf was accorded a respect correctly not granted to her painter colleagues in the Bloomsbury Group; Joyce's *Ulysses* was an exemplar of *montage* for figures such as Sergei Eisenstein and the novelist Alfred Döblin. Ironically, given the language barrier, these British or British-based writers were considerably more familiar to Central European modernists than were contemporary British painters, architects, photographers or filmmakers. But the interest was not reciprocal; with some advanced exceptions, such as the translations by Edwin and Willa Muir of Kafka's novels and short stories and Hermann Broch's Viennese modernist novel *The Sleepwalkers*, Central European modern literature was barely known in England.[1]

Compared with the 1920s, it was at least now clear to many British intellectuals that something had been going on in Central Europe. Because of this, by the time Hobsbawm and Canetti were writing their memoirs, there was a much more fully formed popular idea of what the society they had emerged from looked like. This came substantially through the interpretations of a tiny group of British writers who had seen the Weimar Republic and 'Red Vienna' first-hand – Wystan Hugh Auden, Christopher Isherwood and Stephen Spender. The reason they were all in Berlin and Hamburg at the start of the 1930s was very straightforward. As Isherwood recalled in the least fictionalized of his many memoirs, *Christopher and His Kind*, published in 1976, he had been promised something by Auden, who had moved to Berlin as early as 1928. 'It was Berlin himself he was hungry to meet: the Berlin Wystan had promised him. To Christopher, Berlin meant Boys.'[2] Similarly, *The Temple*, Stephen Spender's then unpublishable 1929 novel of sexual

self-discovery – with a sideline in architectural discovery, featuring plenty of scenes in clean-lined modernist villas and references to 'the Bauhaus in Dessau' – features a thinly disguised Auden making much the same recommendation. 'Germany's the Only Place for Sex. England's No Good.'[3]

Some in the circle were later to regret they didn't get to go to Paris instead, where they might have got to meet Picasso and the Surrealists, but the sexual libertarianism that was one outcome of the German Revolution of November 1918 meant there was no better place in Europe than the Weimar Republic to be a gay man (like Auden and Isherwood) or a bisexual one (like Spender). Not only were homosexual acts legal, there were socialist lobby groups such as Magnus Hirschfeld's Institute for Sexual Research that actively fought for the rights of what would, decades on, be known as LGBT people; Isherwood briefly worked for the Institute, as did future émigrés in London such as Arthur Koestler and the psychologist and lesbian activist Charlotte Wolff. The sexual attraction of the Weimar Republic to Auden, Isherwood and Spender shouldn't be regarded as sub-political – rather, for them sex and politics were deeply intertwined. Each of them would do all they could to aid refugees, marrying them if necessary. But it was almost by accident that these three otherwise very typical and conventional public-school champagne socialists were initiated into Weimar Culture. Isherwood in particular gave us the most famous representations in *Mr Norris Changes Trains* and *Goodbye to Berlin*, especially the story 'Sally Bowles', published as a novella by the Hogarth Press. Like the filmmakers Dziga Vertov or Walter Ruttman, Isherwood aimed to record with a 'Kino Eye', objectively recording the 'decadence', sexual freedom, cynical humour, scything satirical art and political unrest he found purely incidentally, while going to Berlin so he could have sex with the men he wanted to without worrying about being jailed for it.

Because of all of this, Auden, Spender and Isherwood saw the advances in modern architecture and design, in music, literature and theatre, and they had a front-row seat to witness the tragic defeat of Weimar's socialist and communist movements and the rise of Nazism. They were able to sympathize with the Weimar Republic's escapees, but ultimately they would remain too ironic and embarrassed to be as radical in their own work as the figures who had inspired them, like Brecht and Toller: something like Isherwood and Auden's *Journey to a War*, a travelogue of the Sino-Japanese war, is very much like the

Footlights trying to do Joseph Roth, and their play *The Ascent of F6* is rather public-school Brecht. It is unsurprising that Auden, Spender and Isherwood experienced an exceptionally brief affiliation with socialism, which they dropped almost instantly with the signing of the Nazi-Soviet Pact of 1939.[4] But it should be remembered that they combined this distant sympathy with socialism together with a moral seriousness and a quiet rage, as exemplified in Auden's great poem in memory of Ernst Toller, the anarchist playwright who, just days before leaving New York for London, hanged himself in May 1939, when 'the Europe which took refuge in your head' had 'Already been too injured to get well'.[5]

Isherwood's *Prater Violet*, a roman-à-clef about his collaboration in 1934 with the Austrian Expressionist screenwriter and director Berthold Viertel on the flop film *The Little Friend*, provided a picture of these Weimar refugees that was both gently mocking and genuinely tragic. Viertel, aka 'Bergmann', is obsessed with the political effects of the English weather, which he sees as the cause and consequence of indolence and ignorance: 'It is the English themselves who have created this fog. They feed upon it, like a kind of bitter soup which fills them with illusions. It is their national costume, clothing the enormous nakedness of the slums and the scandal of unjust ownership.'[6] This jolly-foreigner bit suddenly becomes harrowing when Bergmann finds himself marooned in Britain during the last doomed struggle of 'Red Vienna' in 1934, as the famous Karl-Marx-Hof was literally besieged by the Austro-Fascists in their coup d'état:

> The great modern tenements, admired by the whole of Europe as the first architecture of a new and better world, were now described by the Press as 'red fortresses' and the Government artillery was shooting them to pieces ... Bergmann listened angrily to every news-broadcast, bought every special edition. During those first two days, while the workers still held out, I knew that he was hoping against hope. Perhaps the street fighting would grow into a revolution. Perhaps International Labour would force the Powers to intervene. There was just one little chance: one in a million. And then there was no chance at all.[7]

But the English, of course, did not understand what this meant, nor did they comprehend the importance of first Germany and then Austria becoming fascist, antisemitic, antisocialist dictatorships. How could they, in their insulated little island?

5

Luxury War for Aliens

Many of the exiles saw themselves as bearers of uncomfortable truths, bringers of bad news to an island which was fundamentally uninterested in anything much that happened on the other side of the English Channel, so long as it didn't impinge on its vast intercontinental empire. Again, it won't do to exaggerate too much that insularity – Britain at this time had a Fascist movement, which though never on the scale of those of Central Europe, successfully gained the support for a time of a mass-circulation daily (the *Daily Mail*), while large swathes of the country – especially the north-east of England, Central Scotland and South Wales – were still suffering from the Great Depression at the end of the 1930s. Communism, while never a mass movement in the United Kingdom, made significant inroads in some close-knit impoverished areas, such as mining villages in Scotland, Yorkshire and Wales, and in the slums of London's East End; it also had much more influence on Britain's approximation of an intelligentsia in the 1930s than it had in the previous decade. But the impression that Britain's political culture made upon many of the Weimar exiles was still of somewhere that could not truly understand the terrifying scale of what was happening or what was at stake in Europe, and could not be relied upon to properly mobilize against it. As Koestler put it, 'the only mitigating circumstance' for the negligence of somewhere like Britain, whose government alternately supported, ignored and appeased Hitler right up until the eve of war, 'was of a psychological nature'. That is, that the sheer magnitude of the Nazi evil simply 'sounded like something straight out of science fiction' to the British public, so they refused to believe in it until it was too late.[1]

Koestler's hectoring, understandably bitter memoirs, written in the 1950s, come back to this point again and again – alternately finding Britain's ignorance attractive and frustrating. Koestler, a bully and rapist

who was, by the time of writing a vehemently anti-Communist novelist and essayist, had been a roving Communist journalist in the Weimar era and the immediate years after. In his capacity working for the many-pronged apparatus of the Comintern's media mastermind Willi Münzenberg, he had seen the fall of the Weimar Republic, the famine inflicted upon Soviet Ukraine, the crushing of 'Red Vienna', the disastrous referendum campaign that handed the Saarland to Nazi Germany in 1935, and the Spanish Civil War, where he finally became unable to stomach the brutal political chicanery of the USSR and its subordinate parties. Coming to Britain – among other things to promote his Left Book Club volume on that civil war, *Spanish Testament* – he was charmed and maddened by how much Britain seemed to have stood wholly apart from this bloodbath. At first, Koestler was pleasantly surprised that even the British Communists were merely silly rather than being sinister: 'they were English in the first, Communists in the second place, and I found it difficult to take them seriously. Their meetings, compared with those on the Continent, were like tea parties in the vicarage; they put decency before dialectics and, even more bewilderingly, they tended to indulge in humour and eccentricity.'[2]

When the war broke out, this incomprehension actually continued. Judith Kerr, the Berlin-born-and-raised children's book author and daughter of the much-feared Weimar theatre critic Alfred Kerr, wrote about this in the second volume of her fictionalized memoirs, *Bombs on Aunt Dainty*. Anna, a young art student, now speaking fluent English without an accent, is on a train from London to Cambridge when she is asked, 'Going up to Cambridge for the weekend?', by a wealthy-looking middle-aged woman. They chit-chat about the city, and then the woman asks: 'And where do you come from, my dear?' 'For some inexplicable reason,' Kerr writes, 'she found herself saying, "Berlin", and immediately regretted it.' As Anna proceeds to explain herself, the woman on the train is incapable of understanding what 'anti-Nazi' might have meant, and is particularly baffled that Anna and her family should want Britain to *win* the war:

> 'Against your own country?' said the woman. 'We don't feel that it is our country any more,' began Anna, but the tweedy woman had become offended with the whole conversation. 'I could have sworn you were English,' she said reproachfully and buried herself in a copy of *Country Life*.[3]

This experience of being misidentified and misunderstood – whether you were trying to keep yourself to yourself, like Judith Kerr, or touring around the country giving lectures, like Koestler – was captured most acutely in a short comic poem by Oswald Volkmann, a German-Jewish migrant who escaped Nazism for Birmingham, but who was interned in the Isle of Man as an 'enemy alien' in 1940:

> We have been Hitler's enemies
> For years before the war
> We knew the plans of bombing and
> Invading Britain's shore
> We warned you of his treachery
> While you believed in peace
> And now we are His Majesty's
> Most Loyal Internees.[4]

This experience could be literally maddening, with the refugees as a series of ranting Cassandras dropped in English suburbia, warning of imminent catastrophes that were impossible to believe in – carpet-bombing, concentration camps, genocide – until they happened.

We will turn presently to the placing of refugees from Nazism in *British* camps, but it should first be noted that there were efforts made to convince those in power in Britain that the experiences and knowledge of these 'aliens' would be useful in a war against the fascist empire from which they had narrowly escaped with their lives. The 1940 book *Germany: Jekyll and Hyde* by the liberal German journalist and *Observer* contributor Sebastian Haffner – a passionate historical account of the internal politics of Nazi Germany and how such astonishing nonsense and extreme violence had come to be accepted by a large part of its population – was written specifically in the hope that it would be read in the corridors of power (and it did apparently gain the interest of Churchill). Haffner had the experience common to so many prominent émigrés of being ignored. When it came to the thousands who had escaped and were eking out a precarious life in London, Manchester and Glasgow, legally barred from taking on many jobs and relying usually on charity, Haffner described how this 'ever-swelling stream of men' were described in dehumanizing language by the British press as a flood, a burden.[5] More pointedly, he argued that the ignorance exemplified

by the British public and the British state towards the escapees from Nazi Germany was actively self-defeating when the war began – after all, these émigrés knew Germany better than anyone else. Within a few weeks of this book being published, Haffner found himself, like around 30,000 other Central European refugees from fascism, behind barbed wire on the Isle of Man.

Readers in Britain in the 2020s might have a certain shudder of horrible familiarity on seeing what the *Daily Mail* had to say in the late 1930s about the exiles from Nazism who had found their way to this island. In a 1938 story headed 'GERMAN JEWS POURING IN TO THIS COUNTRY', the paper that had only two years before shouted 'HURRAH FOR THE BLACKSHIRTS!' stated that 'the way stateless Jews are pouring in from every port of this country is becoming an outrage'. This was given an interesting cultural colouring by the *Sunday Express* the same year, which wrote of how, among others, 'Psycho-Analysts', arriving en masse from annexed Vienna, were 'overrunning the country'.[6] It bears repeating that Britain did much less than it could have done. At the Evian Conference on Jewish refugees, held in 1938, Britain, like all other countries involved, refused to come to an agreement to take in those seeking asylum. The British government is sometimes praised for welcoming children and adolescents through the *Kindertransport* programme, ignoring the fact that the parents of most *Kindertransport* refugees were murdered in the next few years.[7] Hostility was generalized, and the ignorance went right to the top, as encapsulated in Neville Chamberlain's immortally stupid words after signing the Munich Agreement with Hitler in September 1938, handing him the Sudetenland, and with it the industrial arsenal of Czechoslovakia, in a speech broadcast live to the BBC:

> How horrible, fantastic, incredible it is that we should be digging trenches and putting on gas masks here because of a quarrel in a far-away country between people of whom we know nothing.[8]

The Sudetenland was, even then, a mere few hours' flight to London for a German bomber plane. It would soon become clear that obviously the refugees were right about something, as their warnings about Nazism were borne out by the failure of the attempt to appease the Third Reich at Munich in 1938. After assuring Britain and France that

it would be content with annexing only the German-speaking industrial highlands of Czechoslovakia, in 1939 Germany annexed the Czech lands of Bohemia and Moravia, set up a puppet fascist state in Slovakia, and, finally, after a pact with the USSR that horrified the many exiles who had allegiance to or sympathies with Soviet Communism, invaded Poland. What happened next didn't suggest that this experience had led to anyone learning much from recent events.

The very word used in the press and the bureaucracy about these émigrés – 'aliens' – was explicitly dehumanizing, suggesting an absolute separation between natives and foreigners, a divide that would be satirized in the famous 1946 guide *How to Be an Alien* by the Hungarian humourist George Mikes. The background to it can be found in Britain's first immigration laws in the early twentieth century, which very quickly changed the country that provided both shelter and indifference to the exiled radicals of the nineteenth century, from Marx to Herzen to Kropotkin to the Paris Communards, into one which was much more legally stringent towards wandering Central and Eastern Europeans. The 'Aliens Act' of 1905 was a response to the fact that increasing numbers of Jewish migrants were arriving in England, from pogroms in the Russian Empire (which included the Baltic states, Ukraine, Belarus and much of Poland). Most were only stopping off on their way to the United States, but many stayed, usually settling in the East End of London, the south side of Glasgow, and northern Manchester. They were usually poor, culturally distinct and Yiddish-speaking – visibly not 'assimilated'. This caused a major moral panic in the British press. The *East London Advertiser* put it with particular thuggery: 'people of any other nation, after being in England for only a short time, assimilate themselves with the native race and by and by lose almost all their foreign trace. But the Jews never do. A Jew is always a Jew.'[9]

This poses the question of why it is that East European Jewish migration became such an issue at that particular time, given that migration – Sephardic Jewish, Irish, Italian, and from the colonial Caribbean, Africa and India – had been tolerated, if not necessarily welcomed, in the nineteenth century. These Ashkenazi Jews had arrived during an economic downturn, leading to migrants being attacked in now-familiar terms, for taking our jobs, changing our culture, and so forth. Class and race were combined in the scaremongering and ensuing cases of panic. The historian David Cesarani has rooted the 'aliens'

furore of the 1900s in the fact that early twentieth-century Jewish immigration coincided with a national sense of crisis, with the threats to the establishment from universal male suffrage and the labour movement intersecting with economic wobbles and increasing competition from other countries (not least, Germany). This multifaceted problem was, many politicians and thinkers proposed, resolvable through some kind of 'social imperialism', in which a divided country would be reconciled through new ideas of cross-class national solidarity and racial superiority; Cesarani coined the phrase 'anti-alienism' to describe these notions of a unified British community inherently threatened by outsiders.[10] The widespread distrust of refugees from Nazism can be explained by the persistence of this anti-alienism into the 1930s. It culminated in the internment of most refugees in 1940.

The number of refugees was initially very small – by the end of 1937, only 5,500 of the 154,000 people who had fled Nazi Germany were living in Britain – and the harsh restrictions of the Aliens Act remained fully in place. Even this tiny number of migrants elicited the ire of Conservative politicians. During a parliamentary debate on 'aliens', the Tory MP for Tottenham North, Edward Doran, asked the House of Commons in March 1933 – the very month the Nazis cemented their power through a rigged election – about the fact that 'hundreds of thousands of Jews are now leaving Germany and scurrying from there to this country'. He asked 'are we prepared in this country to allow aliens to come in here from every country while we have 3,000,000 unemployed?'[11] Doran concluded 'if you are asking for a von Hitler [sic] in this country, we will soon get one'.[12]

Yet in 1938, with *Kristallnacht*, the Anschluss and the British-approved annexation of the Sudetenland, many thousands more were forced to flee their homes, and British policy became a little more humane, with the Home Office deciding to accept more refugees over the objections of MI5, who believed in their infinite wisdom that Hitler was encouraging Jews to move to Britain in order to create a 'Jewish Problem' in Britain. By spring 1939, there were 20,300 adult refugees from Germany, Austria and Czechoslovakia, and 4,800 children, a number that doubled with the outbreak of war; later, at the close of the war, between 7,000 and 8,000 orphaned concentration-camp survivors were admitted.[13] With the exception of many of the Poles, Jewish and otherwise, who arrived in Britain during and immediately after the war, a large majority

of these people were middle class. The government belatedly realized they weren't, unlike in 1905, dealing with penniless arrivals from the shtetls, and directed these new professional arrivals to the 'distressed areas' of the north-east, Central Scotland and South Wales. Hundreds of factories in government-funded industrial estates in places like Team Valley and Trafford Park were owned by recently arrived German and Austrian industrialists. As a consequence, the migration increased levels of *employment*, not unemployment. And some significant forces were aiding refugees – Labour MPs such as Josiah Wedgwood, Sydney Silverman, Philip Noel-Baker, independent MP Eleanor Rathbone, and the Bishop of Chichester George Bell were all prominent supporters, as were the trade unions, the Communist Party, the Quakers, and several British Jewish organizations. An Academic Assistance Council, set up by William Beveridge, and the new popular press like *Picture Post* and Penguin Books (the first of which was set up by émigrés, with the second employing them heavily) were publicly supportive. Maybe English reserve could be helpful after all. The Hungarian Jewish painter George Mayer-Marton, who escaped Vienna with his wife, the pianist Grete Fried, wrote ironically in his diary, as he was processed through the British border-control system in September 1938:

> We observe the English art of 'splendid isolation', their culture of bureaucratic niceties, good manners and cold souls, their complete consideration for others out of consideration for their own peace and quiet.[14]

And then, in 1940, anti-alienism returned with a vengeance, accompanied by the demand that *all* German, Austrian, Czechoslovak and Hungarian citizens in Britain be interned in camps, irrespective of their political record or their race. Internment was the direct consequence of an orchestrated press campaign, which rather tellingly came from much the same newspapers and journals that had the most explicit sympathy with Nazism. On 1 March 1940, the *Daily Mail* wrote of how allegedly 'millions of relatives of men in the fighting forces are perturbed at the latitude allowed to the aliens within our gates'. The article used that whining, nervy, passive-aggressive voice that readers of the *Daily Mail* in the 2020s will know well. Addressing the Home Secretary, John Anderson – initially reluctant to use mass internment – the *Mail* sneered 'the Home Office's childlike belief in the integrity of these people may

imperil our safety. It is not good enough, Sir John.'[15] On 23 March, as the internee and historian Ronald Stent relates, 'the *Daily Mail* published a letter from "Brigadier, Eastbourne", urging that all enemy aliens should be compelled to walk around with armlets showing their country of origin. The Brigadier no doubt got his idea from pictures of Jews walking round Germany with yellow stars pinned to their breasts'.[16]

The European correspondent of the *Daily Mail* at that time was one G. Ward Price, who had written several articles in support of the Third Reich and of the British Union of Fascists (BUF); in 1937 he published a book in praise of Hitler and Mussolini – who he considered to be his friends – *I Know These Dictators*, published by the Foyles-sponsored Right Book Club. Price remained close to pro-Nazi circles right up to the eve of the war. And yet, rather astonishingly, it was Price who led the charge to imprison tens of thousands of (mainly Jewish) anti-Nazis as a way of, apparently, helping to win the war against Nazism. In a *Mail* article on 20 April 1940, he, like many others, pointed to the alleged role of a 'Fifth Column' in the fall of the Netherlands, and screamed at his readers:

> Act! Act! Act! Do it now! The rounding up of enemy agents must be taken out of the fumbling hands of local tribunals. All refugees from Austria, Germany and Czechoslovakia, men and women alike, should be drafted without delay to a remote part of the country and kept under strict supervision.[17]

On 21 June, the *Sunday Express* joined in, warning against the fifth column supporting the fifth column, 'THOSE INFLUENTIAL FRIENDS OF DANGEROUS ALIENS'. For the small journal *TRUTH*, run by Joseph Ball, an MI5 officer, likely originator of the notorious 'Zinoviev Letter', and chair of the Conservative Party, there was no use pointing to the fact that most of these people had just escaped from Nazism, and that as Jews they could not be seriously expected to aid the Third Reich. He coined a phrase to describe these people: the 'Refu-Spy'.[18] Even the *Guardian* and the *Jewish Chronicle*, previously the newspapers most sympathetic to refugees, strongly advocated internment – similarly, so did the Board of Deputies of British Jews, which lamented the 'thoughtless behaviour' of German-speaking Jews in 'North London'.[19] Internment did not, of course, fully satisfy the *Mail*'s demands – the conditions were far too

mild. We were a *soft touch* for *refu-spies*. On 18 May, an article headed 'LUXURY WAR FOR ALIENS' pointed out that in the new internment camps on the Isle of Man the aliens had hot and cold water, could exercise, and were even allowed the use of a cinema.

So who was interned? Certainly, a small minority of Nazi-supporting Germans, fascist-supporting Italians and British fascists were interned, and a much smaller number of Japanese residents. Apolitical British Italians and older British Jews were particularly liable to fall through the cracks of the citizenship system, in a way rather similar to the recent Windrush Scandal, with Londoners or Glaswegians who had lived in the United Kingdom nearly their entire lives being interned or deported because they had never seen the need to become naturalized. But the government's own estimate was that 85 per cent of 'enemy aliens' were 'refugees from Nazi oppression'.[20] Of these, between 80 per cent and 90 per cent were Jewish. A system of categories was set up, Category A and B being for those considered genuinely politically risky, and Category C just for those men and women with German, Austrian, Italian or Japanese citizenship aged between sixteen and sixty. Yet even within Categories A and B, the government made some curious choices. On Stent's account, 'the first wave of MI5 priority suspects included more anti-Nazis and Jews than real Nazis'.[21] As the internment process began, with internees sent to temporary holding camps, these people were literally thrown in with real Nazis, who taunted and threatened them. Meanwhile, those who fought in the International Brigades 'found themselves in category "A" or "B" almost to a man'.[22] It is hard not to read this as the pre-emptive jailing of those considered in the United States during McCarthyism to be 'premature anti-fascists' – the people who opposed Nazism out of principle, rather than because the British state had instructed them to do so.

This, unsurprisingly, has led some people to assume that this process represented Britain's deep state preparing not for the defeat of Nazi Germany, but for the co-operation with it that would be the result of a successful invasion. There is no proof of this, and it is equally plausible that it was just a particularly moronic example of widespread British ignorance and insularity that so many émigrés had come up against. The blanket policy of interning all refugees lasted just briefly, with democratic mechanisms resilient enough in British life to spur on a counter-reaction as strong as the initial 'aliens' scare. But it is an enduringly disturbing episode. The artist Walter Nessler recalled being

led with other internees through the streets of Liverpool past hostile crowds, who yelled and spat at them.[23]

Most disturbingly, the process was remarkably similar to the internment and deportation that took place in Vichy France as it co-operated with the Nazis. There, it was the stateless Jews who were the first to be deported to the death camps in occupied Poland, and they were at first held in odd places such as the unfinished high-rise housing estate of Drancy in the Paris Banlieue. The geography of internment evokes the British Holocaust that didn't happen. In London, anti-Nazi refugees were held in the hangars of the art deco Olympia exhibition centre in Kensington, or in the new Butlin's holiday camp at Clacton-on-Sea in Essex. In the north-west, they were herded into the unfinished Huyton council estate in Liverpool, or, if they were particularly unlucky, the notorious Warth Mills in Bury, Greater Manchester, a derelict textile factory. Conditions there were appalling, as a historian of the internment wrote:

> The main building had a broken glass roof and rotting floors and was rat-infested. There was virtually no furniture; meals had to be eaten standing up. It was alleged that it housed 2,000 men with 500 others camping in the hall. Living-conditions were extremely primitive; the toilets were buckets, the medical facilities woefully inadequate. Huyton was only marginally better: people there slept on straw, and the camp started with only one doctor; four suicides were reported and there were two unsuccessful attempts. Many inmates suffered from mental disturbances, and nearly one in three internees was unfit.[24]

The internees were then mostly moved on to the Isle of Man, until the ships could be prepared to deport them to the empire's white dominions, Labour-governed Australia and New Zealand in particular (Canada was very reluctant, and South Africa at first refused to take anyone). These were the first deportations of their kind since the early nineteenth-century practice of compulsory transportation to Australia was abolished. There were moments of horrible comedy in all of this: in July 1940, a CID squad barged into Hampstead Library to arrest the many Germans and Austrians who were expected to be reading there.[25] Many were, unsurprisingly, baffled by all this. The commander of Huyton Camp in Liverpool presumably – hopefully – joked as another group of inmates arrived at his camp, 'I didn't know there were so many Jews among the

Nazis'.[26] As the first deportees arrived in Australia and Canada, observers were surprised that the Germans and fascists they had expected emerged and requested Kosher food.[27]

The immediate result of all this in Britain was, unsurprisingly, a wave of antisemitism. A Mass Observation survey on the issue found that respondents estimated there were two or four million refugees, as opposed to tens of thousands.[28] Public support for 'collaring the lot' was solid. Yet only a few weeks later the decision started to be reversed. This was largely because of public shock at the sinking in July 1940 of the deportation ship the SS *Arandora Star* by a U-boat, with 805 people killed. Following that, many survivors were taken on the HMT (Hired Military Transport) *Dunera* to Australia. This ship was staffed partly by ex-convict 'Soldiers of His Majesty's Pardon'. They, and the conventional officers and soldiers on board, proceeded during the long journey to beat, taunt and in some cases torture the passengers. This became publicly known as shocked Australians witnessed these emaciated, sick internees – with a striking lack of Nazis among them – trudge off the ship.

There was a scandal, and the ship's military officers were court-martialled. A public campaign, including a Penguin Special,[29] demanded an end to the policy of mass internment. Some of the figures demanding this are unsurprising – H. G. Wells, writing in *Reynolds News* and taking the pretty plausible conspiracy line, accused the government of 'doing Goebbels' work', while Michael Foot satirically asked the obvious question in the *Evening Standard* in July 1940, 'Why Not Lock Up De Gaulle?'. But even some Tory MPs, such as Victor Cazalet (who called the internment a 'bespattered page' in British history in Parliament) and, surprisingly, Neville Chamberlain, criticized the policy. George Bell, Bishop of Chichester, reported to the House of Lords that on a visit to the camps in the Isle of Man and Huyton he found a striking waste of good immigrants: he 'was astounded at the quantity as well as the quality of the material available – doctors, professors, scientists, inventors, chemists, industrialists, manufacturers, humanists – they all want to work for Britain, freedom and justice'.[30]

Of course, it wasn't only geniuses and intellectuals and managers – the 'brightest and best', as a later government would call its preferred migrants – who were interned. For instance, Ronald Stent notes that the Hutchinson camp in the Isle of Man included many elderly British Jews from London, Manchester and Leeds, who happened not to have the

right papers but had lived in Britain almost all their lives (the same was true of most of the Italians). These generally Yiddish-speaking, usually working-class people were particularly confused and upset by the experience, and, writes Stent, 'the attitude of a few – not many – toffee-nosed *Herren Doktoren* also did not help them. They could be seen every day wandering aimlessly along the perimeter fence.'[31] Nonetheless, most of the people we will meet in this book were interned. They included famous names like Nikolaus Pevsner, John Heartfield and Kurt Schwitters, all holed up in camps carved out of the spaces in and between the tall Victorian boarding houses of resort towns like Douglas on the Isle of Man, where these rows were criss-crossed and broken up with lines of barbed wire and sentry posts, in an image of ordinary middle-class Englishness turned horribly sinister. Suffering through the horrific journey on the HMT *Dunera* were the *Bauhausler* Ludwig Hirschfeld-Mack and the Communist writer Walter Kaufmann, who would both decide to stay in Australia, the photographer and historian Helmut Gernsheim, who would return to Britain, and the Warburg Institute art historian Ernst Kitzinger, who made his way to the United States. The socialist writer and vigorous opponent of the Nazis Rudolf Olden was among the hundreds killed in a U-boat attack on the SS *City of Benares* in September 1940.

After they were released from internment, most of the German and Austrian figures in this book volunteered for and were accepted into the Pioneer Corps, a military engineering unit that was heavily involved in the Normandy landings. This was, perhaps, an acknowledgement that they weren't dangerous after all; but the memory of imprisonment without trial by the apparent rescuer remained. The internment and the deportations complicate the comforting idea that these émigrés were welcome injections of new, self-affirming energy into the bourgeois institutions of British public life. In 1940, they were considered an existential threat to the country, no matter how spotless their anti-fascist record. If anything, anti-fascism made them all the more dangerous. As we will see later in this book, the Isle of Man experience bore some similarities to the way in which the Gulag served as one of the main sites of experimental science in Stalin's USSR. During his internment, the modernist housing architect Bruno Ahrends designed an imaginary rebuilding of Douglas as a skyscraper metropolis; Nikolaus Pevsner began the *Outline of European Architecture* that would make his name as a Pelican paperback while wondering what to do with himself in these camps;

Kurt Schwitters gave performances of his Ursonate sound poetry to his fellow inmates, made collages out of porridge, and did realist portraits of his friends for cash and favours. Lesser-known artists produced dozens of moving woodcuts and prints of camp life. It is clear that the experience was a haunting one, and quite unsurprisingly would cement a certain feeling of alienation from a country that was otherwise a refuge.

There was, of course, no Nazi Fifth Column in Britain – the opening of the Third Reich's archives in 1945 showed that it didn't even keep a list of reliable BUF members and fellow travellers. What it *did* have, of course, was a list of 3,000 people that would be immediately entrusted upon invasion to the *Einsatzgruppen*, the SS battalions who carried out the first wave of the Holocaust in Ukraine and Belarus. Along with an often bizarre catalogue of mainstream British figures such as J. B. Priestley and Noël Coward, it listed hundreds of precisely the same people who were then in British internment camps, such as Pevsner, Heartfield and more. If they had ever got here, the Nazis would have found these people all ready for them – already in camps.

6

A Question of Interest to Racists

Most of the émigrés, then, as we've seen, were middle class. Although most were professionals, they were not necessarily *intellectuals*, making the group of people this book discusses a minority within a minority. But as the various insinuations and surveys of who was interned should make clear, a large proportion – a clear majority – of those who were exiled in Britain during the 1930s and early 1940s were Jewish. Not all of them though. Walter Gropius, Oskar Kokoschka, John Heartfield, Kurt Schwitters, Bill Brandt, John Gay, Lotte Reiniger, Ernst Müller-Blensdorf, Jan Tschichold, Feliks Topolski, Adam Kossowski, Hein Heckroth, Friedrich Hayek and Sebastian Haffner were among the refugee intellectuals and artists who had no Jewish ancestry. However, a majority of the people we will discuss in this book had at least one Jewish parent. Some were from deeply assimilated backgrounds, as with Viennese Jews such as Ernst Gombrich, while others were from the Eastern European, Orthodox milieu in which Isaac Deutscher and the painter Josef Herman were raised. All the people in this book lost friends and family in the Holocaust, most of them parents, sisters and brothers.

Within a shared Jewishness there was enormous disagreement and differing experiences of Jewishness and Germanness that long predated the question of Englishness. Many of the best-known figures of the emigration would stress that as far as they were concerned, they had been made Jewish by the Nazis, a position put bluntly by Naum Gabo – 'Hitler made me a Jew'.[1] In any other respects ethnicity and religion were questions of indifference to most. Gombrich, for one, considered that Nazism made him a Jew more than any personal allegiance to the category on his own part; he considered any attempt to identify a distinctively Jewish Central European culture to be 'a

question of no particular interest except to racists'.[2] Neither those who, like Isaac Deutscher, chose the internationalist culture of the Communist movement (or its dissident fringes), nor those, like Gombrich, who chose a liberal, humanist Europeanism, saw themselves as being defined by any sort of religio-cultural identity. But that isn't quite the same as saying their Jewishness was accidental or incidental to the culture they created.

Deutscher's most famous essay on this subject is 'The Non-Jewish Jew', based on a lecture given to the World Jewish Congress during Jewish Book Week in 1958. In it, he pointed to a list of great Jewish and irreligious political-philosophical figures of the modern era, at least three of whom would at some point find refuge in London – Spinoza, Heine, Marx, Freud, Luxemburg, Trotsky – and described their Jewishness and un-Jewishness as universalists, internationalists and great synthesizers of ideas. These people 'were a priori exceptional in that as Jews they dwelt on the borderlines of various civilisations, religions and national cultures ... each of them was in society and yet not in it, of it and yet not of it. This is what enabled them to rise in thought above their societies, above their nations, above their times and generations, and to strike out mentally into wide new horizons and far into the future.'[3]

In some senses, Deutscher's 'Non-Jewish Jews' bear scant resemblance to many of the figures who made their names in Britain. A staunch anti-Hegelian such as Karl Popper, an exemplary assimilated Viennese Jew, would vehemently dissent from the idea that the Non-Jewish Jews were all great systematizers and generalizers, for instance. But the point stands for others who would be important within the emigration. For Deutscher, 'Non-Jewish Jews' are 'all determinists', who 'all hold that the Universe is ruled by laws inherent in it ... they do not see reality as a jumble of accidents or history as an assemblage of caprices and whims of rulers'.[4] This position also implies a criticality towards nation states of any kind, whether post-imperial Britain or the new post-war Jewish state in Palestine established partly under British auspices. Not everyone would have gone as far as the passionately anti-Zionist Eric Hobsbawm, who late in life asserted, with some bravery, that:

> I have no emotional obligation to the practices of an ancestral religion and even less to the small, militarist, culturally disappointing and politically aggressive nation-state which asks for my solidarity on racial grounds.[5]

Note, there, 'culturally disappointing': the worst insult that someone like Hobsbawm could muster. But an indifference to Israel, more than fervent support or hostility, was most common, as Marion Berghahn found in her sociological studies of surviving émigrés in the 1970s and 1980s.[6] Yet some in the cultural emigration were passionate Zionists, like the architect Erich Mendelsohn, the publisher George Weidenfeld, and the historian of Austrian Jewry Josef Fraenkel; Emeric Pressburger and Michael Powell even planned to make a celebratory film about the Zionist leader Chaim Weizmann. Some, such as the apocalyptic Expressionist painter Ludwig Meidner, would turn to the Orthodox Jewish faith of their grandparents and great-grandparents in an Isle of Man internment camp. Others considered their Jewishness so unimportant that they never spoke about it unless practically forced to do so, like Nikolaus Pevsner and Berthold Lubetkin; this has led in some accounts to an identity-politics bafflement that an earlier generation did not consider their ethnicity to be a defining thing about themselves, with authors seeing the Jewishness of these figures as a dark 'secret' about which they were in denial, rather than simply a blunt fact that many in that generation found uninteresting.

Many accounts of the Central European émigré culture stress the peculiar *Germanness* of these Jews, and their firm adherence, even despite, or perhaps because of German Fascism, to the culture of Goethe and Beethoven, Thomas Mann and Bertolt Brecht. Certainly, after 1933 the exiles were the true representatives of the achievements of German literature, film, art and music – which took until as late as the 1970s to start to seriously recover from what Nazism had done to it, whether in East or West Germany. The middle-class homes these exiles had grown up in were musical, literate, multi-lingual and comfortable, the lush dreamworld described in the later 1930s by the Paris-based émigré Walter Benjamin in his beautiful and strange account of *A Berlin Childhood Around 1900*. But that wasn't true for everyone, particularly east of the Elbe. Deutscher owed his world view to one quite specific Jewish environment of the pre-Holocaust world, which was shared with émigré artists from Poland such as Jankel Adler and Josef Herman, and with much of the East End of London, as depicted in Emmanuel Litvinoff's *Journey through a Small Planet*. This environment was Yiddish-speaking, and was defined in the older generation by Orthodox Judaism, and with the youth by activism in the Jewish Labour Bund or the Communist International, or leftist Zionist groups like Hashomer Hatzair or Poale

Zion. This was a culture that had at once a great cultural specificity and an equally intense political universalism. Deutscher retained a deep scorn for middle-class German Jews, like the philosopher Martin Buber, who found God and enthused for the 'obscurantist' Orthodox culture from which he'd escaped. After 1945 Deutscher shifted somewhat from his earlier anti-Zionism into a milder 'non-Zionism' – on the very logical grounds that his family would have survived if they had fled to Palestine – but, soon before his death, the occupation of Gaza and the West Bank in 1967 led Deutscher to return to his original position.

Similarly, for Deutscher, in the British environment ethnicity provided no kind of identity or solidarity. He knew very well that antisemitism was very far from dead, even here – 'from my own experience I know that looking for a flat in London, in Hampstead, say, you can be told that the neighbours would object to a Negro tenant or a Jew moving in, but they would certainly welcome *you* as an exception'[7] – yet he would not countenance the idea of a 'unified "Jewish community", as if it were an all-embracing entity', something which he considered to be 'meaningless' given that it 'contains not only antagonistic social classes; it has also been divided, so to speak, geographically',[8] both in the long-standing ethno-linguistic divides into Ashkenazim, Sephardim and Mizrahim, but within European and American Jewish 'communities' themselves. These lines ran through the émigrés and within British Jewry in general, which added these new additions to a 'community' already divided between affluent Sephardim with Portuguese or Dutch roots, and impoverished or socially mobile recent Ashkenazi migrants from the Russian Empire. Marion Berghahn's *Continental Britons*, based on interviews with germanophone Jews in Britain during the 1970s and 1980s, is full of cutting comments from these exiled Viennese, Praguers and Berliners about ignorant and acquisitive Jewish Britons, and the distrust was fairly mutual, replicating the tension and distrust between German Jews and *Ostjuden* that already existed in pre-war Germany or Austria.

For some figures, outsiderness was something to be celebrated, a matter of pride. Charlotte Wolff realized on escaping Nazi Germany and settling in Britain that:

> I had become aware of what it means to be a Jew – that no nationality bestowed on me would make any difference to my Jewishness. I was an international Jew for good, whether I was a stateless person or a citizen of

another country. I was not only prepared to accept this status, but rather liked it. I have stuck to it ever since, without fear or hesitation, and when now asked about my nationality I answer: 'I am an international Jew with a British passport.'[9]

This outsiderdom makes it all the more extraordinary how much a certain definably 'English' approach to modernism in the arts originated with these émigrés. The very phrase 'the Englishness of English Art' was coined by Nikolaus Pevsner, a Jewish art historian from Leipzig, and perhaps could only have been. Sometimes a conservative reconciliation really was the effect of the émigrés' work – that hardening and flattering of English insularity and intellectual provincialism that Perry Anderson pointed to in the 1960s – but equally often, they synthesized and surpassed all of these cultural traditions, and in so doing made aspects of British life and British culture legible and open to criticism from those who had hitherto 'muddled along' and accepted British ways of doing things as entirely normal.

One could put in this category the manner in which Pevsner, a universal thinker, a Hegelian progressive, and a 'Non-Jewish Jew' if ever there was one, first systematized British architectural history, and crucially also explained it in a way that was actually accessible and understandable to those not in a few Oxbridge cliques. You could add how architects such as Berthold Lubetkin and Peter Moro were the first to take the hard-line modernism that had been effectively imported from Berlin into London in the early 1930s and to anglicize it, adding paradox, decoration and the picturesque. You can see it in the eccentricity of photographers such as Bill Brandt and John Gay, who arrived on our side of the Channel and saw a nation of dreamers in a surreal landscape. And you can find it, as we saw when we began this introduction, in the gleaming, sanitary, Constructivist Palace of Health that Eugene Rosenberg and Naum Gabo gave us facing the Houses of Parliament. So much in British Culture was, through this, *transformed* by its encounter with Weimar Culture, not affirmed. That transformation, in short, is the subject of this book.

I reluctantly take for granted the notion that national differences, however concocted and propagandized, do have some basis in reality. Most of the people this book discusses believed that they did, and saw themselves as bearers, willingly or otherwise, of generalized Central European

culture which faced a similarly European but in crucial respects deeply strange Anglo-Saxon (and sometimes Celtic) culture. The misunderstandings between these were so familiar and obvious at the time that they formed the basis of a bestselling comic tract. George Mikes was a Hungarian Jewish journalist who came to Britain in 1938 to cover the Munich Crisis, and decided to stay, and despite internment in 1940, did so for the rest of his life (a liberal, he was in no way tempted to return to Communist Hungary after 1945). The very title of his 1946 book *How to Be an Alien* cements the way in which 'Central European' equalled 'Alien' in the public mind. It offered a guide for an imagined new arrival from the still war-ravaged continent, through an apparently baffling and inexplicable new world. Subjects ranged from Tea, Hypocrisy, Weather, Central Heating (and the lack thereof), to Town Planning, Buses, Queuing, and the gibberish that comprises so much of the English language ('a fishmonger is the man who mongs fish; the ironmonger and the warmonger do the same with iron and war. They just mong them').[10] Most usefully, the book explained the mysteries of English intellectual life, or what there was of it. 'In England,' wrote Mikes, 'only uneducated people show off their knowledge'; an observation that is not factually true as such, but still holds true on a rather deeper level.[11] He warns:

> In England it is bad manners to be clever, to assert something confidently. It may be your own personal view that two and two make four, but you must not state it in a self-assured way, because this is a democratic country and others may be of a different opinion.[12]

If none of this had some basis in fact, it wouldn't have been funny; which it was, and still is.

I also ought to be clear, too, about my definition of the term 'Central Europe'. It makes sense to treat it as a bloc, because isolating just the German émigrés makes little sense; a carrier of a German passport like Pevsner had much in common with a Hungarian national like Ernő Goldfinger, a Polish national like Feliks Topolski, a Czech like Ernst Gellner, or an Austrian passport-holder like Gombrich. Moreover, both political events and the general cross-fertilization of intellectual life brought people constantly back and forth across the borders of the new states of 1918. If 'Central Europe' as a geographical concept is nonsense – the exact midpoint between the furthest tip of Norway, the southernmost

point of Greece, the Urals, the Caucasus and the Atlantic coast of Portugal is actually somewhere in Belarus or Lithuania – then so too is Europe itself. It is less a continent than a series of oddly shaped peninsulas and islands in western Asia, and, unlike Africa, Australasia or North and South America, there is no actual geographical feature – an ocean, a Suez or Panama canal – that cuts it off from the larger continent. The end of the Cold War has only reinforced the notion that Western Europe is the 'real' Europe, the civilized part of it, and so 'Eastern Europe' is seen as an insult rather than a neutral category. My definition of Central Europe is fairly traditional, however. It is, roughly speaking, the lands of the Holy Roman Empire, and later, of the Prussian/German and Hapsburg/Austro-Hungarian Empires that were broken up in 1918 – that is, what is now Germany, Hungary, Czechia, Slovakia, Austria and much of Poland. It does not include Scandinavia, the Low Countries, or the former territories of the Russian Empire such as Finland, the Baltic States or (most of) Ukraine, or of the Ottoman Empire such as (most of) Serbia and Romania, or Bulgaria and Greece.

Central Europe is a part of the world that has mostly been under some form of German cultural domination since the Middle Ages, though Russian imperialism made its own distinct contribution to brutality there in the middle of the twentieth century. Central Europe includes places that 'went Communist' after 1945, and places that did not. Its great cities include Berlin, Brașov, Bratislava, Brno, Budapest, Chernivtsi, Cluj, Cologne, Debrecen, Dessau, Dresden, Düsseldorf, Frankfurt, Gdańsk, Graz, Hamburg, Katowice, Kraków, Leipzig, Ljubljana, Lviv, Munich, Novi Sad, Poznań, Prague, Timișoara, Trieste, Vienna, Weimar, Wrocław, Zagreb – to give them their currently used names, which were not necessarily their most commonly used names during the 1930s. Most of these appear in this book, along with the debatable lands of Warsaw and Łódź, which were part of the Russian partition of Poland but make little sense cut off from that country as a whole. I have also bent my own rules for some figures crucial to the story of Weimar Culture's journey to Britain, such as Naum Gabo, born in what is now the Russian Federation, but educated in Munich and spending much of his career in Berlin; the Georgian-Polish Berthold Lubetkin, educated in Moscow, St Petersburg and Warsaw, but trained in Frankfurt and Paris; and the Bulgarian Elias Canetti, who built his career as a writer in Vienna and Berlin.

I have, however, mostly ignored the French, the Balts, Russians,

Belarusians and Ukrainians, the (not very diasporic) Dutch, the (neutral, and hence safe) Swiss, and the Scandinavians. This is despite the presence in Britain, briefly or more enduringly, of a few notable French intellectuals, like the philosopher Simone Weil; Russians, like the Cambridge-educated modernist novelist Vladimir Nabokov, the liberal philosopher Isaiah Berlin, the mosaicist Boris Anrep and the Moscow Maly Theatre director turned spectacular suburban cinema furnisher Theodore Komisarjevsky; Finns, like the architect Cyril Mardall and the art historian Tancred Borenius; and Danes, like the engineer Ove Arup or the urban historian Steen Eiler Rasmussen, author of the great *London: The Unique City*. I have also mostly ignored the post-1945 emigration away from Communism, aside from the Poles already in Britain who decided not to return. The story of the Ukrainians, Balts and Yugoslavs who arrived in the 1940s is of great interest, but it is not part of this book's story. Similarly, neither the Hungarians who escaped the suppression of the revolution of 1956 and settled in Britain (like the architect Peter Tabori or the novelist Stephen Vizinczey), nor the Poles who escaped to Oxford or Leeds from the antisemitic purges in Warsaw in 1968, like the philosopher Leszek Kołakowski or the sociologist Zygmunt Bauman, feature here. There is a bias towards the simple facts of settlement and survival. And there is also the absence of those who did not make it, and slipped through the cracks of an arbitrary asylum system – like the Bauhaus teacher and designer Otti Berger, who despite trying to settle in Britain was not granted leave to remain here. She had to return home to Croatia, from where she was deported to Auschwitz in 1944. Any story of success is forced to ignore these appalling failures.

This is a book about the visual arts, which means it reveals many absences from the non-visual side of interwar Central European intellectual life. The emigration in the natural sciences was vast, including such figures as Albert Einstein, Klaus Fuchs, Max Born, Rudolf Peierls, and many others; it deserves a large book of its own. Musicians – a cohort ranging from mainstream figures like Fritz Busch and Carl Ebert, founders of the Glyndebourne Festival Opera, and Rudolf Bing, founder of the Edinburgh International Festival, to experimenters like the radio producer Ernst Schoen or electronic pioneer Ernest Berk – appear only sporadically; their absence is, I confess, largely the product of my own lack of expertise in the subject. The psychoanalytical enclave in London and psychologists in general are mostly absent, whether in cases of genius

like Melanie Klein or cases of fraud like H. J. Eysenck. There are only a few employees of the BBC or the universities of Oxford and Cambridge in this book, and they mostly appear rather glancingly, as is the case with philosophers such as Karl Popper and Ludwig Wittgenstein. The story of many of these people has been told already; their reduced presence here is down to a partial agreement with Perry Anderson's thesis about the conservative influence of the emigration. In the universities and the media, there are exceptions to the rule, but by and large the effect was indeed to bolster and replenish the British establishment, and so I have chosen not to retell that story. In the visual arts, this is by no means as clear, and it is this tale, about how the culture of the Weimar Republic and the Central European avant-gardes linked to it encountered and changed – or were changed by – early twentieth-century British culture, that is told here.

This book's many chapters are divided into four long parts on the cultural transformations sparked by the immigration from Central Europe, and they chart how it unfolded – sometimes slowly, sometimes suddenly – between the start of the 1930s and the neoliberal era of the late 1970s and 1980s, when an extremist Prime Minister slapped a book by an Austrian émigré down on the table and told her party 'this is what we believe!' The four parts are organized according to a particular artform – the photograph and the film; the book; the work of art; the building and the city. The first part deals with those arts that László Moholy-Nagy called 'the New Vision' and is about how photographers and filmmakers whose trained eyes were rooted in the avant-garde culture of Constructivism and Expressionism redirected them to everything from dole queues to Eton, and in the cases of a few Hungarians, were able to introduce a dreamlike surrealism into the dowdy world of British cinema. The second part is on publishing, and the ways in which a print revolution in 1920s Germany, in design and in the development of cheap, well-designed mass-market books, found its way to Britain. The third part is on the 'fine' arts of continental modernist sculpture and painting, and the ways in which they worked their way into British life, sometimes through surprising routes, such as the Church. The fourth and final part is on architecture and town planning, the places where the revolutionary effects of the migration have been most obvious.

I have in this a firm bias towards things that you can still *see*. Paintings and mosaics you can go and look at, sculptures on and in public

buildings, books and magazines you can search for in your local second-hand bookshop, films you can find easily on a streaming service, buildings where you might live; otherwise, to argue that the emigration had a lasting effect on everyday life would make little sense. This does mean that certain important aspects of Central European culture have fallen by the wayside – not just music, but also theatre and dance, with very little on the emigration to Britain of such crucial figures as Rudolf Laban, Kurt Jooss and Ernst Toller. Product design, which survives poorly outside museums or the more outré markets and antique stores, is also rather neglected, though remarkable things were achieved by Central European migrants such as Jacqueline Groag, Tibor Reich and Bernat Klein in textiles,[13] by Lucie Rie in ceramics, by Gaby Schreiber in plastics, and in the metalwork of the *Bauhausler* Naum Slutzky, among others.

Writers of fiction and poetry also go largely undiscussed, as the language barrier was insurmountable for novelists like Gabriele Tergit and Stefan Zweig; though both Koestler and Uhlman adapted with success to English, while the socialist poet Erich Fried built a reputation as a German writer while remaining in his London exile. Others, such as the novelists Elisabeth de Waal, Ulrich Alexander Boskwitz and Anna Gmeyner, have only recently been (re)discovered; more, I suspect, will be in future.[14] But in a book on visual culture, these figures appear only as commentators. So this is not a complete picture of the emigration and what it was up to in British cultural life; it is *a* story, not *the* story. Within all this I want to stress how the changes brought by the Central European emigration were, however subtle they may have seemed at the time, immense and, largely, positive. I want to stress the way in which they upset the hierarchies of this class-ridden island, rather than reinforcing them; and the ways in which they cast onto Britain what Bertolt Brecht called, in a new German word, a *Verfremdungseffekt* – an 'alienation effect' – in such a way as to render what would otherwise seem normal and uninteresting into something strange and unusual. The aliens made us all a little bit alien too.

PART ONE

Camera Eyes

Film und Foto from Budapest to Blackpool

> *It seems to me ironical that the magazine which owed its original success to the intuition of a 'bloody foreigner', that the British were ready for something more serious, and at the same time more lively, than anything they were getting, owed its death to a loss of faith, to the sense that anything will do and the public should be given the sort of commonplace trash it 'really wants'. But it was not bloody foreigners but, in the main, one hundred per cent British citizens who argued like this.*
>
> Tom Hopkinson on the demise of *Picture Post*[1]

7
Stefan Lorant Dreams of England

Our scene is a Gestapo prison in Munich, 20 July 1933, soon after the Nazi seizure of power. Our protagonist is one Stefan Lorant, who mere months before had been editor of the *Münchner Illustrierte Presse*, one of the most popular publications in Germany – one of several photo-weeklies in the Weimar Republic that combined journalism, humour, modern design and political positions expressed with varying degrees of subtlety. Huge round-ups of potentially hostile journalists followed the full Nazi takeover of power in March of that year, and Lorant, a young Hungarian liberal, was among those thrown in jail. Waiting for months to find out what he was being charged with, hearing beatings and torture from the cells of the prison in which he was confined, he lies back on his bunk and imagines the better place, not too far away, that he and other prisoners hope one day to escape to.

'I love England,' he writes in his diary:

> My happiest days were those I was able to spend in London. I love the City, Oxford Street, Pall Mall and the Strand. I love the little restaurants in Soho and the endless streets of the East End. I love the docks and the wide spaces of the ports. I love the chimes of Big Ben and the bustle of Victoria Station. I love the street musicians and the political gossip in the saloon bars. I love the taxis and the motor-boats in the Thames. I love the flowers in Hampton Court and the speakers in Hyde Park.

He continues, listing all the places, all the values, in this quiet, close but distant country that were the exact opposite of a Nazi prison in Munich:

> I always wanted to live in England. Whenever I had any free time I went to London. I would plunge into the crowd at the Derby, I would sit on the

stands at Wimbledon and in the scorching heat at Lords; I would drive along the Great West Road to Maidenhead in the dark, and think myself in Paradise on the banks of the Thames. It was the longing to know the country to which Shakespeare belonged that drew me to England, and a longing to know the people to whom personal liberty is the most sacred possession – the people that stands in a body behind each of its citizens, that will not tolerate interference with the freedom of its sons by any country in the world. The solidarity of the English people, the distinctive quality of their thought, their superiority, their conception of the gentleman, make them the guardians of civilisation in Europe.

His dream, as he lies on that bunk, is not an idle one, but one which could, in the right circumstances, become reality. 'My dream was, and still is, to be able to live in England.' Lorant and his fellow prisoners were learning English, he tells the diary. 'We all want to be able to speak English well when we come out. For we all mean to go to England then.' He concludes his raptures about the island a night's journey from Hamburg by trying out a little of what he'd been teaching himself in his cell:

I am, you are, he, she, it is . . .
I am learning English.
England! I love you.[1]

Within a couple of years, saved from the Gestapo by his Hungarian passport, he was in England, editing the first of a series of magazines that would transform British media.

Stefan Lorant, who published these diaries in the book *I Was Hitler's Prisoner*, quickly translated into English in 1935 and a bestseller as a Penguin 'Special', has a claim to be the person who brought real photojournalism to Britain. With first, tentatively, *Weekly Illustrated* from 1935, with the somewhat more niche monthly *Lilliput* from 1937, and then much more dramatically with *Picture Post* from 1938, he effectively brought British magazine design, photography and politics into the twentieth century. He did so in a sometimes uneasy alliance with a Conservative publisher, Edward Hulton, and left Britain for America as early as 1940, placing his magazines in the hands of his English colleague Tom Hopkinson, but the photographers who made the magazines what they were remained mainly German, Austrian and Hungarian. What is ironic

in all of this is that these magazines – particularly *Lilliput* and *Picture Post* – specialized in eccentric Englishness, in observations of all that was 'typically' British. As the journalist and novelist Keith Waterhouse later remembered, 'what *Picture Post* did (brilliantly) was to explore the fascinating range of small social foothills' of British life – street parties, amateur dramatics, village fetes, fishing, market days, games, all the things that would have captured the eye of a non-British observer as unusual.[2] Lorant, as one of *Picture Post*'s historians writes, 'hardly knew Britain at all and could see it with fresh eyes'.[3] His lack of familiarity with the realities of the country – the one that he dreamed of in clichés in a Gestapo prison – meant he was able to capture them better than anyone actually raised here. Bloody foreigners may not have always been welcomed by the majority, but the eye on Britain that was so enthusiastically welcomed by *Picture Post*'s millions of readers just before, during and after the Second World War was a distinctly Central European one.

Lorant was not necessarily the most innovative or unusual of Central European magazine editors, but he happened to be the one in the right place at the right time to dramatically change British print culture. Of course, there were British photo-weeklies and photojournalists before Lorant brought them over from Germany, Austria and Hungary, but there was nothing on the level either of American magazines such as *LIFE*, or the illustrated papers of the Weimar Republic such as the *Berliner Illustrierte Zeitung* and the *Münchner Illustrierte Presse*.[4] The Communist Party of Great Britain briefly tried to emulate one of the most famous of these, the German Communist Party's *Arbeiter Illustrierte Zeitung (A-I-Z)* – which had risen to a mass circulation through its photo-stories, dynamic design, and satirical photomontages by the Dadaist John Heartfield – as the *Workers' Illustrated Newspaper (WIN)*. But this small British Communist Party was never in the position to have the same mass reach as the media empire presided over by the German Communist mogul Willi Münzenberg; the nearest equivalent was the English version of the glossy propaganda magazine *USSR in Construction*, printed and produced in Moscow. What mass market there was for photo-magazines resided in would-be-aristocratic publications such as *Tatler* and *Queen*. So fundamentally, the illustrated magazine in Britain starts with Stefan Lorant, a charismatic and somewhat slippery character.

Lorant did not begin his career as a journalist. He was born István Reich in 1901 into a bourgeois Hungarian Jewish family with a large

The magazines of Stefan Lorant, from 1932 to 1939.

apartment on the prestigious Aranykéz Utca in Budapest, the co-capital of the Austro-Hungarian Empire. His upbringing was wholly secular, and according to his only biographer, Michael Hallett, he 'vigorously objected to being described as Jewish', and changed his name to Lorant at the age of sixteen.[5] His later career in crusading photojournalism had its roots in the Hungarian Revolution of 1919. Before 1918, Budapest was officially the joint capital of the empire with Vienna, and was the sole capital of the sprawling Hungarian crown lands, encompassing what is now Slovakia, Croatia, western Romania, northern Serbia, and Transcarpathia in Ukraine. Following the wartime defeat of Lorant's homeland in November 1918, a working-class uprising in Budapest brought to power first the Social Democratic Party, and then the new Hungarian Communist Party under the leadership of Béla Kun, who for a few months led a turbulent 'Republic of Workers' Councils' before being brought down by a Romanian invasion and replaced with a violent right-wing dictatorship under Admiral Miklós Horthy. Like many young intellectuals in Budapest, Lorant was enthusiastic for this brief Communist experiment. At the time, he was the editor of a student newspaper. On his own account, he went to the Communist Commissar for Culture, the philosopher György Lukács, and asked him for the resources to take over the houses of wealthy Budapest residents who had fled the revolution, to turn them into vacation homes for working-class children.

Many years later, Lorant recalled that each member of his student group became 'head of a villa for twenty to forty boys. We organized them and educated them. My mother cooked meals in the morning. A doctor examined them and 70 per cent had tuberculosis. I'm still haunted with that memory'.[6] Lorant was very briefly imprisoned during the White Terror that raged at the start of the Horthy regime, denounced by the wife of the janitor[7] of his family's luxurious apartment block. Upon release, he fled to Vienna, and then to Berlin, where he became a commercial film cameraman, and, eventually, director. Lorant was a teller of tall tales, and he claimed in this capacity both to have given the Weimar-turned-Hollywood star Marlene Dietrich her first screen test (he told her she'd never be famous), and to have had a 'serious relationship' with the Nazi, actress and director of *Triumph of the Will* Leni Riefenstahl, albeit 'before Hitler'.[8] His career in photojournalism and in editing began in earnest in 1927 at *UFA-Magazin*, the promotional journal of the vast German film conglomerate responsible

for Expressionist classics like *Metropolis* and *The Blue Angel*. Lorant edited a special issue on *Metropolis*. His fellow Jewish Hungarian and occasional collaborator, the Bauhaus polymath László Moholy-Nagy ('we spoke in our own language'),[9] claimed this was 'the first modern pictorial magazine'. Lorant's wife, Niura Norskaja, was an exile from Kyiv, where her parents' factory had been nationalized. As he claimed in *I Was Hitler's Prisoner*, their shared-exile status united two people squeezed between the political extremes of the time: 'Niura came to Berlin from Russia to escape the "Red" revolution. I was driven out of Hungary by the "White" revolution.'[10]

On the strength of his work for *UFA-Magazin*, Lorant became in 1928 its Berlin editor, and then, from 1932, the editor of *Münchner Illustrierte Presse*. Its publishers were Knorr and Hirth, who stayed aloof both from the right-wing politics that were overtaking *UFA*, which was bought out by the nationalist mogul Alfred Hugenberg after the financial failure of *Metropolis*, and the open Communism of the *A-I-Z*. In *I Was Hitler's Prisoner*, Lorant wrote that 'there were almost as many political convictions in the firm as there were newspapers, journalists and employees', but for two exceptions: 'we had no National Socialists, and no Communists. An embittered fight was conducted against these two parties.' He also claimed that as the Weimar Republic collapsed into violence, 'the only paper which steered clear of all politics, and of which I was the editor', was the *Münchner Illustrierte Presse*, the most important illustrated weekly paper in South Germany. Indeed, its only political view was a distrust of National Socialism, a distrust which most of the big German newspapers shared.[11] The trumped-up pretext for his imprisonment was a bizarre artefact of Lorant's somewhat playboy-like lifestyle – he had received a postcard from an actress visiting the USSR, which was considered enough to collar him for Soviet sympathies.

Lorant's first port of call upon being freed by the Gestapo was again Budapest, where compared with Germany there was a certain amount of freedom of expression within limits, in the last decade of the Horthy regime; Lorant edited a weekly supplement for the Budapest daily *Pesti Napló* ('Pest Diary'), where he employed a more glamorously modern design than he had at *Münchner Illustrierte*. He then, as he had dreamed, made his way over to England in 1935, working first as a journalist; in *Everyman*, the magazine of book publisher J. M. Dent's mass-market classics press, he asked 'What Has Become of the Exiles?', and spoke on

their behalf: 'the political prisoners from Hitler's Germany have found a friendly welcome here in England. We seek to express our thanks by enriching English science, art and literature with our work', despite the fact that they were 'no more than foreign refugees – tolerated by the country, in constant fear that their permits to stay may not be renewed, liable to be deported any day from their country of adoption'.[12] This fear would eventually drive Lorant from the country to the United States in 1940, but his first effort to 'enrich' English photojournalism came with *Weekly Illustrated* in 1934, and the following year, the autobiographical *I Was Hitler's Prisoner* became a bestseller, selling more than half a million copies and being picked up by Penguin Books for their 'Specials' series of polemical paperbacks.

Weekly Illustrated was an attempt to reinvigorate one of the journals of the old left – *The Clarion*, which was once by far the most popular left-wing publication in Britain, and boasted an entire network of readers, supporters, and clubs for cycling enthusiasts (some of those clubs survive to the present day). Under the editorship of Robert Blatchford, *Weekly Illustrated* was strongly 'social imperialist', anti-immigration, and often racist, but its readership had collapsed by the mid-1930s under the pressure of competitors like the hugely popular trade union-owned *Daily Herald*. Little of the original *Clarion* survived its transformation into the bright, populist new magazine. But it brought Lorant into contact with left-wing journalists such as Tom Hopkinson, and, most importantly, he brought over his favoured photographers from *Münchner Illustrierte*, Kurt Hübschmann and Hans Baumann. The pair, trained in the dynamism of Constructivism and the sharp-eyed, hard-edged realism of the *Neue Sachlichkeit*, or 'New Objectivity', would photograph the overwhelming majority of stories for *Weekly Illustrated*, under new pseudonyms designed to disguise their foreignness: Kurt Hutton and Felix H. Man, respectively. Depending on the source, these names were necessary because the photographers' immigration status was precarious, meaning that a byline could give them away to the Home Office,[13] or, according to Felix Man, so that British readers wouldn't realize that 'the backbone of the paper consisted of foreigners'.[14] The first stories, though, would have been very familiar to readers of the Weimar press – defined by humour, strange juxtapositions and an attention to the lives of all members of society, with, this being Britain, the monarchy a favourite subject. Hutton and Man stories like

CAMERA EYES

Men and ships: an early spread from *Weekly Illustrated*, 1936.

'PAY DAY ON THE QUEEN MARY' threw together patriotic tub-thumping, a very New Objectivity joy in the big technology of the big ships, and a sympathetic eye to the working people who were actually building and staffing these behemoths.

At first, Lorant's editorship of *Weekly Illustrated* was not a success, though sales were an improvement on the *Clarion*. Mercurial and used to complete control at the *Münchner Illustrierte*, Lorant told Hopkinson, his closest ally at the paper, 'I cannot work where I am not appreciated, and no one here understands what I am doing. *No one!* Not even you.'[15] He was quickly sacked, and after writing fiction under a nom de plume and a little journalism, in 1937 he founded a very different publication, albeit one equally indebted to the press culture of the Weimar Republic: *Lilliput*. Cooked up by Lorant and laid out in the London flat of the Hungarian Weimar photographer Zoltan Glass, this was an attempt to imitate the satirical, deliberately elitist Weimar monthly *Der Querschnitt* ('The Cross-Section'), which had published

A Walter Trier cover for *Lilliput*, 1945.

a mix of modern fiction like Hemingway, Joyce and Proust in German translation, showcases of modern architecture, reproductions of works by modern artists such as Léger, Picasso, Grosz and Max Beckmann, and 'artistic' female nude photography. Lorant was able to use that publication's occasional cover artist, the Prague-born German Jewish illustrator Walter Trier, who is best known for his light, clever illustrations for Erich Kästner's 1929 children's book *Emil and the Detectives*, and who had fled Germany in 1936. Until he left for Canada at the end of the 1940s, Trier's charmingly cute and sometimes very mildly risqué covers for *Lilliput* would always include a man, a woman and a dog, in a variety of amusing or satirical situations. Inside, translations or new articles by Weimar writers such as Lion Feuchtwanger and Arthur Koestler shared space with whimsical lists, naked ladies, colour spreads (eighteenth- and nineteenth-century illustrations a speciality) and, most famously, juxtapositions of photographs, sometimes with satirical intent, sometimes for gentle mockery or surrealism. These were

very popular, and a juxtaposition of Neville Chamberlain – a hate figure of Lorant's for his appeasement of Hitler – with a gormless, harmless llama was referenced in Parliament in an attack on the Prime Minister. In 1940, Lorant would package the juxtapositions together in a book entitled *Chamberlain and the Beautiful Llama*.

Perhaps more seriously, in 1939, spreads were published in *Lilliput* of scathing anti-fascist montages by the newly arrived John Heartfield – the first time these images had been seen in Britain. Lorant, now free of the partisanship of the Weimar press, was able to work with a KPD-affiliated artist who, he later claimed, he firmly 'admired [for] the montages that he did for *A-I-Z* in Berlin',[16] but who he would never have been allowed to employ at the centrist *Münchner Illustrierte*. The strident Communist must have felt odd about the new company his work shared magazine space with – his agitational scalpel mixed in with soft porn, silly animals, Victoriana and listicles. His montages were introduced as 'Masterpieces of Political Art', and included the image of Hitler in the uniform of the Kaiser, plumed helmet and all, and the classic, enduringly disturbing 'Hurrah, die Butter is alle', originally made for *A-I-Z* and translated not entirely accurately as 'Butter for everyone', both titles referring to 'Goering's famous remark, "Guns are better than butter"'.[17] It depicts an ordinary patriotic German family and their dog, with swastika wallpaper and a framed picture of Hitler, as the delighted family tuck eagerly into rifles, shells, grenades and spaghetti-like cables. Nothing so bizarre and ferocious would be seen in British life again until the punk photomontages of Gee Vaucher for the records of Crass at the end of the 1970s.

Lilliput's success saw it being bought up by a Tory peer and publishing magnate, Edward Hulton, who then asked Lorant to start another weekly; the proposal was, on the Hungarian editor's account, 'to make a Conservative weekly on the lines of the *Spectator*. But,' he told Tom Hopkinson, his *Weekly Illustrated* colleague, who he immediately re-hired for the new project, 'what I shall give them is a picture magazine'.[18] *Picture Post*'s snappy, minimalist title was fortuitous, as Lorant blocked the publisher's plans to call the magazine *LO!*, with the advertising slogan 'Buy *Lo!* See and know!' *Picture Post* was not didactic, and, like *Lilliput*, some of its immediate commercial success must have come from a *relative* daring about sexual matters to which British readers were unaccustomed. An early issue during Lorant's tenure featured a now famous full-page photo by Kurt Hutton showing a fairground ride

in Southend, in which the wind has blown open one young woman's billowing skirts (the picture was staged, and even then Hutton was obliged to retouch the skirt to cover the subject's knickers).

But *Picture Post* did, unusually for a mass-circulation, privately owned paper at the time (except perhaps the gradually leftward-leaning *Daily Mirror*), have a distinct left-wing line, despite its Tory proprietor; Lorant put Heartfield's 'Kaiser Hitler' montage on one early cover. Hopkinson later remembered that 'for Lorant and myself the main interest was that it should be strongly political, "anti-fascist" in the language of the time'.[19] Early issues included the 1939 spread 'UNEMPLOYED!', which had an agitational brute force clearly taken from the punishing exposes of *A-I-Z*, and an important anti-Nazi spread, 'BACK TO THE MIDDLE AGES', a response to the pogroms of *Kristallnacht* – the answer to a question posed by Lorant to Hopkinson: 'How do I hit back at these *bastards*?'[20] The story documented the brutality of the Nazi pogroms, and juxtaposed them with various literary, scientific and humanitarian Jewish individuals – the latter being figures of the twentieth century, the former, escapees from an ignorant medieval past. In the 1940s, the Nazis repaid Lorant by closely copying *Picture Post*'s layouts and style in *Signal*, a magazine translated and distributed across occupied Europe.

There was also a political angle, more implicit, to the very ordinary spreads that *Picture Post* published about working-class and middle-class everyday life (*Alltagsleben*, as they called it in Munich) and about labour, such as the Kurt Hutton-photographed 'THEY BUILT "QUEEN ELIZABETH"', a *Neue Sachlichkeit*-informed portrait of the Glasgow shipyard workers who had constructed a cruise ship, with each giving a little information about themselves underneath a warm but unsentimental portrait. The idea was redolent of the radical Weimar photographer August Sander, whose project 'The Face of Our Time' entailed portraits of people from every layer of society; the photos themselves resemble more the photojournalism of contemporaries like Erich Salomon or Martin Munkácsi. Writing about this story later, the *Picture Post* contributor Robert Kee pointed out it gave the appearance that for the magazine, 'it was not travellers on the . . . Queen Elizabeth who counted, but the men who built her – the riveter, the boiler-maker, the engine-room worker, the joiner. Such individuals were to be photographed as if they might have been subjects for Rembrandt'.[21] This was deliberate. In an editor's letter

in the eighth issue, in 1939, Lorant responded to criticism of featuring such 'ugly' and 'inartistic' subjects by arguing:

> *Picture Post* believes in the ordinary man and woman; thinks they have had no fair share in picture journalism; believes their faces are more striking, their lives and doings more full of interest than those of the people whose faces and activities cram the ordinary picture papers. This goes for dictators and debutantes equally.

Lorant edited the paper for barely two years, before leaving for the United States in 1940, fearing internment on the Isle of Man, or worse. He had tried and failed to obtain British citizenship, and both Hutton and Man had been imprisoned there. He told Hopkinson that 'you British citizens will be all right. But what about us bloody foreigners? We will be sent back.'[22] He was also widely quoted as saying, more curtly, 'Hitler can't hang 50 million Englishmen from lamp-posts, but he can hang 50,000 bloody German Jews, and I don't want to be one of them.'[23] With typical charisma and mildly unreliable cleverness, Lorant gave Hopkinson and the publishers rather different ideas about what he wanted them to do in his absence. He appointed Hopkinson as his successor as editor, with a strongly political brief. As the journalist remembered decades later in his autobiography, Lorant:

> talked to me seriously about the running of the paper in his absence: the success of *Picture Post* had been due, he said, to its left-wing policies, determined opposition to Nazism and fascism, and continued criticism of the Chamberlain line on Germany, which the Prime Minister had evidently not abandoned, although the countries were effectively at war. It was essential, Lorant said, to maintain this strong attitude in the paper and not relax in any way during his absence overseas – with all of which I heartily agreed.

And yet 'a few days later, when I was having a drink with the general manager' of the publisher, he was told Lorant had 'warned us to keep a sharp eye on you while he's in the States because of your left-wing tendencies. He says you're always trying to work things into the paper which could cause us trouble.'[24]

Whichever of these was Lorant's 'real' opinion, Hopkinson was placed

in charge and continued with crusading, leftist spreads in among the stories about working-class life, holidays, funfairs and royals. These included a special issue, 'Plan for Britain', in January 1941, emphasizing that the aftermath of the war must see a reconstruction of Britain so that the Depression of the 1930s could never happen again; among the articles was 'WORK FOR ALL', a piece by the Hungarian socialist economist Thomas Balogh advocating full employment. This, as Hopkinson remembered, 'intensified support among readers, who looked upon the magazine as their mouthpiece, almost indeed as their own property, and it increased the antagonism felt in certain government departments, above all in the Ministry of Information'.[25] The government would not have been pleased with, say, the special issue 'ARM THE CITIZENS!', of 29 June 1940, which was mainly written by the Spanish Civil War veteran Tom Wintringham – commander of the British Battalion of the International Brigade, a dissident Communist and regular *Picture Post* contributor. His issue argued for the formation of

Felix H. Man or Kurt Hutton, 'ARM THE CITIZENS!', *Picture Post*, 1940.

a popular working-class militia that would be able to fight a prolonged guerrilla war in the event of Nazi invasion. It is wild stuff, informing readers how to use bombs and grenades, all around the photograph of a gate across a country estate warning trespassers, with the slogan 'SUCH SIGNS AS THESE MUST GIVE WAY TO A NATION'S NEED'.[26] Unsurprisingly, the Ministry of Information refused to provide *Picture Post* with requested images to illustrate their stories, which sometimes led to them printing blank squares where photos or illustrations would have been. Hopkinson spent the night of the 1945 election at the party of a rival newspaper magnate. As the results came in for a Labour landslide, several guests told him 'your bloody *Picture Post* is responsible for this!'[27]

Yet, though Edward Hulton would initially be sympathetic to the Labour government, the Cold War radicalized him back to the right. He made various attempts – resisted by Hopkinson – to purge Communists from the magazine's staff, before eventually *Picture Post* was finally torn to shreds in 1950 over a three-part piece on the Korean War, by the journalist James Cameron and Bert Hardy, a talented working-class photographer who had been the magazine's major discovery. The first parts were published by Hulton with reluctance, but he finally refused to publish the part that documented atrocities on the South Korean side. Hopkinson was fired, and many of the figures brought into the magazine by Lorant departed. Hulton then dumbed *Picture Post* down into a more straightforward magazine of celebrities and debutantes, tried and failed to re-hire Lorant, and eventually closed it down in 1957, by then a shadow of its former self. *Picture Post*'s first legacy was visual – Hopkinson and Hulton founded the Hulton Picture Library on the basis of its collection. But in the long term, both *Picture Post* and *Lilliput* provide an immense documentary record of Britain in the middle of the twentieth century, as seen by a generation of incredibly talented German, Austrian and Hungarian photographers – Kurt Hutton, Felix Man, Gerti Deutsch, Bill Brandt, Zoltan Glass, Elisabeth Chat, Edith Tudor-Hart, Wolfgang Suschitzky – and it is to this fascinating archive, assembled in the service of both entertainment and information, that we now turn.

The work of Hutton and Man is not always easily distinguishable – partly this is because of the lack of bylines, and partly because of a shared style, which was simple and hard-hitting. Both were from middle-class

families. Hans Baumann, the later Felix Man, was from Freibourg in southern Germany, a town which he later described to British readers as 'dominated by retired colonels, former University professors, industrialists and other well-to-do people'.[28] Kurt Hubschmann/Hutton, meanwhile, shares with a few of our émigrés some experience with Britain before 1933. He grew up in a bourgeois academic and banking family in Hamburg, with a Protestant father and a Jewish mother; in the 1910s he briefly went to Oxford to study law, but quickly quit and, in 1921, moved to Berlin, where he would become an assistant to Germaine Krull, a strongly left-wing experimental photographer. He then worked with Lorant's weekly in Munich, and was told by him in 1933 that, along with Baumann, it would be unwise to stay in the country.

Felix Man's Berlin work as Hans Baumann documented in large part the artistic culture of the Weimar era, which he remembered in the 1980s as a heady combination of experiment and politics, where, emerging finally out of aristocracy and provincialism, 'the cultural events of the German capital were unsurpassed'. These ranged from the concerts conducted by Otto Klemperer and Wilhelm Furtwängler to the Expressionist theatre of Max Reinhardt, to the 'progressive, proletarian theatre' of Erwin Piscator and Bertolt Brecht, 'orientated toward the East, and very much praised by the salon-communists'.[29] It was in this environment that Baumann started his career contributing photographs to *BZ-Am Mittag*, *Morgenpost* and the tellingly named *Tempo*, with intense scenes ranging from the promenaders pacing the neon-lit Kurfürstendamm to apocalyptic images of workers labouring at the Siemensstadt engineering works in the suburbs of the city, along with portraits of the likes of the atonal composer Alban Berg or the Expressionist painter (and later, émigré) Oskar Kokoschka. Baumann was brought to Lorant's attention by the photographic agent Simon Guttman, who would also soon emigrate. On the boat, Baumann was told by the border police that his admission into Britain was conditional on not taking on any paid work, an obvious explanation for his renaming as Felix H. Man; he claimed to have bumped into Lorant by accident in Bloomsbury, and was then roped into *Weekly Illustrated*.

But Kurt Hutton was perhaps the more interesting of the pair, his work being forceful, emotive and wide-ranging – at *Picture Post* it encompassed agitprop-style portraits of workers such as the aforementioned 'THEY BUILT "QUEEN ELIZABETH"' or the 1939 story 'THEY HAD NO

WORK', and social realism with a hint of Constructivist defamiliarization, such as the photograph 'Cleaning Shoes for Sixteen', a surreal, dynamic image from the 1945 piece 'BRINGING UP A VERY LARGE FAMILY', in which a street in Todmorden is lined with children's shoes, in ascending order of size along a sharp diagonal angle, scrubbed by a young woman on her terrace doorstep, an example of how to use an avant-garde idea for a very mundane purpose. Hutton's work is already powerful in *Weekly Illustrated* pieces such as 'MINERS DAY OUT' in 1935. Here, photographs from the Durham Miners Gala have been arranged (presumably by Lorant) into a dynamic montage, where on the right miners are celebrating at the gala – on a carousel ('everyone is gay – despite') – brass bands playing, and marchers unfurling a banner; and on the left Labour Party speakers are haranguing them, each with a slightly different hand gesture – George Lansbury, Stafford Cripps and, at the bottom, Herbert Morrison.

Similarly, 'CARDIFF HAS ITS HARLEM', from the same year, belies its sensationalist headline through Hutton's photographs, mixing raw matter like street boxing matches with an image of black and white children playing together ('They Know No Colour Bar').[30] In each of these stories, the freshness of Hutton's eye isn't the whole story. Alongside the vivid picture of these peripheral working-class British scenes, which couldn't be more distant from the West End and Shakespeare's Britain that Lorant dreamed about in the Munich prisons of the Third Reich, is a basic respect for the person being photographed – unromantically, but without sensation or luridness. It is one of several *Weekly Illustrated* and *Picture Post* stories revealing a sensitivity to racism that is surprising, for the time, and a documentation of Britain's few black social spaces. A few of these images, such as Felix Man's 1936 image of a challenging, quizzical billiards player raising an eyebrow at the photographer in 'Mission in the East End', are now classics; the latter currently serves as the Penguin Classics cover for Sam Selvon's *The Lonely Londoners*, a book published more than two decades later.[31]

The work of *Picture Post*'s photographers showed a great deal of awareness of the avant-garde. The striking image of soldiers wading out from the beach to the rescuers in the Channel at Dunkirk, in the photostory on 'THE EPIC OF DUNKIRK', could easily be by Rodchenko. *A-I-Z* frequently documented working-class life, whether negatively within Germany or positively, in the partly staged 'Life of the Fillipovs',

a photo-series that depicted the happy life of full employment in the Soviet Union. Lorant and Hutton's own version of this included a story on how *Picture Post* was produced, not just by its editors but at the level of the printing and distribution – a mildly Brechtian revealing of the 'hidden abode of production' that Lorant had already tried out at the *Münchner Illustrierte*. For all that, one should not exaggerate the occasionally implicit Marxism lying behind the surface in *Picture Post*. In Berlin, Felix Man had been proud of the fact that 'my little glass eye was everywhere, in the palaces of Heads of State or in the miserable homes of penniless hand-weavers',[32] and this continued in Britain. Kurt Hutton's documentation of a stamp-collecting George VI, or of Winston Churchill laying a tiled roof on his estate, are clearly designed to reduce class barriers within this ultra-class-conscious society in another way, here not by stressing the humanity of the working class but through emphasizing the normality of Britain's ruling class, a social layer which some other émigré photographers turned to document for their sheer surrealism. And of course, none of the émigré photographers were *from* the working class. The Weimar Republic created an important culture around the KPD of 'Worker Photography', with proletarian amateurs often contributing to *A-I-Z*. If *Picture Post* had a worker photographer, it was Bert Hardy, the South Londoner who was recruited to the paper by Tom Hopkinson in 1941.

After the war, in 1946, Hutton returned to Germany to illustrate the *Picture Post* story 'THE GREATEST TRIAL IN HISTORY', namely the Nuremberg trials, for which he captured a terrifying image of a human head 'lampshade' that had been made at Buchenwald concentration camp from the head of an executed Polish prisoner. Hutton's decision to return to his stigmatized country was, understandably, an unusual one. It is wholly unsurprising that few of these photographers went back to Germany or Austria – with the exception perhaps of the Viennese *Picture Post* photographer Gerti Deutsch, who after her return to Austria proceeded to create some haunting work. Born in 1908 to Czech-Jewish and Polish-Jewish parents, Deutsch grew up in Vienna as part of the intellectual (if not actual) aristocracy of the vanished Hapsburg Empire. Before a musical career was halted by illness, she had intended to become a pianist, and according to her daughter, the writer Amanda Hopkinson, she had been taught piano by E. H. Gombrich's mother. Like Kurt Hutton, Gerti Deutsch had some brief experience

of Britain before 1933; as a child, she had been sent to an English all-girls boarding school, from which 'she claimed to have run away at the first opportunity', something she blamed on 'a diet of porridge and cricket'.[33] Her early photographs, recently rediscovered by historians of photography and collected in a 'Sample Portfolio', are remarkable, revealing exceptional Vienna street scenes – especially a somnambulistic image of catering staff on a shabby, working-class street carrying dishes to some unseen party by negotiating the tram lines, worthy in its angularity and dramatic sense of a Constructivist.

Gerti Deutsch returned to Britain before the Anschluss of 1938, but after the coup of 1934, when previously 'Red Vienna' was forcibly shifted to the authoritarian, antisemitic right under the 'Austro-Fascist' regime of Engelbert Dollfuss. In 1936, Deutsch established herself in London as a commercial photographer, working at first for the likes of *Queen* and setting up a private studio – her business card, with elegant Bauhaus typography, advertised 'Gerti Deutsch of Vienna, Children a Speciality'. Deutsch was hired by *Picture Post* at its inception in 1938. She married Tom Hopkinson, it seems as much for love as for the security of a British passport (as in, say, the marriage of W. H. Auden and the writer Erika Mann, daughter of Thomas Mann). Notably, Deutsch was one of the few émigré photographers at *Picture Post* to have refused to anglicize their name. Her most important early *Picture Post* story was on the *Kindertransport*, the Jewish children saved from the expanding Third Reich – an episode about which British public opinion has always been rather excessively self-congratulatory, but Deutsch's work zooms into the emotional life of the children themselves rather than the politics that took them from Berlin, Vienna or Prague to the ports of Tilbury and Harwich in Essex. The story, 'THEIR FIRST DAY IN ENGLAND', mixes informal pictures of these just-arrived Jewish child émigrés playing football or ping-pong with stark, face-on portraits, in which they look at Deutsch sometimes with uncertainty, sometimes with confidence.

The child's-eye view adopted by Deutsch enabled her to smuggle a subversive humour into the occasional worthiness of wartime *Picture Post*. In the story 'CHILD'S VIEW OF THE WAR', accompanying a piece by Mass Observation's Tom Harrisson, the pair record children telling them 'I would ring Hitler. I'd say bomb that school. Hitler would you be dear to me and bomb my school, please. Then I'd give him 6/d for

bombing it.' The children in the story, hunched and sprawled in messy groups over big sheets of white paper, are making drawings of the war to be shown at an exhibition. They were actually photographed at the Willow Road house designed by the Hungarian architect Ernő Goldfinger, whose daughter Elizabeth was included in the photos. The source of Deutsch's best-known photograph, however, is a piece about adults, of a sort: 'A Day in the Life of a Cambridge Undergraduate'. It is very *Picture Post* that this 1939 piece, documenting a frock-coated young man going about his business in the cloisters of the university, has survived to posterity only through the accompanying photographs of the undergraduate's bedmaker, a middle-aged working-class woman who Deutsch photographed in her pinny, laughing freely and happily, all chins and teeth, over a cup of tea. This was the sort of unpolitical, non-agitational image of working-class strength and humanity that simply didn't exist in British media before the émigrés arrived, but which by the 1960s would be reified into the clichés of the Good Old Days before mass affluence.

Gerti Deutsch, 'Their First Day in England', *Picture Post*, 1938.

Deutsch returned to Vienna in 1948, under the pretext of a series of stories such as 'A Foreign Correspondent's Life' and 'Home From Russia', documenting a British journalist in Vienna and the return of prisoners of war from Soviet POW camps, respectively. They document an utterly shattered society, surrounded by ruins, populated by thin, haggard figures in now oversized suits, uncertain of what will come next in a city then divided between the western powers and the USSR. The way in which photographs were part of a larger narrative occasionally obscured their power when seen in isolation – the 'Foreign Correspondent' story diminishes a frightening, Kafkaesque image of the treason trial of the Nazi actor Otto Hartmann, both judge and judged framed in the nightmarishly oversized spaces of the court. After leaving *Picture Post* – and divorcing Tom Hopkinson – Deutsch travelled, and she prepared two unpublished photobooks, one on Japan and one on her native Austria, in which she attempted to come to terms with a country thrown 'back to reality'.[34] These photobooks, like so much of her work, were never widely seen in her lifetime, and like *Picture Post* itself, her career did not survive the 1950s, a fate that befell all but the most savvy of the émigré photographers, those most willing to adapt to British caprices, fashionable tastes and, in some cases, the more restrictive politics of the Cold War.

The work of émigré photographers at *Picture Post* and *Lilliput* was more diverse than its reduction to photojournalism would necessarily imply. The average issue of *Lilliput*, for instance, might include animal photographs by 'Ylla', the nom de plume of the Hungarian Camilla Koffler, or vaguely arty nudes by Zoltan Glass and his brother Stephen Glass; the latter two paved the way for the proliferation of soft porn in British magazines in the late 1950s and 1960s, one of the less wholesome of Stefan Lorant's various legacies. However, the humour, irony and cuteness of *Lilliput* under the editorship of first Hopkinson and especially the future head of Puffin Books, Kaye Webb, meant that it avoided the misogyny and naffness of contemporary imitation magazines such as *Men Only* and *Parade*.

In the immediate post-war era, *Picture Post* was also at the forefront of high-mindedness, pushing for a new democratic socialist Britain in its stories. Among these is a remarkable piece by a relatively unknown émigré photographer, Elisabeth Chat, on the planning of the New Town of Peterlee, in the County Durham coalfield.

Chat was from Graz and had escaped Austria and the Anschluss in 1938; after a spell interned on the Isle of Man she worked in darkrooms and as a medical assistant, before meeting Simon Guttmann, who brought her to *Picture Post*. The December 1948 story 'A MINERS' TOWN TO END SQUALOR' focuses on one of the lesser known of the various post-war New Towns built by the Attlee government. While most were planned around London, Liverpool, Birmingham, Edinburgh and Glasgow to relieve overcrowding in the most densely populated cities in Britain – and were directed very much from the top (a prominent figure was the notoriously autocratic BBC director Lord Reith) – Peterlee[35] (named after Peter Lee, a local miners' leader) was devised by activists, councillors and trade unionists in the Durham coalfield itself. It was, at first, planned by the socialist émigré architect Berthold Lubetkin. Chat's story doesn't focus on the imagined future so much as the reality of the mining villages in the 1940s. The photographs include two head-scarved women looking out through a brick gateway

A New Life Is Talked About
Mrs. Akenhead (right) questions the tenant of a condemned house under the Wingate spoil-heaps. Her opinion will help plan Peterlee.

Elisabeth Chat, 'A Miners' Town to End Squalor', *Picture Post*, 1949.

at washing and slagheaps, and another of a miner gazing towards the sky between a brick wall and a drying pair of trousers. Everyone is looking towards the future, in a present covered in the muck and detritus of the nineteenth century. By contrast, Chat's 1945 story 'THE COUNTRY HOUSE REVOLUTION', which documents another, eventually abortive, part of the programme – the dissolution of the landed aristocracy, as they found themselves without servants, heavily taxed, and under pressure to donate their piles to the National Trust or the Ministry of Works. Chat's two stories demonstrate how *Picture Post*, after a decade of gentle propaganda, seemed to be influencing the progress towards a social-democratic country. The country houses, those seats of imperial power, were being dismantled and turned into museums; the slums and industrial towns, rather than being sites of exploitation and misery, were being transformed into utopian modernist communities. For a time, it may have seemed like this really was the future of Britain.

8
Upstairs, Downstairs

The world that *Picture Post* imagined in the 1940s never quite came to pass, and one way of seeing why could be in the juxtaposition, Lorant-style, of two of its most famous and mercurial photographers, whose fortunes from 1950 onwards were radically different.[1] The first of these is Edith Tudor-Hart, born Edith Suschitzky in 1908 in Vienna to a Jewish, socialist family of booksellers (her younger brother, Wolfgang, was also a talented photographer, and later cinematographer, who we will turn to presently). The second is Bill Brandt, who was born Hermann Brandt in Hamburg in 1904 into a bourgeois Protestant family, with an English father and a German mother. Both Tudor-Hart and Brandt were exceptionally talented, and drawn to the avant-garde of their time – the Bauhaus and Soviet Constructivism in Tudor-Hart's case, Expressionism and Surrealism in Brandt's – and in the 1930s, both specialized in juxtaposing the lives of the British ruling class and working class. Brandt published several books of his photographs between the 1930s and 1980s, whereas Tudor-Hart never did, but the title she had in mind for her unpublished anthology would have fit Brandt's earlier work equally well – *Rich Man, Poor Man*, or *West End, East End*. In 1951, the year after Tom Hopkinson was purged from *Picture Post*, Tudor-Hart destroyed her own archive, in paranoia that her parallel career as a spy for Soviet intelligence would be discovered, and her photographic career did not, like that of other émigrés, survive the decade. Brandt, by contrast, went from strength to strength, ascending to honorary membership of a British establishment that he registered at first with horrified fascination, and increasingly with erotic infatuation.

A vague leftism was common among the émigré photographers and photojournalists. Many were to one degree or another supporters of the Social Democrats in Germany and Austria, a good number had fled the

White Terror in Hungary in 1919, and all of them had the experience of seeing German Fascism first hand. Taken together, this meant that they, like most émigrés, found British indulgence and ignorance of what Nazism really signified deeply frustrating and alienating. It was also common for them to register in their work the enormous gap between rich and poor in their adopted home during the Great Depression. But few were really seriously committed, and were perhaps at most tangentially related, to a general intelligentsia allegiance with 'progressive' forces, which were occasionally believed to be embodied by the Soviet Union and the Spanish Republic. Edith Suschitzky, however, was as much a Communist as a photographer. She studied at the Bauhaus Dessau under its photography expert Wolfgang Peterhans, and though the Constructivist influence is subtle, it can be seen in her photographs of Vienna, such as a sharply angled image of the Prater wheel that was later used for the BBC's magazine *The Listener*, and in a dynamic documentation of a demonstration by Viennese workers. She also occasionally created photomontages, including for British books on the left. Her covers included one of 1930 for G. T. Grinko's *The Five-Year Plan of the Soviet Union*, for the 1934 architectural manifesto *New Towns for Old*, and a dust jacket of 1932 for John Reed's classic account of the October revolution in St Petersburg, *Ten Days That Shook the World* (ironically, a book which would soon be quietly disowned by Communist parties the world over for the prominence it gave to Trotsky, and its lack of mention of Stalin).

Edith Suschitzky travelled to Britain in 1930–1, meaning that she had some knowledge of the country before the Nazi seizure of power in Germany in 1933 and the Austro-Fascist seizure of power in Vienna the following year. She was on assignment in England for her main outlet, the Austrian Social Democratic newspaper *Der Kuckuck* ('The Cuckoo'). It was in this capacity, taking the photographs for stories that would be published as 'WHITECHAPEL – LONDON'S SLUM', and 'THE MARKET OF NAKED MISERY' about the Caledonian market in King's Cross, that she was expelled from the country in 1931. But she had made connections, publishing one of the first British stories on the Bauhaus for the magazine *Commercial Art* in March 1931. She was to marry the Welsh doctor and activist Alexander Tudor-Hart in 1933, the same year she was arrested in Vienna as a courier for the KPD. On emigration to Britain her day job was in portraiture and work

for Abbatt's Toys, alongside work for a variety of magazines such as *Geographical Magazine* and *The Listener*, and agitational material such as the polemical pamphlet *Jubilee Chimp*. This was a collaboration for the Communist-aligned National Unemployed Workers' Movement (NUWM) with the architectural photographer John Maltby, which juxtaposed the relative affluence of a zoo-kept chimpanzee with 'one of her poor relations, man'. She is believed to have begun working for the NKVD, the forerunner of the KGB, in Britain during 1934, through which she had a minor role in the recruitment of Kim Philby.

Although she occasionally talked of Britain being a mere stopping-off point, with Moscow her preferred refuge, Tudor-Hart's work does not show the indifference to British life that you can see in the British work of her KPD comrade John Heartfield.[2] She was inspired by England, and produced excellent, powerful work here, mainly localized to two places – London, where she lived, and South Wales, where the family she had married into were based. Her London photographs

Edith Tudor-Hart in the Rhondda, from *Geographical Magazine*, 1936.

often show quite solitary poverty. Perhaps her best-known photograph shows a dirty, malnourished girl staring into a bakery window, originally taken for a NUWM publication; but there are also works such as the lovely, heroic 'Boys in the Street, London 1935', which makes icons of its working-class subjects while still retaining their childlike humour. Some of these photos reveal echoes of her work in Vienna. A clean, optimistic image in 1938 of Kensal House, a modernist housing scheme designed by Maxwell Fry for gas-board workers, looks back to a photograph from nearly a decade earlier of the proud arches of Red Vienna's emblematic public-housing estate, Karl-Marx-Hof. Both photographs are empty of people.

The photographs that Tudor-Hart took of the mining communities of South Wales and Tyneside, though, are real images of collectivity and collective action. Most were taken for commercial commissions from *Geographical Magazine*, where they sat oddly alongside imperial exotica. There is, in some of these pictures, evidence of a Bauhaus-trained interest in architectural regularity and linearity, as in 'Miners' Cottages, Rhondda Valley, 1935'. In the same series, 'Unemployed Workers' Demonstration, Trealaw, South Wales, 1935' reveals an exemplary use of Constructivist techniques – architectural abstraction, dramatic angles – to make a political point, as the workers march down one angle, and the steep slate roofs of the miners' terraces march down another, giving a sense of great power and urgency, the marchers caught in the geometry of the frame, but surging as if about to stride out of the picture and into History.

Like Gerti Deutsch, Tudor-Hart's work often focused on children. It's likely that both photographers were encouraged towards these more 'feminine' subjects by the sexism of even 'progressive' commissioning editors, but in both cases this shouldn't suggest that they didn't take this work seriously. Tudor-Hart's work repeatedly comes back to scenes of solidarity among children, starting with a rousing, moving photo-series on Basque child refugees being taken in by the city of Southampton following the Francoist bombing campaigns of the Spanish Civil War. Her *Picture Post* stories were propaganda for humane, holistic forms of education, which were, incidentally, being sidelined by the Attlee government as it divided pupils at eleven into the distinct streams of grammar (upwardly mobile) or secondary modern (proletarian) schools. These features include the December 1944 story 'A Girl Learns to Make a

Hat'; the June 1945 story 'Making a Mess Cleanly'; and the April 1949 story 'A School where Love is the Cure', on Montessori schools. Tudor-Hart can be found in *Picture Post* even after Hopkinson's departure, somehow getting past Hulton's anti-communism to publish the story 'Where Youth Has Its Fling' in November 1951.

Tudor-Hart's last major photographic project, *Moving and Growing: Physical Education in the Primary School*, was a commission from the Ministry of Education, and it deploys her sharp Constructivist eye as she focuses on young children playing in a startlingly unruly fashion, leaping about uninhibited and half-naked, unconcerned by adults (they appear to be ignoring Tudor-Hart throughout), swinging from trees and climbing fences in suburban gardens, forests and industrial wastelands. They are works of pure exuberance, showing childish enjoyment for its own sake, rather than as part of some 'strength through joy' ideology or some concept of sport in schools as 'character-building' punishment (something rather hard to imagine for anyone who took part in P.E. in the twentieth century). They are the most joyful images Tudor-Hart ever produced, and the nearest she came to an image of utopia. As much as Elisabeth Chat's images of the Durham coalfield, these are documents of a promised new society, where the Victorian misery of British education

A page from Edith Tudor-Hart's *Moving and Growing*, 1952.

would give way to freedom and exploration. In her work, Tudor-Hart had created a series of images depicting working-class British people as dignified, powerful, and conscious political actors; her later photographs were taken when her political commitments became increasingly unfashionable and personally dangerous. Common to both Tudor-Hart and Chat was a hope that the raw capitalism of industrial Britain would never return, and deserved to be consigned wholly to the past. Some, though, would soon become rather nostalgic for the world of the nineteenth century.

The gradual shift in Bill Brandt's photography from what was considered *at the time* to be powerful social realist reportage into nudes in Victorian interiors, writers' houses in the British countryside and nostalgic images of nineteenth-century streets is one instance of this. Biographers have traced this change to the particularly extreme Anglophilia of the photographer. The man known as Hermann Wilhelm Brandt on his Hamburg birth certificate never admitted publicly to being German. As a man who, according to his biographer Paul Delany, had a compulsive, lifelong fear of being 'found out',[3] Brandt made a specific choice to become British in a much more drastic way than most émigrés. In his first piece for *Lilliput*, 'Unchanging London' of May 1939, he is described as a 'young English photographer'. Brandt's potted biographies in his books made various claims, most often that he was born in South London to Russian parents; presumably the resultant accent led his interlocutors to assume, correctly, that English was not his first language. As Brandt became famous, he would flatly deny to interviewers that he was German. There are various reasons for this. One is that of course he wasn't *wholly* German – his father was indeed English, and this led to brutal bullying of Brandt as a Hamburg schoolboy. His highly bohemian youth was spent partly in Davos, where the always sickly Brandt spent time in a sanatorium for patients with tuberculosis, and partly in Vienna. There he had psychoanalysis as early as in his twenties, learned photography, and developed an enthusiasm for architecture (Adolf Loos' Moller House was one of his first subjects), and for surrealism – a chance meeting with Ezra Pound saw him introduced to Man Ray. Emigrating to London in 1933, Brandt chose a new name for himself – one that was rather fortuitous, with the same earthy clip as a Bert Hardy.[4]

Brandt came at his work from a different angle than people like Hutton, Man and Deutsch – not just because of his more rarefied background,

but also because from the beginning he approached photography as an 'art' rather than a form of journalism. He worked throughout the 1930s for the mass-market press – his first story was for *News Chronicle* in 1933 – but unlike the other émigré photographers, he made the choice to concentrate on his own vision and create his own space in a series of photobooks. The first of these was the 1936 *The English at Home*, a book that at first sold poorly but that has since become a classic of its kind. This rested on the same 'Rich Man, Poor Man' or 'West End, East End' principle dear to Edith Tudor-Hart – a documentation of the startling inequalities in Brandt's adopted homeland. It can be interpreted on one level as pure social critique. A half-asleep Bishopsgate porter, up at the crack of dawn, is juxtaposed with an equally dreamy but rather more idyllic Surrey cocktail party, with the hills descending below the frock-coated dancers. Rows of rainswept roofs evoke the sense of horrifying, alienating endlessness that Karel Čapek had observed in English streets. A miner, his face caked in muck, sits at a politely laid dinner table, checked cloths and wallpaper around him. A splay-legged traffic policeman appears to stand guard over the West End at Regent Street. A working-class family, crowded into a tiny room, gaze sadly into the middle distance. Lovers neck on the grass of a public park. There is a dreaminess, a sense of the protagonists being themselves out of time and out of space, that is unlike the average *Picture Post* story, but the politics are clear and obvious – you are meant to be disgusted by the contrasts of affluence and poverty here. The notion that this is a book of social criticism is reinforced by a preface by the critic Raymond Mortimer, who puts it delicately: 'one's pleasure in being English is somewhat modified by knowledge of this unnecessary, this humiliating squalor. And if one insists on referring to it, one is likely to be called a Bolshy. But it is not asking about these facts which makes people Communists – it is the facts themselves.'[5]

Decades later, Brandt would deliberately downplay this aspect of his work, arguing that his 'social criticism' pictures were 'visually very exciting for me', rather than mere 'political propaganda'.[6] But while in 1936 Brandt was interested in more than *just* facts, he was interested in facts too. Some in his immediate circle, including his brother, the illustrator Rolf Brandt, and his sister-in-law Ester Brandt, were fellow travellers or card-carrying Communists; his photographs were shown at the end of the decade in a survey of documentary works at the Communist Party's

Marx House in Clerkenwell Green (now the Marx Memorial Library). In April 1939, *Picture Post* used some of Brandt's most dramatic work in a thumping story on poverty entitled 'ENOUGH OF ALL THIS';[7] and Brandt's panoramic images of squalid East End slums would be used by his friend Ernő Goldfinger to illustrate his digest of the London County Council's utopian *County of London Plan* for Penguin Books. Certainly, Brandt was someone deeply interested in the strangeness of England. *The English at Home* has recently been described not just as 'the work of a detached observer documenting life in a foreign land',[8] but as 'a fond study of the ways people take possession of their environments',[9] an early effort in a decades-long attempt by Brandt to really make himself English. But these are not mutually exclusive facts, and the fascination doesn't necessarily contradict the harshness of some of the juxtapositions he makes. It is perhaps more true to say that Brandt was interested both in criticism – there is no reason to think he was not sincerely disgusted by disgusting conditions – and in documenting the distinctiveness of a landscape, and in depicting his subjects as thinking, dreaming human beings rather than archetypes.

It is in other places that Brandt breaks with a documentary insistence on veracity and truth, which you could find in the contemporary insistence on 'Factography' in Soviet Constructivism, or in the denunciation of falsity and construction by the French realist photojournalist Henri Cartier-Bresson. *The English at Home* includes Ester Brandt as a 'Brighton Belle', and friends from Brandt's Belsize Park circle acting as aristocrats. The Expressionist fantasia of his subsequent book *A Night in London* (1938) takes this much further, with every picture a tableau of actors performing roles derived from Fritz Lang and Alfred Hitchcock, rendering London as a rain-slicked Gotham of sex, dreams and threat. But then, many *Picture Post* photographs by photojournalists were staged too, from the paper's opening shot of accidental indiscretions at a Southend rollercoaster onwards. It is only as the 1940s progress that a really sharp difference in practice between Brandt and the politicized documentarians opens up. Some of this was surely due to misunderstanding on the part of *Picture Post* itself. His photos were often comically misused – in one example, a joyful image of East End girls doing 'The Lambeth Walk' while leering at the camera was juxtaposed by Hopkinson with a gormlessly uptight image of a member of the Girls Training Corps, as a before-and-after image of social improvement. When they published his

great panoramic images of a satanic but thrilling Piranesian Newcastle or Halifax, Brandt's horrified fascination with sublime scale mixed with punishing squalor was reduced by *Picture Post* to a one-note image of poverty, soon to be swept away by the social-democratic state. Brandt would be commissioned to document this new world, photographing new housing estates in Birmingham for the Bourneville Trust, but it is obvious from them that his real interest lay elsewhere.

A Camera in London (1948) captures Brandt midway through this transformation. Published by Focal Press, run by the émigré Hungarian editor Andor Krasna-Krausz and with a text by Norah Wilson, it stresses in an opening biography that Brandt 'was much influenced by the work of Atget and Man Ray and by the Surrealist films of that time',[10] and has something of a credo:

> it is part of the photographer's job to see more intensely than most people do. He must have and keep in him something of the receptiveness of the child who looks at the world for the first time or of the traveller who enters a strange country.[11]

This was surely Brandt's little acknowledgement that this was exactly who he was. Here, there is a much more palpable fascination with the Victorian world, with grand, proud images of the Italianate streets of Bayswater, and his depictions of Elephant and Castle tube station as a bomb shelter, filled with people asleep but for one bleary eye aimed at Brandt's lens. Norah Wilson's short captions note that some of these effects derived from the war itself, because the Luftwaffe's carpet-bombing created a situation where 'through the gaps new vistas were opened, and for the first time the Londoner caught the full view of St Paul's Cathedral'.[12] There is still political juxtaposition in Brandt's images – 'Mayfair Morning' and 'East End Morning' feature, respectively, the windows being opened on a vast drawing room, a woman in a ragged pinny scrubbing at a doorstep, and the self-explanatory 'Seasonal bleakness over Adelphi rooftops' and 'Lasting bleakness over Shoreditch backyards'. In the latter, as Wilson writes in her commentary, Brandt 'tends to make one have a more friendly attitude towards prefabs'.[13] Alongside these photographs, there is also much more landscape in his work, more Victoriana, more Chelsea, more Hampstead.

This tension between criticism and surrealism arguably came to a

head when Brandt was sent up to the Gorbals, the notorious south Glasgow slum that was then the most overcrowded place in Western Europe, to document 'The Forgotten Gorbals', a place that badly needed to be cleared for the new socialist Britain. By the time the piece was published in January 1948, Tom Hopkinson had sent Bert Hardy up to Glasgow to take some photographs of working-class people, after Brandt had provided a series of epic, haunting and barely populated pictures of 'magnificent Victorian streetscapes'.[14] But Brandt's connection with *Picture Post* was actually severed by Hulton's censorship, not by Hopkinson's worthiness. Brandt's partner and frequent subject, the aristocratic and fine-boned Marjorie Beckett, was one of his close collaborators, and she resigned when he was sacked; his last story for *Picture Post* was in 1950, on the new world of the Festival of Britain. This piece confirms, though, just how much Brandt and the promised land had parted ways. The images of the Dome of Discovery and others are dwarfed by massive, haunting and mud-ridden images of the

Bill Brandt at the Festival of Britain, *Picture Post*, 1950.

industry being cleared for the site. The old brewery demolished to make way for the Festival is ennobled by Brandt with a photograph of its Coade stone lion over a grotty Piranesian brick archway, but, below, the caption describes it as simply 'a bit of Bad Old England'.[15]

A series of Brandt's photographs beginning in the late 1940s and early 1950s – nudes that might have been first intended for *Lilliput*, but veered away from gentle softcore – descend into a private, Freudian, Surrealist world. Thighs, hips and breasts are abstracted, and elongated bodies twist and turn in what are unmistakably Victorian interiors, all high ceilings, heavy wooden chairs, wallpaper and waxed floors. Brandt had always been fascinated with the nineteenth century. Paul Delany argues he was profoundly influenced by a Vienna exhibition of early photography curated by the historian Heinrich Schwarz, including work by pioneers like Julia Margaret Cameron, and showcasing their painterly, 'pictorialist' and deliberately ultra-artificial approach to photography. What makes Brandt's nudes so interesting is how they combine this with the very latest technology – the cinematic 'deep focus' borrowed from Orson Welles's *Citizen Kane*, and Carol Reed's Dresden-trained cinematographer on *The Third Man*, Bob Krasker, placing human figures within vast, detailed interiors – and the mind of the photographer fragmenting into shards. One can make out a sickly sexuality, a class-climbing obsession in Brandt with upper-class women in some of the more ornate nudes, and a more leering use of working-class sex workers in the blunter ones, surrounded by leftovers from the previous century. Brandt was in psychoanalysis at that point (with Barbara Lantos, a Hungarian-Jewish Freudian and Communist exile in Hampstead) and publicized this for an audience. A press photograph by his fellow émigré photographer and *Lilliput* contributor Leila Goehr shows him gazing knowingly at the camera, a copy of *The Living Thoughts of Freud* in his lap.

Those images can verge on a sort of national kitsch when the same ideas are transferred to landscape. Brandt began these at *Picture Post* and *Lilliput*, where he was given remarkable leeway to produce stories that included neither politics (important for the former) nor sex (important for the latter). 'The Vanished Ports of England' in August 1949 or the *Lilliput* stories 'Over the Sea to Skye' in November 1947, 'Hampstead under Snow' in February 1946 or 'History in Rocks' from August 1948 all feature some combination of obsolescence, untimeliness, and

mute, hieratic and monumental spaces and objects, whether man-made or natural. The Hampstead story, for instance, is a work of considerable beauty, set in the Metropolitan Borough where so many of the émigrés had congregated: dark chapels, snow-covered gardens, surviving cottages and Georgian houses, and a Henry Moore sculpture in Roland Penrose's front garden in Downshire Hill ('the other inhabitants did not think that it enhanced the neighbourhood').[16] The captions are keen to tell you which famous writers have lived where, from Byron to D. H. Lawrence.

These achingly British landscapes sometimes nodded to Brandt's Central European past. One historian has argued that the *Picture Post* story 'The Day that Never Broke', published in January 1947, with its lone figures walking through fog, was a direct tribute to Kafka's *The Castle*.[17] But mostly these landscapes derived from an increasingly uncritical, abstracted attitude towards his adopted country, as Brandt made a living photographing the artistic great and good of London for glossy American magazines. This new interest in pure landscape would also feature in Brandt's nudes, across the 1950s and 1960s, with the much-reproduced surrealist images of abstracted naked giantesses on shingle beaches. Similarly, in the 1951 *Literary Britain*, Brandt photographed the homes,

Bill Brandt's Hampstead in *Lilliput*, 1946.

home towns and home villages of various mostly nineteenth-century British writers, producing images whose neo-gothic Victorianism begin to seem a little silly. They were often faked, just as much as his documentary photographs were; for example, the looming sky in the Wuthering Heights of 'Top Withens' was from a different photograph altogether, montaged in by Brandt. If the photomontage techniques brought to Britain by agitprop artists like John Heartfield had involved an attempt to defamiliarize images and create unexpected juxtapositions and productive contrasts, now photomontage was deployed to fill in when reality wasn't clichéd enough.

9
Modern Antiquarians

Bill Brandt was far from the only Central European photographer in Britain to delve into the exotic history of this very new art form; some who had much stronger roots in the Constructivist avant-garde went in a similar direction. In their work, however, the exploration of the nineteenth century was not a matter of nostalgia or nationalism refracted through surrealist eroticism, but a more conscious project of trying to understand what photography was, and where it had come from, a project which entailed uncovering a much less romantic picture of the recent past. Lucia Moholy, born Lucia Schulz in Prague in 1894, was a photographer closely associated with the Bauhaus, through being married (until 1929) to its Hungarian polymath László Moholy-Nagy – in which capacity she lived in one of the Gropius-designed 'Masters' Houses' in the suburbs of Dessau, where she took some of the most-reproduced photos of the school, its buildings and its students. Notoriously, she was almost always uncredited by Gropius – and by her ex-husband – for these photographs, and her authorship has only become clear in recent years, making her one of the most celebrated examples of a woman's art being deliberately occluded by her male collaborators and partners. We will turn to László Moholy-Nagy's years in London soon, which entailed a strange collection of projects on subjects ranging from Eton College to shellfish; but his ex-wife actually managed to get much closer to the British mainstream in her twenty years in the country, producing a bestseller on the history of photography at the end of the 1930s.

Lucia Moholy had left Berlin almost immediately after the Nazi seizure of power in 1933, as a political refugee – her partner, Theodor Neubauer, was a KPD deputy in the Reichstag. She worked quietly in London as a photographer and photography archivist, and in this capacity was asked to write a few of the Pelican Specials, which at the

time were envisaged as an arts and sciences complement to the more straightforwardly political and polemical Penguin Specials. Her *A Hundred Years of Photography* includes several comments common to refugee *Bauhausler* about the aesthetic backwardness of the British in the 1930s. She ends the book with a survey of the trends that emerged in the two decades after the First World War: there is enormous technological experiment, with the emergence of X-ray photography, infra-red photography, the use of a multiple flash to create 1/1,000,000 of a second exposures, and the use by police of photography to reveal the fingerprints of criminals; there is 'photo-montage', of which the best representative is John Heartfield;[1] and there is something that Lucia Moholy calls 'continental realist portrait photography', which she roots in the close-ups of American and especially Soviet cinema, where, in the films of Eisenstein and Pudovkin, ordinary faces in all their expressiveness and individuality were seen on film for the first time. She concedes that these photographs, in which she includes her own (a craggy portrait of an elderly woman), are 'very remote from everything which had been done before. The number of these photographers has been considerable in Russia and Germany, less so in the western countries. To the general public in Western Europe this style seems strange and exotic.' Her adopted homeland, for instance, has 'conserved a strong taste for the soft-focused, gentle and placid portrait photograph of the Reynolds and Gainsborough style',[2] which she illustrates with a particularly glossy and oleaginous Cecil Beaton portrait. This attention to the ways in which interwar Britain remained essentially Victorian in its aesthetic tastes was, more unusually, combined with a survey of the nineteenth century itself, in a strange exploration of the futurism of a bygone age.

Lucia Moholy describes her book's aim as being 'to establish the connection between photography and life [and] a development from its early beginnings as a kind of magic art'.[3] That is, a combination of conventional *Neue Sachlichkeit* preoccupations with veracity and technology, and a conception of photography as something that has much more esoteric, anti-rationalist roots. Although she glances at British photography in her approach, her story is mainly a French one, in which the Revolution of 1848, the Paris Commune of 1871, and the deeply corrupt and unequal but exceptionally modernizing Second Empire that happened in between take centre stage. In this, she was continuing, or rather popularizing, the work of such Berlin Marxist intellectuals

as Walter Benjamin, in his 1931 'Small History of Photography', and Gisèle Freund, in her *Photography in France in the Nineteenth Century*, published in French just a few years earlier, in 1936. In Freund's book, photographers of everyday Paris such as Nadar and Atget are of great importance, as are the anonymous documenters of the arcades and department stores of the Second Empire, and the barricades and massacres of the two great abortive urban insurrections. For Moholy, like Benjamin and Freund, there is a productive tension between irrationality and technology in the photograph, the unprecedentedly accurate means of recording a society that is in the grip of pre-conscious forces of avarice, violence and greed.

This is rooted in the fact that, unlike most other arts, technology is so much part of the art form that in the 1930s, when Moholy was writing, the question 'But is it art?' was still being asked about the photograph. She answers this with a point that anticipates many later definitions of twentieth-century modernist cultures in design, architecture and film – 'photography is an art and a technique'.[4] Moreover, its roots in hobbyists' experiments, in attempts to locate ghosts, and in the quest for the philosopher's stone mean that photography has extremely impure roots, which put it further away from straightforward engineering: it was, Moholy asserts, 'the link between the ancient science of alchemy and the progress of modern chemistry which finally led to the discovery of photography'.[5] Because of this, it was accessible to people from beyond the academies of the fine arts in a way that no art that preceded it could possibly have been. In Hamburg, for instance, a survey of early photographers in the 1840s would have found that 'former painters, designers, lithographers, engravers, actors, singers, doctors, chemists, clockmakers, decorators, an officer, a captain, an innkeeper, a framemaker, various shopkeepers, the proprietor of a merry-go-round were among the dageurreotypists'.[6] After this remarkable churn of ideas and mix-up of classes, photography starts to settle down, becoming a quintessential middle-class art. Here, Moholy goes into some detail on the 'pictorialism' of the nineteenth century, and on the typical family-portrait photograph of the Victorian age, where the bourgeoisie were shown surrounded and encased by an oppressive pile-up of heavy furniture, doilies, carpets, rugs, throws, wallpapers, foliage, corsets, collars and hats. Moholy, the Bauhaus modernist, obviously regards this assemblage as ridiculous, which it is. But whereas these photographs

and objects were valueless in and of themselves, they are, she notes, 'of extraordinary value to the student of social evolution'.[7]

After this book, Moholy's British career becomes more obscure, and she returned after the war to Central Europe – Prague, then Berlin, then Switzerland – in the 1950s, and started to assert ownership of the invaluable photographic archive that Walter Gropius was passing off as his own. But the greatest 'student' of British 'social evolution' among the émigré photographers was from a slightly younger generation: Helmut Gernsheim, born in 1913 in Munich to a half-Jewish family. He began his photographic career in that city in 1934, on the recommendation of his brother, the art historian Walter Gernsheim, who believed that photography would be an apolitical art form that a part-Jewish artist could practise without harassment. This proved not to be the case, and the brothers emigrated to Britain, where both were interned; Helmut Gernsheim was deported to Australia on the notorious HMT *Dunera*, before returning to Britain in 1942. He soon found himself working for the National Buildings Record, documenting the historic British architecture that was in danger of being destroyed by bombing (or already had been); he was also tasked by the émigré art institution the Warburg Institute to build up a photography archive, which became immense, and the source of his incredibly prolific output of books on the history of photography between the 1940s and the 1960s, many of them in collaboration with his English wife Alison Eames. This archive, estimated to be the largest collection of photographs in the world, was his life's work. After various failed attempts to house it with British institutions, Gernsheim sold the archive to the University of Texas. Depressed by his British rejection, he nevertheless 'never stopped thinking of himself as an Englishman'.[8]

We'll take just three of Gernsheim's published collections of photographs: *Beautiful London*, 1950; *Those Impossible English*, 1952; and *Historic Events, 1839–1939*, from 1960. The first volume, by the transplanted Viennese art publishers Phaidon, is a showcase of Gernsheim's photography. Inside a beautifully printed and rather conservative cover featuring the dome of the Old Bailey is a collection of photographs derived no doubt partly from his work for the National Buildings Record, but mainly from the work Gernsheim was tasked with by the Warburg Institute; this was the product of an émigré publisher on almost every level. The book shows a very Warburg approach to historic architecture, in that the nineteenth century features very little, 'the Renaissance' (or

the rather later English baroque that passes for it in this country) very heavily, and there is an eye for the paradoxical. Looking at London as a classical – a beautiful – city would, at the time, have been rather novel. This is flagged up by Phaidon's blurb, which tells us that in *Beautiful London*, 'virtually every aspect of London's appearance is presented in a new light'. So too with the introduction by the travel writer James Pope-Hennessy: 'the largest capital in the world, London is a city which was never planned. It has accumulated. For this reason, and also because its development was chiefly guided by mercantile considerations, London is no longer, at first sight, overtly beautiful.' It is 'nothing but a mass of rural villages – Kensington, Tottenham, Paddington, Camberwell, Edmonton, Hampstead and so on – engulfed in the tide of two centuries of swift urban expansion', though Pope-Hennessy holds out some hope that 'in 1951 the Exhibition buildings for the Festival of Britain may do something to alleviate the dreary aspect of London's South Bank'.[9]

Pope-Hennessy tacitly acknowledges that the book was by someone who, less than a decade earlier, was an 'alien', deported to Australia, by noting that 'it is certain that the stranger – English or foreign – must be initially bewildered by his first sight of London'. Moreover, 'it is not unlikely that he may also be disappointed or repelled'. Because of this, someone who expects classical beauty, order and visual repose – someone from Munich, perhaps – will have to search for it. He has done this successfully, revealing such unknowns as:

> the sphinxes in Chiswick Park, the Tudor tombs at Stoke Newington, the splendid Norman pillars of Waltham Abbey, the Geffryes workhouses at Shoreditch, the small street sloping down to Saint-Andrew by the Wardrobe, the Italian villas on the Paddington Canal, the little graveyard feathery with sheep's parsley in summertime, the Old Church at Edmonton where Charles Lamb lies buried, or that oddest of all Victorian schemes, the Catacombs and Columbarium in Highgate Cemetery, here photographed for the first time.[10]

Some of these revelations can be found in Gernsheim's book, but mostly, this is a more familiar London, the monuments of the West End, the City, and of course Hampstead, with some tentative forays further afield to Greenwich and Chiswick; the book's interest lies in recognizing an underlying classical, European order to London that can be found

Helmut Gernsheim's Phaidon album *Beautiful London*, 1950.

underneath the accretions of the Victorian era, and depicting it with a neoclassical high-contrast starkness.

In his history of photography, written for another émigré publisher, Thames & Hudson, Gernsheim described his own work as an attempt 'to propagate the New Objectivity in Britain'. But if as an architectural photographer, in *Beautiful London*, Gernsheim had the modernist's deep suspicion of the aesthetic landscape of Queen Victoria's reign, with all its irrationalism and lack of order or plan, as a historian of photography, it was his subject.[11] *Those Impossible English* is a spectacular case in point. It is one of several approaches taken by Helmut and partner Alison Gernsheim to presenting and framing their increasingly compendious collection of photographs, here through an annotated book about how photography has documented British society – which means the British class system – between the 1840s and 1940s, another 'century of photography' like Lucia Moholy's. The émigré publisher this time was Weidenfeld & Nicolson, founded by the Viennese journalist George

Weidenfeld. The short texts accompanying the pictures are by the Gernsheims, but there is a long introduction by the late, minor Bloomsbury intellectual Quentin Bell, which contextualizes the texts' primarily visual exploration.

For the Gernsheims, 'our aim was not to illustrate historic events but the life of the people – the pleasures and sorrows of the English';[12] and, they note, whereas Victorian art is worthless nonsense best kept in the basements of municipal art galleries, their photography was of incalculable use in understanding who 'we' are and how we got there. Bell, as the English ruling-class correspondent, gives some pithy summaries of the British class system, and particularly the way in which it upends a familiar European idea that progress comes from the bourgeoisie dispossessing the aristocracy; actually here in England, they fused, and many of these Victorian photographs were taken 'while the oldest families in England were engaged in the exploitation of mineral rights, turnpikes, canals and horse-hoe husbandry ... and nabobs were purchasing boroughs, estates and titles of honour'.[13] Because of this, the new elements of the ruling class were especially preoccupied with displaying their wealth, indulging in conspicuous consumption that would obscure their roots in industry and trade. *Those Impossible English* can seem cosy and nostalgic if flicked through casually, but it can't be avoided that, for the Gernsheims, what made the English 'impossible' was the intricacy and irrationality of their class system, and the ways in which they insisted on using their environments and their dress as a means of demonstrating their status within it.

Photography was the perfect medium for this exploration of the aesthetics of class: it 'shows (and this is its great merit) just how the sunlight fell on the folds of a crinoline or the outlines of a workman's barrow at a given moment in history'. Hindsight, changing fashion and changing politics add further layers of interpretation, which means that the portraits of the Victorians inadvertently boast 'what may be described as "double exposure". On the one hand the scientifically recorded image of the sitter as he appears to us and, on the other hand, the deducible image of the sitter as he hoped to appear to himself.'[14] This double exposure comprises a dialectical exploration of a place and time, both a fascinated glimpse, à la Brandt, at the remnants of an age of unexplored subconscious cravings and desires, but also a very concrete analysis of how class and distinction were expressed through pictures and

environments. We could start with the crowded absurdity of the heavily posed domestic scene in *Those Impossible English*, namely 'Recreation at Home, c. 1856', in which a paterfamilias is bent down before the lap of his daughter. The picture displays how 'a passion for decorating every available surface persisted throughout the century. Prodigious energy was expended on making a room genteel. Note,' the Gernsheims tell us, 'the table-cloths and the glass cases, the lamp and the wall-paper.' They also explain some of the apparently baffling postures: 'the gentleman in the foreground is looking at photographs through a stereoscope, while his daughters play billiards'.[15] On the facing page is 'The Geography Lesson, c. 1851', which showcases the warped version of childhood so sentimentalized at the time. 'Children in large quantities were a characteristic of the Victorian scene. Here, a gentleman, presumably papa, instructs his family in the use of the globe. The youngest child is furnished with a handsome picture book, containing a fine engraving of the Maison Caree' (there is an implication here about 'the use of the globe', explored much further in the slightly later *Historic Events, 1839–1939*).[16]

There are also jokes in *Those Impossible English*. It was common for twentieth-century aesthetes to find the Victorians funny, but the Gernsheims were good at the silly-serious use of ridiculous images to make quite specific political-historical points. Take for instance the farcical 'Margate Beach, c. 1858', where top-hatted and corseted figures seem frozen to the spot on the sands:

> The strange thing about Victorian beach scenes is that sand and sea play remarkably little part. Even the bathing machines in the background appear untidily rejected, and the holiday-makers (if they *are* on holiday) seem to have been lifted straight from their drawing rooms to the sand.[17]

It is impossible to let up for a second, to let propriety slip for the slightest instant. The jokes are elsewhere more surrealist in intent. A bizarre early photomontage made up of what looks like peacock feathers around a pocket mirror features a different woman inset into each feather, with a heavily bearded patriarch, presumably the father to these daughters, in the middle. The Gernsheims have captioned this 'Victorian Fertility, c. 1868', as if to tell us that this was how these bizarre creatures reproduced.

The twentieth-century collection in *Those Impossible English* is less

full of intrigue, partly because many of the photographs have since become 'classics' – Winston Churchill and a line of police surrounding the Latvian Anarchists at Sydney Street, resembling a scene from the Keystone Kops, or 'Scene at the Serpentine, 1925', the news photographer Reg Speller's capture of a uniformed policewoman with a cane chasing naked street children who have somehow made their way into Hyde Park to bathe in the lake. There are also a few images by émigré photographers from the then still-running *Picture Post*, such as what Quentin Bell refers to as 'Hutton's unforgettable photograph of the unemployed man [and] the Eton boys', which is 'much more gripping and convincing commentary' on English inequality than any polemical article or political book;[18] there is also Hutton's staged image of 'The Fair, Southend', here without the knickers retouched out; and there is one of Helmut Gernsheim's own images, from wartime, 'Anxiety Among the Statues, 1942', in which historic sculpture is rendered into strange accidental poses as it is shoved against the wall in its bomb shelter. The Gernsheims' evocative ending to the book is a misty scene over a Victorian village, which the caption tells us is 'the New Town of Stevenage, 1951' – again, no actual image of a more socially equal, modernist future, but the suggestion that it is on the cards, about to rise out of all this Victorian fog.

If *Those Impossible English* is cute, the subsequent volume *Historic Events, 1839–1939* is much more brutal and shocking in its treatment of the nineteenth century. Here, write the Gernsheims, 'photography is the historian of our time',[19] and the time in question is a harrowing one, a hundred years of massacres and disasters leading up to the great catastrophe of 1939–45. The general ideas are similar – tracking the way that photography can grant a retrospective significance to the trivial, constructing an understanding of history based on ephemera – but the focus on 'Events' rather than interiors or buildings results in something much darker. This interpretation is encouraged by the way in which the Gernsheims juxtapose their images, so that the facing pages appear to comment on each other, a vulgar but effective dialectical method pioneered in Britain by Stefan Lorant's 'juxtapositions'. Progress is refracted through disaster: 'The First Public Railway in the World', an 1850 photograph of a rudimentary train on the 1825 Stockton–Darlington line, faces the charred wreckage of the docks of a major German port in 'The Great Fire at Hamburg, 1842', a city that would be destroyed more comprehensively a century later. But here, the

blank emptiness of the photograph would not, the authors note, have been considered newsworthy at the time, and in the *Illustrated London News*, the cover on the event of the fire featured an engraving of the city 'with flames added by an artist'.[20]

Atavism and futurism are constantly thrown together. The Crystal Palace in London and the erection of a colossal embodiment of 'Bavaria' in Munich, the birth of the cinema and the pretentious resurrection of Ancient Greece in the first modern Olympics in Athens of 1896. There are several spreads on colonialism and warfare – particularly of the 'Indian Mutiny', the rebellion against British rule in 1857: destroyed buildings, mutineers hanging from the gallows, and a courtyard in Lucknow showing a few dozen of the two thousand 'Sepoy' corpses left by the British in their wake. Similarly violent are the images of the Opium Wars. Over photos of historic buildings pockmarked with shells and bullets and a scene of scattered corpses, the Gernsheims pointedly note that in the resultant treaty, 'a clause forbade the application of the term "barbarian" to Europeans!'[21] Mixed in with these are apparently celebratory images of new modern construction, engineering and science – the cyclopean frame of the Eiffel Tower at the 1889 Paris Exposition, the Forth Bridge in Scotland, the invention of X-rays and radium – but these too tend to end in disaster. The whiskers and uniform of Lord Kitchener face off against the miserable muddy waste of the trenches; the first stratospheric flight is twinned with a collapsed Zeppelin; George VI is crowned and the Hindenburg airship catches fire.

The Gernsheims also note a few fakes, such as a reconstruction by the pro-Versailles media of the execution of two generals by the Communards of Paris in 1871; but ironically, despite their concern for historical truth, the ephemera the Gernsheims collected sometimes fools them. As was common at the time, they identify one image as depicting the 'Storming of the Winter Palace' in St Petersburg, the key event of the October 1917 Bolshevik insurrection, when it is in fact an image of a subsequent celebratory re-enactment. But mostly, this is a convincing document of how photography can indict a historical period – a project that anticipates in its grimness more recent works that are explicitly critical of colonialism and capitalism, such as *Looking Backward*, Michael Lesy's twenty-first-century uncovering of the roots of current disasters in the nineteenth century through the Victorian photograph. Doing this through what were at the time still basically considered waste-products

was the Gernsheims' great achievement. Once again, at the start of the book, they lament that few have understood the significance of these images, and that newspapers were continuing to destroy their own archives of press photographs, an archive that they imagined being created in Britain, but which never would be. As it is, though, their work represents one of the more radical achievements of an émigré photographer in Britain. Whereas others used an exploration of the nineteenth century as a route to reconciliation or integration with the British establishment, the Gernsheims historicized it, something that cannot but draw attention to Britain's many historic crimes.

Elsewhere, the line between documentation and nostalgia was exceptionally porous, as in the work of the brilliant photojournalist and, later, architectural photographer Hans Gohler, who worked in Britain under the Augustan name John Gay. Unlike Gernsheim, he did manage to bequeath his archive to the nation – thousands of photographs were given to English Heritage (now Historic England), which has used them extensively as illustration. Gohler was an Anglophile, enthusiastic about his adoptive home; he and his partner Marie Gay (née Arnheim, the sister of the gestalt psychologist and art theorist Rudolf Arnheim), also a talented photographer, took their new name after watching a production of that Brechtian favourite, John Gay's *The Beggar's Opera*. Trained at the art school of his native Karlsruhe, Gohler was neither Jewish nor an activist on the left, but was close to the Sterns, an artistic Jewish family in the city; he joined them in Britain via a student visa, in 1935. As a photographer in Britain, he was one of the less famous émigrés, at first – John and Marie Gay were among several émigrés contributing to Krasna-Krausz's Focal Press, where John contributed along with Bill Brandt and Wolfgang Suschitzky to the book *The Rollei Way*, on their favoured compact camera, while in 1939 Marie published with her brother the book *Phototips on Children*.

John Gay worked sometimes for *Lilliput*, but also for a variety of workaday publications – *Country Fair*, *The Strand*, *Farmers Weekly* – and produced his best-known series, on Blackpool, for the first of these in 1949. It's a classic stranger's-eye view of the great resort of the north, funny and peculiar in its images of almost entirely dressed flat-capped men knee-deep in the sea, framed by the Victorian iron tower. But John Gay would gain his reputation based on a series of apolitical documentations of eighteenth- and nineteenth-century London. Starting with *London*

Observed in 1964 – which Andrew Sargent notes is not the work of a 'committed' documentary photographer, but something more quizzical and Brandtian, 'the book of an incomer who was still learning his home town with its alien culture – almost the book of an anthropologist'[22] – this was followed by the more specific *Highgate Cemetery: Victorian Valhalla*, then a book on the London district where émigré intellectuals were clustered, *Prospect of Highgate and Hampstead*, the self-explanatory *John Gay's Book of Cats*, and most interestingly, *London's Historic Railway Terminals* and *Cast Iron*. These were introduced by John Betjeman and Gavin Stamp, respectively, major figures of the 1970s reaction against modernism, now that the new world imagined in the 1940s had been substantially built and found wanting.

In *London's Historic Railway Terminals*, John Gay takes a back seat to Betjeman. The book is exemplary 1970s Victorian nostalgia. Whereas in the 1950s, Gernsheim or Brandt couched their nineteenth-century explorations in irony, whether historical or psychoanalytic, by this point – the book was published in 1972 – Betjeman had little need to pretend he wasn't in love with the products of the high-Victorian era. From the ornate serif typography on in, this book was a celebration of Victorian values. Betjeman was probably aware he was documenting an area that modernists might once have considered their own. In books like the 1928 retro-futurist *Building in France, Building in Iron, Building in Ferro-Concrete* by the Swiss modernist and theorist Sigfried Giedion, or after the war in 1958, *The Functional Tradition* by J. M. Richards, editor of *Architectural Review*, the nineteenth-century engineers were claimed as modernism's parents, though Giedion was rather chauvinistically and inaccurately disparaging about British engineers when compared with French ones. In these books, a distinction would always be made between the iron and glass of the factories, the greenhouses, the bridges, the shopping arcades and the railway stations, and the pompous, heavily decorated historicist buildings that encased them from the street. Betjeman refused to follow this distinction, and embraced both Victorian futurism and Victorian historicism. All of it was rich, and all of it evoked a series of fond personal associations – particular smells, experiences, tastes, surfaces, evoking particular pre-nationalization railway lines and specific landscapes. John Gay follows suit, providing both grand, smoky views of William Barlow's or Isambard Kingdom Brunel's vast metal sheds and close-ups of the terracotta cladding, the stucco and

the ashlar of their associated hotels and waiting rooms. When British Rail was privatized in the 1990s, books like *London's Historic Railway Terminals* were held up as examples of why nationalization was a disaster – page after page of Victorian glory and, at the end, two miserable little pictures of the new Euston station, denounced by Betjeman in high dudgeon.

Published a decade later, John Gay's *Cast Iron: Function and Fantasy* does not involve any axe-grinding, and here, after Gavin Stamp's informative but scholarly introduction, the images take centre-stage, not the text. The book is a celebration this time of that aspect of Victorian culture the émigré photographers had all noticed – the way that the irrational and industrial, the ornate and the mass-produced, were inextricably bound together. These big, full-page spreads, high-contrast, printed with thick blacks and greys, criss-cross the whole country – Felixstowe, Newcastle, Toxteth, Edinburgh, Glasgow, Halifax, Great Malvern, Brighton, Cheltenham. The material, both brittle and endlessly adaptable, made in foundries in Glasgow and Falkirk, can be transformed into art-nouveau tulips, or an Egyptian sphinx, a Greek meander, a Corinthian column, a Mughal dome, a futuristic greenhouse roof, a bench formed from the neck of a swan. If there is a remnant here of an avant-garde sensibility it is a wholly surrealist one – any Constructivist or *Neue Sachlichkeit* values crumble against all this bizarre abundance. It is a blast against good taste, to be sure – this is what killed the cast-iron trend of the nineteenth century, 'dogged by the fatal accusation of vulgarity'.[23]

What is strange in all this revelling in Victoriana is that Gay was actually a capable photographer of that new world dreamed of by *Picture Post*, and a sympathetic observer of modern architecture and modern spaces. Contemporary London was treated by Gay with a great deal of wit and humanism, whether celebratory, like the images of black Brixton in 'Atlantic Road, 1962', or more critical, like the desolate, smoke-covered industrial estate in 'Waiting for the Bus, North Acton, 1965', or just made ordinary in all the city's multiculturalism, as in 'Street Market, North London', also included in *London Observed*. Gay documented new modernist housing estates warmly, without the obsession for banishing human beings from the picture that beset so many architectural photographers. He was commissioned, usually by the architects, to photograph modern buildings including a housing estate in Tidworth, Wiltshire (designed

by the *Kindertransport* refugee Inette Austin-Smith), where Gay juxtaposes the clean lines of the buildings and the exuberance of the children through the upward momentum of their swings; including children in images of modern buildings recurs in his work. There is also a delight in modernist landscapes. Images like the panoramic 'Flats and Housing, Gospel Oak' in London or the serene, picturesque lakeside ensemble in 'Student Accommodation at Durham' are dynamic, confident images of a new modernist city emerging out of the detritus of the nineteenth century; and 'Crown Court, Godalming, Surrey' throws together a Tudor half-timbered arch and a Gropius-like curved glass staircase, with a man and a dog passing between them.[24] In all these photographs, the new world is everyday, relaxed, not a matter of Constructivist melodrama.

As explained in his article 'But One True Viewpoint', a short, programmatic 1936 article that Gay wrote for *Arts Quarterly*, he was another of those émigré devotees of photographic dialectics, and the importance of juxtaposing the apparently unsuited (here, the linearity of a railing and the peculiar shape of that very 1930s bird, the pelican). What was important was to register difference, 'something unusual, something new'.[25] Victoriana was made interesting by its survival into the twentieth century, a living remnant of an earlier, obsolete set of values – no better or worse, but different – and in Gay's photographs of modern architecture and the modernist city, the interest lies in the ways in which these gleaming, regular structures are inhabited by ordinary, non-gleaming people. This approach would be rare, as the modernist environment partly bequeathed by the exiles became the focus for dystopian cinema.

What the jobbing work of the documentary tradition did was ensure a certain breadth of understanding of Britain in the people who worked in it. To be sure, most émigré photographers lived in the Metropolitan Borough of Hampstead, but all the documentary photographers, even auteurs like Brandt, had to earn their living hiking around the country to illustrate stories by others, which brought them into contact with areas of the British Isles that were otherwise seldom frequented by the London intelligentsia, from the Gorbals to Plymouth to Newcastle to Cardiff. This breadth of vision went along well with the all-encompassing ambitions of *Picture Post* to envisage a new, planned, egalitarian Britain that would erase all those north/south and upstairs/downstairs distinctions for good. But if you were not working in this corner of the media, you would not necessarily have the same experience, particularly, sadly, for

those in the avant-garde, who were perhaps more reliant than anyone else on a small circle of supporters in London, Oxford and Cambridge.

Thus it came to be that László Moholy-Nagy's three street-photography projects in Britain dealt with the University of Oxford, the street markets of London, and Eton College. Moholy-Nagy, born to a Jewish family in rural Hungary in 1895, was educated in Szeged and Budapest, where he became active as a leftist artist in the circle of the *MA* group. He fled the suppression of the Hungarian Republic of Workers' Councils – more commonly called in English the 'Hungarian Soviet Republic' – in 1919.[26] He became a prominent Constructivist in Berlin, and was hired by Gropius for an important teaching job at the Bauhaus in 1923, with the brief, eagerly carried out, of sweeping it clean of Expressionism, and reorienting the school towards the 'new unity' of art and technology. But Moholy-Nagy was no cold rationalist, and was one of the great modernist polymaths, curious about everything – an original writer and thinker on new media, an abstract and documentary filmmaker, a book and magazine designer, an advertising artist, a Constructivist painter and one of the first kinetic sculptors – but after leaving the Bauhaus in 1928, he largely made his living from photography. In this capacity he created a series of abstract photograms (that is, photographs made without the camera by exposing objects to light), several fascinating, paradoxical photomontages, and some avant-garde images of cities like Berlin and Marseille, which revelled in high angles and unusual, defamiliarizing perspectives. After moving to London and a flat in the Isokon Building in 1935, Moholy-Nagy became, due to his evident talents and his Bauhaus connections, a regular photographer for the *Architectural Review*, in which capacity he photographed some of the increasingly ambitious modernist buildings in Britain, like the De La Warr Pavilion in Bexhill and parts of London Zoo – the latter being the work of Berthold Lubetkin and the Tecton architectural group. But Moholy-Nagy's three larger projects reveal something of an accidental tragedy.[27]

They are not bad, as such. The book *Street Markets of London*, a 1936 collaboration with the writer Mary Benedetta, captures something of the capital's diversity – with a few visibly Black, Asian and Orthodox Jewish subjects – as well as its eccentricity and antiquity. In his foreword, Moholy-Nagy, declaring that 'the photographer can scarcely find a more fascinating task than providing a pictorial record of modern city life', disassociates the project from 'romantic notions of showmen,

unorganised trade, bargains and the sale of stolen goods', intending instead to provide 'a truthful record of objectively determined fact'.[28] This doesn't quite work out, as there are photographs of burly auctioneers, downtrodden dossers and tables of old medals and Victorian tat, and if anything the images reveal a place of sharp transition, with a row of cars found in an otherwise almost entirely Victorian image of the Caledonian Market.

Still in print today is *An Oxford University Chest*, a collaboration between Moholy-Nagy and John Betjeman published in 1938. It is a fun grab-bag of public-school architectural enthusiasm, with essays on the colleges' arcane homoerotic rituals and an architectural gazetteer by the poet, with drawings by Osbert Lancaster. All but a handful of the photographs were commissioned for the book from Moholy-Nagy, who was affectionately nicknamed 'Holy Mahogany' by the *Architectural Review* circle. The photographs apply Moholy-Nagy's acute upward angles or top-down views to the city's baroque and classical architecture, with occasionally diverting results, as in the close-up of a worn cherubic corbel at St John's College or the rather proto-Constructivist orrery in the Bodleian Library. However – with the exception of a thrilling image of the gossamer-thin iron and glass structure of the Oxford Museum – the book is not really a meeting of architecture and photographer, and little energy is added by the disjunction between artist and subject. Moholy-Nagy's interest in people comes through well in some of the photos, like the image of a little boat in the Cherwell, with a woman slumped face down with her hand in the water, but the indolence of the image is telling.

This is even more the case in the Eton project, the photographs that make up around a quarter of Bernard Fergusson's 1937 *Eton Portrait*, one of the most pointless mismatchings of artist and subject imaginable[29] – the protagonist of a 'New Vision' and a New World, a boiler-suited scientist-artist and utopian socialist who seemed to many to have just stepped out of a time-machine from the future, now reduced to documenting one of the world's oldest centres of privilege and continuous class power. Again, Moholy-Nagy does his best, concentrating on the eccentricities with an eye towards the strangeness of a collection of ten-year-olds in top hats and tails. He makes Constructivist compositions where he can, forming a geometric double-cross out of an image of 'School Yard from the Provost's Lodge' and an elegantly arranged

Moholy-Nagy lost in Eton.

Banana Mess. But it is really no use, and it is no wonder that given this dreary fare to work on, Moholy-Nagy, along with other *Bauhäusler* like Walter Gropius and Marcel Breuer, left for the United States in 1938, where he set up the New Bauhaus in Chicago and published his valedictory *Vision in Motion*, before his early death in 1946 aged fifty-one.

If only he had been given gainful employment by *Picture Post* instead of the *Architectural Review*, we could have been able to see Moholy-Nagy's views of the Tyne and the Gorbals, of Bradford or Manchester or Cardiff, rather than of our most ancient and tedious centres of aristocratic power. Moholy's example is one of a great photographer, and thinker of photography, being wasted on trivial and trite subject matter. Too much of his British work is shallow, concerned only with eccentricities of surface and the oddities of our ridiculous class system, and it seldom penetrates more deeply than that. It is perhaps salutary, however, for an imperial power to be exoticized in turn.

The outsider's view has its uses – without it, the vividness of the work of a Deutsch, a Brandt, a Tudor-Hart would be impossible – but in a place where surfaces and signifiers are used as disguises, it can miss a great deal about how things actually work, and who for. It is unsurprising, then, that one of the photographers who was most able to record

Britain as it is actually lived was Dorothy Bohm, who lived most of her life in this country. Born in 1924, she continued working up to her death in March 2023. Bohm was born Dorothea Israelit in what is now the Russian exclave of Kaliningrad, on the Baltic, but which was at the time the Prussian port city of Königsberg, at the furthest eastern edge of the Weimar Republic. As a teenager in 1939 she was sent by her parents to Britain to put her beyond the reach of the Nazis, and she settled in Manchester, where she learned photography before moving to Hampstead at the end of the 1950s; in the 1970s, she co-founded London's Photographers Gallery. Some of the subjects of Bohm's several books of London street photography are familiar enough – there is, of course, an entire book on Hampstead – but her eye was not. The 1984 book *A Celebration of London*, for instance, a collaboration with Ian Norrie, deals with some of the same spaces as Bill Brandt, John Gay or Helmut Gernsheim – inner London, and the historic architecture of Westminster and the City. But much has happened in four decades, and this is now recognizably the modern city, multiracial, saturated by media, and with the classical and Gothic buildings thrown together with modern office blocks, with gables taken over by lively, Mexican Muralist-style Greater London Council artworks.

Remarkably, given how young Bohm was when she left Germany, some of her images have a strongly Weimar feel, with hints of the *Neue Sachlichkeit*, for example in the blank, bleak image of a policeman presiding over the intricate system of gates that block off Downing Street from the public, or of Constructivism, in the high-contrast geometry of 'The Bank of England Lunchtime' or an image of Alison and Peter Smithson's Economist Building rising up behind the Georgian Boodles Club; but this is combined with a very modern and very English sense of theatre, as with the flamboyant building workers, one white, one black, performing for the camera in 'Stoney Street, Southwark'. There is something spontaneous and relaxed here, which surely comes from a photographer documenting a place she actually knows – a city that holds no mysteries, one that can be understood.

10

The Shape of Things to Come

The great film of British modern urban architecture is Mike Hodges' *Get Carter*, filmed on Tyneside in the early 1970s, when the post-war reconstruction effort was starting to wind down and crumble to pieces. Here, Newcastle and Gateshead are every bit as much the star as Michael Caine's amoral, relentlessly driven protagonist. Through the back alleys and surveying the power stations, along the Tyne's iron bridges and staithes, at the top of the Brutalist car parks and in the new cuboid housing estates, Hodges cuts a section of a city at almost every level, and, quietly, makes the point that the promised New World has carried with it many poisons of the old – corruption, misogyny, violence – and brought a futuristic seediness all of its own. But the lens through which you see Newcastle is, once again, controlled by a Viennese eye. The cinematographer of *Get Carter*, one of the most visually memorable British films of all time, so vivid you can almost smell the warm beer, touch the concrete and taste the blood, was Wolfgang 'Wolf' Suschitzky, the younger brother of Edith Tudor-Hart.

Suschitzky's story was similar, at first, to that of many other left-leaning émigrés working in London in the 1930s as jobbing photographers. He freelanced for *Picture Post*, producing stories like 'A CHANGE IN THE SKYLINE' in April 1949, which documented the construction of a power station in South Wales. He put together, like Gerti Deutsch or his sister Edith, a book of his photographs that would not be published until half a century later. Some of what made his eye distinctive can be found in that little book, finally published in 1989. You can already see a little of *Get Carter* in *Charing Cross Road in the Thirties*, despite the book's setting in London's West End. It reveals a vivid, unashamedly rather seedy cross section of a society, enabled by the complexities Suschitzky found in the famous bookselling street.

Bookshops and cinemas and theatres on the ground floor; working-class 'model dwellings' above; and Lyons Corner Houses open late in the interstices. All classes are on the streets, walking past window displays full of (often vaguely 'European') soft porn, gazed at by bowler-hatted men. But gradually Suschitzky migrated from still photography to the fringes of the British documentary movement as a cinematographer. However, it is perhaps stories such as 'A CHANGE IN THE SKY-LINE' that really point the way to *Get Carter* – an ability to register just how extreme the British industrial landscape could be, and how it barged roughly into people's lives.

Unlike in the fields of photography and photojournalism, no big-name Central European refugees are remembered for their influence on British film. Auteur Theory has led us to concentrate on the great directors, and none of them ever made a film in England – neither the celebrated figures of the Weimar Republic, like Robert Weine, F. W. Murnau, Fritz Lang or

A cooling tower in Glamorgan, photographed by
Wolfgang Suschitzky for *Picture Post* in 1949.

G. W. Pabst, nor those who were lesser known until they built careers in Hollywood, like Edgar G. Ulmer, Robert Siodmak, Douglas Sirk or Billy Wilder. In other visual arts, the already famous, such as Kokoschka and Schwitters, or Gropius and Moholy-Nagy, worked in Britain and made lasting contributions, however brief their stay and however much they resented the place. Most of the great German silent and early sound film directors fled Germany, but they either went first to France and then to Hollywood, or just went straight to Los Angeles, where they proceeded to accidentally invent Film Noir. But the emphasis on directors is profoundly misleading. In fact, cinema might have been for a time the most heavily émigré-dependent art form of all in Britain.

Whereas almost no major Central European *directors* worked in Britain, large numbers of émigrés nonetheless comprised the backbone of the film industry between the 1930s and 1960s. Producers, cinematographers, set designers, composers, costume designers and a few actors all made their way here over the course of the 1930s. Alexander Korda's Denham Studios, set up in exile by a charismatic Budapest-via-Berlin producer, according to one historian 'had such a large number of Europeans working there . . . that the main studio thoroughfare was jokingly referred to by some as "The Polish Corridor"'.[1] Working as a film critic at *The Spectator*, Graham Greene even complained in frankly xenophobic terms in 1936 that Weimar migrants were stunting the growth of British cinema. He is reduced to the following outburst in the historical romance *The Marriage of Corbal*, directed by Karl Grune (famed for the Expressionist classic *The Street* of 1923), a film whose cast and crew were in very large part German, Austrian and Hungarian:

> England, of course, has always been the home of the exiled; but one may at least express a wish that *émigrés* would set up trades in which their ignorance of our language and culture was less of a handicap . . . as far as I know, there is nothing to prevent an English film unit being completely staffed by technicians of foreign blood. We have saved the English film industry from American competition only to surrender it to a far more alien control . . . it is not English money that calls the tune, and it is only natural that compatriots should find jobs for each other.[2]

It should be noted that many of the films Greene was describing are enduringly awful: flimsy 'quota quickies' made at speed. The fact that

Central European émigrés were not creating enduring classics (nothing to directly compare with Weimar-in-Hollywood Auteur masterworks such as Billy Wilder's *Sunset Boulevard*, Fritz Lang's *The Big Heat*, Robert Siodmak's *The Killers*, Douglas Sirk's *All That Heaven Allows*)[3] helps explain why the Weimar contribution to British cinema is rather less well remembered than to, say, architecture or photography. But the fact remains: dozens of émigrés took on those crucial roles that make a film what it is, but this tends to be obscured by Auteur Theory, which treats a filmmaker as an artist in the same way as a writer, painter or musician. The émigré presence in England runs right through until the 1980s, alternating, like British film in general, between glossy period blockbusters specializing in Englishness for export, and uncompromising visions of a modern country, like *Get Carter* itself.

Weimar Culture's relation to film is of necessity more complex than in art, design or architecture, because of the immense amount of capital needed in the film industry, and the overwhelming pull of Hollywood. But in stylistic terms, there are again the two important, sometimes competing, sometimes overlapping trends of Expressionism and Constructivism. Weimar cinema is best known for the former, which grew out of painting and theatrical set design. Its roots on the stage and the canvas are especially obvious in hallucinatory classics such as *The Cabinet of Dr Caligari*, *The Student of Prague*, *The Golem*, or Fritz Lang's *Dr Mabuse* and *Metropolis*. These films are extremely, and deliberately, artificial, an attempt to translate heightened mental states into cinematic space, especially through mannered, gestural acting, dramatic lighting effects and crypt-like or spikily Gothick sets. But they were, unlike Expressionist painting, big business from the start. These films were the product of a commercial film industry, marketed as straightforward horror movies – through which they had immense influence on Hollywood from the very start – and if they had a politics, it was often watered down by the studios, particularly the dominant UFA (*Universum-Film Aktiengesellschaft*), the German motion-picture industry. Seen outside of its breathtaking futuristic city sets, with their elevated highways and skyways above and a belching, blasting industrial underside beneath – with outrageous designs both influenced by and an influence on the course of modern architecture – something like *Metropolis* is distinctly daft, and is still hard for an English viewer to take entirely seriously. With hysterical, mugging performances, it is often unintentionally

funny, while its strained attempt to depict social peace through a union of mindless workers and etiolated intellectuals is extremely conservative, for all its formal and spatial innovation.

In any case, these films were widely seen, including in Britain, where home-grown film was something of an embarrassment. Even after decades where bored historians have been revisionist about anything they can, few would really dissent from the director and historian Kevin Brownlow's 1968 assessment in his history of silent cinema: 'English films, with few exceptions, were crudely photographed; the direction and acting were on the level of cheap revue, they exploited so-called stars, who generally had little more than a glimmer of histrionic talent, and they were exceedingly boring.' The reason for this, he argues, was that British business couldn't possibly imagine that a popular art could have actual artistic value – this was trash for the proles, not to be taken seriously; for British film producers, 'the word "arty" was the ultimate in invective', though as Brownlow points out, the talent was there, but it migrated to the United States as soon as it could, from Chaplin on down.[4] There was also a unique problem, in that British cinema shared a language with Hollywood, but had a close proximity to the much more lively film industry of Germany and France. Those who wanted to do something different were well aware of the problem. The talented Expressionist director E. A. Dupont made two films in England, most notably a wonderfully lurid, neon-lit West End melodrama in the great 1929 silent *Piccadilly*, which convincingly recasts the Berlin demi-monde genre of the 'asphalt film' to Soho.

The young Londoner Alfred Hitchcock, years before he too was lured to Hollywood, was taking notes in paranoia and unease from the Germans at the very start of his career, and went to Munich, where he directed two films and gathered ideas that would be deployed on his murky, lurid 1925 feature *The Lodger*. On his own account, 'my models were forever the German films of 1924 and 1925. They were trying hard to express their ideas in purely visual terms.'[5] Hitchcock made excellent use of Weimar actors, with leads such as a twitchy Anny Ondra in *Blackmail* (1929), a doleful Oscar Homolka in *Sabotage* (1936), and the great Brecht-trained presence of Peter Lorre in *The Man Who Knew Too Much* (1934). But in general, and as in Hollywood, German émigré actors in the British film system were cast as sinister villains, which reached its bizarre apotheosis in Michael Powell and Ludwig Berger's

wild and preposterous *The Thief of Bagdad* (1940), for which *Caligari* star Conrad Veidt in brownface plays Grand Vizier Jafar in the thickest Teutonic accent.

After 1933 the emigration, and the desire on the part of film producers in Britain to employ people who actually knew what they were doing, resulted in increasingly widespread employment of émigrés. Among these was of course Berthold Viertel, better remembered for the account in Isherwood's *Prater Violet* of the farcical process of making the film they worked on together than for the film itself. This is a shame, as *Little Friend*, made in 1934 for Gaumont, scripted by Isherwood with Margaret Kennedy, is an interesting and peculiar work. Viertel was a poet, theatre director and filmmaker, born in 1885 in Vienna; he was on the political left but mainly did commercial work, and was lured to Hollywood early on, writing the script for F. W. Murnau's *City Girl* before being brought to Britain. *Little Friend* is the story of Felicity, an adolescent girl in Kensington who becomes aware that one of her parents is having an affair; nervous, lonely, and ignored and patronized by both parents, she absent-mindedly scoots around London and is nearly run over, being saved by Leonard, a young Cockney errand boy. The film deals with difficult material, which the British cinema was not used to dealing with – mainly sex, and class – with some subtlety, with a relaxed, realist pace breaking out into jagged montage sequences that owe more than a little to the avant-garde; it boasts a subtly atonal, non-diegetic score by the modernist composer Ernst Toch, and a superb central performance by Nova Pilbeam (improbably, her real name) as Felicity. It is only let down by the appallingly wooden performances of the rest of the cast and a tacked-on happy ending. Viertel would make a couple more films in England after this, including a laudatory biopic of one of Britain's most ruthless imperialists, *Rhodes of Africa* (1936), not a topic one suspects Viertel chose for himself, but an indication of what audiences were looking for.

Little Friend owes most to the non-Expressionist trends in Central European cinema. As the 1920s ran into the 1930s, German films became a little less mannered and more urban and hard-edged, and directors like Fritz Lang, Gerhard Lamprecht, G. W. Pabst, Slatan Dudow and Leontine Sagan moved closer to a filmic analogue of the matter-of-fact realism of the *Neue Sachlichkeit*; a trend that culminated in the wonderful impromptu of *People on Sunday* (1930), co-directed

by Robert Siodmak and Edgar G. Ulmer. But these aside, a major cause célèbre in the Weimar Republic were the films of the Soviet avant-garde. Sergei Eisenstein's epochal *Battleship Potemkin* was a flop in Moscow, until it made its way to Berlin and became a blockbuster, while films like Vsevolod Pudovkin's *The Mother* and Dziga Vertov's *Man with a Movie Camera* would similarly be more successful in Germany than in the USSR itself, where audiences were hooked on Hollywood and, understandably, rather more wary of propaganda. The Soviet directors were as hostile as the Expressionists to the rather polite kind of cinema that was popular in Britain, and were equally rooted in artistic movements, with Eisenstein and Vertov both members of Moscow's Constructivist Left Front for the Arts (LEF). But that is where the similarities ended.

The Soviet films, mainly made in the studios of Moscow and Kyiv, were in some ways brutally realistic. Depictions of revolution and oppression were violent and raw, and Eisenstein in particular was obsessed with the real faces of ordinary Soviet workers and peasants, in an age in which all actors, male and female, were caked in make-up; but he cut up the action into elaborate montages, designed often to make political and philosophical juxtapositions out of the raw filmed materials. For Vertov, and other documentarians such as Esfir Shub or Mikhail Kaufman, fiction film itself was counter-revolutionary, rejected in favour of a 'Camera Eye' recording and then reshaping reality. In some cases, the enthusiasm for Soviet cinema in Weimar Berlin – and in Vienna, Prague, Warsaw, if not in the police state in Budapest – would mean international co-productions, through the Willi Münzenberg film empire. The Soviet-funded Prometheus Film would make films along the lines of Eisenstein and Vertov, like Slatan Dudow and Bertolt Brecht's fast, brutally realistic *Kuhle Wampe*, so the lines between German and Soviet cinema were sometimes blurred.

In any case, these films were usually officially banned in Britain, and hard to see. This isn't the reason why none of these filmmakers would ever make films in a part of the world that was – leaving aside Eisenstein's love of *Ulysses* and everyone's love of Charlie Chaplin – hardly on their radar. But they would on some occasions visit, and they were an inspiration to documentary filmmakers in particular. The Oxbridge Communists of the London Film Society were great fans of Soviet cinema, and they brought over Dziga Vertov to screen his early sound film *Enthusiasm: Symphony of the Donbas* in London (he manned the control room, and turned up

the volume so loud he had to be pulled away from the mixing desk). The more complex legacy was through the development of a distinctly British documentary cinema, where imperial administrators gazed enviously at the dynamic cinema of the 'socialist sixth of the world'. The most important émigrés in British cinema were neither Expressionists nor Constructivists, though they would dabble a little in both. They were Hungarians, and they invented Henry the Eighth.

The Kordas, just as much as Stefan Lorant or László Moholy-Nagy, were products of consecutive banishments, first from their native Hungary, then from their adopted Germany, before they arrived in Britain. Alexander, Zoltan and Vincent Korda were respectively born Sándor, Zoltan and Vilmos Kellner, in a middle-class Jewish family – but not in cosmopolitan Budapest, rather in the small town of Túrkeve, in the Hungarian steppe, the *Puszta*. The eldest, and the dominant personality of the three, was Alexander, whose career as a film director began in the 1910s after he set up his own production company, Corvin Films. At that time, and throughout his career, Korda favoured the lush, well-made melodrama, but that didn't stop him getting caught up in the revolutionary enthusiasm of the Hungarian Soviet Republic in 1919. In the account of his nephew, the journalist Michael Korda, Alexander 'accepted appointments to the Communist Directory for the Film Arts, established by the Council of Commissars', where he would be 'joined by a well-known actor from the National Theatre of Budapest named Arisztid Ott, who later achieved world-wide fame in the role of Dracula under the name of Bela Lugosi'.

Like Lenin and his Commissar for Enlightenment, Anatoly Lunacharsky, the Hungarian Communist leader Béla Kun and his culture minister György Lukács believed that cinema would have a crucial role in forming – and proselytizing for – a new socialist culture. Accordingly, in Michael Korda's mordant account, 'Kun lavished a good deal of attention on the Hungarian film industry, which he might have better directed towards diplomacy, finance or national defence'.[6] Alexander Korda made three films in the four months of the Hungarian Soviet Republic's existence, two of them strongly pro-Communist: *Yamata*, about an American slave revolt, and *Ave Caesar!*, a satire on the just-deposed Hapsburg monarchy. Accordingly, Alexander was targeted and jailed under the White Terror of Miklós Horthy. On his release the Kordas fled to Vienna, then to Berlin, to work at the UFA, and after a brief spell in Hollywood they came to Britain in 1930, to create a film industry out of almost nothing.

Alexander Korda was an empire builder, and was more important as a producer than director. He attempted to build a studio system under his control in Britain, with his own Hollywood in Buckinghamshire, Denham Studios, and two production companies – London Films, and later British Lion. Other UFA Hungarian producers would follow, such as Max Shchach, who set up several companies to churn out quickies until going bust in 1938. This would be parodied a few years later in George Mikes' book *How to Be an Alien*, featuring a drawing by Nicholas Bentley of the door to a film producer's office, which reads:

ANGLO-SAXON PICTURES Ltd.
BRITISH CINE-FILM Corp.
UNITED KINGDOM FILM Co.
ENGLISH PICTURES Ltd.
PICTURES of BRITAIN Ltd.
HEART of ENGLAND FILMS Ltd.
Managing Director: SIR IPOLYI PODMANICZKY (British).[7]

Alexander Korda's early British films would at first be family affairs, with Vincent Korda as set designer, Zoltan Korda or the Hungarian screenwriter Lajos Biro writing the scripts, and their UFA colleague Kurt Schroeder writing the music. By far the most successful of these films was *The Private Life of Henry VIII* from 1933, starring Charles Laughton as the murderous king. It was made on a shoestring, by very recent emigrants. The filigreed cabinets and stained-glass windows that frame the court so impressively can be seen to be scribbled on cardboard, a mix of the tawdry and opulent that fits the subject perfectly. As Michael Korda relates, 'Vincent and his crew, communicating by sign language since he spoke no English, worked through the night to turn a bedroom into a banquet hall, and then through the next night to turn it into something else again.'[8] The film would be Alexander Korda's passport to success, one of the most lucrative British films of the decade, perhaps because it so effectively captured a certain kind of British self-perception, with remarkable intuitive skill.

Laughton's Henry is a benign monster. He bellows heartily, he lusts healthily, he stuffs his face with meat and drink, and throws drumsticks around his chaotically opulent palace rooms. He laughs at himself, and everyone else. The popular perception of this fastidious misogynist serial

killer and founder of the Church of England as a sort of Falstaff turned king, jolly and cynical, comes entirely through this film – there are no similar depictions before 1933. Vincent Korda's English son understood how the Kordas had done this. Writing in 1979, he pointed out that 'in a later interview on the subject, Alex declared "an outsider often makes the best job of a national film. He is not cumbered with excessively detailed knowledge and associations. He has a fresh slant on things."' Yet, this was not really a 'national film' so much as a parody of the very idea of a national film. There is no flag-waving, and nothing much to be proud of except the humour. As Michael Korda realized, 'it was Alex's genius to sense that the British, like the Hungarians and Austrians', but unlike the Germans, 'were secure enough to be able to laugh at their own history'.[9] Watched now, it is still a surprisingly enjoyable film, due both to Laughton's joyfully horrible and oddly vulnerable performance, and to a script loaded with flirtatious dialogue and historical anachronisms – a peculiar midpoint between Ernst Lubitsch's costume comedies and *Blackadder II*.

Laughing at history was one thing, laughing at the future quite another. The equally greatest and worst Korda production of the 1930s was *Things to Come*, scripted by H. G. Wells from one of his stodgy late books, directed by William Cameron Menzies, produced by Alexander and meticulously, beautifully designed by Vincent. It is on a magnificent, epic scale, charting first the destruction of an ordinary British 'everytown' in a Second World War, its reversion to barbarism, and then the foundation by a vanguard party of aero-engineers, Wings over the World, of the perfect Constructivist future. Wells was not a modernist in literary terms, as he told his stories of a terrifying or utopian future through conventional realist means (all the more effectively for that, at least in his first novels and stories), but his vision of the world's ideal future was exactly that of the continental high modernists. That is, a high-tech Fabianism, a gleaming world of concrete, steel and glass, rational, functional, devoid of religion or sentimentality. Wells kept a close eye on the production in Korda's Denham Studios, and mostly approved, but for the sound effects added to his immense machine constructions (he correctly predicted that the machines of the future would be silent). These are stunning still, particularly the tubular interior spaces of the future city, pulsing with effects redolent of the light sculptures of Moholy-Nagy, who Alexander Korda – remembering him from Budapest days – had hired to make visual suggestions and models for the film.

Alexander Korda invents British Tradition: Charles Laughton's Henry VIII.

Everytown in the Future: Zoltan Korda gives Constructivism a stiff upper lip.

Michael Korda was right to say that 'Vincent's greatest accomplishment as a set designer was the City of the Future (or "Everytown", as it is called in the film).' It is alternately chilling or beautiful depending on your taste. Emerging after a public intersection vaguely resembling Piccadilly Circus is first destroyed, then transformed into a neo-medieval shantytown, Everytown becomes an underground Metropolis, made of concrete, glass and Perspex, which anticipates some of the futurist architecture of the 1970s and 1980s, like the Centre Pompidou in Paris or the HSBC building in Hong Kong. But the film could never compete with the ribald Englishry that Alexander Korda had brought to the sixteenth century. *Things to Come* is visually brilliant and, after four decades of increasingly apocalyptic free-market capitalism, rather moving in its sincere belief that human problems can be rationally solved, a position that, as we will find at the end of this book, was not popular with all Central European émigrés. It is without humour, and relentlessly pompous and secure in its dogmatic and authoritarian view of human progress. But what can be said about its vision of the future city and of historical change is that *Things to Come* was vastly less silly than *Metropolis*; the same could be said about its acting style, with nicely brusque, stiff-upper-lip performances from Raymond Massey and Ralph Richardson, wholly unruffled by the collapse of a civilization or two.

The Kordas were open to the avant-garde, but within limits – as producers of effects, as the inspiration for futuristic sets, but certainly not people you'd trust putting behind the camera; 'the future' was something a bit like the Arabian Nights Basra and Baghdad of *The Thief of Bagdad*, a cue for Vincent Korda's spectacular sets and special effects. Accordingly, Moholy-Nagy, who expected a much greater involvement in *Things to Come*, was disappointed by the experience of working with the Kordas. Not nearly so much as his Bauhaus colleague Walter Gropius, who had – nominally – designed the studios in which it was made. Alexander Korda had asked him to design the studio in the mid-1930s, but his mode of working – cheap, fast – was unsuited to the Bauhaus director's sensibilities, and he disowned the project.

But it was at the smaller end of the scale in British film – where giant concrete-framed sound stages were not needed – that the Berlin-Moscow influence would be much stronger. As in the USSR, the emergence of a modernist film movement in England is owed in large part to the work of enlightened bureaucrats. In this case, Britain's Lunacharsky was

Stephen Tallents, a Harrow-educated liberal civil servant. He was directly inspired by the effects of Lunacharsky's efforts in enlightenment during the Russian Civil War, as Tallents was in charge of suppressing the Baltic Bolsheviks in the new states of Lithuania, Estonia and Latvia (in the latter two countries, the local Bolsheviks had been the most popular political party). Seeing Soviet propaganda cinema at first hand – presumably the early *Kino-Pravda* newsreels of Dziga Vertov – and keeping up with it as it developed into the sophisticated cinema of Eisenstein, Pudovkin and Alexander Dovzhenko, Tallents made film a crucial part of the Empire Marketing Board that was set up in the mid-1920s as part of an effort to create a single imperial market. In his pamphlet *The Projection of England*, Tallents took inspiration from how the Soviets had created a grand panoramic vision of their own vast imperial space, as a model for the spreading of British 'soft power'.[10] But the cinema arm of the EMB was put in the control of the ascetic John Grierson, the director of hard documentary cinema such as the 1929 *Drifters*, which dropped much of the urban, Constructivist flash and dazzle of Vertov's Kino Eye in favour of something more Protestant, though still thoroughly in debt to the Soviets. After the EMB's Film Board was wound up, Grierson and his team set up a less controversial unit at the GPO, that is, the Post Office.

The 'Projection of England' might have taken inspiration from the Soviets, but it was to be a mainly British – and imperial – project, with remarkably little employment offered to émigrés. This was a deliberate policy. Grierson, writing anonymously in 1936 for World Film News, argued that 'the preponderance of aliens in key positions in the industry not only tends to produce a product lacking national character, but also develops an unhealthy inferiority complex' in the English staff.[11] This was not solely a matter of racism (although it was that too). English documentarians specifically abhorred the Expressionist cinema for its mannered artificiality. However, there was some interest in the short animated films that had become a minor speciality at the edges of Weimar cinema. The Dadaist Hans Richter and the animators Walter Ruttmann and Oskar Fischinger had developed a style of abstract cinema that translated the ideas of Kandinsky, Mondrian and Malevich into moving pictures, Suprematist canvases dancing and pulsing across the screen. Less obviously avant-garde but equally innovative in its way was the work of Lotte Reiniger, a member of this informal

group, whose animated fairytale films, constructed out of moving paper cut-out figures, had a childlike quality belying their cleverness and complexity. Similarly, Moholy-Nagy moved his abstract work into cinema, making a dizzying little masterpiece featuring one of his kinetic sculptures, *Lichtspiele Schwarz Weiss Grau* (1930), following it in Britain with a delightful couple of quasi-surrealist films on animals, *Lobsters* (1936) and *New Architecture at the London Zoo* (1937).

Only two of these directors would ever work in Britain, but their influence was clear on the two brilliant abstract filmmakers who did work for the GPO, the New Zealander Len Lye and the Scotsman Norman McLaren – their films full of pure colour, shape and motion, such as *Trade Tattoo* and *N or NW*, were miles away from the worthy repertoire of British documentary. Moholy-Nagy wouldn't work for the GPO, but his *Lichtspiele* film was spliced into their short *Coming of the Dial*, in 1931, as an image of communications technology rather than a piece of pure abstraction. Of the German animators, Richter moved to Los Angeles, Fischinger made it to Hollywood, where he worked for Disney, and Ruttmann died in Nazi Germany; but Reiniger moved around Europe depending on where she could get funding. Upset by being told that in order to work in the Third Reich, 'my Jewish friends could no longer be my friends',[12] she left Nazi Germany in 1934, and in her travels for work and a visa she produced two films in Britain for the GPO; moving from there to Italy, she was forced to return to Germany during the war to care for her sick mother, but left immediately after it, returning to Britain, where she made a dozen or so more intricate, gorgeous short films. Reiniger's British films of the 1950s and 1960s were made for a London production company run by the Weimar émigré Louis Hagen, which aimed them at the American TV market; they take place in an indistinct fairytale Mitteleuropa and sometimes in an Arabian Nights Middle East, generic stories that anyone could be familiar with.

But the two GPO films, both made in 1938, are very British, amusingly so. The first of them was *The HPO (Heavenly Post Office)*. Like Len Lye's shorts, it is in colour, with a lovely pastel-blue sky and bright-green trees, and is a deliberately frivolous and fun short designed to be shown before features. In it, cherubs descend from the clouds to send the message 'GREETINGS' to various walks of life, urban and rural – terraced houses (always exotic to Central Europeans), up a tree, into a boxing ring. At the end is the message: 'It is heaven to receive a greetings

Exotic Scotland: Lotte Reiniger's *The Tocher*.

telegram! Be an angel and send one!' *The Tocher: A Filmballet* is also enjoyably light-hearted. To tinkling Rossini arrangements by Benjamin Britten, we are in a caricatural Scotland. 'The Tocher' is Scots for 'the Dowry', and in this short a couple, their cut-out shapes jerking prettily around a Highland landscape of lochs, mountains and pines, are at first divided by a goateed, kilted and tam-wearing patriarch, but he is brought round by the GPO's nymphs, who appear and give him a Post Office Savings Book as our shapes share a kiss. But though Reiniger was the only major figure of Weimar's experimental cinema to work extensively in Britain, she wasn't alone.[13]

The GPO's films can be imagined as apolitical or propagandistic according to your level of paranoia, but there were other documentary filmmakers who considered them diverting and trivial, and who connected themselves much more closely to the continental avant-garde. Paul Rotha's wildly ambitious, furiously didactic films are the most explicitly politically radical and 'progressive' among the British documentarians. While GPO directors like Basil Wright or Harry Watt, or

the Brazilian Alberto Cavalcanti, had a camp humour in their work and a reluctance to scare the horses politically, Rotha's work was almost as strident in its politics as anything by Vertov. Rotha's masterpiece, *Land of Promise* (1946), is the most emphatic of all films to have proselytized for the 'new world' imagined by the *Picture Post* circle. In the film, John Mills stomps around Britain looking at its dilapidated, miserable Victorian housing, demanding the end of capitalism and the construction of a new, democratic socialist Britain. Looked at closely, the émigré stamp is all over it. Mills co-presents with a personified ISOTYPE, a figure bearing the visual statistical system developed by the Viennese socialist philosopher-designers Otto Neurath, Marie Neurath and Gerd Arntz (for more on which, see Part Three). The film's images of industrial Britain either neglected by the Depression or going full pelt for the war effort – and the reconstruction – were shot by Wolfgang Suschitzky, who began his career as a cinematographer in the British milieu of socially improving documentary films.

Suschitzky's eye for the looming industrial topography and peri-urban wildness of the mill towns of Lancashire is also lavishly showcased in two shorts for the industrial documentary producers Data Film Unit. Both short films were intended to convince mill managers and bosses that the incoming regulation on workers' rights in the textile industry would increase productivity and, hence, profits, in contrast with the industry's doldrums, laissez-faire notwithstanding, during the Depression. In *Cotton Come Back* (1946), the fluidity and rawness of Suschitzky's footage of townscapes and millworkers contrasts with a stiff and unconvincing narrative, but *Chasing the Blues* (1947) has aged better, with its dancing animated figures prancing around its documentary images of factories and (mainly female) millworkers.

Rotha and Suschitzky's films were, in their different ways, attempts to find a path out of the national camp of the Kordas, and 'The Man from the Ministry' stiffness of much GPO work, but they were both equally hostile to the Expressionist tradition in German cinema, still regarded as lurid, artificial and commercial. But Expressionists could be found on the fringes. The animator and designer Peter Strausfeld was born in Cologne in 1910 and worked in the early 1930s making Expressionist woodcuts, some of which would be displayed in the Nazi 'Degenerate Art' touring exhibition. There is little that obviously links these to the short films he directed for the Ministry of Information

during the war, such as the exceptionally cute warning against excessive power use, *Peak Load Electricity* (1943), bar perhaps a certain angular stylization; but Strausfeld had an important hand in what happened next in non-commercial, alternative British cinema.

Interned on the Isle of Man, he befriended the Viennese émigré film producer Georg Hoellering, the producer of the most explicitly Marxist film of the Weimar Republic, Dudow and Brecht's joyous *Kuhle Wampe*. In 1947, Hoellering took over the Academy Cinema in the West End of London, turning it into one of the capital's most enduring arthouses. Hoellering's own career in film, which after *Kuhle Wampe* included *Hortobagy*, a widely acclaimed film on the Hungarian *Puszta*, and several propaganda shorts for the Ministry of Information, ended quickly with a 1951 adaptation of T. S. Eliot's verse play on the killing of Thomas à Becket, *Murder in the Cathedral*. Strausfeld was the art director, and the staging has some of the stark, formal, hieratic medievalism of Eisenstein's *Ivan the Terrible*. Like *The Private Life of Henry VIII*, it is interesting as a continental reimagining of the distant British past, but it is considerably less inclined to ingratiate itself with its new

A Peter Strausfeld poster for Godard's *Alphaville*.

audience. However, the Academy was for a long time one of the few places in London where world cinema was shown, and in this, Hoellering did British film a lasting service, as did Strausfeld. All the Academy's posters were specially designed by him, in a very original, almost neo-Victorian style of bold, block serifs and colour contrasts, framing stark linocut images drawing on the Expressionist woodcut tradition, etched by Strausfeld from the scenes in the films they were advertising. The look was so distinctive it defined 'arthouse' in Britain until the 1970s.

The Korda organization's response to the idea of the 'Projection of England' was somewhat different, though equally committed to the project. At the start of the war, the Kordas were working in Hollywood, where Alexander Korda made some of his most commercially successful films and worked on the side for British intelligence. *That Hamilton Woman* (1941), on the love of Horatio Nelson for Emma Hamilton, starring the English actors Vivien Leigh and Laurence Olivier, was fairly typical in the way it expressly tried to gain the sympathies of an American audience for the English during the Napoleonic Wars, in order to make Americans more sympathetic to the contemporary British war effort, before Pearl Harbor brought the United States into the war that December. On Michael Korda's account, 'Alex' enjoyed being back in Hollywood, which had completed for him a series of metamorphoses of the insider-outsider – if in Hungary he was 'a Jew' and in Britain 'a Hungarian', in Hollywood he was now perceived as 'an Englishman'. Alexander Korda would soon return to continue empire-building in Britain itself, with his London Films trying to help the Attlee government obtain hard currency by producing successful films for export.

The pattern for these was set by *Henry VIII* and *That Hamilton Woman* – lush costume dramas about an opulent British past, deliberately never so local or specific that they would alienate an American audience, and never with the slightest trace of anything socially improving. Alexander Korda's projection of England was emerging from his mangled Gropius studios in Buckinghamshire, but it was projected *at* America, and the documentary avant-garde's concern with a real, lived England was irrelevant to that aim. For his part, Zoltan Korda came to specialize in 'colonial' films set in India, Africa or the Middle East, a subject which had resulted in one of the Kordas' biggest hits, the mind-boggling high-tech technicolour orientalist dreamworld of *The Thief of Bagdad* (1940), which, aside from the co-direction of Michael

Powell, was a product so international that only the racism is really British; on his own, Zoltan directed orientalist epics, *The Elephant Boy* (1937), *The Drum* (1938) and *The Jungle Book* (1943) among others. According to his nephew, this gave Zoltan Korda a deep loathing of the British imperialism he thus served, something for which he later tried to atone through his 1951 adaptation of Alan Paton's anti-apartheid novel *Cry, the Beloved Country*. In any case, it's unclear whether the export project succeeded, given that London Films' biggest hits were often more realistic, small-scale works such as Carol Reed's Graham Greene adaptations, *The Fallen Idol* (1948) and *The Third Man* (1949). The latter was something of a coming-out for the émigrés, with plenty of Austrian actors finally getting to play Austrians, in this bleak story of a fallen imperial capital overrun by racketeering, Cold War rivalries and moral turpitude. The film's art direction, which convincingly recreated the cafés and sewers of Vienna in Shepperton Studios, was the work of the Hungarian painter Joseph Bato, who had sketched an Expressionist portrait of war-ravaged London in the 1942 picture book *Defiant City*.

But really, Alexander Korda's great service to British cinema was through inadvertently introducing Michael Powell and Emeric Pressburger to each other at Denham Studios in the late 1930s. This partnership of an English director with a Hungarian-Jewish UFA screenwriter, often called The Archers, the name of their production company, is probably the best-known outcome of the Weimar emigration in British cinema. Although their reputation suffered a trough between the 1950s and 1970s, the pair are now widely and correctly considered among the great filmmakers of the twentieth century anywhere, for the sweeping romance of their narratives, the richness of their visual imagination, their determined avoidance of cliché, and their fearlessness of artifice. Much more than Korda's, Powell and Pressburger's films of the war era sometimes spoke on behalf of the social-democratic 'new world' then being imagined, although in a very different fashion to the upstanding realism of the documentarians, who generally had contempt for the duo. The complicated class politics that fizz beneath the polite surface of *A Canterbury Tale* (1944), for instance, coalesce around a hope that a distinctive ancient 'Englishness' can be combined with an Americanized classlessness; the throwing of an aloof English gold-digger into an isolated, Gaelic-speaking Hebridean village in *I Know Where I'm Going!* (1945) is among other things a statement of the value of community over money; while there's little that sums

up the politics of this period more than the credo barked by the falling airman at his distant American radio operator in the astonishing, harrowing opening scene of *A Matter of Life and Death* (1946) – 'Conservative by nature, Labour by experience!!'

Of the two, Michael Powell is usually fingered as The Auteur, largely because of a solo film, the audacious, career-ending sadism of *Peeping Tom* (1960); but he always gave equal credit for all films made by The Archers to Pressburger.[14] Born in Miskolc, Hungary, in 1902, raised and educated in Timișoara and trained as an engineer, Imre Pressburger became effectively stateless when the latter city was absorbed into Romania after the Hapsburg Empire's collapse. Pressburger moved to Germany in the 1920s, becoming first a journalist and then a screenwriter for the UFA. There, he was on the *Neue Sachlichkeit* edge of commercial cinema, co-writing the 1931 adaptation of Erich Kästner's *Emil and the Detectives* with Billy Wilder, and writing *Abschied* for Robert Siodmak. Pressburger was at first one of several émigrés Powell would find himself working with at Denham. For instance, Alexander Korda appointed Powell to salvage *The Thief of Bagdad*, after becoming dissatisfied with the direction of UFA veteran Ludwig Berger, though Powell experienced significant interference in the directorial chair from each one of the Kordas. Powell's decision to embark on a partnership was not accidental, but was based on Pressburger's very distinct qualities – a shared love of music, spectacle, a playful, sometimes dark humour, and an approach to screenwriting that was much more visual than verbal. The Archers regularly employed a dozen or so Weimar refugees in various roles from scores to sets to editing. A few individuals stand out – one is the cinematographer Erwin Hillier, who had begun his career as assistant cameraman on Fritz Lang's *M*. Hillier's work is at its finest in *I Know Where I'm Going!*, where the far north of Scotland is shot with the stark, harsh beauty of one of Bill Brandt's landscapes; Powell considered Hillier 'one of the world's greatest black and white photographers'.[15] Martin Scorsese describes the vision of the Western Isles in that film as 'alien', a way of conveying just how much the middle-class Mancunian protagonist is lost in this harsh, wild place.[16] Although Pressburger was not German, the Anglo-Central European partnership is perhaps turned into allegory in the sprawling *The Life and Death of Colonel Blimp* (1943), with sets by E. A. Dupont's designer Alfred Junge, and starring the talented German actor Anton

Walbrook in a lead role. This film humanizes a pompous old right-wing fool – the sort one can imagine writing letters to the papers to demand all the aliens be sent away to camps – trying to subtly explain how any imagination has been trained out of him by his class and by personal loss, and matches it with the intertwined story of a 'good German', who eventually comes to Britain as an émigré before the war.

A Matter of Life and Death is a film that I, for one, as a sentimental English socialist, find it hard to watch without weeping for what we've lost, and what we could have become. It was written by Pressburger to a government commission, as a film that would relieve some of the tensions between the American and British allies. But its central conceit, in which an airman with a brain injury who has apparently miraculously survived a fall from the sky (inspired by a real event, where an airman safely landed in a snowdrift after falling 18,000 feet from a Lancaster bomber) is fought over by a celestial court, was taken by Pressburger from the Hungarian novelist Ferenc Karinthy's 1936 memoir, *A Journey Round My Skull*, which presented a surrealist account of his own brain injury. In the film, the airman's life is battled over in a bureaucratic modernist heaven, which has somehow failed to collect him at the allotted date, something that the eighteenth-century French aristocrat in charge of the job blames on 'one of your English pea-soupers'. A court case takes place between the bureaucrats above – who insist that 'we never make a mistake' – and the friends of the accidentally living airman; and appropriately, it is never made obvious what is really happening, and what is just happening in the airman's skull.

The heaven is like some sort of vast Bauhaus anteroom, lit, in Alfred Junge's milky-white sets, by dozens of oval skylights, something plausibly inspired either by Frank Lloyd Wright's Johnson Wax Building in Wisconsin or Alvar Aalto's Viipuri Library in Karelia; it is roughly what the airman imagines as he (thinks he) is plunging to his death, a place that is a little like earth, 'if we'd listened to Plato, and Aristotle, and Jesus!' Heaven is reached by a vast escalator, which was built at Denham, and was envisaged by Pressburger to be 'enormously long and wide', and 'neither the top nor the bottom are within sight. It looks like a mixture of Piccadilly Circus escalator and St Paul's Cathedral.'[17] It is lined with statues of great heroes of human thought from Plato to Mohammed to Confucius to Rembrandt, by Eric Aumonier, a sculptor

otherwise best known for a little archer atop Charles Holden's East Finchley tube station. The haunting, slightly atonal theme that plays along the escalator was conducted by Walter Goehr, husband of photographer Leila Goehr – and written by Allan Gray, the pseudonym of the Polish modernist composer József Zmigrod, who had worked both with Schoenberg and for the UFA, writing the parodic, complex and lively score for *Emil and the Detectives*. *A Matter of Life and Death* is moving for its central performances by David Niven, Kim Hunter and Roger Livesey, but also for the way in which it refuses to quite be a satire on an aloof socialist state bureaucracy in the heavens. For sure, the modernist world above looks a little cold and ordered, but it is full of people who exercise their collective democratic rights, just as down below, and when necessary, they will reform the law for the 'uncommon man', not out of some Americanized individualism, but because of a basic humanism that even the heavenly bureaucrats eventually affirm. That heaven should be modernist, and in monochrome, was Pressburger's idea, coming from a man who filled his office with Bauhaus furniture.

Powell and Pressburger were frequently criticized by those who

Alfred Junge's Bauhaus Heaven: *A Matter of Life and Death*.

advocated the *Picture Post* future of upstanding social democracy and documentary realism, and in cinema their major offence was in continuing and intensifying the two traditions that were most distrusted by British progressive opinion: Expressionism and Surrealism, irrationalisms with little obvious social utility. There was also often more than a little hint that their work represented a vision of England that was retrograde, overly romantic, sentimental or cartoonish. They too had participated in the 'Projection of England', but after the war they delved ever deeper into the bizarre, the lurid and the dreamlike, with increasingly hallucinatory films like *The Red Shoes* and *Black Narcissus*, in which extremely English protagonists go insane in exotic locations. These two films were made by the duo's own production company, but Alexander Korda brought them back for the unconvincing Jennifer Jones vehicle *Gone to Earth*, interesting mainly for its violently beautiful treatment of Shropshire, and then bankrolled their most expensive and commercially disastrous film, *The Tales of Hoffman* (1951): a filming of Offenbach's operetta adapted from every Expressionist's favourite teller of tales, E. T. A. Hoffman.

You would have to go to the furthest edges of the avant-garde to find anything so mind-melting as *The Tales of Hoffman*. Its intensely Surrealist atmosphere is owed in large part to the sets of Hein Heckroth, who previously had principally been the costume designer for The Archers. Heckroth had made his name in the Weimar Republic as a designer for the ballet director Kurt Jooss; in the Third Reich, Heckroth was told that to continue working he would have to divorce his Jewish wife. He refused, and went to Britain, along with Jooss, where they worked teaching dance at the 'progressive' Dartington Hall school in Devon. At the start of the war, he was deported on the notorious *Dunera* to Australia, but returned to Britain and moved into film. Heckroth's first major project for Powell and Pressburger was *The Red Shoes* (1948), where dance sequences turn into dream sequences; this is taken much further in *The Tales of Hoffman*. The backdrops for the dances entail lilypads, Max Ernst-like architectural landscapes, French rococo rooms and palaces in the clouds, all lit in the most lurid blues, greens, purples, yellows, with the costumes often creating hybrids of artwork and body. The film is a reversion to the way in which the early films of German Expressionism, like *The Cabinet of Doctor Caligari* or Robert Weine's *Genuine*, were pure visual experiences, based on sets that couldn't possibly occupy any

kind of real space in the ordinary world. *The Tales of Hoffman* is the culture of UFA writ large, made by several people who had worked at the UFA, but it is older, wiser, and without a nationalist ideologue telling it what to do. By this point Powell and Pressburger (and Heckroth) were not so much 'projecting England' as projecting their own feverish dreams.

When the duo split at the end of the 1950s, they would take this love of artifice in some rather different directions, and the relation of the Central European and the English would be scrambled. Powell would create his own firmly English and exceptionally seedy version of Fritz Lang's M, namely *Peeping Tom* (1960), the story of an inexplicably sympathetic serial killer played by the young German actor Karlheinz Bohm. Now regarded as a sick masterpiece, the film is set in a Soho (or rather, Fitzrovia) world of sex workers, porn rags and photography shops. It can't only have been the nastiness of the content that revolted so many critics (and audiences). It was also a consequence of the outrageously bright reds and sudden harsh blacks that the cinematographer, the émigré Otto Heller – who had escaped Prague in 1938 – deployed throughout. A few years after the film's commercial failure, Powell made a film in Yugoslavia with Heckroth, who had returned to Germany, as the set designer. *Bluebeard's Castle*, like *Peeping Tom*, is a film about murderous misogyny, but the similarities end there. It is an adaptation of a harsh, avant-garde opera by the Hungarian modernist Béla Bartók, and in large part an opportunity for Heckroth to continue from where he'd left off in *The Tales of Hoffman*, creating a deliquescent mindscape of glass and iron, lit in greens and purples – the closest anyone had come by that point to translating the slashing chromatic violence of peak Expressionist painting, a Kirchner or a Heckel, onto the screen. In the absence of Pressburger, Powell seemed determined to become even more German, rejecting The Archers' stylized Englishness for a world of violence, paranoia and tortured sexuality.

Pressburger's work on his own has suffered somewhat in comparison, and not only because of the injustices of Auteur Theory, which still tend to assume that Powell must have been the 'real' director of The Archers' films, despite his own protestations to the contrary. The film that Pressburger put his heart into, it appears, was *Miracle in Soho* (1957), which he wrote and produced, based on a 1934 screenplay he had always dreamed of making. Direction was farmed out to Julian Amyes, perhaps

An advertisement for Emeric Pressburger's miraculously unrealistic *Miracle in Soho*.

better known for directing episodes of *The Bill* and *Rumpole of the Bailey*; the film is hilariously miscast, with the buxom and blonde English actress Belinda Lee playing an Italian waif in the main role. It gives a great sense of a producer and writer who is wholly out of touch; its vision of multiculturalism, nearly a decade after Windrush, is almost wholly European, with Soho populated by French, Italian, Polish émigrés, but with no Chinese, Caribbean or Indian people getting speaking parts. At a time in which, as we'll soon see, young directors were starting to put the real urban landscape of Britain on screen, *Miracle in Soho* was determinedly artificial, in the service of a wilfully silly plot in which a young Italian woman successfully uses the power of prayer to keep a man-about-town construction worker, who has a girl on every job at work, in her district for as long as possible. The 'Soho' here is a massive set in Pinewood Studios, designed by Carmen Dillon, who mainly worked on costume dramas. If you're looking for realism, it's preposterous, but it is on its own merits a fascinating giant toy, and the film has plenty of charm through its sheer level of minute detail. However,

placed against the monumental *Peeping Tom*, you feel that if you blew upon this Soho it would fall down. The real future of Britain was being made in places like this, but only a faint echo of it could be heard in Pressburger's film.

By the end of the 1950s, neither Powell nor Pressburger seemed much interested in projecting England, or able to do so, as one retreated into trivialities and the other explored the recesses of his psyche. Pressburger, however, was not quite as aloof and complacent as *Miracle in Soho* might have implied. After the film's failure, he turned to fiction, and in 1966 published his second novel, *The Glass Pearls*. It was a work every bit as brutal, cynical and brilliant as *Peeping Tom* and, like it, was buried under ferociously poor reviews; only recently has it been rediscovered and, like Powell's *Peeping Tom*, rightly hailed as a perverse classic. *The Glass Pearls* brought the reader into the mind of Braun, a Mengele-like Nazi scientist, hiding in London under the pretence of being an anti-Nazi exile, the real 'refu-spy' feverishly imagined by the *Daily Mail* twenty-five years earlier; he spends his time chatting casually with Jewish émigrés, listening without emotion to their own experiences of escape and imprisonment from people like him. Actual London locations, from a seedy Pimlico bedsit-land to the Royal Festival Hall and Heathrow Airport, are rendered with pitiless realism. Above all, the book is about the falseness of memory, and the way in which 'reality' can be wilfully produced and manipulated. Braun's speciality in the extermination camps was in experimenting with the mind, in order to find where 'memory' was located in the brain itself; he regales his English lover with stories of Paris in the 1930s, which are all taken from the memories of his victims; memories that Pressburger took from his own store.[18] Realism, Pressburger appeared to be telling his many critics, was not just undesirable but basically impossible. But in the 1960s, British cinema was pushing in quite another direction – towards the belief that what one could see in front of one's eyes was the real truth.

11
Whatever People Say I Am, That's What I'm Not

There's a dispute, then, in the British cinema of the mid-century about how exactly to realize the 'Projection of England', something that is inherent in Stephen Tallents' original argument, which could equally lend itself to imperial propaganda and social realist polemic: and did, in the Empire Marketing Board and GPO Film Units. The question was as follows. Was this 'Projection' a matter of projecting what England *really was* for people who lived in it, and trying to make arguments through cinema as to how it could be made better for the majority of its citizens, as it appears to have been for the documentary filmmakers? Or was it a way of retaining some kind of global reach in an increasingly post-imperial era, by broadcasting to the world the glorious history and distinct historic culture of an ancient and traditionalist country, and hence finding a new niche in the global market of a US-dominated post-war western world? As this dispute reached into the pop era, some of the most interesting contributions continued to come from Central European émigrés and refugees, by this time of a younger generation.

The arthouse films that could be widely seen at Georg Hoellering's Academy Cinema – and at the National Film Theatre (NFT) built as part of the 1951 Festival of Britain – began to have an effect on what was actually made in Britain from the mid-1950s onwards. Now it was finally possible for Londoners, at least, to easily acquaint themselves with the history and possibilities of cinema beyond Hollywood and Alexander Korda's efforts to emulate it for export dollars. In England, one of the most important and most mythologized moments was Free Cinema, a series of programmes at the NFT shown between 1956 and 1959, presented by its young programmer Karel Reisz. Two of the programmes showcased the New Waves that had emerged on the continent – in France, with screenings of work by Claude Chabrol and

François Truffaut, and (less well remembered) in Poland, with films by Walerian Borowczyk and the young Roman Polanski. The other two programmes, however, bundled up a group of shorts made in London by young filmmakers Lindsay Anderson, Tony Richardson, Robert Vas, Lorenza Mazzetti and that same Karel Reisz. These shorts returned, in some ways, to the social seriousness and hard realism of the EMB or GPO film units, but they dropped the didacticism, the stiffness, and 'The Man from the Ministry' tone. They would project England in a way that was raw, lively, and in tune with the nascent youth culture emerging in cities like London, Manchester and Liverpool.

Some of these films directly discussed migration, with a veracity that makes something like *Miracle in Soho* look even more preposterous. Of the group, Robert Vas was a young Hungarian who had escaped the country not after the crushing of the Soviet Republic of 1919, but after the suppression of the anti-Soviet revolution of 1956.[1] Vas's *Refuge England* is a moving little film in which the director himself expresses the difficulties of living in a baffling country where he can barely speak the language, haunted by memories of what he's escaped from; Lorenza Mazzetti's delightful *Together* was more allegorical, with its deaf-mute dockers having oblique adventures wandering around London's East End. But both figures were at the fringes of Free Cinema. The core group, who would go on to create for themselves a British New Wave briefly comparable to that of France, included two young refugees. Almost all of the Free Cinema shorts, and most of the New Wave features, were shot by the cinematographer Walter Lassally, who had been born in Berlin in 1926 and came to Britain in 1939. Karel Reisz was born in the same year in the industrial city of Ostrava, Czechoslovakia, to a professional middle-class Jewish family. The teenage Reisz was saved from the Third Reich by the *Kindertransport* programme. Reisz's parents were killed in Auschwitz, while Lassally had escaped with his family in 1939.

Reisz arrived in Britain at the age of twelve, speaking no English. By the time he was in his thirties, as an authoritative film critic, running the journal *Sequence* with Lindsay Anderson, he did not even have a foreign accent. Given that Reisz had immersed himself in Britain and lived here more than half of his life by the time he came to make films, it would be patronizing to see them as pure expressions of a stranger's eye picking out the exotic and unusual, in the same fashion as the camera eyes of Bill Brandt or Gerti Deutsch; but it would be less questionable

to argue that he lacked the belief that there is a *done thing*, that there is a conventional way of representing British life, which you stray from at your peril. You can see this in *Momma Don't Allow*, a short on Wood Green Jazz Club in North London, co-directed with Tony Richardson and shot by Lassally. It depicts its characters – mostly white teds, hipsters and ordinary working-class youth in the middle of a moral panic over gang violence and 'racialism' – in a tone that is affectionate and non-sensational.[2] There are elements of the recent documentary past, with GPO-style staging devices, such as the way we track the dancers at the start of the film, finishing their jobs as train cleaners, butchers, waitresses, before they go to the jazz club – not to mention the similarly stagey arrival of some débutantes in a Rolls-Royce. But what you remember from *Momma Don't Allow* are the smaller things, like the skinny, dark-haired girl in the white vest who spins and spins, occasionally dancing with others but never looking at them, completely lost in the music. This is something new, a world of suburban youth living for music and living for the weekend, immersed in a new American popular culture. Unlike some figures of the left at the time, such as the sociologist Richard Hoggart, Reisz does not lament the new culture or contrast it with a better, authentic, older working-class culture. This is a new Britain coming into being that neither the conservatives nor the radicals of the 1930s could really have imagined.

In their manifesto accompanying Free Cinema's Programme 3, Anderson, Reisz and Richardson wrote that 'British cinema [is] still obstinately class-bound ... still reflecting a metropolitan Southern English culture which excludes the rich diversity of traditions and personality which is the whole of Britain.'[3] The Free Cinema directors had some very salty words for the way Britain had been 'projected' before them: in a polemical article, Reisz described 'projecting Britain' as meaning, by the late 1950s, little more than 'films about the Lake District, Stirling Moss, old trams, and the beauties of spring'. This meant an ethos where socialism is little more than a 'sort of good housekeeping system: when people have houses, work and food, all is well'. To this, Reisz counterposed a new 'socialist humanism' that would find out what 'social problems continue to exist – old age, the colour bar, juvenile crime – take your pick',[4] and that would bring to documentary filmmaking a sense of poetry and possibility it had hitherto lacked.

Despite the embrace of another Britain, the Free Cinema films were

almost all shot in London, where the directors lived. The only exception is *March to Aldermaston*, made for the CND by the entire group (here including Wolfgang Suschitzky), documenting the historic anti-nuclear demonstration. The features of the British New Wave, however, mostly documented the north of England, and those parts of the Midlands (like Nottingham) that most resemble the north. Of the three main directors, only Tony Richardson – who came from a middle-class family in Shipley, West Yorkshire – was actually a northerner, but all of them were agreed that the north had been under-used in British cinema, particularly in fiction film. It is likely that they also found the north very visually exotic, and in this they had been taught to see by the photographers of the 1930s. The *Picture Post* world lives on in their vision of the country – not to mention in the fact that all of the people looking through the camera were middle class, although at least this time around the actors and screenwriters were not – but it has been stripped of all that well-meaning social critique, which once occupied the texts next to photographs by Brandt or Hutton. Here, the interest is in surface, grain and landscape, a stress on the Gothic qualities of real British urbanism: terrible weather, Victorian architecture, hills, chimneys, dirt, high streets, supermarkets, menacing provincial nightclubs.

The British New Wave directors were enthusiasts for Bill Brandt's 1930s photographs of the dramatic, Expressionistic landscapes of Halifax or Newcastle; when making *A Kind of Loving* (1962) in and around Manchester and *Billy Liar* (1963) in Bradford, John Schlesinger showed Brandt's photographs to his actors as preparation.[5] Reisz does not fetishize Nottingham in the feature debut of *Saturday Night and Sunday Morning* (1960), but the way he documents the factory – matter-of-fact, with characters griping and bickering with each other over the roar of the machines – is on another planet to the documentary films of the 1930s. Likewise, the landscape of chimneys beyond Nottingham Castle does not symbolize anything – the past, the Depression. It's just *there*. Lassally's work on Tony Richardson's *A Taste of Honey* (1961) is particularly detailed in its depiction of the Salford townscape. Lassally was keen to use the actual weather of Lancashire, rejecting the 'received wisdom' that you would have to shoot in the rare days of sunlight. He later pointed out that this was a 'poetic', not a 'kitchen sink' film,[6] and that's especially true of the constantly imaginative way he shot these locations – the Expressionistic twist of a stairwell or a snicket, a moor

framed by a canal-side archway, a dockside bridge shrouded in drizzly chiaroscuro, a pond formed out of the hole left by slum clearance. You are constantly being shown the strangeness and specificity of this place, and for all the sadness and rain and grime these are not 'grim up north' in the way conventionally imagined.

Quite soon, the directors involved got bored, and moved on to something else, often in the form of costume dramas. As a result, a coherent British New Wave fell apart, and with it, this approach to the British urban landscape that was visually dramatic and determinedly unromantic, set in the places where most British people actually lived. But in between, there was a film that registered some of the reasons for the collapse of the New Wave: Reisz's extraordinary *Morgan: A Suitable Case for Treatment* (1966). It is a very loose adaptation of a David Mercer play, which turned on its head the entire Angry Young Man genre Reisz had helped define with the utterly searing, utterly humourless *Saturday Night and Sunday Morning*. Again, the protagonist is an ambitious young working-class man, now a few cuts in the class system above Arthur Seaton, the Nottingham factory worker in *Saturday Night and Sunday Morning*. Morgan is an artist, raised in London by proletarian Communist parents; his mother still working in a greasy-spoon café in her old age. He has, to her immense disappointment, failed to lead the revolution. Instead, he spends his time pranking his upper-class ex-wife through the streets of Chelsea, wallowing in self-pity and self-indulgent fantasies of getting his revenge on the aristocratic art gallerist who has cuckolded him. He dreams of the final working-class uprising, but spends his actual time driving around in a sports car decorated with images of Lenin and Trotsky ('I'm an exile, waiting for the icepick!' he tells a baffled policeman). Social realism has been swapped for a rather *Batman*-like Pop Art style of speed-up and slow-down and intercut B-movie footage. The rain-slicked, grimy brick terraces of Nottingham are replaced by a gracious Chelsea in full spring, until a final comeuppance in the railway yards in front of Lots Road Power Station. For all its farcical humour, *Morgan* is a rather sad picture of how class mobility has led to confusion and waste, the dream of the new society rendered meaningless by the appeals of sex and consumerism.

After this pessimistic vision of the impossibility of any real working-class revolution, any real decisive change, in this country, why not project England in the way the market wanted? After defining a certain way

The Failure of the Revolution in Chelsea: Reisz's Morgan: A Suitable Case for Treatment.

of seeing the north of England in his cinematography, Walter Lassally eventually became the main director of photography for Merchant Ivory, the exact antithesis of the British New Wave. Merchant Ivory was a production company set up in India by two Indians and an American with the express purpose of selling an unlived vision of England to people who did not live here and may never do so; this was a legitimate enough answer to Stephen Tallents' call for projection, but one based on the purest fantasy and ignoring the great majority of people and places that constitute the island of Great Britain. And yet, the earlier films that Lassally shot and Reisz directed are still beloved for how much they resonate with everyday life; for the thrill of seeing someone really see your home town, of someone making a Nottingham factory worker like Arthur Seaton as flawed and charismatic as a Brando character. At least in part, a continental eye was needed in order to see *this* country. However new and original these films were, the England they project is at a few removes from the realistic side of Central European filmmaking in the 1920s and 1930s. Eisenstein would have understood the

unpretentiously real faces and expressions, the motion and montage, of *Momma Don't Allow*; the directors of *Kuhle Wampe* and *People on Sunday* may have seen themselves in parts of *A Taste of Honey*. But the lineage of grandiose futuristic spectaculars such as *Metropolis* would have its own successor in Pinewood Studios in the 1960s, in the work of a Berliner who had renamed himself Ken Adam.

Klaus Adam was born in Berlin in 1921, where his family ran a department store; he was sent to public school in Britain at least in part to get him and his brothers out of Nazi Germany. His Jewish family were dispossessed of their holdings and hounded out of the country by the end of the decade, but they survived. Adam later recalled the effect of the visual environment he'd grown up in, the affluent, commercial West End of Berlin in the 1920s and 1930s: 'my background as a boy growing up in Berlin with architects like Mies van der Rohe, Walter Gropius and Erich Mendelsohn obviously had some influence on me'.[7] After changing his first name to Kenneth and becoming one of the few Germans to fly for the RAF during the war, he worked as an architect, at one point for one of Mendelsohn's associates from his time in London; then Vincent Korda, the set designer of *Things to Come*, encouraged Adam to move into cinema. He was the only real successor to the younger Korda in British cinema in the intensity and melodrama of the artificial environments he would build as a production designer. Adam received his Oscar for near-perfectly recreating the lighting and spaces of the eighteenth century for Stanley Kubrick's *Barry Lyndon*, but he is most loved for a series of tongue-in-cheek futuristic sets, starting with *Dr Strangelove* in 1964, but culminating in seven instalments of the James Bond series.

The Bond films have their own role in the collapse of the 'Projection of England'. Their producer was Harry Saltzman, a Canadian enthusiast for arthouse cinema, who had set up Woodfall Films at the start of the 1960s for the express purpose of releasing the films of the British New Wave, including *Saturday Night and Sunday Morning* and *A Taste of Honey*. But in an 'if you can't beat them, join them' gesture he then founded Eon Productions, just as specifically geared towards Bond, which would be shot at Rank's studios in Pinewood, only three miles away from Denham in Buckinghamshire. These films are so much the antithesis of the British New Wave that it is extraordinary they shared the same producer. The films of the New Wave aimed to be about Britain

as it is, unsentimental, raw, if not unpoetic; Bond films are Britain for export, a cartoonish image of a fundamentally Victorian country aimed at leveraging a dissolving political armed power for the purposes of cultural soft power. If the films of the New Wave, made in large part by Central European refugees, were – especially *A Taste of Honey* – sympathetic in their depiction of marginal experiences, with prominent black British or gay protagonists, Ian Fleming's Bond is a misogynist, an antisemite, a flagrant racist. The supreme expression of this is in the genre of the Bond Villain himself – almost always a Central European (albeit sometimes a 'Nazi') with mangled English syntax, with a mad theory of one kind or another that has driven him to try to take over the world. One of the most notorious was named by Fleming after Ernő Goldfinger, whose deployment of modern architecture in Fleming's beloved Hampstead was an unpardonable crime; the eponymous villain of *Goldfinger* has an addiction to *gold*, of course. And of course, each Bond villain lives in a modernist lair. Ken Adam designed those lairs.

There are common features to these film sets – raked, vaulted sections, depicted in detail using deep focus – but they're consistently wildly imaginative, from the multi-level Fort Knox in *Goldfinger* to the Brutalist volcano with internal monorail of *You Only Live Twice*, to the immense supertanker set of *The Spy Who Loved Me*. Adam's last and greatest environments for Eon's Bond films appear in the insufferable, gripping *Moonraker* of 1979. The film is in some ways just a sequence of epic sets. Early on, we have MI6's own HQ, which is of course a panelled classical Georgian house with framed oil paintings that conceal interactive video screens – an ideal of lethal high-tech hidden behind historical continuity that was common both to the Baldwin-Chamberlain 1930s and to Thatcherism. Then there's the first lair of our Central European villain Hugo Drax – a reconstructed French baroque château, with opulent interiors, a short helicopter ride away from a vast concrete Cape Canaveral-style space complex – while Roger Moore's Bond first meets (ahem) Dr Holly Goodhead in what is very clearly the top floor of the Centre Pompidou, a wild neo-Constructivist arts complex opened in Paris the previous year. But the major lair is a *promenade architecturale* that is one of the genuinely most extraordinarily odd spatial experiences of the era. A Mesoamerican pyramid conceals a Frank Lloyd Wright grotto full of nymphs who try to strangle Bond with a giant snake; escaping from there, he advances to a pyramid of constantly shifting

video screens, over which Drax presides atop a high-tech throne; and then we literally blast off into space, to a floating Brutalist complex of domes and capsules, linked, in the style of *Things to Come*, by tubular overhead passages. Here, the events that drove Adam and his family to Britain are burlesqued, as the crazed Drax tells Bond of his evil plans to create *a master race in space*. But who exactly the fascist is in the Bond films, the villain or the hero, remains unclear.

PART TWO

Books and *Buchkunst*
Central Europeans Redesign the British Book

I find it consoling, in these days when civilization appears to be tottering, to think that the great tradition of European book-printing has been revived ... Where could such qualities be more desirable than in the work of passing on the wisdom of the great poets and thinkers by means of books available to Everyman?
 Jan Tschichold, 'On Mass Producing the Classics', 1947[1]

12

The Radical Autodidact's Bookshelf

At any time between the 1930s and 1970s, if you were to peruse the bookshelves of the average political activist, mature student, trade unionist, art student or art-gallery-goer – among others – you would find certain publishers were particularly popular, and that they all had a certain *look*.[1] The publisher that dominated all these shelves was, of course, Penguin. Some of the Penguins would be from a general list of fiction and non-fiction, but most of them were from special curated series. There would be the Penguin Classics, with their elegantly pseudo-antiquarian covers, their hand-drawn medallions in the centre, colour-coded as to the country or region they had originally come from. There would be the blue Pelicans, non-fiction books on history, science, art, education, cinema, music, nature; and those with children would have a stack of the junior versions of these, in the bright, slightly surreal world of Puffin Books. In the 1930s or the 1960s, there would be a contingent of Penguin Specials: punchy, polemical and urgent books on the issues of the day, on fascism, socialism, poverty, housing, war, with red spines. Alongside these might be the reader's local volume of 'The Buildings of England', a series of guides to the architecture of the English counties. The enthusiast or the amateur aesthete might have alongside these some King Penguins, slim, colour-printed hardback picture books, and perhaps one or two of the much grander volumes of the 'Pelican History of Art', heavy but elegant hardback tomes that came in cardboard slipcases.

The contents of the shelves would go further than Penguin, of course. In the 1930s and 1940s, especially, there would be the tiny colour-coded hardbacks of Everyman's Library, which would have sat slightly oddly on the shelf due to their more florid design, their hints of Victoriana. There would, in the same two decades, have been another, slightly more large-format series of hardbacks from the Left Book Club – their red

volumes officially 'not for sale to the public', but in wide distribution due to the club's tens of thousands of members. There would have been slim books of poetry, in Faber's 'Paper-Bound Editions', with typographical rather than pictorial covers, as enigmatic as the books' contents. There would also have been books on art, culture and archaeology – the 'Britain in Pictures' series, which was especially popular during the war, and had volumes on everything from hills to glass to letter-writers to canals, or the New Naturalist books, which concentrated on the flora and fauna around you, with illustrated books on the birds and wildlife of urban Britain. From the 1950s onwards there would be the black paperbacks of Thames & Hudson's 'World of Art' series, which covered even the most difficult and intransigent modern art – made accessible to the most penniless student. Usually sharing space with these would be a few cheap Phaidon hardbacks, with their colour reproductions by Renaissance, Impressionist and modernist painters, or their surprising bestseller, *The Story of Art*, and perhaps a few books on ancient civilizations or British counties, published by Paul Elek. Those practising the still relatively fresh popular art of photography might have a few 'How To' books from the Focal Press, guides to how to use their favoured camera, or how to photograph people, buildings or wildlife. With a bookshelf like this, entirely circumventing the academic publishers – Oxford, Cambridge, Harvard – and the luxury art publishers, a person of modest means could have given themselves an entire university education, with each class costing the price of a pint or a pack of cigarettes. Although cheap books had been around for a long time, they tended to specialize in bestsellers and, occasionally, the most obvious of classics; but by the 1940s, someone on an average wage could build up an entire library that previously might have only belonged to an academic or a wealthy connoisseur.

This new popular library owed its existence in very large part to the Central European emigration. In some cases, the process was very straightforward. Phaidon, for instance, was a Viennese publisher, founded in the 1920s and, from the 1930s on, specializing in inexpensive books on art; its publisher-editors Béla Horovitz and Ludwig Goldscheider were forced out of Austria by the Nazi takeover in 1938, and re-established the firm with the help of the English publishers Allen & Unwin. Thames & Hudson was also the project of two Viennese artbook publishers who had escaped in 1938, Walter and Eva Neurath; Walter, with his fellow Viennese refugee Wolfgang Foges, had previously

run the firm Adprint. Walter had worked on a freelance basis pitching and producing illustrated books to other publishers, specializing in edited series such as 'Britain in Pictures' and the 'New Naturalist' for Collins, 'The New Democracy' for Nicholson & Watson, and the King Penguins. Paul Elek was a Hungarian, while the Focal Press, as we've already seen, was the project of the Hungarian-Jewish Berlin film critic Andor Krasna-Krausz.[2] But there is more here than meets the eye.

Those Faber poetry books, for instance, were all designed by the émigré German typographer Berthold Wolpe, with tasteful but inventive covers relying wholly on colour and lettering. But the continental influence went much further with Penguin. Penguin Books was founded by an Englishman, Allen Lane, the member of a bookselling family and initially a leading figure at The Bodley Head; but Penguin Books modelled itself, we will soon discover, on a German publisher of English paperbacks. Its books were designed, from the 1940s onwards, by a sequence of talented exiles – Jan Tschichold, Hans Schmoller, Germano Facetti, Romek Marber, among many others – with extensive editorial input from the Leipzig art historian Nikolaus Pevsner, who edited the King Penguins, the 'Pelican History of Art', and both edited and wrote himself that massive undertaking, 'The Buildings of England'.

The Left Book Club, meanwhile, a joint project of the publisher Victor Gollancz, the Labour intellectual Harold Laski, and the Labour MP and Communist fellow traveller John Strachey, was modelled on the mass socialist cultural organizations built by the great Communist media mogul Willi Münzenberg. In the Left Book Club's editions, and in the Penguin Specials that were modelled upon them, the veterans of the bitter conflicts of European politics would explain what was happening to a British readership that were told by their mass press and their politicians that whatever was happening in Berlin, Barcelona, Vienna or Prague had nothing to do with them. Of the books on our semi-imaginary autodidact's bookshelf, only J. M. Dent's Everyman did not receive significant influence from the former Hapsburg and Hohenzollern lands. In an unorganized, rather accidental way, these publishers had a seismic effect on popular education in Britain, taking a country that had been conservative in both aesthetics and politics and seducing it with serious ideas through beautiful design and, it should be noted, exceptionally competitive price points. It is this library that we will explore in this part of the book.

13
Letters and Spaces

At the heart of this shift was a change in the culture of design that took place between Moscow and Berlin in the 1920s. The Central European publishing culture of the Weimar era was never wholly dominated by the Expressionist, Dadaist or Constructivist avant-garde, but here, as with the magazine culture of the period, these currents had a presence in the mainstream of book publishing that would have been highly unusual in Britain. Publishing ventures that were associated with radical trends ranged from the explicitly socialist to the more technocratic. In the former category there was Malik-Verlag, founded by John Heartfield's brother Wieland Herzfelde. Initially favouring the chaotic and viciously satirical books of Berlin Dada – including the picture-books of George Grosz, such as *The Day of Reckoning* and *The Face of the Bourgeoisie* – Malik-Verlag became successful with mass-market editions of socialist writers like Upton Sinclair and Maxim Gorky; similar publishers such as Odeon in Prague favoured fusions of Dada and Constructivism. Hanging over this was the influence of Soviet Constructivism, which was particularly suited to the poster-like design of book jackets, and which included official publications of the Communist Party until the mid-1930s. Although what was inside them could be more conventional, there were also highly original, free-form illustrated books such as Rodchenko's *About That* and El Lissitzky's *For the Voice*, both designed for the Communist Futurist poet Vladimir Mayakovsky. Beneath all this lay the distant echo of Italian Futurism, which aligned itself strongly with Fascism in the 1920s, but whose books, designed by the likes of Fortunato Depero, still pursued an aesthetic of 'Words in Freedom', thrown across the page with abandon to produce emotional and violent effects. Meanwhile, in the second half of the 1920s, the Dessau Bauhaus's *Bauhausbücher* series aimed to bring together all

the various trends of the European avant-garde, publishing alongside German authors like Walter Gropius, Paul Klee and Oskar Schlemmer, books from France (Albert Gleizes's *Cubism*), the Netherlands (Piet Mondrian's *New Design*) and the USSR (Kazimir Malevich's *The Non-Objective World*). Needless to say, artists or writers from Britain could not be found even in the extensive longlist of planned editions compiled by the series' editor, László Moholy-Nagy.

In all these ventures, you can find the distinct design innovations of the Central European avant-garde. Sans-serif fonts, asymmetrically arranged; a great deal of white space; integrated photographs as a crucial part of the design; photomontage; and an approach to layout derived both from industrial blueprints and abstract painting. The absence of Britain in avant-garde book design was not, of course, absolute, however much the relative conservatism was patently obvious to contemporary observers. Modernist book covers that were not a million miles from those of the Berlin, Moscow or Prague vanguard were produced by the American artist-designer Edward McKnight Kauffer, for instance; and the Vorticist Wyndham Lewis, by now something of a 'one-man avant-garde', produced self-designed books that had some of the spleen of Dada, the machine clang of Constructivism, and the cruel politics of Italian Futurism.

But it would be wrong to imply that everything being produced in Germany, Austria, Czechoslovakia and Poland was revolutionary and dramatically new. One of the major trends was what was called 'reformed traditionalism', which rejected the crass, kitsch, florid and cluttered designs of the late nineteenth and early twentieth century just as strongly as did any Constructivist; but rather than shifting from there into abstraction, it drew instead on the book design of the Italian Renaissance, producing designs that were relaxed, limpid, easy to read, and exceptionally elegant. Here, British influence was crucial. British typographers, evolving gradually out of the book-design reforms of the Arts and Crafts movement – with William Morris's Kelmscott Press as a touchstone – had produced very impressive work in the 1910s and 1920s, which was noticed internationally. At the forefront was Stanley Morison, at the Monotype Corporation, who developed Times New Roman for that newspaper, one of several neo-Renaissance typefaces he either created or discovered in the interwar years; Oliver Simon, the typographer and designer of the prestigious Curwen Press; Edward

Johnston, who developed the London Underground's typeface; and the morally appalling but very talented Catholic polymath Eric Gill, whose Gill Sans, developed in the late 1920s for the London and North Eastern Railway, became, along with Paul Renner's Futura and Herbert Bayer's Universum (both developed in Weimar Germany), the most instantly recognizable modernist typeface of the first half of the twentieth century.

This precedent was followed by the German type designers who sat between modernism and the neo-Gothic typography favoured by German Nationalists (and by the Nazis, after they took power). Important here were typographers like Hans Mardersteig, Rudolf Koch, Carl Ernst Poeschel and Berthold Wolpe, and certain publishing series such as Insel-Verlag's Insel-Bücherei – a series of slim illustrated cheap hardback editions of meticulously precise design, with an eccentric list ranging from butterflies to Goethe. Mardersteig was possibly the most respected of the 'reformed traditionalists'. His career as a designer began in 1919, at the start of the Weimar Republic; he was the co-creator of the journal *Genius*, an Expressionist art magazine that published high-quality reproductions of otherwise hard-to-see paintings by the likes of Erich Heckel, Franz Marc and Karl Schmidt-Rottluff. Rather than moving from Expressionism to Dada or Constructivism, as did so many of his contemporaries, Mardersteig moved to Verona. There, he delved into the typographical world of the Italian Renaissance, founding a printer-publisher, the Officina Bodoni. In Verona, Mardersteig changed his name from Hans to Giovanni, and was given official permission by Mussolini's government to recast the neoclassical typefaces of the eighteenth-century designer Giambattista Bodoni, and to produce a special edition of the works of the nationalist poet Gabriele D'Annunzio. For the most part, the Officina Bodoni produced delicate editions of selected classics, often working closely with Stanley Morison and Monotype, but taking pride in small-scale hand-production and expensive, antiquated materials such as vellum. This was an unlikely basis for international fame, but it did come. Mardersteig was commissioned by the Scottish mass-market publisher Collins to create Fontana, a modernist typeface that was actually based on a Glasgow font from 1760. He has been described as 'the finest printer of the century'.[1]

Chronologically, the earliest of the book series that we would find on our autodidact's bookshelf, and one which was perhaps most obviously

an attempt to catch up with the rest of Europe, was Gollancz, Laski and Strachey's Left Book Club. Published by the firm of Victor Gollancz (founded in 1927 by a British Jewish Christian Socialist), the organization was very consciously an attempt to create in Britain the sort of modern socialist culture that had been developed in the Weimar Republic but strangled in 1933. However, when it came to design, the Club avoided the astringent photomontage designs of its nearest Weimar equivalent, Malik-Verlag. Coming without dust jackets, the Club's selections were designed, like all Gollancz publications, by Stanley Morison, in a spacious, limpid 'reformed traditionalist' style, with an instantly identifiable logo and a sans-serif typeface, set at the top of the book's cover and classically centred, so combining modernist and traditional elements.

If the aesthetic was somewhere in between London and Berlin, so too were the contents. Among the few Club books that have retained a reputation as classics of their kind, some were English – Ellen Wilkinson's *The Town That Was Murdered*, George Orwell's *The Road to Wigan Pier*, and (for better or worse) Stephen Spender's *Forward from Liberalism*, all of them interventions into the politics of Depression Britain. There was also a huge amount of polemical work that has aged badly, to put it mildly. But the fact is that a huge number of the books were either published by émigrés or translations from the German – a vast and strange list ranging from Lion Feuchtwanger to Arthur Koestler, from the gay sexologist Magnus Hirschfeld to the Frankfurt School economist Franz Neumann, from the dissident socialist Paul Frölich to the NKVD spies Jürgen Kuczynski and Otto Katz. A subscription to the Club also got you a regular journal and, crucially, access to a social-political circle of Book Club meetings, where you might find yourself watching a Kino group's screening of Eisenstein films or a reading by Langston Hughes.[2] Although Koestler's depiction of the 'LBC' as a harmless sewing circle of teachers and other members of what passed for an English intelligentsia is a little unfair (in Inner London or in the north, membership was mostly working class), it is hard in retrospect not to see it as an organization of people who were wading way out of their depth.

Notoriously, the Left Book Club published explicit defences of Stalin's grotesque show trials, and it was strongly pro-Soviet at a time when this entailed an abdication of basic intellectual responsibility. The Club's story has often been told through the vehemently critical eye of one of its black sheep, Orwell, whose *The Road to Wigan Pier*

was published by the Left Book Club with an introduction tempering its alternately acute and bigoted second half criticizing the British left. In an article on Arthur Koestler, Orwell asked readers how many Left Book Club titles they could remember – this, in 1946, when the LBC still had another two years left of its life – and argued that its flaws were due to the fact British editors could not have possibly been able to understand totalitarianism, or a continent where 'things have been happening to middle-class people which in England do not even happen to the working class':

> Most of the European writers . . . have been obliged to break the law in order to engage in politics at all: some of them have thrown bombs and fought in street battles, many have been in prison or the concentration camp, or fled across frontiers with false names and forged passports. One cannot imagine, say, Professor Laski indulging in activities of that kind.[3]

Orwell pointed readers who might have wanted to understand rather than excuse the Soviet and Nazi regimes instead to Victor Serge, Ignazio Silone and Arthur Koestler (who, as Orwell well knew, had published two books with the Club). He was absolutely right to contrast the embarrassing, pompous trash of, say, Sidney and Beatrice Webb's *Soviet Communism: A New Civilisation?* with the real literature of Central European survivors, but it was faintly nonsensical to lay the blame for this at the foot of the Left Book Club. In fact, in the way it combined some enduring classics, still in print (which includes not just *Wigan Pier* and *The Town That Was Murdered*, but émigré contributions like Franz Neumann's *Behemoth*, Koestler's *Scum of the Earth*, Paul Frölich's *Rosa Luxemburg*), with a large amount of Fabian and Stalinist pabulum, the Club was a pretty accurate reflection of the reality of left-wing thought in the 1930s and early 1940s both in Britain and Germany. It's conspicuous today that the Club missed most of what are now the more widely read Weimar writers of the left, ignoring Bertolt Brecht, Joseph Roth, Hannah Arendt, Siegfried Kracauer, or the later 'Western Marxist' canon of Walter Benjamin, György Lukács, Ernst Bloch and Theodor Adorno. It is anachronistic to have expected anything different – these writers were not widely published in English until the 1960s.

The misunderstanding between imitation and original was, however, very real. Victor Gollancz's bumptious memoirs give some clues

as to the atmosphere of this time, and the mutual incomprehension between the Stalinists and their British admirers. He insisted, understandably, that the British Communists of the 1930s were the 'salt of the earth', those rare people 'who loathed social conditions before the war, understood what Hitler was about, and [were] concerned to do something about it',[4] but he recalls with baffled horror a conversation in the aftermath of Willi Münzenberg's suspicious 1938 disappearance. The German Communist media mastermind had been called back from France to the Soviet Union during the Great Purge, but refused to go, fearing certain death; instead, he finally turned publicly against Stalin. Gollancz was told by the British Communist leader Harry Pollitt that in refusing to return, Münzenberg was a coward, and that *he* would have returned as requested – an idle boast, given that British Communist leaders were never important enough for Stalin to consider them worth killing (Münzenberg would be killed in France, likely by the NKVD, in any case). Reading this exchange, one gets the sense of two people on earth fervently discussing events on Mars.

If the Left Book Club was one way of translating the various ideas in German book publishing into English, another equally influential if less dramatic example was the other way around. One publishing innovation of late imperial Germany was the mass-market literary paperback. The Leipzig publishers Reclam had pioneered these in the late nineteenth century, beginning with a paperback of Goethe's *Faust*; by the 1910s, mass-market literary paperbacks were so popular that the publisher commissioned the early modernist architect Peter Behrens to design a vending machine for Reclam paperbacks. Growing out of these were the Leipzig-based Tauchnitz Editions, based on the inapplicability of British copyright law in Germany. By the 1920s, Tauchnitz had filled train-station bookshops across Europe with ugly, flimsy but exceptionally cheap editions of contemporary British writers – who were, much more than British artists, great innovators of the time, and very popular abroad, ranging from the utopias and dystopias of H. G. Wells to the bourgeois realism of John Galsworthy. These were read both by English and American travellers, and by locals who were learning what was then rapidly replacing French as the global lingua franca. At the start of the 1930s, three aspiring publishers in the historically anglophile port metropolis of Hamburg spotted an opportunity. The Tauchnitz editor and creator of the Insel-Bücherei series, Max Christian Wegner, the

publisher Kurt Enoch, and the editor Johann Hermann Reiss – raised in the arts-and-crafts Garden City of Hellerau outside of Dresden but schooled in Britain where he renamed himself John Holroyd-Reece – founded a publisher called Albatross. Its remit was much the same as Tauchnitz – cheap English-language paperbacks that were 'Not To Be Introduced Into the British Empire' – but in terms of design, Albatross looked dramatically different.

Tauchnitz books were wilfully cheap-looking – white paperbacks with thin paper, their spines easily broken, and their covers little more than frontispieces, they appeared to suggest that, with books, you would *get what you paid for*. At Albatross, Enoch, Wegner and Holroyd-Reece realized that the key to annexing Tauchnitz's market was design.[5] They came up with a plan to colour-code all their paperbacks – green for travel, red for crime, orange for short stories, yellow for serious novels and essays – and commissioned Hans Mardersteig to come up with an overall aesthetic. Mardersteig's covers combined the qualities of modernist graphics – clear sans serifs, bright colours, space – and of classicism, with the titles centred within a formal border. At the bottom was the logo: a stylized black and white albatross. The book size was also unusual. It used the golden section, with dimensions of 181 x 112 mm; irrespective of its alleged perfection of proportion, it was perfect for fitting in the pocket, with any hints of nineteenth-century heaviness or pomposity banished.

As for the content, the Albatross Modern Continental Library, as it described itself, went (like Tauchnitz before it) for a canny mix of populism and modernism. The first range of books, published in January 1932, included James Joyce's *Dubliners*, Sinclair Lewis's *Mantrap* and Aldous Huxley's *The Gioconda Smile*, along with a novel by the now-forgotten popular novelist Warwick Deeping. Very surprisingly, Albatross managed to keep this up beyond the Nazi seizure of power in 1933. Of the founders, Enoch was observantly Jewish, while Holroyd-Reece was both a British citizen and part-Jewish; at its inception, Tauchnitz had launched a campaign against Albatross as being 'un-German'. The Third Reich gradually forced out Enoch (who fled to France and then the United States) and Holroyd-Reece (who went to France and then back to Britain), and corralled Albatross into a merger with Tauchnitz. But the publishing project continued, and the planned programme of publishing cheap editions of major British and American

High Design goes Abroad: one of Hans Mardersteig's Albatross covers.

modernist writers was largely fulfilled, with Albatross publishing beautifully designed cheap editions of D. H. Lawrence and Virginia Woolf, books unpublishable in Britain such as *Lady Chatterley's Lover* and *Ulysses* (both within plain white covers), and books otherwise unpublishable in Nazi Germany, by Sinclair Lewis and Aldous Huxley (both of whom Albatross was forced to censor, not for sex but for politics). This apparent paradox is owed largely to the Nazi regime's need for foreign currency, a large amount of which Albatross was bringing into Germany. But their achievement in the last years of the Weimar Republic was clear enough. Albatross Books were fast, modern, bright, urban, a million miles away from both the flimsiness of Tauchnitz or the William Morris-influenced mass-market hardbacks of Everyman. They were the first real mass-market modernist paperbacks anywhere in the world, putting what was once considered rarefied and incomprehensible in anyone's pocket for just a few Pfennigs.

Penguin, from its founding in 1935 onwards, was, at first, some sort

of fusion of Everyman, Albatross and the Left Book Club. It was a more conventional business than the Club, and a more genuinely 'British' proposal than Albatross, with a greater modern approach to the out-of-copyright classics than J. M. Dent's little hardbacks, though its most influential editor was an intellectual (and later, politician) of the Indian nationalist left, V. K. Krishna Menon. Penguin's interest in the Left Book Club might seem surprising, given that it was, irrespective of Allen Lane's vague social-democratic sympathies, a normal capitalist business, and one that made its living from crime stories and popular novels – as did Gollancz – but this affinity was very much present. One of Penguin's major innovations, the Penguin (and, briefly, Pelican) Specials, which ran from 1938 onwards, were a response to the way that the LBC had supercharged political debate through books, eliciting both a brief anti-communist Social Democratic Book Club from the Labour right and a fascist-sympathizing, pro-appeasement Right Book Club centred around Foyles Bookshop in Charing Cross Road – something satirized by the *Daily Mirror* cartoonist David Low, through a sketch of book clubs in pitched battle. Penguin Specials intervened in this through volumes that, like those of the LBC, were frequently based on trying to open the readers' eyes to what was happening in Central Europe; the books were usually, if not exclusively, written by émigrés, sometimes under pseudonyms. These cheap paperbacks included, as we've seen, Stefan Lorant's *I Was Hitler's Prisoner*, and an exposé of Nazi terror, Edgar Mowrer's *Germany Turns the Clock Back*; two volumes criticizing the selling out of Czechoslovakia in the Munich Agreement, *Europe and the Czechs* by Sheila Grant Duff and *They Betrayed Czechoslovakia* by the pseudonymous 'G. J. George'; Konrad Heiden's critical biography of Hitler, *One Man Against Europe*; a dictionary of world politics by the Czech scientist and economist Walter Theimer; and the dissident socialist Franz Borkenau's study of *The New German Empire*.[6] Alongside these were books on refugees and internment, which aimed to combat the widespread xenophobia towards German-Jewish migrants then being fanned by the popular press.

Unlike the Left Book Club, Penguin combined this with cultural specials on what in politics gets called 'hinterland', through the Pelican Specials on Design, Music, Ballet, Film, and, as we've already encountered, Photography. Again, most of them extensively showcased continental achievements – there was even a specialized volume on *Modern German*

Art, to counter both the 'Degenerate Art' exhibition in Munich and the British ignorance of the subject, a book we will return to. Not only were these an emulation of the Left Book Club's themes and successes, the Specials were distributed at meetings of the Club, with its tens of thousands of enthusiastic members a targeted market. But unlike the LBC, Penguin were keen to keep a certain plausible deniability on their (non-communist, but clearly centre-left and anti-fascist) politics. Accordingly, the Specials included a single book taking the opposing line, *Germany and Ourselves*, advocating not mere appeasement but an alliance between Britain and Nazi Germany, written by the right-wing peer the Marquess of Londonderry.

The Penguin Specials were, however, just one part of the increasingly extensive publishing empire Allen Lane was building. The main bulk of Penguin's output was patently inspired by Albatross. If, as Penguin's later designer and typographer Hans Schmoller put it, 'it is not in dispute that the publication by Allen Lane of the first ten Penguins in 1935 was the event to which virtually all paperback developments in the western world ... can be traced', that was, he wrote, only possible through their 'parricide' of Albatross.[7] Lane borrowed from Enoch, Wegner and Holroyd-Reece the colour-coding (in Penguin's case, green for crime, orange for fiction, red for travel, and blue for the non-fiction Pelicans), the golden-section book size, the centred, sans-serif cover design, and of course the bird. Rumour had it that in Lane's office at The Bodley Head, editors sat around trying to come up with an appropriate bird to emulate Albatross, before somebody said 'What about a Penguin?' Holroyd-Reece later claimed that Lane had 'adopted the Penguin format as a result of a detailed discussion with me before he founded the company'.[8] He considered the plagiarism to be fair game, as they drew on the same distant source: both the Albatross and Penguin paperbacks, with their golden-section proportions, were stolen from Leonardo da Vinci's notes on the ideal book size, albeit as first applied to the common paperback by Hans Mardersteig at the Hamburg publisher. And borrowing an idea from Reclam, you could for a time buy Penguins in vending machines – 'Penguincubators' – placed in selected Woolworths stores in the second half of the 1930s until the cost of repairs brought the practice to an end.

But compared with Albatross, Penguins could be a little gawky. The basic three-colour tripartite design – white and black, with the coded

colour, the title centred in Gill Sans, and the Penguin or Pelican at the bottom – had been quickly worked up by Edward Young, the new firm's Production Manager, who was not a trained designer, and it showed. The early Penguins and Pelicans now look charming enough – a canny amateur's successful attempt to copy Albatross without making it too obvious – but looking at a selection of 1930s Penguins you will find a lot of sloppy design, with the letters bunched clumsily together, symmetrical layouts that slope uneasily towards the edges of the page, messy typography inside the books, and an incoherent selection of performing birds; something exacerbated between 1939 and 1945 by the wartime economies on books. Allen Lane decided at the end of the war to do something about this, and so hired a German designer and typographer, famous even then: Jan Tschichold.

By the time he had been hired by Penguin, Jan Tschichold was based in Switzerland, and had built up a reputation as one of the finest, most delicate practitioners of 'reformed traditionalism', working on various Swiss editions of the classics in a manner close to the work of Stanley Morison or Hans Mardersteig. But Tschichold was German, not Swiss; born in Leipzig in 1902, he grew up in a family who worked in the city's book-publishing industry – extensive and innovative, as we've seen. He worked in the early 1920s for Insel-Verlag but made his name as a typographer and designer first through violently rejecting the elegant, precise, classical-modernist values of the Insel-Bücherei or Albatross. Between the mid-1920s and mid-1930s, he was one of Germany's foremost Constructivist designers, working in a manner very close to that of Herbert Bayer, László Moholy-Nagy at the Bauhaus, or Aleksandr Rodchenko and El Lissitzky in Moscow; in fact, so besotted was Tschichold with the Soviet designers that for several years at the turn of the 1930s he actually signed his name 'Iwan Tschichold'. He was, unlike the majority of his contemporaries in Constructivism, a trained printer, and used this expertise in polemical books such as *The New Typography* and *Typographical Design*, which strongly advocated overthrowing the entire design heritage of the past, no matter how reformed and elegant.[9] Tschichold also went one step further than his colleagues in Berlin, Dessau and Moscow by trying to systematize the experiments of the avant-garde into a new orthodox approach to design and typography, which would supersede all others. Tschichold's Sovietophile tastes, his public support of the centre-left SPD, and his

commitment to a design ethos the Nazis saw as a form of 'Cultural Bolshevism', saw him imprisoned for six weeks by the Gestapo on the Nazi seizure of power in 1933. He fled to Switzerland, a country that was for the most part a cold house to Weimar cultural refugees, especially those on the left – he was lucky to have been accepted in the country and was able to settle there, perhaps at the cost of relative political quietude.[10] But as late as 1935, when he published *Typographische Gestaltung* in his Swiss refuge (translatable as *Typographical Design*, but published in English thirty years later as *Asymmetric Typography*), Tschichold was still writing as a fervent revolutionary.

Decades later, this book was still controversial. Its translator described it in 1967 as putting forward a 'a new and revolutionary approach', one that 'has not found much favour in England'.[11] Some measure of its effect on British designers in the 1940s and 1950s, a time when Tschichold's later style held sway across much of British publishing, can be read from W. E. Trevett's description of it as being 'among the campfires of typographers ... the great underground book of the century', with the writer's rejection of his own views still a baffling event, one that 'caused a turbulence among designers that is yet to settle. How *could* he? And how *could* he then do those classical solutions so maddeningly well?'[12] Skimming through the book, the scandal is clear enough. The illustrations are dominated by the works of Soviet Constructivism, with words, polygons and abstract shapes floating free in the designs of El Lissitzky, such as his cover for the journal *Veshch-Gegenstand-Objet*, or his layout of Mayakovsky's *For the Voice*. There is also a great stridency in the rhetoric.

Early on, Tschichold identifies his enemy, by illustrating a 1922 newspaper page of German advertisements with various eclectic, often hand-drawn-looking typefaces – Expressionistic, Gothic, late Arts and Crafts, cinematic, kitsch. 'Disgust with such degenerate type faces and arrangements led the author to attempt to eradicate them entirely.'[13] He attacks the ideas and the neo-medieval typography of William Morris as a 'shirking of reality', based on a 'battle against the comparatively harmless machines of his own day', which 'was lost from the start'.[14] Rather than fighting it, the machine and its possibilities should be embraced – even the hand compositor 'can now and again learn from the machine'.[15] Tschichold also frequently compares the project of the New Typography to that of modern painting and modern architecture; his project is one of 'freeing typography from ornament', on the precedent of art forms

that made 'rhythms and proportions' their point of reference rather than decoration or association.[16] In the 'disgusting' typographical chaos of his page of advertisements, he finds that the fixation with effect and ornament resembles the way in which, in the pompous imperial buildings of the late nineteenth and early twentieth century, 'the rooms behind were highly impractical and had to be arranged to fit the facade'.[17] The appeal of the New Typography, like that of abstract painting, was the way in which it acknowledged the reality of its art form and refused fantasy. It was strictly two-dimensional, flat – print on a page that was pretending to be nothing else; Tschichold reserved particular vitriol for 'three-dimensional' shading in typefaces. Type was an industrial art, a form of engineering: in both typography and the new abstract modern art and architecture, 'the artist must first make a scientific study of his available materials and then, using contrast, forge them into an entity'.[18]

Looked at more closely, however, and this manifesto reveals its continuities with the Neo-Renaissance design culture of the Officina Bodoni or the Insel-Bücherei. On the first page of the book, Tschichold cites the Czech Constructivist critic Karel Teige, but to endorse his argument that the typefaces of the Renaissance were more useful to modernists than those of William Morris. Tschichold praises the work of Stanley Morison and recommends the use of Gill Sans. His quarrel with British designers was more a matter of their conservative layouts than their elegant typefaces; 'England,' he writes, 'is no bad example.'[19] In 1967, Tschichold added a modest footnote to one of his denunciations of centring, where he noted that 'the harsh rejection of the previous style [is] a condition for the creation of a new one'[20] – and here, he clearly believed that the modernized classicism he had then achieved was precisely that new style, freed of the excesses and childishness of its first years. But within that earlier book is a constant insistence upon order, decency, morality, and the need for an attempt to create a series of rules and guidelines for the New Typography, so that any printer could do it. In the process, Tschichold was taking a fairly wild movement, a deliberately disruptive avant-garde based upon experiment and shock, and trying to transform it into a logical system. The typographer Herbert Spencer described this project as being of necessity an anti-avant-garde one that 'if it had succeeded would have done much to vitiate' avant-garde design, 'and to diminish its essential vitality and flexibility'.[21]

You can see some of the effects this created in Tschichold's most modernist designs. His covers at the turn of the 1930s were strictly Constructivist – for a travel book by the Anglo-German writer and photographer Colin Ross, he uses an arrangement of floating shapes and tilted sans-serif text, as punchy as a poster, as abstract as a Malevich painting. His layout for Erich Grisar's *Neue Sachlichkeit* photobook, *Through Europe with Camera and Typewriter* (1932), is a good example of how this played out inside the covers. This was a critical travelogue by a Social Democrat and worker-photographer that was soon banned by the Nazis, published by *Der Bücherkreis* ('The Book Circle'), a socialist book club which was one of the Left Book Club's Weimar inspirations. Looked at casually, this photobook is in some ways close to Lissitzky or the Bauhaus, with its asymmetry, sans serifs and spaciousness, but look closely at it and you will see that an obsessive sense of order has been marshalled to create layouts that are, paradoxically, exceptionally relaxing to look at, limpid rather than strident, restful rather than

A cover from Jan Tschichold's modernist years, before the road to Damascus.

revolutionary. The design does not draw undue attention to itself, letting Grisar's alternately panoramic and bitter street photography take centre stage. It is this strange combination of vehemence and grace that marked out Tschichold's work. It is something that looks simple, but involves an extraordinary amount of labour – including of compositors and printers – to get exactly right. Many years later, Tschichold would argue that 'in its inaccessibility', typography 'resembles great music',[22] and the comparisons that have been made between his work and his fellow Leipzig man J. S. Bach are not facetious: order, space and harmony are the guiding principles of this work, modernist or otherwise.

It was because of this radical work in Germany that Jan Tschichold was first hired to work in Britain, in 1935, in which capacity he designed letterheads for the Bradford publishers Lund Humphries, and an issue of the British advertising journal *The Penrose Annual*. A decade later, however, and Tschichold had rejected nearly everything about modernist design but for its precision, use of blank space and its sans serifs (but now for titles only). In 1946 he explained this shift in his work as follows:

> It seems to me no coincidence that this typography was almost wholly a German creation, little welcomed in other countries. Its impatient attitude stems from the German preference for the absolute ... I saw this only later, however, in democratic Switzerland. Since then I have ceased to promote the New Typography.

Tschichold argued that the Nazis had practised an ideological 'deception', where their medieval rhetoric was based upon the deployment of the most advanced technology. This meant that they 'could not abide the honest modernists who were its political opponents. But they themselves, without knowing it, stood very close to the mania for "order" that ruled in the Third Reich.'[23] This is a little rich: there was no greater obsessive for order and the absolute in typography than Tschichold, and his shift away from hard-line modernism certainly didn't mean a relaxation of ideological fervour. It also paralleled a change within Tschichold's old imaginary homeland, the Soviet Union. Over the course of the 1930s, Soviet graphic design had stiffened and become increasingly classicized, increasingly florid, just as it had in Nazi Germany. A comparison of the asymmetric, dynamic covers of the Soviet magazine

Contemporary Architecture with the centred serifs of its Stalinist successor, *Architecture USSR*, shows a shift which actually parallels that of Tschichold himself, though it is done with considerably less style.

Comparing *Asymmetric Typography* to a compendium of Tschichold's post-conversion essays, *The Form of the Book: Essays on the Morality of Good Design*, reveals the clearest continuities; namely, that here was a typographer who was not taking any hostages. In 'Clay in a Potter's Hand' (1948), Tschichold declares that 'many of today's readers have grown used to poor typography because they read more newspapers than books and thus *kill time*, as it is so succinctly termed'.[24] He insists that 'good typography can never be humorous'.[25] He demands, in 'Graphic Arts and Book Design' (1955) that 'book artists have to slough off their own personality completely'.[26] He allows for personality in book jackets, but only because they are a lesser form: 'the jacket is first and foremost a small poster, an eye-catcher, where much is allowed that would be unseemly within the pages of the book itself'; but 'as a rule, book jackets belong in the waste paper basket, like empty cigarette packages'.[27] He begins an essay on the apparently routine subject of 'Typesetting Superscript Numbers and Footnotes' (1975) with the sentence: 'To begin with, let us enumerate what is repulsive and therefore wrong'.[28] In 'Ten Common Mistakes in the Production of Books' (1975), Tschichold denounces white paper as 'highly unpleasant for the eyes and an offence against the health of the population'.[29] It easy to imagine that such a figure would have a hard time in the empiricist, sloppy world of British publishing, and so it proved.

Upon taking over the design of Penguins, Tschichold asked Allen Lane for copies of everything the firm had printed up to that point, and his influence on what followed was to be equally total. During the period from 1947 to 1949 in which Tschichold lived in London, he was handling as much as a book a day for Penguin, and again, a very casual glance at the average Penguin book before and after his work there would reveal superficial continuities. He redrew the Penguin (Tschichold considered Edward Young's ungainly graphic of the bird to be 'deformed') and changed the lettering on the Penguin logo – and that would seem to be that, at first glance. But look again and you'll notice a quantum leap in elegance. In two randomly chosen examples from the 1930s and the late 1940s, the first cover shows the Gill Sans letters randomly cluttered, the different lines unevenly spaced, the text poorly centred. In

Graham Greene in Penguins, before and after Tschichold.

the second, all this clumsiness is gone, and that Bach-like quality of harmonic perfection has been achieved, via extraordinarily simple means: the command from Tschichold to the compositors that 'capitals must be letterspaced'.

It is clear that Tschichold took the Penguin job – well paid as it was – largely because it fulfilled a hope he had sustained through the Weimar and Swiss years, that he could one day work in real mass production.[30] Penguin were perfect for this, both because they were on some measures the largest paperback publishers on earth at that point (which they remain today), and also because they combined this with a high-mindedness about both form and content, boasting what Tschichold's friend, the American typographer Beatrice Warde, called a 'rather severe simplicity which in this machine age often ironically characterises the better-class commercial article from the kind of rose-garlanded, bead-trimmed object that the "public" of the bargain basement is supposed to prefer'.[31] Translated to the specifics of the job in hand, this meant that Penguin's designs were a way of making cheap things look good,

maintaining a standard that could not be sneered at. Ethics was one thing, though, and precision was quite another; and Penguin's mass production was far from the seamless Fordist assembly line that Tschichold might have been led to expect.

Tschichold's time at Penguin began with bitter conflicts over his *Penguin Composition Rules*, a set of guidelines that every compositor working on a Penguin Book had to follow. This was a more complicated matter than a contemporary reader might imagine, at a time when books are laid out on computer and printed through extensive use of automation. As any Londoner of a certain age knows, 'the print' was a world unto itself, a working-class employer that had its own rules. At the time Tschichold was working there, Penguin did not own a printworks, and achieved its large print runs through contracting out to a huge quantity of printers across the country, each of whom would take liberties of varying scales with Edward Young's standard design depending on the whims and skills of each firm, not to mention how much factory work was able to cope with deadlines. Printing was not, paradoxically enough, a profession that lent itself to standardization. In a 1950 lecture, 'My Reform of Penguin Books', Tschichold related that the machine workers in the printshops were not bothered by his reforms, but that with the compositors, the most skilled men in the factory, he 'came up against a stone wall'.[32] Tschichold was very surprised to find that 'the differences between the best English printing (e.g. Oliver Simon at the Curwen Press) and the average is very great – far greater than in Switzerland or the USA', something he put down to a poor standard of technical education: 'while I was in England, I learned to appreciate the value of our own Further Education Courses and Trade Training Schemes in Switzerland'.[33] He was shocked to find that compositors seemed, above all else, *uninterested in their work* – printing was a job, like any other. With some pride, Tschichold declared that 'along came a man who not only wanted everything changed, but also, in this most conservative of countries, produced an entirely new set of typographical rules!'[34] Still a revolutionary, after all.

This was clearly not a happy experience. Tschichold would again and again have to destroy dummy copies made by compositors, forcing them into the – relatively laborious – consistent letterspacing of capitals, something that involved manually spacing out each letter rather than letting the machine do it for them. This meant that the look of mass production

involved intensified hand labour on the part of the unwilling compositors. Tschichold's assistant at Penguin, the Danish typographer Erik Ellergard Frederiksen, remembered later that 'if printers did not do their work properly he would shout *"Whom do they think I am? I am not somebody so-and-so, I am Jan Tschichold!"* '[35] – though, when challenged, rather than shouting at the printers, he would smile and pretend not to be able to speak English.[36] Frederiksen ruefully suggested that Tschichold's stay in London 'would have been happier had he only tried to understand better the especial way of living, so contrary to strict German attitudes'.[37] But the fact is, as the comparison above of the pre- and post-Tschichold covers makes clear, the experiment worked. After he had imposed his will on the compositors, Penguin Books all maintained this level of quality, right up until the 1980s. This is partly because the Rules, once they were fully understood, were, while strict, not particularly complicated: the centring that Tschichold had derived from Edward Young's imitations of Hans Mardersteig was 'comparatively simple, and even the inexperienced compositor without intelligent guidance cannot commit grave faults there'.[38] After 1949, Tschichold's hand-picked successor, Hans Schmoller, a less authoritarian but equally obsessive figure, was able to enforce the maintenance of these qualities of order and space.

In his last year at Penguin, Tschichold managed to make some more radical changes. He transformed King Penguin from a slightly inept imitation of the Insel-Bücherei into a series of a similar level of consistent quality; designed a new vertical layout for Pelicans that would be developed impressively under Schmoller's tenure; and he took the new Penguin Classics in hand, transforming their gawky neoclassicism into a design of peerless clarity, simply through shifting the roundel image for each 'classic' from the bottom of the page into the centre, evenly letterspacing the capitals, and introducing a Mardersteig-style border to the overall design. For Tschichold, this was one of the projects of which he was most proud. In a 1947 essay 'On Mass Producing the Classics', he contrasts the appalling state of the world with the utopian project of putting these books in reach of any English reader. 'I find it consoling,' he wrote, 'in these days when civilisation appears to be tottering, to think that the great tradition of European book-printing has been revived'; and 'where could such qualities be more desirable than in the work of passing on the wisdom of the great poets and thinkers by means of books available to Everyman?'[39]

Tschichold's legacy in paperback publishing in Britain is perhaps more extensive than in Germany or Switzerland, due to the way in which his reforms were doggedly carried through over several decades by Penguin and other firms. Even in the 1980s and 1990s, when much of this legacy lay in ruins, Penguin redesigned the Classics using Sabon, one of Tschichold's late typefaces. Most important was the way in which an entire host of émigrés from the late 1940s onwards, under first Tschichold and then Schmoller, used paperbacks as their canvases, bringing about an accessible proliferation of modernist design that went beyond anything achieved during the Weimar Republic.

14
No Bosoms No Bottoms, No Brashness No Vulgarity

One way of understanding these books is to look at what they were not. Paperbacks have a dual parentage – Penguin and Pelican's high-minded, slightly Weimar-inflected high-design selection of the best fiction, non-fiction and classics (and, of course, a large crime list), and the 'pulp' paperbacks of the United States. These latter were disdained by Allen Lane as 'breast sellers': vulgar, ugly and pornographic books catering to the lower human instincts, used to flog the lurid, sometimes outright fascistic sadism of authors like Mickey Spillane. For a time, however, Penguin tried to get into the pulp market in the USA, and got their fingers badly burned. In a collaboration with the American publisher Ian Ballantine, a separate Penguin Books USA was set up during the war; it was believed that the much larger market (and the much greater availability of paper than in rationing-era Britain) might help sustain a company which, with its large print runs, constant expansion, and ambitious ventures and sub-lines, was financially always somewhat precarious. The person who Allen Lane and Ballantine put in charge of the new Penguin Books USA was, ironically enough, Kurt Enoch, one of the three men behind the Albatross Modern Continental Library, which was then in the process of collapsing, its existence as a German publisher of progressive English writing made all but impossible by the war.

Enoch and Ballantine believed there was simply no prospect of the Mardersteig-Tschichold style of minimalist, precise design succeeding in the American market. Rather than being bought in separate sections in bookshops and newsagents, paperbacks in the United States were sold mostly through news stands, alongside the blare of the magazines and newspapers, and candy stores were as likely a place to be selling books as bookshops and train stations. At first, Enoch and Ballantine compromised, by commissioning full-colour covers for American Penguins and

Pelicans from Robert Jonas, a talented commercial artist. His images – whether the romantic tensions caught in the faintly surrealist illustration for Dorothy Baker's novel *Trio*, or the cover for a very New Deal volume on a compromise between socialism and capitalism, *Sweden: The Middle Way*, where an in-between political system is neatly outlined in the cover design, executed in the national yellow and blue – combined the geometric clarity of Constructivism with a bright and brash aesthetic that drew on the Works Progress Administration posters of the time. Even these images were clearly a little too high-minded for Penguin Books USA, though, and Jonas's covers started to become more lurid. The last straw for Allen Lane was an edition of Ludwig Lewishohn's novel *The Case of Mr Crump*, which was renamed *The Tyranny of Sex* for the American Penguin edition and given a cover featuring a badly drawn blonde woman in a state of partial undress. 'The cover of *The Tyranny of Sex* makes me sick, and I will be very glad indeed when our name stops being used for books of this nature,' Lane thundered.[1] He cancelled the project of what he now referred to as 'Porno Books', taking the financial hit.

In the aftermath, Kurt Enoch remodelled the publisher into the New American Library (NAL), divided between Signet, with the same remit as Penguin, and Mentor, with the same remit as Pelican. The name of the former was his little joke; as the paperback historian Paula Rabinowitz points out, given that 'birds were forbidden (Penguin had a lock), the clever founders of NAL hit on Signet as a sly allusion to that ugly duckling'.[2] Quite how ugly that duckling was can be seen by one of Signet's early bestsellers, the first American paperback edition of George Orwell's *Nineteen Eighty-Four*.

It won't quite do to see this wholly as a matter of English prudishness and American licence. A few years later, Lane would risk possible bankruptcy by publishing *Lady Chatterley's Lover* in paperback, and then fighting for it in the courts as a matter of principle rather than profit – though the offending paperback was in a simple cover produced under Hans Schmoller's direction, with a stylized image of a Phoenix and no human body parts in sight. It was a matter of ethics, and of not patronizing the reader by assuming the only way you could make them pay attention was by aiming your appeal at the loins rather than the head. In most other respects, though, Enoch's New American Library was basically the same project, in terms of making knowledge and art easily accessible to working-class and lower-middle-class readers, and over

the decades Signet and Mentor would publish similar books to Penguin and Pelican. They were rather less ambitious – markedly more right-wing and aligned with McCarthyism – while Penguin continued to be broadly on the left, especially under the 1960s editorship of the socialist bookseller Tony Godwin. But it was nonetheless believed by the NAL that self-education had to be a matter of carrot and stick – come for the breasts and the leather, stay for the political allegory. So Signet's *Nineteen Eighty-Four* is an image of science-fiction sex horror, all fetishistic Anti-Sex League uniforms, burly, square-jawed members of the Thought Police and the back-cover question 'Who will YOU be in the year 1984??' Compare this with, just a few years later, Penguin's first picture cover for the same novel. It was made by the Milanese designer Germano Facetti, who had done time in the Nazi concentration camp of Mauthausen. Encased in a Bauhaus-style grid was a photomontage of a tunnel spiralling upwards to one giant, glaring eyeball. It was equally horrifying and equally science-fictional, but vastly subtler and more

Pulp Totalitarianism/Abstract Totalitarianism.

powerful than NAL's pulp horror – a cerebral but highly immediate image of what it meant to live in a totalitarian system.

Schmoller, the designer of that *Lady Chatterley* cover, and Facetti, of that brutally effective but distinctly avant-garde *Nineteen Eighty-Four* cover, were the main drivers of Penguin's distinctive look after Tschichold's departure. Émigré designers were not the *only* important people at work on that look – almost as important in terms of imagery and design were English designers such as Derek Birdsall, Richard Hollis, Alan Spain and David Pelham, or the American Gerry Cinamon – but they were working within a framework and within rules set by continental émigrés, who dominated the style of these books right up until the 1970s. The most important if most self-effacing of these was Tschichold's successor at Penguin, Hans Schmoller, a man whose 'monument', as his colleague Gerry Cinamon asserted, 'is every bookshelf in the country'.[3] A Berliner, Schmoller was born in 1916 into a progressive, artistic Jewish family; his father was, as Cinamon recalled, 'a pioneer of infant welfare clinics in the city', his mother a designer of folded paper lampshades.[4] Schmoller had originally intended to become an art historian, but decided to become a typographer because the universities were closed to Jews after 1933. Apprenticed in 1934 to the Jewish book printers Siegfried Scholem after being turned down by Rudolf Koch, Schmoller emigrated in 1937, as he had won a place at Monotype's Technical School in London. Fearing he would not be allowed to settle in Britain, he applied for a vacancy at a missionary printworks in Basutoland (now Lesotho), the Morija Press. His work for Morija was delightful – a simple, classical and at times witty shoestring version of the Officina Bodoni – and it gained him some notice in Britain itself. Nonetheless, at the start of the war Schmoller was interned as an enemy alien; as the only one in Lesotho he was rather a special case. He was then imprisoned between June 1940 and April 1942 in a camp in Witwatersrand in South Africa, with the great Weimar housing architect Ernst May as a fellow internee. Around this time, both of Schmoller's parents were killed in Auschwitz.

After the war, Schmoller landed a job at Oliver Simon's Curwen Press in London, on the strength of having spotted a small typographical mistake, and from there he was noticed and then specifically named by Tschichold as his replacement, upon Tschichold's resignation from Penguin in 1949. Although he kept the *Penguin Composition Rules* firmly

One of Hans Schmoller's designs for the Morija Press.

in place and oversaw the internal layouts of every Penguin Book until 1976 according to those standards, Schmoller, unlike Tschichold, used pictures in his books extensively. He took over an experimental layout Tschichold had designed in 1948 but not used, changing the horizontal strips of the three-colour design into verticals, with a space in the middle for a monochrome image. These were kept simple – usually line drawings, extremely rarely photomontages or photographs – and the strictures resulted in some extraordinary images, such as Virgil Burnett's sketch of a dying man writing an entire bed of papers around himself for Samuel Beckett's *Malone Dies*. Some of the most interesting cover images were by émigré artists, and these show the breadth of what could be achieved in the small allocated box. There are curios such as the cover for *Three Men in a Boat*, by the Czech illustrator Dorrit Dekk (born Dorothy Fuhrmann in 1917, she had trained as a theatre designer with Max Reinhardt and emigrated in 1938), who sketched a curious Mitteleuropean version of a Home Counties cruise, with the

Thames in the foreground and an English country church in the background; and there are high-modernist icons such as Erwin Fabian's extraordinarily sinister cover for Kafka's *The Castle*. Fabian – who escaped from Nazi Germany to Britain in 1938 at the age of twenty-three, was deported to Australia in 1940, and fought in the Australian Army before settling back in Britain – rendered the titular fortress as a stylized, Expressionistic assemblage of abstract elements, as baffling, looming and impregnable as the castle that K constantly tries and fails to enter throughout the book.

It was also Schmoller who designed the first covers for Nikolaus Pevsner's series 'The Buildings of England'. Taking as their inspiration Tschichold's centred, formal new layout for the Penguin Classics, these covers laid out the series title above, the county in question in the middle (both in Eric Gill's delicate serif Perpetua), and borrowed the roundels from Tschichold's Classics design, here filling them with a detail from one of the buildings illustrated inside. Some of these features too were by émigré designers, with the roundels of *The Cities of London and Westminster* and *Somerset* designed by Berthold Wolpe (who we will encounter again soon). The other Central European designers who Schmoller would employ tended to share his 'reformed traditionalist' tastes. Among these was the talented Elizabeth Friedlander, a typographer and designer who had developed the font 'Elizabeth' for the Bauer foundry in Frankfurt. Friedlander took the helm for *The Penguin Scores*, which featured coloured patterns around a formally framed title for each musical score; and at Penguin Classics, where Tschichold's design was continued until the mid-1960s, Friedlander designed roundels for dozens of books, including the trireme in full sail for Penguin's bestseller at one time, *The Odyssey*, along with similarly stylized roundel logos like the dove for the *Acts of the Apostles*, the runes for *Njal's Saga*, and the Tsarist eagle for *War and Peace*.[5]

Probably the most enduringly beautiful of Schmoller's covers were for The Penguin Poets, where he dropped a rather florid Tschichold design in favour of a new layout, in which a wrap-around pattern was carried across the back, front and spine.[6] The design is strongly in the tradition of the Insel-Bücherei, which had been split after the war into two rival companies, respectively in West German Frankfurt and East German Leipzig. Anyone who has visited a second-hand bookshop in Leipzig, Dresden or Berlin will recognize the sight of a row of patterned

One of the first run of 'Pevsners', to Hans Schmoller's designs.

Insel-Bücherei covers as being remarkably similar to the effect of the row of Penguin Poets that you might find on the stall of a South Bank book market in London. The designers were aware of each other's work – in the 1980s, after Schmoller's death, the Leipzig Insel-Bücherei's designer Hans-Joachim Walch fondly recalled driving him around the cities and countryside of his native East Germany. It might seem that the cheaply made but exceptionally well-meaning and slightly stiff design common in East Germany and the design of mass-market paperbacks in an anglophone capitalist country would not seem particularly obvious comrades, but circa 1960 they were distinctly similar, as you can see by glancing at, say, the Insel edition of Hans Holbein's *The Dance of Death* and a typical Penguin Poets volume of the time like their *Baudelaire*.

The drawings and lithographs on Schmoller's covers could be dramatic, sinister, moving and surreal, but they remained monochromatic and severely tasteful. The West German designer Hermann Zapf remembered Schmoller himself as being, unlike Tschichold, able to see the

'shades of grey', and respecting 'other ideas and opinions', but he firmly 'disliked funny designs, unfunctional book typography, childish and eye-catching arrangements simply to attract attention, solutions influenced by advertising people';[7] an ethos summed up by one of the designers he contracted to work at Penguin, John Miles, as a deliberate refusal to compete with the pulps: 'above all, no trying to beat Pan at their own game: no brashness no vulgarity'.[8] Schmoller felt sad that staff never warmed to him – 'I've been here twenty years, and they never call me Hans,' he once told Gerry Cinamon[9] – but after his death, Penguin editors were firm about his importance. For Dieter Pevsner, who edited the Penguin Specials of the 1960s, Schmoller was crucial because 'he was a passionate believer in paperback publishing, and in Penguin in particular, because book design and mass publishing had, in his view, the same task – to bring clarity and joy to the largest possible number of people'. Or, as it was put more pithily by Judy Nairn, 'in the end, he *was* Penguins'.[10] Schmoller was a man of firm principles, and he absolutely refused to work on the covers for a paperback series by the inexplicably indulged P. G. Wodehouse, because of his wartime collaboration with Nazi Germany.

Schmoller was a modernist within limits. Although he didn't believe you could read a novel set in sans serifs (let alone one that was, as the Bauhaus once advocated, set entirely in lower case), he kept his Harmondsworth office furnished with Bauhaus chairs. Schmoller was aware he wasn't suited to introduce more strongly modern covers to his own design, particularly when Penguin decided to attempt a short colour series in order to compete on their own terms with the pulp publishers Corgi and, especially, Pan, who were starting to rival Penguin's previously unopposed position as Britain's major paperback publisher. Pan resolutely avoided any notion of good taste, but had their own instantly recognizable Penguin-style 'grid' – a bright yellow square containing the title of each book – and they had their own émigré designers, whose work made rather clear that having been educated in 1920s Berlin or Budapest did not necessarily make you a high-minded modernist. Among their most prolific designers was the Hungarian illustrator and children's book author Val Biro, whose work for Pan is relatively tasteful, and the German Jewish commercial painter Rudolf Michael Sachs, who emigrated to Britain in the late 1930s. Sachs signed his extensive work for Pan as 'Sax', and worked in the straightforward pulp-fiction tradition of dames and guns, painted with lurid aplomb.[11]

[Cover image: PAN-Books — THE CONSUL AT SUNSET, Gerald Hanley]

Sax and Violence: an émigré designer at Pan.

As a way of heading off all this without compromising Penguin's design values, in 1956 Schmoller hired the British designer Abram Games, as part of an attempt to convince Allen Lane – even more hostile to brash covers than he had been before the failed experiment of Penguin Books USA – that colour covers could be done without 'bosoms and bottoms'.[12] Games's covers were laid out in sans-serif capitals, with the colour coding indicated by a new version of the Penguin logo, and each cover was in full colour, with most of them given over to photomontages or paintings, by Games himself (who sneaked some quite voluptuous bosoms and bottoms into his covers for Gabriel Chevallier's *Clochemerle* novels) and a variety of freelance artists. Among these was Erwin Fabian, who designed another eerie montage for the crime novel *The Case of the Baited Hook* by Erle Stanley Gardner; and several more featured illustrations by Hans Unger, another German-Jewish Berliner. Unger had been taught graphic design in Berlin under the commercial artist Jupp Wiertz before escaping Nazi Germany in 1936, bound first,

like Schmoller, for South Africa. During the war, Unger became a decorated war hero for escaping from an Italian POW camp. He was based in London from 1944, but frequently travelled in Africa and Asia, and as Naomi Games recalled, 'around this time, he developed an interest in stained glass and mosaics, employing these techniques in his poster work' (with Eberhard Schulze, he designed tiled murals for Oxford Circus and Green Park tube stations, and for the Penguin Offices in Harmondsworth, West London).[13] As an adventurer himself, Unger was an obvious choice for the Expressionist heat-haze image of the mountains of Malawi that decorates Laurens van der Post's *Venture to the Interior*.

But the full-colour covers project was cancelled in 1958, and nothing similar was tried for another few years. There were also parts of the Penguin empire where the Tschichold-Schmoller approach was simply inappropriate. One of these was the Penguin Specials, where the loud, telegraphed typographical covers of Edward Young lost a great deal in being rationalized and quietened down by Tschichold; the series wouldn't revive until the 1960s, when it returned with a new design by Germano Facetti and a more politically radical editorship under Dieter Pevsner, Nikolaus's son. Similarly, the children's novels, stories and picture-books of Puffin suffered from being made more polite. The books had thrived just before the advent of Tschichold, and were the brainchild of the editor Noel Carrington, who was inspired, as a Penguin historian relates, by 'the example of educational Russian titles shown to him by the artist Pearl Binder'.[14] The early books, which were essentially illustrated booklets, followed the precedent of Soviet children's authors such as Samuil Marshak by telling the stories of everyday things and technologies – railways, ships, houses, and so on. Some of these picture-books were by émigré artists, such as a series on 'The Giant Alexander' by the Polish duo of Jan Le Witt and George Him; a colourful 'Brer Rabbit' series illustrated by Walter Trier; and most tellingly, *The Story of Furniture*, a lovely volume co-written by the designer of Utility Furniture, Gordon Russell, and the Czech modernist architect Jacques Groag. Puffins became duller and more conservative in the 1950s, with a few exceptions (such as a fabulous neo-medieval cut-out cover by none other than Lotte Reiniger for Roger Lancelyn Green's retelling of the Arthurian legends). They were revived in the 1960s under the control of the former *Lilliput* editor Kaye Webb, who

drew on her time at Stefan Lorant's Surrealist creation to make Puffin into something more fittingly anarchic.

Another place where 'reformed traditionalism' didn't quite work was the modern classics, especially given that as the 1950s continued, hard-line modernist design became much more common in public life than it had been in the 1930s, without Penguin keeping up. This time, modernism entered Britain via the United States, then being aesthetically colonized by Bauhaus designers like Herbert Bayer and Mies van der Rohe; via Switzerland, which had dramatically moved on from Tschichold's chastened classicism to develop high-modernist fonts such as Helvetica; and via the high style of the Italian 'economic miracle', showcased by *Domus* or *Casabella* magazine, and the industrial design of companies ranging from Olivetti to Vespa. So at Penguin, Allen Lane and the new editor Tony Godwin hired Germano Facetti as art director, and he proceeded to overturn much of what Tschichold and Schmoller had achieved in compromising between the modern and the classical. Facetti was a modernist and had no compunction about it. Although Milan is fairly close to Central Europe not only geographically but also in its architecture and temperament, and Facetti's traumatic war as an anti-fascist partisan and concentration-camp prisoner was very close to the experiences shared by many of the subjects of this book, he is obviously outside of our remit, but for one fact. The design that Facetti settled upon as the model for the entire Penguin line to follow was produced by a Polish Jewish refugee, Romek Marber.

Marber was born in 1925 in Turek, Central Poland, and was deported as a teenager from Warsaw to the ghetto of Bochnia, near Kraków, when the Nazis invaded the country. He very narrowly avoided being sent to the extermination camp of Belzec by the manager of the forced-labour factory where he worked, though he would later be deported to Auschwitz, which he survived. Marber, now an adult who had spent his entire adolescence in ghettos or concentration camps, left Poland in 1946 for London, to which his father and brother had escaped. Every other member of his family had been killed in Belzec. Marber, who lived to the age of ninety-four, and eventually told this story in a memoir, *No Return*, learned graphic design in London, not in Warsaw. He studied at London County Council's St Martin's College, then a technical school on Charing Cross Road, and, unsurprisingly, remembered 1950s Britain as relatively bright and optimistic, particularly for the way in which

design would erupt into the austerity cityscape, as in Abram Games's posters. To get to St Martin's, Marber recalled in the 2000s:

> I travelled by underground to Tottenham Court Road station. Emerging from the train, confronting me were beautifully executed and amusing large landscape posters for *The Times*, *The Financial Times*, and for Guinness, signed 'Games'. My face would light up in a smile, for an aspiring graphic designer this was a good start to the day.[15]

By the 1960s, Marber was a freelance designer, including for *The Economist*, and it was from there he was noticed and hired by Facetti for Penguin.

In 1962, Marber was one of several designers selected for another experiment, a new common cover for the Penguin Crime series, which was still then published in Tschichold's version of the 1930s design, and hence looked increasingly dated (design not being *entirely* timeless). Marber's solution was a strict grid, based – like Mardersteig's book dimensions, still used for all Penguin paperbacks – on the golden section, but with any Renaissance references left there. This was much more pure modernism, with a stark sans serif (Akzidenz Grotesk, known to British printers as Standard) and a grid that could be seen to be a grid. Initially, most of the illustrations in the large space left in the grid for these were by Marber himself. He would reject the idea that his design owed much to his appalling experiences, and was irritated at being commissioned to design various covers for books linked to the English language, pondering whether this was 'because of a theory that "others see you as you don't see yourself" ... I am not convinced this is true.'[16] But the covers are, appropriately for the subject matter of a crime series, exceptionally sinister; the images are often distorted, rough and almost punkish.

There is also a dark humour to them, with each Dorothy L. Sayers cover, for instance, featuring a little white stick-man encountering the mishaps described in the novels. The way in which these images mix drawing, photomontage and image manipulation derived from Marber's unpretentious approach to design, with work being made at the designer's home (he was always a freelancer), by hand, rather than in a design studio. The roughness of his work is part of what makes it feel very distinctively 1960s; although Marber did not return to Poland until the 2000s, his covers share

Grids and Swastikas: Romek Marber's new look for Penguins.

the disruptive, paradoxical neo-Dada character of contemporary designers in Poland itself, such as Jan Lenica or Roman Cieślewicz, who made extensive use of photomontage in their celebrated film posters. This was in some ways an accidental product of British backwardness. 'At St Martin's,' Marber remembered in 2007, 'drawing prevailed; image-making and lettering were seen to be important and the ideals of the "craft movement" held sway. Design which was not created with one's hands was tainted as inferior and the Bauhaus was seen to belong to Central Europe.'[17] Out of these limits, Marber created work that looked not back to the Arts and Crafts movement, but towards the future. The Marber Grid has been frequently referenced and acknowledged in recent years, with versions of it used knowingly by the record label Ghost Box and publishers Dostoevsky Wannabe; still now, it immediately evokes that distinct fusion of hard-line modernism and the home-made.

Facetti used his position at Penguin to force most of Penguin's lists into the Marber Grid – into the orange fiction covers, in the series of

handbooks on cookery and sport, and into Pelicans. The famous Pelican aesthetic in the era of the New Universities and the Open University – abstract, Brutalist and enigmatic – comes from their use of Marber's design. The fun that illustrators had with it can be seen, for instance, in the stylized bureaucratic heads floating in empty space in Erwin Fabian's design for William Whyte's *The Organization Man*, or in Hans Unger's wonderful design for a rare Pelican fiction title, the sociologist Michael Young's dystopia, *The Rise of the Meritocracy*, where a smug abstracted meritocrat smirks out from above layers of a new class society; while émigré designers like F. H. K. Henrion and Hans 'Zero' Schleger would develop new designs along Marber's lines for Penguin Science and Penguin Education. For Penguin Classics, Facetti came up with his own centred design in black, using Helvetica, but he forced the new Penguin Modern Classics into the Marber grid, against the advice of Schmoller. The Berlin typographer resented Facetti's appointment, privately describing him as a 'failed architect', and more importantly noted, correctly, that his innovations destroyed the hitherto perfect unity between the cover and the book inside.[18] But Schmoller's own fairly charming design for the Modern Classics, using Eric Gill's serif Joanna, was staid compared with the Marber grid. It was unsurprising that Facetti won the argument; he also replaced the commissioned artworks favoured by Schmoller with paintings or sculptures taken from the period of each book. In some cases, however, Schmoller could still get his way: when Penguin published the first paperback edition (since the Albatross, in any case) of *Ulysses*, Schmoller insisted on using his own serif typographic design for the cover, a design with a power and simplicity that suited the book much more than trying to convey its teeming energy with a single image.[19]

As this generation aged, Penguin's most interesting covers were being produced by a younger group of British designers who had grown up on stylish paperbacks, and by the 1970s there were more examples of this to choose from than just Penguin – though here, too, the designers had often been raised and trained in Central Europe. In the 1950s, a much freer style than Penguin's strict spaces and grids could have been found in the dust jackets of Jonathan Cape, in the riotous, scrawly style of the designer Hans Tisdall. Something of a polymath, Tisdall, who combined designing with painting, public murals and mosaics and textiles, was born with the improbable name of Hans John Knox Aufseeser in Munich in 1910, where he studied Fine Art. He moved to Britain before

the Nazis took power, in 1930, and took his anglicized name in 1940 from his wife, the fabric designer Isabel Tisdall. Another major figure was Berthold Wolpe, who like Tschichold had already been a name to conjure with before he moved to Britain. Born in 1905 in Offenbach, near Frankfurt, Wolpe was the principal assistant to Rudolf Koch and, when Koch died in 1934, became the major proponent of his particularly picturesque and playful version of the 'reformed traditional' style.

Earlier works that Wolpe produced with Koch – various tapestries and books with small print runs – have a Bauhaus character to them, but not in the sense in which that was understood by the 1930s. Their affinity was with the eccentricity of Paul Klee rather than the severities of Herbert Bayer's New Typography. Wolpe was hired by Monotype in 1935, with Stanley Morison commissioning from him the cursive font Albertus; the same year, Wolpe received a letter from the Reichskammer der Bildenden Kunst, Berlin. It informed him: 'as you are Non-Aryan and therefore do not possess the necessary reliability to create and spread German cultural values, I forbid you to further practise your profession as a graphic designer'.[20] Aside from the evil and bizarre nature of the claim, what is interesting here is that Wolpe, like Schmoller (but unlike the younger Tschichold), was working in a traditional, calm and relaxed style that one might expect a reactionary government to endorse. What marked out Wolpe's work, though, was an extremely non-Nazi quality: humour. It is hard to imagine Schmoller or Tschichold designing the logos for comics, which Wolpe created for *Eagle* and others. That sense of play can be seen especially well in various dust jackets he designed for Gollancz, freelancing for Morison, their usual designer.

Morison's dust-jacket style for Gollancz was, outside the Left Book Club, deliberately over the top. For example, the *For the Benefit of Mr Kite* neo-Victorian poster manner, all pointing hands, arrows, absurd and inflammatory slogans and pull quotes, with the words CHEAP EDITION in big letters for reprints, something Allen Lane would have abominated; and all this in a strident colour scheme of red-on-yellow. Some of the best of these designs were actually Wolpe's, and in this capacity he developed another font, the slanted, jagged, Expressionistic and dramatic Tempest, which Gollancz would still be using decades later. Wolpe had developed it for a Louis Golding novel, *The Pursuer*, 'in which', a colleague recalled, 'he wanted to create a type that would give the feeling of flight and pursuit'.[21]

From Gollancz, Wolpe moved to Faber and Faber, where he worked from 1941 until 1975, producing thousands of book covers. These, like all of Wolpe's work, were mostly strictly typographical, though all in a sometimes perverse style, best seen in his brilliant type-only covers for Faber's poetry books. This restriction was due initially to economy. Wolpe's simple style fit neatly with the demands of austerity in this period: as one colleague remembered, 'Berthold immediately showed that calligraphy and typography by themselves could replace the elaborate art and process-work the firm had experimented with in the thirties.'[22] In all of this making virtue out of necessity, Faber had a tendency to draw attention to the fact that you weren't buying a hardback, as paperbacks are less profitable to publishers than hardbacks. For years, Wolpe branded 'FABER PAPER-COVERED EDITIONS' on the covers of paperbacks, as if to signal that these were in some ways a lesser product. But Penguin, too, would switch to hardcovers when they embarked on a particularly *significant* project.

One of Berthold Wolpe's typographical covers for Faber.

15
New Ways of Seeing Old Art

The key figure here is the Leipzig-born, Dresden-trained art historian Nikolaus Pevsner – born Nikolai Pewsner into a middle-class Russian-Jewish family, with a progressive, liberal mother who he adored, and a father in the fur trade who he appears to have disdained. Pevsner edited three book series for Penguin Books: the King Penguins, which ran through the 1940s and 1950s before being discontinued; 'The Buildings of England', which Pevsner both edited and mostly wrote – which we will return to in a later chapter; and the 'Pelican History of Art'. 'The Buildings of England' and 'Pelican History of Art' were both wildly ambitious, and both continue to this day, though they are now published by Yale University Press (Penguin offloaded them after the death of their sponsor and fervent supporter, Allen Lane). The King Penguins are mostly known today to collectors and mid-century design fetishists; they are also, as with Penguin's inspiration from Albatross, a direct attempt to emulate a German publishing project – Insel-Verlag's series of slim, affordable, gridded and patterned hardbacks, the Insel-Bücherei. The idea for the King Penguins as an emulation of that series also came from Central Europe, after a fashion.

King Penguins were devised by Adprint, an unusual 'book packaging' business founded by two Viennese émigré book publishers, Wolfgang Foges and Walter Neurath. As we will soon see, a great many famous and *quintessentially English* book series owe their existence to Foges and Neurath, most famously the 'Britain in Pictures' and 'New Naturalist' books, both published by Penguin's competitor, Collins. Without the capital to set up a publishing firm of their own (yet), Foges and Neurath offered an in-house service where they, and a large team of émigré editors, designers, researchers and printers, would effectively produce books for a bigger publisher, who would then market them

at large. Of Adprint's many endeavours, King Penguin was specifically Wolfgang Foges's idea, sold to Allen Lane as an attempt to simply copy the Insel-Bücherei format for a new series of books; Foges also suggested to Lane that they be produced in one of Central Europe's major industrial areas – the Sudetenland, the heavily German-speaking border area in Czechoslovakia – as they would be able to handle the task of colour printing and accurate reproduction better than the British printing industry. Unfortunately, he suggested this in 1938, the year in which the Sudetenland was annexed by Nazi Germany, so Adprint had to rely on British printers instead, which had some consequences; early King Penguins are often ineptly printed, although somewhat charmingly so.[1]

The format was well established by Insel: books of usually around sixty to eighty pages and texts of no more than 10,000 words, with integrated pictures and text in the main essay and a series of (often colour) plates at the end; all this hard-bound, with beautifully patterned covers, each of them different, and stiff spines (these, as collectors will know, are apt to fall off). The subject matter for an Insel-Bücherei volume could include short texts by a major author (Goethe, Schiller, Shakespeare), poetry (with an early volume of Rilke being one of their bestsellers), and presentations of artworks: medieval miniatures, photographs of sculptures; woodcut artists such as Dürer and Holbein were particular favourites. All of these were copied but for an avoidance of poetry and fiction, concentrating instead on the 'art' side of Insel's programme. The editor of King Penguin for its first two years was the art historian and British Museum curator Elizabeth Senior, who had studied in Munich in 1930, so was familiar with Weimar's unusual culture of art history; Senior had also helped to bring several émigré art historians to Britain. Pevsner only took over after her death in 1941, when Senior's flat in Islington was hit in an air raid. He edited the King Penguin series from 1943 until it was discontinued in 1959.

Elizabeth Senior's King Penguins, which had a standardized design – a coloured grid to the corner and the spine, with a title and small image centred at the top, a cute and amateurish attempt at replicating the Insel-Bücherei's serial style – included several books by émigré art historians. In them, these Berlin-, Vienna- and Munich-trained men (the émigré art historians were not all men, but all those published by Penguin were) faced the challenge of presenting their ideas in an accessible, populist form. Although King Penguins were slightly more expensive than

Pocket Curios: Insel-Verlag and King Penguin.

Penguin or Pelican paperbacks, these were still mass-market items. One of the first books was *Portraits of Christ*, co-written by Senior and Ernst Kitzinger, one of the many art historians who had been forced to emigrate after the Nazi seizure of power in January 1933. Kitzinger, who was from a Jewish family, was working on his PhD when Hitler became Chancellor; he left the day after his viva, first for Italy, and then, as Mussolini passed his own racial laws, for Great Britain, where he wrote a highly influential guide to *Early Medieval Art in the British Museum*. Around the time *Portraits of Christ* was published, Kitzinger was deported to Australia on the notorious *Dunera*, and, from there, he left for the United States.

Another early, slim volume was *Caricature*, co-written by an art historian, Ernst Hans Gombrich, and a psychoanalyst, Ernst Kris, both from Vienna. The pair had collaborated on a project on the history and psychology of the caricature in the city, which they had later summarized for the *British Journal of Medical Psychology*; *Caricature* was perhaps a Quixotic attempt to condense this project into a popular, illustrated story, featuring colour plates that begin with an Egyptian papyrus and end with Mickey Mouse. This running together of high and low is deliberate, given that 'our mind is not divided into watertight compartments. Whoever has watched the audience of a gruesome thriller oscillating between horror and explosive laughter will have realised how close the uncanny and the comic can border on each other'.[2] That intersection is at the heart of Gombrich and Kris's book, depicting a game in which:

> we may relapse into a stratum of the mind where words and pictures, rules and values lose their well-established meaning, where the king may be changed into a pear and a face into a simple ball. And thus we are led back on a lightning excursion to the sphere of childhood, where our freedom was unhampered. In the eternal child in all of us lie the true roots of caricature.[3]

There is a large sweep here, which takes in the sculptor and architect Gian Lorenzo Bernini and the essayist, parodist and caricaturist Max Beerbohm, but the central point is that caricaturists, Gombrich and Kris insist, 'enjoyed the freedom denied to great art'.[4] Where the British audience stands in this is interesting, given it was widely considered that this

country had not been particularly significant in the history of visual art. When émigré art historians tried to find a British artist who they considered to be truly significant and unusual, they often cited William Hogarth, for the way in which he combined the spatial and chromatic effects of 'serious' art with a deliberately didactic representation of a society and its morals. 'When caricature came to England it was a more or less sophisticated joke, as Hogarth himself described it. When it left England to conquer the world, it had developed not only into a branch of art, but also into a weapon.'[5]

There is also a politics involved in the use of this weapon, given that the authors were refugees from fascism writing at the start of the Second World War – and given that both Gombrich and Kris were then working for the British government on the analysis of Nazi propaganda. But the politics is very much implicit, and can be found in the praise of the caricaturist as 'a dangerous fellow', whose 'work is still somewhat akin to black magic. With a few strokes he may unmask the public hero, belittle his pretensions, and make a laughing stock of him. Against this spell even the mightiest is powerless.'[6] For the most part, however, King Penguins, even or perhaps especially under Pevsner's editorship, were a complete reverse of the Penguin Specials, with their strident politics and urgent subjects. King Penguins were in a sense a kind of escapism, a source of fun and pleasure during the war years and the austerity that followed. If their celebration of British nonsense could be seen as faintly propagandistic when compared with an imagined German humourlessness – irrespective that many of the people working on the books were German or Austrian – it was only very mildly so. Mostly, these books were celebrations of the British everyday, from the birds in your garden to Highland tartans to old clocks, from roses and ships to the pleasures of the Isle of Wight; and proportionally, Pevsner hired fewer émigrés to write these than had Elizabeth Senior in her short tenure; Pevsner's reputation as a stern Teutonic cataloguer is belied by the cabinet of curiosities he assembled here.

The design of King Penguins was a similar matter of unexpected lightness. After some typically fun and clumsy experiments early on, Jan Tschichold took the King Penguins in hand during his tenure at the publisher; given that he had worked at Insel-Verlag, Tschichold knew exactly what he was doing, and the picture and print quality increased sharply, along with the elegance of the designs. For these

eccentric volumes Tschichold availed himself of all the historic typefaces that had been revived by Stanley Morison at Monotype; 'Centaur, Pastonchi, Poliphilus, Scotch Roman, Lutetia and Walbaum' all run across the covers of these little hardbacks.[7] Some of Tschichold's finest covers were for the series, such as *A Book of Scripts*, a beautiful celebration of the Renaissance printing that had become his model, or *The English Tradition in Design* by John Gloag, which combined classicism and abstraction in its lettering and patterns. Some of the commissioned designs, unusually for Tschichold, were even deliberately funny, such as the Austrian textile designer Marian Mahler's joyful and bizarre cover for *Ballooning* (on, well, Victorian ballooning), or the scrawly tangle of W. S. Bristowe's self-explanatory *A Book of Spiders*. These show how much under Pevsner's editorship, rather unexpectedly, the series had become considerably less serious and art-historical. Dürer woodcuts, the Bayeux Tapestry and Russian icons were in there, to be sure, but they went alongside books on birds, spiders, 'popular art', tulips, butterflies, toys and mushrooms (two books!).

A fine example of these is the émigré Viennese artist Hans Schwarz's delightful Christmas-themed cover – stylized sketches of children, toys and snow scenes – for *Compliments of the Season*, a 1947 King Penguin written and compiled by Leopold Ettlinger, an art historian who taught at the Warburg Institute, an émigré institution that we will turn to presently. *Compliments of the Season* was very much a typical King Penguin in that it took an apparently unserious subject – Christmas cards – and analysed it thoroughly, albeit with tongue noticeably in cheek. In a context where, then as now, anything invented by the Victorians around the same time as telephones and record players is popularly considered to be age-old and deeply rooted in our history, Ettlinger was keen to point out how extremely novel and modern these cards were. Christmas cards were 'an essential feature of English Christmas ... only one example of the Victorians' flight from the drab and horrific conditions of industrial civilisation into the pleasant realm of fantasy, romance and sentiment'. They were rooted in how during the eighteenth century, 'a comparatively secure and civilised period in England, sensitive men and women developed an artificial nostalgia for the less secure and less civilised periods and places of the world's story'[8] – an economical and brutal way of describing a way of thinking that besets us still. This fakery should be recognized for what it is, Ettlinger insists. Christmas cards

came from the top – the earliest examples that we would recognize as such being devised by Henry Cole, the first director of the Victoria and Albert Museum – and from the start they were a mass-produced capitalist product.

This was the 1940s, and so the embrace of popular art was by no means unequivocal: Ettlinger insists on the importance of the high and low divide. 'To treat a Christmas card as a work of art would be a serious misjudgement,'[9] he asserts; the very point is that 'the Christmas card is a work of popular art. Popular art always demands colour. The ordinary person with an untrained eye seems unable to appreciate the subtler uses of line and form.'[10] Ettlinger notes that in the cards real Christian imagery is rare, and what imagery there is in the Victorian card could also be a 'saccharine disguise for sex appeal', as illustrated by a distinctly creepy card featuring a naked nymph.[11] But at the same time, these cards were an enormous repository of dream-images derived from fashion and, at a few removes, from design. Ettlinger shows how you can find in Christmas cards as they developed a series of trends derived from Kelmscott, Aubrey Beardsley, Omar Khayyam; and more recently, 'cubist and surrealist cards have made their appearance in our day alongside the traditional designs, while the scenic art of Walt Disney may be made the excuse for some of the "fruit jelly" landscapes, snow scenes and quaint old villages which were the stock-in-trade of the cheaper designer of the nineteen-thirties'.[12]

There is nothing eccentric, quaint or kitschy, however, about Pevsner's only authored contribution to the King Penguin series. *The Leaves of Southwell* is an illustrated guide to the carved capitals at the top of the columns and pillars of the chapterhouse at Southwell Minster, the incongruously grand church of a small market town in what was then the mining district of Nottinghamshire. These medieval capitals are decorated as oaks, vines, maples, bryonies, hawthorns, hops, all easily identifiable as such. Pevsner, as a modernist, is keen to point out that while leaves on capitals 'have a functional justification', in these you could see a Gothic constructional logic being stretched by 'the caprice of an artist who knew very clearly how far he could go in veiling functional lines without confusing them'.[13] The book can be enjoyed purely for its gorgeous photographs by F. L. Attenborough, and for its description of the leaves and motifs of the church; but there is an underlying argument. One of them is a Ruskinian one, about the 'Nature of Gothic', a time when:

Neither the term architect nor the term sculptor was in use. Architecture and sculpture issued anonymously from the cathedral or abbey lodge, that is workshop, not because there was no creative genius, but because it was taken for granted.[14]

That was the vision of a communal, collective architecture which once inspired the Bauhaus. The other argument is that Southwell Minster is a *European* building, one built to the highest continental standards and which, as Pevsner tartly points out, English aesthetes would flock to if it were in France, rather than between Newark and Mansfield.[15] Finally, there is an insistence that these organic forms, which proliferate in the architecture, art, literature and philosophy of the time, should leave us 'with the only explanation which historical experience justifies; the existence of a spirit of the age, operating in art as well as philosophy, in religion as well as politics'.[16] This invocation of the 'spirit of the age', commonly applied by Pevsner to the need for a real modern architecture, was just as applicable to these beautiful, tiny works of medieval architectural sculpture. There is, in this gorgeous little book, a strong argument for something rather controversial: looking at history with modernist eyes.

So, why were there so many German and Austrian art historians, and why were so many of them in Britain? And what were these serious art historians doing writing about Mickey Mouse, Christmas cards and Catholic kitsch? The first of these questions is the more easily answered. In Germany and Austria, there were a thousand people who were trained art historians (in Britain, there were effectively none). A quarter of these individuals were Jewish.[17] This meant that they lost their jobs either in 1933, when Jews were barred from posts in public institutions such as universities and museums within Germany's 1918 borders, or in 1935, when the even harsher Nuremberg Laws were passed, or in 1938, when Austria was annexed. A number of these historians escaped to Britain, particularly as neighbouring countries like Czechoslovakia, France and the Netherlands became unsafe in turn; many of these historians would by the end of the 1940s make their way across the Atlantic to the Ivy League universities or to New York and Los Angeles. But as to why art history had become such a major discipline in Germany *specifically* (as opposed to France, or Italy, or Sweden, or Spain, or Russia, let alone Britain), the answer is more complicated.

There had been histories of art of a kind for a long time, and British writers had produced some of them, with the works of, for example, John Ruskin or Walter Pater being widely read abroad for their very different reasons. The art-historical traditions that German and Austrian scholars brought with them could vary quite extensively, particularly depending on whether they had studied in Vienna, Hamburg, Berlin, Dresden, Leipzig or Munich, but what they all shared was a certain attempt to systematically analyse art – to turn art history into a 'science' rather than merely a form of appreciation.

Britain, irrespective of Ruskin, or of Bloomsbury art historians such as Roger Fry, was as underdeveloped in terms of art history as Germany was overdeveloped. As Christopher S. Wood points out, the first Oxford chair of an art-history department was the German émigré Edgar Wind, who was appointed in 1955, while Cambridge first offered a degree in the History of Art as late as 1970.[18] What Britain *did* have was a highly developed culture of artistic connoisseurship, based on dating, valuing and authenticating the works of the Renaissance and the Baroque. This culture might have centred on the same body of knowledge. Most early twentieth-century German art historians, who were, like British aristocratic connoisseurs, from a northern country where the Grand Tour was a rite of passage for upper-class aesthetes, focused their lives' work on Italy between the fourteenth and eighteenth centuries. However, they did very different things with the information they uncovered. For an enthusiastic connoisseur of Italian Renaissance architecture, like the Bloomsbury Group-affiliated amateur architectural historian Geoffrey Scott, the appeal of Italy lay in its apparent contrast with the *shoulds* and *oughts* of nineteenth-century British architectural polemic, the Neo-Gothics, the Arts and Crafts and soon, the Modernists, who believed that certain forms of architecture were morally and ideologically superior. The architecture of the Renaissance, by contrast, was valuable for its humanism, its simple rules of thumb and its use of the 'human scale'. For a neo-baroque architect such as Edwin Lutyens, meanwhile, the Renaissance and Baroque were 'the high game', a set of strange and curious rules and motifs that you could play with endlessly to create unusual, sublime or humorous effects.

For the German art historians, however, the Renaissance was interesting for its cosmology, for its ideology, for the way in which it related to a wider society. Most of all perhaps, studying the Renaissance was a way

of understanding a trans-historical, would-be-scientific absolute that they called 'form'. One of the major figures of German-language art history in the early twentieth century was the Swiss writer Heinrich Wölfflin, author of works such as *Renaissance and Baroque* (1888) and the *Principles of Art History* (1915), which even managed to attract the attention of Bloomsbury. What marks out a book like *Renaissance and Baroque* is partly its level of abstraction: the way in which Wölfflin personifies these art-historical styles, and outlines the different approaches to space and volume – form – in different artistic or architectural eras. This focus on the sheer physicality and effect of *form*, rather than on biography or attribution – the former being the focus of art critics of the era, the latter the interest of the connoisseurs – can still result in some incredibly powerful descriptions, which the effete world of art appreciation couldn't access. So at the Vatican, Wölfflin finds that 'the curved staircase leading up from the Piazza to the church of St Peter's ... looks like some viscous mass slowly oozing down the slope', where the 'effect of yielding to an oppressive weight is sometimes so powerful that we imagine that the forms affected are actually suffering'.[19] Michelangelo is for him the father of the Baroque due to his deployment of the 'advanced expression of imprisoned matter'.[20] Inside St Peter's – and this is often *the* baroque church as much as it is *a* specific baroque church – Wölfflin finds that:

> The space of the interior, evenly lit in the Renaissance and conceived as a structurally closed entity, seemed in the baroque to go on indefinitely. The enclosing shell of the building hardly counted: in all directions one's gaze is drawn into infinity ... clouds stream down with choirs of angels and all the glory of heaven; our eyes and minds are lost in immeasurable space.[21]

This was a heady, exceptionally difficult yet surprisingly rewarding way of writing.

Some of this is, to be sure, anticipated in the stylistic synopses of Ruskin – this is effectively 'the Nature of Baroque' – but it is more systematic, more Hegelian, more firmly based on that idea which Pevsner evoked at Southwell about the expression of the spirit of the time – that is, the spirit of the age, the *Zeitgeist*. Baroque, for Wölfflin, is 'this great phenomenon, appearing like a natural force, irresistibly carrying all before it', the 'origin and cause'[22] of which he sets out to explain. What is particularly important here is the attempt to make a 'scientific'

study of *style*. Style is 'an expression of its time in so far as it reflects the corporeal essence of man and his particular habits of movement and deportment ... it is self-evident that style can only be born when there is a strong receptivity for a certain kind of corporeal presence'. The example Wölfflin chooses for this is deliberately trivial:

> We have only to compare a gothic shoe with a Renaissance one to see that each conveys a completely different way of stepping: the one is narrow and elongated and ends in a long point; the other is broad and comfortable and treads the ground with quiet assurance.[23]

You can follow this sort of physiognomy of art in all manner of directions. A recent study lists among Wölfflin's many disciples Marxists like Sergei Eisenstein and Walter Benjamin, along with conservatives like Ortega y Gasset or Marshall McLuhan. You could follow his focus on the style and spirit of time and place either into modernism, which had its own reasons for asserting the existence of a *Zeitgeist*, or into racial theory, which insisted that different cultures created different and, at the extremes, totally separate and irreconcilable ways of being in the world that could be seen and understood through their art. This is the direction in which Nazi art historians such as Hans Sedlmayr and Wilhelm Pinder took Wölfflin's work in the 1930s.

As an actual teacher of Art History in Munich and Berlin between the 1900s and 1920s, Wölfflin taught a generation of art historians, including many of those who made their way to London. Some of these, such as Walter Friedlaender, one of the first German art historians to have emigrated to Britain in the 1930s as a stepping stone to the United States, were somewhat less high-flown. Friedlaender's *From David to Delacroix*, a stylishly written 1930 summary for students of a very politicized period in art, translated into English in 1939, evokes most of all the work of his friend Kenneth Clark, both in the fluency and vividness of the writing, and the striking blindness to the pornographic nature of so much of the nineteenth-century art it focuses upon. Clark himself would be a major sponsor of the émigré art historians, as would Anthony Blunt, a young left-wing art historian who was then writing for the old connoisseur journal the *Burlington Magazine*, and as the art critic of *The Spectator* – and who of course was also a Soviet spy. Both were instrumental in the early years of the Courtauld Institute of Art,

Britain's first school of Art History, which was opened in the 1930s with the bequest of a Manchester textile magnate. Many émigré art historians would teach there, but the best-known were associated with a new institution, which was transferred from Hamburg, and was unusual and ambitious even by German standards – the Warburg Institute.

'The Warburg' still exists, in Bloomsbury, as an integral part of the University of London, in a purpose-built edifice of the 1950s, to a moderate classical-modern hybrid design by the architect Charles Holden. It still contains within it the famous 'Warburg Library', which you enter through a door featuring above it a hardwood lintel etched with the Greek word MNEMOSYNE, the name of the goddess of memory. We have come across the Warburg a couple of times already – as the sponsors of Helmut Gernsheim's photographs of London's classical architecture, as the scholarly home of King Penguin authors like Leopold Ettlinger and E. H. Gombrich – and it is worth pausing to explain exactly what it was, and who the Warburg in question was.

Aby Warburg, born in 1866, was the eldest son of a powerful German Jewish banking family. Uninterested in going into the family firm, Aby made a deal with his younger brother Max, that Max would take over what would have been Aby's position in the bank, with the proviso that, in exchange, Max bought him any book that Aby asked for. Drawing on the resources in his growing library, Aby Warburg gradually developed his own idiosyncratic form of art history, in which aesthetic appreciation was massively downgraded in favour of an attempt to understand the ways in which different societies repeat and contrast in their use of a series of motifs and archetypes, with sources ranging from pre-Columbian America to the advertising world of Weimar Berlin.

In this, Warburg, although mainly a writer on the art of Ancient Greece and the Italian Renaissance – like any other art historian of his time – was without doubt a modernist, and someone committed to montage and juxtaposition as a way of warding off sweeping, stale, clichéd and familiar approaches to the art of the past. In the 1920s, he gave his library to the University of Hamburg, which housed it in a purpose-built brick Expressionist edifice. As at its London successor, that word MNEMOSYNE was emblazoned over the entrance. The Warburg Library effectively became an institute of art history, training the likes of the philosopher Ernst Cassirer and the art historian Erwin Panofsky, both of whom would briefly stay in London before settling

in the United States. Warburg's own last years were spent compiling an immense photomontage *Mnemosyne Atlas*, which was begun in 1924 and left unfinished on his death in 1929. It consisted of a collaged map of the 'afterlife of antiquity', using 'principles of connection' between artworks, clothes, advertisements, machines, photographs, mounted on sixty-three boards coated in black hessian. Although never completed, in recent years the unfinished work has been exhibited in Berlin.[24]

The Warburg's work was both difficult and, in a sense, democratizing, through the way in which it refused to recognize boundaries between high and low art, primitive and advanced cultures, the scholarly and the amateur. In 1930, after Aby Warburg's death, the Warburg scholar (later Oxford's first Professor of Art History) Edgar Wind delivered a lecture on 'Warburg's Concept of *Kulturwissenschaft* [that is, the knowledge or science of cultures] and its Meaning for Aesthetics'. He argued that Warburg's contribution rested in large part on bringing together 'fields which even professional art historians have tended on the whole to fight shy of – the history of religious cults, the history of festivals, the history of the book and literary culture, the history of magic and astrology'.[25] Assessing the Warburg Institute and fitting it into the story of twentieth-century modernism is not easy, because of the esotericism of the project and its apparently peripheral, non-political nature compared with much of Weimar Culture. In his classic book on *Weimar Culture*, Peter Gay noted that Aby Warburg's personal politics were eccentric – he was a monarchist – and that the entire project was essentially one rich man's obsession. Similarly, although 'the austere empiricism and scholarly imagination of the Warburg style were the very antithesis of the brutal anti-intellectualism and vulgar mysticism threatening to barbarize German culture in the 1920s', its material wasn't obviously 'culturally Bolshevik' in the manner of a Moholy-Nagy or a Tschichold. Those who were then raiding the offices of hundreds of designers, artists and thinkers would have 'found no material for suspicion in the Warburg Institute's publications on the worldview of St Augustine, the contents of medieval encyclopedias, or the iconography of a Dürer engraving'.[26] It is surely unlikely that the Institute would have been hounded out of Germany were it not that both Aby himself and many Warburg scholars were Jewish.

After Warburg's death, the Institute in Hamburg was managed by the art historians Fritz Saxl and Gertrud Bing. After the Nazi takeover in

1933, its staff faced harassment and physical attacks from SS and SA thugs; Bing and Saxl tried to convince universities in both Britain and the United States to take the Library before it was closed and broken up by the Nazi government, eventually succeeding when the Courtauld and the University of London took the Institute under their wing in 1934, where it was housed first in the stodgy office block of Thames House, then in the high-Victorian Imperial Institute, and then outside London 'as if on a Kibbutz' in the village of Denham in Buckinghamshire,[27] and finally in Charles Holden's purpose-built headquarters in Bloomsbury. The Warburg sometimes aimed at some sort of public presence, hosting during the war a successful 1941 exhibition on 'British Art and the Mediterranean'.[28] In 1948, Saxl and Rudolf Wittkower published a large-format illustrated book on the exhibition, which goes into more detail on their aims. The exhibition was intended as 'a kaleidoscopic survey', 'which is unrolled before the reader'. The first half was on the slow unfolding of the Mediterranean influence in the Roman era and beyond, being akin to 'those cinema pictures where the opening of a flower from the bud is shown as a consecutive movement'; and the second half, from the sixteenth century onwards, was 'like those [cinema pictures] which show a horse jumping a fence, in a number of shots recording every single position of the leaping animal'.[29]

Similarly cinematic was the illustrated book's mode of presentation, rooted in Aby Warburg's notions of juxtaposition and montage: a selection of close-ups of 'The Human Face in Celtic Art'; frontal, classical images of 'The Roman Face', followed by its local variant, 'The Roman Face Transformed', that is transformed by British sculptors into something more schematic, long and etiolated; two pages of flowing, monastic line drawings of Christ and the saints; panels showing the influence of Byzantium as soldiers returned from the Crusades, and depicting the Corinthian capitals in northern Gothic churches; the return of the pagan gods in late medieval manuscripts; the emergence of the geometric, strict English interpretation of Palladio, shown through a series of perfectly symmetrical photographs and drawings; juxtapositions of Italian caricature and that of eighteenth-century England; the 'recurring inspiration of Michaelangelo' with the strange bedfellows Inigo Jones and William Blake; the transformation of Edinburgh into the 'Athens of the North'; and, of course, several pages of photographs of the English baroque churches of Sir Christopher Wren and Nicholas Hawksmoor,

many of them by Helmut Gernsheim. The book concludes with a juxtaposition on 'the loosening of classical ties', which throws together a page set in Stanley Morison's Times New Roman with photographs of Victorian and modern sculpture and of Herbert Baker's vast, Albert Speer-like Council Chamber in New Delhi, an example of how 'shortly before the war we witnessed all over Europe a tentative, if not always successful, return to classical standards'.[30] What is so interesting in this book is the back seat that the texts take to the juxtapositions – the history is read almost entirely through a complicated dialectic of images.

In Britain, however, the Warburg gradually moved away from some of the stranger aspects of Aby Warburg's work, as represented so impressively in *British Art and the Mediterranean*. Saxl and Bing aimed to complete the *Atlas Mnemosyne* and gave E. H. Gombrich the task, but he never did so, which was perhaps due to his own stringent opposition to any notion of a *Zeitgeist*; as we will see, Gombrich's vision for the Warburg Institute was much less speculative and ambitious than that of the art historian who gave its name. Nonetheless, most of the more interesting and unusual art history that was written in Britain between

History as Juxtaposition: the Warburg's 'British Art and the Mediterranean'.

the 1930s and 1970s came out of the Warburg, and influenced culture and society in some very unexpected ways. We owe to the Warburg Gombrich's *The Story of Art*, the most widely read history of art in the English language; it is also arguably to the Warburg that we owe the emergence of Brutalist architecture, as we shall see.

Nikolaus Pevsner's position in all this is paradoxical. He read widely, but was a disciple neither of Warburg nor of Wölfflin. If he was anybody's student, it was the Dresden art historian Wilhelm Pinder, who was both a great popularizer of art and a fanatical German nationalist and supporter of Hitler. In the former capacity, Pinder wrote two of the Blue Books, a series of affordable, popular paperbacks on 'German Culture' that were sold throughout the early twentieth century and provided, as we'll see, the inspiration for another of Adprint's borrowed Anglo-German art books. Pinder wrote the volumes on the *German Baroque* and the *German Medieval Cathedrals*, and moved sharply to the right during the 1920s. According to the co-author of *Portraits of Christ*, Ernst Kitzinger, another of Pinder's students, by the 1930s his teacher was 'completely caught up in the definition of Germanism', with any comparisons to foreign cultures aiming at 'visual confrontation, to show that the two were quite distinct, and to derive the German essence'.[31]

When Pevsner, Pinder's colleague at the University of Dresden, left for Britain, having been, as a Jew, dismissed from office (his enthusiastic conversion to Lutheranism notwithstanding), Pinder was kind and hypocritical enough to write him a reference. Pevsner himself refused until very late truly to understand the degree in which Nazism was every bit as extreme as it claimed to be, with its antisemitism much more than mere 'propaganda', but rather a deadly serious ideology aimed at the physical extermination of people like him and his family. Proud of the uncontroversial fact that in large part modernism in architecture and design was a German project, Pevsner not only believed that the modern architecture of the German *Neues Bauen* would have a place in the Third Reich,[32] he also briefly believed that the Third Reich might have a place for him. He was extremely mistaken in both cases, but even after emigrating from Germany he submitted under a pseudonym an article to the Nazi art journal *Kunst der Nation*, 'about how art might respond to the new dictatorship'.[33]

None of this necessarily proves that Pevsner was 'a Nazi', or even that he was on the political right. As early as 1932, he wrote that his

allegiance was essentially to the left, and in Britain he was to be a lifelong Labour voter. Rather, it suggests that this rather unpolitical man had been led through a belief in distinct national artistic styles and national cultures into a position where he was endorsing the philosophy of the very people who were intent on the extermination of his kind. Out of all this – the influences of Wölfflin and his disciples on 'form'; the belief in the *Zeitgeist* and the progressive succession of styles; Warburg's theories of art history as *Kulturwissenschaft*, a matter of connections and juxtapositions; and Pevsner's own increasingly tortured engagement with German nationalist theories of art – Pevsner carved his own monumental History of Art.

When conceived by Pevsner in the 1940s, the 'Pelican History of Art' was intended to extend to fifty volumes, which would encompass the entire world history of art, employing the most important scholars from around the globe to do so. Rather than these books being packaged as affordable paperbacks, however, this was to be a prestige project. Although the books remained relatively cheap compared with the academic or connoisseur press of the time, these were luxurious items. The 'Pelican History of Art' is the least typical Penguin product of the three series that Pevsner edited for the publisher, maybe Allen Lane's most unusual project of all. Until a select few paperback editions were printed in the 1970s and 1980s, its volumes consisted solely of large-format illustrated hardbacks, initially packaged with slipcases, printed on thick, high-quality paper. Unlike in the King Penguins, there was a strict separation between the text and the colour plates, as it was considered unlikely that British printers would be able to handle the quality of reproduction that Pevsner and Allen Lane considered the books required if they printed images alongside text.

The design, once again, was a largely continental affair. The dust jackets (and of course, the contents) were designed by Hans Schmoller in a delicate combination of modernist asymmetry and graceful, neoclassical typography. Each front cover had the title on one side, a carefully chosen photograph from the plates on the other, and a spine featuring a specially drawn ecclesiastical version of the Pelican logo by Berthold Wolpe, a 'Pelican in Piety' – the bird feeding its young, though appearing more like a Phoenix than a Pelican – and the covers were coloured differently for each volume.[34] Unlike the King Penguins under Pevsner's editorship, the authors commissioned were very frequently German or Austrian.

Although some of the most important volumes were by American and, often, British historians – including two of the series' highpoints, John Summerson on English classical architecture and Anthony Blunt on the Renaissance in France – the preponderance is striking. Of the forty-eight volumes that Pevsner managed to edit (later, with assistance from Judy Nairn and the Austrian émigré Peter Lasko) before his death, fifteen were written by Central European art historians, more than a quarter of the total. These were a disparate group, including venerable historians and others who built their careers after the war, and mixing Jewish émigrés – Warburg historians in particular – with several figures who remained in the Third Reich. This is not entirely surprising, given both the German dominance in developing art history in the twentieth century, and that, as with the King Penguins, the model was a German series. According to Susie Harries, 'Pevsner had in the back of his mind the model of the German *Handbuch der Kunstwissenschaft*, a general history of Eastern and Western art', although 'he intended this new Pelican History of Art to be on a grander scale ... it was the grandeur of the idea that attracted Allen Lane'.[35] The grandeur was very obvious from the early volumes designed by Schmoller, so heavy that they were best read while sitting at a table, rather than, as with most Penguins, on a train.

Along with their relative unwieldiness by Penguin standards, these books introduced a form of scholarship that was exceptionally unusual in Britain. A case in point is the volume on *Art and Architecture in Italy, 1600–1750*, by Rudolf Wittkower of the Warburg Institute, published in 1958. Wittkower, who had trained with Wölfflin in Munich but was more attracted to the more historically grounded and eclectic approach of Aby Warburg, made his name as a writer in English in 1949 through his book *Architectural Principles in the Age of Humanism*, published as volume 19 of the 'Studies of the Warburg Institute'. The controversy this book caused is best understood in the context of the British understanding of the Italian Renaissance, which was owed largely to a beautifully written, apparently logical but basically trivial book from 1914: *The Architecture of Humanism* by Geoffrey Scott. An attack on the moralistic and contradictory 'fallacies' – ethical, romantic, biological, mechanical – that impeded enjoyment of architecture in nineteenth-century Britain, Scott's book held up as an alternative what he believed to be the purely aesthetic, apolitical, amoral approach to architecture developed in fifteenth- and sixteenth-century Florence and

Rome. Scott argued that 'Renaissance architecture in Italy pursued its course and assumed its various forms rather from an aesthetic, and, so to say, internal impulsion than under the dictates of any external agencies. The architecture of the Renaissance is pre-eminently an architecture of Taste. The men of the Renaissance evolved a certain architectural style, because they liked to be surrounded by forms of a certain kind.'[36] Moreover, any influences other than those of pure aesthetics and pure pleasure were essentially irrelevant, because they had little importance in Italy during that period. 'The revolutions which architecture underwent in Italy, from the fifteenth to the eighteenth century, corresponded to no racial movements; they were unaccompanied by social changes equally sudden, or equally complete; they were undictated, for the most part, by any exterior necessity.'[37]

Wittkower destroyed this argument in *Architectural Principles in the Age of Humanism*. Scott's theories were based, it soon became clear, on a combination of wishful thinking about a sensual and sun-loving Mediterranean distant from our miserable island polemics, and simple ignorance about Renaissance Italy. Warburg had stocked his library with an enormous amount of material on Renaissance Florence and Rome, which Wittkower was able to consult in order to prove that, on the contrary, the Renaissance favoured an architecture that was deeply ideological, deeply religious, deeply cosmological – it was in many ways the worst possible place to go looking for an architecture without polemic and without theory. For instance, at Giuliano da Sangallo's church of Santa Maria delle Carceri, Prato, with its idealized Greek Cross plan, Wittkower finds that:

> its majestic simplicity, the undisturbed impact of its geometry, the purity of its whiteness are designed to evoke in the congregation a consciousness of the presence of God – of a God who has ordered the universe according to immutable mathematical laws, who has created a uniform and beautifully proportioned world, the consonance and harmony of which is mirrored in His temple below.[38]

Renaissance architects were Neoplatonists, not Empiricists. To be sure, they did not believe in a modernist or industrial 'constructional logic', nor in Ruskinian 'truth to materials', but there was more than one way of moralizing architecture. 'The conviction that architecture is a science

and that each part of a building, inside as well as outside, has to be integrated into one and the same system of mathematical ratios,' argued Wittkower with a wealth of evidence from fifteenth- and sixteenth-century texts and building plans, 'may be called the basic axiom of Renaissance architects.'[39] The likes of the architect Leon Battista Alberti were 'convinced of the mathematical and harmonic structure of the universe and all creation', and because of this they believed not simply that forms pleased people for their own sake, or because of something that British critics liked (and still like) to call 'the human scale', but because of cosmic, celestial mathematics. 'If a church has been built in accordance with essential mathematical harmonies', Renaissance designers and artists believed, 'we react instinctively; an inner sense tells us, even without rational analysis, when the building we are in partakes of the vital force which lies behind all matter and binds the universe together.' To give another example, it is because of this belief in celestial mathematics, rather than simply because it was 'pleasing', that the circle was 'given special significance' in the Renaissance.[40]

In architecture schools, *Architectural Principles in the Age of Humanism* caused a sensation, by helping architects to finally look afresh at the architecture which had been reduced to familiarity, effete game-playing and stuffy cliché by the Edwardian baroque and Neo-Georgian architects of early twentieth-century Britain. In a 1960 preface to the book's paperback edition, Wittkower wrote that:

> to my surprise [*Architectural Principles in the Age of Humanism*] caused more than a polite stir. Sir Kenneth Clark wrote in the *Architectural Review* that the first result of the book was 'to dispose, once and for all, of the hedonist, or purely aesthetic, theory of Renaissance architecture,' and this defined my intention in a nutshell. The book is concerned with purely historical studies of the period 1450 to 1580, but it was my most satisfying experience to have seen its impact on a young generation of architects.[41]

Among these were modernists such as Alison and Peter Smithson or James Stirling, who were inspired by Wittkower's analysis of Alberti, Sangallo or Palladio's ideal plans, modular volumes and Golden Section geometries, and their integration of theory and design, to develop a radically reduced version of modern architecture they called the New

Brutalism. If you look at some of the work produced as a result – say, James Stirling and James Gowan's Brunswick Park School for the London County Council in Camberwell, South London – you can see the ideal Platonic geometries and mathematical obsessions of Renaissance architects interpreted in a brusquely modern idiom.

Wittkower's volume for the 'Pelican History of Art' did not have quite the same dramatic effect, because Pevsner's brief discouraged polemics and arguments in favour of immense summaries. The books were not introductions for non-professionals as such – although they were forced by Pevsner to avoid jargon, the historians often assumed a knowledge of art history – but they were not written solely for academics either. They sat somewhere in between, so much of *Art and Architecture in Italy, 1600–1750* is a straightforward, historically grounded study of the Baroque. But that grounding still takes the reader very far away from the tales of simple sweetness and light. Rather, *Art and Architecture in Italy* has a nightmare atmosphere, one that comes from a concentration on the way in which the Papacy, through the Counter-Reformation, took the Renaissance and distorted it into an instrument of ruthless power – the architecture not of Humanism, but that of the Inquisition:

> With the sack of Rome in 1527 an optimistic, intellectually immensely alert epoch came to an end. For the next two generations the climate in Rome was austere, anti-humanist, anti-worldly, and even anti-artistic ... but the practice of art was far from being extinct. It was turned into an important weapon to further Catholic orthodoxy.[42]

On the super-charged, powerfully physical Baroque of Bernini and his contemporaries, Wittkower finds that 'the technique of these artists is that of persuasion at any price', where 'the improbable and unlikely is rendered plausible, indeed convincing'.[43] It would be contrary to Wittkower's intentions, but it is very tempting, to read in this a deliberate evocation of the horrendous events that he and his generation had lived through, that had forced them to flee their homes and had killed so many of their friends and relatives, and a hard-nosed attempt to understand a culture that emerges out of state power, irrationality and propaganda; that in the process Wittkower brutally assaulted the English Neo-Georgian belief in an apolitical classicism was a side effect.

By its nature, the 'Pelican History of Art' kept any reflection on the

horrors of the twentieth century at the level of these hints and implications. The most up-to-date volume, Fritz Novotny's study of *Painting and Sculpture in Europe, 1780–1880*, written by an Austrian scholar of Paul Cézanne (Novotny was not a public supporter of the Anschluss or of Nazism, but, not being Jewish or a socialist, did not feel the need to emigrate), stops just before anything too uncomfortable. But again, it *hints* at it, with the roots of the Nazi campaign against 'Degenerate Art' found in Novotny's account of the public scorn directed at William Blake and Vincent van Gogh by the academies of the nineteenth century, and on the manner in which these institutions suppressed the creative forces of the time. What is much more noticeable at this distance is the staggering Eurocentricity of the 'Pelican History of Art' project. There is one volume on China, one on India, one on the 'Ancient Orient' (Assyria, Akkadia, Babylon, the Hittites, etc.), one on Egypt, one on pre-Columbian America, and one on Russia, with everything else – forty or so volumes – focusing on Western and Central Europe. There are very few women writers, and no writers at all from outside Europe or America. This was conservative even for the period in which the books were published, between the 1950s and 1970s. Moreover, for Belgium to outweigh the entirety of Asia, and for Africa to simply not appear after ancient Egypt, looked inexplicable by the time Pevsner's original volumes concluded in the early 1980s.

But returning to the crucibles of art history in Berlin, Munich and Vienna, there is a rather startling collection of sheep and goats to be found in Pevsner's selected authors. Among the former you could find Paul Frankl, a scholar of the Gothic from Prague, another pupil of Wölfflin's; he fled the Nazi occupation of his country in 1938, to the United States, and wrote the volume on *Gothic Architecture*, completed on the day of his death in 1962. Otto Brendel, author of the instalment of the series on *Etruscan Art*, was dismissed from office in Germany because his wife was Jewish; he emigrated first to Durham in north-eastern England in 1936 and then the United States in 1938. Richard Krautheimer, also a student of Wölfflin, close to Warburg scholars such as Wittkower, and the author of *Early Christian and Byzantine Architecture*, fled Nazism for America, as in 1937 did Jakob Rosenberg, author of the volume on *Dutch Art and Architecture*. Henri Frankfort, the Dutch archaeologist who wrote *The Art and Architecture of the Ancient Orient*, an opponent of the racist speculation that often crept into oriental art history, had been living in Britain since the 1920s, and became the director of

the Warburg Institute in 1948. Horst Gerson, author of *Art and Architecture in Belgium, 1600–1800*, had been born in Berlin and emigrated to the Netherlands, where he lived throughout the war and managed to survive, though his parents were murdered in the concentration camp of Theresienstadt.

Of the goats, however, there was Eberhard Hempel, an art historian in Pevsner's old department in Dresden. Hempel had been a member of the far right, if non-Nazi paramilitary Stahlhelm, in the Weimar Republic; he signed a 1933 letter written by scholars in support of Hitler. Hempel was the author of *Baroque Art and Architecture in Central Europe*, an area considered 'German' both by his colleague Wilhelm Pinder and by the Nazis; clearly happy to work under different regimes, Hempel remained in East Germany after the Communist takeover in 1948. Gert van der Osten, co-author of *Painting and Sculpture in Germany and the Netherlands, 1500–1600*, had his PhD supervised by Paul Frankl, who was Jewish, but Osten worked in Germany throughout the Nazi period, as a close collaborator of Pinder. During the war Osten was an officer in the Wehrmacht on the Eastern Front and then a Soviet prisoner of war, as was Wend Graf Kalnein, co-author of *Art and Architecture in the Eighteenth Century in France*, who studied art history in Bonn before fighting in the Wehrmacht. Theodor Müller, the author of *Sculpture in the Netherlands, Germany, France and Spain*, was another pupil of Pinder, as well as of Wölfflin, and worked in Germany through the Third Reich. So too did Ludwig Heydenreich, who had been a student of Erwin Panofsky at the original Warburg Library in Hamburg: he hid the only copy of Panofsky's habilitation thesis without telling anyone about its existence, and it was found only after his death. After the war, Heydenreich headed with Wolfgang Lotz, his co-author on *Architecture in Italy, 1400–1600*, the post-war Munich Central Institute for Art History. It was housed in the city's former Nazi headquarters, right next to the Führerbau.

However utterly Eurocentric the project was, most of these historians who had been on the other side in the Second World War had moved on from the outright race science that most of them had espoused during the Nazi era, and produced solid scholarly volumes. The issues with the 'Pelican History of Art' lay elsewhere. There was the already mentioned question of the volumes falling between the expert and non-expert, and their opulence and weight. In the later 1960s, they were redesigned by Alan Spain in a version of Germano Facetti's black Penguin Classics grid,

and then select volumes were redesigned again in the 1970s by Gerry Cinamon as starkly modernist white paperbacks, this time finally with the photographs integrated into the text, which made them considerably more readable – the practice of reading a giant volume and flicking to the back for the photographs was and remains intensely irritating to the non-scholarly reader. These paperbacks, redesigned by Cinamon again with black covers in elegant serifs, were what the 'Pelican History of Art' looked like when Pevsner died in 1983. The paperbacks were altogether more accessible but also less daunting, less impressive, less special, though the texts themselves remained formidable.

It is not altogether surprising that Penguin should have offloaded the series when it faced a financial crisis in the 1970s and 1980s. Moving the series – which still continues, and is still named the 'Pelican History of Art' – to Yale University Press meant sending it back to academia, and with that, a certain de-anglicization. For Peter Lasko, who was the head of Art History at the new University of East Anglia, a deputy editor of the series, and the author of *Ars Sacra*, a particularly beautiful volume of the 'Pelican History of Art' on the subject of early medieval 'minor art', this was evidence that Pevsner had succeeded in his aims:

> The separate treatment of Britain is no longer as necessary as the founding editor, Sir Nikolaus Pevsner, believed it to be in the 1940s, when the series was first planned. Then, British art needed special emphasis, largely because it was comparatively little known outside these islands. The fact Britain is a part of Europe is now wholeheartedly accepted.[44]

Words that were, sadly, rather premature. By the time Lasko wrote this in the 1990s, these beautiful, informative and extremely large books had been overtaken by events, and read strangely when surrounded by Marxist, Feminist, Post-Colonial or Postmodernist interpretations of art history. Art History was now an accepted academic discipline in Britain's plate-glass universities, and even in Oxbridge. None of this had been anticipated in the series. The books still had a place, especially for anyone working on Classical, Gothic or Renaissance art, but art students were far more likely to be reading another history of art entirely: a less deliberately planned, less grandiose series of black paperbacks, published and edited by two Viennese émigrés who named their publishing house after the rivers that ran through London and New York.

16
'Red Vienna' Goes to the Art School

As already noted, the King Penguin series was devised by the Viennese publishers Wolfgang Foges and Walter Neurath for their 'book packaging' company Adprint. It was one of many series of illustrated books that Foges and Neurath's production company managed to sell to English publishers. Some of these are famous – for Collins, they created the much-loved 'Britain in Pictures' series, which ran during and immediately after the Second World War, and the 'New Naturalist', an unpretentious, sometimes unusually urban guide to British wildlife, which is still in print. Other series, such as 'The New Democracy' (created for Nicholson & Watson) or 'The Soviets and Ourselves' (created for Harrap), are tied much more tightly to their time – to the New World of democratic planning promised during and after the war, and to the alliance with the USSR that crumbled after it. These are intriguing and unusual projects, which harnessed both the mainstream and the avant-garde of Central European publishing, and introduced them to a British market that had for the most part nothing remotely similar to these visually rich, informationally dense little books.

As publishers in Vienna, Foges and Neurath were supporters of the project of 'Red Vienna', the social-democratic state within a state that was admired across the rest of Europe in the 1920s and early 1930s – though the men were not so closely aligned, for they had to immediately escape when Viennese socialism was violently suppressed by Austrian Fascism in 1934. Neurath, in particular, was always explicitly a socialist. As the historian of émigré art publishers Anna Nyburg points out, he was a 'fiercely political' figure who 'was committed to the idea of showing and explaining the world to young people like himself who had not completed a University education'.[1] Although Neurath would soften politically (in Britain, he was a supporter of the Fabian Society),

in Austria he had been, like Edith Tudor-Hart, a member of the small Communist Party – small because the relative radicalism of the Austrian Social Democrats made them less unappealing to impatient youth than their German counterparts. As a young Marxist, Neurath was part of a commune of intellectuals called *Neustift* (New Foundations), which aimed to create and encourage a socialist culture;[2] and as an enthusiast for art, he lectured to what he later described as the 'Austrian equivalent of the Workers Educational Association', the *Kunststelle*.[3] Foges, meanwhile, was the co-founder of a short-lived socialist art and culture journal, *Die Neue Jugend* ('The New Youth'); he was the first of the two to emigrate, setting up Adprint in London in 1937, to be joined by Neurath, who managed to escape Nazi Austria after a time in hiding underground, a year later.

Neurath's major success before the Anschluss, as an editor at the publishers Steyremühl-Verlag, was a 1935 book by the young art historian E. H. Gombrich. Neurath had sent him a British history of the world for children to review, for potential inclusion in a series on 'Science for Kids'. Unimpressed, Gombrich decided to write one himself. The one book that Gombrich, who fled Vienna the year after, would write in German, it was only published in English seventy years later as *A Little History of the World*, when Gombrich's first book became his second bestseller. The distance of nine decades obscures some of what is progressive in the book (as with most of Gombrich's histories, the world outside of Europe and parts of Asia does not really exist), but it had a gentle scepticism towards capitalism, nationalism and race 'science', and a strong pacifism, not to mention a sympathetic if faintly mocking account of socialism. (For Marx, 'there were no longer any real occupations. There were just two sorts – or classes – of people: those who owned and those who didn't. Or as he chose to call them, capitalists and proletarians, for he liked using words from other languages.')[4] This was more than enough for the book to be banned upon the Anschluss in 1938.

As his later colleague at Thames & Hudson, Tom Rosenthal, points out, 'Neurath belonged to a European tradition of publishing where the series, or what the French call a collection, was the norm if not the rule.'[5] One of these series we've already explored, but the most successful aside from King Penguin was 'Britain in Pictures'. Edited by the poet and musician W. J. Turner, with an almost entirely British team of writers for its dozens of bright, slim volumes, it was harder than King Penguin for

anyone not familiar with German books to guess how Central European a project it was. The writers for 'Britain in Pictures' consisted of a litany of the most emphatically, sometimes insufferably English of all those at large in the British culture of the 1940s: George Orwell, Edith Sitwell, John Betjeman, Rose Macaulay, Cecil Beaton, John Piper. There were volumes on *English Painters, English Drawings, English Clocks, English Social Services, English Cricket, English Inns, English Conversation* and, when the focus needed to be more imperial, *British Statesmen, British Explorers, British Orientalists, British Ships, British Maps, British Courage*. In fact, this paroxysm of island backslapping was at every level except for the texts an entirely Central European endeavour. The 'Britain in Pictures' project was government-backed as part of the wartime propaganda effort, which meant that in 1940, most of Adprint's staff had to be quickly released from the Isle of Man internment camps into which most of them had been dumped. The staff was mainly female,[6] and included among others Marie Neurath, the statistician, designer and partner of the Viennese socialist polymath Otto Neurath (no relation to Walter); Eva Feuchtwang, a Berlin art dealer who was moving into publishing; the designer and typographer Elizabeth Friedlander; and the Warburg art historian Hilde Kurz, who had the all-important position as Picture Editor on this highly visual series.

Even the feature that almost all the books had, the words 'BRITISH' or 'ENGLISH' (more seldom 'SCOTTISH', once 'IRISH', and once 'WELSH') prominently in the title, preferably right at the start, was borrowed from a German precedent. In fact, the entire project was, like the King Penguins, a then-unmentionable direct copying of a German publishing series – the Blue Books, published by the Leipzig publishing house of the German nationalist Karl Robert Langewiesche. These books were originally devised during the First World War, again as an obvious propaganda initiative – a reminder of the green, green grass of home, or rather, the delights of *German Baroque, German Cathedrals* (both written by Wilhelm Pinder), *German Water Towers, German Paintings, German Mountains, German Rococo, Old German Cities*. Unlike the 'Britain in Pictures' books, the Blue Books ran for decades, from the 1920s until the 1960s. Although they were published by a company that generally supported the German right, during the Weimar Republic the Blue Books even featured a couple of volumes of beautifully photographed modern architecture, on *Buildings for Community*

in *Contemporary Germany* and *Residential Buildings and Housing Estates*, in which the clean lines and dramatic angles of *Neues Bauen* social housing and brick Expressionist public buildings are framed by the rather stiff, traditional design and the Gothick blackletter font.

Conservative as the Blue Books were, they remained typically lovely products of the Leipzig publishing industry, with good paper, illustrated dust jackets, an elegant serif typeface and with superb reproductions of photographs, all at a very affordable price. Every single thing about the series was copied by 'Britain in Pictures', except that the colour of each volume is different, the format is slightly smaller, and the image in the centre of the cover was drawn rather than photographed. Were it not for the war, Langewiesche could happily have sued.

A look at some of these volumes will give a sense of what Neurath, Foges and Kurz were up to here, and how their anglicization of the Blue Books worked as wartime propaganda and national self-congratulation. George Orwell's 1947 *The English People* (initially trailed as *The British People*, presumably until the team read Orwell's insults for the allegedly more fanatical and austere Celts) is a less insurgent rewriting of his earlier *The Lion and the Unicorn*, a charming enough potboiler; for this, Kurz commissioned a drawing of a speaker gesticulating on the stump at Speakers' Corner in Hyde Park, watched by English people with various levels of curiosity. The pictures she selected are all depictions of ordinary Englishness, urban, suburban and rural, north and south, pubs, factories and gardens of the Home Counties; most of them were recent, and aside from two drawings by Henry Moore, most are realist. There are great English eccentrics like L. S. Lowry and Edward Ardizzone, and irrespective of Orwell's insistence that continentals would never really understand English values, the first image is a busy, Expressionistic drawing of Piccadilly Circus by the Polish émigré artist Feliks Topolski. Kurz's choice of images for John Betjeman's *English Cities and Small Towns* (1943) is similarly interesting for trying to show a 'real' England rather than just the tourist's mass of monuments, green fields and villages. Even more than Orwell's book, it can be enjoyed purely visually, with its colour plan of sixteenth-century Canterbury, its nineteenth-century shop fronts taken from contemporary Birmingham advertisements, its John Piper aquatint of Brighton, its watercolour of the factories lining the Leeds and Liverpool canal and its panorama of heavily industrialized Halifax, its Turner engraving of the Gothic

horror of Ely Cathedral, and its wonderfully naïve Georgian lithograph of Dawlish seafront in Devon. In these images, there is a sense of discovery and enthusiasm in the throwing together of these disparate ways of seeing a still unfamiliar country.

What the books are not, however, is modernist; unlike in the Blue Books, there is no volume in the 'Britain in Pictures' series celebrating new public buildings or housing estates. Indeed, some of the books take time to admonish continental modernist design as a typically un-English form of abstraction. The typographer Francis Meynell's *English Printed Books* is a handsome tribute to the sensible, conservative and high-quality English book, from Caxton to Ravilious, immediately dismissing the entire Penguin project on the first page by telling us that nobody would ever want to 'furnish a room' with *paperbacks*. Meynell cites the books of 'the Surrealists and Dadaists of France', which are 'by no means "readable", or intended to be',[7] and dismisses the 'New Typography' as a simple mistake, where 'in the nineteen-twenties German printers made a vogue, copied occasionally even now in England, for sans serif types . . . arguing that the greater simplicity and "logic" of this letter made it more legible. They were doubly wrong',[8] ignoring the fact that familiarity and depth are easy on the eye. But not all of the Adprint book series followed this conservatism – two, in fact, were late examples of modernist publishing at its most radical.

Adprint's three series 'The New Democracy', 'America and Britain' and 'The Soviets and Ourselves', along with the firm's one-offs such as J. B. Priestley's *Theatre Outlook* or Stephen Spender's *Citizens in War and After*, were resounding propaganda for a new, democratic socialist world order, and a new, planned Britain, just as much as 'Britain in Pictures' embodied the rather more familiar propaganda for the war effort.[9] Even the 'America and Britain' series concentrates on the United States of the New Deal, the Works Progress Administration and the Tennessee Valley Authority rather than of Hollywood, General Motors and the Empire State Building. These programmatic books were not, unlike the King Penguins or 'Britain in Pictures', copies of some Leipzig book series, but their approach was absolutely modernist and absolutely Central European – this time much more proudly and obviously so, right down to the use of modernist fonts like Futura for the headlines and captions. All these books mixed together photomontage dust jackets, Isotype charts by Otto and Marie Neurath, and stark, realistic

photography by the likes of Kurt Hutton or Wolfgang Suschitzky, sometimes assembled into discrete photo-essays in the style of *Picture Post*. Of all the British books at the time, they most resemble the experiments of the avant-garde, comparable at times to something like Moholy-Nagy's Bauhaus Books in their visual density and intense belief in the new. It is interesting how much, compared to the other series – bestsellers at the time and beloved of collectors ever since – these books have fallen through the cracks of the Cold War.

This is understandable, perhaps, in the case of 'The Soviets and Ourselves'. With texts edited by the Scottish Christian Socialist John Macmurray, this series consisted of three books, *Landsmen and Seafarers*, *Two Commonwealths*, and the amusingly titled *How Do You Do Tovarisch?*, each of them with Isotype charts, extensive use of photographs and photomontage dust jackets by John Heartfield. (Like most of his British montages, these are very far from the dynamism and venom of his best work, consisting of simple juxtapositions of British and Soviet scenes.) What is intriguing about those books at this distance is that they expand out from the deliberate give-them-what-they-want parochialism of 'Britain in Pictures' to treat the British Empire – or 'Commonwealth' – and the Soviet Union both as species of empire, or, rather, empires allegedly in the process of de-imperializing themselves. This leads to many juxtapositions that now look extremely uncomfortable – comparisons of the goldfields of the Transvaal and the Lena, of the elimination of Shamanism in Soviet Asia and illiteracy in Nigeria, side-by-side images of the fertile fields of Queensland and the Volga, and images of starving peasants 'before collectivization' (in reality, the collectivization of Soviet agriculture was a disaster, leading in Ukraine and Kazakhstan to one of the most lethal famines in recorded history). This approach is in some ways admirable in trying to explain and describe an 'alien' society to a British reader, but its assumptions about the progressive nature of command economies and empires does show through.

There is less to be embarrassed by in 'The New Democracy' series, except perhaps for the failure of the existing post-war Britain to live up to the hopes it so longingly depicts. Its volumes included Stephen Taylor's *The Battle for Health*, part of the propaganda effort that would help create the National Health Service, and the outline of a future of full employment in *There's Work for All*, written by the Hungarian leftist economist Theodor Prager with the young member of the

planning organization PEP (Political and Economic Planning) – and future Labour peer – Michael Young. One of the most interesting in the series is *Women and Work* by the economist Gertrude Williams, a book on something the Labour government was actually rather keen to put back in its box – the massive female participation in the labour force during the war. The picture editor of the series was the documentarian Paul Rotha, and around a third of the book is taken up with humane, lively documentary photographs of women in stereotypically 'male' professions: lumberjacks, mechanics, engineers, lorry drivers.

The Isotype charts are the most enduringly fascinating thing about this clutch of books (on eBay, you will find them sold at a sharp markup by Isotype specialist sellers in the Netherlands). We have briefly encountered the Isotype Institute in Paul Rotha's film *Land of Promise*, and we will come across the charts again over the course of this book, but it is now worth pausing to explore what it was and what it was trying to do. ISOTYPE – the International System Of TYpographic Picture Education – was a picture language developed by three people: the Austrian positivist philosopher and socialist economist Otto Neurath, who attempted to devise a democratic planned economy and self-build co-operative housing in the early days of 'Red Vienna' after 1918; the German Constructivist and libertarian communist artist Gerd Arntz, who devised the pictorial figures that would become the 'letters' of the language; and the German graphic designer, or as she preferred to describe her role, the 'transformer' Marie Neurath (née Reidemeister), who had the task of taking the raw materials the trio assembled and turning them into graphs and charts. Initially working for the Municipality of Vienna, and then for a multiplicity of clients from private businesses to (briefly) the government of the Soviet Union, the aim of the Isotype Institute was to present information about the world in such a way that only a rudimentarily educated – or entirely uneducated – readership and audience could grasp it in some of its complexity. Although much of this was straightforwardly educational raw information on geography and society, the three developers were especially interested in presenting the contradictory and tense aspects of the world system, with their graphs giving visual form to the inequalities between classes and nations.

The visual impact of these graphs was so vivid and, importantly given the apparent high-mindedness of the endeavour, conveyed so much fun – the colours are so bright, the use of Paul Renner's Futura for the

type is so enduringly powerful, and there is a real wit in Arntz's figures, with their stylized indications of class and place – that they were popularized even in Britain before the Institute was forced to escape here, with Secker & Warburg (no relation) publishing a translation of their *Modern Man in the Making* in 1939. Soon after that, Otto and Marie Neurath escaped from the Netherlands – where they had sheltered from their native Germany and Austria – the week that the Nazis overran the country. These great technocrats and depicters of modern society's vast scale and complexity landed on the sands of Kent on a raft. Following their internment, the Isotype Institute managed to resume its work in Oxford, and after Otto died in 1945, Marie carried on its work in a series of brilliant, colourful, witty and politically sharp charts for Adprint.

Some of the means by which Isotype achieved its ends can be seen in a graphic from *Landsmen and Seafarers* titled the 'History of National Expansion'. It elegantly tries to reveal the different 'character' of the British and Russian empires, showing Russia's gradual annexation of the Eurasian plain, the Caucasus and Central Asia as the absorption of one, continuous landmass, and the British occupation of a similarly vast territory happening across the oceans, piece by piece from Canada to South

Soviet Empire, British Empire.

Africa to India to Australia; here, the book's argument is understood in a split-second. But there are more abstract graphs to be found too, such as the one about the progress of the 'Conquest of Nature' in the two empires, as plague, wolves (howling, in the graphic), fires and inundations are shown besetting Russia right up until the twentieth century.

J. B. Priestley's *Theatre Outlook*, meanwhile, is an enjoyable book advocating the nationalization and community ownership of all theatres, written as a manifesto for the newly created Arts Council by the great voice of populist socialism on the wartime airwaves. The Isotype charts in the book are there to make pointed arguments about the way class and geography limit access to the theatre. In a chart showing the price of a theatre ticket, you can see how tickets have gradually become cheaper compared to whisky and cigarettes (so why not buy a ticket?); and in two geographical charts, you can see the extent and types of theatres in England's major industrial areas, the Midlands and the North, showing how few repertory theatres there were outside of the big cities and how certain areas (especially mining districts) were starved of anything other

Cultural Provision in the English Midlands.

than one or two Variety houses. Similarly, there's an intense attention to inequality in the Isotype charts for *Women and Work*, in which the huge differences in earnings for the same work – particularly in industry – is shown very clearly; as is the surely linked relative lack of women in the trade unions. Meanwhile, the onset of labour-saving devices is shown in a graph on 'The Changing Home', in which the pictograms for childcare (a cot), cooking (a pan) and washing (a dangling stocking) are replaced in 'The Future?' by a single pictogram of a Hoover.

After Adprint was wound up at the end of the 1940s, Isotype lost its outlet in popular, accessible and cheap books; it proved to have been one of many brief flashes of radicalism during and after the war that gradually disappeared as Tory governments, capitalist normality and a new affluence asserted themselves in the 1950s. Marie Neurath now focused her activities on children's books for the publisher Max Parrish; first still in an obviously Isotype style, which she then subtly adapted into a clever, parodic version of ancient styles of art for the 1960s series 'They Lived Like This in Ancient Times'. These books were still educational, still a means of explaining complex ideas through visuals, and some of them – such as *Railways Under London* from 1948 – are quite beautiful. However, the idea that education could be something continuous, rather than just for children, and that this could be done in a way that wasn't hectoring or patronizing in the style of 'The Man from the Ministry', did not really survive the 1940s.[10] Accordingly, it's not accidental that the revival of interest in radical theories of education in the 1970s also meant a revival of interest in Isotype, with the University of Reading eventually taking on the Isotype Institute's extensive, rich archive.

Marie Neurath's move into children's books was paralleled by many other avant-garde émigrés; books for children proved to be an outlet for work that was otherwise regarded with suspicion, much as it was in the later Soviet Union, when the likes of Ilya and Emilia Kabakov or Erik Bulatov spent their days making children's books and their evenings creating conceptual art. Sometimes these books were clearly aimed at schools, first and foremost, as in the case of Neurath's series 'They Lived Like This in Ancient Times', which ran for many years, with over twenty-five volumes on everywhere from 'Chaucer's England' to 'Old Japan', 'Ancient Mesopotamia' to 'Ancient Mexico'. They drop entirely the obviously modernist aspects of the Isotype language, such as Gerd Arntz's little playmobil-like

figures and the sans-serif fonts, but show how the approach could be used to present historical data and historical difference.

Similarly educational was Jacques Groag's *The Story of Furniture*, a Puffin picture book produced with the Cotswolds furniture designer Gordon Russell, and a brave attempt to explain the principles of modern design to schoolchildren. Groag was in a sense one of the great tragic figures of the emigration. He was an important architect, working as the project architect both on the Wittgenstein House and Adolf Loos's Moller House in Vienna, and designing several unusual, and unusually comfortable, modernist houses in and around his native Oloumuc, Czechoslovakia. In his London exile, however, he never managed to rebuild his career, but did help produce the cheap, attractive functionalist 'Utility' furniture that Russell was commissioned to design by the government; there is a great photograph of Aneurin Bevan approvingly inspecting an exhibition of Utility furniture with Groag lurking in the background.[11] *The Story of Furniture* is designed and illustrated by

How much does your chair weigh, Mr Groag?

Groag, with a text by Russell, and it ends with two facing pictures of a stuffy, dark, crammed Victorian interior, without sun or joy, and a modernist flat, with lots of glass, space, and room to play – 'Now, you see, we welcome the sun and have come to regard furniture as part of the equipment for a pleasant life rather than as something to impress our friends . . . We have discovered that people are more important than things.'[12] In the two images, Groag's pastel colours and gentle simplicity of line anticipate the work of Raymond Briggs rather more than they resemble the paintings of Le Corbusier.

A lot of other children's books by exiles were obviously made just for fun. The work of the Polish duo Jan Le Witt and George Him, always credited as Lewitt-Him, was a case in point. Both born in the 1900s, the duo – born Jan Lewitt and Jerzy Himmelfarb – had gained a reputation in Poland both for their poster designs and for children's books illustrating works by the modernist poet Julian Tuwim, like *Lokomotywa* ('Locomotive', 1938). In Britain they continued their poster design practice for the Ministry of Information and various corporations, but put out more children's books, such as the 'Red Engine' series by Diana Ross.

Once upon a time there was a Little Red Engine. It lived in a shed with a Big Black Engine and a Big Green Engine at the junction of Taddlecombe, where the great main line to the North, and the great main line to the South met the little branch line on which the Little Red Engine was running.

A Polish train through Old England.

These little books, published by Faber, matched the tale of a train with beautiful, simple, eccentric illustrations in a distinctly Central-Eastern European style of flat colours, spiky Gothic houses, spindly figures and a friendly sense of abstraction, where the modernist refusal of realism and perspective is rendered cute rather than aggressive.[13] In the 1960s, Le Witt returned to the abstract painting with which he began his career in interwar Poland, but Him carried on with children's books, including 'The Giant Alexander', a lovely series of tales of an unmissable alienated figure who finds himself first out of place and then highly useful on the streets of London. It was written in the 1960s by the editor, designer and former child refugee Frank Hermann, who came to Britain in 1937 at the age of ten, and had grown up reading Lewitt-Him's children's books of the 1930s. These constitute just the tip of an iceberg of children's books, in which a huge number of émigrés participated – Judith Kerr, Hans Tisdall, Walter Trier, Val Biro and lesser-known figures like Dora Adler, George Buday, Klara Biller and Bettina Ehrlich, all of whom produced their own illustrated books. The Expressionist engraver Hellmuth Weissenborn even found himself illustrating a work by Enid Blyton, that icon of English philistinism, for the Biblical children's book *The First Christmas* (1945), for which he created little paper dioramas of the Christ Child and his attendants that were then photographed. The degree to which any of this was particularly subversive may be debatable, but what is clear is that the experiments that were otherwise marginalized in the Cold War continued their shadow-life in the nursery library.[14]

As to books for adults, there was a gradual recovery from the reaction that saw the decline of the Isotype Institute into relative obscurity or the watering down and then closure of *Picture Post*. From its rather opportunistic beginnings, Adprint had developed into a genuinely ambitious project, aiming to bring the Constructivist avant-garde's revolution of everyday life into British homes. After conflicts between its founders Foges and Neurath led to the firm's demise, Walter Neurath's next project was perhaps more influenced by a somewhat more conservative Anglo-Austrian art publisher: Phaidon. Founded by the publisher Béla Horovitz and the art historian Ludwig Goldscheider, Phaidon, with its classical, Platonic name, was established in Vienna in 1923 as a classics line, but by the mid-1930s had carved out a niche as a publisher of art books, most on acceptably historic subjects, although with a few on artists who were considered 'Degenerate' by the Nazis, such as Vincent van

Gogh. In 1938, Horovitz and Goldscheider escaped the Anschluss and through a joint venture with a British publisher were able to continue Phaidon's project in London, and to save their papers and archives from Vienna. Although there was much less ideology and idealism here than in Neurath and Foges' endeavours, Phaidon had also noticed that art publishing in Britain catered largely to a moneyed elite, and it aimed to fill the gap that left. Horovitz and Goldscheider were committed to making difficult ideas and rarefied artworks accessible, sweeping away from their books any jargon, snobbery or obfuscation and presenting the art in a democratic, straightforward way, as we've seen in the case of Helmut Gernsheim's vision of an unexpectedly classical, graceful *Beautiful London*. Early British Phaidon books, like Goldscheider's large-format photobooks on Michelangelo or Kokoschka, or the small-format volumes on Baudelaire and Erasmus, or Ferdinand Gregorovius's little book *Lucretia Borgia*, had a similar look to Jan Tschichold's redesign of the Penguin Classics: graceful, neo-Renaissance, visually clear and quiet; *Bildung* on a budget.

The book that made Phaidon, of course, was E. H. Gombrich's *The Story of Art*, first published by them in 1950 and frequently updated until the author's death in 2001 at the age of ninety-two. It may seem counter-intuitive that the man who was then the director of the Warburg Institute, and hence assembling and maintaining Aby Warburg's extensive, esoteric and multilingual library of connections and associations in its new purpose-built Bloomsbury home, was also the author of probably the most popular book on art ever published. Gombrich had a talent for genial, unpatronizing explanatory writing, as was obvious from his *Little History of the World*, but it could be argued that the apparently rarefied Warburg world lent itself to removing much of the mystery and bullshit surrounding art. The great achievement of *The Story of Art* lies in its *freshness* – the way in which, at least when he is looking at and describing art, Gombrich never uses a cliché. His language is always clear, his judgements are remarkably open-ended, unprejudiced and unsnobbish, and there is a careful avoidance of the class judgements so common in an art world based on 'connoisseurship'.

Famously, Gombrich asserts at the beginning of the book, 'I do not think that there are any wrong reasons for liking a statue or a picture', but 'there are wrong reasons for disliking a work of art'. These 'wrong reasons' are those based on *preconceptions* – often mistaken – about

skill, ineptitude, veracity, politics, class and the *Zeitgeist*, all the received ideas that people unthinkingly take with them when they enter an art gallery and a museum.[15] Gombrich is especially keen to sweep away the aura that surrounds modern art (which he supported, until Conceptual and Pop Art tried his sturdily empiricist patience). As in his King Penguin on *Caricature*, he draws on very populist examples to make this case. 'There is no mystery about these distortions of nature about which we hear so many complaints in the discussion of modern art. Everyone who has ever seen a Disney film or a comic strip knows all about it.'[16] What is needed is 'the will, the leisure and the opportunity', and with that, 'anyone can become a "connoisseur"'.[17]

There is so much that is admirable in *The Story of Art* that there are things to learn in what it excludes. Women are notoriously non-existent as anything other than models. There is also an extreme Eurocentrism, although this is tempered somewhat by Gombrich's open-minded comments on the so-called 'Primitive Art' of South America or West Africa. He argues strongly that those artworks were not mere expressions of 'undeveloped' peoples or rudimentary societies, but distinct ways of seeing. Like the Egyptians or Byzantines, these people knew exactly what it was they were doing; they were neither clumsy nor foolish. Similarly, he is keen to admit just how much trash the nineteenth century produced. 'Even historians today,' he writes in 1950, 'know very little about the official art of the nineteenth century'. Although he predicts this would change (it hasn't yet), 'it will possibly remain true that since the great revolution' of modernism, 'the word Art has acquired a different meaning for us and that the history of art in the nineteenth century can never become the history of the most successful and best-paid masters of that time. We see it rather as the history of a handful of lonely men who had the courage and the persistence to think for themselves.'[18] Seventy years later, so it has remained. And as in the *Little History*, there is a certain sardonic wisdom in the connections Gombrich makes between art and power. 'On all the monuments which glorify the warlords of the past,' he finds when looking at Assyrian battle scenes, 'war is no trouble at all. You just appear, and the enemy is scattered like chaff in the wind.'[19]

What becomes conspicuous at times is Gombrich's lack of interest in social history. As a close ideological ally of Karl Popper, who opposed the 'Open Society' to Plato, Hegel and Marx, Gombrich believed that the abstractions of Marxism or any notion of a *Zeitgeist* or a 'purpose' to

history necessarily lent themselves both to bad (because vague, unspecific and lofty) criticism and to totalitarianism; therefore, he harshly opposed sociology entering into the discussion of art. As the Italian historian Carlo Ginzburg pointed out, this meant Gombrich had to significantly depart from his Warburg precursors such as Fritz Saxl or Aby Warburg himself, for whom the discussion of class, the market, inequality and social hierarchy was entirely compatible with the writing of art history, and in fact, was essential to it. 'There is no doubt that the terrain into which Gombrich has led us is certainly firmer,' wrote Ginzburg, 'but also more barren.'[20] Gombrich consciously dampened down much of the theoretical energy and excitement, not to mention the politicized moral force, of Central European artistic culture, and settled it down into a solid Empiricism that was more compatible with Oxbridge English culture.

Thames & Hudson was formed in 1949 by Walter Neurath with Eva Feuchtwang. In her own account (as Eva Neurath, after their marriage four years later), the publishing house was born out of the enthusiasms of the Weimar Republic. Founded by two people who had not attended university, the stated intention of Thames & Hudson was to create a 'museum without walls'.[21] In the book of *Recollections* that was published after her death, Eva Neurath, born Eva Itzig to a vegetarian, socialist, feminist family in Berlin, recalls coming of age in a time 'alive with conflicting movements'. Her youth was all Bauhaus Balls ('one made one's own costume, often thin and transparent – good at the ball but cold in the icy winter air'),[22] Eisenstein films ('I was so totally swept away by the film about the October Revolution in Petrograd that I found myself together with the rest of the audience standing up, clapping and shouting'),[23] new architecture, new literary and artistic trends and social experiments, a world brought crashing down at the start of the 1930s. She stresses, however, the conservatism of much of the German middle class in which she was raised, in a shocking school anecdote:

> Karl Liebknecht, the radical Social Democrat and head of the so-called Spartakus Bund, and Rosa Luxemburg, also in the leadership of the Bund, were murdered in June 1919 by the Deutsches Freikorps. These two people were greatly admired by my mother, in particular Rosa Luxemburg, who indeed was a most sensitive and poetic writer, whose letters from prison are widely published now and a joy to read ... [my and my sisters'] school was Right-wing, Deutschnational, and great joy was expressed when both

these murders were announced. I came home and found my mother, surrounded by my sisters, in violent tears standing by a window. I, however, being innocent and ignorant, cried, 'Mummy, Mummy, hooray! Rosa Luxemburg is dead!' I believe she did not talk to me for weeks. I did not know why; it was a terrible thing.[24]

After working in Berlin as an art dealer, then escaping to Britain after *Kristallnacht* (with her second husband Wilhelm Feuchtwang) and being struck by the 'never-ending rows of houses'[25] on Kilburn High Road, internment, and work for Adprint, Eva became the co-chair of Walter Neurath's new illustrated book publisher Thames & Hudson. This was a joint venture with an American publisher (who soon pulled out), its production handled by Jarrolds, a Norwich printer that had proven themselves adept at handling Adprint's demanding colour books. Although, as was mentioned at the time, the backgrounds of the couple meant that 'Danube and Spree' was more apposite, the name Thames & Hudson was adopted because the publisher, though based in London, was intent on being international; from the start, its books were translated and distributed across Europe and the Americas.

Again, the Neuraths devised various illustrated series, in the Leipzig style of Adprint's celebratory, educational or political 'collections'. They were a slightly motley lot. Among those that sold well were the archaeology series 'Ancient Peoples and Places', which had vivid photomontage covers by the Bauhaus-trained artist George Adams, previously Teltscher, who had fought in the International Brigades before escaping to Britain with the assistance of the Quakers in 1938.[26] The locations, as would be the case for Thames & Hudson generally, were geographically fearless, with subjects familiar in the 'Pelican History of Art' like the Etruscans or the Greeks rubbing shoulders with Balts, Phoenicians, Lapps, Seljuks, Persians, Peruvians, Koreans, and a volume on the ancient people of the mysterious land of Wessex; there was also a heavier and duller series on the more familiar subject of 'Great Civilizations'.

Other series were not quite so popular, such as a short-lived one on 'The Presence of the Past', influenced by Jungian psychology (another of the Neuraths' enthusiasms), edited by the archaeologist Jacquetta Hawkes. There was a series on 'New Nations and Peoples', which mostly celebrated the countries that had emerged as a result of decolonization, a sort of illustrated guide to the Non-Aligned Movement; an illustrated

'Library of European Civilization', which included future classics like Peter Brown's *The World of Late Antiquity*, but ran right up to the recent past, in A. J. P. Taylor's tart and panoramic *From Sarajevo to Potsdam*; like so many Adprint books these worked just as well as a visual experience, with Taylor's book a charged montage featuring the crazes and disasters of the interwar years; there was also a series of illustrated biographies of artists, writers and their 'worlds'. By now, printing costs had fallen and illustrated books had become less luxurious. Thames & Hudson's books had low price points even for the time, and were visually impressive but unfussy, with simple, clear modernist designs by their in-house designer, Shalom Schotten – another Austrian émigré, who in the 1930s had escaped from Czechoslovakia to France then Palestine. Schotten became an artist relatively late in life, making silk-screen posters during the 1950s in the new state of Israel, one of those 'New Nations', before he moved to London to study graphic design.

But the project for which the Neuraths will be most remembered, and the one that is still in print and still expanding, is the 'World of Art', a series which did everything that comparatively staid projects such as Phaidon or the 'Pelican History of Art' avoided. Its premise was very simple – short books, usually by academics, about a particular artist, museum or movement, illustrated, in elegant, Swiss modernist black covers, with a logo of two dolphins by Elizabeth Friedlander. It had no masterplan, no fifty-volume attempt to tell the story of all art. The Neuraths remained modernists enough to realize that such a thing was pointless, intuiting that the subject would be constantly changing and expanding, and could never possibly be definitive or conclusive. With a couple of exceptions, they avoided the historians of the Warburg Institute – increasingly part of the British Establishment in any case – and brought in many new voices, along with some more familiar names such as Herbert Read.

Within its first few years, the 'World of Art' had scored a number of coups, publishing the first serious books in English on the Russian and Soviet avant-garde (Camilla Gray's *The Russian Experiment in Art*) and on Dadaism (Hans Richter's *Dada*). In this way the series was finally opening up to British readers the Central European avant-garde that had been so poorly understood when its members washed up on the shores of the English Channel, which many survivors themselves became rather reluctant to explain or defend. The 'World of Art' books were neither exhaustive like the 'Pelican History of Art', nor quite populist

in the mould of Gombrich's *The Story of Art*, but their bibliographies and pointers opened up the subjects to further exploration. And within them was everything that the Oxbridge art-history culture, which had only just been established, had tried to keep out of its borders, everything that Gombrich had left out of his *Story of Art*. The 'World of Art' opened the floodgates. Yes, there were volumes on *Athenian Red Figure Vases*, *Art of the Byzantine Era*, *Mycenaean and Minoan Art*, and *The Classical Language of Architecture*; so there should be. But alongside their black spines you could now find *Aboriginal Art*, *Contemporary African Art*, *Women, Art and Society*, *Conceptual Art*, *Caribbean Art*, *Posters*, *Photomontage*, *Pop Art*; so it should continue.

Eva Neurath recalled near the end of her life, upon seeing the success of the 'World of Art', that 'Allen Lane considered Thames and Hudson to be providing a service to the reading public in terms of art books similar to what he was doing with Penguin'.[27] This is among other things a tacit admission that the Neuraths had done exactly what it was that Neurath

The New World (of Art).

and Pevsner had failed to do with the 'Pelican History of Art', through its grandiosity and pomp. Walter Neurath chose to be buried in Highgate Cemetery near Marx.[28] Of course, he had founded a profit-making business, or several, and had done well out of it. He had travelled a great distance from being a young Marxist in hiding, as the Nazis occupied Vienna. But the richness of the museum without walls that the Neuraths built still carries some of the grandeur of 'Red Vienna' to the bookshelf in every bedsit and every shared flat of every art student, gallery-goer and provincial autodidact in Great Britain and elsewhere.

There is still something missing here, in this assessment of *Buchkunst* and *Kunstgeschichte* in Britain. We have found that liberals such as E. H. Gombrich thrived, as did social democrats like Nikolaus Pevsner and Walter Neurath; and some Marxist creators of art books, like the hybrid designer-artist-statisticians of the Isotype Institute, managed to make their mark here for a time. But there was another group of art historians who emigrated from the European continent after 1933, who are much less often part of the picture of how the émigrés arrived and revolutionized British print culture and our understanding of visual art. At the time, however, they were much less obscure than they are now; perhaps, if any need rescuing from the oblivion to which the radical edge of the emigration was consigned with the Cold War, it is them. There were four card-carrying Communist Party-aligned émigré art historians working in Britain between the 1930s and 1950s, but none of them ever published with Penguin, Phaidon or Thames & Hudson.[29] Their actions and their influence were more shadowy, and there is evidence that ranks were closed to keep some of them out of university positions and book contracts.

These four consist of three Hungarians and one Anglo-German. The latter was Francis Klingender, who was born in 1907 in Lower Saxony and raised there by English parents; the family were interned during the First World War, and Francis was bullied at school in Germany for being 'English', before moving to Britain as a youth in the mid-1920s. Like Eric Hobsbawm or Bill Brandt, Klingender can't be described as a refugee as such – given he was born eligible for a British passport – and the degree to which he was either German or English can be disputed, though by all accounts his accent placed him as German in the extremely cadence-conscious world of 1920s London. Rather, Klingender's work thrived on always being somewhere in between the two cultures. After early jobs in Germany, working for the Berlin publisher Rudolf Mosse (major sponsors

of modern architecture, with a flamboyant Erich Mendelsohn-designed Berlin HQ) and in Britain, with the Anglo-Soviet trade company ARCOS (before it was closed down by a Conservative government as a threat to national security), Klingender became at various points a lecturer in sociology at the University of Hull, an arts journalist for *Picture Post*, the Communist *Daily Worker*, and more niche publications like the *Burlington Magazine*, and was an active member of the Communist Party of Great Britain. He carried out research into the big-business domination of the film industry on behalf of John Grierson of the GPO Film Unit, but Klingender's major publications were all on art – on the depiction of animals, on Goya and Hogarth, and the classic *Art and the Industrial Revolution*.

The Hungarian Marxist art historians Frigyes Antal, Johannes Wilde and Arnold Hauser were all, like Stefan Lorant, Alexander Korda and László Moholy-Nagy, part of the double or triple migration that happened to the participants in the 1919 Hungarian Soviet Republic. In Béla Kun's revolutionary government, György Lukács had given the young art historian Frigyes Antal the task of creating a socialist museum system, in which capacity Antal surveyed the art treasures that were in the possession of the Hungarian bourgeoisie so that he could nationalize them and place them in new, free, public museums. Like Lukács, Lorant, Korda and Moholy-Nagy, Antal, along with his deputies Wilde and Hauser, fled the White Terror to Vienna. There most of the trio worked in some capacity in museum curation, before fleeing either with the Austro-Fascist coup of 1934 in the case of Antal, or with the Anschluss in 1938, for Wilde and Hauser. All of them worked for most of the rest of their lives in Britain. Wilde worked closely with Kenneth Clark at the National Gallery and wrote monographs on Michelangelo and the Venetian Renaissance; during the war, he joined the army, was accused, groundlessly, of being a traitor, and was placed in an internment camp in Canada. Hauser, of the three, had the most conventional academic career, in that he managed to secure a lectureship at the University of Leeds. His four-volume *Social History of Art* was published in the early 1950s by Routledge; it elicited the praise of the exceptionally hard-to-please Theodor Adorno at the newly repatriated Frankfurt School in West Germany, but was notoriously denounced as a work of sloppy scholarship and ideological rigidity by E. H. Gombrich, a summation of everything he distrusted about Marxism.

In Britain itself, it was Francis Klingender and Frigyes Antal (who

renamed himself Frederick) who were most influential. In fact, what is perhaps most unexpected in their work is the level of interest in, and praise of, British art – very unusual among the émigrés. The Warburg retained some partial interest in the English baroque (showcased in *British Art in the Mediterranean* and in Gernsheim's *Beautiful London*), but their main preoccupation remained where it always had been – in Greece and in Italy. Pevsner, as we'll see in a later chapter, was a major exception, devising an entire theory of 'Englishness' to subsume everything from Turner to Blake to the London County Council's Alton Estate in Roehampton, but the social history of this 'Englishness' was not apparent at anything more than a fairly superficial level. Klingender and Antal, however, genuinely appeared to believe that British Art was of world-historical importance, and that it had been ignored by continental art historians because it was much more obviously connected to the great developments of the eighteenth century onwards – imperialism, urbanization, industrialism, capitalism. Both Klingender and Antal wrote important studies of William Hogarth, who, as we've seen regarding the King Penguin book on *Caricature*, was being recognized by émigré scholars as the creator of a new, didactic art that aimed to reveal the different layers of a class society. Hogarth satirized each of them in turn, without sacrificing his mastery of the artistic values of space, light and surface. Both Klingender's *Hogarth and English Caricature* – an annotated exhibition catalogue of 1945 – and Antal's *Hogarth and His Place in European Art* – written around that time but published posthumously in 1962, slotting his achievements into the canon – hailed Hogarth as one of the great artists of European history.

Yet outside of the realm of Florentine Renaissance specialists – his life's work was a widely praised social history of that city and its art market – Antal might possibly be best remembered as the mentor of Anthony Blunt, the Courtauld and Warburg scholar, 'Pelican History of Art' author and Soviet spy. Blunt's biographer Miranda Carter describes Antal as a 'tall, dark, attractive, often irascible' figure, who was 'given to extreme views; even his fellow émigrés thought of him as a loner'. He instructed Blunt in Marxism, which Antal then publicly espoused in his columns for *The Spectator* and the connoisseurs' publication the *Burlington Magazine*: taking its name from the Royal Academy, this journal rather incongruously published many Marxist writers in the 1930s and 1940s, under the editorships of Herbert Read, the Finnish

Bloomsbury associate Tancred Borenius, and the Viennese art historian Edith Hoffmann.[30] Antal's major English essays were published there, in a magazine originally aimed at upper-class art collectors.

In the 1960s, Perry Anderson used Antal's failure to build a career or even a stable income in Britain as evidence of how leftist trends in the emigration were suppressed. He contrasted Antal with Gombrich, whose 'primacy is not explicable merely by reason of his undoubted merits. Here too a filtering mechanism has been at work, in which the traditional culture has selected what is congenial and disregarded what is not. Antal, a social historian of Florentine painting, was kept outside the university world. Gombrich, associate and admirer of Popper and Hayek, has been canonized at large.'[31] Yet Antal, unlike Arnold Hauser, was grudgingly respected by Gombrich himself, who later recalled that 'of the Marxist art historians around, he was by far the most learned and sophisticated ... he was not a negligible person, and I can quite understand that Blunt was impressed by him'.[32] Reading Antal's scattered works today, some of the rudimentary approach of early Marxist art history is obvious enough, but so too is an openness and curiosity that sets him far apart from a stereotype of the Marxist as unthinking ideologue, ready to dismiss anything unsound as 'bourgeois'.

In terms of methodology, Antal had much sympathy with the Warburg Institute, and he praised it in a *Burlington Magazine* essay 'Remarks on the Method of Art History', published in 1949. He sets Aby Warburg up as an alternative to the formalism of Heinrich Wölfflin, praising his 'wide interest in many cultural and historical disciplines', and approvingly cites the Institute's Gertrude Bing on how Warburg 'succeeded in rescuing the work of art from the isolation with which it was threatened by a purely aesthetic and formal approach'.[33] Antal's own approach can be found in 'Reflections on Classicism and Romanticism', an essay published in 1935 for the *Burlington Magazine*, which goes over some of the same territory as Walter Friedlaender's *From David to Delacroix* (1930), but in a much more obviously political fashion, tying the French artists of the revolutionary period to distinct factions. Some of this is now rather antiquated, such as the attempt to create 'a division of David's art, according to its subject, into a classicistic type which is regressive, and a naturalistic type which is progressive', with his 'Revolutionary period' notable for its totality, 'when his life and his art, his politics and his historical paintings formed an inseparable whole'.[34] In general, Antal – like

Lukács – appeared to believe that the more naturalistic a work was, the more it was necessarily tied to politically 'progressive' currents – something that led them both into apologetics for Stalin's assault on modern art in favour of a fairytale 'Socialist Realism'.

What is much more interesting in 'Reflections on Classicism and Romanticism' is Antal's account of the painter Théodore Géricault, the hero of the essay, whose work he sees as becoming increasingly liberated from the tedious world of nineteenth-century 'History Painting' through his engagement with radical movements, and in particular, through Géricault's time in the world's most advanced capitalist city, London. There he was drawn, in pieces like *Entrance to the Adelphi Wharf*, to depict the tensions between vast works of engineering and enduring hard work and poverty: 'how interested he was, agreeably with his extreme liberal outlook, in the sad and dreary aspects of the popular, industrial quarters'. In this, Géricault 'genuinely carried on the art of Hogarth, the most unambiguously and militantly bourgeois-minded of all English artists', whose sometimes snobbish satires were 'carried a step further' to genuine radicalism by Géricault's sympathy with the poor.[35] It is in the recognition of these sympathies that you can anticipate the work of another of Antal's disciples, John Berger.

Klingender's best work was also animated by a fascination with Britain as an urban, industrial moloch, whose best artists were fixated on the contrast between rich and poor, and the potentials and horrors of a liberated technology. *Art and the Industrial Revolution*, originally published by Oliver Simon's Curwen Press in 1947 and published in paperback by Paladin in 1968, was a colossal achievement, still one of the most powerful and strange books ever written on British culture. There was, at the time, almost nothing remotely like it, save perhaps for the unfinished collage of materials on the Industrial Revolution, *Pandaemonium*, by the filmmaker Humphrey Jennings. *Art and the Industrial Revolution* even garnered high praise from John Betjeman, generally a giggily xenophobic scourge of anything produced by any 'Herr Professor Doktor', but who recognized that nobody else had managed to represent the shock and awe of the creation of industrial Britain in print.

The book could be divided into one section of text, and a stunning, Warburgian photo-essay in its last quarter, which throws together the industrial painting of John Martin and Joseph Wright of Derby, the sketches and plans of the great nineteenth-century engineers, engravings

of Merthyr Tydfil as the heart of the Biblical Apocalypse, and visions of a cybernetic Shropshire. Klingender's sources were remarkably catholic, in the Warburg manner – oil paintings, for sure, but also poems, pamphlets, broadsides, engravings, newspapers, blueprints, which pull together technology, imperialism and capitalism in ways that are often deeply counter-intuitive. Built on a foundation of coal – at the start, Klingender cites the seventeenth-century poet John Cleveland's couplet '*England*'s a perfect world, hath Indies too/Correct your maps, *Newcastle is Peru*'[36] – the foundries of the West Midlands and then the mills of Derbyshire, Lancashire and Yorkshire created a new world. Within a century, Klingender notes, Britain had been rendered unrecognizable through industry. He compares Daniel Defoe's seventeenth-century Tour around Britain with Arthur Young's journey of 1768. The contrast revealed a country that:

> resembles a gigantic laboratory. Everywhere exciting experiments are in progress; engineering feats undreamed since Roman times are being carried out; a new sense of power is stirring in the north.[37]

In the Midlands, Klingender finds that the iron forges and unprecedented metal bridges of Coalbrookdale 'exercised an almost irresistible attraction over the artists of the English school of landscape drawing from its first beginnings to its culmination'.[38] Marx appears, addressing a meeting of the London *People's Paper* in 1856, recounting how 'at the same pace mankind masters nature, man seems to become enslaved to other men or his own infamy', creating an 'antagonism between the productive powers and the social relations of our epoch', where the working class are 'as much the invention of modern times as machinery itself'.[39] What Klingender and Antal saw when they raised the curtain was something that appeared to interest neither the English connoisseurs in Bloomsbury and Mayfair, nor the continental scholars deep in the occult shelves of the Warburg. Britain was not, in fact, a weirdly out-of-time, conservative country that had somehow sat out all the conflicts of the twentieth century. This was its *appearance*, a high-Victorian historicist facade draped over the most intensely modern, urban and industrialized country in the world, one that had drawn the entire globe into its market. Never mind the persistence of antiquity, here was the very birthplace of modernity, and that remained the case whether its art practitioners and art historians used sans serifs and photomontages or not.

PART THREE

In and Out of Place
'Degenerate Artists' in Ordinary Britain

Let me tell you that you can't go on indefinitely painting the view from your window and pretend that it is all there is in the world, because it is not, you know.
Naum Gabo on the BBC, 1945[1]

17
How German Is It? – Three Exhibitions

There are two ways of expressing bigotry in British journalism. One is the model favoured both in the 1930s and today by the *Daily Mail* and *Daily Express*, where the voice expresses the opinions in question as their own, albeit with the speaker usually in the persona of a victim rather than aggressor; the other, similarly popular then and now in the *Guardian* and the *New Statesman*, is to state the bigoted opinion in the voice of someone else who is *supposed* to be bigoted. It isn't the writer's view, of course not, but it is an opinion a liberal like the writer has to bear in mind, because this is the way of the world. So it was with Raymond Mortimer's *New Statesman* review of an 1938 exhibition at the New Burlington Galleries, Mayfair, 'Twentieth Century German Art'. It was held, as the writer pointed out, in response to a touring exhibition of '*Entartete Kunst*' – 'Degenerate Art' – which was then touring around the cities of the Third Reich. 'People who got to see the Exhibition,' Mortimer wrote, 'are only too likely to say: "If Hitler doesn't like these pictures, it's the best thing I've heard about Hitler." For the general impression made by the Show upon the ordinary public must be one of extraordinary ugliness.'[1]

This exhibition was the very first in Britain to systematically document the art of late imperial Germany and the Weimar Republic. The Expressionists of *Die Brücke* ('The Bridge') and *Der Blaue Reiter* ('The Blue Rider'), the Dada montages of Max Ernst, Raoul Hausmann and Kurt Schwitters, the satirical and allegorical paintings of Max Beckmann, George Grosz and Otto Dix, and the more utopian Bauhaus modernism of Lyonel Feininger or Oskar Schlemmer – all were introduced to Londoners for the first time as products of distinct schools of art that had emerged in the cities of Germany. These are now regarded as canonical modernist artists, considerably more so than the French (let alone

British) painters whose careers began between 1918 and 1938. But for Mortimer – by no means a philistine or a fool, and someone we have already encountered introducing Bill Brandt's surrealist photographs of British townscapes – these figures were simply gross, ugly and uninteresting. 'In so far as the German Exhibition at the New Burlington Gallery is propaganda, it is, in my opinion, extremely bad propaganda.'

It isn't necessarily that British intellectuals scorned modern art; rather, they knew what it was, and it wasn't German. As the minor Stuttgart Expressionist and émigré Fred Uhlman found on his arrival in Britain, English audiences were 'used to the Ecole de Paris', and 'loathed the often brutal and aggressive aspect of German Expressionism'.[2] Mortimer, like most of the British intelligentsia, was a passionate Francophile, and shared the belief common in the Bloomsbury Group that modern art came from Paris; and, with the partial exception of Surrealism, it did so around 1908, in the form of Fauvism and early Cubism, which mediocre painters such as Vanessa Bell and Duncan Grant were still evoking in the 1930s. This is the Mediterranean utopia that Bloomsbury aesthetes such as Geoffrey Scott believed in – a sensualist land untouched by ideology, technology and conflict – and adherence to it meant that the shifts and revolutions that Central European art underwent between the 1910s and the 1930s were beyond someone like Mortimer's frame of reference. Pre-Hitler Germany had, it transpired, a bafflingly differing approach to art to Mediterranean 'humanism'. Rather than a dreamy, sun-kissed world of gorgeous colour and form, this was an art of brutal satire, aggressive colours, scything, scratched-out lines, fervour and cruelty. For Mortimer, rather outrageously, this meant that the art resembled the ethos of its persecutors. 'These German painters in their passionate pursuit of expressiveness at any cost, use the utmost violence of colour and design. Emphasis is all. And the result is a combination of coarseness and hysteria, two of the chief qualities that make the Nazi régime so detestable.'

It is almost too obvious now to point out that a show which contained the paintings and sculptures showcased in 'Twentieth Century Art', held at the Tate or the National Gallery, would be a blockbuster; some of the paintings in question have travelled to some of the world's most visited galleries and museums, and have been reproduced on countless postcards and trinkets; at the time of writing in mid-2024, the big populist exhibition in Tate Modern is on *Der Blaue Reiter*.

And yet much of the British intelligentsia firmly rejected this art in the 1930s, exactly the people who would otherwise be most considered 'progressive' champions of modernist values and cultural freedoms. It is therefore unsurprising that the major artists who lived in Britain during the 1940s, from Oskar Kokoschka to Kurt Schwitters, were for the most part uncelebrated and unnoticed, rediscovered only decades later when they had either died or returned home. But as in so many other fields, talented artists who were not of the first rank, and who are not likely ever to have entire shows dedicated to their work at the Guggenheim, MOMA or the Centre Pompidou gradually came to thrive in Britain. While some of the greatest artists of the twentieth century were treated with bafflement and scorn, others built lives in England, Scotland and Wales. The underside of a Schwitters, marooned, poor and misunderstood in Barnes and Ambleside, was the career of someone like Hans Feibusch, a so-called 'Degenerate Artist' of Jewish origin who came to be the most favoured muralist of the Church of England. So in considering the fate of the many Central European painters and sculptors who found refuge in Britain, we will keep our eye not so much on what did not happen – an embrace by the establishment of Dada, Expressionism and Constructivism, such as took place when the Weimar generation arrived in New York at the end of the 1930s – but on what did happen, a series of strange and interesting careers in art in places where posterity is generally not looking.

But first, we need again to understand what it was that Central European artists were running from. The best place to do that is to look at the series of exhibitions which 'Twentieth Century German Art' was aimed against. The exhibition of *'Entartete Kunst'* – 'Degenerate Art' – opened in Munich in July 1937, before travelling around the Reich, and it included a staggering quantity of modern art, subjected to the most absurd racist reaction and scorn. It remains the darkest moment in the history of art in the modern age, the artistic equivalent of the book burnings that took place across Germany's town squares with the Nazi seizure of power in 1933. So what exactly was 'Degenerate Art'?

The phrase derives from the polemics of Max Nordau, a Hungarian (and, ironically, given it was soon attached to race science, Jewish) critic of modern art at the turn of the century. But its development into a systematic part of Nazi ideology really derives from the books of the German architect Paul Schultze-Naumburg, particularly *Kunst*

und Rasse ('Art and Race'), first published in Munich in 1928 and then regularly republished and updated during the Third Reich. Like many modern architects, Schultze-Naumburg's career was rooted in the Deutsche Werkbund, an institution that bridged the gap between the arts and crafts and modernism as a means of sponsoring German designers in industry. While German modernists developed through their rejection of the excess and 'decadence' of nineteenth-century eclecticism and ornamentation a fearless new architecture that would be dubbed an 'international style' by American critics, Schultze-Naumburg remained passionately committed to classical values in design and art to the exclusion of all others. In fact, other values were not just regarded as misguided, as they were by British traditionalists at the same time, they were *sick* – the products of physical and mental illness, and products of those people who were, for a fascist such as Schultze-Naumburg, not entirely human: principally, Jews and 'negroes'.

In his books, Schultze-Naumburg made a series of dramatic photographic juxtapositions, in the manner that was popular, ironically, with liberal modernists such as Stefan Lorant – the broken bodies of war victims and the victims of disfiguring illnesses next to the distorted figures of Expressionist painting, for instance, to prove that in both cases we were dealing with the less than human. Schultze-Naumburg argued that modern art's aim is to 'distort primitive man into the grinning mug of the animalistic cave dweller ... we see everywhere a preference for and emphasis on manifestations of degeneration familiar to us from the army of the sunken, the sick and the physically deformed', an art epitomized by 'the idiot, the whore, and sagging breasts'.[3] Unsurprisingly, Schultze-Naumburg was an adherent of the National Socialist German Workers' Party, and his work was popular in many Nazi circles. It is true that Joseph Goebbels, the man responsible more than anyone else for Nazi cultural policy, had been an enthusiast for German Expressionism in his youth.[4] It is also true that Mussolini's Italy provided an example of a far-right regime that willingly employed both Futurists and the local Constructivists of the 'Rationalist' architectural school in its propaganda. Accordingly, there was initial opposition to Schultze-Naumburg's sort of crude anti-modernism from within German Fascism, particularly its 'Strasserite' wing of fascist anti-capitalists around the politicians Otto and Gregor Strasser; but after publishing some articles more sympathetic to modern art in 1930, the Strassers received a specific reprimand from

Hitler: 'there is only one eternal art that has validity, Graeco-Nordic art'.[5] This non-existent form of art informed Nazism's aesthetics, which favoured a grotesquely kitsch form of pompous neoclassical painting and sculpture, summed up perhaps in the burly he-men of the sculptor Arno Breker or the unnerving body-beautiful realist triptychs of the painter Adolf Ziegler. A new temple for this sort of art was built soon after the Nazi seizure of power – the House of German Art, a drab and unimaginative stripped classical hulk in the centre of Munich, which stands to this day.

Before the Nazis took power, certain art movements were designated as 'Culturally Bolshevik' and specifically repressed when Nazi local governments were elected. The Bauhaus's move from Dessau to Berlin and its subsequent closure was the most notorious of these. This accusation was not wholly untrue in all cases, despite the disclaimers of many artists in American exile during the McCarthy era. There were to be sure plenty of expressly apolitical modern artists in Germany, with prominent examples such as Max Beckmann or Paul Klee; and there were a handful who were decidedly on the political right, such as the Expressionist painter Emil Nolde, who thoroughly welcomed the Nazi takeover, though it would not welcome him. But the association of modern German artists with the left was not mythical. There were examples of explicit Communism, both in Berlin Dada, when Grosz and Heartfield joined the new KPD at its 1919 inception, and in Constructivism, with its emergence out of the USSR in the first instance and the Bauhaus's turn to the far left under the 1928–30 directorship of the Swiss Marxist Hannes Meyer. More common was a vague commitment to the original socialist values of the German Republic proclaimed in November 1918. To cite one obvious example, most major German artists participated in the *Novembergruppe*, founded that month, to support the revolution that overthrew the Kaiser and briefly looked likely to usher in a democratic socialist republic. For the Nazis, both Communists and Socialists were mortal enemies, so the distinction was irrelevant. Accordingly, the first exhibition of 'Degenerate Art', that is of modern art held up for public ridicule, was actually of *Kunstbolshewistische Bilder* – Art-Bolshevik Pictures – and was held at the Mannheim Kunsthalle in 1933.

The 'Degenerate Art' show in Munich was more ambitious in scale. It was a complement to the 'German Art Exhibition' of 1937, held at the new House of German Art, which showcased the Nazi art of

Breker, Ziegler and the like, and which, for the Nazis, was distressingly unpopular. Goebbels came up with the idea of assembling modern art that was in public collections as a counterpoint to the positive ideals on show at the 'German Art Exhibition' – a show that would demonstrate the idiocy and ugliness of German democracy and German socialism, and hence build support for the otherwise not particularly convincing neoclassical alternative. It also had the bonus of currying favour with Hitler, who was after all an amateur Edwardian painter, and who had a violent hatred of modern art. Although the juxtaposition would lose its relevance as the exhibition toured, originally it was clear – 'Degenerate Art' was on show in the Munich Archaeological Institute, opposite the House of German Art. The process of accumulating the art was straightforward: a group of five Nazi critics and artists led by the painter Adolf Ziegler was tasked by Goebbels with going through the art collections of Germany to accumulate modern art to put on the pillory.[6]

There was a lot of it to find. As you go through the startlingly long list of artists whose work was in 'Degenerate Art' – Kirchner, Lissitzky, Moholy-Nagy, Beckmann, Barlach, Grosz, Dix, Kandinsky, Mondrian, Nolde, Chagall, to name just a few – it is important to remember that every one of these artworks had been bought by a national museum or a municipal gallery. It is in its twisted way a testament to just how enlightened the artistic culture of the Weimar Republic actually was, in that public institutions had bought literally hundreds of superb modernist paintings and sculptures at a time when the Tate didn't even own a Picasso. Indeed, attention to this was drawn by Ziegler and his team of malevolent curators. Artworks on display were accompanied in many cases with a note attached to the wall reading 'paid for by the taxes of the German working people'.[7] This very *Daily Mail* attention to the misuse of taxpayers' money on disgusting and ugly modern art was the subject of Ziegler's oration as he opened the exhibition, where he reminded visitors: 'We now stand in an exhibition which contains only a fraction of what was bought with the hard-earned savings of the German people and exhibited as art by a large number of museums all over Germany.'[8] The effort succeeded, at any rate. 'Degenerate Art' was a blockbuster, with two million visitors, five times the number who visited the 'German Art Exhibition' across the road.

In terms of what was put on show, 'Degenerate Art' was wholly

ecumenical in its rejection of modern art. Everything was a target. As Olaf Peters writes, 'all currents of modern art since 1905 were affected. Expressionism, Cubism, Futurism, Dadaism, Verism, *Neue Sachlichkeit* and Constructivism were all included', and posters for the show were designed as parodies both of Expressionism and Constructivism, but Expressionism was the major target.[9] This poses the question of why. Expressionism was already quite old news. The main two groups – the flowing, Fauvist-influenced work of 'Blue Rider' artists in Munich like Franz Marc, Wassily Kandinsky or Gabriele Münter, and the more violent, deliberately punishing work of 'The Bridge' painters like Ernst Ludwig Kirchner, Ludwig Meidner or Erich Heckel in Dresden and Berlin – were both products of the 1900s. Each had long since dispersed by the middle of the 1920s. In general, Expressionism had declined sharply after a second wind with the German Revolution of 1918, when some of the painters imagined the Millennium was at hand; it was dismissed as sentimental by the Dadaists (most of them ex-Expressionists,

Expressionism Ridiculed: the catalogue for 'Entartete Kunst'.

in Germany) and as silly and backward by the Constructivists. This was often *pre*-Weimar art, with the Republic's artistic culture dominated by the hard-edged realism of the *Neue Sachlichkeit* (which had Expressionist roots, especially visible in the paintings of Max Beckmann) and the abstraction of Constructivism. One suspects that the prominence of parodies of Expressionism was due to something very straightforward – its distortion of the human body and the face, which was abstracted and transfigured in the work both of 'The Blue Rider' and 'The Bridge' painters, in a manner that Schultze-Naumburg connected to racial degeneracy and physical repugnance. The exhibition aimed to elicit horror both at the crudity of the painting and at something more distinctively fascist, a horror at the physical forms depicted, which the curators connected with their attempt to prove that certain groups of people were intrinsically subhuman.

In the first category was straightforward idiot philistinism that was not distinctively fascist. The catalogue, for instance, juxtaposed two violently distorted drawings by Oskar Kokoschka with an amateur portrait, and asked readers:

> which of these three drawings is presumably an amateur work by an inmate in a madhouse? You will be astonished: The one at the top right! Both of the others, by contrast, have been called masterly prints by Kokoschka.[10]

Elsewhere, the ideological racism of the show was made much more explicit. 'Degenerate Art' was divided into several distinct rooms, in which artworks were piled high, with 'voices of reason' coming from Hitler, Goebbels and Alfred Rosenberg placed above and around the canvases and sculptures. Rooms included 'The Cultural Bolsheviks' Order of Battle', 'Madness as Method', 'Crazy at Any Price', 'The Ideal – Cretin and Whore', 'German Farmers: a Yiddish View', 'In Germany the Negro Becomes the Racial Ideal of a Degenerate Art', and a room devoted entirely to Jewish artists, 'Revelation of the Jewish Racial Soul'. It included the charming and then already famous work of Marc Chagall along with the apocalyptic Expressionism of Ludwig Meidner, and some rather delicate canvases by two lesser-known figures, Jankel Adler, a painter from Poland, and Hans Feibusch, a young artist from Frankfurt. Notably, although only six of the 112 artists included in the exhibition were Jewish,[11] modern art was implied to be a Jewish plot throughout.

The response to this in London, the 'Twentieth Century German Art' exhibition, had a variety of different aims. It aimed to hold the boorish absurdity of the 'Degenerate Art' exhibition up to public view; it aimed to support some of the artists in question, many of whom were at that moment fleeing their homes; and it also involved an attempt to argue with the Nazis on their own ground, that is, the belief in a national character of art. This is not quite so paradoxical as it may seem; in his belief in a nonsensical 'Graeco-Nordic' art, Hitler showed he was actually not very interested in specifically German artistic traditions. He and Heinrich Himmler were much more supportive of the historically ludicrous attempt to prove that the art of Ancient Greece, firmly rooted in the eastern Mediterranean and far closer culturally to Egypt and Iraq than it ever was to anywhere north of Italy, was in some way 'Nordic'. The London exhibition's attempt to prove that 'Degenerate' art was in fact 'German' art reflects the prominent role played in it by the art critic Herbert Read. An Anarchist and a northerner raised in a village in the mostly industrial West Riding, Read was already at variance with the Bloomsbury Group, and his enthusiasm for German modern art was both unusual and personally generous; we have already encountered him being complimented by Kurt Schwitters as the only living Englishman who understood art. But Read's idea of what German modern art entailed was quite personal and local, and didn't necessarily tally with what German modernists thought of their own work.

In 1933, in his widely read book *Art Now: An Introduction to the Theory of Modern Painting and Sculpture*, Read introduced a readership he expected to know nothing about the subject to some of what had been happening in German art just before and then during the recently suppressed Weimar Republic. In the preface, he draws attention to this suppression as an example of the dangers of misunderstanding modern art. 'The pragmatic Englishman,' he writes, has 'a hearty scorn of a phenomenon so disturbing to his complacency as modern art', something aided by just how badly and flimsily modern art has been described to him, in terms of wafty generalizations such as Roger Fry's doctrine of 'significant form'. This has consequences, Read continues, as could be seen in the 'recent events' in Germany. Nowhere else were so many modern artists collected by municipal and national galleries and employed by the state; but then, suddenly, as the new regime came to power (mere weeks before Read finished his manuscript), 'artists and museum directors were

dismissed from their posts', while 'modern paintings and sculpture were relegated to the cellars or suffered worse indignities'.[12]

Read's explanation of how this happened had its own consequences. The Nazi war on modern art 'was entirely the result of a rash and inconsiderate identification of modernism in art and communism in politics'.[13] This was not nearly so arbitrary as Read was making out, given the actual socialist commitments of many Weimar artists. But Read wanted to make another point. Here, he argued, was an art that we, British people, who inhabit a dark, hilly, rainy island in the northern corner of Europe west of Norway and north of Normandy, should be able to understand. This was especially the case with German Expressionism, and the work of sculptors such as Ernst Barlach or painters like Emil Nolde. Expressionism's 'nordic genius' (Read uses a lowercase 'n' here) is 'of particular relevance for us', because 'much of the feebleness of contemporary British art may be due to an unnatural affectation of Latin elegance and intellectuality – admirable virtues, these, but not the qualities we find, for example, in Gothic art, or in the work of typical northern artists like Dürer, Rembrandt, Rubens or Blake'; whatever Bloomsbury might think, the artists of *Die Brücke* 'ought to be sympathetic to our own Northern temperament'.[14] As with Expressionism, so too with the art of the *Neue Sachlichkeit*, the paintings of Grosz, Beckmann and Dix: 'such realism, sardonic in its essence, is not likely to be acceptable to those who want art to be pretty, or even to be beautiful in the classic sense. It is no lovelier than the sardonic humour of Swift; or of Rowlandson'[15] – an identification of modernism with the caricatural, anti-realist tradition of eighteenth-century England that we have encountered already in this book.

This argument was continued in the catalogue to the 'Twentieth Century German Art' exhibition, written by Read. It lays out a stall designed to claim this as the *real* German art, an art with 'original qualities deriving from a native tradition', which was 'for various reasons overshadowed by the nearer and more highly organised art of France'. He continues to argue that 'this type of art is in essential conformity with the historical traditions of German art – the art of Cranach, Altdorfer, and Grunewald'. One suspects that this anti-French and by implication anti-Bloomsbury rhetoric was deliberately designed to wind up critics such as Raymond Mortimer, which was perhaps unwise.[16] It is unfair to conclude from this that Read was trying to argue with the Nazis on their

own terms[17] – to link a country's art to its climate and landscape is not racism, discussion of national 'character' is commonplace both then and now, and was a very real thing for newly arrived émigrés – but it was in many ways an inappropriate argument given how much the Nazis insisted upon seeing modern artists as a foreign body within German culture. Rather than arguing that such a way of seeing art and people was stupid and inhumane, Read argued that German modernists were in fact deeply German – true, but surely irrelevant when the issue was the necessity of arguing against the association of 'kunst' and 'rasse'.

The catalogue to 'Twentieth Century German Art' also reveals the delicate balance that the curators – Read, along with the émigré art historian Edith Hoffmann, among others – tried to strike between opposing the 'Degenerate Art' exhibition and striking a blow against fascism, for artistic freedom, and the risk of causing a diplomatic incident at a time when the British government still pursued a policy of appeasement. The curatorial team was international, wide-ranging and fractious.[18] A plan

Expressionism Defended: the catalogue for 'Twentieth Century German Art'.

for the show was drawn up by Noel Norton, the woman who directed the progressive London Gallery, along with the Czech art historian and later *Burlington Magazine* editor Edith Hoffmann, to put together an exhibition to be called 'Banned Art'; charged with putting together the pictures were the Swiss gallerist Irmgard Burchard and, initially, the German curator and collector Paul Wertheim, along with the art dealer Charlotte Weidler, who was at risk given she was still living in Nazi Germany; several of these people were linked to the diplomatic service, making the process especially delicate. Although Read's role was crucial as the show's ideologist, salesman and also its physical organizer, in charge of the hanging and organization of the artworks, it was not entirely his baby. So although the catalogue informs visitors that 'profits will be donated to the relief of refugee artists',[19] the organizers are also keen to insist that the project is apolitical, and moreover, that works by artists still living in Germany were taken from existing collections, absolving those artists from the possible danger to life and freedom of having participated in an anti-fascist exhibition.

Like the 'Degenerate Art' exhibition, 'Twentieth Century German Art' took in the gamut of late imperial and Weimar German art, including the Dada of Hausmann, Grosz, Dix, Schwitters and Willi Baumeister (who was still in Germany), the Constructivism of Oskar Schlemmer, the one-off Klee, and the only doubtfully modern Georg Kolbe, a sculptor who was then being gainfully employed by the Third Reich to sculpt a bust of Francisco Franco. But as with the Munich show, the accent was on Expressionism, with an extensive showcase of Nolde, Kirchner and especially Beckmann. There were also many artists who were 'now working in England'. It is notable that nobody on the list was in the first rank of German moderns, unlike those listed above, who had made their way to Paris, New York or Amsterdam rather than London; the best-known name today perhaps being the Bauhaus designer Grete Marks. Some of the others we will soon encounter, however – the sculptors Georg Ehrlich and Fred Kormis; the painters Martin Bloch, Hans Feibusch and Fred Uhlman – and some we have met already, such as the future *Lilliput* cover artist Walter Trier and the future Powell and Pressburger costume and set designer Hein Heckroth, who was represented by a 1935 canvas of a dancer. Some of these compromises angered those artists who had already made their way to Britain. Paul Wertheim and his friends Otto Freundlich and Oskar Kokoschka pushed for a more

political exhibition, and protested against the inclusion of the Nazi-favoured Kolbe.[20]

The exhibition received a remarkable amount of publicity for a show at an elite, private Mayfair gallery, publicity that it received precisely because it was received as a political exhibition and an anti-fascist statement. There was even a tie-in Pelican Special, a mass-market paperback titled *Modern German Art* – it also served as the unofficial catalogue, and copies were given away for free to all attendees. The author, we were told on the poster-like typographical cover, was 'A VERY WELL-KNOWN GERMAN ART CRITIC WHO FOR SPECIAL REASONS MUST HIDE HIS IDENTITY UNDER THE NAME OF **PETER THOENE**'. 'Thoene' was actually the much less Teutonic-sounding Oto Bihalji-Merin, and rather than being a German, he was actually a Yugoslav, from Zemun, now a suburb of Belgrade but before 1918 in Vojvodina, the Hapsburg part of Serbia. He was indeed an art critic by profession, and was also an early member of the Communist Party of Yugoslavia; that party's repression saw him emigrate to Weimar Berlin. After 1933 he was driven like so many of his generation across Europe, but he wrote *Modern German Art* from a refuge in Zurich, not London. After the war, Bihalji-Merin returned to Yugoslavia and became an important cultural bureaucrat in the only socialist country never to have repressed modern art, something that owed a little to his influence.

Modern German Art was, of course, introduced by Herbert Read, who recapitulated his arguments in favour of the Englishness of German Art, and lamented that it was 'almost entirely neglected' not just by the public but by the English intelligentsia too.[21] This he ascribed partly to the manner in which German culture was made taboo by the First World War, to France's proximity and prestige, but Read also roots modern German art in a much longer-term trend, in the way the Renaissance had obscured that 'other standards do exist, belonging to the Gothic North'. It is this which explains why we 'ignore the art of a people more akin to us in race and temperament'.[22]

Amusingly, Bihalji-Merin makes nothing of this argument – there is little here that roots Expressionism in the traditions of a northern Gothic. In fact, his argument centres on the nineteenth century, and roots German modern art in France, particularly Gustave Courbet, in the reaction to a new, urbanized industrial world, and in German reactions to French Impressionism and Post-Impressionism. As he tells the reader: 'evolution

takes places [sic] through conflicting trends; new vistas are opened up by new knowledge'.[23] He does note how Expressionism broke with its French antecedents. Bihalji-Merin told his British paperback readers of the way in which Kirchner and *Die Brücke* produced violent, dystopian, hallucinatory images of the new megalopolis of Berlin, in opposition to the Impressionists' 'glittering, vivacious' images of Paris: 'the German Expressionists, taking ethical content as their point of departure, tried to formulate the inner dissonance produced by the spirit, the menace, and the soullessness of cities'.[24] Meanwhile, Bihalji-Merin sees the more abstract and mystical world of *Der Blaue Reiter* as a strange synthesis in which 'Meister Eckhart, that is medieval German mysticism, and Albert Einstein, or the modern theory of relativity, encountered each other in the twilit forest of romantic ideas'.[25] He also, perhaps unsurprisingly given his politics, insists on the way in which the October Revolution in Petrograd created a new art that immediately thrilled the artists of the new German Republic, the art of Tatlin and Malevich, 'who, touched by the tempestuous breath of the Revolution, believed that they had found not merely new values in art, but a new language of art ... Malewitsch [sic], Tatlin and Lissitzky, among others, have utilized the cool weapon of mathematical tables and static examination against the overbrimming soul, against moujikdom and Dostoivesky [sic] gloom'.[26] Or, as George Grosz and John Heartfield once put it in a slogan at one of their Berlin Dada happenings: 'ART IS DEAD, LONG LIVE TATLIN'S NEW MACHINE ART'.

The text of *Modern German Art* is bolstered with badly reproduced, sometimes cropped images of paintings, with the muddy monochrome photogravure lending itself poorly to the colours of Marc, Feininger or Kandinsky – here at least, Raymond Mortimer's claim that the entire 'Twentieth Century German Art' exhibition was bad propaganda makes more sense, though the thickly outlined painting of Max Beckmann survives the printing process much better. There is, curiously given the author's Marxism, little in the way of rousing rhetoric in the book. Bihalji-Merin's invocation of the 'Degenerate Art' exhibition is melancholy:

> Walking through the fantastic rooms of the Exhibition of 'Degenerate Art', opened in July 1937, we read the complete history of German art in the past century. The walls turn to documents, the martyred creatures of art speak out, since the age, obedient to the voice of power, is struck dumb.[27]

This is very much a product of a terrible historical moment, with fascism in the ascendant, war imminent and, as would surely have been in the back of Bihalji-Merin's mind, the socialist modern art of Malevich and Tatlin now almost as persecuted in the socialist hope of the world as it was in Nazi Germany. It is hard to imagine many of Penguin's thousands of enthusiastic 'Specials' readers, having read this book, emerging with an enthusiasm for Expressionism or the *Neue Sachlichkeit* – it was too gnomic, professional and bleak a book for that.

In any case, the professed apolitical nature of the exhibition fooled nobody. Hitler lodged an official protest at the exhibition, giving a speech at a 'Day of German Art' in Munich in which he sarcastically referred to Britain 'delighting the world with an exhibition' that was 'clearly supposed to show the opposition between the cultured achievements of the great "November" names in the line of Dada, Cubism, etc, and the poverty of today's German art'.[28] This was of course *exactly* what Herbert Read and Edith Hoffmann were doing with the New Burlington Galleries exhibition, and Hitler's intervention was for that excellent publicity; it also led to the left-wing Artists International Association leafleting the exhibition, printing an unofficial flyer that drew attention to the fascist suppression of art and pointed out that this was what would soon be happening in Spain, if Franco had his way; the flyer ended with the slogan 'SUPPORT SPAIN'.[29] The great American bass-baritone and actor Paul Robeson performed at the exhibition's opening, and there was a tie-in production by a musical collective led by Ernst Schoen of Brecht and Weill's *Threepenny Opera*, both gestures that were surely indicative of the event's politics. But the curators persisted in disavowing their aims, as did some of the artists.

One of the stranger moments of the 'Twentieth Century German Art' exhibition occurred with a visit from Max Beckmann, who had fled Germany on the day of the 'Degenerate Art' exhibition's opening, and was now living in Amsterdam. Beckmann's work was one of the relative hits of the Mayfair show. The central panel of his *Triptych of the Temptation of St Anthony* – painted in 1936–7 and one of the exhibition's showpieces – was printed on the cover of the *Times Literary Supplement* as it reviewed the show. Perhaps no artist made Read's case for Weimar art as something German, Northern, Gothic and apolitical – while at the same time caricatural and 'sardonic' – quite so as well as Beckmann.

After an early free-flowing Expressionism, Beckmann's style developed from 1918 into a hard-edged realism, etched with harsh black-outlined figures, stylized but reasonably anatomically correct compared with the work of *Die Brücke*; his figures, often vividly coloured and intensely, itch-scratchingly erotic, arced themselves in tortured poses in allegorical compositions that were interpreted at the time and afterwards as indictments of the 'decadence', political violence and commercialized sexuality of the Weimar Republic and incipient German Fascism; interpretations that Beckmann alternately courted and repudiated in a perverse speech in which he recounted his conversations, in a dream, with William Blake.[30]

The exhibition was not entirely a failure. There was a certain amount of public interest – the *Daily Telegraph* noted that 'a remarkable number of people from the north of England' were visiting the exhibition,[31] which will have pleased its co-curator, and some of the work sold, albeit for far less than the curators expected; again, the north was enthusiastic, with several works on paper being picked up by the public Whitworth Gallery in Manchester. Reviews were often negative, although there was a certain amount of curiosity, and strongly positive reviews in the *Manchester Guardian* and the left-wing *Daily Herald*; the reliably progressive Anthony Blunt praised the show to the skies in *The Spectator*. In the *Sunday Times*, Eric Newton, noting that 'England, whose instinctive sympathies are always with the under-dog, has at least developed a curiosity to know what kind of art it is that has deserved such whole-sale excommunication', pointed out that the reasons why English gallery-goers had to be told about German modern art was because 'to-day it has a political significance that has nothing to do with its artistic value'. It was built, as Read himself pointed out, on a foundation of ignorance: 'if England had merely wanted to know what German artists had been doing during the post-war years, the present exhibition could have been got together ten years ago'.[32] One reason why it was not could be found in the pompous bigotry of, for example, the reviewer for the art magazine *Apollo*, who blustered that 'German art suffers, it would seem, most from "bad form". Like the German language itself, it lacks clarity; it is incontinent, both in its furor, the *furor teutonicus*, and in its sentiment – its *Schwärmerei*.' Germany, after all, has never produced great art; Grünewald, Dürer and Holbein 'were, as painters, only half-great'.[33]

However much of a stir might have been caused for a few months in 1938, Herbert Read was clearly discouraged by this experience. Around a decade later in 1949, the German critic and curator Willi Grohmann – who in the Weimar Republic had purchased numerous modern paintings for the Staatliche Gemäldegalerie, and was therefore inadvertently one of the sources for the Munich pillory-showcase of modernist painting and sculpture – wrote to Read suggesting an exhibition of ten years of German art in Great Britain. This would have worked as something of a follow-up to 'Twentieth Century German Art', showing this time the scale of the work that had been created following emigration. Read was reluctant. 'You must remember,' he wrote to Grohmann, 'the complete ignorance of which prevails here in the sphere of German art', an ignorance extending even to 'Kokoschka, though he lives here'.[34] The attempt to convert the British to a northern aesthetic had, apparently, failed. And yet, in one of the places where art history is not usually looking, a very different exhibition had taken place in between 1938 and 1949, which laid the foundations for the most extensive public collection of twentieth-century German art outside Germany and the United States. This collection was held not in Mayfair, but in the industrial East Midland city of Leicester.

In 1944, the Leicester Museum and Art Gallery, a handsome early Victorian neoclassical building on New Walk, a tree-lined pedestrian parade in the centre of the city, hosted an exhibition called 'Mid-European Art'. It included many of the same figures who had appeared both in 'Degenerate Art' and in 'Twentieth Century German Art'. It included paintings and drawings by Feininger, Heckel, Kandinsky, Macke, Marc, Nolde, Pechstein, and emigrants then living in London such as Kokoschka and Uhlman. Its four-page catalogue featured a wonderful woodcut by Lyonel Feininger on the front, a spikily Gothic street-scene straight out of *The Cabinet of Dr Caligari*. Inside, the curators made no grand claims. In this aggressive art:

> The efforts to find new ways are bold, not always successful but always courageous. The development was never completed. The rise of Hitlerism destroyed the schools and the spirit, exiled and suppressed the men and their works. Modern Art was persecuted. Here we can only show and judge what was attempted before this catastrophe overtook the creative spirit of a continent.[35]

> **MID-EUROPEAN ART**
>
> **EXHIBITION**
> FEBRUARY 5—27, 1944
> CATALOGUE THREEPENCE
> **LEICESTER MUSEUM AND ART GALLERY**

Expressionism Rescued: the catalogue for 'Mid-European Art'.

They then thanked 'all those who loaned their pictures', who 'have rescued them from certain destruction'. Once again, they told the visitor that 'of all the trends in modern painting, the least known to the English public are those of the mid-European countries'.

Now, 'Mid-European' was interesting terminology. Rather than 'German Art', the Leicester curators stressed the *internationalism* of Expressionism and the *Neue Sachlichkeit,* not some sort of autochthonic emanation of the German genius, succeeding Cranach and Dürer and Holbein, but the product of a world of intra-European exchange, where many of the artists were not even German. This might have been designed to distract Leicester gallery-goers from any identification of these artists with the adversary of two world wars, but they were also quite correct as to the facts. This was work created in Austria, Hungary and Czechoslovakia as much as in Germany's pre-war borders. It was the product of 'the Scandinavian Munch, the Czech Kokoschka, the German Franz Marc of the "Blue Rider" group ... Feininger, an

American, Klee, a Swiss, and Kandinsky, a Russian of the "Bauhaus" (the first truly modern school of organised building, painting and craftsmanship)'. Perhaps accordingly, the public reaction was much more positive, and Leicester was able to build upon this to assemble over time an extraordinarily impressive collection. Visiting the gallery on New Walk today is a strange experience, ranging through the big café, the interactive ephemera and the bright signage and information mostly aimed at children, all the faintly desperate paraphernalia that we have come to expect in a country where all public art galleries outside of London have been reduced to penury by fifteen years of austerity. However, the top floor is filled with works that you might otherwise expect to find on the walls of the Tate or the Pompidou or MOMA. Glorious canvases by Franz Marc and Lyonel Feininger hang alongside a dense assemblage of drawings, sketches, prints and canvases, which follow these German artists into their emigration, with superb Expressionist paintings from the 1950s and 1960s by émigré artists such as the Austrian-born Marie-Louise von Motesiczky.

The Leicester Museum and Art Gallery was already 'progressive' in the 1930s, and in 1936 it featured Weimar artists such as Moholy-Nagy, Kandinsky and Ernst in an exhibition of 'Contemporary Art'. It was reviewed positively in the *Leicester Mercury*, which found in it 'a voyage of adventure'.[36] Leicester continued to build up its Expressionist collection, which in the 1970s the city's art curators proudly described as 'nationally unprecedented' in its showcasing of 'an aspect of modern European art that has, to an unfortunately large extent, been neglected and overlooked by our public galleries'.[37] The paintings came from the holdings of the Hess family, industrialists in Erfurt, in what was then East Germany, who fled fascism and arrived in the English Midlands. Thekla Hess literally had to smuggle out of Nazi Germany some of the great, colourful Expressionist canvases that became the foundation for the Leicester collection. It is built around four paintings owned by the Hess family that the museum purchased at the end of the 'Mid-European Art' exhibition: Lyonel Feininger's crystalline urban landscape, 'Behind the Stadtkirche' (1916); a thuggish portrait by Emil Nolde, 'Head with Red-Black Hair' (1910); the star of the show, Franz Marc's flowing, radiating 'Red Woman' (1910); and another cityscape, 'The Bridge at Erfurt' (1919) by Max Pechstein.

Hans Hess became assistant keeper of art at the Leicester Museum

and Art Gallery under Trevor Thomas, who was the likely author of the catalogue and conception of 'Mid-European Art'. Thomas became, in a horrible irony, the victim of bigotry and persecution in Britain rather than in Germany – he was dismissed from his position at the end of the 1940s for his homosexuality. However, his project was continued for decades to come, and is still expanding. It seems that, much as Read might have hoped, visitors have viewed the art with an open mind in an industrial city without pretensions, and in a place lacking preconceived ideas about what modern art is, untouched by the francophile/Bloomsbury idea that modern art was necessarily something Mediterranean and pretty. Indeed, on a winter visit to New Walk, a green oasis in a dense, polluted, rainy, visually chaotic but invigoratingly multicultural small city of red-brick warehouses, grey churches and new minarets, you can get some sense of exactly why Read thought this art was suited to this island. Leicester is patently not Paris or Dieppe or Provence; but it could be Erfurt.

18
'Finchleystrasse' and Other Londons

The 'Mid-European Art' exhibition was co-organized by the Leicester branch of the Free German League of Culture (FDKB in German) – a left-leaning group of German émigrés who mounted exhibitions, published pamphlets, and mainly had meetings in which anti-fascist Germans could encounter and talk to each other; that there was a Leicester branch at all is some indication of the League's reach. Nonetheless, the émigré capital remained London, or rather a quite specific corner of London. Numerous sources and memoirs claim that the German – or rather, German, Austrian, Hungarian, Czech and Slovak, and predominantly Jewish – emigration to what was then the Metropolitan Borough of Hampstead was not lost on London Transport's bus conductors. What exactly they would call a certain stop differs according to the memoirs you're reading – but most agree that conductors would regularly call out *'Finchleystrasse!'* on arriving at the long, wide arterial road that connects shabby West Hampstead with the spacious semis of Golders Green.[1]

The Viennese social-democratic exile, journalist and novelist Hilde Spiel had decided, along with her partner Peter de Mendelssohn, as had Sebastian Haffner, to live in Wimbledon – a 'beautiful, green, utterly bourgeois district', in which, despite living there for around two decades, they 'were never invited into a single English household'. She recalled that on her bus trips to North London, where 'almost the whole German-speaking immigrant community were to be found within a narrow radius',[2] the conductors would shout upon entry into the borough's southernmost suburb, *'Schweizer Häuschen!'*: Swiss Cottage.[3] Some other accounts repeat what must also have been an oft-said cliché of the time, that the only language you would hear in the lifts at Belsize Park tube station was German.

In 'Finchleystrasse' is the commencement, if it begins anywhere, of the political-racial trope about 'North London' as the location of a left-wing or liberal intelligentsia, dog-whistlingly implied to be Jewish, that is such a fixture of British political life. Most of the famous émigré artists and architects lived here, and Hampstead has a greater density of 1930s modernist houses than anywhere else in Britain. Some institutions that still exist, such as the North-Western Reform Synagogue (Alyth) in Golders Green, founded in the 1930s by Berliners, the JW3 Jewish Community Centre on Finchley Road or the Camden Arts Centre just opposite, owe their existence to the Central European emigration. What was the Metropolitan Borough of Hampstead – since the 1960s, the wealthier part of the much larger and more working-class London Borough of Camden – was made into a heartland of the London intelligentsia, an artists' quarter that, with its hills and views and diverse architecture, could be (and was) compared to Montmartre and Montparnasse. This transformation really began in the 1930s. In the Victorian and Edwardian era, artists lived in Holland Park if they were wealthy and successful, Chelsea if they were a little less so; and as the name granted to it at the time and since implies, the Post-Impressionist scene of the 1900s and 1910s was based around Bloomsbury, several miles further into the centre of London.

Of course, there were already Fabians and poets and artists in Hampstead, but the place was not particularly 'fashionable'. It was both comfortably bourgeois – except for the railway lands around West Hampstead station – and had relatively affordable housing; this made it an appealing place to settle for these overwhelmingly middle-class refugees. In the 1940s there were, on one estimate, 25,000 German-speaking 'aliens' living in Hampstead, which made up a huge chunk of its population – around 45 per cent according to one figure.[4] Culturally, if there was one individual at the centre of this, it was the Stuttgart artist and lawyer Fred Uhlman, who we have already encountered in passing a few times. Uhlman was a second-rate Expressionist-lite painter, a superb if hardly prolific writer (his desperately sad 1971 novella, *Reunion*, about youth, antisemitism, friendship and fascism, has deservedly become a minor classic), and a first-rate organizer and benefactor of the anti-fascist emigration in London.

Uhlman, who grew up in an upwardly mobile Jewish family in Stuttgart, was very much a lawyer first and an artist a distant second. In the late years of the Weimar Republic he joined the Social Democratic Party

(SPD), meaning that 'towards 1932 I was Chairman, Secretary, Treasurer, and one of only two members of the SPD Lawyers Association in Württemberg'.[5] He defended numerous socialists and radicals in court, which placed him in great danger when the Nazis took power. He left Germany immediately in March 1933, and drifted across Europe – it was in Paris that he decided to give up law to become a painter – before he met the English aristocrat Diana Croft in a Spanish resort. After, on his own account, failing to join the International Brigades to fight fascism in that country, he married Croft, over the strong objections of her father, a Tory politician who 'hated Germans and Socialists and Jews, and probably hated artists too'.[6] Near the end of the 1930s the couple set up home in Downshire Hill, Hampstead. Armed with a lot of money, a very large house, a great many contacts in the emigration from Germany, Austria and Czechoslovakia, and a scorn for the parochialism of English art ('everybody in Paris agreed that if one wanted a good laugh the thing was to see the Pre-Raphaelites' in the Tate, Uhlman remembered; but he found Stanley Spencer even more hilarious),[7] the Uhlmans proceeded to set up an organization to help émigré artists. The Free German League of Culture was established by Uhlman on the model of the associations of German-speaking émigrés who had thrived in Paris, and in Prague before the Munich Agreement. The FDKB's nucleus was the Oskar-Kokoschka-Bund, a group of left-wing artists centred around the great Austrian Expressionist painter. Like the London-based Artists International Association with which it was closely linked, the FDKB had politically ecumenical aims and members but quite quickly became essentially a Communist front organization, something that Uhlman as a SPD member found depressing but could do little about.

Downshire Hill became the unlikely fulcrum of the displaced leftist aesthetes of Weimar, 'Red Vienna' and golden-age Prague. In late life, Elias Canetti recalled how, in the 1940s, he was perpetually 'visiting some resident painter, sculptor or writer' on the street, one whose order he found pleasing as a modernist: 'the houses were normally two storeys high, simple, classically proportioned, the absence of superfluous frippery so agreeable that it was always a pleasure to stroll down it, even when I didn't have any particular business there'.[8] The business in question was often one of the 'summer parties in [Uhlman's] garden', 'popular affairs' for the 'Hampstead intellectuals'. Canetti, not somebody who suffered fools gladly, regarded Uhlman with contempt

as an opportunist, a bad painter and a social climber, but nonetheless remembered him as 'absolutely indefatigable', and 'the soul of this Kulturbund'.[9] Its activities were extensive, and many of them were just meetings – and cabarets – that were intended to create little pockets of 'Red Berlin' and 'Red Vienna' within this pretty, enlightened, but conservative district.[10] Often in collaboration with the Communist-linked Artists International Association, the FDKB put on various exhibitions in London just before and during the war, but largely failed to find their public, for obvious reasons. Uhlman himself, whose sister and parents were murdered in the Holocaust, firmly stated that 'I have never hated "the" Germans',[11] yet not only British audiences, but also many émigrés were unsure about the plausibility of an Other Germany. Albert Einstein politely refused to join the Free German League of Culture because it had 'German' in its name.

One of the two most famous members of the FDKB was 'Johnny Heartfield', as Uhlman called him. In December 1939, the FDKB put on an exhibition of work by Heartfield, 'One Man's War against Hitler', which along with Stefan Lorant's promotion of his work in *Picture Post* and *Lilliput* introduced the British public to Heartfield's agitational, bitterly ironic anti-Nazi photomontages, the best of which he had produced in his Prague exile for *A-I-Z*.[12] Heartfield lived in the Uhlmans' house in Downshire Hill for five years, before moving to his own place in Highgate at the end of the war. Uhlman, who believed that Heartfield would gladly have thrown him in the Gulag if he could (Heartfield certainly had a genial contempt for his paintings), writes wryly in his memoir about the personal friendliness and lack of violence about the man whose work was so ferocious. 'A charming, modest, meek and mild little man', Heartfield was given two rabbits by the Uhlmans to cook as a gift soon after he arrived, which he refused to kill, accidentally creating a rabbit colony in their garden; 'he had to spend hours gathering food for them on Hampstead Heath'.[13] While Uhlman was interned in the Isle of Man, Heartfield shared their house with Francis Klingender, and it became the centre of what there was of Communist art in North London.

The other figure who was for a time at the heart of the FDKB was Oskar Kokoschka, who, following the Munich Agreement that handed a chunk of Czechoslovakia to the Nazis, took the first plane out of Prague to London, capital of the country Hitler seemed least likely to annex. With Kokoschka was his wife Olda, £10, and an unfinished

canvas, but they had taken nothing else with them. He was immediately given a job by Fred Uhlman to paint his brother-in-law, as a means of tiding him over. Kokoschka was, by then, a household name, 'famous all over Central Europe, but at that time almost completely unknown in England except to a few connoisseurs and art dealers'.[14] His path to this status was complicated. Born into a Germanized Czech family in 1886, Kokoschka was from a working-class background, his father a struggling goldsmith; there is a chippiness about Kokoschka that comes out in his autobiography and letters, unusual in his mostly materially privileged generation of artists; he was offered a place to study painting after his talent was discovered by his schoolteacher. As a young painter trying to find a way out of the ornamental nudes of the Secession, the local branch of Art Nouveau, Kokoschka became a protégé of the pioneering and extremely eccentric modern architect Adolf Loos. Kokoschka made his name in the late 1900s with a series of brutally misogynistic drawings and paintings, particularly the cycle 'Murderers, the Hope of Women', which accompanied a play he published with the same name. Physically imposing and passionate, he was one of the many conquests of the notorious Alma Mahler; his first great paintings, such as *The Bride of the Wind* (1913–14), are wild, melodramatic depictions of their illicit relationship, which parallel *Die Brücke* in their sexuality, violence and abstract, anti-naturalist use of colour. Working with the Berlin gallery *Der Sturm*, Kokoschka became one of the foremost German Expressionists, without belonging to any school.

At this historical distance, though, Kokoschka looks like one of the most classical and traditional of all the Expressionists. His gaseous swirls of paint and the heavy physicality of his bodily forms connected him with Rubens, while his interest in light and in heavily worked, thick, painterly brushstrokes meant he could be understood as an Impressionist, of sorts. Kokoschka had a terrible First World War, shot, invalided out, and carried prone in an open railway carriage across Eastern Europe. After the war he supported the November Revolution in Germany, but within limits. When street fighting between socialists and the rebellious army during the attempted right-wing Kapp Putsch of 1920 damaged a Rubens painting in the Semper Gallery in Dresden, the city he moved to following the war, Kokoschka protested. This earned him the scorn of the Dadaists George Grosz and John Heartfield, in what became known as the *'Kunstlump'* debate, where they firmly asserted

that the revolution was more important than Old Master paintings. Kokoschka was not so sure.

In the 1920s, he travelled throughout Europe, and basked in acclaim both in his adopted Germany, where the Weimar government chose him to represent the Republic at the 1931 Venice Biennale, and in Vienna, where his family still lived. The socialist administration of that city commissioned him to create a large painting for the Town Hall. He chose a subject he'd seen from his mother's house in the suburbs, an orphanage converted from the old aristocratic Schloss Wilhelminenberg, in front of whose baroque portico he saw children 'playing happily ... in the palace and park which before the revolution belonged to the archduke'. In his words, 'I took my subject from them. I painted the *Wiener Sozialistische Kinderfursorge* – the children's welfare of socialist Vienna.' The painting's panoramic perspective, with its figures in vast flowing space, was modelled on the great Brueghel paintings in Vienna's Kunsthistorisches Museum.[15]

Kokoschka was horrified by the violent suppression of 'Red Vienna' in 1934, during which the rest of Europe stood by while the Viennese working class was destroyed; after the war he was still furious, and ironically noted of Chancellor Dollfuss, then remembered mainly because he was assassinated by Austrian Nazis, that perhaps 'the democratic world possibly did not know about his gunning of workers who had only a few rifles, or of the deeds of his army chief Prince Starhemberg, destroying a group of the, then, most modern buildings erected in Europe for housing workers'.[16] As a Czech of sorts, Kokoschka moved to Prague, took citizenship, painted the foreign minister Jan Masaryk, and tried to interest the government in his detailed programme for educational reform. Never a revolutionary, his alignment with reformists like the Viennese municipal socialists and Masaryk earned him great enmity from the Third Reich; he did not take being classed a 'Degenerate Artist' by the Munich exhibition lightly, and confronted it in his pugnacious *Self-Portrait of a Degenerate Artist*, where he gazed proudly at the viewer, chin jutting forward.

In British exile Kokoschka began to paint political allegories, a departure for a painter who, before and after this, was a painter solely of landscapes and nudes; these allegories might have been inspired by the way that contemporaries and near-neighbours such as Gombrich and Klingender searched around for something interesting in the apparent

vacuum of British art, and landed on Hogarth, James Gillray and Thomas Rowlandson. Stylized, grotesque little Hitlers, Mussolinis and, with the vehemence one should expect from a Czech, Chamberlains start to appear in Kokoschka's paintings of the time. But at first, he seems not to have got much else out of the experience. In London, the Kokoschkas drifted around from, first, 'a cheap boarding house full of immigrants of all colours',[17] eventually to a block of flats on Finchley Road, 'Finchleystrasse' itself. Kokoschka did not appear to be particularly inspired by London, and, as we will see presently, he spent much of the Blitz in Cornwall, and later moved for a time to Ullapool in the Scottish Highlands; his most interesting British work was painted there, not in Hampstead. Even other émigrés sometimes found Kokoschka imperious and eccentric, as would befit someone extremely famous suddenly arriving in a country where very few had heard of him and nobody cared who he was. Canetti recalled being told by Kokoschka that his scholarship to the Vienna Art Academy could have gone to the young Adolf Hitler, another struggling petit-bourgeois applicant – if he hadn't got his scholarship, Kokoschka believed, none of this would have happened. Fred Uhlman, similarly, wrote incredulously in his memoirs that Kokoschka had once explained at length that Picasso was nothing but a bad imitator of his work.

This paranoia may have been compounded by the fact that, as Canetti recalled, 'it was a bad time for Kokoschka. No-one knew him in London. German Expressionism had no presence, everything was directed towards France.'[18] And yet, if there was a concerted effort on behalf of the cultural emigration and its friends like Herbert Read to drill the importance of *one* artist into the British public's minds, it was Kokoschka. Working from a studio at the top of an office block in Mayfair, he painted ambassadors and socialites, produced posters, and *Christ Descending from the Cross* dedicated to children dying of hunger and cold that he claimed to have personally posted all over the London Underground in Christmas 1945; and he participated in public exhibitions such as 'What We Are Fighting For', held in 1943 in the ruins of the bombed-out John Lewis store on Oxford Street, where he hung an immense, chaotic and violent allegorical canvas depicting torture and crucifixion. In Kokoschka's recollection, the indifference with which this horrifying work was met only confirmed he was right to come to this country in the first place:

> My paintings attracted little notice, because they contained no promise of an idyllic peace. Yet I marvelled that in the middle of a war for survival no-one bit my head off. That was only possible in England; there I would hope to carry on my life, not as a talented refugee, but as a free human being.[19]

There was, nonetheless, much collective effort on Kokoschka's behalf, while émigré contemporaries who are now equally famous – most obviously, Kurt Schwitters – were barely known and even less discussed. Two émigrés wrote monographs on Kokoschka, with his collaboration: Ludwig Goldscheider of Phaidon produced the publisher's first volume on a contemporary artist, with large colour plates showcasing Kokoschka's lurid, violent, bright palette; most interesting was a study for Faber by his fellow Czech-Viennese émigré, Edith Hoffmann (with the obligatory introduction by Herbert Read), which tried to explain Kokoschka, and with him an entire disappeared world, to the English reader.

Hoffmann was keen to tell those who were, apparently, still shocked by Kokoschka's paintings that, by the 1920s, they were already yesterday's news; there is still a sense of shock in her book that the pre-1914 world of state antisemitism, vulgarity and militarism returned and mounted an assault on the likes of her and Kokoschka, who 'were labelled un-German, *kulturbolshewistisch*, blamed again for the same things which had earned them reproaches thirty years before', at a time when these older artists thought they had become Old Masters.[20] Hoffmann also introduced readers to something else they might not have expected. Kokoschka may not have been inspired by the Finchley Road when he was living there, but on his earlier stay in the city in the 1920s he painted the Thames, in a series of bustling, fresh and wild landscapes that went wholly unnoticed at the time (in Britain). Of these, she writes that *Tower Bridge* was 'perhaps the only picture ever painted that adequately conveys an impression of the peculiar character of London's dock area: boats across the river, cranes, spires and chimneys point innumerable fingers skyward. Noise, movement, activity and infinite variety are conveyed in a mysterious, indefinable way.' In these paintings, 'the city which to many a visitor is a blackish-grey sea of houses, its river whose attraction is by no means as easily perceived as that of the Seine or the Danube, are endowed with vibrant life, with sweeping curves and fiery colours which excite curiosity and exercise

irresistible fascination. Although very few Londoners at the time knew it, London had found its painter.'[21] If so, London still didn't know it twenty years later.

The *Christ Descending from the Cross* that Kokoschka and his wife pasted up on the walls of North London tube stations was not the only poster by a continental émigré that someone travelling – or sheltering – in an Underground station might have seen in the 1940s. In fact, if the story of German Expressionism in Britain appears as one of bafflement and rejection, the walls told another story, in which the other major art movement of the Weimar Republic was actually thriving in its new island home. London Transport, especially, commissioned everyone from the *Bauhäusler* László Moholy-Nagy to the commercial designer Hans 'Zero' Schleger to design its posters, and during the war the Ministry of Information followed suit for its propaganda, produced by the likes of F. H. K. Henrion and Lewitt-Him.[22] Most if not all of these posters were designed in a commercial version of Constructivism, though it was now quite distant from its roots in post-revolutionary Petrograd. London Constructivism was based in Hampstead too, and was given particular impetus by the architectural migration, as could be seen in collective housing like Lubetkin's Highpoint in Highgate, or the Isokon Building in Belsize Park, which housed a score of modernist artists, architects and Soviet spies.[23] So it's unsurprising that two of the first-rate names of twentieth-century art were living in that area at the end of the 1940s: Piet Mondrian, the Dutch painter whose gradual elimination of everything from his work but straight lines and primary colours created some of the most endlessly fascinating paintings of that or any other era; and Naum Gabo, the Russian sculptor who had been an early pioneer of Constructivism in Moscow, then Berlin, then Paris.

Mondrian was invited to London by Ben Nicholson, who visited his Paris studio in 1934. From being a minor post-Bloomsbury painter, Nicholson underwent one of those lightning conversions that were also then happening to British architects like Maxwell Fry, suddenly switching to a strict geometric art of circles and right angles, often in relief form; by contrast, you can look at Mondrian's paintings from 1910 to 1920 and see him inching, step by step, towards his hard-edged, strictly controlled, Theosophically justified 'Neo-Plasticism'. Nicholson, who was in a relationship with the much more interesting sculptor Barbara Hepworth, was by the mid-1930s the only British artist whose work

one could imagine being included in those surveys of international Constructivism that had been carved out of the art museums of the nineteenth century; you could put one of Nicholson's reliefs in, say, El Lissitzky's 'Abstract Cabinet' in Hanover, or Władysław Strzemiński's 'Neo-Plastic Room' at the Museum of Art in Łódź, Poland, without anybody noticing that the painter was English, something that could not have been said of Stanley Spencer. Henry Moore, whose sculpture had also developed organically into abstraction under its own lights, and who along with Hepworth was the first internationally important British artist of the century, was also part of this North London circle – as inevitably was Herbert Read, who lived nearby. From their Hampstead base, Nicholson and Hepworth tried to take under their wings some of the modern artists being pushed ever further westwards by the advance of fascism.

Mondrian's dearest hope, as he found himself in the 'Degenerate Art' exhibition and hence became anxious for his safety, was that he would be granted a visa to the United States. When that at first failed to materialize, he accepted Nicholson's offer of accommodation in his house at 60 Parkhill Road, Belsize Park, with a space in which to paint above Nicholson's own studio. It was spacious, in a rambling Victorian house, but the view was not to Mondrian's taste: he was heard to lament that the lush green back garden over which his room looked contained 'far too many trees'.[24] When the Blitz began, Hepworth and Nicholson escaped to Cornwall, and asked Mondrian to join them, but he refused – he had finally got his American visa, and he was off. Mondrian developed a taste in Hampstead's cinemas for the films of Walt Disney, which he would continue to admire in America; but otherwise, the only evidence in his work of two years spent in England is the title he gave to one of his grids, which was begun in London and completed in New York: 'Composition, 1939, Trafalgar Square, 1939–43'. A square it might have been, but it is patently obvious that an artist like Mondrian would be more inspired by the futurist grid of Manhattan than by the rambling irregularity of Hampstead.

The same was not quite true of Naum Gabo. In fact, for a time, the Russian artist was at the heart of what seemed a new world centre of Constructivism. As two of his biographers put it, 'moving to England gave Gabo a new lease of life, both personally and artistically', and in the decade he was there he 'acted as a catalyst in the emergence of

English Constructivism'.[25] Gabo was aware that a movement was coalescing in Britain around the émigrés, and was keen to be a part of it; he met his second wife in London, the American Miriam Franklin, and was happy to leverage his status as a living emissary of the Soviet avant-garde (and, crucially, unlike his still-living contemporaries like Rodchenko or Lissitzky, a status unencumbered by NKVD spies or the need to endorse a current party line). He would regale his London friends with 'vivid stories about listening to Lenin address the masses on the streets of Moscow'.[26] You can get a sense of this 'English Constructivism' by looking at *Circle: International Survey of Constructive Art*, the compendious one-issue 1937 journal that Gabo edited with Nicholson and the young architect Leslie Martin, which they devised in a Hampstead ABC tea shop – pointedly, not in a pub.

Circle is a survey of Constructivism as it existed after its political edge was significantly blunted by the repressions of Stalinism and Nazism, but Gabo was there at the inception, in the post-revolutionary Russian Empire. He was born in 1890 the son of an engineer in a Jewish family in Bryansk, in the far west of Russia; like his more explicitly Marxist contemporary El Lissitzky, he was unable to study in a Tsarist Empire that maintained quotas for Jews, and went to study in Germany. While Lissitzky went to Darmstadt, Gabo went to Munich, where, while officially learning to become a scientist, he took an interest in art, attending Wölfflin's lectures. He spent the war in neutral Scandinavia, and returned to Russia after the revolution, and plunged, with his brother, the sculptor Antonin (Antoine) Pevsner, into the revolutionary art circles of the time, when artists such as Tatlin and Malevich were placing their art in the service of Communism – for the former, to transcend art, for the latter, to realize it. Gabo and his brother, who were then developing out of figuration into works of increasingly pure, abstract, jagged form, were ideologically closer to Malevich. To sum up the difference between the positions, Tatlin's school imagined they would create new, better, revolutionary teapots from the ground up; Malevich's pupils were happy to decorate existing teapots with abstract paintings.

Gabo and Pevsner's 1920 *Realistic Manifesto* was one of the first statements of Constructivism as a form of revolutionary art that would combine aesthetics, science and revolutionary politics, but it was quickly overtaken in its radicalism by the 'Productivists', hard-line disciples of Tatlin such as Aleksandr Rodchenko, Gustav Klutsis and Varvara

Stepanova. They imagined themselves going into the factories and creating useful things – stoves, machine tools, buildings, chairs. In the event, most of their work was in book, magazine and poster design, and increasingly theatre and exhibition architecture, fields in which they created extraordinary images and spaces until the mid-1930s when their work became increasingly ponderous, imperial and heavy, and some, like Klutsis, fell victim to the Great Purge. Gabo and his brother strongly disliked the shift towards an 'anti-art' position, and given the penury of the new Soviet state and their connections in Germany, they moved – as did Lissitzky – to Berlin. Both were welcomed by the German Constructivists around the journal G and the Bauhaus; but unlike Lissitzky, Gabo was not a Communist, preferring the anarchism of another London exile, Petr Kropotkin, and he did not return to the USSR. Nonetheless, Gabo did not renounce his Soviet citizenship until McCarthyism made it wise for him to do so, and he participated in some Soviet competitions, as for the 1932 Palace of the Soviets. Even in his London exile, he tried in Productivist style to interest industrialists in his designs for coat hangers, fireplaces and cars, with minimal success.

The Constructivism of *Circle* was 'progressive', broadly anti-capitalist and egalitarian, but it was not Marxist; this was 'Constructive Art', not the 'anti-art' that Gabo's Soviet contemporaries imagined. Tatlin and Malevich are included, though, as was the technocratic British Marxist scientist J. D. Bernal, another Hampstead neighbour; Herbert Read was there too, because he tried to enjoy everything progressive, though in his contribution you can notice less enthusiasm than he has for Expressionism. The group editorial speaks of a 'new cultural unity slowly emerging out of the fundamental changes which are taking place in our present-day civilisation; but it is unfortunately true that each new evidence of creative activity arouses a special opposition, and this is particularly evident in the field of art', such as 'popular taste, caste prejudice and the dependence upon private enterprise'.[27] Gabo's own introduction to 'The Constructive Idea in Art' tells us that 'our century appears in history under the sign of revolutions and disintegration',[28] and he lists the enormous technological and political changes that had happened in the previous forty years, with more expected to come. Out of this chaos will come order.[29] It is the breadth of the collection that is truly impressive though, ranging from Barbara Hepworth's invocation of Stonehenge to new housing in Los Angeles and the remarkable 'Functional Warsaw'

city plan by the Polish Constructivists Szymon and Helena Syrkus; compared with contemporary documents across the Atlantic like the Museum of Modern Art's pinched, pedantic volume on *The International Style*, you can read *Circle* to get a sense of the excitement of the modernism of the 1930s, and how it was once going to transform the world, not just the interiors and exteriors of rich people's houses.

Gabo's own work in London benefited from an unexpected high-tech resource. He was interested in materials, particularly, drawing on his scientific training, in plastics, and it was in Hampstead that he discovered the Ruskinian principle of 'truth to materials'. You can see this in the bulky, blob-like work he carved out of that quintessential English classical material, Portland stone, but much more so in a material he discovered on a visit to the ICI factory in Welwyn Garden City – Perspex, a new clear plastic, invented by ICI for windscreens. Gabo went wild for Perspex, and his sculptures of the late 1930s and early 1940s use it to form extraordinarily modern, lightweight, translucent works such as the series of 'Linear Constructions', many of which are in British galleries. His work was published in the BBC's journal *The Listener*, and he even participated in a radio debate with William Coldstream on abstraction versus realism, where his approach was unexpectedly charismatic, as could be seen in the riposte to the realist painter that serves for the epigraph for Part Three of this book.[30]

How these ideas were continued in Cornwall is a subject we will come to presently, but London Constructivism faded as quickly as it emerged, when many émigrés left for the United States – not just Mondrian, but also *Bauhausler* like Gropius, Moholy-Nagy and Marcel Breuer – while leading proponents within Britain such as Nicholson and Hepworth, or the architects like Lubetkin, came to be more interested in classicism or irrationality. Post-war 'Finchleystrasse' would not be a centre of Constructivism, at least not until it was revived in the 1970s by a new generation of architects and designers (particularly the Camden Council Architects' Department), when most of the original proponents were either in America or dead.

It was at this time, the slow years of the 1950s and then the acceleration of the 1960s, in which some of the increasingly ageing Expressionists who had settled in London came to record the changes that were happening in their adopted home. They were among the first people in London to prefer cafés to pubs. Cafés were usually provided by two chains,

ABC and Lyons, which were frequented by many émigrés as the nearest thing to the convivial culture they remembered from Berlin, Vienna and Prague, much more so than the murky, woozy, masculine world of the pubs – but in general, cafés where they existed closed early and were hard to find. Accordingly, what did exist became highly important – Canetti favoured a Hampstead caff called The Coffee Cup, which still exists, but most popular was the Cosmo Restaurant on Finchley Road, which was allegedly frequented by Sigmund Freud in his brief time in Hampstead, and featured Franz Marc reproductions on its walls.[31] Intellectuals huddled in North London coffee houses frequently recur in the English paintings of one of the lesser-known émigré painters, the Czech-Jewish Expressionist Friedrich (born Bedřich) Feigl.

Feigl was born in 1884 and grew up in Prague; his mother's family were from the city's famous ghetto. This district of the city was much mythologized at the time in works such as Paul Wegener's Expressionist films *The Student of Prague* (1913) and *Der Golem* (1920), and in the international reception of Franz Kafka – who Feigl knew and painted – as representative of a baffling and paradoxical, cabbalistic and irrational medieval Prague. Feigl's work was also strongly Expressionist, and he participated in *Bewegung* ('Movement'), a group of Viennese painters active after the First World War. In the 1920s he lived in Berlin, but worked frequently on themes connected with his family background, creating lithographs for a book on the Prague ghetto in 1921. With Hitler's rise to power, Feigl moved back to the Czech capital; on the advice of his friend Kokoschka he made for London when Prague was occupied by the Nazis in 1939, and escaped by the skin of his teeth, being arrested en route to London but released. In London, he painted views of Tower Bridge, took part in FDKB activities, exhibited at the Leicester Museum and Art Gallery, and resumed a friendship with a Belsize Park neighbour, the Prague-born art historian J. P. Hodin. The art historian Nicola Baird writes of how their friendship inspired Feigl's repeated paintings of cafés. Hodin argued that 'most of the modern principles in art and literature have been worked out over a sociable glass of wine or cup of coffee – in Paris, in Vienna, in Prague. But where does one meet these people in London?' The Cosmo was the place where the refugee artist circles tried to answer this question, 'to recreate continental "kaffe haus" culture in London',[32] where artists would nurse for hours a single coffee and cake while discussing ideas, politics and such. In

Feigl's painting *Restaurant*, inky, grey, gangly figures are hunched over tables, deep in debate; behind them are plate-glass windows, casting a very un-pub-like bright light.

If there was a doyenne of post-war 'Finchleystrasse', however, it was the Austrian Expressionist Marie-Louise von Motesiczky. Although she was already a notable painter in the last years of the Weimar Republic, most of her working life was spent in Hampstead; in her late life in the 1970s and 1980s she was visited and profiled as a living relic of a Hapsburg modernist culture then being discovered as its last exponents began to die off – polite, regal, heavily accented and elegantly dressed, but strange and sometimes violent in her work, a peculiar mixture of avant-garde and aristocratic. Of the émigré painters living in North London in the post-war years, Motesiczky has benefited most from gradual rediscovery, with her work eventually gaining a specialized room in the Tate; her *Self-Portrait in a Red Hat*, painted in exile in 1938, featured recently on an Austrian stamp. Her work is often very personal – particularly a long-running series of portraits of her mother, who escaped Nazi Austria with her to London – but there is also a quizzical, sharp and peculiar eye on her particular corner of the English capital.

Motesiczky's family took Czech citizenship when the Hapsburg Empire collapsed (meaning she was never interned), but she was born and raised in Vienna in 1906, to a wealthy Jewish dynasty of industrialists and financiers, who had been ennobled by the emperor in the nineteenth century (hence the 'von'); her grandmother had been analysed by Freud. Her decision to become a painter was owed to the influence of a friend of the family – Max Beckmann. She later compared his appearance in her cultured but bourgeois family in early 1920s Vienna to the arrival of 'a winged creature from Mars'. She was instantly fascinated by his violent, puzzling, vivid paintings and was delighted that:

> I should be chosen as the only one among all the people I knew to recognize that his pictures were beautiful rather than ugly, and that the man from Mars was a good rather than evil spirit – all this was very strange, even stranger than the events Alice in Wonderland experienced when she fell into the deep, dark hole.[33]

Motesiczky was part of an informal academy of aspiring painters Beckmann taught at his home in Frankfurt, and already by the late 1920s she

had incorporated his influence into taut, pugilistic essays in the *Neue Sachlichkeit*. They are skilful and powerful, but so obviously Beckmann-influenced that they could have been marketed, Renaissance-style, as 'School of Max Beckmann'. Over time, her work adapted Beckmann's influence into a distinct personal approach, in which the artist often appeared herself, as in *At the Dressmakers*, a haunting 1930 painting she later donated to the Fitzwilliam Museum in Cambridge. It depicts the artist herself staring starkly at the viewer while being stitched into a ball gown, and is a totally realized work that can be placed alongside paintings from the time by Beckmann, Otto Dix or Christian Schad without any embarrassment.

Humour is not generally a feature of Expressionism, as many reviewers of the 'Twentieth Century German Art' exhibition pointed out, but this is not at all true in Motesiczky's case. Sometimes her humour is exceptionally dark, as in *The Travellers*, a 1940 allegory of those panicked, dangerous journeys across the English Channel in little boats that she and so many others had just taken. It is night, the sea is turbulent, and on a raft are four figures: a woman checking her reflection in a mirror, a shadowy, elderly figure staring out to sea, a young man in shorts dipping his toe in the water, and at the centre, a voluptuous naked woman carrying a huge wurst. Near the end of her life, Motesiczky described the painting as depicting:

> The mood which my mother and I and many other émigrés all experienced: we didn't know where we were heading, everybody was looking for a visa to Japan or America and we were all clutching for dear life onto a few precious objects we'd managed to take with us.[34]

Tellingly, later critics who were more trained in piety than she ever was interpreted this precious object as a Torah scroll – before she confirmed it was in fact a large Austrian sausage.

Motesiczky's frequently noted charm and beauty meant she was able to get away with some brutal caricatures of the émigré artist community. She had been 'sort of adopted' by Kokoschka,[35] and he appears obliquely in *Two Women and a Shadow* painted a decade later in 1951, and now in the Leicester collection. This large painting depicts the artist herself and Olda Kokoschka sitting elegantly on a sofa, with the overbearing, grinning, jutting-chinned silhouette of the Great Man appearing behind

them. Making Great Male Intellectuals look somewhat ridiculous was a Motesiczky speciality, as in *Conversation in the Library*, one of many paintings featuring a diminutive Elias Canetti, her long-term lover. In paintings like these, her paintwork became more bristly, thicker, her line more irregular and elongated, moving further away from Beckmann's precise, hard figures – but she was still very much a painter of the *Neue Sachlichkeit*. Motesiczky was not a Surrealist. These were real people in real space, and the figures and faces are often English, which she referred to as 'the exotic English faces; marvellous eccentric old ladies and a whole race of quixotic gentlemen, a sanctuary of human individuality, intricate and inexhaustible'[36] – but they are presented in uneasy, anti-realist, dreamlike scenarios. Her work is full of mediation, and full of screens – mirrors, most often, but also televisions, as in the great *Miriam*, which is in the Lentos Kunstmuseum in Linz, Austria, but feels extremely English and early 1960s in its seediness and sexual tension. A young woman with thick, piled-up hair and wearing a lot of makeup lounges wistfully in a cluttered, stuffy room, in bra and skirt; behind her, a detuned little television swirls with static. Here, for once, old Vienna and Swinging London meet and are fascinated by each other.

Motesiczky lived in the most affluent part of Hampstead, between Finchley Road and the Heath, which she painted without cliché in the typically provocative and odd *Nudes at Hampstead Pond* (1988); neighbours in and around her house in Chesterford Gardens were Walter Neurath and Gombrich, along with the music critic and theorist Hans Keller and the portraitist Milein Cosman. Nonetheless, until she was elderly, Motesiczky's work was still better known and better exhibited in Germany, Austria and the Netherlands than in her adopted homeland. It is sad to think that her hilarious *On the Finchley Road at Night* (1952) is hanging in the Stedelijk Museum in Amsterdam rather than in a London gallery – the boxy, unsexy little cars that J. G. Ballard later recalled as the most shocking thing about austerity England are bouncing ineptly up the arterial road, with Italianate villas of the street murky in the background, so ornate and pompous that they could very easily be on the Mariahilferstrasse in Vienna.

Not every Central European painter in London lived in NW3. Expressionists like Martin Bloch or Henryk Gotlib lived and painted in Kensington and metropolitan Surrey, respectively. Some émigré artists were put to work by arts institutions like the National Gallery

and the War Artists' Advisory Committee to document the effects of the Blitz, particularly upon the great baroque buildings of the City of London by Wren and Hawksmoor – coincidentally those buildings that the Warburg Institute regarded as Britain's main link with the European mainstream – resulting in impressively jagged woodcuts from the Leipzig-trained printmakers Katerina Wilczynski and Hellmuth Weissenborn.[37] But nonetheless, the London represented in much of the émigré scene can appear somewhat limited to either middle-class inner suburbia or the monuments of its then-ravaged centre. There were other artists, particularly though not exclusively those active on the left, who either actively sought out working-class London, or simply depicted it because they were working class themselves. In the former category could be placed the 1948 book *The Other London* by the Hungarian artist and critic Imre Hofbauer. Seeking out the people who the new welfare state of the post-war Labour government hadn't reached, Hofbauer's inky, sometimes almost photorealistic drawings depict the homeless and the itinerant around the alleys and markets of the East End, a suddenly bustling, heavily populated, warm and chaotic city in comparison with the suburbs of other émigré painters; the work can inch towards Socialist Realism in its burly figures, though not in its close attention to idiosyncrasies and details, from the crumbling back walls of East End houses to funeral scenes seen from above.[38]

In the latter category, of artists who were of the working class whether they liked it or not, was Ernst Eisenmayer. Born in 1920 into a poor Jewish family in Vienna – his father was an electrician – the young Eisenmayer studied art at night classes. Trying to escape Austria with the Anschluss, he was arrested and sent to Dachau; he was released, one of the last people ever to have been, and he managed to make it to Britain – where he was quickly interned. Upon release, he worked on the shop floor at a factory in Acton,[39] creating artworks on the side, which gained him the attention of the FDKB and of Kokoschka in particular. Eisenmayer's woodcuts of London in the 1940s are on one level some of the purer products of German Expressionism in British art. Even the critics of the 'Twentieth Century German Art' exhibition were inclined to credit the quality of the woodcuts as against the paintings; the technique, which was after all developed initially in Germany by Holbein and Dürer, was transformed by the *Die Brücke* artists, or by the independent, socialist artist Käthe Kollwitz, into scything, stark works

of great simplicity and power. In the woodcuts he produced in 1948, Eisenmayer uses this technique to depict the ignored corners of London, as in a particularly grand-guignol image of still-industrial *Southwark*, or the extremely familiar but desolate streetscape of *The Snack Bar, Vauxhall*. Other woodcuts consist of figures in the landscape of this endless, sprawling, alien city – the gnarled but sympathetic pair, *Two Pensioners in the Tube*; while *Football and Prefabs, West Kensington* is a taut study in contrasts, with its kickabout next to boxy, temporary replacement houses in a Blitzed street.[40]

'Finchleystrasse' was not working-class London, then, but it was not aristocratic London either. The émigré painter who was most able to describe that – still very present – world was the Pole Feliks Topolski, a painter and muralist obsessed with pageantry. Born in 1907 and trained at the University of Warsaw, Topolski was part of an informal group of Polish Expressionists, the Wolnomalarska Lodge, along with other important figures of the avant-garde who we will encounter later, such as Aleksander Żyw and Franciszka Themerson, though Topolski was always something of a populist. Topolski's public work began with a monumental frieze of national heroes, including the recently deceased dictator Józef Piłsudski, painted for one of the halls of the University of Warsaw: painted in a distinctive wiry, free-handed, scribbly and deliberately rushed style, about which he remembered 'a colleague at my Polish school-of-art called my pictures "Kupy" – "vulgar"',[41] though a less polite translation of that word is 'shit'. Topolski moved to London in 1935 after visiting the city to cover George V's Silver Jubilee, which he found incredibly piquant in its antiquated ceremony; decades later, he recalled his 'enchantment' that in London 'the nineteenth-century uniforms' were still worn, and a country still immersed 'in Victoriana pomp-and-circumstance', continued to exist in the twentieth century.[42]

After 1939, he became an official war artist both for the British and Polish armies, but was wounded in the Blitz rather than on any of the various fronts he painted. Topolski, though sympathetic to the left, was not attracted to the Communism that took over his country in 1948, and remained in Britain when the war was over; the work that made Topolski's name was a mural called *Cavalcade of the Commonwealth* painted for the Festival of Britain in 1951 but picked up after it by the relevant viceroy and installed at the Victoria Memorial Hall in Singapore. It was an immense image of pageantry showing the picturesquely

various peoples of the British Empire, shown in Topolski's flowing, rhythmic hand, and it made an unlikely friend for Topolski – Philip Mountbatten, the Greek prince who was married to Princess Elizabeth, the heir to the throne. When he became Duke of Edinburgh at her coronation, he commissioned Topolski to record the event in a massive mural in Buckingham Palace, which the duke generously declared 'will never be mistaken for anything other than Feliks Topolski's view of the Coronation of Queen Elizabeth II in 1953'.[43]

Following the success of this mural, Topolski started drawing, designing and printing his own *Chronicle*, which derived from his journalistic work as a sort of Expressionist newspaper, documenting the events and personalities of the day. Topolski had burrowed further into the British Establishment than any other émigré artist of his generation, and his evident love of the pomp, the nonsense, the drums and trumpets and outfits of the British Empire meant that he was very attuned to the image of Britain that is most beloved by tourists. But he was also attuned to the ways in which these traditions could be put to other uses.

Topolski was perhaps the only artist who could have both illustrated a very official documentation of one side of the London ruling class, in the beautiful volume *Topolski's Legal London*, and to have made the drawings for the book produced by *Oz* magazine to support them in the famous obscenity trial elicited by their 'Kids Issue'. Topolski's love of depicting personal display – redcoats, turbans, wigs – meant that unlike some of his contemporaries, he certainly noticed the 1960s, and the way in which the swinging Londoners turned the pageantry he painted on its head. He wrote fondly of 'the upsurge of proletarian assertions – "Teddy Boys", the mock Edwardians', and 'the hippie mock-uniforms; war-surplus, but also second-hand red-coats, trailing ball-dresses and dusty feathery hats for girls. Coincidences these were not', but rather a way 'the young propelled the changes by costume-mockery' aimed at the old ruling class.[44] Topolski's life's work was an immense mural of London pageantry and public life created over four decades in a series of panels across his studio under one of the railway arches opposite the Royal Festival Hall; he was, he wrote in 1981, 'painting throughout my life the same "panorama", varying/enlarging/broadening in themes/experience – from the Warsaw fourteen-inches long parade of personages to the present attempt at an overall summation zig-zagging 600 feet'.[45] The mural, which he called *A Memoir*

of the Century, was to be 'twelve to thirty feet high, and roughly continuous, patched-up and overlapping, punctuated by three-dimensional relief accents ... an environment of painting'.[46] It was completed before his death in 1989, and opened to the public as 'Topolski's Century', as part of the old 1951 Festival site's cultural extravaganza, a short walk from the Festival Hall, the Hayward or the National Theatre. But Topolski's work, never particularly fashionable, was certainly no longer so by the 2010s. The arts cuts of the austerity era saw his mural reduced massively in size, with a characterless bar placed inside, and the former studio renamed Bar Topolski. Perhaps in future someone will be inspired by this example of tourist London, much as he was inspired by the silly parade of George V's jubilee.

The underside of Topolski's London full of splendour and melodrama was a place that could be deeply melancholic to outsiders. A Warsaw contemporary who recorded this aspect of the capital was Halina Korn, born Halina Korngold in Warsaw in 1902. She was married to the (much more famous) Polish Expressionist painter Marek Żuławski, but her own work is a deceptively naif depiction of a strange, disconnected city, as in the beautiful, haunting painting *Bus Stop*, now in the Ben Uri gallery in her adopted home of St John's Wood: it depicts a queue waiting, expressionlessly, beneath one of Hans Schleger's modernist bus stops. Korn's entire family were killed in Auschwitz and she suffered from poor mental health, which was, unsurprisingly, not unusual among her generation.

Two female painters who came to Britain when very young similarly produced some of the most enduring, unsentimental and hard-edged images of working-class London after the war. Käthe Strenitz was born in Czechoslovakia in 1923, and like Karel Reisz was among the hundreds of Czech Jewish children and youths saved by the humanitarian Nicholas Winton, though the rest of her family were killed. On arrival in England she was sent to a farm in Hampshire, where she was undernourished and slept on a floor, but Winton's wife Grete sent a few of the drawings she was making on the farm to Kokoschka in London, who recommended her for a scholarship to study art at Regent Street Polytechnic. After completing her studies she married an émigré who ran a plastics factory in the railway lands between King's Cross and Camden Town – the subject of the poisoned yellow, orange and grey landscape of her *Backyard of the Otaco Factory, 16 Market Road* – and

it is this landscape of factories, warehouses, canals and scattered Victorian and Georgian slums that became the subject of Strenitz's career as a painter, with some excursions to even denser and stranger industrial landscapes in south-east London, such as Shad Thames in Bermondsey. She later attributed this interest in the blackened remnants of the Industrial Revolution – then very far from 'regeneration' – to her first encounter with London, at Liverpool Street station, where the *Kindertransport* refugees arrived.[47] As she recalled: 'I saw this enormous black antediluvian station and felt what a horror and how interesting.'[48] When the King's Cross area started to be cleaned up with the arrival of the Eurostar, the British Library, and the development of the railway lands behind, her paintings became a record of what was once there, and are extensively reproduced in the recent book *The King's Cross Story* by historian Peter Darley.

Strenitz's paintings are a striking – and surprisingly uncelebrated – application of the Expressionist eye to London, but the workers themselves are objects in those landscapes; they aren't the subjects. They *were* very much the subject of her contemporary Eva Frankfurther, whose work has recently been gaining some of the attention usually denied to post-war British social-realist painting. Frankfurther was a Berliner, born in 1930 in a comfortable Jewish family in the suburb of Dahlem; they fled in 1939, at the last point when they would have had any chance of survival. She grew up in Belsize Park, studied art at St Martins, and then after travelling to Italy returned to England and very sharply broke with this North London world, leaving her family and working in the East End as a washer-upper in a Lyons Corner House. After a couple of years of this, Frankfurther went on to be a factory hand at the vast Tate and Lyle sugar refinery in Silvertown. This wasn't the picturesque old-time East End of Imre Hofbauer's book *The Other London*, with its rookeries, funerals and garrets, but something even harder to comprehend, a vast industrial city of respectable Victorian houses that was largely unknown to Hampstead intellectuals regardless of where they had been born. And yet, Frankfurther's focus there was entirely personal – the figures, faces and lives of the people she worked with. In the late 1950s she spent eight months in Israel, where she was 'disturbed' by the fate of the Palestinians, and generally depressed by the experience. As her sister remembered, she asked 'Why when you start again would you then carry on in the same sort of way?'[49] Pointedly,

her drawings made in Israel focused on the then habitually ignored and repressed Palestinians as much as the Israelis.[50] She then came back to London again, and was accepted to study social work at the London School of Economics. In 1959, still suffering from depression, she took her own life.

Frankfurther's work apparently passed largely unnoticed at the time, being exhibited only in and around Whitechapel; but she was memorialized in 1962 in the tiny book *People*, which featured a memoir by the Welsh painter and critic Mervyn Levy – followed by a sort of scrapbook of her drawings and paintings, without titles, sometimes several to a page, giving the book the feel of something she might have carried in her pocket. Levy tells the reader of how 'as a worker in the East End she was a staunch trade unionist and saw in the machinery of the movement a means of bettering the worker's lot. In no sense was her compassion sentimental'.[51] It is this lack of sentimentality that is so remarkable in her work, given it features such emotive subjects – young workers already ragged from labour, rough sleepers, mothers and children – and also in how often it depicts what was then the novelty of an increasingly multicultural working class, in paintings such as 'West Indian Waitresses', a matter-of-fact 1955 painting of two of her co-workers in the Lyons café. Her work was never lurid, and it never exoticized her black colleagues – they were just her friends and workmates.[52] Frankfurther's practice as an artist – realistic sketches and paintings, unpretentious and detailed – was Expressionist only in the sense of Kollwitz; there was little that was abstracted or distorted, and few could have been shocked by her pictures, perhaps not even the British. But in them, much more than in the work of any of her contemporaries among the émigré painters, you can see a little glimpse of the future of London.

19
Central Europeans in the Celtic Fringe

If most refugee artists settled somewhere in the NW postcodes of London during the 1930s, many would gradually fan out across the country in the next decades. Much of this was due to the expansion of higher education and the popularity of art schools in the 1960s and 1970s, but there was also a particular attraction of those parts of the island of Great Britain that were not 'English'. The distinction was initially obscure – the conflation of 'Britain' and 'England' was probably at its height in these years – but it gradually attained more importance, with a resurgence of Scottish, Welsh and to a degree Cornish nationalism by the 1970s. This movement by émigré artists and others to the non-English periphery, which has more recently been encompassed in the idea of a politically distinct 'Celtic fringe', took various forms. Much of it was in the form of tourism, particularly to the coastal areas and the picturesque beauty spots, where far more dramatic landscapes contrasted with the calm, green and wealthy south-east of England that most refugees had first encountered. Some of this movement by artists to the periphery took a more serious form. It became a matter of finding new subjects and new homes in these places that were incredibly distant from the polite but oblique and cold English middle-class life that many Berliners, Praguers, Budapesters, Viennese and Varsovians found extremely alienating. As in the work of Eva Frankfurther in the East End, this was also for some artists a political shift, away from a bourgeois enclave in the metropolis towards what they imagined to be the real working-class life that Hampstead might imagine and idealize, but could not possibly understand or experience.

But it should be remembered that the first move away from 'Finchleystrasse' was forcible. The Isle of Man, to which many of the protagonists of this book were deported in 1940 and 1941, was for a little while a

strange accidental centre of Weimar Culture and of modern art.[1] Some of this activity consisted of artists just getting by, as in the watercolour portraits that Kurt Schwitters made for cash and fags. Some of the art documented the bleak surroundings. Other work made elsewhere celebrated what the internees themselves had managed to produce while imprisoned. In the transit camp at Huyton in Liverpool the Austrian painter and graphic designer Hugo Dachinger painted on a newspaper – a common substitute for canvas – a remarkable Dadaist portrait of the theatre director Kurt Jooss, in the form of a poster. When he was sent to the Isle of Man and interned in Ramsay, Dachinger organized an exhibition of 'Art Behind Barbed Wire' in 1940.[2] The following year it travelled to London. Dachinger's poster for the show, with its barbed wire at an acute angle across the image, is as vivid and dynamic as anything on the walls of the London Underground. But the Isle of Man itself is and was one of those anomalous parts of the British state: never incorporated into the United Kingdom, never sending MPs to Parliament, with a unique and much-exploited tax status, much like the Channel Islands off the coast of Normandy, which were in this period occupied by Nazi Germany.[3] Manx is a Celtic language and on some level it could be argued that the island is part of this 'fringe', but its historic conservatism hardly made it appealing to those who were imprisoned there. To my knowledge, none of the artists or writers who were interned ever returned to the island. There are a few landscapes among the many works produced by interned artists – such as by Martin Bloch, who was a big enough name to be escorted outside the camp by an armed guard so that he could paint *en plein air* without in some way working for the enemy. But by and large, the delights of Man's mountainous landscape appear not to have particularly inspired those who were consigned there.

A possible reason for this, one suspects, is the peculiar form the internment took. The holiday homes of resort towns on the Isle of Man like Douglas, in serried rows along the seafront, were encased with barbed wire and turned into teeming tenements. As Fred Uhlman describes it, Hutchinson Camp in Douglas was 'a block of small boarding houses ... completely surrounded by barbed wire', in which 'there were nearly sixty houses, each housing some thirty to forty, who mostly had to sleep five to a room' (though 'by combination of luck and speed I found a small room with only two beds', the other taken by the Constructivist architect Carl Ludwig Franck).[4] This resulted in a strange, and very

urban environment, which you can see in a lot of the artworks produced during the internment. The many woodcuts and paintings made in Hutchinson Camp stress this surrealism, and the depictions are often harsh. Hugo Dachinger's *Officer Standing Behind Barbed Wire Fence*, for instance, depicts a ridiculously comic, blimpish, moustachioed officer standing smugly between the barbed wire and the repurposed B&Bs, in a cutting image of English pomposity and ignorance. In any case, such an environment was not propitious to hill-walking or getting to know the locals, both of which could land an internee in serious trouble.

Exploring the peripheries of Britain was much easier if you had one of those passports – Czechoslovak, Polish, or Soviet – that made you safe from internment. The first location outside the metropolis where several Central European artists moved either temporarily or semi-permanently was Cornwall. Already by the 1930s, the coastal towns and villages of this culturally distinct peninsula had for a long time been seasonally occupied by painters down from London, subject to what one art historian calls a 'a benign cultural colonialism', where people from the capital and the industrial Midlands discovered and remade coastal Cornwall as a kind of internal 'Mediterranean'.[5] This rested on the early de-industrialization of the peninsula, with its mining industries and ports already much reduced by the end of the nineteenth century, leaving these – relatively! – sun-kissed beaches, blue bays and craggy hillscapes ready for a wave of new development. A couple of generations of artists had kept holiday homes here by the time Ben and Winifred Nicholson in the 1920s and 1930s came to favour the St Ives area, and even found their own authentic Douanier Rousseau-style 'primitive' artist in the form of Alfred Wallis. By this point, Cornwall played a similar role in British modern art to the coastal areas of Provence in French Post-Impressionism. But the fixation on this ancient and parochial landscape of south-west England also made the art that resulted a somewhat unlikely enthusiasm for those who were already irritated with English provincialism; with an element of scorn, one art critic called the styles later defined as 'St Ives art' a form of 'extremely English romantic mysticism'.[6]

Nonetheless, for a time Expressionists and Constructivists did find a safe haven in England's south-western peninsula. With the start of the war, Oskar and Olda Kokoschka, who as Czechoslovak citizens were not under any threat of internment, relocated from the Finchley Road

to Polperro, a tiny resort with a small fishing harbour, on the south coast and east of St Ives; although the artist was a German-speaking Austrian, and a gentile one at that, his status as a Czech citizen was enough to protect him from the eyes and ears of the British secret service. Down in Polperro, in the artist's own account, 'we could breathe the pure sea air' that you just couldn't find in a flat in West Hampstead, and found an intensity of light that is much harder to encounter in London's foggy, dingy streets; 'we lived in a block-house on the cliff looking over the sea', Kokoschka later remembered, with views that recur in paintings such as *Polperro II* (now in the Tate), a liquid panorama of rocks and waves. Yet this was painted under some duress, given that 'unfortunately, for security reasons, painting in the open air was soon forbidden; instead, I took up sketching on the beach, with coloured pencils'.[7]

As ventriloquized in Edith Hoffmann's authorized biography, Kokoschka's Polperro exemplified 'an English landscape perceived by a foreign temperament', with the vivid green that frames the blue in *Polperro II* being 'the colour that strikes the foreign traveller on his arrival in this island, though it may never strike an eye familiar with its brilliance'. But by venturing so far from the Home Counties, Kokoschka managed to find within these green fields an appropriately Expressionist landscape, where he could paint 'the torn, rocky coastline, the steep road curving round the bay, the sea and the sky so often troubled by furious winds, the shrieking seagulls and the boats accustomed to rough sailing'. For Kokoschka, Polperro was 'not the picturesque seaside village known to so many holiday makers' but 'a fantastic edge of the earth where land and sea battle incessantly'.[8] The allegories of the artist's 'political' period were also often painted in Cornwall. The sour canvas *Private Property*, where a woman stands in front of a typical English middle-class seaside house before a prodigious catch of large fish, was the artist's seething response to the world of the 'English riviera' – as Hoffmann put it, 'the knitting women of Cornwall seem to have annoyed Kokoschka'.[9] His satire on appeasement, *The Crab*, takes place in what is instantly recognizable, for all the thick daubing and scraping of the paint, as a fishy and craggy Cornish beach. A swimmer in a turbulent sea (with Kokoschka's jutting chin) on the verge of drowning was intended by Kokoschka to symbolize Czechoslovakia, while a gigantic crab that passively watches the swimmer's imminent death represented Neville Chamberlain. Even

in the double exile of Cornwall, attempting to enjoy the sea views, Kokoschka was unable to restrain his frustration and horror at the British indulgence and ignorance of German Fascism.

Perhaps puzzlingly, the Weimar artist who managed to settle most happily in Cornwall was the most ultra-modernist of all, the determined Constructivist and revolutionary Naum Gabo. He lived in Carbis Bay, a mile east of St Ives, between 1940 and 1946. He had moved there with Hepworth and Nicholson, who already spent much of the year there; relocating on the peninsula full-time was a response to the London Blitz. Gabo, fully aware that as a Jewish anarchist with a Soviet passport he would face certain death in the event of a Nazi invasion, found the notion of sheltering in a remote corner of England appealing; it was, as he described it, 'quite a spot of paradise considering the conditions in which the world lives, though it is somewhat windy'.[10] There were probably few places in England so distant from the German bombing of the ports and industrial cities as western Cornwall, but even then, Gabo could not entirely escape.

In his diary of 21 April 1941, Gabo recorded that from his clifftop bungalow he could see Plymouth, one of the most heavily bombed cities, on fire – seventy miles away to the east. 'I saw the sky glowing . . . I observed these hellish fireworks for a long time'. He 'went to sleep trying to forget what I had seen, trying not to think or imagine what was happening to the people under those lights in that blazing and bombarded city'.[11] Gabo, who had no illusions about Stalinism and was frequently irritated by the starry-eyed naïveté of British Communists, was nonetheless deeply moved by the Soviet war effort. In this capacity he contributed a photomontage cover depicting the Red Army to Edward Hulton's magazine *World Review*, deliberately in the crude agitational style of one of El Lissitzky's later montages. Gabo continued the propaganda for a Constructivist future he'd engaged in while living in Hampstead; in the same magazine, he warned rather presciently in a 1942 piece called 'Prepare for Design' against the risk of 'uniformity' in post-war reconstruction. He advocated that planners look to the more improvisational and diverse Constructivist artists and architects of Central Europe rather than to the more arid, symmetrical city-plans of Le Corbusier.

While urban reconstruction may have been on his mind, it is hard to imagine anywhere quite so far from the glittering, communal cities

Gabo had imagined in post-revolutionary Moscow and 1920s Berlin, as the bungalow suburb of Carbis Bay, a resort carved out of a dead mining town at the end of the nineteenth century. Naum and Miriam Gabo rented a house called 'Faerystone'. Some of the embarrassment was no doubt reduced by the practice of whitewashing the interiors of the houses, something the Gabos and the Hepworth-Nicholsons had learned from Mondrian, who did the same to his Victorian Hampstead studio – with pure white walls, maybe you could imagine yourself in some Constructivist communal house or *Siedlung*. Sometimes the sculptures created by Gabo reflected his new maritime, semi-rural home. *Spiral Theme*, for instance, was inspired by the many shells that he and Miriam collected on St Ives beach, and he worked in Tintagel stone in the 1945 sculpture *Granite Carving*. Most of the time, however, Gabo was still working in those ultra-artificial materials he had sourced from the ICI factory in Welwyn Garden City – though he had to apply for a special licence for them as these valuable plastics were being rationed by the government. This continued commitment to the machine-made was at least part of the reason why the avant-garde triumvirate of Gabo, Hepworth and Nicholson fell out near the end of the war.

The spats within the group partly resulted from the natural exchange of ideas that happens within any artistic clique. The nylon threads that linked the forms of Gabo's mid-1940s sculptures were used first by Hepworth, while the egg-like forms she began to use around the same time were borrowed from Gabo, a move to which he reacted with considerable pique. But above all, Hepworth and Nicholson, and in London, Henry Moore, were all moving further and further away from Constructivism. Hepworth's work increasingly became *of* the landscape of the far west of Cornwall, rocky, organic, monumental, looking as if it had always been there. Gabo's did not. There was no Perspex in Neolithic Britain, and doubtfully he was bothered about that fact. Gabo was still essentially a futurist, and the English couple were not. Nicholson, for instance, preferred Gabo's work in photographs to the plasticky reality, and complained that 'the material in which he works is almost repulsive to me'.[12] On the other side, in a letter to Herbert Read, Gabo ranted about the English artists' abandonment of Constructivism, and claimed it was the reason why their collaboration and friendship had to end:

> I informed them and all their friends and patrons that the idea of Constructivism is not a trough to be fouled by pigs who have gorged themselves, nor is it a curtain for a stall, and that I am no longer their partner.[13]

The 'St Ives Artists' now included younger figures around the original Hampstead three, like Patrick Heron and Peter Lanyon, who as the 1940s went on became an increasingly definable group. They had decreasing space for an emissary of the pure blaring force of Constructivism, though there were exceptions. Lanyon remembered how contemporaries such as Nicholson and Heron were appalled by all those clear plastics, which meant they missed the point of what Gabo was up to – these clear, machine-made materials created a purity and weightlessness that masonry could not achieve. Gabo showed that you could use 'space like sculptors use stone'.[14] It would, however, be another few decades before this insight was truly understood in Britain; and by then Gabo was off, to a lucrative career in the United States, though he retained a warm affection for wartime Britain and the refuge he had found there.

It is noticeable that a certain *depopulation* can be found in the work of the modernists in St Ives. This extends beyond the passionate abstractionist Gabo and the Kokoschka who was so depressed by Cornish knitters, to artists who worked there for most of their lives. The most obviously modernist was Paul Feiler, a Frankfurt-born painter who emigrated as a teenager and studied painting at the Slade in London before being interned; after the war, he painted some harshly urban landscapes, all metal bridges and gasworks. These were suddenly replaced, as he took a studio in Kerris, near Penzance, with an increasingly purist series of hard-edged abstract paintings, produced from the 1960s until Feiler's death in 2013.[15] These beautifully capture Cornwall not as a 'place' in terms of its personal 'eccentricities', but through its highly abstract qualities of light and space. The Viennese artist Albert Reuss, a realist who produced some slightly sentimental work for 'Red Vienna', was saved from the Nazi takeover of his city by a Quaker journalist from Falmouth, who helped him settle in Mousehole south of Penzance. His Cornish paintings, produced over many decades, return obsessively to barren seascapes, painted in a stark, dreamlike style. Canvas after canvas features deserted beaches, littered with shards of coral and seaweed, bare cliffs and twisted fences.[16]

While in no possible kind of sense 'Mediterranean', the Scottish

Highlands have a similar place in the middle-class imagination to Cornwall. Like that peninsula, the lands north of the Highland fault line were depopulated and reconceptualized for tourism, although much earlier, and much more violently with the Highland Clearances. They do, however, offer spectacular Expressionist panoramas of the sort that Edith Hoffmann described in Cornwall: here, if anywhere on this island, you could find a real tempest, in 'a fantastic edge of the earth where land and sea battle incessantly'. One of the most fantastic edges of the earth is Wester Ross, where mountains shaped into unearthly forms by ancient meteor showers shelter a series of tiny, stricken fishing villages, many of them planned by landlords as part of the Clearances. One of these is Ullapool, where Kokoschka stayed during 1944, producing a series of pencil sketches. He remembered this place in his autobiography for the *artificiality* of its desolation:

> The bleak Scottish moor-land is a human creation. In the early nineteenth century the local lairds evicted their tenants in order to get a higher rent from Englishmen shooting grouse. All landscapes are given their shape by man; without a human vision no one can know what the world really is.[17]

The Ullapool landscapes are tentative, but dramatic – scrawled outlines of jagged hills and seascapes, in livid greens and purples. These were worked up by Kokoschka into the hallucinatory *Ullapool-Landschaft* of 1945, and a rather more placid *Scottish Landscape with Sheep*.

But unlike in Cornwall, most of the work made on and in Scotland by émigré artists was urban, and figurative. That's particularly the case with three quite different artists, who all came to Scotland due to, accidental or otherwise, the movements of the Polish army – Jankel Adler, Josef Herman and Aleksander Żyw. Only the last of the three would settle in Scotland for the long-term, but each of them engaged with the country in some depth. They were also Polish Jews, whose situation was both starkly different from that of most Poles, and also from most German and Austro-Hungarian Jews, particularly those who were able to escape to Britain. Poland had a substantial Jewish proletariat, working in small factories and workshops and concentrated in big cities like Warsaw and Łódź and in small towns in the east of the country. They were often linguistically and politically separate from the Slavic Polish population, speaking Yiddish along with – and, for older Polish Jews, rather

than – Polish. They organized politically either in a Bloc of Minorities with Poland's then-huge Ukrainian and Belarusian population, or in the revolutionary socialist Bund. Young Polish Jews tended to be more politically radical and poorer than those to their west, and were often objects of discrimination from the assimilated Jewish communities in cities like Berlin, Frankfurt, Vienna, Prague or Budapest, as 'Ostjuden'.

After the death in 1935 of the relatively enlightened dictator Józef Piłsudski, an ex-socialist leader who retained a horror of racial chauvinism, a new regime in Warsaw would pass explicitly antisemitic legislation. While not as shockingly draconian as the Third Reich's Nuremberg Laws, Poland's antisemitic laws included measures such as a 'numerus clausus' designed to keep Jews out of universities – there were even 'ghetto benches' designated for Jewish students. Within the Polish army, these attitudes were especially acute. The 'blue army' of its founder Józef Haller was notorious for committing pogroms when Poland regained its independence in 1918. Nonetheless, Adler, Herman and Żyw all identified as Polish patriots, and in Adler and Żyw's case fought in the Polish Army of the West that was hastily formed from Polish émigrés in 1939. Much of that army managed to escape the Nazi occupation of France, from Dunkirk; it was then reorganized, retrained and settled in Scotland.

Of the three artists, the best known at the time was Jankel Adler, born in 1895, who grew up in a family of ten children in the multi-ethnic and strongly left-wing textile city of Łódź, founded by the Tsarist Empire in the mid-nineteenth century as a 'Polish Manchester'; he then moved to the Weimar Republic, and on its fall emigrated to France. Some measure of his fame can be found in the fact that when in 1924 the great *Neue Sachlichkeit* photographer August Sander wanted an artist for *Face of Our Time*, his photo-cycle of the class system of 1920s Germany, he chose Adler, who sits on a stool, confident, legs apart, staring intensely at Sander's camera. As a painter, Adler had begun working in Yung-Yidish, a group of avant-gardists in Łódź, before his emigration to Düsseldorf, where he became heavily influenced by the paradoxical machines and peculiar creatures in the work of Paul Klee, with whom he taught for a time. It is strange that Adler has not had any recent rediscovery, as he was phenomenally talented, and his paintings are still incredibly striking and original, distortions of the human body with a raw sensuality and roughness of texture. In 1937, his work was placed next to Marc

Chagall and Hans Feibusch in the 'Jewish' room of the 'Degenerate Art' exhibition, where the deliberately primal aspect of his work was used to suggest the painter was 'subhuman'. Adler did not take the Nazis' scorn passively – he had published an anti-fascist appeal in the last semi-free elections in Germany, in March 1933, and escaped very soon after.[18] While living in France, he joined the Polish Army with the outbreak of war, and as noted was evacuated at Dunkirk, before being sent by the British to Scotland, with the rest of that force. He was then invalided out of the army due to a heart complaint, resuming his work as a painter in what was then still the 'Second City of the Empire', Glasgow. He would later die of his heart condition, in 1949, aged fifty-three.

Adler quickly made contact with Glasgow's own modern artists – particularly with the Scottish Jewish Expressionist sculptor Benno Schotz and the veteran post-impressionist J. D. Fergusson, and he joined an existing colony of artists living in the small, picturesque Borders town of Kirkcudbright.[19] While there he painted the wonderful 1943 *Venus of*

VENUS OF KIRKCUDBRIGHT (1943). In the possession of the artist. 44" × 34"

An Arcadia in the Scottish Borders: Jankel Adler's Kirkcudbright.

Kirkcudbright. Its stylized, heavily abstracted central nude, with mask-like features, places her right hand on a weird, organic apparatus that could be machine, could be easel, and could be some form of creature; the surface is gritty, and at the left corner, the board of the canvas has been uncovered. Like a lot of Adler's work there is a humour here, but it remains an uneasy, powerful image, with the peculiar slight smile on the model's otherwise blank face a potentially optimistic one, with a suggestion of shelter and welcoming in a situation of chaos and horror. The great complexity and richness of the painting reflects the scope of Adler's abilities. A younger painter who Adler would mentor in Glasgow, Josef Herman, described them as follows:

> Just as Jankel's mind was a world's library, so his mode of painting was built upon the traditions of many countries and many peoples. In this lay his sophistication. Whether the source was some ornamental design from a Jewish ritual object, or colours from Coptic materials, decorative shapes from Persian pottery or medieval manuscripts, he assimilated and made use of everything that stimulated his taste and on which he could improvise.[20]

Josef Herman was perhaps for a time the best-known émigré artist in Britain, particularly through his depictions of the mining communities of South Wales; but his first encounters with this country were in Glasgow, a city that, with its grandiose imperial monuments, tall tenements and wide-open spaces, bears a certain resemblance to his native Warsaw, much as Edinburgh, with its central castle, royalist trappings and powerful local intelligentsia, resembles Kraków. Herman was born Marek Josek Herman in the Polish capital in 1911: his father was a cobbler, and his mother was illiterate. They lived in the Jewish proletarian slums of Warsaw; his memoirs include a hair-raising scene of the pogroms in the city at the end of the First World War, when the Haller army attacked any Jews with beards and, in his account, beat up a few bearded gentiles caught in the crossfire. He remembers, 'it somehow slipped our mind to cheer the independence of Poland. We just forgot all about it.'[21] Herman left school at thirteen. He was attracted to socialist politics through an uncle who was active in the Bund; as a teenager Herman was apprenticed to an anarchist typesetter, who introduced him to trade unionism, in an environment that was for him 'a

sort of university'.[22] After getting lead poisoning, he tried to work in graphic design, and from there became a painter, joining an association of socialist artists in Warsaw called the Phrygian Cap, after the headgear worn by the Jacobins in the French Revolution.

As a designer, Herman was briefly attracted to Constructivism, which was a major force in the Polish capital, where it was associated with the social-democratic left whose existence was tolerated by the Piłsudski dictatorship; two architect-couples aligned to the Constructivist Praesens group, Helena and Szymon Syrkus and Barbara and Stanisław Brukalski, designed a series of impressive trade-union-sponsored social-housing estates in Warsaw's suburbs that are comparable to those of Berlin and Frankfurt.[23] In his memoir, *Related Twilights*, Herman recalls his attraction to this style as a young designer: he was intrigued by Constructivism and by Malevich's Suprematism; and he 'particularly liked' El Lissitzky, and 'what the Suprematists and the Constructivists were doing with letters, their devotion to a flat graphic surface', with stark, hard block colours in white space. But 'soon afterwards I wanted nothing of this'.[24] From then on, and for the rest of his career, Herman would, like Eva Frankfurther a little later in the East End of London, concentrate on painting people – the working class especially.

Herman and the other Phrygian Cap artists, like the photomonteur Mieczysław Berman – Poland's equivalent to John Heartfield – were socialists and realists, although not necessarily in the Soviet sense; their first exhibition was held in a social club in one of those Constructivist housing estates in the suburb of Rakowiec. Their manifesto broke with the formal primacy of Constructivism by asserting that 'technique is secondary to theme'.[25] The emotional intensity and political critique of the great Expressionist woodcutter Käthe Kollwitz was the group's major inspiration. However, the environment of Poland in the second half of the 1930s was increasingly oppressive for a young left-wing artist, and Herman emigrated, first to Belgium; as he later put it, he 'felt oppressed in Poland, under its fascist regime, both as Liberal and as a Jew',[26] and in Brussels he linked up with a local group of politically committed Expressionist painters. But in 1940, Herman escaped as the country was invaded by Nazi Germany. Arriving on the Kent coast, as a Pole he was sent by the Foreign Office to Scotland, as that's where the Poles and the Polish army were, and in Glasgow he met with Adler – an old Warsaw contact – and was brought by him into the city's small but

progressive art scene. In a sense, Herman must have found Glasgow in some ways familiar. The Gorbals then had a sizeable Yiddish-speaking working-class Jewish population. Herman was also able to work for leftist art projects such as the Glasgow Unity Theatre, for which he designed some remarkable Constructivist costumes recalling the Meyerhold or Tairov theatres of 1920s Moscow, for the propaganda play *We Are This Land*. The Unity Theatre then produced Herman's own more surreal and humorous play *Ballet of the Palette*. Both plays were well received by the young socialists of Red Clydeside.

Nonetheless, Josef Herman's years in Glasgow are much less well known than his later time living in the South Wales Valleys, and he seldom depicted the city itself or its inhabitants. Something else was on his mind. Herman was, unusually for a twentieth-century artist, a vivid, talented writer, and his memoirs and journals, written from the 1940s onwards, are filled with memories of the destroyed world of Warsaw's strongly left-wing and strongly local milieu of *Yiddishkeit*. The Bund were hostile both to assimilation – that is, to subsuming their Jewish identity into the Catholic Polish population – and to Zionism, with its revival of Hebrew and eventual goal of setting up a new state in the Middle East. Although he would later travel to Israel and make works that sympathetically depicted the communal, Jewish labourist world of the Kibbutz, as a Bundist Herman was a proud speaker of Yiddish rather than Hebrew. The Yiddish-language theatre and Yiddish art that thrived between the 1900s and early 1930s in Poland and the west of the USSR were among his great passions; as Herman later called it, Yiddish was not for him a mere dialect but 'a language of rebirth, pride and self-discovery'.[27] It was this world, then being ground into dust by Nazi Germany, that Herman would try and recreate in the work he made in Glasgow.

As he would write in the 1970s, Herman, traumatized and in mourning for his family and their world, all wiped off the face of the earth by German Fascism, 'walked the streets of the Scottish city' until 'all I could see was what my memory wanted me to see, a fabric of distant life which was nonetheless part of me'. He was in no mood to criticize the poverty of the Warsaw slums, but remembered instead the life and culture of the place, the humour, the affection: 'of course I romanticised my scenes. I followed a dream, perhaps a collective dream. The reality, I well knew, was shoddy in many of its social aspects, but my memory

of those people was beautiful . . . I was a lover, not a documentarist.'[28] In his Glasgow years, he produced dozens of rough ink-wash drawings of that world – of the tenements and cobbled streets, the bearded elders, bustling mothers and raw youths from what had then been transformed into a walled ghetto, whose inhabitants were being deported and exterminated in death camps like Treblinka – and drawings of those who would fight a doomed but heroic battle with the Nazi occupiers in the Ghetto Rising of 1943. Herman desperately tried to recall what was there before, aware he would never see it again.

At this time, Adler was in Herman's account his 'constant companion' – 'both of us were Yiddish-speaking, we were both from Poland, hence we could look into each other's faces with understanding. In the company of others we were a conspiracy of two.'[29] In Glasgow, both artists would find out that their entire families had been murdered in the Holocaust. Herman had a breakdown, and credited Adler with helping him to recover. Some measure of the extreme ignorance that even sympathetic British bureaucrats and critics displayed of what was happening to people like the Adlers in Łódź and the Hermans in Warsaw can be found in a short interaction that Herman had with Sir Kenneth Clark in London in 1943, when he was trying to obtain work from the Wartime Artists Advisory Committee that Clark headed up. Clark – who was not known for antisemitism or racism in general, and had helped various refugees find employment – clearly found Herman's intense drawings and paintings an unlikely fit for the programme. He told him: 'Mr Herman, you are a very talented painter, but my advice to you is to go back to Europe.'[30] The place he had 'come from' was at that very moment being wiped off the face of the earth.

Although he would 'come to love' Glasgow, Herman initially found the city lonely and alienating. Like Adler, he was able to find some interest in the more picturesque corners of semi-rural Scotland – rather than Kirkcudbright, he was attracted by the small fishing towns of the West Highlands and the Hebrides. He fell for the likes of Mallaig, Stornoway 'and more places' he had by the 1970s 'forgotten the names of', recalling their 'dream-like tranquillity', with each village 'a planet all its own', where 'one forgets the distant hustle and one is reminded of more durable rhythms'. Alongside his scenes of old Warsaw, Herman would sketch the fishermen and dockers of these rainy little settlements, in which he found 'each figure self-contained in a grand form', with 'each

group telling the simple tale of human bondage' – and 'all this happening in slightly moist, soft Highland light'.[31]

That moist light would feature frequently in the work of Aleksander Żyw, the only one of the three to make Scotland his home for decades rather than a few years. Żyw is one of the few émigré artists in Britain whose work became more rather than less radical over time, a shift caused by his reaction to the horrific events that were taking place around him. Born in 1905, he was from a Jewish family in Lida, a small town in what is now Belarus, in the eastern *Kresy*; he moved to Warsaw at an early age and, when studying painting, gained a travel scholarship, and became an itinerant Impressionist painter around the Mediterranean. He was in Corsica when the Second World War broke out, and immediately applied to join the Polish Army; he escaped the fall of France in 1940 by travelling through Spain and Portugal, before making his way to Britain and to the army in Scotland. The Polish Army was notoriously antisemitic – Jankel Adler, for instance, was put on arrival in Scotland into a disciplinary camp claimed by one historian to be used for 'communists, Jews and homosexuals'.[32] Another Polish-Jewish socialist who had joined up, the great historian Isaac Deutscher, then a Trotskyist journalist, protested against the army's bigotry and caused a national scandal in raising it publicly, having to be moved to a different unit. Nonetheless, there appear to have been enough enlightened people in the force to have hired Żyw as an official, embedded war artist.

Alongside his paintings of this displaced army's manoeuvres in the Scottish countryside, Żyw produced several images of Edinburgh and its working-class districts such as Leith, which cast a fresh eye on a city that could be rather in love with a very contrived image of itself. He published some of these images in a slim 1945 book, *Edinburgh as the Artist Sees It.* In his introductory essay, H. Harvey Wood – the critic who helped found the Edinburgh Festival with the Austrian opera impresario Rudolf Bing – describes Żyw as 'massive in his proportions, discriminating in his taste and leisurely in his habits', hence 'combining in his person the most characteristic features of this city'.[33] You can see this in Żyw's panorama of Arthur's Seat and Holyrood Palace, scratched-out drawings of the Old Town – such as the angled bridge and the twisted tenements in *The Village of Dean*, or the *Der Golem* skylines of his views of the castle, showing a city that is already a pre-prepared set for a German Expressionist film, every bit as much as pre-war Kraków or

Prague – scenes from an unmade *Der Student von Edinburg*. As Wood points out in his essay, Żyw was able to see just how weird Edinburgh is due to his outsider's eye: 'what has moved and what has impressed him has been what *we* are too inclined to take for granted – the physical majesty of the city, its dramatic skylines, its startling vistas'.[34]

After the war, Żyw's work became suddenly violent, abstract and incredibly forceful; his son Tommy Żyw argues that this shift took place after his father learned that his family had been murdered in the Holocaust.[35] These paintings, such as the distorted, harsh, outlined figures of the 1948–9 *Sussanah*, shocked critics at the time – a London exhibition was reviewed with the words 'Żyw has gone berserk', and suggested that the thickly applied paint suggested 'an artist who was said to sell his paintings by weight'.[36] Although they initially shocked their audience, the paintings made for Żyw a second career as a much more fearless modern artist. Like Herman and Adler, he had no 'home' to return to, and would settle in Edinburgh in 1945. He took a cottage in the picturesque corner of Dean Village, and hired the (then) young modernist architect Basil Spence to convert it.[37] For the next twenty years, he frequently painted Edinburgh, and here, as with Kokoschka in London, a place had very much found its painter. Żyw didn't try to paint Edinburgh 'as if' it were the Mediterranean, as if its light was pure and clear: rather, in canvases such as the vast and brooding 1952 *Holyrood Palace*, with his palette of dark browns and greens and his angular modelling of the buildings and hills, he produced a true Scottish Expressionism. After he had perfected this, Żyw in 1970 moved to Tuscany, where he spent the last twenty-five years of his life.

Like Scotland and Cornwall, Wales could offer exotic landscape to those depressed by the south-eastern English suburbia they had escaped to; and here too, in Wales, some émigré artists settled into pre-existing artistic colonies and middle-class resorts. Particularly influential here was the neoclassical architect and socialist Clough Williams-Ellis, who founded on his land in coastal North Wales the town of Portmeirion, constructed out of architectural salvage as an attempt at creating an 'Italian Hill Town' on the edge of Wales; this obviously had appeal to artists, and the feeling was mutual. Williams-Ellis commissioned the 'Degenerate Artist' Hans Feibusch to create some fanciful murals for one of his ingeniously faked buildings in the new resort, and he wrote the texts for a book of drawings of the North Wales landscape by Fred

Uhlman, published by the Hungarian émigré Paul Elek (who published a series on the pleasures of the English counties, 'Vision of Britain', edited by Clough and his wife, the socialist writer Annabel Clough Williams-Ellis). But it was industrial South Wales that was of much more interest to several painters who found themselves in 'the Valleys' or the industrial ports in the 1940s.

That continental modernist painters should have moved, either for a short stay or a long-term residence, to this heavily industrial but dramatic, stricken place is because this was also an exceptionally politically enlightened area with a tradition of non-conformism, socialism and working-class self-education. It was also an area that had suffered greatly during the Depression, and in the 1940s money and industrial capital were suddenly being directed there by social-democratic planners; accordingly, a few émigré industrialists opened new factories in 'the Valleys'. That's how the painter Heinz Koppel came to document the area in the 1950s. Koppel was a young German-Jewish painter, born in Berlin in 1918, whose family emigrated in 1933 to Czechoslovakia; in Prague, he was taught painting by Friedrich Feigl, but had to flee again in 1938 with his father – his ill mother did not escape, and was murdered in the death camp of Treblinka. After emigration, Koppel studied painting in London under Martin Bloch and then moved to Dowlais, a mining village near the metalworking town of Merthyr Tydfil, where his father had founded a zip-manufacturing company. Koppel taught art classes to miners and their families and was an early member of the 56 Group, a fiercely independent collective of Welsh painters who aimed to create their own art scene proudly distant from London. Koppel's paintings of Dowlais and Merthyr are very much in the Expressionist tradition, with wild colours and jagged ridges of mountains, church towers and chimneys, but as the 1950s progressed the pictures take on a street-level mordancy, as in the caricatural, surreal *Merthyr Blues*, now in the National Museum in Cardiff, where the figures in posters bellow out songs above howling dogs and a teeming, chaotic streetscape.

The painter with the biggest reputation working in South Wales was Ernst Neuschul, a major *Neue Sachlichkeit* painter perhaps now best known for his large, matter-of-fact but sympathetic painting *Black Mother* (1931) in the Expressionist collection of the Leicester Museum and Art Gallery. Neuschul was born in 1895 to a Jewish family in Ústí nad Labem, in what is now the Czech Republic. He built a career in

Germany as a painter, first in the scything, bitter style of *Die Brücke* and then in a more deadpan, rather ostentatiously 'decadent' and lubricious manner; and he was an active member of the KPD. By 1933 he was chair of the *Novembergruppe*, but he emigrated to Czechoslovakia after the Nazis came to power. Neuschul then briefly moved to the USSR, where, with the Great Purge, German-speaking Communists were at even greater risk than they were in Nazi Germany; he was tipped off by a friend in the government just in time to be able to escape back to Czechoslovakia, and then had to flee that country in turn in 1939. He was aided by David Grenfell, the Labour MP for Gower, a former miner who had worked to help Czechoslovak refugees come to Britain. With Grenfell's help Neuschul settled in Mumbles, the picturesque suburb overlooking industrial Swansea. Moving ever further from Expressionism, he painted some imposing, statuesque canvases of workers in South Wales, such as the monumentally proportioned, red-head-scarved cockle-picker labelled *Untitled*, and the more optimistic, smiling *Cocklewoman* of 1940; the latter he donated to the Glynn Vivian Art Gallery in Swansea 'in deep gratitude to the people of Swansea for offering home and shelter to the refugee from Nazi oppression'.[38]

Although he was grateful for the refuge, Neuschul was lonely as an artist in Swansea, and after a few years he moved to Hampstead. There he became active in the Free German League of Culture, and his work grew increasingly abstract. By this time, though, living fifteen miles north of Swansea in the nearby mining town of Ystradgynlais, and having relocated from Glasgow, was Josef Herman, who for the rest of his life would be both deeply committed to the human figure, and to painting it at work in South Wales. Herman, like Neuschul, had been encouraged to move to South Wales by a Labour supporter, in his case a local activist he had met in London, David Alexander Williams. Herman's first vision of Williams's home town was an epiphany that he returned to frequently in his writing and his painting, where the workers walking in the dense terraced streets surrounded by steep valleys were suddenly hit by a ray of sunlight. This was a moment that Herman recorded – in italics – in his memoir as one of the most important of his life:

> *This image of the miners on the bridge against that glowing sky mystified me for years with its mixture of sadness and grandeur, and it became the source of my work for years to come.*[39]

Herman would live in Ystradgynlais for eleven years; other modernist painters of his acquaintance such as Martin Bloch and the Polish Expressionist Marek Żuławski came there to visit and to paint. For this to happen in a picturesque village in Cornwall, the Highlands or North Wales was one thing; for the South Wales Valleys to be treated as a sort of industrial Dieppe, crowded for a time with continental painters, was something rather different.

Herman's vision of Ystradgynlais was an outsider's one, necessarily – he saw it with great intensity in all its strangeness – but it was not an alienated one. In fact, he seems to have found in the town the cure for the alienation he had experienced in Glasgow and London, and he felt accepted in Ystradgynlais from the outset. Famously, he recalled:

> 'You're no stranger here,' I was told the very day I arrived. A day later I was addressed as Joe and now I am nicknamed Joe-bach.[40]

Herman's paintings of the town, for all their raging colours and doom-laden mists and fumes, portray the people living there with great humanity and sympathy. His miners are enormous figures, to be sure, heroic and massive in poses of solidarity and togetherness, but they are not cartoons or statues. The suffering brought on by their work, and the dangers of it, are imprinted on their bodies and faces. Although at the time he was close to the Communists in the Artists International Association, Herman felt scorn for Soviet Socialist Realism, with its idealized hero-workers: 'I feel only revulsion,' he asserted, 'in front of Stalin-Prize winning pictures depicting smirking miners in spotless hygienic mines in what might be called an optimistic style of petty-bourgeois academicism that tries to flatter the workers.'[41] His figures were both monuments and people, a difficult balance that Herman mostly achieved through the sheer confidence of his painting.

Herman was aware that being in such a little town posed the risk that he would create exotica, and he tried to resist it. Artists, 'when they come to small places ... look for the so-called "characters"', but these 'are lamentably alike everywhere. They are the same in Wales as in Poland, as in Scotland, among the Jews or Flemish peasantry.' Rather, he was interested in the masses, both in their massness and their individuality. 'The miner is the man of Ystradgynlais,' he writes. Looking at them, 'sometimes I thought of old Egyptian carvings walking between sky and earth,

or dark rocks fashioned into glorious human shapes, or heavy logs in which a primitive hand has tried to synthesise the pride of human labour and the calm force which promise to guard its dignity'.[42] Herman also noticed the importance of the chapel tradition, and of socialist politics, and the way they were melded together in places like this. 'Even underground I saw men falling naturally into oratory', and he tried to find in this the source of the place's 'passion' – 'it is this passion which lights up the inspiration, and makes some of them read through heavy volumes of economics, sociology and philosophy, and prepare themselves for the task of leaders'. But all this was also a consequence of how dangerous their work was to the miners' health: for those that he could see visibly dying of silicosis, there was 'no more passion left'.[43]

Years after Kenneth Clark's astoundingly tactless rejection, Herman's work in 'the Valleys' started to be noticed outside of Wales, and he worked up two large-scale paintings of miners as murals – the unfinished *Miners Singing* (1950–1), now in the National Museum in Cardiff, and

Josef Herman's *Miners* mural, on show at a Whitechapel Gallery solo exhibition.

Miners (1951), painted for the Materials Pavilion in the 1951 Festival of Britain, then moved to the Glynn Vivian Art Gallery in Swansea, where it still stands. *Miners* is a work of both incredible pride and incredible bleakness, with its dark blacks and reds shrouding the hunched, helmeted figures, who are resting after their day's work underground. Herman appears to have understood and admired the strength and solidarity engendered by this labour, but unlike a Soviet Socialist Realist he was also keen to record that this is work that's dirty, distorting and painful. This empathy derives surely in part from Herman's own experience as a worker, one who had to quit his job as an apprentice printer due to lead poisoning. But it must also derive from the solidarity granted to him in turn by the working-class people of Ystradgynlais. They had welcomed a Polish-Jewish artist who spoke with a strong accent, kept strange hours, had odd habits, and painted strange pictures, as a neighbour and as a comrade.

20
New Figures in a New Landscape

There is a stretch of the River Thames along which you can find, almost in deliberate sequence, a series of public open-air sculptures by émigré artists that range from Socialist Realism through populist modernism through to abstraction, in a half-mile walk from Waterloo Station to St Thomas's Hospital. Most of the sculptures were commissioned by the London County Council. Many owe their existence ultimately to the LCC's Festival of Britain, that great showcase of the promised social-democratic future held in 1951 on the South Bank of the river around the new modernist Royal Festival Hall. The Festival was a three-dimensional entry in the 'Britain Celebrates Itself' genre so popular in the middle of the century, as could be seen in all those book series like 'Britain in Pictures', 'Vision of Britain', Pevsner's 'The Buildings of England' and in many of the King Penguins, and like these, the émigré contribution to the Festival was significant. In fact, the Festival can be seen as an immense showcase for émigré artists and sculptors, though this was hardly stressed by its organizers.[1] But what sort of sculpture was on display, and what new figures were being placed in these new spaces?

Feliks Topolski's mural *Cavalcade of the Commonwealth* and Josef Herman's *Miners* were only two of several large-scale works by exiles prominently displayed in the Festival, which ranged from high-minded images of labour on view on the South Bank to a playful Guinness-sponsored mechanical clock at Battersea Pleasure Gardens, designed by Lewitt-Him. Two of the largest of the monumental, almost Soviet modernist-realist hybrid sculptures displayed at prominent places on the South Bank were by émigrés: *The Islanders* by the Viennese Siegfried Charoux, a gargantuan, slightly cubistic concrete family in high relief on a vast concrete slab; and *The Sunbathers* by the Hungarian Peter Peri, again featuring massive, slightly abstracted realist figures, this time

Union of Soviet British Republics: Siegfried Charoux's *Islanders* at the Festival.

naked, and cantilevered from another concrete slab. These two works were suggestive of a new idea in British public art – immense figures of ordinary people, in modern materials, integrated with the new scale and new spaciousness of modern architecture. This moment – where heroically scaled realist sculpture met equally dramatic buildings, both at the service of a particular vision of a more egalitarian future society – was brief, and it very rapidly fell out of fashion artistically,[2] but it has left its legacies across Great Britain.

After the Festival ended, its main sponsor the London County Council continued its impressive sculptural programme. A Labour one-party state between the early 1930s and its abolition in the mid-1960s, the LCC was a spearhead of the welfare state, and from 1948 onwards began a 'Triennale' of open-air sculpture exhibitions in public spaces such as Holland Park and Battersea Park. This is why the South Bank, which the LCC went on to develop into London's cultural centre, features that sequence of monumental sculptures by émigrés. A short walk

around Waterloo Station will take you not just to Naum Gabo's *Revolving Torsion* at St Thomas's Hospital and Feliks Topolski's *Memoir of the Century* under the arches leading to Hungerford Bridge, but also to public sculptures such as *Motorcyclist*, an angular figure by Siegfried Charoux; the *Shell Fountain*, a towering cascade of abstracted seashells by the Czech sculptor Franta Belsky; and then just across the approach to Westminster Bridge, *South of the River*, a formidable abstract by the German-born Bernard Schottlander in front of Becket House, a Yorke Rosenberg Mardall office block adjacent to St Thomas's; a visit to the area can also, at the 'Festival Church' of St John's Waterloo, bring you to equally monumental murals by Hans Feibusch (which we will come to presently). Some of these were removed for a time, ranging from a few years to several decades, but with the recent revival of interest in the Festival, the South Bank, and London's social-democratic moment more generally, many of these sculptures have been put back in place. Charoux's *Motorcyclist* was recently reinstalled on a site near the old LCC headquarters at County Hall, and Peri's *Sunbathers*, which was long considered lost before being found discarded in a Blackheath hotel, now stands affixed to a wall in Waterloo Station itself.

Peter László Peri's remounted Festival *Sunbathers*.

Some of the most successful émigré sculptors were responsible for the sort of sculpture that goes mostly unnoticed in urban space. The Croatian-born sculptor Oscar Nemon, for example, produced grand realist statues of great men from Freud to Churchill to Montgomery. In some ways, the story of émigré sculptors is useful for those who would argue against the radicalizing effect of the 1930s emigration. The work of the Estonian Jewish sculptor Dora Gordine, whose career travelled a westwards path from Tallinn to Paris until eventually ending in Kingston-upon-Thames, is another case in point. Her stylized, soft-lined figures once stood in power stations, office blocks and hospitals. A *Mother and Child* still survives at the entrance to the Royal Marsden Hospital, Sutton, but her work is now best seen at Dorich House, the house-museum in her self-designed Brick Expressionist studio in Kingston; it is serene, realistic and classical, and it would take a huge amount of ideology for it to be considered 'degenerate'.

If one looks at, say, the 1960 catalogue for the third of the Battersea Park sculpture exhibitions, it is rather striking how much of the work by émigrés is relatively conservative. Statues by Charoux, Gordine, or lesser-known sculptors who escaped to Britain in the 1930s such as the German Uli Nimptsch or the Czech Karel Vogel, are straightforward realist figures, placed along the paths and bushes next to increasingly wild and strange forms by the likes of Lynn Chadwick and Eduardo Paolozzi. Work that might have been very outré and striking in 1935 was, twenty-five years later, rather mild and reassuring; perhaps the sculptors, who had all gone through horrifying experiences in the inter-war period, might have rather liked it that way – an expression of the serenity and security of their island refuge. But this sense of reassurance was also because of their continued fixation on a particular conception of modern sculpture as heroic art for ordinary people. However, by the end of the 1950s this style had become desperately unfashionable as new, much younger heirs to Expressionism, Dada and Constructivism went back to the original source, searching for the raw power of the first moment rather than the softened, adapted, becalmed versions that were brought to Britain or developed within it.

That is not to say there were no Constructivist public sculptors from an émigré background working in post-war Britain. A few seconds' stroll from Naum Gabo's *Revolving Torsion* at St Thomas's Hospital, on the raised green lawn in front of the slick red stone grid of Becket

House, is Schottlander's *South of the River* from 1976, a full-scale abstract work carved out of steel, resembling a pair of vast turbines in implied perpetual motion. Its plinth proudly declares the artist as having been born in 'Mainz, 1924'. Schottlander was a true high modernist, but came to sculpture from a career in product design, not fine art. Emigrating with his parents to Leeds as a teenager in 1939, Schottlander became a welder in a factory, while taking night classes at the city's art school. After the war, he was extensively praised for a series of lamp fittings that had some of the spindly elegance of Charles and Ray Eames, though they were apparently functionally rather deficient. At the turn of the 1960s he moved from welding to sculpture, always in heavy industrial materials and frequently executed in a strident red, in the vast, minimalist, unsentimental, machine-made manner then associated with sculptors such as Anthony Caro.[3] In the 1960s and 1970s this gained Schottlander several prominent commissions, often in universities – such as the bright-red elemental shapes outside of the Rootes Building at Yorke Rosenberg Mardall's University of Warwick; the series of minatory, almost hieroglyphic objects outside the Whitworth Gallery at the University of Manchester; or the oblique series of four giant forms placed around the New Town of Milton Keynes. These

Modern Hieroglyphics: Schottlander and Rosenberg on the South Bank.

late works exhibit the sculptor's interest in anthropology; Schottlander's sculpture was described by the architect and critic Theo Crosby as 'heraldry of the machine age'. Nonetheless, it was not representational or realistic, and did not 'say' things – Schottlander took the hard-line position that 'sculpture is the art of silence, of objects which must speak for themselves'.[4] He is wholly a post-war sculptor, not someone who straddles the two eras, and hints of the utopian dreams of the Bauhaus or Moscow's VKhUTEMAS in his work can be found in other contemporaries who did not spend their childhood in the Weimar Republic.

Sculptors in Britain after the war who *had* been sculptors in Central Europe in the 1920s and 1930s tended to be less fearlessly modern. A look at some of the biographies of prominent refugee sculptors might explain this apparently paradoxical mixture of political radicalism and relative artistic conservatism. Given the socialist politics of some of these artists, this combination might seem to be a consequence of the shift in Soviet art in the late 1920s from abstraction and experimentation towards a somewhat melodramatic and heavy realism, but it could just as much be rooted in 1920s Social Democratic Vienna. The city council of the Austrian capital also favoured monumental architecture for its workers' housing schemes, and additionally featured an extensive programme of applied art – relief sculptures on walls, sculptural groups at the entrances to estates, busts of radical figures in prominent niches, mosaics, murals and decorative panels, all of which were executed both to beautify the new working-class environments, and to give a glimpse of what the socialist future might be like. This also served to decrease the rate of unemployment, given how many artists lost work as Vienna descended from being the capital of an empire stretching from Trieste to Lviv into a dwarf state south of Bavaria and Czechoslovakia. Given the politics of Vienna in that period, it isn't surprising that many of these artists would emigrate, and eventually find themselves in Britain.

Certainly, the career of the sculptor of that *Motorcyclist* on the South Bank, Siegfried Charoux, begins in the crucible of 'Red Vienna'. Charoux was born in 1896 in a gentile Czech family, as Siegfried Buchta; Charoux was a cartoonist's pen name – 'Chat Roux', Red Cat – based on his mother's maiden name, Charous. He spent a decade as a political caricaturist for a socialist newspaper, and then moved into sculpture; among his major commissions was a large high relief with the title *Frieze of Labour* placed over the entrance gateway of Zürcher-Hof, one of

Vienna's many monumental housing estates. It is a scene of construction in a raw, slightly stylized form of realism, with its burly working-class figures modelled roughly and aggressively, emerging out of the stone blocks themselves as they build their new Vienna. Charoux then won a prize for a memorial to the Enlightenment philosopher and playwright Gotthold Ephraim Lessing, in Judenplatz, at the historic heart of the city's Jewish community. In the year it was finally unveiled, 1935, 'Red Vienna' had been overthrown by cannons and shelling, and Charoux, who had refused to work for the new Austro-Fascist government, made his way to Britain. Three years later, with the Anschluss, this moderately brutal regime was replaced by a much more violent one, and the Lessing monument was melted down. However, in the 1960s, towards the end of his life, Charoux was able to work on a new version, which still stands on the site today.

In Britain, the Tate bought some of his works and he had a degree of success, though he was nonetheless interned in 1940,[5] and gained British citizenship after the war. His British work is on occasion straight-up Socialist Realism, though of the more organic and visually imaginative Viennese type rather than the Soviet version. The Viennese example was at the front of his mind when he was designing for the LCC's housing estates. In an address to the Royal Institute of British Architects (RIBA) in 1953, Charoux pointed out the difference between a London council estate and a Viennese one, as follows:

> When I first came to this country 18 years ago, the London County Council was building blocks of flats to replace slums, and these blocks of flats have now become slums themselves. They are mean, hard-looking machines for living, without a soul, and the people look the same. I also remember the flats built in Vienna to replace the slums there . . . I recently saw those flats and not one of the buildings has deteriorated at all. They have a soul: they are living things, and the people are proud of them.[6]

This is due not just to their 'sculpture and mural paintings', but also to the simple fact that 'there is no meanness' about the Viennese estates. In Charoux's LCC commissions, he would try to bring the Viennese ethos, rather than the specific Viennese look, to the new places.

The earliest result is *The Neighbours*, a sculpture unveiled in 1957 by the London County Council as part of their Quadrant Estate near

Highbury Corner, a spacious modernist group of terraces, rather Arts and Crafts gateways, and mini tower blocks among trees. This project was highly praised at the time by critics such as Ian Nairn, and is still in good condition today – a graffiti-free, green and quiet space in the inner city, suggesting that Charoux's hopes for LCC housing were, for a time, fulfilled. In his sculpture, two ordinary-looking London blokes, freely cast in a rough, approximate mould rather than precisely modelled, sit down as if after a day's work; they lean on each other, and look as if they might be enjoying a drink, or betting, or doing something else not entirely revolutionary. Rather than standing at the grand entrance to a big centralized block of housing, the sculpture is in among the trees, with a gentle informality to the arrangement. There is a warmth and humour in Charoux's sculpture, too, which you can't necessarily find in the chiselled faces and muscular labour of his stiff, formal Zürcher-Hof group, the *Frieze of Labour*. It is as if the relative irrationality and mateyness and lack of ideology of the English proletariat, so frequently discussed by puzzled European socialists, has rubbed off a little on Charoux. The chests of the Vienna workers are bare, showing off their impressive pecs; by contrast, the two workers in *The Neighbours* have their sleeves rolled up and are wearing loose, comfortable overalls. That relaxed humour is even more obvious in Charoux's South Bank *Motorcyclist*. With his helmet and uniform he is obviously a working biker, a courier, rather than someone biking for fun – but there is a lot of fun being had in the machine-like rendition of this diminutive figure (now further diminished by being shoved into the corner of some unlovely public-private space in a new speculative development), whose bike resembles an extension of his body.

If Charoux's monumental *Islanders* served as one of the Festival of Britain's visual heralds at one end, Peter Peri's *Sunbathers* performed the same function on the approach to Waterloo Station. It is one of dozens of realistic concrete sculptures by Peri across London and the Midlands, and it consists of two nudes in red-coloured concrete, sprawled out, turning towards one another. Originally, Festival visitors could look down on this sculpture, as they might in looking at reclining sunbathers on a beach; currently, it stands on a wall in the upper gallery of Waterloo Station, which rather misses the original point but does emphasize how Peri's figures often appear to spring from the walls at dramatic, structurally daring angles. The sculpture is now the most publicly prominent of

an extraordinary oeuvre, by an artist who was a pioneer Constructivist, but became in exile for a time probably Britain's most prolific Socialist Realist artist. He was praised as one of the major artists of his generation by the likes of Francis Klingender, Anthony Blunt and John Berger – who based the Hungarian Communist émigré protagonist of his first novel, *A Painter of Our Time*, partly on Peri, partly on Frederick Antal. Peri's shift from abstraction to realism might have mirrored the wider changes in the cultural policies of the Communist movement he supported from the 1910s until the 1950s, but in any other respect his work was deeply idiosyncratic – instantly recognizable, technologically innovative, and, like Charoux's later sculptures, unashamedly eccentric.

Peter Peri was born László Weisz in 1899 to a working-class Jewish family from rural Hungary, and was raised in Budapest. After school, he was an apprentice stonemason, and this remained his profession when the 1918–19 revolution broke out in Budapest in the aftermath of the First World War. He joined the Communist Party and was a fervent supporter of the 1919 Hungarian Soviet Republic; like so many protagonists of this book he fled when that brief experiment was overthrown, first via Vienna to Paris, where he was deported as a subversive alien, and then to Berlin. In that city he began working as an artist, making contact with the *MA* Group of Hungarian Constructivists, which included László Moholy-Nagy, with whom he mounted a joint exhibition in 1922. Peri's early Constructivist work is strictly abstract, graph-like, in a manner that led him then to architecture – he submitted an entry to the 1924 competition for the Lenin Mausoleum in Moscow, and briefly worked as an architect in Berlin City Council, then a hotbed of socialist modernism under its chief architect Martin Wagner. But Peri came to realize this wasn't really where his talents lay. Communist artists in both Berlin and Moscow were moving towards representational art, and in 1928 Peri did the same, becoming a sculptor and also working as a satirical cartoonist for the KPD's daily paper, *Die Rote Fahne* ('The Red Flag'). Peri was active in the last dying actions of the German Communist movement, and fled Germany in 1933 not long after punching a Gestapo officer at an anti-Nazi demonstration. Like a few other émigrés who settled in Britain, he was lucky enough to have a British spouse, making settling in the country much easier than it would have otherwise been for a Jewish Communist modern artist. This was his second wife, Mary Macnaghten, a music student and granddaughter of the Victorian

social reformer Charles Booth. They had met through the KPD in 1929. She was briefly arrested in 1933 for distributing anti-fascist leaflets at the Siemens factory in Berlin after Hitler's seizure of power. The couple were clearly in great danger, and so fled for Britain that year.

On arriving in Britain, Peri was penniless. He had been unable to bring any of his sculptures with him; the concierge of his flat in a Gropius-designed block destroyed all that he had left behind.[7] In various ways, Peri had to start anew, and did so through a curious material choice. Finding that bronze was much more expensive in London than in Berlin, he experimented with the wonder material of modern architecture – reinforced concrete. First of all, he made it himself, with cement and rudimentary wire mesh; but this choice also led to the unusual possibility of sponsorship. His first London exhibition, of 1938, carried the name 'London Life in Concrete', and he had been granted both money and some materials by the Cement and Concrete Association, who were keen to prove that they were producing more than just grey slop. Peri's concrete was polychromatic, rich with surface interest, and depicted dozens of lively human figures, in work and at play, in scenes from everyday life in his adopted city. He developed this concrete into his own personal 'Pericrete', a coloured aggregate of concrete and polyester resin; it is this material from which *Sunbathers* and many other of Peri's sculptures were made.[8] The parallel here with the material shifts in modern architecture was obvious, especially given Peri's own previous history as a Constructivist painter and modernist architect, and he hoped his work would become a part of modern architecture – which, for a time after 1945, it did.

Peri was for a time a successful artist, and lived in a flat opposite Hampstead Heath, on Willow Road, a few doors up from his fellow Hungarian Marxist and concrete enthusiast Ernő Goldfinger. Perhaps the most complete example of Peri's work still surviving, and the one that best captures his politics, eccentricity and humour, and humanity, is a series of sculptural decorations on the South Lambeth Estate, a social-housing development in Vauxhall, South London, near the Thames, built in 1948. This was a fairly ordinary London County Council estate of big brick blocks with long access decks, built in parallel rows, quite distant from the gleaming blocks by Walter Gropius that Peri had known from Berlin, but still with great opportunities for enlivening expanses of bare brick; the idea was suggested by Peri to the LCC rather than the

A Memorial in Pericrete at Vauxhall Gardens.

other way around, with the artist proposing to model the figures in wet concrete on site, hence 'creating a direct and vital contact between the artist and the people in the tradition of Renaissance fresco painting'.[9] There are three groups of sculptures on the estate in coloured Pericrete. A mother and children playing on the stairwell of Horton House; boys playing football at Wareham House; and the most poignant, *Following the Leader*, a descending spiral of children playing on the stairwell of Darley House, intended as a memorial to the Blitz, then still a very recent and raw memory in this neighbourhood. The figures are all realistic, but never 'heroic'. They wear ordinary 1940s clothes and have ordinary 1940s haircuts, their bodies are skinny like those of working-class British people at the time, and there is an underlying honesty in the depictions that is neither cruel nor harsh, but straightforward, matter-of-fact.

This very close integration of modern architecture and realistic sculpture works so well in part because Peri never entirely rejected his Constructivist past. On his own account, Peri's 'interest in people, the

way they live and their relationships to each other was so strong' that he 'returned to representational art', while being keen to point out that he 'never separated my work from my constructivist experiments'.[10] Abstraction 'was a historically essential cleaning process', which 'tore down the frills' of the nineteenth century,[11] leaving the space open for new ways of depicting people in their communality and individuality, in their work and in their dreams. It was on the strength of unashamedly friendly and emotive works like those on the South Lambeth Estate that Peri received various commissions from schools and colleges through the 1950s and 1960s. There were around a dozen commissions for sculptures on and around the comprehensive schools of Leicestershire County Council, on schools and community centres in the East End of London, in Huddersfield, and in newly expanding universities such as Exeter and Loughborough. Exeter University's 1959 *Man of the World* is a good example of these works, in its daring cantilever from a brick wall over Devonshire House. Another of Peri's skinny Pericrete figures bursts out of the wall, handling the model of a DNA molecule. After 1956 and the Soviet invasion of Hungary, scenes like this, where stylized, slightly abstracted human figures would hold aloft the totems of progress, became the new paradigm in Soviet sculpture during the Khrushchev 'Thaw'. But Peri, unlike some of his contemporaries, did not return to East Berlin. The revelations of the 1950s about the scale of Stalin's crimes led to Peri leaving the Communist Party, and while still referring to himself as a socialist, he became a Quaker – a rather fitting choice, given the friendliness and austerity of Peri's wonderful, still too ignored and patronized work.

Not every émigré public sculptor was a committed socialist, and some were much happier to work for public and commercial commissions at will. The work of Franta Bělský, another rather populist, friendly figure whose sculptures can be found extensively in public spaces, is a case in point. They were made by an artist who was a refugee twice over, first from Nazism, second from Soviet-style Communism. Bělský was born in 1921 into a middle-class Jewish family in Brno, a large industrial city that was at the forefront of the modernist culture of interwar Czechoslovakia; his father was an economist, and Franta grew up mainly in Prague, where in 1938 he enrolled into a commercial art school. Within months the Third Reich's occupation first of the Sudetenland and then of Bohemia and Moravia wiped his country off the map. The Bělskýs

then emigrated to Britain, and Franta, after a stint at the Central School of Arts and Crafts in London, enlisted in the Czechoslovak army in exile.[12] He returned to Czechoslovakia after 1945, then governed by the Communists – who emerged as by far the largest party in free elections that year, the only Eastern Bloc country where they ever won a fair contest – in coalition with the liberals and social democrats who had run the country between the wars. In this interregnum between dictatorships Bělský carried out a few notable sculptural commissions in Prague, before fleeing again in 1948, when the Communists forced out their coalition allies in a violent coup and installed a full-scale Stalinist regime of considerable brutality.

In Britain, Belsky – his name now anglicized – resumed his studies at the Royal College of Art, and then carried out some very establishment commissions. Like Oscar Nemon, his CV includes many of the important men of imperial Britain. Belsky's first monumental sculptural commission outside Czechoslovakia was for a statue of Cecil Rhodes in Bulawayo, in what was then Rhodesia, and he also made the bust of Lord Mountbatten in Trafalgar Square. Like Nemon, he frequently returned to the subject of Winston Churchill, who he had encountered as a soldier in the Czechoslovak army. But Belsky can also be credited with a couple of the genuinely 'iconic' sculptures of the social-democratic moment in Britain. One of these is, like Charoux's work at Highbury Corner or Peri's for the South Lambeth Estate, a commission for a London County Council housing estate, the Avebury Estate, in Bethnal Green, completed in 1959. The bronze sculpture, *The Lesson*, shows a young mother teaching her child how to walk, one of many family-values sculptures commissioned by public bodies at that time. What is so noticeable and attractive in Belsky's sculpture, though, is the cartoonishness and warmth of the work, with its generous curves and serenely smiling faces, something a little between Maillol, Brancusi and Disney. It fulfils very neatly an aim of Belsky's that he later explained as follows: 'you have to humanise the environment. A housing estate does not only need newspaper kiosks and bus-stop shelters but something that gives it spirit.'[13]

In the same spirited style, Belsky designed the bronze *Joy Ride* for the New Town of Stevenage, unveiled in 1958. This is one of the few public sculptures of this, or any period, that sums up an entire political and social moment, and which serves as one of the definitive images

The Joy of the New Town: a postcard of Belsky in Stevenage.

of an entire town, the sort of thing that gets put on postcards or on official notepaper. *Joy Ride* was commissioned for what was the most important of the first wave of the planned New Towns that were mostly placed at the edge of the green belts of Britain's larger cities, with a ring of them around the capital, mainly aimed at rehousing working-class Londoners in green, spacious towns built around light industry. Local opposition to Stevenage New Town saw its railway station sign defaced as 'Silkingrad', after the Labour minister (Lewis Silkin) who was driving the programme through. Perhaps because of this battle, it features the proudest of all the New Town centres, around a central pool and clock tower by the architect Leonard Vincent. Just overlooking this is a raised plaza, which has no particular purpose other than to provide a place to look at the town centre from above. This is where *Joy Ride* stands, in the same cute style as *The Lesson*, but looking like a farcical sequel, where instead of patiently teaching the baby how to walk, the mother is carrying her rather precariously on her back – upside down. Later, a small relief panel of Lewis Silkin, also by Belsky, was added nearby.[14]

It wouldn't be too fanciful to argue that while Peri's work resounds with the full-throated socialism of the first few years after the war, with the materials of both the sculptures and the housing they were affixed to having a certain brusque austerity, this big bronze in a colourful square

of bright glass buildings speaks much more of affluence and, with the department stores just below, of consumerism and abundance. Sadly, consumerism hasn't been quite so good to Belsky. Some of his finest sculptures were for speculative office buildings. These works include the semi-abstract *Shell Fountain* by the stodgy Shell Centre on the old South Bank Festival site, a sculpture which, though listed, is in storage at the time of writing; and what looks to have been a fabulous fountain at the Arndale Centre in Manchester, which was completely dismantled and discarded when that shopping mall was redeveloped after the IRA bombing of 1996.

If much of this sculptural work has a celebratory approach – a hailing of a new society and an attempt to enliven new environments designed along vaguely socialist lines – there were also sculptors whose public work returned frequently to the horrors that had brought them to Britain in the first place. Among these was Georg Ehrlich, born in 1897, a Viennese Expressionist who was the husband of the children's book illustrator Bettina Ehrlich, and was at the centre of the Austrian cultural organizations in London. Like Charoux, he had worked for the City Council in the 'Red Vienna' era, and some of this work survives – the delicate 1932 *Mother and Child* in a quiet corner of the busy Karlsplatz, and another artwork in a housing estate. In Friedrich Dittes-Hof, one of the city's mammoth courtyard social-housing complexes, Ehrlich sculpted a moving little plaque commemorating an event in the Depression winter of 1931, when the residents of Dittes-Hof took homeless families into their apartments; it depicts two skinny children, caught in a tight embrace. Several of Ehrlich's works were destroyed as the persecution of modern art reached Vienna with the Anscluss, but there are several in public spaces in Britain, at least two of them in churches. (As we will see, this was not unusual, and Ehrlich's first *Crucifixion* was made in 1920; a friend of the sculptor remembered that 'to Georg, Jesus was a Jew and Mary a Jewess'.)[15] The earliest of Ehrlich's public sculptures in Britain is a symbolic *Pax*, a recumbent figure in the memorial garden built in Coventry near the city crematorium in 1945; it was followed by *Bombed Child*, a frankly Expressionist bronze in Chelmsford Cathedral of a physically beaten, dead-eyed woman cradling a dead child, one of the harsher works by émigré artists in British churches. But in *Young Lovers*, which stands in the churchyard of St Paul's Cathedral, two adult figures are locked in a tight embrace similar to the children at

Dittes-Hof, two images separated by three decades of hard-won solidarity and warmth.

A more explicit memorial can be found in the unlikely location of Dollis Hill, in suburban West London. Fritz, later Fred, Kormis was born in 1897 into a Jewish family in Frankfurt. Fighting in the First World War on the eastern front, he was taken prisoner in 1915, and was imprisoned for the rest of the war in a POW camp in the depths of Siberia. He worked as a portrait sculptor in Frankfurt in the 1920s, but as a committed socialist he fled Nazi Germany as soon as he could.[16] He was interned in Britain, and is one of the figures gazing at the mermaids in Martin Bloch's painting of the Isle of Man's imprisoned intelligentsia, *Miracle in the Internment Camp*. Like many of the sculptors above, his work was modern but not strikingly or aggressively so, and after the war he made a career as a sculptor in public space. The shield-bearing *Everyman*, on a plinth midway up a post-war red-brick commercial building in Stratford-upon-Avon was sculpted by Kormis, for instance, commissioned by the building's architect, Frederick Gibberd. Kormis's largest commission, and one of the few anti-fascist memorials in Britain, was for a site in Gladstone Park, a suburban public space in Dollis Hill.

Among Kormis'a friends and benefactors in London was Reg Freeson, the left-wing council leader of the London Borough of Brent and later its MP, before he was deposed by Ken Livingstone, an unseating that owed a little to Freeson's allegiance to Labour Zionism.[17] Freeson, whose background was in the socialist and nationalist movement Poale Zion, was intensely aware of the tragedy of European Jews, a subject about which Kormis had tried to interest the British government, with a proposal for a British Holocaust Memorial. This design was rejected and eventually donated to Yad Vashem, the memorial in Jerusalem to victims of the Holocaust. What was built under Freeson for Brent Council, however, was a large-scale sculptural group dedicated to 'Prisoners of War and the Victims of Concentration Camps, 1914–1945'. The twisted, torqued bodies of the three figures in the sculptural group show a strong Expressionist influence, an approach that lends itself to the physical and mental extremities the sculpture set out to depict. On Kormis's description, each figure was meant to embody one of the mental states of a camp inmate. 'First there is the numb shock of realizing you are a prisoner in the hands of the enemy. Then there is the dawning awareness of your predicament and the primitive conditions.

The next phase is the thought of escape and freedom. After that many succumb to despair and a sense of hopelessness. Others overcome their dejection and manage to escape.'[18] The sculpture, which was completed in 1969, is easily missed even in Gladstone Park, Dollis Hill, a sprawling park with a view across West London, and its placement in one of outer London's poorer, habitually ignored boroughs means it has had a difficult history – an attack in 2003 saw the head of one of the figures cut off, though the group was recently restored to something like its original state, and the memorial garden around it is well-kept. Kormis was one of those sculptors whose political work was less an affirmation of the post-war settlement than it was an attempt to create minatory works that would remind people of the horrors of fascism and war itself – obviously a difficult thing to attempt in any art form, and not lending itself to restful, optimistic public sculpture.

Two of the most talented German sculptors living in Britain in the middle of the century could be described as public sculptors *manqués* – artists whose work clearly demanded large sites and public spaces, but who for various reasons never managed to gain the commissions that were granted both to socialists like Peri, Kormis and Charoux, and to apolitical figures like Belsky. Both Theo Balden and Margarete Klopfleisch were committed Communists, who had been involved directly in anti-Nazi resistance before they escaped Germany, and both had been actively involved in the exile circles of the Oskar-Kokoschka-Bund in Prague and the Free German League of Culture (FDKB) in London; both Balden and Klopfleisch eventually returned to try and build a socialist country in East Germany (the DDR). Otherwise, their experiences diverged, with Balden eventually building a career in the DDR as a major public sculptor, whereas Klopfleisch was largely ignored. Balden was the elder of the two. Born Otto Koehler in 1904 in Brazil to a German family, he grew up in Berlin and studied at the Weimar Bauhaus under Moholy-Nagy; he joined the Communist Party in 1928. In 1934, a year after the Nazi seizure of power, he was arrested and imprisoned for his resistance activities. After his release in 1935, with a false passport under the nom de plume 'Theo Balden', he crossed the border into Czechoslovakia, from where he had to flee in turn in 1938 for England.[19] In Hampstead, he was a leading figure in the 'Finchleystrasse' scene around the FDKB before being deported to Canada. On returning to Britain in 1941, he got a job in the Midlands industrial city

of Derby working on educational sculptures for local schools; he also helped run, with his partner the textile designer Annemarie Romahn, an international club for Central European émigrés in Derby, who he found disappointingly inartistic and apolitical compared with those he had known in Hampstead.

His Derby work often comprised small-scale sculptures for 'demonstration', for illustrating concepts in classrooms. Others may have been ways of showing children what a sculpture is, and the properties of touch and contour and material that it might have; a possible example is the smoothly hooded *Group of Nuns* in the city's museum. But Balden's work in Britain during the 1940s, though it was often made for the very workaday purpose of education in an industrial school, often returned to the horrors that were then taking place; one example is the relief panel *Wandering Jew*, made in 1943 and now in the Ben Uri collection in London. Like Peter Peri, Balden's work clearly showed his Constructivist training in otherwise realist figures, busts and low reliefs – a sober approach to geometry, a meticulous planning and abstraction of the human figure – but it had a fully Expressionist sense of urgency and horror. Perhaps surprisingly, this work was regarded with considerable local interest in the Midlands, not only in his adopted Derby, but also in Stoke-on-Trent, where the city museum featured an exhibition of his work in 1947, the year he then emigrated to East Berlin. In the DDR, Balden, to his credit, refused to knuckle down and produce the sort of sentimental, artistically conservative Socialist Realism the state demanded. He was amply rewarded in 1956 after de-Stalinization with numerous public commissions, including major sculptures of Communist heroes such as Karl Liebknecht, and a few family groups in the vast new housing estates of the 1960s and 1970s; ironically among these, in the Müggelpark in the Berlin suburb of Friedrichshagen, is *Siblings*, a rather Franta Belsky-like scene of a young woman and a baby playing. This sculpture could easily be imagined in one of the estates of the London County Council, suggesting something of what we might have had if Balden had decided to remain in Derby.

The career of Margarete Klopfleisch, on the other hand, is that of someone who was unable to thrive on either side of the Cold War's divides – something which, notwithstanding the precedent of Käthe Kollwitz, might be because such strident and politicized art was being made by a woman. She was born Margarete Grossner in 1911, into

a working-class gentile family in Dresden; her father was a carpenter, and her mother died young, and to her horror, her father then married a supporter of Hitler. The young Grossner moved in Dresden's art circles, working as a model in the classes of the great Dada and *Neue Sachlichkeit* painter Otto Dix. She joined the KPD's youth organization, where she met and fell in love with the Communist activist Peter Klopfleisch. In 1933 he immediately fled, and she remained working underground for the now clandestine Communist Party before escaping to Czechoslovakia. There, the couple reunited but were penniless and often relied on soup kitchens. But this was also where she began to paint and sculpt, and joined the Oskar-Kokoschka-Bund. From Czechoslovakia, she was among the many members of that group who were helped to escape, on the very last transport to leave the country for Britain, in March 1939. Her specific benefactor was the Surrealist impresario Roland Penrose, who employed her as a cook. He rather creepily wrote to the photographer Lee Miller that 'the German refugee girl has arrived. She is not the ravishing bohemian in distress I had hoped for. In fact she is anything but prepossessing'. He noted nonetheless that she was 'not entirely without brains'. Penrose helped her to enrol in art classes in Reading.[20]

Klopfleisch's work was small-scale, made of the cheapest materials, usually wood, and was harrowing. Two of her 1941 studies for *Despair* can be found in the Expressionist collection of the Leicester Museum and Art Gallery, and they have a Goya-like straightforwardness, with howling female bodies clutching at their hair. These were expressions of personal rather than collective agony. In 1939, the artist was joined by Peter Klopfleisch, still working clandestine for the KPD, who had escaped via Poland. The couple, who had not married in Czechoslovakia – to do so would have necessitated a visit to the German Embassy, and therefore arrest – finally got married in the sylvan surroundings of Maidenhead, where they lived and worked before both were interned. Peter was deported to Australia and Margarete to the Isle of Man. While there, she suffered a miscarriage, and had serious complications in the camp hospital, and a life-saving operation had to be performed. In her daughter Sonja Grossner's account, 'an exhibition of handcraft and artworks made by internees for a new camp commandant saved my mother's life'. Margarete's friends in the camp 'put her sculptures right at the front of the table hoping this would help highlight her

need for help'. In particular, 'one sculpture modelled in clay of a woman in despair about the loss of a child caught the new camp commandant's eye'. Despite the language barrier, he evidently understood he was being told something, and apparently 'ordered immediate medical help'.[21]

After the foundation of the DDR in 1948, Margarete Klopfleisch repeatedly petitioned to be allowed to emigrate to East Germany, but initially she was not permitted to do so by the East German state. Her daughter suggests there was considerable suspicion of the Klopfleisches on the part of the Stasi, as was commonplace regarding anyone who had spent the war in the west, rather than in Moscow, as had the handful of Stalinists who had somehow avoided being killed in Stalin's purges and who headed the DDR government. Eventually, Klopfleisch booked a holiday in Dresden in 1960, and then simply refused to leave. At first, she and her work were treated with great brusqueness, and some of her sculptures were actually confiscated by the Stasi. In the 1970s, a few public exhibitions began to give her some public exposure, but for the most part her experience of East German state socialism was deeply disillusioning. Klopfleisch also wrote poetry, some of which has recently been published and translated. It ranges between urgent and impatient socialist poems of the 1930s ('I'd like to scream in their faces/Come to an agreement worker crowds/Free yourselves from Capitalism!'),[22] to the following poignant autobiographical verse, of 1976, which could work as an elegant, Brechtian portrait of the endless between-state that she and so many other émigrés endured:

> I had to wander through the world,
> Could never stay where I liked,
> I was thrown to and fro,
> And so learned to love wind and weather.[23]

21

A Mundane Calvary

In February 2022, I visited St Margaret's Church in King's Lynn, the small port town in Norfolk that was once the North German Hanseatic League's main *Kontor* in Britain. In the medieval era, the town was one node in a North Sea – Baltic sequence of seafaring ports, most of them ploughing their wealth into elaborate Gothic architecture, often in brick. St Margaret's is the grandest church in King's Lynn, almost on a cathedral scale, but like most English cathedrals it is made of stone, not brick. In the entrance to the church, just past the narthex, aligned with the symmetry of the nave, was a statue. Easily mistaken for an abstract in the tradition of Barbara Hepworth – flowing, viscous, curved – it resolves itself if you look closely into a hooded, huddled figure, who might be praying or might just be hunched against the cold. A few days before, Russia had launched a full-scale invasion of Ukraine, and hundreds of thousands of people were escaping to the European Union and to Britain, in the largest migration within Europe since the aftermath of the Second World War. During this time, the church projected the blue and yellow of the Ukrainian flag, drawing attention to the sculpture and the person who sculpted it.

The sculpture was carved by Naomi Blake. It was donated by the artist to the church in 1990, is called *Refugee*, and is one of dozens of sculptures Blake was either commissioned to do or she gave to churches, synagogues, and Britain's few memorial spaces to the Holocaust. Blake was born in 1924 and raised in what is now Ukraine, in the western town of Mukachevo, in the mountainous Carpathian region at the borders with Hungary and Slovakia. The town has been part of Ukraine since 1945, but the country Blake was born into was Czechoslovakia. Mukachevo was in the region generally then referred to as Subcarpathian Ruthenia, its population being largely either Rusyns, who spoke a language closely related to Ukrainian, or Jews, speaking

Yiddish. The region had briefly been part of independent Ukrainian statelets in the aftermath of the Second World War, but was granted to Czechoslovakia by the post-war peace conferences. It was the poorest region of a country that was otherwise one of the period's economic success stories, and after the absorption by Nazi Germany of what is now the Czech Republic, the region declared itself independent, creating a state that existed for three days before it was annexed by Miklós Horthy's Hungary. When the Nazis installed the fascist Arrow Cross party in power in Budapest in 1944, nearly all of the region's Jews were deported to Auschwitz and killed.

This is what Naomi Blake survived. She was born as Zisel Dum, into a large family – most of her ten siblings were killed in the deportation. She had been sent to Auschwitz in 1944 but had managed to survive both the camp and the subsequent death march as the Red Army approached. Unsurprisingly unwilling to stay in Europe after the war, she emigrated to the British Mandate of Palestine, where she joined the paramilitary Palmach organization in the war that created an independent Jewish state. She was shot by a British soldier, and while in hospital she began to sculpt. Soon after she met Asher Blake at the socialist Zionist youth organization Hashomer Hatzair, in which they were both active, and married him; they moved to London in the 1950s, and she studied sculpture at the Hornsey School of Art.[1] As a professional sculptor, she dedicated her life to trying to draw attention to and enshrine the memory of the experience that she, and the millions like her, had experienced in the twentieth century – persecution, deportation, racial genocide, escape, refuge. This was expressed usually through her bronze figures, sometimes monumental, sometimes smaller in scale, black, faceless – an instantly recognizable style, semi-abstract but deeply emotive, and once you've seen one of them, you will spot them in multiple churches. They attempt to offer consolation and reconciliation, but without sentimentality; Blake worked for churches and not, say, mosques or gurdwaras precisely *because* she believed that the Christian Church bore some responsibility for what happened; according to her daughter Anita Peleg, Blake was personally agnostic, telling her that 'if there is a God, I'm very angry with him'.[2] Her work tries to offer humanity and consolation in all this, but seeing Blake's *Refugee* in King's Lynn in the week when millions were being forced across the Ukraine/EU border, it was profoundly depressing to realize that all of this goes on happening.

Blake was one of several Jewish sculptors, muralists and mosaic-makers who worked extensively for British churches from the 1940s onwards – a remarkable and perhaps somewhat surprising legacy, which extended all the way from lettering (often etched in stone by the typographer Ralph Beyer) to lighting (often flickering through candelabras by Benno Elkan). This is a puzzle for various reasons. The record of the Church of England was not perhaps as appalling as some other Churches in the twentieth century, but nonetheless any history of antisemitism or of the racism spread by European imperialism would surely have to place the Church at its centre. Many clergymen were very much aware of this, and the extensive employment of refugee artists – in both the Church of England and the Catholic Church – was part of various attempts to address this legacy, whether through advocating ecumenicalism within Christianity or religious tolerance outside of it. A few prominent church figures were explicitly anti-fascist and socialist, such as the Dean of Canterbury Hewlett Johnson, a fellow traveller of the Communist Party of Great Britain. But the most prominent figure in bringing refugee artists into the Church was one of his predecessors in Canterbury, and subsequently the Bishop of Chichester, George Bell. A former teacher in the Workers' Educational Association in the industrial north, Bell was a proselytizer in the new popular publishing of the 1930s and 1940s. He published both a Penguin Special on the Church's relevance to an epoch of wars and persecutions, and a history of the English Church for the 'Britain in Pictures' series.

Bell, and others within the Church, were involved in humanitarian efforts to aid refugees on a basic level – getting them into the country, first of all – and in his case, opposing the blanket internment of those refugees, one of many unpopular positions the bishop took in the 1940s (he is rumoured to have been considered for the post of Archbishop of Canterbury before he made public his opposition to the RAF firebombing of German cities). Bell was also keenly aware that the nineteenth-century Church had commissioned too much sentimental and clichéd new art – the sort of wet greetings-card stuff that Ernst Kitzinger criticized in a King Penguin volume, *Portraits of Christ*. And yet the Expressionist tradition from which many of the émigrés derived their influence had produced some impressive religious works. Ernst Barlach's work in German churches showed that artistic modernism could reintroduce some of the fervent intensity so obvious in the

sculptures and altarpieces of fifteenth-century Northern Renaissance artists. As we've seen, most, if by no means all, refugee artists in Britain were Jewish. Very few were observant Jews, but neither were they Christian converts, at least not at first – more common was atheism or agnosticism. But they were welcomed by Bishop Bell and others like him, who saw they had suffered the terrible experience of persecution and exile, a twentieth-century calvary, which paralleled that described in such detail in scripture.

But what was in it for the artists? Certainly, the horrors they had faced led some into contemplating religion. Peter Peri illustrated an edition of *Pilgrim's Progress*; Ludwig Meidner, the great German Expressionist painter of the Apocalypse, moved towards Orthodox Judaism; both he and Jankel Adler created work in the 1940s based on the Book of Jeremiah, which was, as one historian points out, with its 'burning cities, stranded families and refugees in the wilderness',[3] a fairly accurate portrait of contemporary events. Jewish modernist painters had also – as the 'Degenerate Art' exhibition recorded with scorn – created paintings on Christian themes already, particularly Marc Chagall, who would later create many stained-glass windows in cathedrals. This was also a result of the prohibition on graven images in most if not all Jewish denominations and synagogues.[4] Hans Feibusch, the Jewish 'Degenerate Artist' who would go on to become one of the most prolific mural painters in the history of the Church of England, 'almost envied' the figurative possibilities within the Christian Church.[5] There are works by refugee artists in synagogues, including many by Naomi Blake, but they are smaller, more abstract, and simply more scarce; among them are a series of impressive modernist stained-glass windows made across synagogues in London by the Polish Holocaust survivor, artist and architect Roman Halter, which have a cubistic as well as a sacral quality. But the traditions were in many ways too different. Feibusch's own murals commissioned for the West London Synagogue were eventually removed and granted to a German-speaking Christian church in Whitechapel.

Because of this, rather remarkably, the most impressive artistic response in public art to the twentieth-century European Jewish tragedy can, in Britain, be found most often in Christian churches. That this art is so little known owes something to a particular misfortune – that these artists came to work in the Church at a time, the 1950s and 1960s, when attendance would suddenly and unexpectedly collapse, and their work was

often placed in modest little modernist churches on housing estates in the suburbs. What survives a little better is the work in the Catholic churches that were thrown open to new experiments by the Second Vatican Council. This meant the Catholic Church was also now heavily involved in working with émigrés, especially in North-West England, though in both Catholic and Protestant traditions works have been destroyed, dismantled or discarded, churches demolished, and murals painted over. Nonetheless, there is a great deal of it still extant, particularly in the case of Hans Feibusch, who became de facto a 'church artist' from the 1940s practically until his death in 1998 at the age of ninety-nine.

Two of Feibusch's works can be found in the informal émigré artist showcase that is the area around Waterloo Station. St John's Church, an elegant but slightly cheap early nineteenth-century neoclassical structure opposite the eastern side of the station on the approach road to Waterloo Bridge, was declared the official 'Festival Church' during the 1951 Festival of Britain. The bombed church was redesigned by the architect Thomas J. Ford around two murals above the altar by Feibusch. The largest of the two small paintings is a *Crucifixion* rendered in a recognizably Expressionist style, with a convincingly agonized Christ, and the disciples thrown in anguished shapes around him; below is a more serene image of the Christ child being adored by his mother and sundry angels. The scenes are extremely familiar, but Feibusch's line is fresh – flowing, intuitive, passionate – and the colours are extraordinary. These are straightforwardly the brightest works to have been placed in a British church since the Middle Ages, with greens, yellows, pinks shaded in the *Crucifixion* by an unearthly, apocalyptic purple light behind the cross. Being small, the two paintings have to fight to hold this large, square, white, classical space, but even from a distance the colours challenge its emptiness. They are, like much of Feibusch's work, a strange combination of anguish and sweetness – the postures of his figures and the aggression of his colours are violently Expressionist, but the flowing line, the pastel shading, the gamine smiles on the lower scene with the baby Jesus, all come close to courting kitsch in their unashamed attractiveness. From here, Feibusch would be asked to paint murals or altarpieces for around forty churches (and a couple of synagogues) across Britain.

These two paintings in Waterloo were not Feibusch's first works for the Church of England, but they were the most prominent and public.

The path by which he got there was curious. We have already come across Feibusch, as one of the Jewish artists assigned to a specially abusive 'Jewish' room in the 'Degenerate Art' exhibition in Munich, where his dreamlike, stridently coloured but soft and flowing *Floating Figures* was, in an act of staggering bigotry, exhibited to prove the moral torpor of German Jewish artists – the 'Revelation of the Jewish Racial Soul'. Feibusch was, to be sure, a modernist painter, committed to finding fresh, immediate approaches to his subjects rather than relying on tradition and custom, but he was one of the mildest, warmest of modernists, concerned with making straightforward emotional connections rather than shocking, jarring or puzzling his audience. He was born in Frankfurt in 1898, fought in the First World War on the western front, and then studied painting in Munich and Paris. He emigrated to England in 1933 after being expelled from the Frankfurt Association of Artists as a Jew; as with Peter Peri, escape was made easier because Feibusch's fiancée, Sidonie Gestetner, was British. In London he created posters for Shell and the London Passenger Transport Board, and began to create murals in a similar weightless, slightly fluffy, faintly surrealist manner to *Floating Figures*. One of his patrons was a committed modernist, Maxwell Fry, who would soon go into partnership with Walter Gropius himself. But before that, Fry created one of Britain's first houses following all of Le Corbusier's 'Five Points', the Sun House in Frognal, Hampstead; it initially featured a mural by Feibusch. So too did Fry's slightly later Sassoon House, a small block of modernist flats in Peckham, where Feibusch's stylized mural panel of a horse and rider still stands above the entrance. Feibusch also worked for the eccentric, populist, neoclassical architect Clough Williams-Ellis, on some murals in one of the ingeniously faked Renaissance buildings of his holiday village, Portmeirion in North Wales. But what was more fateful was Feibusch's meeting with the church architect Thomas J. Ford, beginning with a *Footwashing* mural in a (since destroyed) suburban church in Colliers Wood, South London.

Ford was an unusual partner for a German-Jewish modernist 'Degenerate Artist'. His practice was concerned with restoring C of E churches and building new ones in a neo-Regency style, which took some of the structural minimalism of modern architecture and placed it alongside traditional church layouts and Grecian decoration – a long way from the fearless concrete functionalism of 'The New Frankfurt'. The

architectural historian Gavin Stamp, describing the restoration of St John's Church at Waterloo, referred to Ford (understandably) as 'that dreary architect'.[6] Ford was also not a particularly enlightened man; in the account of Feibusch's biographer David Coke, Ford at first 'disliked and distrusted foreigners, especially Jews',[7] a view he came to revise over the course of his long-term partnership with Feibusch. This resulted in some of the happiest conjunctions of art and architecture in the artist's long career, such as the 1950s housing-estate churches in Battersea and Rotherhithe, South London, that house some of his most flamboyant and fiery murals.

Like many of the more successful émigré artists, Feibusch was essentially a populist. He was praised for this by some of his more intractable contemporaries; his fellow German émigré Hans Tisdall, for instance, whose own mural work – like the recently remounted mosaic series 'The Alchemist's Elements' (1967) for the University of Manchester Institute of Science and Technology (UMIST) – is wholly secular, fearlessly abstract and technophile. Tisdall considered that Feibusch's work owed its quality to a freedom from good taste; in a letter of appreciation in late life, Tisdall noted that while he had been unfortunate enough to have '[drunk] the commotion of artistic life and racketeering with my mother's milk', meaning that 'a place for me in the artworld was inevitable', Feibusch's father, on the other hand, was a dentist, meaning he was not raised with a received idea of what was 'good' and 'bad' art.[8]

A desire for emotional connection and understanding burns from the pages of Feibusch's great 1946 manifesto, *Mural Painting*. This is a book full of the excitement and also the horror of the immediate post-war period, when the need to reconstruct the world was seen as being especially urgent. On one level the book is a history of mural painting – Roman, Gothic, Renaissance and Modern, with many of the photographic plates sourced from the Warburg Institute – but it is much more an argument about modern architecture, and the way in which its flat, unornamented planes actually offer new spaces for expression rather than bare, functional emptinesses. 'We are,' declares Feibusch, 'on the onset of a new building era; tremendous tasks are to be undertaken'.[9] He doesn't question the necessity of modern painting or modern architecture, and is, as with most of his contemporaries, brutally frank about the deficiencies of the aesthetics of the nineteenth century: 'the industrial age misused pitilessly both Christian and Pagan mythology for its robust

self-gratification till nobody could bear their hollow forms any longer'.[10] But there has to be something other than just rejection and nihilism in that rejection – the times called for much more.

Feibusch fully expected to be working on modernist buildings, and didn't particularly question this (although in fact, his immense oeuvre includes nearly as many new murals in old spaces), but he was keen to argue that 'an occasional draught of old art, as a stabilising or corrective influence, might not be so bad';[11] he cautioned that irrespective of the Nazi rejection of modern architecture, 'no country was as thoroughly organized and rationalized as Germany, and we have seen the frightful results'.[12] There had to be something more than just purism and functionalism – there had to be emotion, expression, some kind of statement of human aspirations other than through structure. In practical terms, 'two separate processes have to be fused: the space-shaping one of the architect and the picture-shaping one of the painter'.[13] In this, Feibusch had some specific things to say about the artistic approaches a new mural painting might take:

> In our painting, in our architecture, in our science, we no longer think in solid bodies and masses; they have all become somewhat diaphanous and it is the forces inside, the strains and stresses, movement and counter-movement, that are essential.[14]

That combination of the gauzy and the forceful runs through Feibusch's murals, giving them their somewhat strange and uneasy combination of modernist confidence and gentleness. He ends his book arguing that there is an ideal client for this new modernist muralism – the Church.

The problem of modern painting and the Church was twofold, with fault lying both on the side of the ancient institution and the contemporary painters that Feibusch was encouraging to work with it. 'The Church,' he wrote with typical honesty, 'has lost her superb taste and become used to the horrible, degraded things that commercial unscrupulousness has foisted on to her; of modern art she knows nothing.' But whereas the artist may be 'religious in his own way', he is very likely 'no longer conversant with the doctrine and ritual of the Church'. He cautions against those who would simply treat a church commission as another job – 'do not attempt to paint religious pictures unless you feel that you move naturally and gladly in the world out of which

they come'[15] – and also, against the sentimentality that could creep into church commissions. And here, it becomes clear exactly why Feibusch considered that the Church specifically was the solution to the problem of fusing modern painting and modern architecture. Its vision of the world, and of humanity, would seem to be the only one that could really adequately express what the world had just been through, much more than any simple celebration of progress, or even of reconstruction. The damage was so enormous that it was impossible to go on as before:

> The men who come home from the war, and all the rest of us, have seen too much horror and evil; when we close our eyes terrible sights haunt us; the world is seething with bestiality; and it is all men's doing. Only the most profound, tragic, moving, sublime vision can redeem us.[16]

Feibusch would create some secular murals, such as his heroically scaled work for Newport Civic Centre in South Wales, and murals for synagogues, such as the since relocated panels for the West London Synagogue or the paintings on Biblical themes he donated to the foyers of the Liberal Jewish Synagogue in St John's Wood; but it is perhaps unsurprising that he was, for a time, converted to Christianity by Bishop George Bell.[17]

Feibusch was in a category of his own, but after him the émigré artist who perhaps created the most prominent collection of works for the Church of England was the Hungarian Jewish painter, sculptor and stained-glass artist Ervin Bossányi. Born in 1891 into a liberal, assimilated family in a province of Hapsburg Hungary that is now in Vojvodina, Serbia, Bossányi grew up in Budapest, where his father was an antiquarian bookseller. From early on Bossányi was a skilled Expressionist painter, with his Hungarian works showing some of the light-filled grandeur of Lyonel Feininger. Although apolitical, Bossányi left the country in 1919 in the wave of antisemitic violence that followed the crushing of the Hungarian Soviet Republic, and followed a brother who had settled in the old Hansa capital of Lübeck in northern Germany. There, he had a remarkably successful career both as a painter and as an applied artist, and though many of his murals have been destroyed, enough still survives in North Germany to give a sense of what sort of an artist he was before emigration. Bossányi created statues, such as the bather at a still extant fountain in the resort of Bad Segeberg, ceramic

murals for a restaurant and a girls' school in Hamburg, and a series of large-scale murals for Lübeck City Library, which were painted over in the Nazi period as 'Degenerate' – only one of them was salvaged after the war. In these, he continued in an Expressionist style, but with an increasing sweetness and easiness, his figures usually smiling, wide-eyed and beatific. But his first major work in stained glass was a commission for the city council of the North German metropolis, Hamburg.

Between 1908 and 1933 the city architect of Hamburg was Fritz Schumacher, who combined in his work the dark-brick Gothic building traditions of the region with a twentieth-century angularity and abstraction, making the city a place of pilgrimage for aficionados of Expressionist architecture. One of his largest personal projects was Ohlsdorf Crematorium, a structure resembling some fusion of miniature cathedral and futurist brick hangar, in the suburbs of the city. The abstract, pulsating, incredibly bright stained glass that ran along the narrow, full-length strip windows of the main hall was designed by Bossányi. This was his greatest pre-war achievement, but also one that invited criticism from various directions. Nazi hostility was no surprise – in 1933 Schumacher was dismissed from his job and Bossányi soon had to flee the country. The architect wrote to the painter in bafflement and despair that their shared project, which had been intended as a free, non-denominational sacred space, was now considered an example of 'cultural Bolshevism'.[18] Given the building served all faiths, Bossányi worked with the Jewish community in the suburban district where it was placed, but they fell out badly. This led him to sever any ties to his (anyway ancestral) religion, declaring that he 'belonged to all religions, not just Judaism'.[19]

Nonetheless, one of Bossányi's first works when he arrived in London in 1934 was an abstract stained-glass window in the opulent, high-Victorian New West End Synagogue, created as a memorial for Lady Emma Louisa Rothschild, who died that year. It is one of several examples of glass by Bossányi in London in the 1930s, most of which is heraldic or symbolic rather than figurative. Among these are the glass coats of arms in Uxbridge Station, designed by the London Underground's architect Charles Holden. On his journey to Germany and the Netherlands in the 1920s with Frank Pick to gather ideas for tube stations, Holden had been particularly impressed with the brick train stations of the Hamburg Hochbahn and with Schumacher's public

buildings, where he would have encountered Bossányi's glass work. At the end of the 1930s, Holden commissioned Bossányi to design glass for Senate House, the Portland stone skyscraper he had designed for the University of London. This is again heraldic, with Bossányi designs symbolizing the constituent colleges and institutions of the University, although some of his work is figurative, such as in the window dedicated, fittingly enough, to the Worshipful Company of Glaziers and Painters of Glass. These examples of applied art are very pretty, and they enliven the minimalist, somewhat austere buildings in which they're placed, but for really large commissions Bossányi had to wait until after the war.

Most of Bossányi's immediate family were murdered in the Holocaust. On his own account, he first tried to convey his mourning in *Noli Me Tangere*, a window he made in 1946 for the Victoria and Albert Museum, showing an idealized mother and child in exceptionally bright blues and reds. Following this, Bossányi was commissioned by the 'Red Dean', Hewlett Johnson, to design four windows in the south quire transept of Canterbury Cathedral. This space flanks the centre of the immense mother cathedral of the Church of England, and the windows were commissioned for quite functional reasons. The clear windows of the transept were casting so much light on the thirteenth-century Gothic windows opposite that it risked permanently damaging them; a new set of windows would drastically reduce this effect. Two of them are small and high, and unobtrusive – only the person looking for them would find the windows – but those below are among the largest in the cathedral, and are impossible to miss.

On the right is *Peace* (both, helpfully, have descriptions of the figures and themes placed nearby). Children – one white, one African, one south Asian, one east Asian – are gathered by an imposing, white-bearded Christ, whose angular, oversized features have some of the hieratic, abstracted power of ancient Mesopotamian art. He holds up two gigantic hands, deliberately enlarged to emphasize the bright-red spots where the nails were hammered into the cross. The theme is a liberal one, in which you can see, in Bossányi's words, Jesus Christ 'gather and unite the children of different races of man', so that 'henceforth they are inseparable brothers and sisters',[20] but the treatment is extraordinary, not just in the imposing stylization of the figures and the modern, artificial colours – which cast the most intense blues and reds on the stone walls of the quire – but also in the peculiar beatific cast

of the children. Like Feibusch, Bossányi has been criticized for being overly 'sweet', and it is not hard to see why – as in the *Noli Me Tangere* window at the V&A, his children have such large eyes that they could be anime characters. Bossányi knew what he was doing here, of course – these angelic creatures are obviously designed to stress an absolute innocence – but these details sit remarkably strangely with the modernity of the whole. It is not quite so much an issue in *Salvation*, on the right side of the quire, because all the figures have their eyes closed. Dedicated, in Bossányi's words, to 'Justice as being in the name of Christ',[21] this is very clearly a political, historical scene. Christ and his angels are liberating a concentration camp, setting free an emaciated, bearded, olive-skinned figure, identifiably stylized as Jewish. In among the radioactive colour of Bossányi's window, the black gates of the camp thrown aside stand out as a sudden shock of reality.

Above are the smaller windows, sweetest of all – a cute *Christ on the Waves* 'dedicated to FAITH' and a more abstract *St Christopher*, 'dedicated to ACTION'.[22] In front of the group of windows is a candle donated by Amnesty International, an eternal flame burning for 'prisoners of conscience and all those who suffer unjustly for their beliefs and actions'. It is a reminder that Bossányi was attempting something quite audacious here – works that would embody the suffering of the twentieth century and at the same time be easily understood. Although he would be commissioned after Canterbury to make windows in Oxford, Ely, the company town of Port Sunlight on Merseyside, and Washington DC, Bossányi's work in Canterbury Cathedral was controversial – for its brightness, modernity, sheer brashness, and one suspects, the artist's nationality and race. In the 1960s, a little brochure on his glass was published by the Friends of Canterbury Cathedral. Perhaps tellingly, it refers to Bossányi throughout as a Hungarian, even though he had not lived there since 1919 – 'the use of pure primary colour, instinctive to the East European, is in his blood'[23] – but not once as Jewish. Nonetheless, the work speaks for itself. It treats an experience of concentration camps that millions of Jews had suffered; it treats Christ as a Middle Eastern figure with a Rabbinic beard, not a pale pre-Raphaelite Anglo-Saxon. Moreover, the attempt to represent 'all races' in the *Peace* window was not accidental; the bright colours and the intricate patterns of Bossányi's work were the artist's attempt to synthesize Gothic, Expressionist and Indian art, the latter being one of his major fixations.

As he once insisted: 'I have to confess I am not a European. I mean, of course, my spirit. No, I should say I am an oriental who went astray.'[24]

How successful this is depends perhaps on personal taste. Anyone adhering to the idea that post-Holocaust art has to be brutally harsh and intractable – Francis Bacon's *Three Studies for Figures at the Base of a Crucifixion*, let's say – would surely find these windows cloying, while anyone looking for traditional Christian iconography would find their riotous, almost psychedelic colour disorientating and baffling. But they achieve a great deal of what Bossányi set out to achieve. Most of all, he wanted these windows not to be *ignored*. As he recalled, his intention in one of the most-visited buildings in Britain was to make sure that his windows weren't apprehended with the careless, distracted gaze of the tourist. Because of this, he made his figures massive, brash and overwhelming. 'The mosaic windows with their many hundreds of tiny figures are mostly looked at in a summary, museum-visiting way, and rarely are they really seen, profoundly received. My aim is just this latter effect,' he wrote.[25] In this, the windows are a success – they freeze the visitor in their tracks, and force them to confront Bossányi's vision.

Feibusch and Bossányi both had a close relation with the Church of England, meaning they had large, prominent public commissions. Other artists who have attempted a similar synthesis have not been quite so lucky. One was George Mayer-Marton, a Hungarian-born Viennese painter and muralist who has only recently been rediscovered for an extraordinary series of works he produced in the north-west for the Catholic Church. Born György Mayer-Marton in Győr in 1897 into a secular Jewish family, Mayer-Marton is one of the most tragic figures among the émigré artists. His brother and his parents were all killed in the Holocaust, and his wife, the pianist Grete Fried, was unable to cope with the stresses of emigration; she died in a psychiatric hospital in Epsom. Although Mayer-Marton was once secretary of the Hagenbund, the Viennese association of progressive artists, very little of his work from before emigration survives. What work there is, in terms of paintings, is often deeply melancholic, often expressed in bleak landscapes, as with the desolate *Frozen Trees at Capel Curig*, in the Ben Uri collection. But in the 1950s, he devoted his life to teaching, and to the creation of mosaic murals, mostly – if not exclusively – on religious themes.

Mayer-Marton fled the Anschluss in 1938, and was able, due to his Hungarian citizenship, to do so relatively smoothly, taking some of his

work with him to London, but all of it – apparently everything except for a few works on paper and the artist's collection of violins – was destroyed in a single raid in the Blitz in 1940. He began a new career in the north-west in the 1950s, teaching at the Liverpool College of Art – where among his favourite students was the brief member of the Beatles and abstract Expressionist painter Stuart Sutcliffe – and founded there a School of Mural Painting. Mayer-Marton did create some secular murals, in schools in Lancashire, and for a Liverpool shipping company; but they have all been destroyed, leaving only his work for the Catholic Church, an important force in the north-west through the large Irish communities of Liverpool and Manchester. Much of this work too has been threatened with destruction. His large *Atonement* mosaic at Liverpool Cathedral was originally in a church in Bootle, and was saved and reconstituted when that building became derelict. At the time of writing, a mosaic *Crucifixion* in a modernist church in Oldham, closed to the public for some time and partly painted over, has just been listed, though what will happen to it now is unclear. Little of this seems to be connected with anything especially shocking in the works themselves, but more with the way that modern churches, especially in northern housing estates left to rot by local and central government, are particularly vulnerable structures. They are sometimes destroyed, or their artworks have often been painted over or obscured in order to make the churches look friendlier and less intimidating, in the hope this might bring back some of the vanishing congregation.

Mayer-Marton's work is unusual even for its time. In the angularity of his line, rooted in Cubism and Expressionism, he is a modernist, but all his major murals are executed in a strictly Byzantine mosaic, created with the ancient method of assembled tesserae pieced together by the artist in situ, on a ladder. Mayer-Marton had studied the Byzantine mosaics of Ravenna on a journey to Italy in the 1920s, and his assistant on his murals in North-West England has argued that he tried as much as possible to remain faithful to the eastern Christian mosaic tradition.[26] The results have a strange but fascinating combination of the modern and the antiquated – the Pentecost mosaic now in Liverpool Metropolitan Cathedral has some of the ingenuous, proto-surrealist oddness that you can find in so much early Christian art. Like Byzantine work, it is often on the verge of erasing the distinction between architecture and art, the mosaics being closely integrated with the architecture in

the most complete surviving work of Mayer-Marton's, at St Clare's, a Franciscan church in the north Manchester council estate of Blackley.

This work is in a large, elegant, spacious modernist church on an arterial road, and contains a large central mosaic over the altar of the titular saint, with smaller mosaics on each side of the font. The central figure of St Clare, one of the followers of Francis of Assisi, a proponent of 'joyous poverty', is shown being crowned by Jesus and Mary, and holding a glowing monstrance and standing on a sword, symbolizing peace; below, grass and flowers are growing. She is flanked with architecture, specifically by Romanesque towers, as she would be in an actual work of the tenth century.[27] The mosaics on the font are delightful little images of fish and phoenixes, in a raw and rough and beautifully coloured style, with large tesserae inset into the niches of the marble. The ensemble is exceptionally light. Even on a miserable Manchester day, the blue of the central mosaic of St Clare is illuminated by the high windows, and the atmosphere is of calm, rather than of mourning or Expressionist *sturm und drang*. It is an impressive work, particularly for its quietness. The mosaic is exceptionally (eastern) Mediterranean, and it is difficult to argue there is anything specifically Jewish or Central European in it, or in Mayer-Marton's mosaic murals in general, though some have tried.[28] It is restful compared with Bossányi or Feibusch's work – and much less prone to accusations of kitsch – but it shares with them a resistance to the conventions of the nineteenth century. Mayer-Marton goes back to the earliest years of the Church, melding its traditions with the visual forms of the twentieth century, creating something that merges Thessaloniki in 500 AD and Dresden in 1915.

The only émigré artist who rivalled Feibusch, Bossányi and Mayer-Marton in the intensity of his work for the Church was Ernst Müller-Blensdorf, a North German sculptor and pacifist who ended up spending many decades of his life working in the small town of Bruton in Somerset, where his carved wood crucifixion – one of the purest British responses to the Northern Expressionist vision of Ernst Barlach – stands in the local church, and the local museum keeps a collection of his jarring, intense sculptures. Born Ernst Müller in 1896 – he took the 'Blensdorf' from his wife – in Schleswig, on the Danish border, he was raised in a gentile middle-class family, with his father a doctor and his mother a pianist. As an adult he became a seaman, and in that capacity was interned as a German enemy alien in British South Africa during the First World War,

an experience he recalled as formative for his art, both in terms of the experience of captivity and for the encounter with the intensity and power of African sculpture, a major crush for German Expressionists in general. After the war, Müller-Blensdorf decided to become an artist, studying sculpture and ceramics in Munich and Düsseldorf, where he was taught by Paul Klee and the Ukrainian Constructivist Alexander Archipenko. Although he recalled the influence of the paradoxes of the former and the sculptural voids of the latter, the most obvious influence on his work is Ernst Barlach – strong, angular, Gothic, Hanseatic figures that reach back to the Middle Ages, without any Pre-Raphaelite sentimentality.

His work in Germany, often applied on Expressionist buildings, survives reasonably well. Still in place is a sculptural panel depicting working-class families in Oberhausen Railway Station (it was removed under the Nazis but reinstalled after the war), and sculptures integrated with heavy Brick Expressionist buildings such as the Telecommunications Office in Elberfeld, Wuppertal, and the Tax Office in Hagen. Here, Müller-Blensdorf was one of many artists working on strident Cubist-Gothic ornaments for public buildings, especially in North Germany and the industrial Ruhr, where these three sculptural groups can still be found, rather extraordinarily given that some of them are particularly distorted and aggressive – exactly the 'Degenerate Art' that was usually taken down from public spaces. And this did indeed happen to his war memorial in Neviges, where the local Nazi Party boss was upset by its 'effeminate' pacifism.

As a convinced pacifist, Müller-Blensdorf considered his life's work to be a proposed monument to Fridtjof Nansen, the Norwegian explorer, polymath, politician and humanitarian responsible for the non-national 'Nansen Passport' that saved many people's lives in the migrations that followed the First World War. In 1933, the artist moved to Norway, and hoped there to realize the sculpture, overlooking the harbour in Bergen. Instead, he had to flee the country in 1940, as it was overrun by the Wehrmacht – like Kurt Schwitters, he was on the last boat out to Britain. As a Norwegian citizen he was not interned, and moved to Bruton in Somerset because some Austrian contacts of his lived there and planned to open an art school; it didn't work out, but Müller-Blensdorf remained. Although his *Annunciation* stands in Salisbury Cathedral and his *Angel* and *Prophet* in Liverpool Metropolitan Cathedral, even more than others of his generation his works for churches can be found

in some startlingly mundane locations – the suburbs of Bristol, or the Southampton exurb of Chandlers Ford.

The most powerful of these works, however, stands in his adoptive Bruton. It is a peculiar town, recently becoming a retirement village for a section of the London super-rich, with a branch of a major Swiss art gallery just outside it, but Müller-Blensdorf's crucifixion in the church of St Mary the Virgin is brutally, compellingly ordinary. Like most of his British work, it is in wood, which he adopted for the same reasons Peter Peri adopted concrete – bronze was prohibitively expensive, especially for a penniless refugee – but given an additional personal resonance through its source, as the wood was taken from a sycamore tree in the sculptor's Somerset garden. There are no games with style here: this is a crucifixion and can be seen to be one. Like Feibusch or Bossányi, Müller-Blensdorf was a populist, who asserted that 'in my work communication with the onlooker is of great importance'.[29] But this is also, in its way, a startlingly abstract work, with Christ bunched up into a

Barlachian Brutalism in Bruton.

compacted tube of agony, staring, accusingly, while nailed to the stone walls of a pretty country church in the West Country. It's a blast of bracing North Sea air blown into the soft rolling hills.

A distinct group in terms of Christian modern art was formed by the émigré Polish Catholic artists working in Britain. They form a somewhat special case among Central European émigrés in general, as they were fleeing not only from Nazi Germany – which fought a war of extermination against Poland, culminating in the total destruction of Warsaw after the failed uprising of 1944 – but also from the Soviet Union. The Soviets had carved up Poland with Nazi Germany in the Molotov-Ribbentrop Pact of 1939, and after 1945 firmly kept a smaller, and newly ethnically homogeneous Poland in its sphere of influence, despite the lack of popularity of a local Communist Party that Stalin had decimated in the Great Purge. Of the Polish émigrés in Britain, some of course had come earlier, for their own reasons, like Feliks Topolski; but most had either come with the Polish Army in France, evacuated at Dunkirk, or with the so-called 'Anders Army', under Władysław Anders, made up of the thousands of Poles who had been deported to Siberia by the USSR. When the Soviets entered the war, those Poles who had survived were permitted to leave, which they did through Iran, then joining up with the British Army in Italy and North Africa. After 1945, when it became clear that the Soviets had no intention of allowing a democratic regime in Poland, most Poles in Britain settled here for good. Moreover, many of them were made effectively stateless by the shifting of Poland's borders westwards, which saw Poland annex large swathes of industrial Silesia and maritime Pomerania from Germany, at the expense of the multi-ethnic, rural eastern *Kresy*, the beloved heartland of the Polish landlord class, which was absorbed into Soviet Lithuania, Belarus and Ukraine. A 1947 Act of Parliament officially naturalized the 250,000 Poles who had fought mostly in the Anders Army, arguing with some truth that they no longer had a home to go back to.

This gave the Polish emigration a much more anti-communist cast than the German or even the (pre-1956) Hungarian or Czechoslovak emigration. It was also, in some – if not all – cases more conservative and traditionalist. Those in the Polish military hierarchy who had not been killed by the Soviet secret police in the Katyn forest were usually, after 1945, living in West London. They had been the pillars of a country which, before the war, was if not a fascist regime as such, an

antisemitic right-wing dictatorship. Significant civil society did persist in 1930s Poland, both from the right (the Catholic Church, the state, and the army, each of which had significant building programmes, with some impressive churches and office complexes) and the left (which, via the trade unions and the Polish Socialist Party that remained legal under the dictatorship, built impressive modernist workers' housing estates in Warsaw and Łódź). These traditions were all drawn upon by the Polish artists working in British churches after 1945.

The West London boroughs of Kensington & Chelsea, Hammersmith & Fulham and Ealing became the heart of the displaced 'Polonia'. A humble Kentish ragstone Victorian church, St Andrew Bobola, became the natural choice for the many Anders Army veterans in the area, and so was transformed from the early 1960s onwards into the 'mother church' of the Polish émigré settlement, and doubled as a showcase for Polish sacred art. Much of it was the work of the architect Alexander Klecki, born in 1928, who also created some of the harshly Expressionist artworks in the redesigned church, such as the aluminium Christ the King above the altar. Much of the glass in the church, meanwhile, was painted by the modernist Janina Baranowska, born in 1925, who had been deported to the interior of the USSR and was with the Anders Army as it left Siberia. She was a pupil of the great East End modernist David Bomberg, one of the few British painters of the interwar years who can stand comparison with those of Central and Eastern Europe; her style was similarly Expressive and crystalline. Baranowska won a 1979 competition to commemorate the Polish airmen who made an important, and seldom-discussed contribution to the Battle of Britain. The church window that was chosen is in the north transept. In its combination of a Catholic icon and an abstract play of light suggesting the flight of the airmen, it is a remarkable integration of modernism and Catholic traditionalism.[30]

But if there is a single artist in the British 'Polonia' who stands out, it is Adam Kossowski. Born in 1905 in Nowy Sącz, in the part of Poland that had before 1918 been part of the Hapsburg Empire, Kossowski was a successful painter in 1930s Warsaw. He won a commission to design murals for a new Central Railway Station; in 1939, he was among those who thought it would be safer to escape the Nazi invasion by going over the Soviet border. Instead, he was arrested and deported into the inhospitable Soviet interior – first to Kharkiv in Ukraine and then to the Arctic, where he barely survived when he was released to

join up with the Anders Army. In the camps, he had a religious experience and vowed that, if he ever escaped, he would devote the rest of his life to God. After settling in Britain in 1943, Kossowski joined the Guild of Catholic Artists and worked, mostly, on Christian themes. Among his largest works was a series of ceramic murals at the Carmelite monastery in Aylesford, Kent, integrated with a new, Brutalist extension to the Gothic building. He worked in many other Catholic churches, in the non-denominational Chapel in Queen Mary University in the East End of London, and even completed some secular work for local authorities, such as a delightful mural for the North Peckham Civic Centre on the Old Kent Road, South London.

Kossowski's chosen material was perhaps an odd one – not bronze or mosaic or even wood but clay, a cheap, malleable material that perhaps appealed to someone whose work was motivated by the memory of extreme suffering and a profound religious devotion. His murals, whether showing the history of the London Borough of Southwark or the stations of the Cross, are vivid, colourful and sometimes slightly childlike, though they have a hard core of almost fanatical religious intensity that belies their occasional naïveté. To single out one of these, the most fitting might be his ceramic mural over the entrance to St Mary's, a modernist church on a housing estate in the small industrial town of Leyland, Lancashire, then being developed as a government-sponsored New Town. The church was designed by Jerzy Faczyński. The architect had been part of a Polish School of Architecture established in Liverpool during the war, a school that influenced some of the Brutalist generation for its interest in monumentality, communication and baroque geometries, some of which is reflected in Faczyński's Leyland church. It is in a Le Corbusian tradition, with an emphatic concrete rotunda and a dramatic, sculptural tower, but full of expressive, emotional and colourful work inside, an entire cathedral's worth of art crammed into its small space, illuminated by abstract glass. Faczyński and Kossowski would not have liked the comparison, but the church closely resembles the modernist churches that were built in Poland between the 1960s and 1980s, after the Stalinist regime was replaced with a less violent and authoritarian but still forcibly Soviet-aligned government. These churches, like the Arka Pana in another industrial New Town, Nowa Huta outside Kraków, fearlessly fused Brutalism and Catholic kitsch, making them exceptionally heady architectural experiences.

Over the doorway is Kossowski's frieze. It depicts the Last Judgement. At the centre is Christ the King, here, as Kossowski's spiky lettering declares, 'TO JUDGE THE LIVING AND THE DEAD'. He has an unforgiving glare, surrounded with a yellow cloud from which angels are blowing their trumpets to herald the Apocalypse. On the left, the elect pay Him tribute; on the right are the fires of hell, with distorted, howling figures shielding themselves vainly – and flanking them are monstrous creatures, only partly human, mostly beast, in dark reds and purples (Kossowski described the USSR where he was imprisoned as a 'subhuman land'), ready to devour those figures for all eternity. None of Kossowski's expression here is imaginable before 1918 – this is without any doubt modern art, rooted in Expressionism and in Picasso – but this is the old-time religion. Appalling crimes have taken place in this century, but the faith in Kossowski's Last Judgement is that, one day, the time will come when those who committed them will be punished.

22

Micro-Dada

Much of the art we have come across here was left behind by artistic change and fashion between the 1960s and the 1980s. It might have drawn from the avant-garde in which many of the artists had once engaged, as young tyros in Vienna, Berlin, Budapest or Prague, but it was a realist art, high-minded and serious, devoted to social progress or spiritual transcendence; it was also a populist one, based on the fear that avant-garde trends had alienated and ignored 'the people'. This type of art was strongly supported by critics and curators on the political left, such as John Berger and Anthony Blunt, and by those at the establishment centre, such as Kenneth Clark. However, it did not aim to please critics but instead an imagined public in the street, the housing estate or the church. It is well represented in the provincial art galleries of Britain from Southampton to Swansea, because it was widely collected at a time when local authorities were most confident and most interventionist, but it has only recently been taken seriously by art historians. The reason for this is the direction in which modern art in Britain shifted from the end of the 1950s onwards. In the work of Anthony Caro, Mary Martin or the later Victor Pasmore, hard-line, unsentimental Constructivist abstraction became fashionable again, without the organic and sensual leavening given to it by the St Ives artists; and more importantly, the New Brutalism, Pop Art and Conceptualism all drew heavily on the source of a Central European art movement that was, by the second half of the 1930s, forgotten as a sort of infantile disorder – Dada.

Dada began in Switzerland during the First World War, at the notorious Zurich Cabaret Voltaire, when exiles, injured former soldiers and draft-dodgers from across Europe gathered to emit a derisive howl of disgust at the society that had allowed such slaughter to take place. It

drew on paradox, horror, slapstick and nonsense (Hugo Ball's sound poem 'Karawane' shares a lineage with Lewis Carroll's 'Jabberwocky'), and pioneered the use of photomontage to produce bizarre and jarring juxtapositions. After the war, Dada migrated across Europe and the United States, and especially importantly to Berlin, where George Grosz, John Heartfield, Hannah Höch and Raoul Hausmann adapted it to the revolutionary chaos of the time, either (or both) through a targeted missile of scorn hurled at the old imperial ruling class, or through the unambiguous embrace of Communism. But by the middle of the 1920s, Dada had dissolved – Paris and New York Dada into Surrealism, and Berlin Dada into Constructivism (though a few Germans, particularly the Cologne painter Max Ernst, were far more inclined towards Surrealism). Some of those working in Britain from the mid-1930s until the late 1940s had a past in Dada, some as central figures, such as Heartfield and Schwitters, but they had all moved on from its combination of vicious nihilism, deliberate wind-up tactics and artistic intractability. Because of this, a huge amount of what comprised Weimar Culture was simply lost and wholly misunderstood, and the émigré culture that became so important in Britain during the early years of the welfare state had nothing much to do with it.

Behind many of the improving sculptures and murals there were artists committed to carrying on an uncompromising modern programme, one that did not place popular communication first and foremost. They included a handful of individuals – only one of whom really had his roots in the original Dada of the late 1910s – who were creating avant-garde works such as photomontages, sound poems and parodies, published by cranky small presses. They were not elitists, necessarily – in fact, many of them were every bit as committed to an idea of communicating with ordinary people as any realist housing-estate sculptor – but they did not believe that the paths to such a communication should resemble those laid down by Bishop George Bell or Sir Kenneth Clark; and given how much this work ended up anticipating mass phenomena such as Pop Art and Punk, they may have been correct. At first, the most important of these artists was probably a Berlin-born gallery-owner, café impresario, drifter and charlatan who went under the name of Jack Bilbo.

You can see Jack Bilbo in his prime in a Pathé news item from 1947, 'Jack Bilbo, Sculptor'. Interviewed by the hilariously RP-voiced newsman and asked for his 'new year's message', a heavily bearded, curly-headed

man in a duffle coat asserts, in Teutonically accented English, that 'any fool can be anti'; then, looking right at the camera rather than the interviewer, like the star Bilbo so clearly is, he adds, *'any fool can destroy'*. He is sitting on the lap of a giant sculpture of a naked woman, his entire body between her enormous breasts.[1] This statue was part of 'Sanctuary', a group of naif colossi symbolizing peace and solidarity, and it stood, for a time, in the front garden of a bungalow in Weybridge, Surrey. At the end of the war, Bilbo, and his wealthy and equally pseudonymous English wife Owo Bilbo, had moved from London, where they ran something called the Modern Art Gallery, to this affluent commuter town in the hope that there they could open an entire Museum of Modern Art; these gigantic and freakish statues were part of that project, one that ended sadly at the end of the decade when Jack and Owo, disappointed by their failure to convert the stockbroker belt to world peace and modern art, relocated to France. The burghers of Weybridge then proceeded to destroy all of Bilbo's statues – with dynamite.

The Weybridge colossi were the culmination of one of the most curious careers in the history of modernism. Jack Bilbo was born Hugo Baruch in Berlin in 1907, to a German Jewish father, a theatrical entrepreneur, and an English gentile mother.[2] He grew up in the Weimar Republic's *Hauptstadt*, where he lived on the fringes of the radical art and theatre movements of the time, and gained a reputation through largely entirely invented autobiographical writing, particularly through the bestselling *Carrying a Gun for Al Capone*, in which he improbably claimed to have been the Chicago gang lord's bodyguard; it was translated into English in 1932. It was around this point that Baruch changed his name to 'Jack Bilbo' – derived apparently from Jack London and a variant spelling of the Basque port, with the effect of making him sound like one of Brecht's 'American' characters in his great plays of the time such as *St Joan of the Stockyards*, *Mahagonny* or *Happy End* (which included a 'Bilbao Song'). Bilbo was active in anti-fascist politics in the early 1930s and was very probably jailed after the Nazi seizure of power. After his release he moved to Spain, where he ran a café in Majorca, then moved to the mainland, ran a nightclub, and commissioned for himself a modernist villa in Sitges. He supported the Anarchists in the Spanish Civil War, but as the outcome of that conflict became clear he fled to his mother's native country, and resumed his fantastical activities in London.

Bilbo was a graphomaniac, and the publisher of dozens of self-designed books full of stories, polemics and manifestos, but his first book aimed at English readers in his adopted country was the memoiristic *I Can't Escape Adventure*, which tells the story of 'the celebrated Hugo Baruch' from Berlin to Majorca to Sitges to London.[3] It probably tells something that wasn't a million miles from the truth, from his father's life running 'a luxurious gambling-club in Berlin called *Bühne und Film Klub* in the Kaiser-Allee', where 'he made an enormous amount of money, which be promptly blew',[4] to young Hugo's time in prison, to his escape to found the Polynesian-style Waikiki Bar in Majorca.[5] It was also around this point that Bilbo, who had no artistic training or obvious previous inclination towards art, decided to become a painter. His bright, lurid canvases and especially his fascinatingly intricate, cross-hatched and spidery drawings do suggest what would happen if a deeply sincere conman with a taste for the exotic decided to take up modernist painting – too knowing to be 'outsider art' and too childishly inept to be compared with those artists he was obviously interested in; these paintings are in a genre of one. Bilbo exhibited them in London and made contacts with the modern art scene in the capital, though perhaps he made many more contacts in the Isle of Man, where he was interned in Onchan Camp. He appears in Fred Uhlman's memories of the artistic scene in the internment camps, where:

> the great 'celebrity' was Jack Bilbo, who gave a lecture: 'Why I kept silent for such a long time, by Jack Bilbo, *alias* Ben Traven'. Next day, somebody announced another lecture – 'Why I kept silent for such a long time, by Moise Rosenblatt, *alias* Goethe.'[6]

Upon his release, with a massively expanded address book, Bilbo founded in 1941 in London the Modern Art Gallery, Britain's first specialized, dedicated institution of its kind.

The Modern Art Gallery is perhaps not as central in histories of modern art in Britain as it should be, perhaps because of Bilbo's peculiar character, but it was of great importance in the creation of a serious modern art scene in central London (it was first housed on Baker Street, before moving towards a larger site on Charles II Street off the Haymarket). It maintained a collection of artworks by figures who

were even then considered largely accepted classics – Renoir, Cézanne, Degas – and held pioneering exhibitions of Picasso (astonishingly, Bilbo failed for some time to sell a nude he had bought from the artist) and of Kurt Schwitters, Bilbo's Isle of Man friend. Bilbo's 1944 show about Schwitters was the only exhibition dedicated to him during the eight years he lived in Britain. Bilbo held the first dedicated shows in Britain of modern black artists, and a show of modern British women painters. Bilbo – described affectionately by Schwitters as a 'kunst-gangster' – was a fool in the Shakespearean sense, using absurdity as a way of speaking truths that would otherwise not be accepted.[7] Like most of his generation, he had experienced appalling things – his father committed suicide in exile after being dispossessed by the Nazis, and his mother was murdered in the 'euthanasia' programmes that preceded the Holocaust. He makes his political position, and the link between politics and art, clear in his self-published mission statement, *Reflections in an Art Gallery*:

> Sometimes a Knight of the Bowler-Hat Brigade asks me why I am an anti-fascist. I answer him ... because I am an artist, and as such the yellow skin of a Chinaman, the black of a Negro, or the brown of an Indian is just as beautiful as the white of a European. I know no racial differences, no 'Herrenvolk'. Unlike the nazi, I like to create, not to destroy. I know I cannot take without giving.[8]

Bilbo made equally clear a rather unusual disdain for the snobbery of the art world for someone who was running a boutique art gallery in the West End. Modern art, for the Bilbos and for the Modern Art Gallery, was not 'intellectual', but emotional: of art critics and intellectuals, he asserts 'these people should not visit my gallery, because here they won't even find a mirror to reflect their own emptiness'. This *épater les bourgeois* rhetoric sounded more convincing from an entirely self-taught outsider, a dodgy geezer who had done time, than it might have done from most of his contemporaries. 'Art,' Bilbo proclaims, 'should be for the masses. The masses I want to come to my gallery, the man in the street.' The aim was not art for art's sake, but art as part of 'the fight against dictatorial reactionism', and as a contribution to creating an 'oasis of sanity in a world of false values'.[9]

Bilbo also used the gallery as a way of publishing his verbal output

on art, life and the world, where he took on those values directly. He maintained for the Modern Art Gallery's publishing arm a subscription service, where for a donation of your choice you could be sent works on a variety of subjects: art books such as *Famous Nudes by Famous Artists* and *Laugh with the Piffles*; philosophy books including *No Heaven no Hell* and *Common Sense*; and adventure and fiction books such as *Carrying a Gun for Al Capone* and *Out of My Mind*; and an autobiography, published in 1948 and entitled *Jack Bilbo by Jack Bilbo: The First Forty Years of the Complete and Intimate Life Story of an Artist, Author, Sculptor, Art Dealer, Philosopher, Psychologist, Traveller, and a Modernist Fighter for Humanity*. In this capacity, he published a manifesto, *The Peace and Progress Plan*. Surveying the awful state of the world in the aftermath of the Second World War and the onset of the Cold War, Bilbo, 'as a non-politician and an ordinary man-in-the-street, [suggests] the following real PEACE AND PROGRESS PLAN'.[10] It would be his major statement against

Jack Bilbo is not about to work for the Church.

militarism, capitalism and, most of all, against ignorance – against a society where 'to-day, your conscience is distorted and polluted by propaganda which teaches that killing is patriotism, sex is sin and love unnecessary sentiment'.[11] Bilbo's solution to this predicament featured sixteen points. They included: 1. Abolish All Frontiers; 2. Abolish All National Currencies; 3. Abolish Completely All Armies, Navies and Air Forces and all War Industries; 4. Introduce a Compulsory International Language; 8. All national resources to belong to all and cannot be owned by any private individual; and 13. No Prisons. They also included things that are, in theory, now accepted in many countries: 6. Complete Freedom of Thought, Speech and Religion; 13. Abolish the Death Penalty; and 14. Unarmed Police Only. By the time this manifesto had been published in 1952, however, Jack and Owo Bilbo were gone, having emigrated, leaving the ungrateful island and the philistines of Weybridge, to settle in France, moving back to Berlin soon after, where they ran a pub.

Bilbo's decade or so of silly-serious neo-Dada activity in London, Onchan and Weybridge was highly public, publicity-hungry and garrulous. The next experiment in real avant-gardism from exile artists was quieter, but more sustained and more influential, a decades-long burrowing. This was the Gaberbocchus Press – named as an imaginary Latin translation of Lewis Carroll's 'Jabberwocky' – run between 1948 and 1979 by the husband-and-wife couple of Stefan and Franciszka Themerson, a pair of Polish émigré polymaths who had settled in London during the war. In their decades of publishing, Gaberbocchus put out a great deal of work that filled in the gaps in knowledge about the avant-garde – monographs on Jankel Adler and Kurt Schwitters along with Schwitters and Raoul Hausmann's novel *Pin*, the first English translation of Alfred Jarry's *Ubu Roi*, and their own project *Europa*. But alongside them were children's books (including one by Bertrand Russell), drawings by the poet Stevie Smith, the first edition of Raymond Queneau's *Exercises in Style*, and the Themersons' own peculiar books, often elaborate jokes on philosophy and perception. These existed in their own strange little world, but could be read as a sourcebook both for the pop and avant-garde movements of the 1960s and 1970s. Paul McCartney will surely have acquired his enthusiasm for Alfred Jarry, and the rock band Soft Machine their adherence to 'Pataphysics', from a Gaberbocchus book; one could imagine Gaberbocchus

publishing John Lennon's nonsense book of poems and short stories, *In His Own Write*, if it were a little bit cleverer and funnier.

Importantly, the Themersons were not people who were merely archiving from a historical distance, trying to discover the lost world of the avant-garde. Rather, they were, before 1939, leading lights of what is one of the most interesting – but least-known in the West – of the avant-garde movements in Central Europe. Both were from materially comfortable Jewish families in the Polish intelligentsia. Franciszka Weinles was born in 1907, in Warsaw, where her father was a painter, and Stefan Themerson, whose father was a doctor, was born in 1910 in nearby Płock. They met in the 1930s in Warsaw, and worked alternately as authors of children's books – most famously the parable about architecture and space, *Pan Tom Buduje Dom* (which they later translated into English as *Mr Rouse Builds His House*)[12] – either together, or apart. The extra living that Franciszka earned from illustrating such bestsellers as Jan Brzechwa's *Kaczka Dziwaczka* (roughly, *Strange Duck*) was ploughed into the making of avant-garde films. They made five experimental shorts together, in a fast-cut montage style, somewhere between the strident Kino Eye of Dziga Vertov and the playfulness of GPO Film Unit directors like Len Lye. The most famous of these shorts at the time was *Europa*, made in 1931, which put on film a visual interpretation of a poem by the Polish Futurist Anatol Stern. This remarkable work, which the Themersons took with them to Paris, was banned by the Nazis; it was believed that all copies were destroyed, until one was discovered in 2019.

In 1962, Gaberbocchus excavated the remnants of this project, publishing *Europa*, an illustrated book that contained, first, a translated near-facsimile of the 1929 edition of Stern's futurist poem, with the original design and illustrations by Mieczysław Szczuka, in a manner that combines the clarity of Constructivism with the paradoxes of Dada. The poem itself is a full-blown blast of 1920s Left Art, which, as the Themersons put it in their cover blurb, 'makes no distinction between social and aesthetic commitment'. In the poem, alongside the images of Chaplin, the film strips of boxers and the fragments of machines, Stern blasted and blessed the new industrial world and sang of his hope of revolution. It is worth quoting a section, just to give some sense of how different a world this was from the sombre yet populist one being created by the mature émigré artists surveyed so far. By contrast, we're here in a world of:

Krzyczy rejent: „Moje panie,
czas już skończyć to gadanie!"
Doktor także lubi ciszę,
do starostwa skargę pisze.

Two faces of the Themersons: for children . . .

at last
at last
free !
o—to stamp out the
flagellant of labour
flogging himself with tragedising
o—to stamp out the tragedising of
 the
ethics of labour
to honour
the decalogue of the
stomach

I am covered by a milliard lips
by an organised
proleteriat of cells a
revolt of gullets !

**this throng of raging bacchantes
is one centimetre of my skin**

. . . and for adults: the English edition of *Europa*.

faded tapeworms of
newspapers
sweet
virulent
bacilli of words
are shoved into our mugs
by the gluttonous fraternity of
scribblers of
presidents of
ministers of education
china of the west!!
stop poisoning us
we are not rats!
o if we could only be
a proletarian swarm of rats
we could
bite the
white
fleshy
fingers
which incessantly push towards us
the
white
poisoned
dust of
powderised pages
grand
showerbath
of meetings
the massage of propaganda
the gospel of terror
this is the chasm
into which we jump
since we cannot jump
into heaven.[13]

Along with this presentation of Stern's poem, the second half of the book prints what were then believed to be the surviving fragments of

their filmic interpretation, with contemporary reviews and descriptions of a film that 'reigned [sic] protest – angry and desperate, against the conversion of human masses into cannon fodder or soulless automatons',[14] bound in Teresa Żarnower's original photomontage cover for Stern's poem. It was a complete presentation of an avant-garde usually ignored in favour of what was happening to its east and west. In the early 1960s, this was extraordinarily heady stuff, showcasing what Michael Horovitz, in his introduction to the book, called 'a mixture of techniques unheard-of-at-the-time – and hardly absorbed to this day. We might take it as a signal, there is still no English for *collage* . . .'[15]

Like many left-leaning Jewish Poles, the Themersons found Poland's shift to the right in the late 1930s uncomfortable, and the couple moved to France in 1938.[16] When the Germans invaded Poland, Franciszka and Stefan were for a time separated. Franciszka managed to get to London, where she worked as a cartographer for the Polish Government in Exile, while Stefan first volunteered for the Polish Army in France, and when it was disbanded he was trapped in occupied France, for a time in a prison camp – he didn't escape to London until 1942. Alone in London in 1941, Franciszka Themerson painted some deeply strange pictures of her new environment, such as *Air Raid*, and of Underground bomb-shelter sleepers in *Piccadilly Line*, which yoked together abstraction, the schematic and friendly style of her children's books, and depictions of the odd people she now lived among. Themerson was baffled by the world of 'bowler-hatted figures in the City' and an intellectual scene apparently populated largely by 'elderly titled and bejewelled ladies who would fall asleep between one exclamation of "Oh how very interesting!" and another'. She found herself 'completely entangled in this strange world, half Lewis Carroll, half Ionesco', and her canvases in which English types suddenly find themselves in a strange new abstract world was a way of dealing with the alienation and uncertainty she felt at the time. Confronting the alienation directly would have resulted in angst-ridden canvases, which she rejected – 'I have a horror of expressionism'. Instead, 'a perverse thought occurred to me: How would all these little very important people behave in my abstract canvasses?'[17]

This combination of the apparently childlike and the subversive would run through much of what Gaberbocchus did upon its foundation in 1948; the Lewis Carroll-derived name roots their own particular approach to Dada and Surrealism in a country whose art hardly lacks for paradox

and eccentricity. At Gaberbocchus the couple edited the books, Stefan wrote many of them, and Franciszka illustrated and designed most. The first was a wonderful little hand-printed book about, and composed with, Jankel Adler, written by Stefan: *Jankel Adler: An Artist Seen from One of Many Possible Angles*. It is an early example of their style of tackling complex ideas in apparently very simple and accessible language – an approach that is deceptive, as there is no compromise here, no populism. The Themersons believed that avant-garde ideas could be explained to everyone, but *on their own terms*, not through being softened and adulterated. So in the Jankel Adler book, we begin with a childhood tale from the painter. At the age of four, he saw a lizard on the kitchen floor of his family's tenement flat in Łódź, which he remembered as having a human face belonging to one of his schoolfriends, a boy named Mak. This creepy little episode is made into a parable about how Adler became a painter – he provides line drawings illustrating the process – and about avant-garde artistic perception, what it is, and what it isn't.

Stefan's writing style is often in a question-and-answer format, like so:

Who governed the city of Łódź at that time?
A Tsarist Governor-General.
Who remembers the Tsarist Governor-General today?
Nobody.
Who remembers the little green lizard?
Jankel Adler.[18]

Of course the authors are not Dadaists enough to try to convince the English reader this all really happened. Adler, Stefan is keen to point out, 'now knows that the Mak-lizard incident happened only in his mind'. But he is equally keen to show how this little incident has wider ramifications. Quoting Adler: 'if it is possible that such a thing can happen in a mind, then man's mind is far more interesting as an object of investigation than the exterior world. Then man's mind is an Africa which should be explored, it is an instrument of creation which should be developed and used. And consequently, there are many things which are worthwhile . . .' Then the questioner returns:

What, for instance?
For instance: writing poetry;

composing music;

painting pictures;

photographing the nebula Andromeda and the path of an electron;

trying to rebuild society so as to raise the material and cultural standard of life.[19]

That is a fair summary of the Themersons' life's work. Adler's own eye – expressed in the drawings that, point by point, tell the tale from the encounter on the kitchen floor to his career as a painter of equally fantastical things, with economy, wit and strangeness – is also tempered, as is the Gaberbocchus project, by everything that has happened since. The family in that kitchen are all dead. Adler recalls this epiphany in the present day in London, but 'the floor, the kitchen, the flat, the house and the street of the city of Łódź are distant and remote, saturated with blood, covered with ashes: he encounters them only in the newspapers.'[20]

Moreover, the Themersons and Adler together are also trying to impress something on the questioner, an imagined baffled English reader something a little like Jack Bilbo's 'Knight of the Bowler-Hat Brigade'. 'A Certain Gentleman,' Stefan recalls, 'noted one day in J. A.'s studio, after declaring that he knew nothing about painting, "What is it all About?" Is it possible to answer that question?' he asks:

> I think it is. One should start by eliminating: J. A.'s pictures are not a drawing room window through which one looks at a landscape;
>
> are not a pane of a shop-window through which one looks at a still-life;
>
> are not a keyhole through which one looks at an interior;
>
> are not the frame of a stage, where lifeless actors await the lowering of a delayed curtain.[21]

So instead, you have to look at them like Adler looked at the lizard, even though 'adult people are generally too tired to look at and accept new shapes, newly created and not yet classified things, the new objects of art'.[22] In this, the importance of the apparently childish aesthetics and the deceptive simplicity of the Themersons' work in Britain reveals itself. If you can connect with that childhood openness – not 'innocence', but freshness of vision and lack of preconceptions and received opinions – then you can understand the art of the avant-garde. Not,

of course, that the Themersons were above making themselves the object of their own parody. In *Critics and My Talking Dog*, written in the 1950s, they create a scenario to pour scorn on their own idea that merely by changing your mode of perception just a little bit, you can suddenly 'see' modern art that preconceptions would otherwise blind you to. The book describes an experiment in which our protagonist operates on his dog's sensory apparatus. What if you adapted a dog so that its eyesight was as acute as its sense of smell? The answer is that it would become an exceptionally verbose avant-garde art critic, slipping between English and French: 'it is with his *eyes* that he sniffs now,'[23] Stefan laments, as his dog pronounces breathlessly on Constructivism, Pop Art, Cubism, Social Realism, and 'the new industrial landscape', leading the author to yell 'Shut up!' at his dog. He has to take measures: the dog 'is not allowed to talk in the street. Imagine the sensation it would create. Not so much among Englishmen as among other dogs.'[24]

As true avant-gardists, the Themersons were able to describe experimental art in a way that lacks the strained attempt to make the unfamiliar familiar, that feeling that quite different and culturally alien preoccupations are being imposed on the material, which is common even in sympathetic critics like Herbert Read. That is, they saw Dada as Dadaists, albeit Dadaists who had grown older, calmer and perhaps wiser. This is particularly obvious in their portrait of Kurt Schwitters, published in 1958 on the tenth anniversary of his death, as *Kurt Schwitters in England, 1940–1948*.

We have occasionally cited Schwitters, who was, along with perhaps Heartfield, Kokoschka and Gabo, the artist that a contemporary critic or historian would be likeliest to consider the most art-historically 'important' figure of the period to have really *settled* in Britain, as opposed to short-stayers like Mondrian, Tschichold, Moholy-Nagy, Breuer or Gropius; but we have not yet paused to look at his work in any depth. Developing out of Dada his own personal MERZ art based upon commercial-waste products, Schwitters was, by the early 1930s, one of the best-known modern artists in Germany, with his work collected by various museums.[25] He was famous as a painter and maker of collages and montages; as a graphic designer for the city of Hanover and for various manufacturers; as a sculptor of peculiar objects made of discarded by-products; as an architect of sorts, creating in his flat a three-dimensional living environment, the Merzbau; as a poet of organized nonsense, in his delightful

hymn to an 'Anna Blume', and as a pioneering 'sound poet', in the precisely arranged coos and bellows of his 'Ur-Sonate'. Expressly apolitical, Schwitters was from a bourgeois gentile family in the northern provincial city of Hanover, which made its living from property investments; Schwitters and his wife Helma continued to manage these to supplement the living made from his MERZ activities. He was a genial figure in the German avant-garde, warmly regarded by many Dadaists; Hans Richter later recalled how Schwitters did and didn't fit into the movement. While Berlin Dada aimed to destroy art for good and replace it with some egalitarian Tatlinesque machine art of the future:

> Schwitters was absolutely, unreservedly, 24-hours-a-day PRO-art. His genius had no time for transforming the world, or values, or the present, or the future, or the past; no time in fact for any of the things that were heralded by blasts of Berlin's Trump of Doom ... On the contrary, every tram-ticket, every envelope, cheese wrapper or cigar-band, together with old shoe-soles or shoe-laces, wire, feathers, dishcloths – everything that had been thrown away – all this he loved, and restored to an honoured place in life by means of his art.[26]

This was, if not too high-minded a way of describing it, a project of redemption, where rather than destroying art, pretty much anything could – if put together properly – become art. Schwitters was personally close to El Lissitzky, and his graphic work and his collages have a quasi-architectural clarity and order of arrangement that is obviously indebted to Soviet Constructivism; his Merzbau, a towering column of waste dubbed by Schwitters 'the Cathedral of Erotic Misery', surrounded by a sculpted route around niches and 'grottos', with spaces allotted for his favourite artists like Klee, Lissitzky, Feininger and Kandinsky, can be seen as a perverse response to Lissitzky's total environments like the 'Proun Room' of 1923, or the 'Abstract Cabinet' he designed in 1927 for the Hanover Provincial Museum in Schwitters' home town. Schwitters too was building a kind of new world, but one made up of the commercial waste of the old one, with its tawdry colours and attention-grabbing shapes and slogans reimagined as components of a new visual and verbal language. And crucially, his work was often very funny, and deliberately so.

Many of Schwitters' closest friends emigrated after 1933, and he

privately sent some of them, like Tristan Tzara, photographs of the misery and propaganda of Nazi Germany – 'the Hitler posters which hung in tatters from the walls in Hanover, ration cards with minimal quantities of food'[27] – at great personal risk. Nonetheless, Schwitters remained in his home town until the 'Degenerate Art' exhibition revealed a course towards persecuting even the quietest, apolitical members of the avant-garde. Invited to an 'interview' with the Gestapo in 1937, Schwitters thought better of it, and escaped to Norway, where he built a second Merzbau at his house in Lysaker, in the Oslo suburbs. However, the invasion of Norway in 1940 saw him escape on the same freighter that was taking Ernst Müller-Blensdorf and many others who expected imprisonment or worse under a Nazi occupation. This was the last boat that managed to transport émigrés fleeing Nazism from Norway to Britain. Landing in Leith in June 1940, Schwitters was immediately interned – and for longer than most.

As we've seen, Schwitters was beloved of the other internees in Hutchinson Camp, Douglas, on the Isle of Man, who he regaled with readings from the 'Ur-Sonate'. He made a living painting rather sad, dark portraits of inmates like Klaus Hinrichsen, Siegfried Charoux and Fred Uhlman, a man surely aware that as an artist he wasn't fit to lick Schwitters' filthy boots. Uhlman remembered him in his memoir two decades later. 'On the walls' of his dormitory:

> hung his *collages*, made of cigarette packets, seaweed, shells, pieces of cork, string, wire, glass and nails. A few statues made of porridge stood about, a material more impermanent than any known to mankind, and it emitted a faint but sickly smell and was the colour of cheese, a ripe Danish blue or Roquefort.[28]

Schwitters also, he notes, always carried a knife for the purpose of cutting out pieces of lino, which he used as canvases. By the time Uhlman was writing in the mid-1960s, these smelly collages were already selling for very large sums of money, and he expressed regret at not having collected any of them. It must have been peculiar to have watched this apparent eccentric reclaim, posthumously, the fame he'd lost in Nazi Germany, but nobody appears to have been embittered by this; Hutchinson inmates, meeting at camp reunions, used to exchange exclamations from the 'Ur-Sonate' as a code for initiates.

Eventually released from internment at the end of 1940, Schwitters joined the Free German League of Culture and had some contacts in émigré circles, but was never central to them. Rather than living somewhere off 'Finchleystrasse', he took an attic flat in Paddington and then a flat in suburban Barnes, eking out a precarious, impoverished existence on the furthest fringes of the London art scene. In 1944, Jack Bilbo's exhibition of forty of Schwitters' collages, paintings and sculptures at the Modern Art Gallery saw just one sold; the Museum of Modern Art in New York kept up contacts with Schwitters, but Bilbo, Adler and Herbert Read were among his very few real allies in London, where his work met with general incomprehension and hostility. Schwitters showed his work at a few group exhibitions raising money to aid wartime allies like China and the USSR (the last held at Ernő Goldfinger's Willow Road house overlooking Hampstead Heath), and sent letters asking for financial support to Kenneth Clark, an unlikely figure to be supporting the projects of Dada and Merz, letters that unsurprisingly went unanswered.

Even the more unashamedly modern artists seemed to have little patience for him; Ben Nicholson complained to a friend that 'Schwitters is an ass and a bore'.[29] In London, Schwitters was frequently ill, suffering a stroke in 1944, a broken femur in 1947, and frequent asthma attacks. Perhaps because of this, in 1945 he and his partner Edith Thomas – who he had met at his Paddington bedsit, rechristening her 'Wantee' because she would, in the English manner, ask frequently if he wanted tea – settled in Ambleside in the Lake District, where he was evidently reinvigorated. There Schwitters produced a series of astonishing collages, some of the most striking of his career, and worked on a third and final Merzbau – or rather, Merzbarn. He died aged sixty in a hospital in Kendal in January 1948, the day after he received his British passport, and was buried in an unmarked grave.

Gaberbocchus's book *Kurt Schwitters in England, 1940–1948* presents some of the paintings, photomontages and texts composed by the artist in his eight years of exile in Britain. The Themersons had met him in 1944 at a PEN conference to commemorate Milton's defence of free speech, *Areopagitica*, and they were obvious kindred spirits. Another loyal friend was Herbert Read, who had showcased Schwitters' work in *Art Now* and in the 'Twentieth Century German Art' exhibition; this enthusiasm was reciprocated in a montage printed in the book: a lovely

collage of Read, which the authors saw created in situ, constructed 'with Herbert Read's photograph cut out of a copy of *Picture Post*, on the spur of the moment in Franciszka Themerson's studio in London in 1944, from odd bits found in the corners'.[30] Stefan's memoir of Schwitters is full of 'the undisguised warmth of his rebellious yet constructive life',[31] and offers a useful description of what it was Schwitters was up to: 'the heresy of giving new value to odd and downtrodden, overlooked bits of reality – be they tiny bits of wire or bits of words – by putting them together into some specific kind of relationship and creating a new entity'.[32] The memoir also includes the programme of a recital that Schwitters gave at the London Gallery in 1947, at which he read 'Furor of Sneezing', 'Eve Blossom Has Wheels', 'Anna Blume' and 'Hullo, Baby!', along with portions of the 'Ur-Sonate'. The BBC, Stefan notes, were invited to the reading, and Schwitters hoped they would want to record the performance (in the Weimar years, several recordings were made of Schwitters' sound poetry), but 'the gentlemen left in the middle'.[33]

While this was written and published, the Merzbarn still stood in situ, in Elterwater, five miles outside of Ambleside. The original Merzbau had been destroyed in the RAF bombing of Hanover in 1943, and Schwitters was not able to visit the Oslo successor (it was in turn destroyed by fire in 1951), and he mourned its loss as his life's work, on which he had striven for more than a decade. The new Merz building was, as the sick Schwitters was aware, likely to be the last of his environments, and he worked on it intensively for the last year of his life. The notion that the United States welcomed émigré artists whereas Britain regarded them with hostility and scorn is slightly exaggerated, but it undoubtedly applies to Schwitters, who was unable to sell a painting in Britain but was granted $3,000 (a large sum at that point) by the Museum of Modern Art in New York for the purposes of creating a new Merz building. It would necessarily have to be near the Ambleside home of Schwitters and 'Wantee', and by this time they had made a name for themselves in the local community around the Lakes, where he was regarded as 'a gentle madman, who painted portraits for a few pounds'.[34] Schwitters was unpretentious enough to be quite happy to earn a few quid (as he had in the internment camp) painting portraits and landscapes, which show, more than his collages but like his commercial-waste sculptures, an interest in natural form and texture.

He entered some paintings of flowers to a local flower show, and was delighted to be awarded a prize. Schwitters was disappointed by the modest prize money, he wrote to his son Ernst – 'But the honour! People here know now that I am able to paint flowers.'[35]

After searching the area for some time, Schwitters chose the site for his last Merzbau upon being offered a lean-to by a local farmer and architect he had befriended. One historian describes it as being 'a hay-barn that had been rebuilt in 1943 on the foundations of a gunpowder magazine'. It was a five-mile walk from Ambleside, in a forest. It had 'an earthen floor, and no window panes, electricity or heating'.[36] Compared with the rich mutant Constructivist grandeur of the Hanover Merzbau as seen in photographs and reconstructions, this was a much more ascetic space; but it had an austere beauty of its own. Edith Thomas recalled to Stefan Themerson that 'the quietness and changing panoramic views of the landscape seen from the little hill where the Barn stands comforted his wounded soul',[37] and although this combination of windswept, wooded beauty and harshness seems a strange end to the career of such an urban artist, it has an astringent beauty all of its own, with a material palette that included 'found rocks, branches and even flowers ... broken wheels and bits of rubbish'.[38] It was left unfinished when Schwitters died.

The original Merzbarn itself still survives, but is closed to the public after having recently been refused an Arts Council grant that would have secured it for visitors; not as much has changed here as some might like to think, and a space that in Germany or the United States would have its own car park and gift shop is instead rotting away in the rain – which is perhaps how Schwitters might have preferred it. Nonetheless, it is very easy to visit one side of the Merzbarn, which was removed in 1965 by the Hatton Gallery in Newcastle, under the direction of the Pop Artist, teacher and archaeologist of the avant-garde Richard Hamilton, where it has stood ever since.[39] What you can immediately sense is its enormous connection to its original place – the hard, grey drystone walls that are used throughout Cumbria and Northumberland. As in the original Hanover Merzbau, Schwitters had ambitions for the Merzbarn – a complex system of routes and grottoes – but most of what survives is just this wall, which he cut away to create a huge plaster enclosure, filled with bits and bobs in niches, around a beautiful expanse of organic sculpture, feeling like the painted entrails of a

stone monster. Hermetic, sensual and rather gross, it is an appropriately intractable monument to a man who was subjected to some of the worst of British national hypocrisy and ignorance.

Schwitters was not a rancorous man, and though he complained about the neglect his art faced in Britain, he does not seem to have been particularly bitter. His genially strange version of English can be seen in a short text he wrote for a friend to explain the concept of Merz, which is much better uncorrected:

> The picture is finished when you cant take away or put in it anything without disturbing the present rhythm ... The material gives a certain mouvement, another may assist or fight it, and the composition collekts all single mouvements to a rhythm. Perhaps one can feel the rhythm of london and give in an abstrakt picture a simular rhythm.[40]

What Schwitters *did* acquire in his eight years in England was an excellent ear and eye for bullshit, just as he had for the imperial and commercial tat of Germany. His texts and collages, especially those he produced in 1947, are full of our own distinctive cant and nonsense, which appears to have both delighted and infuriated him. The repeated phrases used to fill silences, the avoidance of any serious subject, he captured perfectly in the two lines of one of his Merz poems, reprinted by the Themersons in their book:

> When I Am Talking About the Weather
> I Know What I Am Talking About.[41]

He was also extremely adept at capturing the particular meanness of austerity Britain, and in particular our atrocious caste of cruel, ignorant and self-important landlords. In a 1945 short story, 'The Landlady', he gives voice to one of these, in a jagged and spiky but well-observed English:

> 'A landlady I am, and you may speak to me. For example, the government has ordered us to save fuel. When you use the gas, don't take a match, because that is fuel. Do it like me!! I take a piece of an old newspaper, the margin. You can read the paper without the margin; and take the light from the kitchen fire ... If it is not successful and it blows out on the

way I try two or three times more. I am tough! Finally I get it to light the gas, and the match is saved. If you do that two or three times a day think how many matches you save in one year. That is because I think! I am a thinking landlady!!!'[42]

One of Schwitters' major sources had always been the mass media and print culture – advertising, magazines, newspapers, bus tickets, receipts, bank statements, all of which regularly appear in his Weimar collages. The same would be the case in Britain. Here, he was actually connecting a circle, given that his own world of nonsense and waste had a potentially tabloid quality; in 1936, four years before he escaped from Norway to Leith, a section of the 'Ur-Sonate' was included in a 'funny old world' type column by the *Daily Mirror*'s columnist 'Cassandra', who had found it in an old issue of the Anglo-French avant-garde journal *Transition* (there is an alternative universe here, perhaps, in which a Merz poem-reciting Schwitters appears as a feature on *Eurotrash*). Fellow Weimar émigré Stefan Lorant's *Picture Post* was a favourite source for the late Schwitters, and little shards of it can be recognized here and there, in among an avalanche of British consumer rubbish, from Bovril to Watney's to the *Daily Mail* to pin-up girls to the cult of the Royal Family – a perfect analogue to the twirly-moustached junkers who appear in all the early Dada montages. This is all assimilated and then upended and assembled anew in vivid collages of 1947 such as C 21 *John Bull*, the proto-Pop Art *En Morn*, with its pretty blonde starlet captioned with the slogan 'What We Are Fighting For', or the self-explanatory *This was before HRH the Late DUKE OF CLARENCE AND AVONDALE. Now it is a Merz picture. Sorry!* Unlike, say, John Heartfield, who never acquired an interest in the particular quality of consumer rubbish in his years in Britain, instead creating duller versions of his German montages, Schwitters' pulling of everything English and German into the maw of Merz meant that, unlike some other émigrés, his work was germinal for a new generation of British artists over the next few decades.

In these montages, we are fully in the world of the avant-garde, and just a short step from Pop Art. Only the rough texture and the presence of mould and mess really differentiate these from the Pop montages and paintings of Eduardo Paolozzi, Richard Hamilton or Pauline Boty.[43] And we are only a slightly bigger step away from punk, with its purgative

MICRO-DADA

yell of disgust at England's dreaming. One of the many alternative-universe versions of Schwitters is one where he is on a stage, barking out his 1946 'London Symphony' over a blaring one-chord drone, once again turning shit into gold.

Imagine it after a shout of '1, 2, 3, 4!':

A B C
Preston Preston Preston Preston
Bank
Bovril the power of beef
Bovril is good for you
John Pearce
Riverside 1698
What you want is Watney's
Dig for victory
Prize beers
Sell us your waste paper
Rags and Metals
Any rags any bones any bottles to-day
The same old question in the same old way.[44]

PART FOUR

A Refuge Rebuilt

Visions of Planning, Building and Reconstruction

'Don't want it on paper,' said Mr Tom Rouse,
'I want you to build me, to BUILD me a house!'
'Of course, Mr Rouse, but first I think what you want, then
I draw what I think, then I build what I draw!'
 Stefan Themerson, *Mr Rouse Builds His House*, 1950[1]

23
Bringing the Gospel

If there is any field where the emigration from Central Europe after 1933 is popularly regarded to have had the most decisive effect on British life, it is architecture. Figures such as Nikolaus Pevsner, Berthold Lubetkin and Ernő Goldfinger are nationally known names in a way that Stefan Lorant, Jan Tschichold, and even Naum Gabo, Kurt Schwitters or Oskar Kokoschka are not. 'Pevsner' became a British English noun, to describe an architectural-guide franchise that has long since departed from its initial source; Lubetkin became a sort of folk hero, his work celebrated in public murals, documentary films and popular novels; and Goldfinger suffered first the ignominy of a reactionary spy novelist using his name for a super-villain, before attaining a similar cult status as a great man of hardcore modernism, his buildings appearing on mugs and tea towels, and his self-designed house being kept for the public by the National Trust. What makes this especially impressive is that before the mass migration caused by the Nazi seizure of power in 1933 and the Third Reich's subsequent spread across Europe, Britain was a laggard in modern architecture, to put it mildly. Many have argued, and with pardonable and minor exaggeration, that there was simply no modern architecture at all in Britain before Hitler came to power and caused the emigration of a generation of talented modernist architects. The story goes that they then came here and brought the modernist gospel, suffering in consequence decades of obloquy in the 1970s, 1980s and 1990s, only to triumph eventually as a new generation in the twenty-first century realized the scale of their achievements, from 'The Buildings of England' to Finsbury Health Centre to Trellick Tower.

This is not the whole truth, but it is most of it; it is certainly more true than some of the recent revisionist attempts to complicate this story. We should start with the obvious. Between 1919 and 1929 the

Expressionist, Cubist and Constructivist trends in modern art gradually coalesced in architecture, creating a distinctive new form of design, almost classical in its purity and proportion, but ultra-modern in its embrace and display of new technology, and its rejection of ornament, heavy masonry construction, and historical precedent. It could be found in France – especially in the private houses being designed by the brilliant and incorrigibly self-publicizing Swiss architect Le Corbusier – in Spain, and in new states such as Poland, Hungary, Austria and Romania, as well as in Scandinavia; but its greatest extent occurred in the Netherlands, the Soviet Union, and especially Germany and Czechoslovakia. There, modern architects used what was generally then called the 'New Building', the *Neues Bauen*, in the design of entire new suburbs, and even a few towns. Those four countries were the heartlands of a Congrès International d'Architecture Moderne (CIAM), which pulled together the major architects, on the suggestion of the Soviet designer El Lissitzky. In 1932, a pair of curators at the Museum of Modern Art in New York dubbed this conglomeration 'The International Style', although with the exception of a few pioneers in the United States, Mexico, Brazil and Japan, it was really a European phenomenon, and a Central-Eastern European one at that, until after 1945.

One European country was absent from the creation and development of 'The International Style', however – Britain. This makes architecture a particularly extreme example among the art forms in this book. Although after the brief flowering of 'Post-Impressionism' and Vorticism just before the First World War, British modern art was marginal and cowed, it did exist. The likes of Paul Nash, Jacob Epstein and David Bomberg made serious work in the 1920s, which was to a small degree noticed abroad, and both these artists and the vanilla modernists of the Bloomsbury Group kept in touch with developments on the continent, mainly in Paris. They had no equivalents in architecture. Until the mid-1930s, there were no British delegates to CIAM; the architect Howard Robertson, whose Royal Horticultural Hall in Westminster was state-of-the-art for British architecture of the 1920s, sheathing its spacious concrete interior in a forgettable classical facade, was asked to contribute to CIAM in 1929, but he refused, in disdainful terms:

> In the first place we have not here a modern movement similar to that in Europe. The average English view to what is modern in the form of

housing does not I think correspond with that Abroad. There are, for example, no Housing schemes of the type which I have seen in Germany and elsewhere.

Moreover, he added, 'English architects are not very interested in sending their work Abroad.'[1] So the early stages of the development of the 'International Style', documented in something like Walter Gropius's 1926 *Bauhausbuch* titled *International Architecture*, or Walter Curt Behrendt's *The Victory of the New Building Style* (1927), contained no British participation whatsoever. There were genuinely startlingly few British modernist buildings that would have even remotely fit the definition of the 'International Style' before 1933. We can list them below.

In 1925, Peter Behrens, an already veteran German architect whose industrial buildings had been one foundation of the style, was commissioned by the toy-train manufacturer W. Bassett-Lowke to design for him a very mildly modernist flat-roofed house in Northampton, replacing an earlier house commissioned before the war by the Glasgow architect Charles Rennie Mackintosh (ironically, one of the few figures of his time who had been influential in Central Europe). Soon after, this house was borrowed by the Scottish architect Thomas Tait as the module for Silver End, a small company town in Essex. At the very end of the decade, the Vorticist painter turned architect Frederick Etchells was commissioned by the advertising agency Crawford's to design its offices in High Holborn in London, which were then built in a strident but luxurious modernism of chrome and concrete; Amyas Connell and Basil Ward, two architects from New Zealand, designed High and Over, a large villa in the outer London metroland in a Hollywood version of the International Style. Soon after, the young architect Joseph Emberton created a passable Constructivist building for the Royal Corinthian Yacht Club, in Burnham-on-Crouch in Essex; it was in 1932 the only British building included by MOMA in *The International Style*. By 1933, work had begun on another company town in Essex, East Tilbury, to the designs of the company architects of Bata Shoes, Czechoslovakia. One could add to that some industrial buildings obviously inspired by continental precedents. The basic American-inspired factory designs of the period, concrete and glass grids, were essentially indistinguishable from continental modernism, though usually hidden behind grand frontages. The engineer Owen Williams created some startlingly

ambitious structures in the early 1930s, such as the Boots factory in Beeston outside Nottingham and a series of printworks for the *Daily Express* in London, Manchester and Glasgow; he denied inspiration from the avant-garde, but comparing these with his freely ornamented structures in the previous decade, like Wembley Stadium, speaks for itself. Norah Aiton and Betty Scott designed a De Stijl-inspired factory in Derby for Aiton's father's steel-pipe manufacturing company (she had studied in the Netherlands); it is hard to notice its radicalism today, but in not putting the factory behind a masonry facade it was unusual for the time.

In addition to these, a few buildings emulated other trends happening in European architecture at the time. Elisabeth Scott's Shakespeare Memorial Theatre in Stratford was a competition-winning design of 1928 for a hard-edged brick building in the Expressionist style popular in Hamburg and Amsterdam. In a similar vein, Giles Gilbert Scott, scion of a famous architectural dynasty, had shifted from traditional Neo-Gothic into a more minimal and sombre manner, seen most famously in Battersea Power Station. Meanwhile, several eclectic cinemas and a few theatres showed the influence of 'art deco' (as it was called from the 1960s on), an eclectic melange of random historical plunder – Egypt, the Gothic, ancient Assyria, Mesoamerica, North Africa – with an added pinch of modernist spice that was popularized by the 1925 Paris Expo. It was much more popular in France and Belgium than the 'International Style' would be until after the war. That really was the lot – a few swallows that didn't make a summer. After 1933, the list becomes much longer, and even if some of the buildings were designed by British architects such as Maxwell Fry, Wells Coates, Elisabeth Benjamin or Colin Lucas, it was immeasurably indebted to the continentals.

But to be sure, the émigrés who came to Britain after 1933 did not bring with them an architecture that was *wholly* unknown here, as the short list above demonstrates. The first German modernist to achieve notice in Britain, aside from the older Behrens, was Bruno Taut, the Expressionist-turned-Constructivist whose housing estates in the suburbs of Berlin were the pride of the Weimar Republic's capital. He visited Britain in 1929 and wrote a series of articles for the art magazine *The Studio*, which were collected in 1930 into the book *Modern Architecture*, published by the journal. They knew they had a hit on their hands, and trailed the book with an advertisement, which included the following text:

> By Bruno Taut, *the famous German architect*. This is the first book on the subject to be specially prepared for the English language. Illustrated as it is by the most outstanding architecture in the new style, which is one of the most imposing aspects of modern progress, this book can only be described as epoch making in character.[2]

Taut was one of the friendliest and most nuanced of modernists, and the most interested in learning from cultures other than his own; it is rather a shame he did not build in England, but on the evidence of buildings from his own post-1933 exile in Turkey and Japan, he would not have simply designed clones of his German work. Taut's articles combined, on the one hand, an account of what the new architecture was, and on the other, speculation as to where it might fit into British life. He reminded readers that 'the origins of the so-called New Building may be dated back to the engineering triumphs of the nineteenth century – the Crystal Palace of London and the Eiffel Tower at Paris'. He illustrated his Berlin housing projects, informing surely puzzled readers that 'the work of the architect of to-day lies no longer in the making of so-called designs, but in the interpretation of a new social order. He is to be the organiser and the intelligence of the technical and constructional arts.'[3]

Nonetheless, Taut was impressed with Georgian Cheltenham, Highgate and Bloomsbury in London, and by bow-windowed, glassy Regency terraces in Southampton, which he illustrated extensively in *Modern Architecture*. Taut had no axe to grind, and in 1930 he didn't think there was any prospect he would have to live in Britain; but though he did stress that while 'England assumed the lead in the early days' in modern architecture, it had lost that lead some time ago. Its architecture had settled into a not unattractive garden-city mediocrity, unlike Germany, where 'there is a far more definite tendency to oscillate between the extremes of the very best and the very worst standards of building – a phenomenon quite unknown in England'. He praised the English 'anxiety not to get in each other's way, to help and not to hinder their fellows, is for those who visit England a striking feature of the country'. Taut had some cautionary words, however, for British architecture's obsessive cutesiness. 'Prettiness applies to babies, and possibly young girls too, but houses meant to withstand wind and weather should not be judged from the same standpoint.'[4]

By 1934, a few architects working in London agreed. Connell, Ward

Bruno Taut explains Modern Architecture to Britain.

and Lucas as well as Wells Coates were designing increasingly serious, impressive modernist houses. Coates had developed with the furniture entrepreneur Jack Pritchard one great block of flats, the Isokon Building or Lawn Road Flats, in Belsize Park, Hampstead, which we've encountered a few times already. The tiny flats here, which the architect modelled on the cubicle-like living spaces of Constructivist House-Collectives in Moscow, played home to many architects, artists, photographers, spies, and of course Agatha Christie; many of the most famous modernist exiles lived there at one time or another. The trope of the technocratic German modernist architect was familiar enough among the cognoscenti for one to feature in Evelyn Waugh's first novel, *Decline and Fall* – one Otto Silenus, discovered by the socialite protagonist through 'the rejected design for a chewing-gum factory which had been reproduced in a progressive Hungarian quarterly',[5] a job impressive enough to qualify him for the remodelling of her Tudor house into 'something clean and square'. Silenus, practising in Hamburg

Housing Scheme at Zehlendorf, Berlin. Architect, Bruno Taut

The Studio explains Bruno Taut.

but educated in Moscow and at the Bauhaus, has a tendency to make gnomic pronouncements on architectural function:

> 'The problem of architecture as I see it,' he told a journalist who had come to report on the progress of his surprising creation of ferro concrete and aluminium, 'is the problem of all art – the elimination of the human element from the consideration of form. The only perfect building must be the factory, because that is built to house machines, not men. I do not think it is possible for domestic architecture to be beautiful, but I am doing my best.'[6]

Again, the fact that modernism was well known enough in 1928 to form the punchline to a joke for an upper-class novelist doesn't prove that modernism was not an import – indeed, the entire point of the joke is that it was exactly this. When Central Europeans arrived in large numbers in the early 1930s, they entered a niche little scene for gentleman amateurs, and brought to it a degree of expertise, seriousness and experimentation that was hitherto absent, helping to make Britain by the end of the 1930s

into one of the world centres of modern architecture, which it has largely remained ever since, however much that architecture might still be the subject of controversy and culture wars. There is little really comparable to this in any other field in Britain, where an absolute revolution in an art form was brought about mainly through emigration; you would have to look at the pop cultural upheavals of the 1970s and 1990s as a result of migration from the Caribbean and South Asia to find anything akin. In architecture, migrants brought openness, rigour, experimentation and internationalism to an imperial island whose culture was much more self-satisfied and smug than its cultural achievements deserved, and huge swathes of the built environment were changed for the better as a result. That is why the folk-hero image of Lubetkin, Goldfinger and Pevsner persists, and why you don't find murals of Edward Maufe or Beresford Pite on the walls of housing estates.

Between seventy and eighty architects left Germany for Britain between 1933 and 1939;[7] we could estimate a similar number to have come from both Nazi-occupied Austria and Czechoslovakia in 1938, a handful from the hard-right dictatorships in Hungary and Romania, and from late 1939 onwards, many more from occupied Poland, with Liverpool University housing for several years an entire Polish School of Architecture. In among the tens of thousands who emigrated, this is not a huge number; they were, like the sculptors, painters and photographers, a minority within the minority, and as we shall see, not all of them were particularly committed modernists. But modern architecture was, like modern art, one of the major targets of the Third Reich's cultural policies. By 1933, right-wing governments had chased the Bauhaus out of first Weimar, then Dessau, into Berlin, where it was finally forcibly closed that year. Hitler's own bigoted tastes, together with the prominence of the traditionalist architect Paul Schultze-Naumburg in fascist cultural policy in Germany, meant that, aside from industrial buildings (and, during the war itself, bunker design), German modern architecture ended as a movement in 1933. But modern architects themselves were free to work for the new state on private houses, in industry, and in the new stripped classical style, provided they were not either Jewish, active on the political left, or worst of all, both. German Jewish architects, even if they were fairly conservative, had to escape for their lives, while gentile modernists largely escaped out of choice, except for an influential handful who were active in the SPD or the KPD.[8]

Where they came to was often hostile, to be sure, with the existing British prejudice against continentals and 'aliens' sitting alongside a hostility to this strange new architecture – which already housed thousands in Frankfurt or Berlin but was an outré taste at best in London or Manchester. The émigrés arrived in a time of Depression, and accordingly were widely accused of taking the jobs of your ordinary honest British architect; the small British Union of Fascists kept tabs on émigré designers. But the far-right's culture war on modern architecture never reached the same pitch in England as it had in Germany, where the impressive extent of modernist activity was more than matched by an obsessive, racist and highly 'post-truth' counter-movement directed by the likes of Schultze-Naumburg, which eventually won out. You can see a distant echo of it in *Modernismus*, a 1934 book by retiring RIBA president Sir Reginald Blomfield, in which he declared: 'the new architecture is deliberately cosmopolitan. For myself, I am prejudiced enough to detest cosmopolitanism. I am for the hill on which I was born. France for the French, Germany for the Germans, England for the Englishman'.[9] *Modernismus* was at worst racist and at best small-minded, but it undoubtedly lacked the maniacal, biological, genocidal intensity of a Schultze-Naumburg. Blomfield disliked this architecture on bigoted grounds, but he did not believe its designers and sponsors to be subhuman.

Nonetheless, this little scare did have some effect. In reaction to pressure, restrictions were placed on the activity of émigré architects, particularly on their taking public-sector jobs. This meant that there was to be no equivalent in Britain until 1945 of the large housing estates that modern architects had designed in their countries of origin, as so few were employed in local authorities. Émigré modernists had to go into partnership with local architects – Walter Gropius with Maxwell Fry, Eugene Kaufmann with Elisabeth Benjamin, Erich Mendelsohn with Serge Chermayeff (a Chechnya-born architect who grew up in Britain); while the architect and writer F. R. S. Yorke headed his notepaper for his various architectural firms with the names, successively, of the Hungarian *Bauhausler* Marcel Breuer, the German hard-line modernist Arthur Korn, and finally of course both the Slovak Eugene Rosenberg and the Finn Cyril Mardall. As is so often the case, the 'taking our jobs' argument was mythical, partly because immigrants tend to build their own communities and markets. This happened in England too, with North London in particular becoming a centre of modern and sometimes

traditional architecture for an intelligentsia clientele, often Jewish or from an émigré background. Also, by the mid-1930s, the Depression had effectively ended in London, the South-East and the Midlands, though before the Second World War began it raged furiously in the North, Scotland and Wales, each of which had, to my knowledge, no major buildings by émigré architects before 1945. The south-eastern and Midland building boom witnessed some extremely minor émigré input, but was mostly covered by speculative builders, who erected the ring of Mock Tudor housing around London and Birmingham in this period. So until the very end of the decade, when the likes of Lubetkin's Finsbury Health Centre demonstrated a new-found scale, confidence and curiosity about the local environment, modern architecture in Britain was a boutique industry, localized almost entirely in London and the Home Counties; luxurious, arty and marginal.

When they looked at these Mock Tudor houses being erected in front of their eyes, some Central European modern architects might have reflected on the unexpected twists and turns that had brought these into being. As English critics and historians have been pointing out since the 1930s, the Arts and Crafts movement, British domestic architecture and, particularly, the development of the Garden City were all of pivotal importance for continental modernism. Central European modernism emerges at a remove or two from the Deutsche Werkbund, an industry-sponsored association of designers and architects that aimed to improve the design of German industrial products and German housing; what did not derive from the Werkbund can be traced to early twentieth-century Vienna, and particularly the work of the anti-ornament warrior Adolf Loos. Both the Werkbund and Loos were comprehensive Anglophiles. In his polemical magazine *The Other*, Loos tirelessly argued that English plumbing, English tailoring and English railway carriages were the pinnacle of civilization, which Central Europeans needed to emulate, and fast. The Werkbund argued much the same in a less bizarre vein. Its first director, Hermann Muthesius, was the author of *The English House*, a compendious book on Edwardian Arts and Crafts and 'Free Style' domestic architecture. Both Muthesius and the Viennese – particularly the late Art Nouveau architect Josef Hoffmann – were also huge fans of the Glasgow architect Charles Rennie Mackintosh, and they kept his reputation alive at a time when his commissions had all but disappeared at home.

What these early Central European modern architects admired so

much in British architecture was, above all else, comfort. This would lead to some shock on the part of their students, when they arrived here in the 1930s to find draughty, mouldy houses, and central heating as a luxury product. But in the Surrey villas designed by Edwin Lutyens or Charles Voysey, which Muthesius had written up on his travels around the country before the First World War, there was an architecture where pleasure and relaxation were considered far more important than external display. The free plans, the space and hence the air, the large windows, the favouring of unpretentious brick or whitewash over fancy stonework or plaster-cast baroque, the integration with trees and landscape – these were all formative for the architects who would invent 'modern architecture' as we know it in the 1920s.

Similarly formative was the Garden City, which continued this emphasis on comfort and repose into urban planning. As propagated by its founder, the Fabian radical and urban planner Ebenezer Howard, the Garden City advocated the creation of New Towns that would combine the verdancy, space and quiet of the country with the concentration, collective life and industry of the city. This was emulated in Germany almost immediately, in Hellerau, the Dresden Garden Suburb – partly designed by Muthesius, and the place where the Anglo-German publishing impresario John Holroyd-Reece would grow up. Other estates would follow soon after, such as Falkenberg, on the outskirts of Berlin, the first of several housing estates designed by Bruno Taut, who gave it a dash of wild colour and lush gardens, combining his enthusiasms for both British domestic architecture and German avant-garde Expressionist painting.

In 1910, the Frankfurt-born Ernst May was one of the architects employed by the socialist Arts and Crafts architect and urban planner Raymond Unwin. The work in Unwin's office at that point included Letchworth Garden City and Hampstead Garden Suburb, where May helped design some of the buildings. He recalled this as the city architect of Frankfurt-am-Main, eighteen years later, when he published an obituary for Ebenezer Howard in *Das Neue Frankfurt*, the propaganda journal of that city's impressive modernist housing campaign. Between 1925 and 1930, when he departed to design cities in the Soviet Union, May was the lead designer and planner of a series of flat-roofed, abstract, cubic housing estates for working-class residents all around Frankfurt. These were, at the time, the most extensive modernist housing developments in

the world, rivalled only by the trade-union housing association projects being designed by Taut in Berlin at the same time. The Frankfurt housing estates were, if looked at in plan, just Garden City housing, with extensive landscaping, spacious layouts and a predominance of the private, single-family house with a garden – as rare in urban Germany then as it is now – over the flat. But in aesthetics the Frankfurt designs could not have been more different, with no sentimental looks backwards; they were also much more modern in their construction. May's business partner Eugen (later, Eugene) Kaufmann was in no doubt that in Letchworth and Welwyn, Howard had 'prepared the ideas of modern rational architectural and city planning'. For Kaufmann and for May, their modernist housing was a way of carrying on the 'idea and meaning of Howard's work' reflected in their own designs.[10]

By the time he wrote this in his memoirs, Kaufmann had been living for some time in a modest, cubic brick house to his own design in Pentley Park, perhaps the most generously verdant street in the whole of Welwyn Garden City; this may well have been the fulfilment of a dream, the embodiment of the anti-totalitarian oasis of quiet and conservatism that the likes of Arthur Koestler found so appealing about early twentieth-century Britain. As a student in Berlin and Munich, Kaufmann had been 'more impressed by reading *Garden Cities of Tomorrow* than by any of the lectures [he] had to attend', and he ended his life living in a Garden City.[11] It is hard to imagine anything more unmitigatedly English than Welwyn Garden City, with its hare-brained banishment of the energy, diversity and density of real urban life, its monofunctional zones, its blandness, the beauty of its trees and the banality of its buildings, its hatred of the reality of cities and the aesthetics of industry while placing a large and profitable industrial estate out of the view of the houses. But all of these things – bar the last, the disdain for an industrial aesthetic – were shared by the modernists of Frankfurt such as Kaufmann. They were just puzzled as to why this beautiful new world, with its space, air and trees, should decide to ape the specific *look* of days gone by. When he finally visited the Garden Cities in the 1920s, Kaufmann considered the buildings themselves to be 'dated', their retrograde design showing them up as being 'not really a twentieth-century creation'.[12] But he was impressed enough to settle in Welwyn and to build his house there. Changing his name to Eugene Kent, he worked in the planning of new housing and designed very few buildings, among them his little house in

Pentley Park. Visit it today, and you will find Kaufmann's house almost hidden by trees and surrounded by two other essays in the very mild, flat-roofed modernism of local architects, dwarfed by the rangy gables and appliqué wooden beams all around.

The architects of a city to the east of Frankfurt would have more success in doing the Garden City in Britain their way. In East Tilbury, just east of the easternmost outpost of the Port of London, on a desolate marsh, the Bata shoes company of Zlín, Czechoslovakia, built a factory and a factory town, from 1932 onwards, and conceived it as a miniature copy of the town in Moravia where the company was based. The fact of a large Czech corporation building a factory in Britain is less strange than it may now appear. The Czech lands were the most industrial and urban part of the Austro-Hungarian Empire, and after 1918 they helped the new state of Czechoslovakia – joined with poorer, more rural Slovakia – to become an industrial powerhouse. By 1930, characters in British novels would refer to Czechoslovak mass-produced goods in much the same way they would refer to Japanese goods in the 1950s and 1960s or Chinese ones today – high-tech, cheap, a little flimsy. The Bata Company, under the command of Thomas Bata and his half-brother Jan Bata, was also a European pioneer in what the Marxist philosopher Antonio Gramsci christened 'Fordism' in these years – that is, the use of 'scientific management' on the shop floor, a fully mechanized production line, and a strict disciplining of labour with the reward of cheap housing, cheap consumer goods, and the promise of a quiet family life. Zlín, as designed by Bata's architects František Lydie Gahura and Vladimír Karfík, was a peculiar fusion of very high modernism and a certain Anglo-Saxon traditionalism. Its architecture was, from the early 1920s onwards, relentlessly modernist, including long rows of workers' houses with flat roofs and emphasized concrete frame construction, cubic, laconic and abstract, but on an anglophile pattern with private single-family homes, very few flats, and both front and back gardens.

The checkerboard layout of the cuboid houses of Zlín, which pepperpotted the housing with green space, was borrowed from Raymond Unwin's work in Letchworth Garden City, even if the recognizably mechanized, mass-produced and futuristic houses themselves couldn't have been further from Unwin's picturesque neo-Tudor cottages. From the early 1930s onwards, Bata expanded into factories across Europe and North America – Bataville in France, Moehlin in Switzerland,

A Postcard View of the original Bataville, Zlín ...

... and of its British clone, East Tilbury.

Borovo in Yugoslavia. In Britain there was East Tilbury, and smaller Czech enclaves in Maryport in Cumbria and Ayrshire, south-west Scotland. East Tilbury still exists as a company town in fairly good condition, even though the company itself has long disappeared from the area. The cubic houses have not been given pitched roofs, the gardens are well maintained, and the little Constructivist community centre – originally the Bata Cinema – still exists and maintains an exhibition on the town's history.

Most of East Tilbury consists of semi-detached single-family houses, the majority of them modest, with a few larger detached houses for foremen and managers, but the skyline is dominated by the massive graph-paper concrete expanse of the factory, with its water tower still bearing the Bata logo; and the Bata Hotel, a dormitory for the lowest-paid workers, which was converted into studio flats a decade or so ago. East Tilbury is startling for being both so English, and so Essex – endless marshland views, caffs, St George flags and all – and for being so obviously foreign, as there is nothing much else like this in Britain; the handful of post-war modern houses, with their pitched roofs and weather-boarding, look so much more familiar. Yet Gahura and Karfík's tiny modernist town in Essex appears to have passed with little architectural controversy. It was distant from where metropolitan eyes were looking; and though Central European and avant-garde, it was Czech rather than German, meaning no stereotypes were readily available. Any controversy was more likely to be political. Bata were socially conservative, meaning its planners identified not with the political left, but with a progressive capitalist managerial paternalism that was extremely familiar in Britain; examples were villages like Robert Owen's New Lanark, Titus Salt's Saltaire, William Lever's Port Sunlight, and the recently contemporary semi-modernist Silver End at the other side of Essex. Bata did not like trade unions – the social benefits of working for the corporation were gifts granted by the company, not rights that workers had won through struggle.[13] Bata tried to keep the unions out of East Tilbury; though ironically, the company's combination of mass production and social conservatism was influential in Communist Czechoslovakia after 1948, where Gahura and Karfík continued working.

The ironies of this became clear when in 1951 the company, managed then by Bata's Jan Tusa, sacked four East Tilbury workers 'without warning or explanation', likely because they had been involved in

trade-union activity. In the Bata Eviction Defence Committee's pamphlet on the events, *The Bata Story*, it was claimed that the four 'thought the Bata system was fine' until they were fired, and then 'the sack was followed ... with a demand for possession of their houses, held under agreements which required them to leave their homes whenever they ceased to work for the company'.[14] Local residents apparently 'refused to help, because they feared the same fate might overtake them if they did'.[15] Activists from the local Communist and Labour parties, dockers from Tilbury proper, and car workers from Dagenham all came to fight the eviction, and called upon Thurrock Council to nationalize the Bata Estate; the factory complex and company town had been a thorn in the side of local trade unionists because of how poorly unionized Bata was, with both a comfortable and cowed workforce. The four workers won their case and were rehoused in the area – but in an act of purest spite, they and their children were banned by the company from using the Bata Cinema.

Compared to all this, it is remarkable how the apparently alien architecture received little comment – a Czech Constructivist New Town just emerged in Essex without much fuss. This suggests that modernist housing was significantly less frightening if, as in suburban Frankfurt and Berlin or in Zlín itself, it took the form of single-family houses; but it remained something that was alien to the British construction industry and its capabilities. During construction, after problems with the first house-cubes on Bata Avenue, which had been expensive to build and performed poorly in the damp Essex climate, the company realized that they would have to do something drastic to make sure it really resembled the original blueprint. From then on, workers were brought in from Zlín to finish the job.[16] Today, East Tilbury feels both out of place and extremely of it – the landscape as flat as the roofs.

Another, more obviously picturesque but similarly top-down modernist import just before 1933 came to Devon, in the form of the redevelopment of Dartington Hall, just outside of Totnes, into some sort of very approximate English analogue to the Bauhaus. In the mid-1920s, a medieval hall was purchased by an Anglo-American upper-class couple, Leonard and Dorothy Elmhirst, who proceeded to transform it, under the influence both of the Bauhaus and the educational endeavours of the Bengali polymath Rabindranath Tagore, into an avant-garde educational facility. Dartington would educate several generations of

artists and radicals, and was a centre of Keynesian economics – the think tank Political and Economic Planning was set up at Dartington, and one of its number, the sociologist Michael Young, wrote the 1945 Labour Manifesto there. Émigré economists such as the Hungarian Thomas Balogh worked at Dartington, as did various other 'alien' institutions and individuals, such as the ballet school of Kurt Jooss and the sculptor Willi Soukop, whose curious animal statues are dotted around the site. Because of this, Dartington often features on the edges of histories of the émigré presence in 1930s Britain. But architecturally, the new, Bauhaus-style buildings that the Elmhirsts commissioned were not designed by an émigré – or rather, not an émigré to Britain.

The architect of High Cross House, the headteacher's villa at Dartington built in 1932, and a series of dormitories built slightly later, was William Lescaze, a Swiss architect and pupil of the early modernist architect Karl Moser. Lescaze had emigrated to the United States in 1920, where he was, along with Rudolf Schindler and, slightly later, Richard Neutra, one of a few Central European modernists working in the new, raw cities of America who kept in close touch with and extended the avant-garde work taking place on the continent. Although most skyscrapers today root themselves in the proto-modernist work of Louis Sullivan, the first professedly, ideologically modernist, ornament-free, functionalist skyscraper in the USA was the PSFS Building in Philadelphia, designed by Lescaze in 1929, two decades before Mies van der Rohe's first glass skyscrapers in Chicago. Lescaze would go on to design the first modernist public-housing estate in America, Williamsburg Houses in Brooklyn, and it was on the strength of this American work that he was hired to work at Dartington. Next to the warm stonework, spiky rooflines and general extreme cuteness of the main estate, Lescaze's work stands out stark and cold, whether in the bright colours of High Cross House or the abstract geometry of the dormitories. It is unsurprising that an attempt to extend this project into a small estate of holiday homes in Torbay, a step out of the rarefied world of Dartington into ordinary *Fawlty Towers* England, was met with great opposition; a local newspaper headline cried 'why can't they stick to their own back yard instead of foisting bunker architecture on ours!'[17]

Dartington, for all its qualities, is a good example of why we did not have a Bauhaus. While at its height in the second half of the 1920s, the German school was at the centre of an industrial city, and built

trade-union schools and council estates, Dartington was that exceptionally British establishment thing, a 'progressive' private school in the deepest, greenest countryside. However, the Elmhirsts were among the entrepreneurs and philanthropists who brought the former Bauhaus director Walter Gropius to Britain, offering him contacts and some potential jobs. Gropius arrived at Dartington in June 1934, soon after he came off the boat at Harwich in Essex, to find, in his words:

> An ancient gothic palace erected by the bastard brother of the English king in the fourteenth century. A vast park with trees as I have never seen. Fantastic wealth, 60 motorcars albeit rather plain, one saw no servants apart from the classic butler, the lord served himself at the table! The wife is an American and has an enormous fortune, thus they are determined to spend 600,000 pounds annually, earmarked primarily for educational purposes. Two research institutes, a dance school, model farms, sawmills, laundry, weaving mill, etc., all of it planned to solve modern production problems. A large section of the coast has been purchased to establish a bathing resort.[18]

He was disappointed, on his visits to Dartington, to find that Lescaze had already bagged all the major jobs, including that abortive resort, leaving Gropius with little to do but remodel a sixteenth-century outbuilding into the Barn Theatre (since the 1970s, a cinema), where the exposed roof beams do perhaps have some distant allegiance to the notion that form follows function.

There were two really major, first-rank German modernist architects, already world famous and at the height of their careers, working in Britain in the 1930s: Gropius, and Erich Mendelsohn. Both left near the end of the decade for the United States, and both had gained only a handful of British commissions, which included some scattered houses and one public building each, both of them in small towns. Gropius and Mendelsohn make a tempting comparison, particularly because their commissions for private houses in London were next to each other – Levy House, by Gropius (and Fry), and Cohen House, by Mendelsohn (and Chermayeff), two luxurious villas on Church Street in Chelsea, then still an artist's quarter with many studios, and accordingly a place that could be sympathetic to the continental avant-garde. The King's Road is nearby, where one of the first really large-scale International

Style buildings in Britain would soon be built a few years later, the still spectacular whipcrack curve of Peter Jones Department Store, modelled on Mendelsohn's German stores of the 1920s. Both Levy House and Cohen House are – or rather, were – rendered in white stucco, and made little compromise based on the context or the weather; Gropius's house has a curved projection to the street, but its original qualities have been made almost invisible by black-tile cladding. Mendelsohn's equally uncompromising, low-slung and rectilinear house adjacent has fared much better, looking elegant still and continued, rather than destroyed, by a 1970s renovation by Norman Foster, which added a large glass conservatory, also visible from the street. This shows already the different ways in which architects could kick back against traditionalist, conformist English architecture, and the ways in which it could kick back at them.

Gropius was in a delicate position as an émigré. Although he had left the Third Reich for England as quickly as he could, in 1934, it took him a few years to truly concede that there was no place for him or his work in the 'New Germany' – something which makes him different to those who left in fear for their lives. He even participated in an exhibition of German industries in 1934, and entered the competition for a new headquarters of the Reichsbank, which instead was won by a chillingly vacuous, stripped, classical design. But Gropius knew, because the Bauhaus he founded had been chased out of first Weimar then Dessau then Berlin by far-right local governments, that any state commissions were highly unlikely; he was also surely aware that his work for the labour movement, such as the *Monument to the March Dead*, an atypically wild, Expressionist design honouring the trade unionists who had fought against the abortive right-wing Kapp Putsch in 1920, was a permanent black mark against him. Although his closest friends and associates in emigration – the architect and designer Marcel Breuer, and the polymath László Moholy-Nagy – were both Hungarian Jews, Gropius avoided public anti-Nazi pronouncements, and continued to do so right up until the war.

Certainly, Gropius was a reluctant émigré *in Britain*. Although he was always publicly complimentary, and clearly glad to be honoured by the RIBA and feted by the embryonic modern movement in Britain, Gropius's letters to colleagues such as Martin Wagner and Marcel Breuer reveal just how utterly unimpressed with Britain he was, both upon

arrival in 1934 and on departure four years later for the United States. In November 1934, he wrote – in the Bauhaus's no-capitals writing style – a hilarious letter to the Berlin planner Martin Wagner, who had just been dismissed by the Nazis. Safe in London, Gropius blasted how 'chilly draughts, which supposedly kill germs, are virtually organized here', while 'everybody lies in bed nursing colds, roasted by the fireplace on one side, while on the other a cold draught blows through the rooms'. He was amazed that such a rich country tolerated such discomfort, and decided it was 'out of puritanical self-denial, for it is exactly the same with food'.[19] At the end of the year, he described Britain, again in a letter to Wagner, as simply 'an a-cultural country', defined by 'general cluelessness and lack of artistic ability'.[20] And after leaving the country for America in 1938, he wrote with uncontrolled delight to Marcel Breuer, imploring him to make the same trip if at all possible:

> it's fantastic here! don't tell the english, but we are both ecstatic that we have escaped the land of fog and psychological nightmares. air as clear as glass, a lot of sun, and roman blue skies ... the welcome was terrific! new york is an amazing city that simply bowls you over, the skyscraper city ... the view from the roof of these giants really makes your heart turn inside out.[21]

It is not that he found absolutely nothing in England of value. From Manchester factories to the Crystal Palace, he saw and admired some of modernism's nineteenth-century functionalist precursors, and was impressed by the work of Jack Pritchard's Isokon company, which employed various Bauhaus exiles to design furniture and advertising. However, compared with the immense possibilities, gigantic scale and fearless modernity of the United States, it was no contest.

Perhaps, too, Gropius's comments about England were slightly churlish. After all, in 1935, Faber published *The New Architecture and the Bauhaus*, a summation of Gropius's work that recapitulated much from the *Bauhausbücher* that Gropius had published in Dessau. The establishment credentials were impeccable. Capital letters were used, as was an elegant serif font; it was translated by the aristocratic critic Philip Morton Shand (an uncle of Camilla Parker-Bowles), and featured an introduction by London Transport's bureaucratic Maecenas, Frank Pick – although his proclamation that 'the country may count itself

fortunate in being able to entertain him in this period of transition'[22] didn't result in any actual commissions for Gropius. The book marked the first of many attempts to secure Gropius's reputation as a pioneer of modernism – his particularly early (1911) glass curtain-walled factories for the shoe-last company Fagus in Lower Saxony, and the Deutsche Werkbund exhibition in Cologne, of 1914, are prominently illustrated, as if to say 'I did it first' – and as the real driving force of the Bauhaus.

This was important, because the real history of the Bauhaus was deeply strange. Set up in the heady days of the German Revolution in 1919 as a public institution, it was at first a mystical and explicitly socialist institution defined by a sort of cosmic Ruskinism, dabbling in theosophy and various forms of utopian mysticism; from 1922, it developed under the influence of the seductive techno-utopia of De Stijl and the Soviet avant-garde into a Constructivist school of design; then in 1928, it was reoriented firmly to the left, under Gropius's hand-picked successor, the Swiss architect and Communist Hannes Meyer. Under Meyer, the Bauhaus – as a collective – built a trade-union training school in Bernau outside Berlin and finished the council estate that Gropius began in Dessau, and for the first time turned a profit, largely from sales of wallpaper; but Meyer was then fired, with Gropius's approval, for donating money to striking miners. Meyer's successor, Mies van der Rohe, had his own socialist skeletons in the closet, having designed a magnificent, pugnacious brick memorial to the murdered Rosa Luxemburg and Karl Liebknecht, but he nonetheless willingly carried out the brief of purging the left – and politics of any kind – from the Bauhaus school. Its final incarnation, which lasted barely a year, was as a private architecture design school in Berlin.

One can see a measure of this sheer diversity in some of the Bauhaus teachers and students working in Britain in the 1930s: the architect and tubular-steel chair pioneer Marcel Breuer; the Communist activist and Expressionist sculptor Theo Balden; the equally committed Marxist spy, photographer and progressive educationalist Edith Tudor-Hart; the protean László Moholy-Nagy, and the alchemical photographic historian Lucia Moholy; as well as product designers such as Naum Slutzky and Otti Berger. All this activity was simplified by Gropius into something much neater. The Bauhaus now was a force for standardization and rationalization in industry and construction, a force for sanity and beauty, which set out to 'solve the ticklish problem of combining

imaginative design and technical efficiency',[23] with its workshops simply 'laboratories for working out practical new designs for present-day articles and improving models for mass-production'.[24] There was not to be anything here that would frighten the British establishment; Gropius reminds us that he was descended from a line of classical architects, followers of Karl Friedrich Schinkel, 'the "opposite number" of your [John] Soane', and concludes, 'my conception of the role of the New Architecture is nowhere and in no sense in opposition to "Tradition", properly so-called'.[25] Yet, Gropius epitomized the strange paradox of interwar modern architects, appearing both as people absolutely of the past – he is a European bourgeois paterfamilias, the boss of a firm, a bow-tie-wearing 'Herr Professor doctor' – and people of the future. Gropius was obsessed with new materials and technology, and keen to create novel, non-hierarchical forms of education and of collective, collaborative, self-effacing creative work. So *The New Architecture and the Bauhaus* shifts back from its sober and sensible tone to spend several pages advocating buildings that could be constructed out of panels in hours, reconfigured by their users, and permanently mobile. This is all a long way from Schinkel.

Gropius's four completed British buildings, in partnership with Maxwell Fry, are a rum lot. There are the Denham Studios for the Kordas, which he immediately disowned; there is the unrecognizably altered Levy House in Chelsea; and there are two projects where he willingly shifted from an aesthetic of concrete, glass and steel into something ostensibly much more English. One of these, the Wood House, designed for Jack Donaldson, a Labour Party politician in Shipbourne, Kent, is the least known of all – it is close to London geographically but secluded outside a village, meaning it is seldom visited. It was built entirely in wood, and of all his British projects, was a personal project of Gropius himself with his assistant and fellow émigré Albrecht Proskauer, and little input from Fry. The other project, Impington Village College, was completed by Fry after Gropius had left for the United States, and has often, rightly or wrongly, been considered immensely influential on the domestication and taming of the 'New Architecture' in Britain.

The college was built for a village now subsumed in the Cambridge Urban Area, as part of a 'village colleges' programme by the educationalist Henry Morris; it is by far the largest of Gropius's English

commissions, for a modest but expansive and prominent site at the heart of suburban Impington. The college has a free plan, like the Bauhaus itself, an object in green space with long glassy wings open to the sun, surrounded by trees – but all this modernist-pastoral was common enough in Gropius's German work. What has often been considered to be 'British' in Impington is the use of the same yellow stock brick used for ordinary housing and industry in Cambridgeshire, and in eastern England more generally. Again, this is a little questionable. At the end of the 1920s, Hannes Meyer's Bauhaus had used a simple, cheap stock brick in its blocks of flats in Dessau and, especially, in the trade-union school in Bernau – and so too had Gropius, in a labour exchange his firm designed in Dessau. So it may all have been an accident, but it is likely that this Bernau school – which was, like the Finsbury Health Centre, to feature as an emblem of the promised post-war future on Abram Games's 'Your Britain: Fight for It Now' series of wartime propaganda posters – was interpreted as such after 1945. It's likely that the Bernau school was influential both on British schools and colleges, and through the long and successful career of one of Gropius's apprentices, the young London architect Eric Lyons, on speculative modern housing.

The final straw for Gropius in Britain was the rejection by a committee of dons of a proposed (again, brick) extension for Christ's College, down the road from Impington in Cambridge proper, an extension including offices and accommodation. The dons first delayed the scheme, until eventually cancelling it for, in their words, 'too frank modernity'. At around this point, the call from Harvard University came – and Gropius was gone. Marcel Breuer would soon follow, after having built in England even less – a house in Angmering in Sussex, two houses for masters at Eton College of all places, and a temporary but influential pavilion for furniture manufacturers Gane in Bristol. The latter building integrated its flat roof and free plan with local rubble stone, in a manner that was copied frequently after 1945, even though the building was no longer then standing.

Gropius returned to Britain on a few occasions, and seemed to have warmed to it now he no longer had to live there; in 1973, his widow Ise Gropius pondered 'what cultural contributions England could have created' if the likes of Gropius, Henry Morris and other social reformers of the time had 'been given full reign instead of being held down by the heavy hand of Baldwin which ruled Britannia at the time. All survived,

but at what cost!'[26] That's as may be, but looking at Gropius's American work suggested otherwise. Breuer flowered into a flamboyant, brilliant Brutalist architect in American exile, willingly taking modern architecture in expressive, rough and irrational directions that evoked the earlier, Expressionistic Bauhaus, rather than its founder's codification of it. Gropius, however, subsumed himself in a collective firm, the Architects Collaborative, which built some good if deliberately generic and anonymous modern buildings in the United States and West Germany. What did for Gropius's reputation was a willingness in late career to work as a consultant on big private projects, lending his prestige to the loathed Pan Am skyscraper in Manhattan, and in London, to the much smaller but equally uninspired Playboy Club on Park Lane. You are not likely to pass this building and sigh for a road not taken.

But that is *exactly* what you might well do on visiting Erich Mendelsohn's De La Warr Pavilion in Bexhill-on-Sea, East Sussex. It is a work of architecture that still maintains its rare fusion of modernist rigour and sheer enjoyment, and is all the more impressive for its total lack of compromise. It has thrived since a renovation in the 2000s took away some of the accretions of its various incarnations as the pleasure palace for a conservative, elderly Sussex seaside town, despite – or, perhaps, because of – the fact that it displays no perceptible adaptation made by Mendelsohn to his new clients. If Mendelsohn had designed a building on the seafront on the Baltic, it would have looked exactly like this (and would have needed just as much maintenance, as these smooth white surfaces need a lot more work than the brick of Impington – though it should be noted Mendelsohn had requested cream tiles from Czechoslovakia to coat the building, which were rejected as too expensive). In the 1950s, when the modernism of the 1930s was seen as rather passé for its deliberate ignorance of climate and its extreme abstraction, John Summerson pointed to the contrast between Impington Village College and the De La Warr Pavilion, and in Gropius's favour: if 'the Mendelsohn building is a dramatic personal piece cast up, whale-like, on an English promenade', then 'the Gropius building, in its sincere engagement with everyday problems had a good deal more to say to the English architect and in fact proved to be the corner-stone of a new tradition in school design'.[27] That's true enough, and that's also why it is Mendelsohn's building now that stands as a famous icon of high modernism, the subject of innumerable tea towels and tat, with thousands of people a year visiting Bexhill

just to see it, whereas Gropius's building is a straightforward, good school in an outer suburb of Cambridge.

Mendelsohn was, in the middle of the century, considered a challenge to modernist historiography, because he had thrown the same things up in the air as the modernist mainstream – industrial architecture, Cubism and abstract art, a disdain for applied ornament and historicism – but had then assembled them in a radically anti-classical, anti-rationalist way. Starting with his astrophysical observation Einstein Tower in Potsdam, and developing out from there to the Mossehaus newspaper headquarters and the Universum cinema in Berlin, in factories in Luckenwalde and Leningrad, in the metalworkers' union headquarters in Berlin, and especially in a sequence of increasingly audacious department stores in Stuttgart, Wrocław, Chemnitz and finally in the German capital, Mendelsohn put concrete, glass and steel together in compositions that surged, billowed and charged, straining against the limits of an inanimate art form. MOMA included him in *The International Style* book/exhibition, but always included a chiding line in their descriptions, noting Mendelsohn's lack of sobriety and decorum: exactly the qualities that make his work so enduringly exciting, and help it to still carry a futurist charge that has gradually departed from the work of many of his contemporaries. Irrationalism and swagger are, of course, useful qualities to have in a seaside resort building, places that exist for the purposes of *having a good time*.

The De La Warr Pavilion, like so many modernist projects of the 1930s – and unlike the overwhelmingly state-sponsored projects of the 1940s to 1970s – is the personal indulgence of one rich man, the Earl De La Warr, mayor of the Victorian resort of Bexhill. He was radical only by the standards of that town – a Labour peer, he joined Ramsay MacDonald's 'National Labour', set up for their austerity coalition with the Tories in 1931. There had for a few years been plans to build a leisure pavilion in the town, and a dreary Neo-Georgian design had been drawn up in 1930 by none other than Maxwell Fry. In 1934, De La Warr held a competition for the new building, intended to serve much the same sorts of functions as similar pavilions in seaside towns from Brighton to Bournemouth – concerts, tea dances, cafés, a cinema, a promenade, a place to shelter from the sun or more likely the rain. He awarded it to Mendelsohn, newly arrived in London. To his credit, De La Warr rode out the objections of the town – hardly delighted with having a Jewish refugee design an

abstract new public building in the middle of it – and from the far right, which used the competition to attack the RIBA's qualified welcome of German-Jewish émigrés. *Fascist Weekly* yelled its horror at the alleged fact that 'at a time when so many of our young and vital architects are in a desperate position, the Royal Institute of British Architects chooses to welcome alien architects', who the paper described as 'fugitives' who have been 'lavished' with encouragement the RIBA 'conspicuously withhold from the younger architects of their own race'.[28] Uncoincidentally, Marshall Sisson, a member of the British Union of Fascists and minor architect who worked in a compromised mix of Neo-Georgian and modernist design, had entered De La Warr's competition.

Whether it's true to argue Mendelsohn didn't kick back against Englishness in the same way as Gropius is unclear – what is more accurate is that he simply seemed indifferent to it. He didn't denounce England in his letters to friends, as had Gropius: his mind was just elsewhere. Already when the Pavilion was under construction, Mendelsohn was dividing his time between London and Jerusalem. A romantic, Orientalizing Zionist, he believed it was possible that this corner of the British Empire, populated largely by Palestinians but promised by the British government to the Zionist movement, could 'achieve a union between Prussianism and the life-cycle of the Muezzin'.[29] Introducing a collection of the architect's letters three decades later, Nikolaus Pevsner – surely thinking of his own terrible misreading of the political situation in 1934 – wrote that Mendelsohn was 'more clear-sighted than many' in the face of Nazism, understanding exactly what it meant. He left the country almost immediately, as soon as the Nazis took power. Mendelsohn was, as the Lutheran convert Pevsner put it, 'a convinced, self-conscious Jew – an "East Prussian Oriental", he has once called himself jokingly'.[30] In Palestine, Mendelsohn shed no tears for Germany, and was 'reminded of our tears-and-Bach country only in bad dreams and in flashes of boundless ignominy'.[31] That is not to say he wasn't interested in the British project – quite the contrary – and he kept in close touch with it whenever he wasn't in Jerusalem. Edgar Jackson, a theatre architect brought in to help with the design of the Pavilion's auditorium, remembered Mendelsohn as 'a vague but enthusiastic fellow frightfully keen on getting things done quickly without much talk'.[32] Writing to his wife Louise, Mendelsohn described the Pavilion's construction as 'a great joy'. In his typically exalted manner, he declared in March 1935:

The situation is first class: seen from the sea, the building looks like a horizontal skyscraper which starts its development from the auditorium. Seen from the street, it is a festive invitation. The interior is truly music. The Lord De la Warr told me so: he was quite excited ... my only wish now is that the world shall remain at peace and that we can rebuild it.[33]

Sadly, this was not to be. Disappointed in Palestine, Mendelsohn then moved to the United States, where among other commissions he designed a mock-up German city district in the desert, so that the US Air Force and the RAF could test the effects of saturation bombing.

An informed eye can see exactly what the De La Warr Pavilion has taken from Mendelsohn's earlier buildings. It is technologically innovative, way beyond anything most British architects were capable of at the time in engineering terms – the engineer on the project, the recent Austrian arrival Felix Samuely, used a welded steel structure for the Pavilion, Britain's first; he would go on to engineer some of the wilder modern buildings of the 1930s, 1940s and 1950s before his early death in 1959. The long volumes and the curved projections come from Mendelsohn's department stores, and the still outrageous central staircase, with its chrome surfaces and its swooping momentum, is recognizably much the same design as Mendelsohn had provided for IG-Metall, the German metalworkers union, for their Kreuzberg headquarters a few years earlier. But if Mendelsohn's building made no compromise with Britain, British architects would plunder it extensively in the second half of the 1930s. Cinema designers such as George Coles for Gaumont, or Harry Weedon and Cecil Clavering for Odeon, produced literally dozens of imitations of Mendelsohn's work in brick and faience for town centres and new suburbs across the country, especially in outer London and the Midlands. That Mendelsohn's British legacy would be luxurious cinemas, dream palaces, rather than schools, is fitting enough; though they all lack his essential integrity. After the war, this sort of architecture of seamless public luxury became unfashionable, in favour of Anglo-modernisms that were alternately cutesy or aggressive. Because of this, Mendelsohn's British work really does represent a possible modernism that never quite came to fruition here – an architecture that combined the avant-garde's fearless quest for new forms with a very ordinary pursuit of pleasure.

24
Architects In Between

As we've seen in abundance, there was a twofold feeling of 'foreignness' as a result of the Central European emigration to Britain in the 1930s – an acute feeling by refugees and emigrants that the country they were arriving in was quite drastically culturally different to the continent, and a similarly sharp view, sometimes positive, sometimes negative, espoused by the British, that these continental Europeans were bringing an 'alien' culture with them. In architecture, more than in any other art form except perhaps cinema, this posed the problem of how to adapt to a dominant Britishness, or, more frequently, Englishness. This could be done pragmatically by the new arrivals, namely, getting work by designing buildings that British clients found familiar, or more ambitiously, through gradually reforming modern architecture so that it more closely fit with British materials, climate, landscape and prejudice. Arguably, this process of acclimatization was every bit as important – and probably, more prevalent – than the revolution of Mendelsohn and Chermayeff, bringing the pure unadulterated blast of Weimar Culture at its most radical and dropping it on the English seaside. These more apparently compromised reactions also, in some cases, pre-dated the radicalism of the mid-1930s, and drew on a Central European architectural culture that was itself more compromised than the narrative of a triumphant new architecture sweeping all before it might suggest – as in *The Victory of the New Building Style*, the title of one book from the late 1920s.

The first Central European modern architecture to be widely imitated and discussed in Britain did not come from the Weimar Republic, but from the tiny new rump republic of Austria, and specifically Vienna. Between military defeat in 1918 and the fascist coup of 1934, Vienna was a laboratory of socialist culture. The city government's activities were various, but are usually summed up in its housing programme, the

largest and most ambitious in the world during that time. It was also stylistically quite conservative. Socialist modernists such as Josef Frank were sidelined in favour of the students of the early twentieth-century proto-modernist Otto Wagner, the designer of Vienna's subway system and the Postal Savings Bank in a high-tech and monumental variant of Art Nouveau. Wagner's disciples favoured big, urban city-blocks with representational sculpture and artwork, which chimed with the city council's own belief in the necessity of building quickly and densely. Among these architects, who stood in the middle of the polarized debate between tradition and modernity, was Michael Rosenauer. Over the course of the 1920s he had designed a neoclassical villa for the composer Richard Strauss, the modernist Dorotheum auction house, and council estates such as the typically monumental Schimon-Hof. Rosenauer was Jewish, but in 1928, when he moved to London, the events of the next decade were scarcely conceivable; Rosenauer moved to London to become a consultant on housing for the London County Council, which was interested, even under Conservative rule, in Vienna's housing programme.

It is difficult to prove Rosenauer's direct involvement, but from the late 1920s onwards the London County Council's own very extensive housing programme resembled a rather cheaper, more standardized version of 'Red Vienna'. The programme included grand archways, monumental arrangements and spacious interior courtyards. However, those that in Vienna were furnished with fountains, sculptures and trees were, in London, usually little more than scrubland and bins. The exception perhaps was the most obviously Vienna-inspired Ossulston Estate, a vast and heroic complex between Euston and St Pancras stations, one of several estates that featured sculptures and ceramics by the artist Gilbert Bayes. Other councils followed suit. Similarly Conservative-dominated Liverpool embarked on a huge council-housing programme under Lancelot Keay that emulated Vienna's 'Hof' in the local red brick at estates like the Bull Ring near Lime Street station; Aberdeen council did the same in the local grey granite at Rosemount Court. But Rosenauer himself did not design council housing. In fact, he specialized in vast Neo-Georgian or art deco luxury buildings that had the density, stylistic in-betweenness and monumentality of Vienna, but for a wealthy clientele. Some of the London blocks of luxury flats that Rosenauer designed in the 1930s, like the sweeping but restrained U-shaped mid-rise edifice of Arlington House, overlooking Green Park, are chic, modernist and European; others, such

as Troy Court on Kensington High Street, are barely distinguishable from the 'mansion blocks' being built for the wealthy at the time by London's prestige architects. Rosenauer's most interesting building was post-war, an office block in Mayfair for Time-Life – truly Viennese in its opulent materials, fearless urban scale, and its integration with sculpture and artwork, here by Henry Moore among others.

Rosenauer had never been a committed modernist, so there is no sense here that he was compromising his ideals for the sake of his new clients. But there are some examples where this is the only likely conclusion. There are a cluster of houses designed by German and Austrian émigrés around Maresfield Gardens and Netherhall Gardens in Hampstead, just off 'Finchleystrasse', where guessing which was which on stylistic grounds would be deeply deceptive. Numbers 72 of the former and 42 of the latter are perfectly ordinary Neo-Georgian houses, with bay windows, sensible red brickwork, plaster mouldings and absolutely nothing that would suggest them to be anything other than insufferably English. They are actually designs by Hans Sigmund Jaretzki, a Weimar modernist who had designed some impressive office blocks and cinemas; his best surviving work in Germany is a residential complex at Florastrasse in Pankow, with generous curved balconies and projections accentuating the drama of the street junction. It seems Jaretzki was happy enough to do a little Neo-Georgian work on the side to make a living, and his clients were not necessarily those that you might expect – some of his Hampstead houses were actually designed for German émigrés, not all of whom wanted to stand out as did those who moved into the Isokon Building in Belsize Park. It is notable, however, that when modernism became more dominant after the war, Jaretzki returned to it, with buildings such as the restrained brick grid of Wembley United Synagogue, a simple building surrounded by semis and bungalows that is being converted into a mosque at the time of writing.

Jaretzki's Berlin contemporary Rudolf Frankel was apparently not quite so happy about the compromises he had to make with British taste. Frankel was an important architect in late 1920s Berlin, particularly through his design of a vast housing complex by Gesundbrunnen Railway Station, the Atlantic Garden City. While the famous *Siedlungen* in Berlin and Frankfurt were 'true' Garden Cities in the sense of being suburban collections of single-family houses with abundant public and private green space, the Atlantic Garden City was really more about

using the term as marketing – it was dense, with tall tenement blocks, though provided with large balconies and trees between them, and with delicate Expressionist reliefs of flowers and pastoral scenes adorning the doorways. It mostly survives, but is best remembered for a feature that did not survive the war: the Lichtburg Cinema, a Mendelsohn-style abstract curve that was illuminated with spotlights and neon. Frankel was Jewish and a prominent figure, so he quickly emigrated from Germany in 1933, first for Romania. In Bucharest there was a building boom in the mid-1930s, with a progressive local government encouraging the construction of many modernist offices, apartments and private houses, among them Frankel's Adriatica Building, a strongly urban, multi-functional building with shops below and a prominent clock tower on the corner.

It is a long way from here to 'Hillcrest', a large and bland Neo-Georgian detached house that Frankel designed in Hampstead a decade later, after escaping to England from a Romania that had shifted sharply to the far right. It is a seriously conservative design, right down to a little portico over the entrance. The authorship of this house was not known until it was confirmed by Christina Thomson's research in the 1990s; she notes that 'Frankel would never talk about the house in Winnington Road, and he would not even give details about it to close friends'; when asked about it, Frankel 'laughed and confessed that he had never thought much of the house: "It didn't look so good to me!"'[1] It is one of a few in North London that Frankel designed in a similarly conservative manner, to keep himself going in exile. This was not an unsuccessful endeavour, at least in terms of money. Other commissions included a house for Merle Oberon in Stanmore, the sober and sedate hilltop outer suburb where he also designed two simple but clearly modernist brick houses, with flat roofs, hard geometries and unpretentious brick walls, for himself and his sister; one is heavily altered, the other is still much as Frankel designed it. After the war both he and his sister were gone, to the United States – Frankel being one of many fine architects essentially wasted in Britain.

Returning to Hampstead, we could continue down Maresfield Gardens to find a few more houses by transplanted Berliners, which veer between modernist experiments and traditional simulations. At number 48 is a fabulous large house by Hermann Herrey-Zweigenthal, an architect who is otherwise known mainly for being co-designer, with the

well-known *Bauhäusler* and Communist Richard Paulick, of the Kantstrasse Garage in Berlin – one of the first modern car parks, a vigorous and powerfully Constructivist design. Number 48 is in some ways equally experimental.[2] It is asymmetrical, with a cantilevered upper floor supported on a thin piloti, with a massive picture window linked through a recessed white strip to a more typically modernist glass ribbon. It is all in yellow brick, and again, given how often this was used in 1920s Berlin, this shouldn't lead us to assume yellow brick to be an 'English' measure, though the house is easily walked past in among all the sprawling yellow- and red-brick houses around. That is, until you notice the upper floor's continuous balcony, detailed with a Swiss cheese pattern of holes, cantilevered at an angle enclosing plenty of space for the ever-optimistic prospect of al-fresco reclining under London skies. A few doors down at number 20 is a much better-known house substantially designed by a Berlin modernist. The house itself is an ordinary big Neo-Georgian Hampstead detached pile, designed and constructed in the early 1920s by local builders, but in 1938 it was purchased by a famous family and transformed into something quite different: a literal, but hardly modernist, transplant from Vienna.

Number 20 Maresfield Gardens is now better known as the Freud Museum. The architect of its reconstruction was Ernst Freud, son of the founder of psychoanalysis. Ernst had moved to London in 1933. He was born in 1892 in his parents' apartment (and, famously, office, based around the consulting couch) in Berggasse, Vienna. After being educated in his native city and then in Munich, Ernst Freud became an architect in Berlin. His oeuvre consisted of several houses for upper-middle-class clients in and around the German Republic's capital, clean but not too frighteningly clinical interiors for its psychoanalysts, and one more hard-line modernist Tobacco Factory. The houses, such as the Franck country house in Geltow, or the Scherk and Lampl houses in Berlin, use a rough brown brick, often with slightly decorative, Expressionist details around the windows and the corners, something common in the architecture of northern Germany; all were for wealthy clients, and it was when one of these – a member of the Mosse publishing family – was murdered by thugs after the Nazi seizure of power, that Ernst Freud emigrated. In London his family connections made for a relatively smooth transition, and among others, he designed the consulting rooms of Melanie Klein in St John's Wood. He also designed some

brick houses in a similar vein to those he had designed in Berlin, such as the pitched-roofed Marx House (the Marx in question was Anton, an émigré banker) in Hampstead Garden Suburb, and, on the other side of the Heath, a close of flat-roofed, rectilinear houses in Frognal, which stand opposite two much more aggressively modernist houses by the English architects Maxwell Fry and Connell, Ward & Lucas.

Purely architecturally, Ernst Freud's major British building is Belvedere Court, a very large apartment building facing an arterial road on the edge of Hampstead Garden Suburb. This is an exemplary piece of purest compromise. From a passing car, it looks strongly modernist, with its four Mendelsohnian curved projections, the horizontality of their windows accentuated by a stone trim, all in a dark, North German brick. Look more closely and you can see this is Weimar Culture as executed by the British speculative builder, with a mansard roof behind the projections, decorative little doorways, and with windows that initially seem to be modernist and ribboned but are in fact wholly conventionally built. Belvedere Court remains a perfect mix of classy and kitsch. Many tenants of the building, which opened in 1939, were Austrian and German refugees, among them a child who would grow up to be the American reality TV presenter Jerry Springer.

Non-architecturally, Ernst Freud's major work is 20 Maresfield Gardens. It was bought so that Sigmund Freud, already dying when he was being forced out of Vienna with the Anschluss, could live out his last days in something resembling the environment in which he had lived

Freud in East Finchley.

and worked in the Berggasse for five decades. Ernst Freud took the Neo-Georgian villa and totally gutted it so that it could be remodelled for Sigmund, his wife Martha and daughter Anna Freud, in the process transforming 'the home into a ruin in order to restore it anew in a more suitable state for us'.[3]

Ernst Freud had hired the photographer Edmund Engelman to record the interiors of the Berggasse flat, which were a sophisticated example of late nineteenth-century Viennese bourgeois taste, with Middle Eastern rugs and throws everywhere, a great density of framed pictures, and a collection of small ancient Egyptian, Greek and Roman statuettes. The family managed to get these out of Nazi Austria, and they were then reassembled in Hampstead, though the different shape of the rooms meant that the simulation could not be exact. Nonetheless, this is *Freud's couch*, here in the centre of the room, and millions can confirm this since the house became a museum in the 1980s, on the death of its long-term resident, Ernst's sister, the psychoanalyst Anna Freud. Like the reconstructed dacha in outer space in *Solaris*, it is a microcosm surrounded with an environment, the suburban ramble of Hampstead, which could not be more different from the dense, hard, urban streets of inner Vienna. Inside, you could try to pretend that the trauma, the disaster, had not taken place – something that no doubt gave Freud Senior pause for thought.

A walk from here would bring you to Hampstead's richest street, Bishop's Avenue – site of a demolished Jewish Old People's Home designed by Ernst Freud, Heinrich Stahl House – or in another direction to Belsize Square Synagogue, still surviving, a liberal synagogue founded by German émigrés around a private house and gradually extended by various modern architects over the decades. The hard brick building in the middle is a design by Heinz J. Reifenberg. Married to the novelist Gabriele Tergit – in Germany, famous, but whose novel of Weimar media lowlife, *Käsebier Takes Berlin*, has only recently been rediscovered in English translation – Reifenberg worked in Cologne and Berlin, and initially the couple chose to emigrate after 1933 not to Britain but to Mandate Palestine; they moved from there to London at the end of the decade for, in his words, 'believe it or not, climatic reasons'.[4] Initially despairing at London's unplanned, messy appearance, he was gradually impressed by British (middle-class) housing, noting the absence of Berlin-style dark courtyards and the importance of comfortable living

rooms with big windows, and the lack of all the pretentious ornament slathered onto middle-class blocks of flats in Berlin. London, he recalled, 'seemed to have been planned from the interior, from the point of view of human habitation'.[5] Reifenberg is nonetheless one of the rare architects whose work seems to have become more dramatic and radical in Britain. There is quite a leap from the conventional houses he designed in the Berlin suburbs to his major British work, the Power and Production pavilion at the Festival of Britain, designed with the Preston architect George Grenfell-Baines; it was a vast glass factory supported with jagged, Constructivistic pillars, and its enormous scale, packed with new technology, was one of the attractions of the festival.

On the other side of Hampstead Heath in Alyth Gardens, Golders Green, is the North-Western Reform Synagogue, also founded by German Jewish émigrés. The original design has been subsumed in later additions, but you can still just about see the work of the original architect Fritz Landauer. In Germany, Landauer was widely known for one of the earliest modernist synagogues, in Plauen, a cubic, flat-roofed block punctuated by small windows and one long strip; it was destroyed during *Kristallnacht* in 1938. By that time, Landauer had designed two synagogues in London, the larger of the two in Willesden, on a tricky, backstreet site near Willesden Green station, a synagogue of an angular, Expressionistic design in polychrome brick that has been almost completely destroyed by its current owner, an Evangelical church, which has clad it in grotesque fake stone. Landauer never successfully learned English, and in the 1940s, he gave up architecture and set up a business manufacturing tombstones.

We could take a tube from Willesden further west, to find the tube stations of Frederick Curtis, born 1903 in Frankfurt to an English father and a German mother; as an architectural academic in his home city Curtis had been a prominent anti-fascist, which gave him a place in the notorious 'Black Book' of people the *Einsatzgruppen* intended to immediately murder on the invasion of Britain. Curtis's tube stations designed after his emigration in 1933, such as Hanger Lane, South Ruislip and Perivale, built in the later 1940s on the Central Line, are all in a low-budget austerity version of Charles Holden's Anglo-modernist tube stations of the 1930s – a neat sequence, given that they were directly inspired by Holden and Pick's trip at the end of the 1920s to see the 'New Architecture' in Germany and the Netherlands.

Alternatively, back in Willesden, we could take a bus from Alyth Gardens down to 'Finchleystrasse' itself, until we find West End Court, one of around a dozen commercial apartment buildings by the architect Peter Caspari. Of all the émigré architects whose work fell between the cracks of modernism, Caspari's is the most flamboyant, a series of alternately luxurious and shabby private apartment blocks that borrow a formal repertoire from continental modernism and fuse its elements with the commercial imperatives and undeveloped construction techniques of British spec builders.

Caspari was educated at a technical school in Berlin, which sent pupils to work as bricklayers and plumbers as training for making good, functional buildings, something that he later remembered as 'a jolly good experience'.[6] On graduation in 1931 he briefly worked for Mendelsohn on his largest building, Colombus Haus, a nine-storey office block and commercial complex on Potsdamer Platz, and in 1933 participated in anti-fascist demonstrations; he had read *Mein Kampf*, and had no illusions about what Nazi Germany was going to entail. Caspari later recalled that 'being familiar with the Nazi mentality of the majority of the German population and having spent my first 25 years in their midst, I had no doubt that Germany was not the country in which Jews could exist let alone thrive'.[7] He quickly moved to Britain, where he was lucky enough to find work as the architect for a property developer, Davis Estates. West End Court is one of the many blocks he designed for that firm over the course of the 1930s, in London, its suburbs and outskirts from Brent to Surbiton, and in one case in Brighton.

The 1930s was a decade when the 'mansion block' typology of dense middle-class flats was revived, mainly in London and the seaside towns umbilically attached to it. This approach to building flats contrasted with both the English private house and with the nineteenth-century capitalist flats of cities like Berlin or Vienna, plaster-encrusted street-facing tenements with darker, meaner tenements behind; *and* with the modernist alternative then being developed, with free-standing blocks in green space. The 1930s mansion blocks were somewhere between, often standing in their own landscaped grounds, but tightly packed into their sites to maximize profits. The most exciting of Caspari's blocks, Kingsley Court, again in Willesden, exemplifies this. It is in a street of tall middle-class houses adjacent to the tube station, hard up against the railway tracks. As German architects tended to, Caspari accentuated the

street junction with a dramatic curve, and then expressed it further with bands of white plaster and red brick, framing large Crittall windows. It is still an invigorating, glamorous sight. Go up close and walk around the block, and you'll see how much work Caspari had to do to maintain this appearance while at the same time keeping the developer's profit margins up, with deck access on the right side of the building, and, on the left, bare stock brick walls and pipes where nobody is supposed to be looking. Like Caspari's other apartment blocks in Travelcard zones 3 to 6, it is both thrilling and tawdry.

Caspari, evidently, agreed. At the end of the 1940s he left Britain. He had been interned, and felt 'deadly offended by the English authorities having treated me as an enemy alien'. Upon reading that apparently 'a foreigner had to live for five generations in England before belonging', he realized that he 'did not have that much time left' and moved to Canada, where he became a prominent modern architect in Ontario, designing much more strictly modernist high-rise blocks in green, open space, no fronts, no backs.[8] After all, contemporary modernist apartment blocks were not supposed to be like Caspari's flats for Davis Estates. They did not have 'fronts' and 'backs', something that was considered to create class hierarchies in design, cheap stuff for the proles and grand fronts for the wealthy. It was considered dishonest, shabby, capitalistic; at the time Kingsley Court was going up, the firm of Tecton, helmed by Berthold Lubetkin, was showing how to design a modernist block of flats where every flat and every view was equal, at Highpoint in Highgate. In the middle of the 1930s, Lubetkin and Tecton, more than anyone else, promised to deliver the *true* modern architecture, the genuine article, the unadulterated product, the uncompromised socialist futurism dimly realized to have once existed in Berlin, Prague and Moscow; until Lubetkin became bored with that, and decided to do something more apparently 'English'.

25

Lubetkin's Megaphone

Berthold Lubetkin remains the most fascinating of all the émigré architects in Britain. His work is probably the most uncomplicatedly beloved of all the British architecture of the 1930s in any style – the Penguin Pool at London Zoo and the audacious Zoo carved out of the grounds of Dudley Castle, the Highpoint Flats in Highgate, the Health Centre, Bevin Court flats and Spa Green Estate in Finsbury; these are surely the most famous and most celebrated buildings of their time in Britain, and with the exception of the pool, which the penguins have long vacated, the most successful with their residents and users. The man behind these was extraordinarily complicated, and he was controversial in his time, particularly for rejecting the International Style in favour of a personal, and increasingly monumental and decorative interpretation of modern architecture from the late 1930s onwards. He disappeared from public life during the war, to become a pig farmer in Gloucestershire, and in some accounts became a recluse after the rejection of his plans for Peterlee, a New Town in County Durham; he only fully re-emerged in the 1980s as a public speaker and champion of the modernist and socialist legacies. Accounts of his personal life differ wildly – he is fondly remembered by friends as a charmer, is celebrated as a distant hero in the novelist Marina Lewycka's *The Lubetkin Legacy*, and condemned as a violent father and 'self-hating Jew' in the fictionalized memoir *In This Dark House* by his daughter Louise Kehoe. Pinning Lubetkin down is difficult. But at the heart of his work from the late 1930s onwards is a simultaneous project of rooting modern architecture in socialist politics and expanding its visual repertoire to bring in paradox, patterns, decoration and monumental planning. In this, aspects of his work that could be described as anglicizing and as Stalinist can actually be seen as deeply, almost inextricably linked.

Lubetkin's origins are disputed, but by now some facts are generally agreed. He was born in 1903, probably in Tbilisi, the capital of Georgia, then in the Russian Empire, where his Jewish father was a railway engineer, before the family moved to Russia proper, where he grew up in an affluent, professional milieu. In 1917, the teenage Lubetkin participated in the revolution, and may have fought in the Red Army in his late teens. He arrived in Britain in 1931 with Polish papers that had his place of birth as Warsaw, which he claimed was a forgery designed to circumvent any problems that might be caused by having Soviet citizenship. What is certain is that Lubetkin's parents moved to independent Poland during the Russian Civil War; his daughter's memoir claims that Berthold was disowned because of his refusal to renounce Communism. Lubetkin has been posthumously accused of denying his Jewishness, something in part owed to an intense privacy and a vehement anti-Zionism, and while this accusation should not detain us unnecessarily,[1] what is without doubt the case is that Lubetkin's parents were confined in the Warsaw Ghetto under the Nazi occupation of Poland and killed in the Holocaust, probably in Auschwitz. If Lubetkin was aware of this, he never talked about it to his children or to anyone else.

Another thing known for sure is that he spent his twenties in an extraordinary journey across Eastern, Central and finally Western Europe. Lubetkin was educated as an architect at two experimental studios, SVOMAS in Petrograd and VKhUTEMAS in Moscow, and counted El Lissitzky and Aleksandr Rodchenko as his teachers. He left the Soviet Union in 1922 to help Lissitzky with the 1922 'Great Russian Exhibition' in Berlin, which caused a revolution in German art, introducing it to Soviet Constructivism and transforming institutions like the Bauhaus. Lubetkin then studied in Warsaw, which he found conservative, and subsequently moved to Frankfurt, where he worked for Ernst May on the city's social-housing programme. He relocated to Paris to work with Konstantin Melnikov on the Soviet Pavilion at the Paris Expo of 1925, the first Constructivist building to be erected. Lubetkin stayed there for several years, taking a job in the atelier of the ferroconcrete classicist Auguste Perret, and became a practising architect in his own right at the end of the decade, with two buildings to his designs erected: a temporary Soviet Trade Pavilion in Bordeaux – lightweight, angular, quintessentially Constructivist, in collaboration with the Belarusian architect Ivan Volodko – and a permanent block of luxury flats in the

Exporting Revolutionary Architecture – Paris, 1925.

Avenue de Versailles, a collaboration with the French architect Jean Ginsberg. The block was widely praised for its precociously intricate plan and its multi-level roof garden. Before he was thirty, Lubetkin had built a career as a sort of Soviet architectural attaché, and an unusually left-wing figure in the Russian émigré community in Paris.

Also in Paris, Lubetkin met Godfrey Samuel, a young English architect and student at the Architectural Association, a private school that at the time was still deeply resistant to any kind of modernism. Through Samuel, Lubetkin got a commission to design a house for a Russian émigré in London, a Mrs Manya Harari. It fell through but he made connections, and got himself a side job for the Soviet government looking for British architects to compete in the international competition for the Palace of the Soviets, a multifunctional public building proposed for the centre of Moscow. In that capacity he met Hubert de Cronin Hastings, the eccentric and modernism-curious editor of the *Architectural Review*. Lubetkin was commissioned to write about the history

of Soviet architecture for the publication. A letter to Hastings reveals Lubetkin's irresistible charm, and the unusual ability among architects of any style to write beautifully, ironically stating that, without an advance, he would not be able to afford his fare back to Paris, and hence be forced to stay in Britain, among 'these hospitable and friendly shores, the lovely English Sundays, comfortable pubs, enchanting Victorian lanterns, witty bamboo chairs and that elegant police force'.[2]

Going into partnership with an Anglo-French-Polish architect, A. V. Pilichowski, Lubetkin then bagged his first British commission, for a terrace of houses in the south-east London suburb of Plumstead, completed in 1932. It is, aesthetically, pure International Style, with its rendered white, elegant, rippled balconies and ribbon windows, but the way it inserts itself unpretentiously into an ordinary street suggested Lubetkin's ironic but sincere love for British domestic architecture.

On the strength of the Plumstead terrace, Lubetkin was asked by a developer to become an in-house architect, which he turned down. There is an alternative history, perhaps, where like Peter Caspari he became a brilliant and compromised commercial London architect, but Lubetkin had other ideas. An architectural collective was formed: the snappily branded Tecton, which was based around Lubetkin, Samuel, and a group of his friends at the Architectural Association (AA), including Margaret Church, who Lubetkin would marry. Over the course of the 1930s and early 1940s, Tecton would pull together a number of talents. Along with the nucleus of Lubetkin, Samuel, Church, Valentine Harding, Francis Skinner and Lindsay Drake, Tecton would also include at differing points the draughtsman and cartoonist Gordon Cullen, the German émigrés Carl Ludwig Franck and Peter Moro, and two English architects who would go on to design some of the finest buildings of the 1960s and 1970s, Peter Yates and Denys Lasdun. Anthony Chitty, one of the group of AA students that Tecton was based around, recalled of Lubetkin that 'we were all absolutely mesmerised and fascinated by this man. He had enormous charisma.'[3]

No wonder. In 1931, before the Nazi seizure of power had brought dozens of émigré architects to Britain but at a time when young designers were becoming increasingly impatient about the British ignorance of and disdain for continental European modernism, suddenly someone came in their midst who personally knew all the greats and had been a witness to recent history. Lubetkin knew architects ranging from

Lissitzky to May to Taut to Le Corbusier, he had witnessed the October Revolution and fought for the Bolsheviks, and he had worked in Moscow, Warsaw, Frankfurt, Berlin and Paris. It is unsurprising that the young British designers were helpless before him. But for all his tendency to embroidery and subterfuge, Lubetkin was not a confidence trickster – he was a genuinely skilled architect, with a deep knowledge of the classical tradition and a sense of space rare in architecture of any era. Tecton soon made a name for themselves through creating absolutely unapologetic modern architecture, pure, glinting, hard and utterly utopian: Highpoint, a block of private flats in affluent Highgate, private London suburban houses like Heath Drive in Gidea Park and Six Pillars in Dulwich, and the clever, witty homes for gorillas and penguins in Regent's Park Zoo. These are all the more powerful for often facing much more compromised examples of what otherwise passed for modernism – Gidea Park was an attempt to do something like the Weissenhof Siedlung in Stuttgart in the Outer London/Essex borderlands, but it consists, Tecton's house aside, of sometimes fun but extremely conservative semis on flat, unimaginative streets;[4] Highpoint faces a Caspari-style block of streamlined brick flats by the architect Guy Morgan, which is completely outclassed by the gleaming white towers opposite. And then Lubetkin shifted the firm, largely through his own personal prestige, into something else. Starting with the second Highpoint, next door to the original, facades appeared that were patterned, and obviously decorative. He'd brought the gospel, only to reject it within a few years.

To understand what happened here, it is worth first understanding Lubetkin's very personal interpretation of Constructivism, the design ideology in whose birth he was a minor participant. Lubetkin sets out his stall in the *Architectural Review*'s 1932 special issue on 'The Russian Scene'.[5] In among some aggressively strident and passionate Marxist rhetoric, a position becomes clear: architecture should be driven by a socialist concern for both the needs *and* tastes of the working class, it should be a science, not an art, and it should be a deliberate and theorized project, not the result of intuitive talent. It is rather incredible that Lubetkin got any work in Britain at all after this, let alone proceeded to turn the British architectural scene upside down. But note, it is the British, not the Soviet scene that would feel the force of his talent. Lubetkin's departure from the International Style was seen

both in his architecture, and in his wider political activities, much as these would appear to contradict each other. The first sign of this shift was Highpoint II. At the first Highpoint, Lubetkin pushed the sceptical engineer, the Danish émigré Ove Arup, to reduce the weight of the building until it appeared as just sheets of thin concrete and strips of windows; but for Highpoint II, Arup proposed a frame structure that enabled the facade to be treated however the architect liked. Inspired, in his own account, by the Persian-style carpets of his childhood in Georgia, Lubetkin treated the frontage as a set of recessions and projections, clad in brown brick and cream tiles. The entrance canopy, a lightweight concrete curve, was held up at the corners by cheap plaster casts of the caryatids of the Erechtheion, the female figures that hold up the smallest temple on the Acropolis of Athens. Many modernist critics were mortified by all of this, but Lubetkin had his explanations ready.

For Lubetkin, Highpoint II was a statement of those values he considered Soviet architecture promised but lacked – particularly, 'dialectics'. It was 'an admonition, anti the fashionable propaganda of the international style which had its roots in another time and another situation', with the patterns and caryatids put there so as 'to stress the underlying importance of order', which 'in its "Palladian" composition points to the value of constant virtues in the vacuum of an uncertain future'.[6] Palladianism, derived from the Venetian Renaissance architect Andrea Palladio, is of course the basis of English Georgian and Neo-Georgian architecture, and the geometries of Highpoint II are rooted in it as much as any banker's villa on Hampstead Heath. They have also been interpreted, unsurprisingly, as a joke. Lubetkin had already shown that the same building could be sold to planning officers by dressing it up in various costumes, so why not add some Greek plaster casts, in the process both winding up po-faced modernist purists and the classicists who saw their icons turned into trophies on a modern building? In Paris, Lubetkin knew some of the Surrealists personally, and his caryatids have been considered a Dada or Surrealist gesture, mass-produced 'readymades' in the Marcel Duchamp manner placed deliberately out of context to outfox the squares. As in Duchamp's own work, there have been some very heated debates on these wilfully silly columns. Lubetkin once said their source was the Warsaw Polytechnic, but his daughter Louise Kehoe claimed that they were copied from his parents' middle-class tenement block on Warsaw's Aleje Jerozolimskie – Jerusalem

Street – which was destroyed as the Nazis razed the city to the ground in 1944. But caryatids were perfectly ordinary features on middle-class apartment buildings of the late nineteenth century in most of Europe.[7]

Highpoint II is best understood as being part of a wider project on the part of Lubetkin and Tecton, to broaden out British modern architecture. The first Highpoint had been praised by Le Corbusier himself, and Tecton's output featured heavily in a 1937 MOMA exhibition which, only five years after its single entry in the same curators' *The International Style*, recast Britain as the new centre for modern architecture. This was not so far-fetched. Writing on the exhibition for *American Architect and Architecture*, Lubetkin noted that this change in prominence resulted partly from the Great Depression affecting Czechoslovakia and France much more than Britain, but also from the defection of the two major centres where he had worked. In Nazi Germany, 'to design horizontal windows is to attract the attention of the secret police', while in Stalin's Soviet Union, 'any attempt to design buildings of a light and joyful appearance is interpreted as an attack on the proletariat by depriving him of the monumental prosperity'.[8] In their absence, 'those countries which had been considered the most conservative' now *appeared* as the most radical. Lubetkin set the reader straight, by pointing out the poverty of the British construction industry, where building legislation made experimentation difficult, and that a lack of 'careful workmanship . . . particularly in the case of reinforced concrete', meant standards of finish well below those of other European countries. But perhaps more surprisingly, Lubetkin also expressed some scepticism about the influence of the emigration. 'The influx of architects from abroad which might have, and in some ways has, proved so happy for English architecture' has also meant that 'in many cases, architectural models have been transplanted in time and space in such a way as to render them meaningless.'[9] Shifting towards decoration – and, importantly, humour – was Lubetkin's way of translating modern architecture into British English.

What made this unusual is that this apparently ingratiating, even conservative change went alongside a much more pointed political radicalism. Tecton were involved early on with the MARS Group, the British branch of the CIAM, which came into its own in the middle of the 1930s with an impressively experimental Plan for London, held at the same Burlington Galleries that would feature the 'Twentieth

Century German Art' exhibition. Lubetkin and the other partners, some of whom, like Francis Skinner, were members of the Communist Party of Great Britain, tried to steer the group in a more explicitly socialist direction, towards backing the Spanish Republic, fighting fascists in the streets, and making plans for the transformation of working-class housing and living conditions. Other modernists, including émigrés such as Gropius, who had their fingers burned in the politics of the Weimar Republic, were anxious to nip such measures in the bud. In response, Lubetkin and Tecton founded the Architects and Technicians Organization (ATO), which included various figures connected with the Communist Party and the Independent Labour Party, though Lubetkin cautioned against it being made an official Communist front.[10]

The ATO's aim, according to Lubetkin, was 'not so much to collect opinions as to gain the confidence and trust of the community by demonstrating that we are on their side, and willing to prove it by participating in direct action'.[11] In a founding statement, presented by Lubetkin at Conway Hall in 1935, the ATO declared that the modern architect was 'still prevented from giving of his best to the community by those powerful entities, representing rent, interest and profits, who resist alike any large scale modification of our social life or of its material surroundings', a failure 'reflected in the inhuman and indecent enormity of our slums, in the strangulation of all attempts at rational town-planning', and which 'is stamped on the architect himself by the inferior position allotted to him'.[12] The ATO believed that this state of affairs would inevitably lead to a British fascism, and hence offered 'uncompromising resistance to Fascism in all its forms'.[13] The ATO aided Tenants' Defence Committees in London's slums, and rose briefly to public prominence with its proposals for constructing deep-level shelters in the months before the outbreak of the Second World War, which Lubetkin was even invited to showcase on television. Rejected by the government, these effectively became public policy when the makeshift shelters the government had offered failed miserably, and Londoners sheltered in the Underground instead.

The ATO's ideas also formed part of Tecton's Finsbury Plan, which envisaged rebuilding one of London's poorest Metropolitan Boroughs around decorative modernist blocks in the Highpoint II style, green spaces and public buildings. One of these was completed before the war, the Finsbury Health Centre. This 'megaphone for health',[14] in

Lubetkin's words – the edifice that would prove 'nothing is too good for ordinary people' – has been written about at length in various places, but it is worth noting both how it integrates Lubetkin's Constructivism and Anglicism. The building is a 'social condenser' in the Constructivist mould, with its generous public spaces lit by glass bricks intended to encourage friendliness and random encounters; the generously planted and now very overgrown little garden and a roof terrace are both features Lubetkin would have come across in the work of his Soviet teachers. But alongside this are very local touches. No white-rendered concrete, but lovely green and brown tiles that are much more capable of enduring rains and the then endemic smog; a symmetry that makes this tiny building look monumental; and over the entrance, below the roof terrace, big, Victorian, serif letters in metal with a trompe-l'oeil effect, drawn by Tecton's Gordon Cullen, who also designed the (long since destroyed) murals inside;[15] the letters, most of all, with their 'as found in Portobello Market' manner, put this place a long way from the Dessau Bauhaus. Lubetkin tried his best to make the building fit with British tastes without being condescending. But the fact that British people will persist in being extremely literal in their notion of what is and isn't 'in keeping', is proven by the building's neighbour, facing it directly since the 1980s – a terrace of Postmodernist council houses, designed as a clumsy, cheap copy of a shabby Victorian warehouse to their left, an almost spiteful contrast to Tecton's optimistic, light and futuristic modernism.

Tecton finally built much of the Finsbury Plan in around five years after 1945, in the form of the Spa Green and Priory Green estates, and the large Bevin Court mid-rise block; it also went on to design and construct an even larger estate in the Metropolitan Borough of Paddington, Hallfield Gardens, at the start of the 1950s. But the experience, by all accounts, was not a happy one, and the firm broke into two parts in 1948, with one half, Skinner, Bailey and Lubetkin, taking over the Finsbury work (and subsequently, three large estates in the Metropolitan Borough of Bethnal Green), and Drake and Lasdun the Paddington estate. Lubetkin was appointed planner for the New Town of Peterlee, founded by coal miners in the north-east, but the experience was similarly unhappy, and he resigned in high dudgeon in 1950. His articles, when they appeared across the next two decades, were denunciatory and sometimes apocalyptic. The reason widely accepted in Lubetkin's

lifetime is that this reflected a passionate socialist's disgust with the failure of the brief attempt at an English socialism after 1945 and the resurgence of consumerism and war, with the reclusive architect looking on in horror from his pig farm. Another explanation, advanced by his youngest daughter Louise Kehoe, is that this turn to bitterness was the result of his losing his family in the Holocaust, a fact he desperately suppressed, leading to outbursts of irrational rage. These are not mutually exclusive explanations. Lubetkin's politics were not a screen for his identity, and it seems entirely plausible he really was racked with feelings of guilt and loss for the family in Warsaw he was forever estranged from. But in all this time, Lubetkin was also designing what in any other context would be an impressive oeuvre, with a large quantity of buildings emerging to his designs, nearly all of them council flats. These were the very projects that he and Tecton had wanted to construct all along in the 1930s, but they were diverted through the reactionary politics of the time into designing homes for intellectuals, flightless birds and apes.

The earliest of these projects, Spa Green, its foundation stone laid by the Minister of Health and Housing Aneurin Bevan in 1946, is by some way the happiest. Its three blocks, two slabs and one curved lower block between, follow the Highpoint II model, with Arup's box frame enabling another Caucasian carpet of tiles, bricks, recessions and projections, with lightweight concrete and tiled canopies on the roofs and the entrances to give a sense of arrival, indicating that each block is special. The site, a small park opposite Sadler's Wells Theatre, is beautifully landscaped, and the buildings have been kept in reasonably good condition, with the original sense of openness and optimism still palpable. With its large flats and balconies, Spa Green set a very high standard for post-war council housing that was, generally, not emulated. The roughly contemporary Priory Green, on a rougher site near King's Cross Station, was larger, less green, and more rectilinear, with its grid of slabs arranged to evoke London squares, a measure rendered invisible by the extremely aggressive security fences erected when the buildings were restored two decades ago. There is less imagination here, and the standards of materials and spaces have already been cut back from those of Spa Green. Again, the facades were patterned and decorated with a variety of facing materials, and this time some public art was provided, with a mural of London scenes by Feliks Topolski that sadly has not survived, and a relief by the Liverpudlian sculptor Kenneth Hughes of a post-war 'family

group' in the Anglo-Socialist Realist style of a Peri or Charoux, which has survived. By this time, the patience of modernist critics had evaporated, and Priory Green was harshly criticized for its 'arbitrary' facades and its betrayal of the purism of the modern movement.

Again, Lubetkin's own lectures and articles provide some explanation of what it was he was up to. For him, the divides between high and low art, or in this case, between the folk art of Georgian carpets and modernism, was artificial. In one of the talks where he recounted the emergence of Constructivism as a living emissary, he argued that what would become early Soviet modernism, whether Vladimir Tatlin's apparently abstract counter-reliefs or Velimir Khlebnikov's sound poetry, grew out of ordinary things such as folk songs, icons, wood-block prints and, of course, carpets. 'Due to a time-lag in development between East and West Europe, in Russia modern art grew organically out of folk art traditions which were identified and revived by the politically motivated and radical populist movement' (though, in a wry reference to Stalinist antisemitism that belies the claim he was a self-hating Jew, Lubetkin notes that 'in Russia my point of view must be regarded as heresy, since they persist in regarding modern art as a scourge and a visitation, imported by rootless cosmopolitan agents').[16] But these patterns have not emerged out of a folk-art tradition in Britain; they have been imposed by the imagination of a highly educated and erudite Georgian-Polish-Russian-Jewish migrant as a means of communicating with an urban working class, and making their dwellings into something more 'special' than a mere agglomeration of housing units.

Lubetkin did have some admiration for the existing models of classical domestic architecture in Britain – at the Hallfield Estate, for instance, the grid of patterned, polychrome blocks is set back from Gloucester Terrace, an opulent Italianate row that he declared would receive 'most reverent treatment'. But Lubetkin was not a postmodernist, and had little sentimentality about the Victorian city on the whole.[17] A possibly more authentic form of communication can be found in the dramatic, colourful signs that Skinner, Bailey and Lubetkin started to add to the entrances of their housing blocks from the late 1940s onwards. These develop the neo-Victorian lettering Gordon Cullen derived for the Finsbury Health Centre, again to add gaiety and humour to the Constructivist aesthetic. A more architecturally pure form of communication can be found in another block, between the Health Centre, Spa Green and Priory Green:

Bevin Court, a Y-shaped block of flats just off Percy Circus, a classical square that once played home to Vladimir Ilyich Lenin in his time living in London. You can spot it immediately through the big red and white sign, in great projecting letters, BEVIN COURT.

This was originally intended to be LENIN COURT, to acknowledge the great leader of the world proletariat; and already during the Second World War, Lubetkin was commissioned to design a Lenin Monument for Percy Circus. Its elegant frame was based around another of Lubetkin's Dada readymades – a mass-produced plaster Lenin of the sort you could buy at one of the CPGB-affiliated bookshops – which meant that when the monument was defaced, as it regularly was by the local BUF, you could buy another head for a few quid and put it in the niche. Because of this, it was essentially vandalism-proof, but the Cold War and the reclassification of the Soviets from allies to enemies meant the monument was eventually dismantled, and the housing block, already under construction, was renamed after the Labour-right foreign secretary and NATO co-founder Ernest Bevin. Francis Skinner claimed the name was chosen so that they only had to change two letters on the sign. The building is now best known for something new in Lubetkin's work. Concerned with creating a feeling of arrival and identification in housing, he had tried entrance canopies at Spa Green, and the spacious anterooms enabled by the larger budgets of the two Highpoints, but at Bevin Court – otherwise a not entirely successful patterned block in the Priory Green manner – everything was charged into an audacious staircase, which channels both Bernini and Rodchenko into an unforgettable experience of baroque space – and that in a block which was provided with lifts anyway.[18]

The question of the link between Lubetkin and his partners' Communism – or more unkindly, their Stalinism – and their efforts to produce effects of friendliness, identification and attraction can also be explained through Lubetkin's return to the Soviet Union in the mid-1950s, after the death of Stalin but before Khrushchev's 'de-Stalinization', as part of a delegation along with Skinner and other British architects. His account of this appeared in an article for the Architectural Association's journal, in which Lubetkin criticizes what he now perceives as the savagery of the modernist buildings of the 1920s and early 1930s. The Constructivists' obsession with 'maximum economy' had, he announced, 'reduced architecture to the level of the

activities of certain species of insects and mammals', entirely 'emptied of all emotional content'. Lubetkin argued that:

> all the aggressive self-assertion with which the functionalists asserted their creed could mask neither the barrenness of their doctrine nor the sterility of their practice. The few remaining buildings of the period bear witness to it. Whatever was intended at the time, these buildings with their barbed wire aesthetics remain for us grim forerunners of the lugubrious architecture of the concentration camp and the crematorium. Their stark harshness is full of a metallic mechanical clangour, a nail-biting pedantry.[19]

Given that Lubetkin learned so much from Constructivists like Tatlin, Vesnin, Melnikov and Ginzburg – his old colleagues and friends – this sudden condemnation must have been a shock. It's hard not to wonder if he's using their example to settle scores with the Brutalist generation, those architects and critics that denounced his move in the 1940s into patterned facades, ornamental details and beaux-arts plans – which began with that attack on his Priory Green estate by the *AR*'s editor J. M. Richards. It corroborates the account of a man unbalanced by rage that comes out in his daughter's memoir, in which she recalls how 'in a hideous emulation of Stalinist revolutionary vigilance, Dad set us to watch over one another and to denounce one another for any perceived infringements' (although the 'Book of Grievances' she recalls him keeping suggests Frank Costanza in *Seinfeld* more than Stalin).[20]

But what that essay also makes clear, however wild the tone, is just how far Lubetkin had travelled from orthodox modern architecture, though he stayed enough of a modernist to have some reserve towards the neo-baroque 'Socialist Realism' that followed. He saw its emergence as required by the need to employ conservative professionals who knew what they were doing, but also because 'in the light of Marxist philosophy, culture ceases to be regarded as a sanctuary, but must permeate the masses and be accessible to everyone, universally comprehensible'. However kitsch it might have been, Soviet architecture managed that, creating monumental ensembles like the Moscow Metro and Moscow State University, whose pathos-filled spatial grandeur 'no architect is likely to forget, no matter how clad in fragments from a monumental mason's catalogue'.[21] What Lubetkin did in the three estates he designed

for the Metropolitan Borough of Bethnal Green – Lakeview, Dorset, Cranbrook – was in some ways an attempt to replicate this feeling of immensity and order, albeit under the discipline of the strict-cost yardsticks of Harold Macmillan-era municipal housing; this certainly ruled out the lashings of marble and gold used in the Moscow or Leningrad Metro, or the spires and crenelations capping the ring of seven skyscrapers Stalin had placed around Moscow.

Lubetkin's subsequent work can be seen as a rejection, to use Stalinist language, of the 'left' deviation – Brutalism, and Americanized steel-and-glass high modernism – and the 'right' deviation, neoclassicism and picturesque planning. For Lubetkin, the first of these deviations had caused the other. 'To think that a building is nothing but a communication diagram, a time and progress schedule or an insulation chart,' he declared in 1975 in a talk for the Open University:

> means that a secret ingredient called 'beauty' must inevitably be called in to be spread over the surface in measured doses according to the budget. Thus belief in 'Functionalism' opens the door to raving irrationalism, and the release of phantoms.[22]

It was once assumed that the great man had little personally to do with the Lakeview, Cranbrook and Dorset estates, which were all built long after he had 'retired' to his pig farm. But recent research rejects this, with stories now emerging of Lubetkin visiting the sites and keeping in touch with the residents of these close-knit East End communities.[23] One of the three, Lakeview, a two-part tower overlooking Victoria Park, does not escape its material limits, but the other two estates are still astonishing and heartbreaking in their conflict between poverty and ambition. Around the time he was working on the first of these, the Dorset Estate – next to Columbia Road Market, and named after the Tolpuddle Martyrs – Lubetkin wrote a text on the baroque, which he described as 'a masquerade' that was 'necessary in order to lift sordid reality onto a pedestal'.[24] This is precisely what the Dorset Estate does. There are Y-shaped blocks that resemble those of Priory Green but cheaper still, with the carpet patterns now made out of pre-cast concrete panels, mixed with red brick, and with relatively indifferent low-rise blocks between these and poky access decks to get to the flats; though importantly, the estate does have the social buildings – a community

A REFUGE REBUILT

Communitarian Constructivism going Cheap: Dorset Estate.

centre and a pub, both rather wittily designed, one as a rotunda and the other with a big barrel roof – that many post-war estates lack. Its highest building was Lubetkin's first tower block since Highpoint I, Sivill House, in yellow brick and a complex pattern of pre-cast concrete shapes, an ingenious and attractive design that has recently been listed. In the Y-shaped blocks and in Sivill House you can find the most incredible staircases, which drop the Constructivism of Bevin Court in favour of an even more baroque approach to space, looping, intersecting and overlapping in frankly disorienting arabesques, all executed with the extremely limited palette the budget imposed, little more than painted concrete floors and iron banisters. They are so strange in their geometries that the thrill of Bevin Court has started to become sinister, vertiginous. There is something undeniably heroic in seeing Lubetkin – and the staircases are usually credited to him alone – trying to push through the limitations of a society that, for all its claims to having become a welfare state, still considered working-class housing in the East End of London to be second-class, and creating out of the rawest and cheapest components something absolutely extraordinary.

Cranbrook went further still. It has its more relaxed elements. Facing Roman Road is a happy little crescent of houses for the elderly, around a statue of the blind beggar by Elisabeth Frink, and a pond – but most of the estate consists of towers, great big chunky point blocks in a strange grey and green pre-cast pattern. The towers all have big mosaic entrance signs with bold neo-Victorian type at their entrances and heraldic coats of arms for the saints they are named after, and they also have – this time a little more restrained – baroque escape staircases, which define the entrances to the flats, several of which face each other on every floor around the central core, a way of escaping from the drab, mean deck-access rows of flats along corridors that make the Dorset Estate's Y-blocks feel so bleak. But there is simply no escaping how much Tower Hamlets Council, which inherited the estate from Bethnal Green, have neglected these buildings. Originally the green pre-cast panels were in mosaic, but this was replaced with a cheap metal. The panels are dirty and tired, and spikes and mesh to keep out pigeons give the buildings a hostile appearance. Lubetkin clearly took the place seriously – some elderly residents still remember his visits – but the meanness can be overpowering. That is, until you notice the perfect, classical row of tall trees that define the Cranbrook's green, parkland setting, with a partly sunken path ploughing right through from the street along this avenue. It is a spatial effect of considerable drama – and a classical one, of the sort you could find en route to some benevolent despot's palace. Lubetkin's biographer and friend, the architect John Allan, reminds us that when 'feeling the "whoosh" of space through the principal avenue' of the Cranbrook, the walker 'may remember that the urban sensibilities of its author were formed in contemplating the Champs Elysees from the Place de la Concorde, in confronting the Neva from Vassilevsky Island'.[25] One great last attempt to achieve the impossible, and create the 'eldorado for the working class' he had dreamed of since the 1920s, and that was the end for Lubetkin.

These late estates were ignored by the contemporary press, and have only recently been rediscovered. It is easy to see why. They were far too decorative to fit with the Brutalist trends in architecture that were emerging at the time, a movement which favoured truth to materials, angularity, dissonance and aggression, and the creation of abstract, singular forms – you can compare these two approaches easily, as both the Cranbrook and Dorset estates are close to formally inventive Brutalist

'cluster blocks' by Lubetkin's old Tecton comrade Denys Lasdun. Lubetkin's late estates also don't quite fit with the 'New Empiricism' that was founded after the war, which aimed to domesticate and anglicize modernism through 'mixed development' and an embrace of the 'picturesque', and which broke modern housing up into small fragments, placed informally around little squares and pocket parks. Skinner, Bailey and Lubetkin's estates were also decorative, and tended towards the little touches that Reyner Banham derided as 'People's Detailing'; but they are also monumental, vast and dominating as ensembles. And it was as ensembles that Lubetkin wanted them to be seen, as images of order and completeness. On reading Lubetkin's 'Credo', written around 1950, which aimed to clarify his position after his resignation from the Peterlee project, one can imagine that the architect was reading the anti-modernist jeremiads of the Hungarian Marxist philosopher György Lukács. Lubetkin here wrote in disgust at 'a decaying, crisis-ridden society', which:

> rejects the notion of continuity in favour of an ad hoc piecemeal engineering, improvised on the spot out of fragments of experience, lots of bits and pieces, odds and ends at hand, with no reference to an irrelevant past or an inscrutable future that may never arrive.[26]

What was being attempted here was, as Lubetkin would have argued, all about *dialectics*. There was, he believed, a way of combining intimacy of detail and a sense of being together in one massive totality, and of uniting locality and internationalism. But he despaired of ever being able to achieve it. In 1957, he tried one last wandering, writing to the Chinese Embassy asking for a job in Maoist China; they replied positively, but it never worked out. Towards the end of his life in the 1980s, Lubetkin was granted the RIBA Gold Medal and was courted by younger architects, which he seems to have enjoyed, but it did not reconcile him. He appealed for his buildings to be demolished because they were 'crying out for a world which has never come into being'.[27] He remains one of the greatest and most tragic architects to have worked in this country.

26
Thoroughly Inlandish

If Berthold Lubetkin was a prophet without honour in Britain by the 1950s, his influence, if not his personal presence, was enormous. Several architects who had been his partners at Tecton went on to careers of great importance, whether nationally, like Denys Lasdun, or locally, with the series of great buildings Peter Yates designed with Gordon Ryder across the north-east. Two of these architects were émigrés. Carl Ludwig Franck, who bunked with Fred Uhlman when interned in the Isle of Man, was Tecton's main draughtsman, and the limpid, elegant drawings of facades that appear in the books on the company are mainly his; Lubetkin himself claimed that in all his career he 'never saw such a talent'.[1] Franck wrote and illustrated some important books on the architecture of the Italian Renaissance, but as a solo architect – taking over the old firm of Joseph Emberton – his major work lay in completing what was left of the Finsbury Plan, in the form of crescents, slabs and towers far larger than any of Lubetkin's, and they dominate Finsbury and Clerkenwell today. They are less obsessive in their patterned decoration than Skinner, Bailey and Lubetkin's buildings, but are visibly of the same school, with great attention paid to entrances and skylines, sculptural roof terraces and grand archways. These features are seen at their most impressive at Turnpike House, a mammoth tower that has featured on two record covers, and been the subject of one of them, *Tales from Turnpike House* by the Londonist pop group Saint Etienne.

Another Tecton partner, the German Gerhard Rosenberg, was deported to New Zealand at the start of the war, where he became influential in that country's small but lively émigré modernist scene. But the better-known émigré architect at Tecton was Peter Moro, from a slightly younger generation than Lubetkin. Born in Heidelberg in 1911 and educated in Berlin, Moro, whose father was a physician and

paediatrician, didn't even know he had any Jewish ancestry when in 1934 he was hauled in before a committee at the Berlin Technical Academy, where students were forced to declare their 'racial purity', and accused of perjury because the university had discovered he had one Jewish grandmother; at the hearing, the veteran modernist Hans Poelzig looked on, shamefaced. On his own later account, Moro 'decided there and then that a country like that was not worth living in and the sooner I could get out the better'.[2] He managed to enrol to study architecture in Zurich with Otto Rudolf Salvisberg, who had co-designed Berlin's White City with Bruno Ahrends, and was then working on a factory for Roche Chemicals in Welwyn Garden City. Moro moved to London in 1936, and tried to get a job with Walter Gropius, but was told 'he had too many foreigners as it was'.[3] Despite managing to get some work at Tecton – Lubetkin's penthouse at the top of Highpoint II is partly Moro's design – Moro was on the verge of being deported back to Nazi Germany when he was helped by the solicitor brother of the architect Richard Llewelyn-Davies, with whom he went into partnership just before the war. Their first house, in Birdham, near Chichester, showed an interest in local materials – rubbly, crumbly stonework – that rooted the flat-roofed, abstract modernism Moro had learned from Salvisberg in this genteel southern English place, and displayed a love of paradox and trompe-l'oeil effects that he learned from Lubetkin. When designing the house in Birdham, Moro had to report every day to the police in Chichester, due to the proximity to the military base at Portsmouth; he later claimed that locals believed the house wasn't bombed in the Portsmouth Blitz because it had been designed in the shape of a swastika, as a navigation aid to German bombers.

After internment and the end of the war, Moro was given a commission of a lifetime. One permanent building was planned for the Festival of Britain, a Royal Festival Hall. The London County Council's Architects' Department, newly reorganized and invigorated by the Scottish modernist Robert Matthew, put together a team led by Leslie Martin, co-editor of *Circle*, and in turn Martin appointed Moro as the detail designer of the Festival Hall. The fact that it appears as a sort of giant scaling-up of the Finsbury Health Centre, with its big, bold serif lettering and its sense of modest monumentality, is owed in part to Moro, and among his roles on the project were detailing some of the delightful touches that have made the Festival Hall so beloved, such as the floating

balconies of the main hall's galleries, and the decorative carpets of the public foyers. But Moro was also a consummate designer of space, and the flowing, interlocking public spaces that make the Festival Hall so successful as a rather socialistic public building are due largely to his influence. Moro would build on what he achieved at the Festival Hall in several more theatres that Peter Moro and Partners would design right up until the 1980s, across Britain and Northern Ireland. Beginning with the vigorous, unpretentious but spatially breathtaking Playhouse in Nottingham and ending with the complex Brutalist geometries of the Theatre Royal in Plymouth, Moro's theatres are quietly among the great public works of the post-war era, combining the wit of Lubetkin with a more realistic, robust approach to materials and spaces.[4]

That Peter Moro – interned by the British state only a few years earlier – should have been designing a great public building was typical of the Festival of Britain. Its informal layout and sense of festive gaiety was derived from Scandinavia, especially the Stockholm Exhibition of 1930, which led Jonathan Meades to call the 1951 event the 'Festival of Aalto': but it was surely really the Festival of Lubetkin. The features with which he had upended serious, technocratic modernism – wavy concrete canopies, surreal sculptures, wild staircases, patterned facades – were all repeated across the site, even though Lubetkin himself was given no work there. As well as Moro's contribution, and the émigré sculptors and muralists we have already come across, there was Hans Reifenberg's Power and Production pavilion, Bronek Katz's Homes and Gardens, and in the West End, a Festival information point by Jacques and Jacqueline Groag. The spire that capped the Festival, the Skylon – a latticework tower by the young architects Powell and Moya, hauled on cables with 'no visible means of support' – was able to actually stand up through the daring engineering of Felix Samuely. This is important, because the Festival has often been celebrated as marking the emergence of a truly local modernism in Britain, defined by terms such as 'Englishness' and 'The Picturesque'. The person who defined those terms, again in the *Architectural Review*, was, of course, a German: Nikolaus Pevsner.

In his unpublished book on *Visual Planning and the Picturesque*, written during the Festival, Pevsner argued that 'the great European importance' of the Festival of Britain was 'that it revealed, in rigorously modern architectural terms, the rebirth of this English concept of the

picturesque', where planning is 'intricate, complicated and full of surprises'. With this change in layout has come a change of style:

> gone is the hardness, the inflexible angularity, the aloof dogmatism of the beginning of the modern movement; gone is the excessive insistence on the social and scientific aspects of architecture. Fantasy and romanticism have come back.[5]

In the 1950s, the *Architectural Review*, with Pevsner especially prominent, moved away from celebrating the modernist hardcore exemplified by Lubetkin's early essays on the Soviet Union, and demurred from the incipient Brutalist movement; instead, the likes of the journal's editor Hubert de Cronin Hastings, the old Tecton member Gordon Cullen, and the young writer Ian Nairn started to embrace pubs, alleyways, music halls, and all the apparently irrational paraphernalia of the English village, town and city. This orgy of Englishness was given a historical underpinning, a rational explanation, by a series of essays and lectures given by Pevsner over the course of the 1950s, as a sideline from his undertaking to document all significant English buildings, in the series 'The Buildings of England'.

We have already encountered Pevsner as art historian – his original training in Dresden – but it is as an architectural historian that he is remembered. In the 1970s and 1980s, he was attacked by the new traditionalists – such as his old student David Watkin – as a totalitarian, either Marxist or fascist, who wanted to fit all architecture into a straight line, a progression of styles that would culminate in a pure, white, rectilinear modernism. This was always a travesty, but it rests on Pevsner's exceptionally honest approach to writing Britain's architectural history: telling you what and why, without bullshit or sentimentality. In his earliest book, first published in 1936 as *Pioneers of the Modern Movement*, he stressed that modernism was first a British phenomenon, visible both in the mechanization of architecture shown in the great railway stations and in the Crystal Palace, and also in the reaction to the way that both historical revivalism and mass production stripped imagination and initiative from the architectural worker, in the ideas of William Morris and the Arts and Crafts movement. But after that, Pevsner was firm that Britain dropped the ball. 'England's activity in the preparation of the Modern Movement came to an end

immediately after Morris' death. The initiative now passed to the Continent and the United States, and, after a short intermediate period, Germany became the centre of progress.' Worse still than this statement of a national deficiency was the way in which Pevsner understood it – as a consequence of the British class system:

> English writers have not failed to acknowledge this fact; but hardly anybody has tried to explain it. One reason may be this: so long as the new style had been a matter which in practice concerned only the wealthier class, England could foot the bill. As soon as the problem began to embrace the people as a whole, other nations took the lead, nations that lived no longer, or had never lived, in the atmosphere of the *ancien régime*, nations that did not accept or did not know England's educational or social contrasts between the privileged classes and those in the suburbs and the slums.[6]

Pevsner made a similar argument in his second book, *An Enquiry into Industrial Art in England*, a survey that was the first evidence of the writer's incredible stamina; commissioned by Birmingham University, and researched in and around the West Midlands, it entailed visiting around 200 factories and trying to understand why their products were made as they were. Such a project was in the egalitarian Arts and Crafts tradition – his epigraph is from William Morris, asking 'what business have we with art at all, unless all can share it?'[7] – and was centred on the most ordinary goods, like cupboards and chairs, carpets and rugs, pots and pans, radios and books (the latter a rare highlight among a generally depressing picture). Most of the industrialists seemed to be baffled that anyone would be interested in the quality of these objects at all; there was, Pevsner writes, 'one instance of a manufacturer suspecting me of spying for a foreign power'.[8] The picture was generally bleak. 'Mirrors must remain oval, bedsteads sumptuously carved and moulded, wardrobes provided with some flowing fillets. Nothing as severe as the products of Central Europe would sell to the English public. The manufacturers are convinced of this.'[9] Citing Herbert Read and Frank Pick, Pevsner argued that 'it is fair to say that in some Continental, especially Central European countries ... the ratio of good design to bad is much more satisfactory than in England', and he quotes Pick, Read and Gloag to back this up. What is more disturbing still is

that what is good in *good* English design is precisely its sobriety and restraint. 'Britain's greatness seems inseparable from Britain's conservatism.'[10] So there were classy but extremely conservative goods at the top, and trash for the masses. This *kitsch* – he used the German word, of which he noted we don't have an equivalent – had emerged because 'the industrial development of the nineteenth century deprived the poorer classes of so much joy in life', so they had to find consolation in longing for 'a splendour which reality does not concede', as exemplified by Hollywood.[11]

Pevsner's project is at its most attractive when based on trying to cut away the pernicious influence of class, snobbery, and the covetously guarded secret knowledge of the connoisseur, which is precisely the reason why he was sneered at by his contemporaries such as John Betjeman, and why the new right of the 1980s smeared this gentle social democrat as a Stalinist. It was also Pevsner's service to those of us who did not learn the correct way of understanding English culture at public school, Oxford and Cambridge. The beatnik novelist Colin MacInnes was a Pevsner aficionado on precisely these grounds. Pevsner, who 'preserved the rare and enriched dual vision of a thoroughly inside outsider',[12] was, he wrote, devoted to giving away their secrets to everyone, with wit, economy and clarity. 'A paradox,' MacInnes wrote in the 1950s, 'among so many in our society, seems to me to be the extreme difficulty, among the welter of informational media, of finding what exactly is going on: what England really is, and the lives of those therein.'[13] Pevsner was not a class warrior – after all, what attracted him to England in the first place was its quietness and conservatism – but he did believe that the mysteries of British high culture should be opened up to all, and more, that it could be understood systematically, as something with causes and consequences. For this he was not forgiven.

However, Pevsner's advocacy of 'the picturesque' was more than just a matter of education, and could lapse into something much more questionable and strange. In the posthumously unpublished *Visual Planning and the Picturesque* and in the 1955 BBC Reith Lectures published as *The Englishness of English Art*, Pevsner attempted to define the national character in a way that recalled the pseudo-science of national art that was being developed in interwar Germany by his old mentor, the art historian and fascist Wilhelm Pinder. Pevsner was also enthusiastic for the work of the Austrian art historian Dagobert Frey, who

published a book praising English art during the war, which Pevsner wrongly believed indicated an anti-Nazi temperament. Actually, Frey was a committed antisemite and fascist who was heavily involved in the looting of occupied Poland's art collections.[14] None of this makes Pevsner's attempt to uncover and explain 'Englishness' necessarily fascistic, but it does suggest that such an endeavour can lend itself to the misty categories of nationalist politics.

Ironically though, because Pevsner's definition of 'Englishness' was systematic and came from a German Jew, it was never really embraced by English conservatives. Pevsner was, as we've seen abundantly in this book, very far from alone in believing there were profound differences in visual culture and manners between Britain and Central Europe. He did not believe these were based in 'blood' or in 'soil', but he did believe they were real, and he tended to reify them into absolutes. He also believed these characteristics could lead to adaptations, and to people from one culture shifting to accommodate the other. This was exemplified by Gropius and Fry's Impington Village College, which Pevsner claimed was 'one of the best buildings of its date in England, if not the best, through its gentle scale, its use of local materials, and especially, its informal planning around an attractive, wooded landscape'. Surprised by the apparent contrast between this and the rest of the architect's oeuvre, he poses a question to himself: 'can it have been the effect of English picturesque notions on the more rigid intellect of Gropius?'[15]

'Englishness' was all about effects like the delicate brick and glass pavilions of Impington gradually revealing themselves through a screen of oak trees; it was about making the irrational rational, about planned surprise, deliberate capriciousness. It was exemplified by the English classical garden, as imagined by Capability Brown or Sir Uvedale Price, which was 'English in a number of profoundly significant ways' that, characteristically, Pevsner itemizes and lists:

> formally the winding path and the serpentine lake are the equivalent of Hogarth's Line of Beauty, that long, gentle, double curve which dominates one kind of English art from the Decorated style in architecture to William Blake and beyond.

The aim of the Picturesque, Pevsner argues, is 'pleasingly to confound'.[16] This was the opposite of the beaux-arts approach to planning, which

resulted in arid early twentieth-century ensembles such as the Mall and Kingsway in London, which for Pevsner were actually extremely un-English, however much they were devoted to a bombastic celebration of the British Empire. In *Visual Planning and the Picturesque*, Pevsner noted that Oxford and Cambridge were universally considered the most beautiful English cities, and that neither of them contained a single symmetrically planned Renaissance axis. Unlike in a Parisian or Roman ensemble, you can only understand Oxford through a complicated system of paths, not through one great single unified image, of the kind Lubetkin desperately tried to forge out of concrete panels in Finsbury and Bethnal Green. Rather, 'you have to walk through the quads of college after college, looking forward and backward, left and right, up and down as you progress, in order to perceive what must be perceived to gain the impressions which matter'.[17]

What Pevsner didn't mention was that you could not (and cannot), as a member of the public, simply 'walk through the quads of college after college'. There is somebody whose job it is to tell you not to, and you will have to consult him or her before they will let you explore the joys of the Picturesque. In an Italian university city such as Bologna the lines are straighter, but everything is public, everything can be accessed at any time of day, and there is no porter in a lodge telling you not to walk through the university without his permission. In Oxford and Cambridge, as generations of tourists have come to realize, almost all the finest architecture is actually private, and you are only allowed in on sufferance; most of what you can actually see as a pedestrian is a series of crenelated stone walls. Pevsner had celebrated English aesthetics and its difference from on the continent, and had ironically missed one of the most important things about English life: the extremely deep roots of privatized, secured space, which the majority have no legal right to enter. This is a surprising omission, as Pevsner had plenty of experience in compiling his books on *Industrial Art in England* and the series 'The Buildings of England', the physical contents of which belonged to wealthy people who did not want them to be looked at by plebs.

But the point of *The Englishness of English Art* was to democratize this carefully guarded sense of anti-despotic space. The Picturesque was the solution to an important conundrum – how to rebuild Britain's Blitzed cities, and how to plan the New Towns in a way that would make them feel like authentic examples of a local urbanism rather than,

as at an East Tilbury, a chilly import from Central Europe. 'We are in need,' Pevsner told his radio audience, 'of a policy of healthy, attractive, acceptable urban planning.' Such a thing was there, ready-made. 'There is an English national planning theory in existence which need only be recognised and developed. It is hidden in the writings of the improvers from Pope to Uvedale Price and Payne Knight', and expressed in Alexander Pope's imperative to 'consult the genius of the place in all'.[18] Pevsner saw evidence that this was exactly what had happened at the Festival of Britain, in the New Towns of Stevenage and Harlow, and in the Alton East Estate in Roehampton, south-west London, where high-rise blocks and maisonettes were placed by the LCC's Architects' Department in the rolling, winding grounds of three eighteenth-century houses. 'If English planners forget about the straight axes and the artificially symmetrical facades of the academy, and design functionally and Englishly, they will succeed,' Pevsner insists;[19] then, they will see that modernist ideas about democratizing the city, and creating spaces accessible to all, are not in fact 'outlandish', but 'thoroughly inlandish'.[20]

27

Back to the Source

Pevsner's definition of Englishness through conservatism, smallness of scale, cuteness and wilful irrationality – and his suggestion that these values should be combined with modernism – was asking for trouble. In the 1950s that trouble didn't come from a reaction from the conservative right, angry that an alien should think he has the right to define us, and that he should make a space for modernism at all, though this would come later. Rather, it came from a generation that would soon emerge, as in painting and sculpture, in open rebellion against these staid values. The opposition in modern architecture was quickly dubbed 'The New Brutalism', and although it was soon associated with hulking, sculptural concrete forms, it initially came from an equal interest in the raw concrete of Le Corbusier's later work, and the more precise, machine-made steel-and-glass classicism that the Bauhaus's final director Mies van der Rohe had developed in American exile. So there were two separate directions that architecture which resisted 'Englishness' and the picturesque might go in – one, a dramatic and formalistic concrete monumentalism, and the other, a clip-together, serene, right-angled continuation of the Bauhaus tradition.

Pevsner strongly disliked Brutalism, though he appeared fascinated as much as repelled by its dissonance, wilful ugliness and irrationality; but he had a great deal of time for the Chicago development of the Bauhaus, which was exemplified in Britain by the work of Yorke Rosenberg Mardall. 'YRM' essentially proceeded as if the Festival of Britain had never happened, and as if designing in Britain between the 1950s and 1970s was not wildly unlike designing in Czechoslovakia from the 1920s through the 1930s. We have seen that continuity already at the start of this book, in St Thomas's Hospital, which so closely resembles the Palace of Pensions in Prague from four decades earlier. YRM's three

partners each brought something specific to the firm's work. The 'Y', F. R. S. Yorke, published in the 1930s two books on *The Modern House* and *The Modern Flat*, which helped define the modern movement in Britain. He was a serial partner of émigrés – *The Modern House* was initially planned as a collaborative work with the Palace of Pensions' co-designer Josef Havlíček, and as an architect, Yorke's office was co-headed by the Hungarian *Bauhausler* Marcel Breuer, and then the German Constructivist Arthur Korn, until Yorke co-founded YRM in 1944. The 'M', Cyril Mardall, was a Finnish architect; his work, with its lightness and lovely materials, is expressed especially strongly in the small Finnish Church he designed for the firm in Rotherhithe, South London.

But the most frequent spokesperson for YRM, and the most experienced architect at the time of its formation, was the 'R', Eugene Rosenberg. Born and raised in Slovakia in 1907, he worked as an assistant for Josef Havlíček's firm with Karel Honzík on the Palace of Pensions, before striking out on his own in a series of inner-city apartment blocks in Prague, all of them exceptionally elegant, and some, such as the Štěpánská Pasáž building, featuring glittering chrome and vitrolite shopping arcades, something between Haussmann's Paris and Korda's science-fiction film *Things to Come*. The tilework that defines most of YRM's architecture comes from Rosenberg's experiences in Prague; the firm would use a standard cream ceramic tile as a module – no tile was allowed to be cut. YRM built extensively after the war – along with office blocks in Swindon and department stores in Sheffield, they were one of the major designers of the post-war British Welfare State, designing NHS hospitals in London, Derry and Hull, council housing in London and in Stevenage, a dozen or so comprehensive schools, and the complete design of the University of Warwick. Rosenberg was a great enthusiast for modern art, and at the end of his life was working on a book about public art and modern architecture, published after his death as *Architect's Choice*, where he was able to present in context his own work with Schottlander, Gabo, Feiler and many others in unifying a strictly rationalist modernism with abstract sculpture. Ultimately, YRM's work may have suggested too much that nothing had really changed after 1945 – that you could still believe, as did the Constructivists of the 1920s, in a completely rational society, which would need an architecture that was clinical, hygienic, ordered and instantly understandable.

Brutalism was much more a reaction to post-war change. According to one of its early protagonists, the architect and historian Alan Colquhoun, the movement came from various sources, positive and negative. The latter consisted of a fierce resistance to the tweeness, localism and pubbish mateyness of Townscape and the *Architectural Review* – 'the picturesqueness and whimsy that typified modern architecture in Britain in the wake of the 1951 Festival of Britain'. In the 1980s, Colquhoun retrospectively claimed the group were driven by 'a puritanical passion', wanting 'to join hands with the continental architects of the 1920s', and 'wanted nothing whatsoever to do with the Englishness of English art'.[1] The academic sources for this reaction often came from émigrés: the scholarship of Rudolf Wittkower at the Warburg; the classical teaching of the architecture school of the University of Liverpool, including its Polish School; and the teaching of Arthur Korn at the Architectural Association.

Liverpool's Polish School of Architecture, which we've already encountered through the remarkable Catholic church in Leyland, Lancashire, designed by Jerzy Faczyński and decorated by Adam Kossowski, was almost unique for being a complete transplant of an entire Central European institution into Britain. Only the Warburg, and the commercial Reimann design school in London, can really compare. The Polish School was based around the Association of Polish Architects (SARP, Stowarzyszenie Architektów Polskich), the school of architecture in the capital, Warsaw. During the 1930s, architecture in that city had oscillated between the Weimar-like social modernism of two husband-and-wife couples, the Brukalskis and the Syrkuses, and the fusions of modernism and classicism from more official architects like Bohdan Pniewski. Both trends were very much present in the Liverpool Polish School, which pioneered a then unusual fusion of high modernism and monumentality; there is little that is picturesque or cute about their vigorous, powerful buildings that were showcased in a 1945 volume of the architecture school's work. Much of it consists of imaginary projects for real sites in the bombed-out towns and city centres of Merseyside: there is a baroque futurist town hall in Crosby, a utopian New Town for Malpas in Cheshire, a glittering new precinct in Liverpool, all of it with a striking fearlessness about crossing the boundaries of good taste.[2]

Some graduates of the Polish School moved to the United States or, in some cases, returned to Communist Poland, but many stayed in Britain.

The Polish School rebuilds Merseyside.

Several of these went on to practise in the Architects' Departments that emerged in most cities, boroughs and counties after the war. Among the students was Jadwiga Piłsudska, the daughter of Józef Piłsudski, the relatively benevolent despot of the 1920s and early 1930s. She became a fighter pilot following her studies at the Liverpool Polish School, and after the war worked as an architect for the LCC. Less exalted names included Alina Zofia Bolesławicz, who developed an unusual and extremely vigorous cuboid brick architecture in partnership with her husband Noel Moffett, which resulted in intense ziggurat-like blocks for the Greater London Council such as Malabar Court in White City and Ashington House in Whitechapel. Another young student was Magda Borowiecka, who left Poland when a teenager at the end of the 1930s and enrolled at Liverpool at the age of fifteen, because she could take her exams there in Polish. She later became one of the architects of Lambeth Council under the leadership of the Communist and William Morris enthusiast Ted Hollamby. Her major monument is Southwyck House in Brixton, better known as the 'Barrier Block', a great cliff of housing with tiny windows onto Coldharbour Lane to protect against

a prospective inner-city motorway (never built); behind the 'barrier' is a long complex of flats stepping down to several rows of terraces, an audacious miniature city.[3] Borowiecka, almost shocked by her own extremism, then moved on to design attractive brick clusters in Lambeth's 1970s low-rise high-density style, like the Dunbar Dunelm Estate in West Norwood.

Traces of the Polish School can also be seen in the aggressive but also decorative modern architecture of the Polish community centres in some of the bigger cities, like POSK in West London or the Polish Millennium Centre in Digbeth, Birmingham. But the school had a powerful influence on many British architects as well, particularly Liverpool-educated designers like James Stirling, Robert Maxwell and Colin Rowe, who would go on to become major creators of the New Brutalism. Rowe, who was a student of Rudolf Wittkower and a Brutalism advocate as a critic and historian, was dazzled by the Polish School: he later remembered 'it was knowledgeable, intelligent, flamboyant', and crucially, 'nothing at all like *anything* to be found in England'. The secret of its success was very simple, that fusion of historical and ultra-modern, as SARP was 'a conservative beaux-arts academy which had become radically modified by an enthusiasm for Le Corbusier'. The Polish architects, Rowe recalled, 'all seemed to possess an inordinate capacity for reducing complicated problems to conditions of exceptional simplicity'.[4] It is this capacity, perhaps, that you can see in the British work of their Polish pupils, for example in the formidable presence of Borowiecka's Brixton Barrier Block.

If the Poles were a strange but exciting peripheral experiment on the edges of the modern movement, then Arthur Korn, another academic presence, was a direct link to what the young Alison and Peter Smithson dubbed *The Heroic Period of Modern Architecture*. And unlike Lubetkin, he was not considered to have compromised his work by deploying caryatids and carpets. Korn was born in 1891 in Breslau (now Wrocław in Poland), and was one of the earliest architects to forge the 'Neues Bauen', in a series of hard-edged private houses in the western suburbs of Berlin. He was never a prolific architect, and most of his work has been destroyed by either war or property development, including Haus Goldstein (a joint endeavour with the civil engineer Siegfried Weitzmann), the building that made his name, a kind of Constructivist villa, and a remarkably restrained and disciplined Rubber Factory in Berlin, though

a handful of his houses in Berlin and Magdeburg do still survive. He also worked as an architectural writer and journalist. Korn's major work as a writer was *Glas in Bau und als Gebrauchsgegenstand*, published in 1929, and translated four decades later into English as *Glass in Modern Architecture of the Bauhaus Period*. It is one of the pivotal architecture books of the 1920s, presenting a series of German, Dutch, Czechoslovak, Polish and Soviet glass buildings, which had no chaff, no art deco or stripped classicism to muddy the image. In his opening essay, Korn notes that glass potentially makes a wall invisible, and hence 'requires the building itself be remodelled, conceived in a revolutionary way'.[5] That revolutionary remodelling is showcased in an extended photo-essay where the dematerialized glass buildings are frequently integrated with slogans, aerials and neon advertising. This was a metropolitan and futuristic image of modern architecture extremely distant from the version of modern architecture as modern classicism that Pevsner and Gropius would try to sell to the British in the 1930s. Korn was also politically active, and an enthusiast for the Soviet Union and Soviet architecture, making several trips to the new country; he first visited the USSR in 1929, and on returning to Germany set up in Berlin a Collective for Socialist Building.

As a Jew and an active socialist, Korn was not safe in Germany after 1933, and he quickly emigrated, fleeing first to Yugoslavia. He travelled to Britain in 1934, following Gropius, but was not able to settle here until 1937, when he threw himself into the MARS Group, being one of the principal authors of its *Plan for London*, to which he brought some of the utopian energy of the impossible town plans he had come across in the Soviet Union. He built little – the only surviving building of his in Britain, to my knowledge, is a small block of London flats in Lettsom Street, Camberwell, designed in his brief partnership with F. R. S. Yorke. It is not, despite what *Glass in Modern Architecture* might lead you to expect, an example of modernist techno-flash, but a very modest three-storey block of flats with a strongly expressed concrete frame (currently, sadly, painted white) and stock-brick infill, very much the sort of laconic, slightly rough modern architecture that the Brutalists would try to create two decades later. Korn moved into one of the flats, and it was here that he was arrested in 1940 and interned. The Met were particularly disturbed to find a large map of London on Korn's wall, an artefact of his work on the MARS London Plan. Korn was interned for an unusually

long time – a year and a half. His friend Jack Pritchard, the founder of Isokon, who had got Korn a flat in the Isokon Building, remembered that 'the police were suspicious that a foreigner – a German, and much worse, a German who had travelled in Russia – should have on his wall such a detailed map of London'.[6] Yet Korn was pleased and surprised by the fact that the police were – however ignorant they might have been – polite, and did not resort to violence.

In 1923, Korn composed a manifesto for the new architecture, which cried out:

> Architecture is passionate love. Rearing. Revolving. Oppressed like us, jerking. Symbol. The flash of a fire signal. What transforms reality into a piece of art is the flash. The burning cities. The burning landscapes.[7]

After the cities actually had burned, he became, quietly, one of the most influential architects in twentieth-century Britain, because he taught the generation of architects who had the most input into the reconstruction of British cities after the destruction of the Second World War. In Korn's era, the Architectural Association became the most important of Britain's (very few) architectural schools. Its students were hired from Sheffield to Southampton to staff the new City Architects' Departments that would remodel a country which had been poorly built by the Industrial Revolution and then smashed to pieces by the Luftwaffe.

This was a task that Korn took very seriously. He firmly believed that architecture should be philosophically and theoretically driven, something which young Brutalists such as Alan Colquhoun, Kenneth Frampton and Alison and Peter Smithson took up with alacrity, rejecting the doughty empiricism of the Festival style for densely argued and intensely justified theoretical work, and reconnecting themselves with the uncompromised modern tradition that Korn in his dotage still represented. Two of his students, the architects Hugh Morris and Andrew Derbyshire – a notable Brutalist, the designer of the University of York and Sheffield's Castle Market – remembered Korn as a man driven by 'revolutionary optimism'.[8] He took a 'passionate involvement in his students' utopian projects',[9] which in the 1950s and 1960s projected increasingly dramatic forms, with cities of interlinked skyscrapers giving way to walking cities, floating cities, and other deliberately unbuildable dream-ideas. Korn, they recall, insisted 'on the design of components,

of buildings and of cities as one job, not three'.[10] The wildly ambitious projects of some of the Architectural Association students of the time who managed to get their work built, such as Jack Lynn and Ivor Smith's hilltop streets-in-the-sky at Park Hill, Sheffield, are testimony to Korn's permissiveness. However, the built results of some of these projects seem to have disappointed him. Morris and Derbyshire remember him touring the LCC's first cluster of tower blocks, at the Alton Estate in Roehampton. Korn 'exclaimed in pitying amazement to the architects – mostly ex-students of his – "You have built these chicken coops, these rabbit hutches! You?"'[11] At the end of the 1960s, the retired Korn returned to Central Europe, and died in Vienna in 1978.

Whereas Korn's presence in British townscapes is not immediately obvious to those not already in the know, this is obviously not true of Ernő Goldfinger. Along with Lubetkin, Goldfinger is the most celebrated and mythologized of the architectural émigrés of the 1930s, and has also engendered fictional portrayals of varying kinds, from the architect in the penthouse flat of J. G. Ballard's 1975 novel *High-Rise* to the supervillain Auric Goldfinger in Ian Fleming's trash novel of the same name, later a film made eternal by John Barry, Shirley Bassey and Sean Connery. The contrasts and similarities between Goldfinger and Lubetkin reveal the very different ways one could be a charismatic alien architect in mid-century Britain. Although both men were Jewish, neither was at first a refugee. Goldfinger moved to Britain because in Paris in 1931 he had met, fallen in love with and married Ursula Blackwell, the heiress of the Crosse and Blackwell condiments empire. Both architects were fellow travellers rather than members of the Communist Party of Great Britain, with Goldfinger going as far as to design the interiors of the CPGB's headquarters in King Street, Covent Garden, and a new printworks for the *Daily Worker* in Farringdon. Both had studied with Auguste Perret, the French classicist and 'constructor' who was perhaps the first architect to truly understand the properties of reinforced concrete. Both regarded themselves as 'classical' as much as modernist architects. Goldfinger even lived at different times in two different Lubetkin buildings, in a flat at Highpoint in Highgate and a bungalow in Whipsnade. However, there was significant antipathy between the two men. According to Goldfinger's son Peter, 'my father and Lubetkin didn't get on at all well together: "Lubetkin is a scoundrel", that's how he referred to him ... My father admired the Penguin Pool terrifically,

but not his domestic architecture.'[12] This has been interpreted as referring to Lubetkin's dark personal life,[13] but it's equally possible to see this as an architectural objection, with the two figures having diametrically opposed ideas about modern architecture.

Goldfinger, born in 1902, was from an affluent, German-speaking Hungarian Jewish family with roots in Galicia and Transylvania, and grew up in Budapest; as a teenager during the short-lived Soviet Republic, Goldfinger was 'on the barricades' in support of the Communists, according to his niece Marianne Goldfinger;[14] this horrified his parents, who sent him away to school in Switzerland. From 1923, Goldfinger studied in Paris at the École des Beaux-Arts. Unlike Lubetkin, Goldfinger had little involvement with German or Soviet modern architecture, and though his love of heroic geometries, skyways, skylines and flagpoles was rather Constructivist (in the late 1920s he designed an exhibition on Marx in Melnikov's Soviet Pavilion in Paris, which had by then been moved to proletarian Belleville), for the most part his modernism was French. It was shaped both by the utopian example of Le Corbusier, and by Perret's more pragmatic, on-site sense of practical building in the new industrial materials. Perret, who was from a working-class family that had been involved in the Paris Commune of 1871, asserted that concrete was a *classical* material, lending itself to a grid-like but strongly modelled architecture of articulated frames. Concrete's surfaces, if treated properly, did not need to be rendered or painted, but would, like stone, have their own qualities of changing with the light, and of ageing gracefully. This set him at odds with most modern architects, who generally rendered their concrete either in bright colours, like Bruno Taut, or in white, as in the International Style of Le Corbusier or the German architects of the Weissenhof Siedlung. Whereas many modernists used the wide spans made possible by reinforced concrete to create wing-like cantilevers and lightweight, shell-like structures, Perret believed that just because you *could* do that with concrete, didn't mean you *should*. His own architecture, as seen in his scattered buildings in Paris between the 1910s and 1930s, or the post-war reconstruction of Le Havre, are a showcase of exquisitely detailed and modelled concrete on a sober, neoclassical grid.[15] These qualities would all be followed in Goldfinger's work, and put him at a remove from most of his contemporaries.

In Paris, Goldfinger designed some interiors and a studio in Le Touquet, and was a delegate to the CIAM (Congrès International

d'Architecture Moderne), participating in the famous floating conference that created the 'Athens Charter' of modernist urbanism; but as an architect his career is almost entirely British, and English at that, with all his buildings in and around London, except for one office block in the suburbs of Birmingham and one house in Oxford. Goldfinger's 1930s buildings are few – much fewer than Lubetkin's – and surviving now there is essentially just the terrace of three houses overlooking Hampstead Heath at Willow Road, and a badly altered but still rather chic shop on Golders Green Road, originally designed for S. Weiss Lingerie. The Willow Road terrace, however, is largely still as Goldfinger and Ursula Blackwell left it when he died in 1987. It was taken over by the National Trust in the mid-1990s, and is the most complete modernist residential interior open to the public in Britain, and one of the most fascinating in Europe – but the terrace of three houses very nearly didn't get built at all. The struggle over Willow Road is the first source for Goldfinger's notoriety.

The site of the Willow Road terraces was occupied by a row of shabby cottages; in 1937, Goldfinger proposed to demolish these in order to build three terraced houses. The campaign that resulted was spearheaded by the Hampstead Heath and Old Hampstead Protection Society, led by future Tory Home Secretary Henry Brooke and allegedly supported by the upper-class journalist Ian Fleming, a local resident.[16] In their complaints about the possibility of a white-walled concrete horror being built on the slopes of the heath, it is clear that the campaigners hadn't actually looked particularly closely at the plans, which were for a house that was concrete framed, to be sure, with visible concrete pillars to the ground floor, but otherwise was rather uncontroversial – its flat roof looks similar enough to the flat, straight parapets of the average Hampstead Georgian house, and the main material you can see is brick, which is used as an infill in the concrete. The most modern element of the terrace is the fully glazed *piano nobile*, which rather gently adapts the existing traditions of North London's architecture to modernist values of spaciousness and horizontality. In this, Goldfinger was both expressing his interest in the English domestic architecture of the eighteenth century – which he regarded as a classical international style, not as a local 'vernacular' – and dissenting from modern architecture as practised in England by the émigrés and their young disciples. As the Brutalist architect H. T. Cadbury-Brown recalled when Willow Road was opened to the public by the National

Goldfinger's lair.

Trust, 'Ernő never took part in the "white architecture" of the Twenties and Thirties. For him, the differences between materials were too important to be glossed over.'[17] Red brick and concrete and glass are what you see, and what you get – no white walls, and certainly no caryatids. The white-wall architecture was, for Goldfinger, 'Kasbah architecture', a backwards-looking fantasy. 'I want to be remembered as a classical architect, not a Kasbah architect,' he asserted.[18]

At the time, the building might have looked uncompromising, something reinforced in encounters with the press by the tall, handsome and curt Goldfinger, who told one reporter in 1937 that 'I could make a lot more money if I designed neo-Tudor or Georgian abominations, but I won't.'[19] However, its design and construction actually involved a rather forgiving attitude to English traditions. This was lost on the preservationists, and it seems that Fleming and company simply assumed that a Hungarian modernist architect – and a red, to boot! – must be planning to build something shocking and strident; either that, or an assumption that aliens had no business building on Hampstead Heath in general. Fleming would take his revenge in his novel, but today Willow Road

feels an entirely comfortable part of the area, and one of those examples, so common in North London and Cambridge, of the British intelligentsia having their cake and eating it. The preserved number 2, where the Goldfingers lived, with its fabulous collection of Surrealist and Constructivist painting, its rows of Penguin books, its comfortable but not too fussy furniture, and its full-height, or rather, full-width view of the Heath, swipes all the best and least controversial elements of traditional and modern architecture; Cambridge's Kettle's Yard and a thousand Cornwall holiday homes start right here. While Willow Road may have alienated the middle classes of the 1930s, it now seems like a model, a progenitor; after all, as Peter Goldfinger, who grew up in the house, pointed out, 'in our house we had the things that later became Habitat things' already in the 1940s.[20] But the good manners of Willow Road are not wholly typical of Goldfinger's work. The architect Betty Cadbury-Brown, who later worked for him, considered that 'it was not terribly Ernő', largely because it was 'trying to fit in'.[21] He would not do this again.

The change in Goldfinger's manner can be seen in a small block of flats in an Italianate street in Regent's Park, built in 1954; as at Willow Road, the proportions are carefully calculated to match the nineteenth-century housing around, but the materials are much harsher, defined by a beautifully finished but exceptionally rugged concrete frame, with ordinary stock brick between. A series of Goldfinger's schools for the London County Council start out well-mannered in the style of Willow Road but become increasingly monumental and unsentimental, culminating in the hulking Haggerston School in Hackney; and then Goldfinger's firm was given commissions by the LCC and its successor, the GLC, for two estates in West and East London around tall tower blocks – Balfron Tower and the Brownfield Estate in Poplar, and Trellick Tower and the Cheltenham Estate in Ladbroke Grove. Both estates are detailed in beautifully wrought raw concrete, with expressive, melodramatic profiles of walkways and service towers, an image of modernism at its most exciting, strident and unforgiving, their surface drama concealing spacious, well-proportioned flats that are the best of the 1960s in Britain.

The two towers have been written about so extensively that they are now hard to recapture in their full force, so much have they appeared on T-shirts and tea towels and mugs, so often have we heard the stories of Goldfinger spending a few weeks living in Balfron and years working

in his office at the bottom of Trellick as it allegedly declined into a crime-ridden 'tower of terror'. It is also fairly well known now that after a period of being hard to let in the 1970s, Trellick has for decades been very well managed as a council block. It is an intimidating, vertiginous work of architecture, so the tenants' association suggested a simple expedient of making sure that the council installed a concierge, and only housed people in Trellick Tower who specifically wanted to live there. The rare flats that sell on the open market via Right to Buy go for £1 million plus, but most people who live there are council tenants. Balfron, always in a less attractive area hard up against the Blackwall Tunnel, was recently emptied of its council tenants and sold on the open market to private investors, in an act of sheer social cleansing.

What is worth looking at here, though, is, first, how much these modernist towers designed by émigrés really embrace the vision of Britain as an industrial country, and of London as a metropolis. They are truly urban, truly futuristic, and resemble the dream-projects of the 1920s more than most of what was actually built in that decade. This is surely why Goldfinger described Balfron as what he'd really wanted to build all his life. His long-term architectural partner James Dunnett described the towers at their nadir of public reputation in the 1980s in terms that would thrill the heart of any Constructivist at Moscow's VKhUTEMAS. 'Goldfinger's local authority housing,' Dunnett wrote, was 'informed by a romantic love of the mass, of a sense of the productive capacity of the teeming urban proletariat of an industrial city, whose very numbers the high-rise form makes visible. The raw concrete, the prominent chimneys of the boiler house, bespeak an admiration for industrial life very different from Le Corbusier's Mediterranean idyll.'[22] And, for that matter, very different from any kind of Garden City, however modernized. At the Brownfield Estate that encompasses Balfron, this is especially obvious, given the proximity of the Festival of Britain's Lansbury Estate, a picturesque, modest attempt to combine modernism and a Dickensian Georgian chumminess. At the Goldfinger estate, you get rows of hard-edged maisonettes around straightforward asphalt squares with trees but without lawns, leading to three monuments – the smaller tower of Glenkerry House, the linking walkway complex of Carradale House, and Balfron itself, all in the same rich, glinting brown concrete.

The other remarkable aspect is just how well built they are. Goldfinger,

Goldfinger builds his dream towers.

for all his interest in classical discipline and order, didn't see architecture as something visual, but as a haptic, spatial thing. As he wrote in an essay on 'The Sensation of Space', published in *Architectural Review* in 1941: 'a particle is snatched from space, rhythmically modulated by membranes dividing it from surrounding chaos: that is architecture ... you cannot see architecture, you can only be in it, as in music'.[23] Following Perret, it wasn't enough simply to offer an image of utopia and then knock it up with prefab components. You had to *construct* it, out of real materials in real space. The architectural historian Barnabas Calder's research into Balfron has shown just how much Goldfinger insisted on the highest quality of all details, day in day out. 'A draft specification for Balfron Tower contains forty-one pages of detailed instructions on the concrete',[24] with the shuttering to be supervised at every stage by the architect. Any slacking on quality would be immediately noticed and immediately condemned. While Balfron was being constructed, Goldfinger found on a site visit that 'a detail designed to carry rainwater away from the face of the wall and thus to slow down weathering had been left out by the builders'. He responded:

Both Garage entrances and the bridges near the Garage and all the bridges have this ½" drip omitted. This is a scandalous state of affairs. Draw all the group leaders' attention to it, so that this sort of thing shall not happen again.[25]

As Jacob Blacker from Goldfinger's firm later remembered, 'every little screw was detailed'. Nothing was left to chance and no cuts were possible without Goldfinger knowing about them.

At the Brownfield Estate, the positive effects of this are obvious, because only a mile or two away you have Lubetkin's Dorset Estate and Cranbrook Estate with which to compare it, built at around the same time to a similar budget. There, Skinner, Bailey and Lubetkin seem to have simply refused to own up to the extreme limits placed on their flamboyance by Bethnal Green Borough's cost yardsticks, and so put all their efforts into formal effects – staircases, axial approaches – while the actual spaces (stairwells aside) are often mean, and the materials shoddy. They have aged poorly, because they are relatively poorly built, all shabby mosaic and dirty tile, and their overwhelming sense of tragedy comes from this attempt to do Constructivist baroque on a budget. Goldfinger, however, had accepted the imposed limits, designing just with concrete and brick. Somehow, heroically, he managed to ensure that what was built was not messed about with. As he once insisted, without any false modesty: 'There are good and bad architects. I am a good architect.'[26]

Goldfinger and Lubetkin demonstrated what could and couldn't be done in the reformed capitalist welfare state that was Britain in the 1950s and 1960s, whether the government was Tory or Labour. Lubetkin's dream of total socialist transformation (to be sure, shared at the level of belief by Goldfinger) had not survived the 1940s, and his attempts to create it architecturally in conditions of austerity, and to continue it if adapted to class rule, resulted in noble failure. Goldfinger accepted the limits set upon him in his projects for the LCC, but was fanatical in ensuring that the budgets for his council flats and schools were not cut back any further than this – that they were built to the highest *possible* quality. This quality of pragmatic realism and acceptance of limits fused rather appropriately with the aggressive modernism that Goldfinger had rediscovered in the architecture of the young, giving his buildings that fearsome, minatory quality, a refusal of sentiment that can be daunting or thrilling depending on your taste.

Taste, however, can tend to detract from the more important issues of the politics of housing and the politics of construction. The debate about Balfron Tower has often been extremely unenlightening, frequently suggesting the building's original purpose – the provision of secure, spacious, well-built and modern public rented housing – is somehow obsolete. That its transformation into private luxury flats has come during a crisis of housing costs, housing supply and housing quality has escaped a few of the more obtuse observers. In reality, Balfron Tower's original purpose is *not* obsolete, given that the free market in housing is evidently not working for most working-class Londoners, and it fulfilled that purpose exceptionally well. The same cannot be said of all the building projects of the post-war era. Sometimes, a work of architecture genuinely cannot fulfil its purpose any longer, and unless listed wholly as a useless monument, it has necessarily to be destroyed. This has been the case with nearly all the British work of the Austrian-Jewish architect and furniture designer Egon Riss, which culminated during the 1950s and 1960s in a series of startling, sculptural, raw concrete towers – just as with Goldfinger's buildings. But Riss's towers were part of collieries. Every single one of them has been demolished.

In Britain, Egon Riss is best known for two pieces of furniture, designed for the dual clients of Penguin Books and Isokon – but in Austria he is better known for a series of social buildings for the healthcare service of 'Red Vienna'. Riss was born in 1901 in Silesia, in what is now Bielsko-Biała in south-western Poland; he was educated at the Technical University in the Austrian capital. In partnership with the architect Fritz Judtmann, Riss designed a series of pale, elegant, minimal and well-built structures for the city of Vienna, including the Porrhaus at the Technical University, a new Sanatorium, and the Arbeiter-Gebietskrankenkasse, the workers' sickness-benefit bank, a sleek block with a Mendelsohnian curved prow. Riss escaped the Anschluss via Prague, but his mother was unable to leave Vienna, and was killed in Auschwitz. In London, Riss was given work and a flat in the Isokon Building by the furniture entrepreneur Jack Pritchard, apparently 'in return for stoking the boilers and doing other odd jobs'.[27] Riss quickly earned Pritchard's trust designing two enduringly bizarre and delightful pieces of furniture. The Penguin Donkey was a miniature bookcase built to handle Penguin paperbacks, with niches perfectly calculated to that ideal book size developed by Hans Mardersteig from Leonardo da Vinci's notes. Its barrel-shaped

carrying body was supported on stubby little splayed legs, hence the name. It was followed by the simpler Penguin Gull, which supported the paperbacks on two curved wings, with a niche in the middle for magazines and bottles; a modified version of this was then devised just for booze, called the 'Bottleship'.

All these pieces of furniture used the lightweight plywood that Pritchard and Isokon specialized in, which was manufactured in Estonia, a country with abundant wood and that specialized in modern design. Allen Lane was enthusiastic for the idea, and gave the Donkeys free advertising inside Penguin books. Unfortunately the war, and the Soviet and then German occupations of Estonia, interrupted the products' mass production, so only fifty were ever made; the Donkeys and Gulls became cult collector's items rather than the household standard items Isokon and Penguin must have hoped for.[28] The playfulness of Riss's furniture designs, which suggested modernism could be something humorous rather than ferociously revolutionary, has guaranteed them an afterlife as much-loved icons of the 1930s and 1940s; like many icons of that period, few people alive at the time would ever have seen one. By contrast, thousands of people between the 1940s and 1980s would have seen the buildings that Riss next designed, although almost no trace of them still exists in three dimensions.

Riss was with the Pioneer Corps during the war, and then got a job as an architect at the Miners' Welfare Committee, who had built a series of pithead baths and social facilities in a moderate modernism in the 1930s. After the coal industry was nationalized, Riss became the chief architect of the Scottish section of the new National Coal Board, starting in 1949. From then on, he designed a series of 'Superpits' in the Central Belt of Lanarkshire, Ayrshire and Lothian coalfields that surrounded Glasgow and Edinburgh, such as Bilston Glen, Rothes, Monktonhall, Killoch and Seafield, opened mostly between 1949 and 1958. They were intended to showcase the clean modernity and gleaming futurism that nationalization would bring to the dirty, painful, laborious and dangerous work of coal mining. Rather than messy, straggling collections of iron and red-brick workings, the towers that housed the lifts and winding gear of the pits were centralized and planned to provide imposing vistas from the surrounding towns and countryside.

The most praised of these, Rothes Colliery, with its two enormous towers the size of ten-storey high-rise blocks, was, judging by

the photographs, one of the most remarkable pieces of architecture in twentieth-century Britain – sculptural, pure, and of astonishing scale and physicality. Riss was not a theoretical 'Brutalist' any more than Goldfinger, but his use of great expanses of raw concrete must have been an inspiration for Scottish Brutalist architects. As the historian of modernist mining architecture Gary Boyd points out, Riss 'brought a consistency of approach, design quality and aesthetic presence that was unparalleled within the British coalfields'.[29] These mines were designed to look fairly indistinguishable from a factory or office complex,[30] and at Monktonhall Colliery the name of the pit was picked out in illuminated letters at the top of a glass tower on spindly concrete legs. This was a heroic effort, but even before Margaret Thatcher's assault on the mining communities the pits were foundering. Rothes, for instance, worked out its seam with great speed, and accordingly closed as early as 1964. Most closed even before the swingeing pit-closure programmes of the 1980s and 1990s. Aside from scraps of the administration blocks

The Futurism of Coal: Egon Riss for the Coal Board in Fife.

and the fan house at Rothes, all of the buildings have been levelled – and replaced with nothing much. These buildings were designed for an aspect of British life that was expected to continue for ever – coal mining, on an island Aneurin Bevan described as being made of coal and surrounded by fish – but they lasted for barely a generation.

Goldfinger and Riss were both 'art' architects – designers who had emerged out of the avant-garde and who took their work very seriously, despite the risk of disputes with their clients. Even in the welfare-state era – perhaps for a time in the middle of the 1960s, *especially* in the welfare-state era – there were also architects who worked entirely for developers, particularly on the package deals between councils and property companies to redevelop city centres to either repair the damage of the Blitz or redress the architectural and planning shortcomings of the Industrial Revolution, or both.[31] The most prominent, and in some ways the most interesting, of these architects was only arguably from a Central European émigré background. Richard Seifert, born Reubin Seifert in 1910 to a Swiss Jewish family in Zurich, would become the architect of many of the most dramatic British skyscrapers from the post-war years. But Seifert doesn't fit any of our definitions, as he was from neutral, safe Switzerland, was not a refugee, grew up in Britain, and was regarded by all but the antisemitic fringe as a British rather than continental architect. That's not quite the case with two other 'developers' architects', Bernard Engle and Rudolf Jelinek-Karl.

The second of these is the least known, and there is no monograph on his work,[32] which was not hugely prolific but always dramatic, displaying an almost science-fictional sense of form. Jelinek-Karl was the designer of the 1939 Rosehill Court in St Helier, south-west London, a startlingly futuristic Mendelsohnian mixed-use block of flats and shops, and of a handful of post-war mini-megastructures, most notably in Bournemouth and Bristol. Jelinek-Karl was born in Switzerland in 1910 and educated in Munich; in the early 1930s, with Germany ravaged by the Depression and the rise of Nazism, he emigrated to France. There he worked for Berthold Lubetkin and Jean Ginsberg's short-lived firm, and subsequently for the Franco-Polish cinema designer Adrienne Górska, before crossing the Channel in 1936. In England, he worked as an assistant to the Canadian-born architect and designer Wells Coates, before setting up his own firm. Rosehill Court seems to have been Jelinek-Karl's first completed solo building. It consists of a central block

with a cinema and dancehall, flanked by two rows of shops and car showrooms on the ground floor with fifty-seven flats above. Rosehill Court takes up an entire street block on a protruding, peninsula-like site that juts into heavy suburban traffic at the edge of the London County Council's sprawling, leafy Arts and Crafts St Helier Estate, one of the biggest council estates of the period. As with so many modern buildings of the 1930s, the contrast between the traditional housing and a commercial modern building is accentuated by the streamlined curves and multiple levels – this is real car architecture, designed to be seen at speed – and then downplayed by the materials, here red and orange bricks of the kind that would be fairly typical in any suburban English housing estate.

The architectural style of this block, which amalgamated the styles of Erich Mendelsohn, Dutch brickwork and Hollywood, would be dropped after the war; but the pile-up of functions and the use of dramatic, speeding curves recur in Jelinek-Karl's commercial buildings of the 1960s. The Round House in Bournemouth, opened in 1969, consists of a two-part rotunda: the lower part is a multi-storey car park with a patterned concrete screen; cafés and restaurants then mark the transition to the hotel rooms. Pedestrians enter through the ground-floor lobby, with the cars above them; they take the lift and then sleep above the cars. Some rooms have views of the sea, others a view of a dual carriageway, as sadly, unlike the TV Towers of the time, the building does not actually rotate. The architecture is as cheap and banal as the congested plan is weird and interesting. The 1959 Rupert Street Car Park in Bristol is more minimal. It is the first of its kind, the earliest ramped multi-storey car park in Britain, and the architectural form is reduced simply to a series of curved concrete floors, nothing much else. It is the sort of building a hard-line 1920s modernist might have built if they had the technology, a completely unsentimental but almost accidentally sculptural work of architecture, transformed into pure form by a relentless concentration on function. It is, sadly, threatened with demolition at the time of writing.

Bernd Engel, who changed his name to Bernard Engle after the war, was more prolific and more controversial. The first shopping mall in Britain to have a truly American outer-suburban scale, the enormous concrete box of Brent Cross, was Engle's last design, completed just after his death in 1976. Engle was born into a Hamburg architectural family in 1902 – his father, Semmy Engel, was a major eclectic architect

in the port city, designer of neo-baroque tenements, neo-Biedermeier houses and neo-Byzantine synagogues. The firm shifted towards modernism when his son was made joint partner – the best surviving example is the Sophieneck residential complex, in the Hamburg suburb of Harvestehude, a building with an International Style vocabulary of large windows, white-rendered walls and gentle curves, though with a still slightly classical symmetry. On emigrating to England in 1935 after Jewish architects were barred from practising, Bernd found a job with the very traditionalist firm of Clyde Young and Partners, whose work – such as the Rudyard Kipling Memorial Buildings, at the Imperial Service College, Windsor – is modernist in neither form nor content. In some of the firm's works, modernist motifs peep out alongside Mendelsohnian curved and De Stijl brickwork, as at their two houses on Manor House Drive in Brondesbury Park, north-west London.

After the war, Engle took over the firm, and steered it towards the newly acceptable forms of modernism, and towards the developers of large mixed-use retail schemes. It is unfortunate that the firm is best known for the monolithic but bland Brent Cross, as earlier schemes are much more imaginative. Like Yorke Rosenberg Mardall, Engle often employed modern artists to add ideas to what could otherwise have been excessively cold and minimal structures. Also, unlike with Rosenberg, Engle preferred the artworks to be integrated with the architecture, rather than a free-standing response to it; so at Buxton House in Huddersfield, a tower block surmounting a retail arcade, the entrance block that demarcates the two parts features a Constructivist mosaic by Richard Fletcher, its lines and colour infill suggesting the abstraction of a modernist town plan. The most interesting example of this was at the Merseyway Centre, a multi-level outdoor mall in Stockport. Engle hired the artist Alan Boyson, who created a modular frieze across the entire retail megastructure, which made it appear as a continuous relief sculpture, and a still unique and strange object in Stockport's largely post-war skyline. This is a long way from the interwar architecture of Hamburg, but shows a continuing interest in treating architecture as a visual medium – at least, until the final disappointment of Brent Cross.

As with painters and sculptors, there are a handful of notable architects who came to Britain as children or adolescents, and were taught architecture in British schools; they made important contributions to

building, housing and planning here but without quite the same sense of bringing a pre-formed ideology and way of seeing to somewhere different, and either rolling with it or adapting to it. Among the more successful of these young refugee architects was Inette Austin-Smith, a very rare woman in the company of these frequently egomaniacal form-givers of modernism. She was born Inge Griessmann in Nuremberg in 1924, to a middle-class Jewish family that emigrated in 1936, settling in Highgate, where her father was able to start a textile business. She studied at the Architectural Association from 1942, served in the army, and was naturalized as Inette Grierson, just before marrying her fellow AA student Mike Austin-Smith. They founded an architectural partnership in 1949, which won numerous awards between the 1950s and 1980s, when the couple retired; the firm continues today as Austin-Smith:Lord.

The Austin-Smiths' designs, mostly for offices, factories and housing, were modest, attractive and optimistic examples of the social architecture of the time. Probably the project of theirs that won most public attention was the prize-winning entry to an 'Experimental Homes' competition, for a reproducible, modular and affordable middle-class house, held in 1958 by the RIBA and *Ideal Home* magazine. Beating off a dozen or so other firms, the Austin-Smiths' proposal was for a model of house that had become very successful as the International Style hit California at the end of the 1940s – low-slung, rectangular, lightweight, bright and defined by large expanses of glass. The houses were built not in Pacific Palisades but in Allesley Village in the suburbs of Coventry, and only four were ever built.[33] Perhaps the most enduring Austin-Smith project is on a similarly modest scale – the Twitten, a sheltered housing development near the centre of the New Town of Crawley. At the edge of a wan development of flats and houses that shows how the Picturesque style devolved into what critics called 'prairie planning', with endlessly winding suburban streets, large and pointless expanses of greensward, a lack of drama, presence, identity or urbanity, this is a tightly packed estate of bungalows and small flats, with good, simple materials – timber, brick. Its sequence of courtyards and enclosures feels like a realized example of one of those Lincoln's Inn-style 'precincts' that, as we'll soon see, the modernists at the LCC imagined as the future of London.

A much better-known, if much less commercially successful, figure of Inette Austin-Smith's generation was the great Glasgow modernist

architect Isi Metzstein, whose work in the firm Gillespie Kidd and Coia, mostly for the Catholic Church, was among the most interesting of the post-war period in Europe. Metzstein was born in 1928 in Berlin; his father died in 1933, and he and his four siblings were raised by their mother. In 1938, the young Isi witnessed *Kristallnacht*, later recalling that as he was walking to his school, which was attached to the local synagogue:

> some children of my class came towards me and said 'Don't go, the synagogue'. The synagogue and the school were attached to each other and the synagogue was on fire ... I didn't know why it was on fire, I just thought 'it's on fire'. So I went to look. Now I realise it was probably the most dangerous thing I've ever done in my life, but nobody paid any attention to me, and of course when I saw what was happening, I went home.

Metzstein noticed as he did so, 'the fire brigade standing by making sure that none of the non-Jewish property was on fire', and 'everybody looking at it and enjoying themselves. The non-Jews I mean. And I just went back home.'[34]

After *Kristallnacht*, Metzstein's mother placed her children on the *Kindertransport*; they were scattered around Britain, with Isi being housed with a working-class Christian family in Clydebank, a shipbuilding town outside Glasgow; he went to a local school and picked up English in, on his own account, six weeks. The schoolchildren, he remembered, 'thought it was very strange and asked me funny questions, but I was a kind of exciting newcomer'.[35] Unusually, his mother also managed to escape Nazi Germany – getting a job as kitchen staff at a country house in Dorset – and after a few years managed to reunite the family in Glasgow, where Isi took evening classes in architecture at Mackintosh's Glasgow School of Art, from which he was given an apprenticeship with Jack Coia. In the 1930s, the Scottish-Italian Coia had built up the firm Gillespie Kidd and Coia as purveyors of very mildly modernist architecture to the Catholic Church in and around Glasgow, mostly working in a faintly brick Expressionist vein. From the 1950s onwards, Coia himself took a back seat in the firm, dealing with clients but leaving the actual architecture to the young duo of Isi Metzstein and Andy MacMillan. As Gavin Stamp points out, 'it is ironic that, while the Roman Catholic hierarchy believed the architect to be

the almost mythical Coia, the designing was in fact carried out by a Jewish refugee from Berlin and a Glaswegian of Highland Presbyterian ancestry'.[36]

MacMillan and Metzstein designed around a dozen churches and nearly as many schools in the post-war years, mostly in the new council estates of Glasgow and in the New Towns then being built across the Central Belt. Accordingly, as Metzstein pointed out, when the welfare state was dismantled, the firm wasn't really able to continue, despite the fact the power of their work had gained them a few prestige commissions for Oxford and Cambridge (their last project was a conversion of a Victorian brewery into Oxford's Museum of Modern Art, in 1987). The Glasgow schools show their modernism at its most aggressive, such as the brusquely Brutalist St Francis Secondary School, in the city's East End, facing Glasgow Green. With its purple brick and grid of exposed concrete, it is hard and industrial, as Constructivistic and aggressive as any of Goldfinger's buildings, but it displays the interest in expressing the section of the building that defined much of MacMillan and Metzstein's work – the frame and layout displayed so legibly that it can be read almost like a diagram. This can also be found in the long, stark ziggurat of Cumbernauld College, in the largest of Scotland's post-war New Towns, and in the tragically derelict St Peter's Seminary in Cardross, widely considered to be the duo's best work.

It is the churches designed between the 1950s and 1970s upon which Metzstein's reputation largely rests. Mostly the product of the Second Vatican Council, they are constantly experimental, with each one completely different from the one before it, and were placed on very ordinary new housing estates. The extant church that best gives an insight into MacMillan and Metzstein's originality is probably St Bride's, built in 1962 in the New Town of East Kilbride. It is a simple brick box from a distance, but up close it has a great richness of texture, with verdigris detailing and intricate brickwork; the builders were told to lay these very Dutch-looking red bricks in any pattern they fancied, creating a sort of accidental abstract artwork across the rear facade. Windows are kept to a minimum, creating dramatic effects where the high windows cast beams of light into the concrete nave. A similar approach can be found in MacMillan and Metzstein's last major project, the complete design from start to finish of Robinson College in the suburbs of Cambridge, a long spine in the same rugged red brick, enclosing a

courtyard and a chapel with stained glass by John Piper. There is an almost monastic intensity about the way the classrooms and accommodation are crammed together along the system of pedestrian walkways. What is especially striking about Robinson College is just how *urban* it is. Many post-war Cambridge colleges, such as Churchill College a mile's walk away, are in rolling green space, pretty and almost rural: Robinson is city architecture.

Metzstein was a Scottish architect – or, as he preferred to say, a Glaswegian architect – and was trained as such. If his roots in Berlin came through, it was in this interest in the texture of a dense, properly urban city, in complete rejection of any kind of picturesqueness or Garden City quality – which is ironic given how many of MacMillan and Metzstein's buildings stand at the edges of greensward in low-density 1960s council estates. Metzstein pointed out in late life that he was 'not nostalgic about Berlin. When they hang a little label on to you at the *Kindertransport*, I object to that, a wee label saying Berlin.'[37] But as a teacher of architecture, he took his students at the Glasgow School of Art to Berlin every year for decades; though he was not, he insisted, 'going home' when doing so, but merely 'visiting'. The appeal of Berlin for him came from something that it shared with Glasgow. Both were mainly working-class industrial cities that were built in a hurry in the second half of the nineteenth century, with tall tenement blocks in rigid streets, squares and grids, bankrolled by property speculators. Both were, by the start of the twentieth century, exceptionally overcrowded, something that incidentally bred a militant working-class movement, which spilled over into mass unrest in 1918–19. From the 1920s on, both cities rebuilt themselves into a lower density – as can be seen in all those garden suburb-style estates and New Towns around Glasgow, which Metzstein had to go to on site visits from his tenement flat in urbane Hillhead.

Berlin's housing, Metzstein pointed out, 'has been a succession of contradictory ideas', with a series of reactions to those tall tenements of 'rental barracks', just as in Glasgow. Tenements 'were much better here than in Berlin housing, where the outside rim on the street was occupied by middle-class families, as you got deeper into the block it was working class and poverty-stricken people', and in response to this, 'Berliners have had a succession of experimental housing exhibitions, with every one a reversal of the previous one'. One example Metzstein

took his students to was Siemenstadt, an estate designed by Walter Gropius, Hans Scharoun and Fred Forbát at the turn of the 1930s, 'which was more or less like tenements but un-urban in a way. Unlike Glasgow, where the tenements are in a very urban structure.' The question of tenements was live in Central Scotland, as its inner cities were (and are) dominated by a typology that otherwise does not really exist in Britain: the European-style block of speculative flats facing a street, with different versions of these flats serving both an affluent middle class and a sometimes desperate proletariat – a totally different situation to English cities, where the private house dominated even in the slums.

In the period Metzstein was working as an architect, the tenement model was fiercely rejected, and to praise the housing was extremely unusual. The post-war Bruce Plan essentially advocated destroying almost all of Glasgow and starting again on Garden City lines. Although it was not implemented, the construction of much low-density housing and spaced-out point blocks in the post-war era made the new suburbs of the Scottish cities look remarkably like those of England. That the Victorian tenements are now widely praised and – in their middle-class versions especially – listed, conserved and well-maintained, is owed in part to Metzstein taking generations of students at the School of Art to Berlin, to see a city where different kinds of tenements have been the subject of seemingly endless experiments, and where density and urbanity were, by the 1980s, being celebrated rather than seen as a deviation from a suburban, single-family norm. It is this mundane Berlin architecture that interested Metzstein, and not the gesturing, dramatic, angst-ridden neo-expressionism of the city's post-1989 'memory architecture' – a genre exemplified by Daniel Libeskind's Jewish Museum, 'which I can't take, both as an architect and as a Jew born in Berlin'.[38]

Not only were Metzstein and MacMillan great enthusiasts for the tenement tradition, they were also among the first teachers and writers to reawaken interest in the great urban architectural buildings that Glasgow boasted in its years as 'second city of the empire'. These ranged from the high-Victorian classical experiments of Alexander 'Greek' Thomson to the proto-modernism of Mackintosh at the turn of the century, and one of their most urban buildings is a small shopping and office block slotted with ease into the grand Victorian grid of Buchanan Street. MacMillan even designed the House for an Art Lover in Bellahouston Park, a translation into three dimensions of an unbuilt entry

Mackintosh had sent to a competition in Vienna, which had sparked much more interest in the Hapsburg capital than he had at home. If the gradual 're-Europeanizing' of Glasgow – the recognition that it is much more a city like Berlin than a city like Birmingham or Boston – is in some ways a success, Metzstein takes some of the credit; but his own buildings for the Scottish welfare state have been poorly treated since the shift here to an Anglo-American neoliberalism. Schools and churches have been demolished, the seminary is a famous ruin, nearly all the housing Metzstein and MacMillan designed has gone, and what survives is often rickety, not helped by the fact it was not always well built. When once asked at a public talk why his buildings so often leaked, Metzstein replied, 'I think because we had to build them outside'. In the 2000s and 2010s, the general shift towards a less dismissive attitude to post-war modernism saw MacMillan and Metzstein's work exhibited, widely published, sometimes listed, and generally embraced by the urban intelligentsia of Glasgow and Edinburgh – but it was too late for much of their actually suburban work. When he and MacMillan won a RIBA award in 2008, Metzstein received it with the words, 'it would have been even better to receive this while we were still alive'. The possibility that the social programmes Metzstein designed for in the suburbs and New Towns could have been reconciled with this interest in the real urban qualities of a nineteenth-century city was never realized, and Metzstein's modernism remains now as a series of superb but usually deeply neglected buildings, facing lawns and dual carriageways.

28

The Planners and the Anti-Planners

As much as 'the architects', 'the planners' have been blamed for a great deal of offences by the keepers of Britishness. They are held responsible, sometimes even more than those other continentals in the Luftwaffe, for destroying much of Britain's historic fabric in the middle of the twentieth century. Although few planners are known to the general public by name compared to architects, the role of Central Europeans in British planning departments between the 1940s and 1970s was very significant indeed. 'Planning' was an almost universally agreed-upon solution to the poverty and immense regional inequality of 1930s Britain. A lack of planning and forethought was, plausibly, considered a major explanation for why, say, South-East England in the 1930s was arguably the richest place on earth whereas North-East England was crippled by unemployment, dereliction and industrial decline. *Almost* universally agreed upon. As we'll see when we look at some Central European plans and planners – urban planners, housing planners, planners of a welfare state, planners of infrastructure, devisers of planned economies – a counter-movement is always there, growing ever larger, which stands against 'planning' in toto. These anti-planners ranged in their positions from the political far left to the far right, but by the end of the 1970s, it was these dissenting voices that had the ear of those in power.

To find a state-of-the-art example of 'Planning' as it was seen at the highpoint of *Picture Post*'s imagined social-democratic future, we could look at a Penguin Book by Ernő Goldfinger and the journalist Edward Carter, laid out in the illustrated, large format usually used for Puffins. *The County of London Plan Explained* aimed to outline for the general reader the LCC's new plan for the reform and reconstruction of the Blitzed city, a book commissioned from the architect, urban designer and town planner Patrick Abercrombie. It's an interesting book, partly

for how it doesn't at all accord with the received idea of this plan and its adherents as anti-urban despisers of all things good and proper and English; at times, the book seems like it dissents a little from the plan itself. In its dynamic layout by Goldfinger himself, making extensive use of documentary photographs by Bill Brandt and Edith Tudor-Hart and drawings by Gordon Cullen, Carter and Goldfinger argue that 'when the LCC plans for London, it is not merely planning these things in an abstracted way *for* people, it is London's own people – through their democratic government, planning themselves'.[1] It lists four 'defects' in London – 'traffic congestion, depressed housing, inadequacy and maldistribution of open spaces, and finally, the jumble of houses and industry';[2] it advocates that, to deal with this, the boroughs should nationalize as much land as they possibly can, and should be barred from ever selling it after they have done so.

Carter and Goldfinger also caution against the notion that 'what is not Blitzed is blighted',[3] encouraging a study of – de rigueur – the Georgian heritage as a new model. Not as a style, but on the basis of the densely packed but green and attractive classical squares and quadrangles of the Inns of Court and Bloomsbury, and the 'lovely streets or squares of Bloomsbury, of Hackney, Clerkenwell, Camberwell, Marylebone', all 'built according to the rules'.[4] The result would be a city made up of compact *neighbourhood units* with full amenities, similar to the

Goldfinger illustrates the London Plan.

'fifteen-minute city' of today, in precincts of low-rise flats with communal gardens, 'where children can run about in safety, the old people sit and the younger people play their games', with, of course, 'ample space for allotments'.[5] Above all, 'the plan rejects the idea that life in the Metropolis must be bad in itself'.[6] But the density and liveliness that Goldfinger and Carter praise is sometimes belied by the drawings of the replanned city, as in a particularly bleak image of spaced-out slabs and parkways with vague green space and sports grounds yawning between them.

The London County Council was always the heartland of 'planning', the biggest and most progressive local authority in the country, and though it marginalized refugees before the war, the new modernist Architects' Department under Robert Matthew that designed the Festival Hall was much more welcoming. Among these émigrés only a few names stand out, particularly two architects who came to Britain as teenage refugees – William Jacoby, a Berliner who designed some interesting Brutalist housing estates in Lambeth, and, working in nearby Southwark, and Hans Peter 'Felix' Trenton, born Hans Tischler in 1926 in Breslau (now Wrocław), son of the Expressionist painter Heinrich Tischler.[7] Trenton was the designer of the immense Aylesbury Estate in Walworth, southeast London, probably the single most daunting example of system-built housing in the capital; it is currently part-way through demolition, though it has been rather more popular with residents than many assume.[8]

However, the most influential émigré figure in the LCC was probably the 'architect-planner' Walter Bor. Like Konrad Smigielski, a figure we'll encounter presently, Bor was part of a generation of designers whose work encompassed both building design and town planning, with major responsibility for the often very dramatic changes in British cities during the 1960s, as the long-promised war on nineteenth-century architecture was finally put into action. Bor had a long career as an architect-planner, which spanned Prague in the 1930s to Liverpool in the 1960s, Milton Keynes in the 1970s and Shenzhen in the 1990s. He was born Walter Bukbinder in Vienna in 1916, and was raised and educated in Prague, from which he fled in 1938 as the Nazis occupied much of Czechoslovakia in the aftermath of the Munich Agreement. Many of his family were killed in Auschwitz. In Prague, he had worked for the progressive firm of Otakar Novotný, responsible for the Cubist Co-Operative Houses in Prague and the International Style Manes building, on the Vltava River. But in the late 1930s, studying in London at the Bartlett School of

Architecture to obtain his British qualifications, Bor found the teachers so hostile to modernism that one of them, Howard Robertson, 'specifically forbade me to even mention Le Corbusier's name'.[9] From 1947, Bor was working for the LCC, and was made responsible for leading the groups clearing out and replanning much of the bomb-damaged slums of the East End and replacing them with the 'precincts' imagined in the County of London Plan. Of these projects, the one Bor was most attached to was St Anne's neighbourhood in Stepney, a series of very green low-rise streets and squares in the shadow of one of Nicholas Hawksmoor's baroque churches. It was Bor's LCC projects that the architectural critic Ian Nairn was referring to in 1966 when he denounced the 'soft-spoken, this-is-good-for-you castration of the East End', which had replaced the smelly but intimate old streets with 'well-designed estates that would suit a New Town but are hopelessly out of place here'.[10] At this distance, they do not look quite so bad – they are dwarfed, like much of the contemporary East End, by gimcrack new speculative towers, much more badly built and even less sympathetic to any historic scale – but they are rather vague and suburban.

During the 1950s, Bor was part of a discussion group of left-wing émigré intellectuals – including Central Europeans like the radio producer Ernst Schoen and the actors Ferdy Mayne and Herbert Lom, along with the American theatre director Sam Wanamaker – that was closely monitored by MI5.[11] Although not apparently a Communist Party member, Bor is best known for collaborating with the Communist architect-planner Graeme Shankland on a plan for Liverpool that would have wiped out great swathes of the existing city and replaced them with skyscrapers.[12] On his arrival in Britain in the late 1930s, Bor later recalled, he was shocked at how the 'infinitely balmy and sublimely peaceful' countryside of Kent was succeeded by 'a seemingly interminable repetition of the same rows of mean little two-storey terrace houses'.[13] So it is odd to read his actual texts on planning, which show a degree of nuance and sympathy that is very much at variance with his reputation as a brutal planner sweeping away the past. In 'A Question of Urban Identity', an *Architectural Review* piece illustrated by Gordon Cullen, Bor wrote one of the manifestos of the 'townscape' movement. Here he asserted that Britain's towns 'all have one great thing in common', whether university or cathedral or industrial – 'they are all unique'.[14] While there was 'an unanswerable case for adapting

the urban fabric of most of our cities to the new needs' – i.e. higher living standards, electricity, central heating, television, car ownership, full employment and all that comes with it – this was no reason to wipe out everything from the past and create a new landscape of open spaces and high blocks. Bor specifically warned against the engineering ideas that created the rather vacuous spaces of the New Towns and new estates. 'Road widenings, open car parks and major road works often have the most devastating effect upon the urban environment.'[15] But Bor accepted, as did nearly all his contemporaries, that there would have to be significant road building – how could there not be, when most people now had cars? Perhaps the flaw in Bor's LCC schemes is that they're neither one thing nor another; not lush and idyllic like real suburbs or Garden Cities, not urban and interesting enough to feel like real pieces of the metropolis. Other architect-planners had some ideas as to how to deal with this conundrum.

The most extraordinary city plans produced by a local authority in the post-war years came from Leicester – as we've seen, a Midlands city surprisingly receptive to Central European culture. Its director of planning from 1962 to 1972 was the Polish planner and writer Konrad Smigielski. In 1964, the new planning department at the Town Hall – only the second in Britain – produced the revolutionary *Leicester Traffic Plan*. This was a response to the increasing dominance of private cars in Britain's then still largely unplanned and unreconstructed cities, which had caused large-scale traffic jams and a vast quantity of traffic accidents and deaths. Since Colin Buchanan's *Traffic in Towns* report to the government a couple of years earlier, planners had grappled with the problem of how to create pedestrian-friendly, safe environments without curbing or discouraging car ownership, something that was then politically unthinkable, with massive levels of car production economically and socially intrinsic to the post-war boom. Smigielski's plan was staggeringly ambitious, so excessive that even the adoption of a small part of it would have had a galvanizing effect. It entailed a massive investment in diverse public transport, with two suspended monorail lines running much of the length of the city, and 'electric rickshaw taxis' to fill in the gaps between these; cars were banned from the city centre, but around it would be an urban motorway flanked by multi-storey car parks, with helipads.[16] This plan, argued Smigielski, made Leicester 'the first city to say "no" to the motor-car scientifically'.[17]

Smigielski in the City: the Leicester Traffic Plan.

These plans were not quite as ludicrous as they may seem today. Leicester is only a medium-sized city, but you can find elements of the public transport imagined by the plan functioning in comparable places from Wuppertal in western Germany to Chiba in Japan, Lausanne in Switzerland and Morgantown in West Virginia, though seldom all at once. But given the British state's aversion to investment in public transport outside of London, it is perhaps unsurprising the part of the plan that was actually built was in the form of the roads and car parks, and very little else. At the end of his tenure in Leicester, Smigielski was a public hate figure, confessing in 1973 that 'the public is bewildered and critical' about the changes in the city fabric. 'Elderly ladies write rude letters to me: "Why do you hate Leicester? Why are you destroying this once gracious city?"'[18] All this was deeply ironic, given that the original point of the *Leicester Traffic Plan* was to preserve as much of the city and its character as possible. Smigielski praised the 'townscape' ideas of Ian Nairn and denounced the idea of preserving 'the odd masterpiece, divorced from its context like some exhibit in a museum', preferring instead to retain 'groups and sequences of buildings'.[19] Even the apparently goofy monorail idea was chosen by Smigielski and his

team because its thin concrete viaducts could be built with the minimum of demolition around them.[20]

Wladysław Konrad Smigielski was born in Tarnów, in the then Hapsburg part of partitioned Poland, in 1908; he fought in the Polish 'Anders Army' with the British in the Middle East and Italy, and when in 1945 he had the choice of staying in Britain or returning to Communist Poland, he chose Britain and rose through the planning system in London, Leeds and then Leicester; after getting his fingers burned in the latter he worked in private practice until he died in Somerset in 1999. Smigielski was trained in architecture, in Kraków and in Warsaw; by 1939, he had become a senior planning officer in Kraków. This famously beautiful city, capital of Poland until the eighteenth century, had, very unusually for a large Polish city, survived the twentieth century basically unscathed, though Nowa Huta, an industrial New Town, was built on its edges in the Communist era. Its medieval, baroque and Austro-Hungarian centre is encircled by Planty, a park replacing the old city walls; when Ebenezer Howard visited the city in the 1910s, he told its planners that it didn't need a Garden City, as it already was one. By the interwar years Kraków had been eclipsed as a population centre by Warsaw and Łódź, and was known as a centre for Poland's sometimes overlapping, sometimes very separate Catholic and Jewish intelligentsias, with the Hapsburg tradition of cafés and boulevards still very much in place. It is perhaps somewhere a little like this that Smigielski had in mind, when he contrasted with British suburbanism the fact that:

> The inhabitants of continental cities live and work in cities, and spend their leisure time in city centres puffing politics, gossip and garlic at each other, in cafés, wine cellars and fountains, or just sitting anywhere on the piazzas and indulging in *dolce far niente*, an important function.[21]

Accordingly, one aspect of the plan that actually was carried out entailed the reconstruction of Leicester's open marketplace.

Many cities were erasing these unplanned spaces of petty commerce in the 1960s, and right up until the 1990s, when cities like Southampton demolished their covered markets, but Smigielski considered this to be the natural place where a genuinely urban life could happen in Leicester. A new market building was constructed, the open marketplace was pedestrianized, and the Haymarket Centre, a new red-brick megastructure

combining a theatre and a shopping centre by the architects Building Design Partnership, occupied one corner of the new square. This was one of the aspects of Smigielski's plan that earned him the most criticism at the time, as several (utterly mediocre) Victorian buildings were pulled down to carve out this space; he wanted to call it a 'piazza', but the city council insisted on calling it a 'forecourt'.[22] Whatever it is called, today it is one of the places that really makes Leicester stand out, a teeming and exciting space at the heart of the most racially diverse city in Britain. In the *Leicester Traffic Plan*, the refugee Smigielski praised the 'unhysterical balance' of the city, and this is still palpable on a weekend afternoon.[23]

A few things that are now standard practice in planning were pioneered by Smigielski, particularly consultation and computerization. In a striking combination of very 1960s sexism and futuristic social-democratic thinking, he made extensive use of consultation, basing his traffic plans not on simply counting cars, but by interviewing residents about where and when they drove and why. The task of carrying out the surveys was given to a hundred young women who were described in the local press as 'Smigielski's Smashers', whose information was then fed into IBM mainframe computers at Birmingham University to process the data.[24] Smigielski also protected several inner-city residential areas that other planners would have considered to be slums and razed to the ground as conservation zones. Certainly at the marketplace, history has absolved Smigielski; the same can be said about the Georgian boulevard of New Walk, where the Doric temple of that Expressionist Museum and Gallery stands, a planned space that was dilapidated and neglected when he took over, but was reshaped during his tenure into the popular pedestrian promenade it is today – albeit at the cost of a motorway being ploughed underneath one corner of it. Much of the reason why Smigielski is still remembered, and still hated, in Leicester is surely due to his personal qualities – he did not mince words, and was known for an 'outrageous arrogant manner'[25] – but it is the roadscape that really disfigures the city, depressingly given the fact it was intended as just one element in a programme of investment dominated by innovative forms of public transport. The city centre is relatively traffic-free and attractive, but around it are roads that are either bleak, suburbanizing, or dramatic but violently aggressive to the existing fabric, as in the underpasses which charge past the medieval church of St Nicholas; some of the worst parts of the inner motorway have been removed in

recent years by Smigielski's successors. 'A city without old buildings is like a man without a memory,' Smigielski argued; but as can be seen at the Haymarket Centre, he was a modernist who believed the new and the old could be made more interesting through coexistence. He was finally sacked in 1972 because of his efforts to list a Victorian building against the wishes of the council.

Smigielski next resurfaced in the public eye in 1978, again in the East Midlands, with another revolutionary plan – for a 'Self-Supporting Co-Operative Village' in the grounds of Stanford Hall, near Loughborough, in Nottinghamshire. Smigielski began this project immediately after being fired by Leicester, commissioned by the Co-Operative Society, who were then operating the Palladian Stanford Hall as a co-operative college. Smigielski intended the plan to be for an actual viable community, though by the time it was published it had, like most of his more interesting ideas, been rejected by the (local) government. But it now reads as a rather visionary document. It envisages a new village that would be solar and wind powered, would use 'salvaged building materials',[26] and whose self-selecting residents would be invited to plan and build their own housing. It would be a genuinely agricultural settlement, wholly self-sufficient in food, but selling produce outside of the co-operative. The work, in craft co-operatives, was expected to be much more fulfilling than the industrial labour the vandalism-prone youth of the 1970s were used to; 'It is not surprising,' writes Smigielski, 'that the most neurotic and strike-prone workers are those employed in the motor car industry in spite of their high wages.'[27] Evidently he had not reconciled himself with the car after his failure to defeat it in Leicester.

The plan is enlivened by Smigielski's own drawings, which include a rather surrealist one of a naked woman in a bath below a detailed diagram of a solar-powered water system, and axonometrics of beautiful ziggurat-like ecomodernist housing arranged around village greens, flanking farms. Although all the buildings he illustrated look distinctly modernist, Smigielski takes care to differentiate the co-operative village from most post-war planning. Even though modern architecture 'had its moments of glory – Le Corbusier, Mies van der Rohe and others', he asks 'Who would book a holiday in Stevenage New Town?'[28] The project's eventual failure can perhaps be traced to its essential modernity. It was not, Smigielski firmly asserted, a project for 'a pseudo-antique English revival village, where two-car urban commuters could escape from

A REFUGE REBUILT

33 Axonometric view of cluster B, showing how buildings can be fitted in between the existing trees without destroying the feeling of spaciousness of this beautiful site. Houses are grouped around a communal green with a duck pond and a nursery school. In the foreground, the animal court with workshops.

Smigielski in the Country: the Nottinghamshire Co-Operative Village.

cities and seek a peaceful life in beautiful surroundings'.[29] No, this was meant to be a real alternative model of settlement, based on a new way of seeing technology and modernity. As he writes in apocalyptic terms in the plan's introduction, of problems that sound extremely familiar at the time of writing:

> Our project expressed a certain philosophy of life which is gradually emerging out of the chaos of our mass-produced technocratic civilisation. It is a reaction against the dehumanising influence of centralised government, resulting in too many controls and bureaucracies, against ruthless exploitation of the earth's shrinking resources, against the uncontrolled pollution of air, water, cities and countryside, against the rising cost of food and the chronic energy crisis.[30]

The figure who Smigielski turns to most frequently as a source is another émigré: E. F. Schumacher, a retired planner at the National Coal Board.

Late in life he found a new audience among young radicals, who read his study of 'economics as if people mattered', *Small is Beautiful*, as a justification for their dropping out of technocratic industrial society, and for their attempt to create a new society through hundreds of similar acts of disaffiliation. Directly citing Schumacher on the alternative renewable-energy sources that would power the co-operative village, Smigielski argues that these technologies, unlike the centralized production and distribution of fossil fuels, were 'most economic on a small scale and under the direct control of a community'.[31] It is startling to recall that this was all written by a man then best known for building a load of underpasses and flyovers.

Given that the modernist émigrés are often remembered as high-technology urbanists – an image encapsulated by Bill Brandt's iconic photograph of a cigar-chomping Ernő Goldfinger in a beret and cravat, seen glowering below Balfron Tower – it is interesting that the 1970s movement towards renewable energies, small-scale settlements, and general anti-urbanism took its cue in very large part from émigré economists, planners and architects. Smigielski is still far better known as a high-modernist motorway planner in Leicester than as a pioneering ecomodernist, but the opposite is true of E. F. Schumacher, born in 1911 in Bonn, better remembered as a guru of the counter-culture than as a long-standing planner in a nationalized industry. Sharing similar views were Schumacher's close friend, the Austrian Anarchist, economist and Welsh nationalist Leopold Kohr; the architect Erwin Anton Gutkind, who went from planning Berlin housing estates to writing urban history for London's Anarchist Freedom Press, and Walter Segal, another Berliner, an anti-fascist exile who, after decades quietly designing modernist office blocks and flats, came to prominence when he devised a kit for self-building houses in South London during the 1980s. All of these people, some of whom did know each other, were united in the belief that planning and modernity did not have to mean urbanism, megastructures, density, big technology and centralization, but could create a bucolic new world of self-constructed houses, renewable technologies and verdant modern villages, controlled democratically by active local communities.

Gutkind's ideas of the 1940s are strikingly evocative of those of the post-1968 years, making him something of a missing link between the two eras. His polemical books either typically advocate big-scale planning or a more anarchic concern for local democracy and devolution.

Gutkind was born in Berlin in 1886, and worked extensively in the 1920s as a housing architect – only Bruno Taut designed more modernist housing in the Weimar Republic's *Grosstadt*. The best surviving of the many estates that Gutkind designed for the municipal Stadt und Land company is Sonnenhof, built between 1925 and 1927 in the dense working-class district of Lichtenberg. Like most Weimar-era *Siedlungen*, it is low-rise (flats, this time, rather than houses) compared with the still-surviving Wilhelmine tenements all around it, but it emphasizes linearity and collectivity in its long, geometric blocks, with a striped pattern of brick and render, in a repetitious manner that has the hammering rhythm of mass production. Gutkind fled Germany for France in 1933, and moved to London two years later, where he worked as a consultant in planning for the LCC. He designed no further buildings, and instead wrote books about regional and international planning, which had an increasingly utopian tone.

During the war, Gutkind published a series of books on 'Creative Reconstruction', which aimed to ensure that the apparent leftward shift in public life during the war was made permanent, in the fear that Britain might reconstruct as carelessly and conservatively after the Second World War as it did after the First; he developed this in the more ambitious book *Revolution of Environment*, published in 1946 as part of an International Library of Sociology and Social Reconstruction, edited by the émigré philosopher and sociologist Karl Mannheim. It links together a polemic on British urbanism with a history of urban forms from Africa to Europe to China to Russia, intended to outline how the 'corridor street' of the nineteenth century is not in fact the historical norm, a result of human nature, but in fact something very new, a total and unprecedented disaster: 'never before,' Gutkind argues, 'have men's living and working places been more unsystematically lumped together . . . Never before has an uncultured atmosphere of such brute intensity dominated the layout and architectural appearance of our towns.'[32] It is clearly written in anxiety that the opportunity for building the New Jerusalem that emerged during the war might soon disappear: 'in spite of a spate of good intentions for the building of a better world, the forces of yesterday are again coming to the forefront'.[33] On one level, Gutkind was most concerned to argue against any recrudescence of nationalism, and a fixation with 'the purely imaginary differences between races and countries'. He rejected the idea of 'reconstruction in

terms of a renascence of "traditional Britain"', and saw 'the worship of tradition' and 'traditional forms' as being 'dangerously akin to a totalitarian state of mind and a hazy mysticism'.[34] No doubt, any notion of 'the Englishness of English Art' as a principle for reconstruction would have filled Gutkind with the purest scorn.

But in terms of what he does advocate, it is a combination of large-scale planning with local democracy – 'what we need is social associations on a small scale and economic integration on a large scale'.[35] Developing the 'neighbourhood units' of the LCC Plan, Gutkind imagines them as nuclei of a direct democracy, in cities reconstructed as parks, with, dotted among them, small, self-governing communities. As with Goldfinger a few years later, the emphasis on parks rather than gardens is not accidental – public and grand, not cutesy and private; Gutkind pauses to dismiss the Garden City idea as 'sheer propaganda by "small-town folk"', but it is not altogether clear what is so different about his alternative.[36] The model he gives for the Park City is Georgian, of course, the only acceptable English reference point for so many continental modernists – Bath in particular, in the way its crescents and circuses were copied across the country. But what distinguishes Gutkind is that emphasis on planning from the bottom up, based on those small local units, and building up a metropolis from that, rather than planning it from the top down. He would soon develop this idea into the notion of dissolving the metropolis altogether, in *The Expanding Environment: The End of Cities, the Rise of Communities*, published by the East End Anarchist Freedom Press in 1953. Here he would argue that the metropolis itself was the problem, implying centralization and concentration. People would be happier, and more able to govern themselves, if cities were to gradually die off, being replaced with those democratic neighbourhood units. In the 1950s, Gutkind, evidently despairing that any of this would be achieved in Britain, left for the United States, where he taught in Philadelphia and wrote an enormous multivolume history of urban forms around the world. He died in 1968; among his American disciples was the Anarchist pioneer of 'social ecology', Murray Bookchin.

Although this subterranean train of quasi-anarchist disurbanist thought would be discovered anew by the generation of 1968, like most of the ideas of Central European modernists, it had its roots in the aftermath of the First World War. One possible starting point for the self-supporting co-operative villages or the notion that 'small is

beautiful' was the squatters' movement that became popular in Vienna in approximately 1918 to 1922. The common Central European experience of that time – the military defeat of the Central Powers, and workers' revolt in the aftermath – hit Vienna particularly hard, particularly being the imperial capital of a vast empire now reduced to being the capital of a country roughly the size of Wales, yet it was a city ten times the size of Cardiff. Supply chains were disrupted to the extent that many ordinary people were reduced to growing their own fruit and vegetables, often on allotments on the outskirts of Vienna. These allotment gardens, along with any other land unbuilt-on in the vicinity of the city, became the centre for a new form of life at the edge of the metropolis, where workers built their own homes around their peripheral plots; the builders of these shanty towns were disparagingly described as *Zigunersiedler*, or 'Gypsy Settlers'.

Perhaps surprisingly, this movement aroused great enthusiasm among the modernists of Vienna. The planner-polymath Otto Neurath, and the architects Margarete Schütte-Lihotzky, best known for creating the functionalist 'Frankfurt Kitchen' for that city's council housing programme, and that unlikely son of the soil Adolf Loos – who was appointed the head of 'Red Vienna's 'Settlement Bureau' – all imagined that something permanent could be made out of this adaptation to emergency. As one historian has written, Neurath believed that an interaction between the anarchic squatters' settlements and the powerful socialist government in the city itself could be a model for a socialism that was '"from above" and "from below" simultaneously'[37] – symbolized by a photograph of power stations, factories and allotments all clustered close together at the edges of Vienna. He edited the magazine *Der Siedler* ('The Settler'), which was aimed at the squatters, and at its height in 1922 had 40,000 subscribers; therein, Schütte-Lihotzky published several designs for simple, adaptable wooden houses that could be knocked up by squatters and could be changed over time so that they could accommodate space for gardening, and expand or retract as families grew or got smaller. By the middle of the 1920s, though, the improvement in the economic situation saw many squatters return to the city, where, waiting for them, were the super-urban giant courtyard blocks of flats being built by the city council, designed by the more conservative but also more urbane architects of the Otto Wagner School, a few of whom, such as Michael Rosenauer, we have already encountered.

The closest a few of these Viennese modernists got to building the anarchic Garden City of their dreams was in the West Midlands of England.

As we've seen, the Isotype Institute founded by Otto Neurath and Marie Neurath along with Gerd Arntz in 'Red Vienna' was about a lot more than a pretty way of designing statistics. The Institute worked extensively in Britain for the first decade after they emigrated to Britain on the eve of the Second World War, whether through appearing as a sort of character in Paul Rotha's *Land of Promise*, or in the many charts they contributed to Adprint's books, until they were reduced with the onset of the Cold War into simple composers of (very good) educational books. The original ambition was for much more than that, and in 1945, the Institute was commissioned by the city council of Bilston, a coal and steel town in the Black Country of the West Midlands, to advise on the planning of the Stowlawn Estate, a garden suburb-style council estate on the town's edges. Initial plans had been drawn up at the University of Liverpool by Charles Reilly, when the town's clerk, A. V. Williams, attended a lecture by Otto Neurath delivered to the International Friendship League, in nearby Wolverhampton, on the subject of Vienna's housing programme before 1934. Williams felt that Neurath's lecture 'made us feel that the pursuit of beauty and happiness could be achieved by the common man',[38] and aimed to capture some of this in the new estate at Bilston. For the next few months, Otto and Marie Neurath were on the town's payroll, and embarked on a research and consultation programme specifically to find out whether it was possible to design a council estate in such a way that it would make people *happier* – a daring thing to do in a town which at that point was extremely polluted, and had barely recovered from the Great Depression, with significant levels of overcrowding and poverty.[39]

The Neuraths' proposals were, for the time, remarkably sensitive and libertarian. The Isoptype Institute's planning advice included that the council 'study the existing community structure in the slums you are rehousing' and, following that, 'mix up individuals: married and unmarried, old and young. Do not create ghettos of, for example, old people who, if they are stuck altogether in flats, will feel isolated, lonely and unwanted. If you put them in with young people, they can do things like babysitting and feel useful and wanted.' Otto Neurath also made suggestions as to how to do this in practice, by making sure that flats and houses all had a mix in them of the young and old, married and

unmarried. Above all, he insisted, 'do not plan housing on a "one size fits all" basis'. Rather than, as was then popular, debating whether to have 'flats' or 'houses', planners should 'work out what sorts of houses and flats to build and who to put in them'. He offered three pointers that are still strikingly open-minded both for the time, in the emphasis on community control rather than the man in the town hall, and even more so when read today, in the world of ASBOs, estate regeneration and scares over youth crime:

> A) The percentage of truly anti-social persons in any community is so small as to be almost negligible.
>
> B) Within reasonable limits there must be the greatest possible decentralisation of administration – administration must go to the people and not vice versa (e.g. small libraries and clinics should be embedded in the estates and, as far as possible, run by the community).
>
> C) All people tend to strive to the utmost of their ability towards a higher standard of living.[40]

Otto Neurath died in December 1945, but the plans were continued by his wife Marie Neurath, who organized and designed an exhibition on the estate in the centre of Bilston so as to canvass public opinion on the plans, in the tradition of the Museum of Society and Economy that the Neuraths had run in 'Red Vienna'.

Around this point, the architect to carry out these ideas was appointed. Ella Briggs, née Baumfeld, born in Vienna in 1880, worked in the United States in the 1900s, where she married a lawyer, Walter Briggs. On returning to her home city in the 1920s, she was a comrade of Otto Neurath's in the socialist modernist circles of 'Red Vienna', where she designed the typically monumental Pestalozzi-Hof and the Ledigenheim student halls of residence, before moving to Berlin at the end of that decade, where she designed some laconic modernist flats in Templehof. Jewish and associated with the left, she unsurprisingly emigrated, escaping to London in 1935, but had great difficulty obtaining work, and was lucky not to be deported. The Stowlawn Estate at Bilston was her only major project as an architect in Britain. It is a great example of how the radical ideas of the Central European 1920s were butchered, or, more generously, translated into English, in the first post-war years.

Briggs's drawings of the Stowlawn estate show an interesting

combination of the typically English garden suburb – low density, with lots of trees – and a rectilinear geometry, with a favouring of short terraces over paired semis, which is closer to the modernist *Siedlungen* of 1920s–1930s Berlin and Frankfurt, without the slightest traces of Vienna's superblocks. The original plan consisted of seven 'village greens', surrounded by houses with a few very low-rise blocks of maisonettes, all painted white in the manner of Berlin's *Weisse Stadt*. Visiting it today – which is easy to do, as the estate is next to the Birmingham–Wolverhampton rapid tram line – the first impression is of startling normality, at least for anyone who has ever lived in a peripheral British housing estate. Space, enormous skies, the smell of cut grass, pedestrian pathways, an overpowering sense of vagueness and accident. This is a Garden City with few trees, as most of these were reserved, as in Bruno Taut's Berlin estates, for communal areas; and six of these 'village greens' were simply built on in the 1960s, with generic low-rise council housing. There are modernist traces to the houses, if you look very closely. Those porches that haven't been replaced through the 'Right to Buy' have clean, geometric lines, and there are vertical windows and little portholes mixed in with the standard suburban 'suntrap' bays. The low-rise blocks of flats mixed in with the houses have big, brick balconies, strongly emphasized.

At first, it all looks a failure in all its original ideas, until you get to the only survivor of Briggs's and the Neuraths' imagined public spaces, Lawnside Green. It is not a conventional suburban lawn but an organic, winding strip of trees, bushes and flowers, reasonably well-kept, snaking past the rows of houses. It is the only place in the Stowlawn Estate where anyone who hasn't already gone looking for it could find anything even slightly deviating from the working-class suburban norm – and I suspect it's a fun place to be when Wolverhampton Wanderers win something. But above all, what is noticeable about the Stowlawn is how much it still accords with a certain idea of 'what people want' in this country, and in that, perhaps the consultation process did what it was meant to: suburban, comfortable, and feeling a bigger distance from industry and the big city than it actually is. The Stowlawn, like a lot of English suburbia, is very multicultural in 2024, and it provides to those who rent from the council or own their home outright a good, decent house, which is more utopian today than it probably ought to be. For anyone who would expect the influence of 'Red Vienna' in Britain to

result in something excitingly urban and modern, it is more remarkable how much a very mundane, sloppy, sprawling West Midlands Englishness has simply consumed the revolutionary ideas of Vienna and Berlin.

The ironies in the libertarian socialism of the Neuraths' and Ella Briggs's plans for Bilston are particularly notable given Otto Neurath's central role as an antagonist for the theorists of what would become neoliberalism. That is, in the 'socialist calculation debate' that took place after the First World War between socialist and capitalist economists, the latter represented by the 'Austrian School' around Ludwig von Mises and Friedrich August von Hayek, the two upper-class liberals who embarked upon a rearguard action to defend a capitalist system they then regarded to be in serious danger. In spring 1919, Neurath was in the employ of the short-lived Bavarian Soviet Republic, where he was drawing up a plan for a socialized economy that would, among other things, involve the abolition of money, and the elimination of the 'free market'. For Mises and Hayek, this was not only foolish but essentially *impossible* – an economy without a free market would not have the 'spontaneous order' necessary to shift and change over time, and would become stagnant, inept and dysfunctional, something arguably borne out by the sudden expansion and equally sudden contraction of Soviet-style command economies before their collapse at the end of the 1980s. Neurath, who was, however libertarian he might have been, always a passionate believer in socialism and a planned economy, was an object of immense scorn for Hayek in his long career, and was among the many targets of his bestselling attack on socialism, *The Road to Serfdom*, published in his British exile. For a brief time in the 1940s, both Hayek and Neurath were working in Britain, and émigré economists had the ear of both political parties.

The reasons why they were all in Britain were mostly a question of happenstance and of Central European politics. By 1940, socialists such as Neurath, and left-wing economists like Michał Kalecki, Oskar Lange and Ferdynand Zweig from Poland, E. F. Schumacher from Germany, or Nicholas Kaldor, Thomas Balogh and the economic historian Karl Polanyi from Hungary, had been given jobs at the London School of Economics, one of the very few of its kind in the world; an institution that had also given a job to the radically anti-socialist Hayek, who was comfortable enough with fascism in its Catholic, Austrian guise, but not in its genocidal, fanatically anti-liberal German form,

and so refused to return home after the Anschluss. But what is also interesting is how much their work rested on an interpretation *of Britain*, based on its role as the crucible of capitalism, the place in which, first on the land and then in industry, a recognizably capitalist system first emerged, before being exported across the globe with the British Empire. Today, perhaps the most read émigré account of this emergence comes from Karl Polanyi, in his 1944 book *The Great Transformation*, which was written in the United States in the early 1940s but based on his research when living in Britain. Polanyi was a non-Marxist Hungarian socialist who had been part of the circle around György Lukács. Although never a Communist (unlike his wife, the Polish-Hungarian activist and writer Ilona Duczyńska), Polanyi reluctantly took a position in the Hungarian Soviet Republic of 1919; this meant he had to flee the subsequent White Terror, but his real political enthusiasm was for English reformist socialism, specifically 'Guild Socialism': the notion, developed in the early twentieth century by thinkers such as G. D. H. Cole, that socialism could be based on free associations of proletarian producers in co-operatives, rather than through centralized bureaucracies of planning.

Guilds, Polanyi wrote in a 1922 essay for a Hungarian émigré journal in Vienna, were 'the true bearers of urban culture in medieval and urban times. Material abundance, sophisticated crafts and genuine fraternal solidarity underpinned the flowering of the guilds of Venice, Florence, London and the Hansa, which were only broken by the "industrial revolution", i.e., mechanization'.[41] A post-capitalist society could base itself, he argued, around their revival by the trade unions, creating 'a society of workers' councils built on the elimination of competition and respect for craftsmanship'. For Polanyi, 'if the working class directs its strength not only to the conduct of wage struggles but also to winning for itself the right to a say in the administration of the factory', then the socialist revolution could be achieved without the need for the violence that attended the Soviet Republics in Hungary and in the Russian Empire. Through the rising power of the guilds, 'the capitalist's role in the factory becomes superfluous', and he simply 'withers away'.[42] This peaceful, libertarian transition to socialism is something Polanyi rather cutely thought was most possible in Britain, with its parliamentary traditions: which meant that in contrast to both Leninist socialism to the east and the imperialist capitalism pursued by the

British government, 'British socialists are more serious and responsible defendants of individual freedoms than the "liberal" "capitalism that confronts them.'[43]

Polanyi left Austria in 1933 with the rise of fascism, and moved to London, where he took a position as a teacher with the Workers' Educational Association and began researching the transition to capitalism in England during the eighteenth and early nineteenth centuries, collecting the notes that he then wrote up in American exile as *The Great Transformation*. While his anglophilia – so unusual among leftist émigrés – is often forgotten, Polanyi has experienced a revival in recent years. His work avoided the common focus at the time upon capitalism as an industrial system, so it seems less limited to the concerns of the twentieth century. His emphasis on the 'double movement' by which the free market first creates crises and then asks the state to step in to solve them describes a ubiquitous feature of the world economy since the Great Financial Crisis of 2008. And particularly, through his interest in the human consequences of liberal economics, Polanyi often seems to speak across the generations to those of us who have lived in the extreme form of free-market capitalism created by the disciples of Hayek since 1979, and seen it lay waste to the old industrial centres from Detroit to the South Wales Valleys. *The Great Transformation* was in part a study of how the world emerged out of the Great Depression, largely through abandoning the cult of 'sound money' and balanced books adhered to by Conservative and Labour parties, but his fundamental argument was one about the very creation of capitalism. For Polanyi, this was a sudden, wholly novel, wholly contingent and dangerous process, which envisaged the creation of an idealist and completely unrealizable utopia of wholly free markets.

Whereas Marx laid most emphasis on industry in the new mechanized moloch of Manchester, Polanyi's focus was on the introduction of capitalism in the English countryside – and on the way in which a series of restrictive laws on workers created for the first time in the history of the world a wholly free market in labour, with the worker treated as a commodity like any other. This shift, he argued, caused a drastic decline in rural living standards, but was even more notable for smashing to pieces the social bonds and responsibilities that held rural society together. This led on the one hand to political action by labourers themselves – the most famous example being the trade union set

up by rural workers in Tolpuddle, Dorset, for which offence they were transported to Australia in 1834 – and by the rural ruling class, terrified at the social chaos they themselves had unleashed, trying to put the genii back in the bottle by setting up a rudimentary and cruel welfare state. This began with the reforms to the 'Poor Law' at Speenhamland, a village outside Newbury in Berkshire, where a system of relief was set up to alleviate the condition of the destitute labourers.

Polanyi was absolutely insistent on the novelty of capitalism. Markets have existed throughout human history, but nobody, Adam Smith included, had ever imagined they could be a means of organizing the whole of society. By a 'market economy', Polanyi meant 'a self-regulating system of markets', that is, 'an economy directed by market prices and nothing but market prices'.[44] His study of the evidence of the late eighteenth and early nineteenth centuries led him to the conclusion that 'human society would have been annihilated but for protective countermoves which blunted the action of this self-destructive mechanism'.[45] While his account of the history of early English capitalism has been challenged from the right and from the left, there are striking parallels to the recent 'double movements' of apparently endless cycles of neoliberalization followed by state bailouts in Polanyi's account of England during the Napoleonic Wars; and with the global heating created by fossil fuels accelerating and climate-induced disasters increasing, there is a chilling resonance in his vision of untrammelled capitalism causing the 'annihilation' of human society.

Most of all, Polanyi emphasized how much the transition to capitalism was a state-directed process, created by parliamentary Acts, while the attempts to clean up its mess happened through panic and fear of revolution: 'while laissez-faire economy was the product of deliberate State action, subsequent restrictions on laissez-faire started in a spontaneous way. Laissez-faire was planned; planning was not.'[46] This was an act of historiographical trolling. The likes of Hayek and Mises argued that capitalism was the result of human nature, spontaneous and uncontrolled; for Polanyi, it was just the opposite, with capitalism being something planned and introduced by governments, but the humane attempts to deal with the degradation it created had roots in deeper traditions. This meant that social planning could be envisaged as something spontaneous and human, rather than a matter of 'intervention' through the big state.

In 1942, the Beveridge Report aimed to slay, once and for all, the English tradition of laissez-faire capitalism, embodied in the figures of 'five giants' – Ignorance, Want, Disease, Squalor and Idleness. It was produced under the name of the Liberal academic and politician who had welcomed dozens of refugee intellectuals to Britain through setting up the Academic Assistance Council. But the team of four ghostwriters who actually composed the report for William Beveridge consisted of two Central European émigrés, E. F. Schumacher and Nicholas Kaldor, and two English Keynesian economists, Joan Robinson and David Worswick.[47] Among its most genuinely revolutionary measures was the abolition of means testing, the humiliating system of inspection to ensure that the recipient of welfare was 'deserving', instituted at Speenhamland and its successors. The new system was to be universal rather than just aimed at 'the poor', funded through tax-based contributions. The newly reorganized system of unemployment benefit, rent control, state pensions and sickness benefit was intended to be a matter of rights rather than charity. It was fundamental to the creation of the National Health Service, and seemed for a time to be the foundational document for a New Britain that would leave behind it a dark, Dickensian past of ruthless calculation, massive inequality and ugliness, advancing into a bright, egalitarian, caring future society, without the need for a violent revolution.

For Hayek, all this was sentimental nonsense, both historically wrong and politically dangerous. One line of attack came in the edited anthology *Capitalism and the Historians*. This was published in 1951 as an anthology of lectures delivered to the Mont Pelerin Society, the proto-think tank that Hayek and like-minded 'neoliberal' economists established in Switzerland in the early 1950s, by which time Hayek himself had moved to the United States. In his introduction to the volume, Hayek argued that the widespread sense of working-class outrage in the early years of capitalism actually derived from a position of increased possibility, rather than from increased misery:

> What for ages had seemed a natural and inevitable situation, or even as an improvement upon the past, came to be regarded as incongruous with the opportunities which the new age appeared to offer. Economic suffering both became more conspicuous and seemed less justified, because general wealth was increasing faster than ever before.[48]

Similarly, the new landscape was actually more comfortable than the countryside from which most workers had escaped, a counter-intuitive thought for those many Central European migrants who had seen, on the train to London from Dover, a lush, rolling – but strangely depopulated – countryside be succeeded by endless rows of identical terraces:

> The aggregations of large numbers of cheap houses of industrial workers were probably more ugly than the picturesque cottages in which some of the agricultural laborers or domestic workers had lived; and they were certainly more alarming to the landowner or to the city patrician than the poor dispersed over the country had been. But for those who had moved from country to town it meant an improvement.[49]

Against Polanyi, Hayek argued that 'it is misleading to speak of "capitalism" as though this had been a new and altogether different system which suddenly came into being toward the end of the eighteenth century'.[50] 'Capitalism' was just the most developed version of a spontaneous human order, though Hayekians have never really adequately explained how, if it is intrinsic in human nature, capitalism as we know it emerged so recently in human history. Polanyi would surely have regarded much of Hayek's anthology as fairly irrelevant, given that his focus was on the degradation of rural labourers, rather than upon the new industrial towns; indeed, the process he described where labourers were forced off the land by mechanization and enclosure rested upon the same phenomenon Hayek observed – that no matter how infernal life was in the new slums and in the eighteen-hour shifts, breathing the barely breathable air in the new factories, it was still better than rural life in the green fields of southern England, which for Polanyi were the real testing ground for the new system of capitalism.

The point of the initial Hayekian polemic was to bring what he saw as the natural home of economic and political liberalism back to itself, luring it away from the influence of his fellow continentals – infected as so many of them were with the bacillus of Marxism – and back to the planning-sceptic, capitalism-friendly condition that every Central European leftist noticed at work in Britain when they spent more than a couple of weeks here during the 1930s. But in Britain itself, few were convinced by Hayek's first assault on planning and on the country's

democratic socialists. In the 1980s, he commented that 'when I was middle aged, nobody believed in the market economy, except me'.[51] There was at least one exception – Winston Churchill, who cited *The Road to Serfdom* during the 1945 election to prove that the welfare state Labour promised to build would have to be administered by 'a kind of Gestapo', which caused public outrage, and proved to be flatly inaccurate as a prediction. Clement Attlee, in turn, drew faintly xenophobic attention to Churchill's source being an Austrian, which was rather silly given one of the Beveridge Report's authors was German.[52]

The theory of the 'road to serfdom' is today – after four decades in which Hayek's admirers have maintained almost unquestioned rule at the top of financial and international institutions – of interest mainly to his disciples in economics departments and the tech industry, who seem uninterested in the total failure of Hayek's theories to avoid crises, depressions and poverty; not to mention their generally poor record in terms of democracy.[53] The 'slippery slope' theory of state planning leading to dictatorship has been surely belied by the long experience of the Scandinavian countries in being both among the most economically 'closed' and politically and socially 'open' in the world from the 1930s until the 2000s. Most likely, it was not an honest argument in the first place, given that when Hayek talked of freedom, he meant the freedom of capital, not necessarily that of human beings; he was perfectly content with dictatorship so long as it was capitalist, as could be seen by his enthusiasm for Portugal under the Salazar dictatorship, and his work for the grotesquely cruel Pinochet regime in Chile. Perhaps all of this wasn't intended as much more than propaganda – effective propaganda, given that Margaret Thatcher once slammed down a copy of his *The Constitution of Liberty* at a Conservative Party meeting in the mid-1970s, bellowing 'this is what we believe!'

But Hayek was more intelligent than this sort of pabulum might suggest. Among his touchstones were two Viennese philosophers, his cousin Ludwig Wittgenstein (to whom he was related on the gentile side of Wittgenstein's family), and his lifelong friend Karl Popper. In the interwar years, these two figures essentially founded Oxbridge philosophy as we know it – their emphasis on the hard limits to human knowledge was of great interest, given the fact that, as George Mikes had noticed, educated Englishmen found any display of knowledge to be rather vulgar. Popper was a former supporter of 'Red Vienna' who

drifted rightwards to the sceptical, pessimistic centre, while Wittgenstein's politics were a bizarre mixture of Hapsburg monarchism and passionate Communism, but their influence was crucial to Hayek's attempt to provide a philosophical justification for capitalism. What was most sophisticated and convincing – and also, most nihilistic – in Hayek's work came from their influence.

This side of Hayek is much more difficult for socialists to refute. It comprises a theory of human knowledge, and the ways in which it could never be adequately represented by any sort of plan. This assault on planning for its intrinsic, ontological inefficiency and ineptitude probably drew more intelligent people towards neoliberalism than his easily refuted apocalyptic vision of a welfare state leading to dictatorship ever did. In the 1970s in particular, when it appeared to many that welfare-state planning – with its empty, graffiti-strewn spaces, its concrete 'towers of terror', and its failure even to guarantee full employment, its original promise – had failed, Hayek's arguments became much more seductive. His target here was:

> The assumption that it is desirable to replace spontaneous processes by deliberate human control ... the Germans have a good word for it: *machtbarkeit,* which expresses the notion that you can shape events according to your wishes. That is basically wrong and becomes very clear if one understands how the human mind and the whole human civilization has developed. It has not been designed intelligently and men would have never been able to design it intelligently. Socialism is still an offspring of the erroneous conception that history can be shaped according to a pre-designed plan.[54]

This is an absurdity given that human beings are:

> constantly acting in order to adapt ourselves to factors that are unknown to us and for this purpose we can only use limited and fragmented information. To put it in a more concrete form: we work in order to serve the needs of millions of people of whom we know nothing ... this has become possible by the spontaneous evolution of a system of communications which, by means of signals, tells economic agents what to do in order to adapt to events we know very little about. The system is the market and the signals are the prices.[55]

Without the free market, many came to believe, the future would look much like Hayek's fellow Austrian Hans Peter Trenton's Aylesbury Estate: an apparently endless, homogenous concrete labyrinth, whose dissatisfied and oppressed denizens could only express their desires through random acts of violence and vandalism. This now appears to many – this writer included – as a pernicious myth that has caused immense damage to innumerable lives over the last forty years, but it is a view which held at the time a significant explanatory power. Perhaps, if one accepted Hayek's views, a trade-off was possible where slower economic growth would be accepted as part of a rejection of capitalism, but that was hardly going to be popular in the post-war years, where growth at all costs was the driver of the new-found mass affluence, and, via taxation, the main way of funding the welfare state that Kaldor and Schumacher helped create. Schumacher would come to regret his role in the creation of a state based on gigantic nationalized industries and centralized bureaucracies, and would shift towards a decentralized Anarchism, which, as *Small is Beautiful* became a bestseller, would prove

The Walkways to Serfdom? The Aylesbury Estate.

equally attractive in the 1970s to the leftist libertarians of a thousand urban communes, and to the right-wing libertarians of Silicon Valley.

A crucial attempt to square this circle came in the work of the Berlin architect Walter Segal. Born in 1907 in Berlin, he ranks among the émigré architects below only Lubetkin and Goldfinger in terms of the public affection for his work, with two streets in Honor Oak Park, south-east London – Segal Close and Walter's Way – named after him. However, his work could not have been further from the different versions of classical modernism that Lubetkin and Goldfinger went in for. For the first four of the five decades in which Segal worked as an architect in Britain, he was a relatively unknown figure. He wrote, both popular books on housing and planning and articles for the architecture press; he designed modest, unshowy modernist buildings in London; and he taught at the Architectural Association. Then suddenly, in the decade before his death in 1985, Segal became something of a guru, particularly to a New Left looking for a third way between a modernism that was seen to have gone stale and bureaucratic, and a facile, retrograde Postmodernism. What made him so important were the connections Segal made between construction, architecture, democracy and control, through his interest in using extremely simple, mass-produced wooden frames as a means for people to build their own houses, independent of both the state and the market. This method would make this carefully apolitical elderly man an Anarchist hero, and led to Labour local authorities such as Lewisham shifting, for a brief moment at the end of the 1970s and the turn of the 1980s, from concrete panel towers to modular houses built by the tenants themselves.

Segal's father Arthur was a talented Expressionist painter and a senior member of the *Novembergruppe*. Accordingly, young Walter grew up knowing the Dadaists and Constructivists of post-First World War Berlin – toys were made for him by the sculptor Hans Arp, and he counted Bruno Taut and Moholy-Nagy as family friends. Segal was, as an adolescent, surrounded by in his words 'an environment of artists, architects, writers, life-reformers, thinkers and truth-seekers, ideologues and mystics, charlatans and cranks, many of whom have left their mark on our time – and unfortunately, perhaps, continue to do so'.[56] This description came from a series of 1974 lectures, printed in the *Architectural Review*, about his memories of the Weimar greats, who were by then starting to die off. Being raised in modernism, Segal was

not particularly impressed by fame and reputation; he was specifically asked to study at the Bauhaus by Walter Gropius but wasn't interested because there was no class on architectural history; the young Segal was curious about everything, so was shocked to find that Erich Mendelsohn only read books about architecture.

Segal's real lifelong influences were not so much high modernists such as Gropius, Mies and Le Corbusier or stylists like Mendelsohn, but the pragmatic socialist architects of 1920s Germany, such as Ernst May and Bruno Taut, unpretentious modernists who mass-produced good single-family homes and low-rise flats with attractive private and public gardens. Segal saw his work as an extension of their ideal: 'equality without sameness ... a less hierarchical world in which each individual's development was encouraged', as Alice Grahame and John McKean gloss it in their recent biography.[57] Segal hit on what it was he really wanted to do early on. His study of building technology made him realize how strange it was that modern architects were designing new components for the mass-production buildings, when mass-produced building products already existed. Why not use these instead? And why not make that so simple that anyone could bolt together a modern house, without 'wet trades' or the building industry? Segal first experimented with this idea in his own La Casa Piccola, a tiny house in Ascona, Switzerland, which still stands; it was built with a wooden frame so simple that the builders were unconvinced it was even viable – 'this is like building with matchsticks!'[58] It was constructed in 1932, the year before the Segals escaped Nazi Germany. Walter worked first in Egypt and then, from 1936, in Britain. He wouldn't build anything obviously similar to this house again for another forty years.

But there are commonalities in his long career. One of them was a commitment to well-designed, non-market housing for which style was fairly irrelevant, which he argued for in his contributions to *Homes for the People*, a group-housing manifesto published by Paul Elek in 1946 with a foreword by the then Minister of Housing Aneurin Bevan; and in the subsequent *Home and Environment* (1948), where Segal drew up plans for single-family homes in terraces or separated by patios, each giving out onto a public green, an early vision of the 'low-rise, high-density' housing idea picked up by Camden and Lambeth councils in the 1960s. The other was a commitment to an architecture of structure rather than surface. This can be seen in the small series of speculative

Making *Homes for the People*, 1946.

infill blocks that Segal designed during the 1950s in upper-class areas of London, of which the best surviving example is in Ovington Square, South Kensington. Here, stucco Italianate terraces are interrupted by a brick and glass grid, with an expressed wooden frame – a quite sharp break with the idea of 'white modernism' being in the Regency classical tradition. Segal rejected early on what became the most criticized aspects of modern architecture by the 1970s – heaviness, raw concrete, gigantism, elitism – but he had no interest in historicism or 'context'. One of his rather stark infill blocks has been painted cream to make it more 'in keeping' with its surroundings, hence disguising the very structural systems Segal was keen to express. But aesthetics was never the point of modernism for Segal. His hero remained Bruno Taut, who he considered to be 'one of the noblest men and finest artists', one who 'loved equality' both in his work and his life, and who 'cared for people and less for dogmatic principles', with a basic humanity 'imbued' in the 'environments he made' in the suburbs of Berlin.[59]

The significance of the 'Segal system' he devised in the 1970s was in reversing the usual way in which social-democratic architects thought of prefabrication. Whereas they saw this as a question of designing or embracing a mass-production system and rolling it out across a large area – as seen to its greatest extent in the Aylesbury Estate – Segal realized, as he related in a 1971 lecture, that he and his generation had 'ignored the simple fact that mass production existed, and that my job was to think of assembly methods. This subtle difference eluded me for 25 years.'[60] He devised a method consisting of mass-produced components that could be bought at any branch of B&Q, made up of 'basically boards and sticks'. With these, it was possible to build a modernist, open-plan framed house with almost no building experience, and given the cheapness of the materials, for this to be done at a large scale. He published and lectured on this discovery throughout the 1970s, in the aftermath of the discovery that small was beautiful, until the idea was taken up by Lewisham Council under its director of housing, the journalist and critic Nicholas Taylor. This Labour councillor was then shifting the council's housing programme towards the idea of 'The Village in the City', the title of his book of the same name, which remains the most humane and readable of the various tracts published in the 1970s against the modernism of the 1960s.

Taylor did not roll out Segal's ideas on the same gigantic scale of the council estates of earlier decades. He didn't need to, as the population of Inner London boroughs such as Lewisham had fallen sharply, and the problem was more one of 'hard to let' estates than long waiting lists. In large part, the borough's essential housing problems had actually been solved by the turn of the 1980s, before 'Right to Buy' and the moratorium on council housing reconstructed them all over again. Taylor allocated a sloping wedge of land to the Segal system, which the septuagenarian architect worked up with great enthusiasm into what is now Walter's Way and Segal Close – a tree-filled gully of recognizably modern but rangy, rather hippy large houses, their structural systems obvious to the untrained eye, which had been built and then lived in by enthusiasts who applied to the council to do so. Segal's partner on the scheme, the South London architect Jon Broome, rolled the system out further during the 1980s and 1990s for housing and public buildings, with further examples across London, Brighton, Nottingham, Colchester, Sheffield and Powys; these include Nubia Way in Grove Park,

THE PLANNERS AND THE ANTI-PLANNERS

The People Make Homes, using the Segal System.

Lewisham, built and inhabited by a Black Power co-operative. In these, Segal and his disciples actually fulfilled the dream of 'Red Vienna's' radical fringe, of a city periphery of 'settlements' built collectively by working-class people for their own use, for their own desires, with 'The Man from the Ministry' a passive enabler rather than an overbearing bureaucrat.

Given the enormous price of land and housing in twenty-first-century Britain, more recent examples using the Segal system have been of a much more expensive, boutique nature. An idea meant for anybody and everybody has gradually become a matter of 'custom design' for well-off enthusiasts or aesthetes. The 'method' was in any case a long and intensive process that was always going to appeal mainly to a few. As Nicholas Taylor later recalled:

> The problem with self-build is that it is labour intensive, and not just for the builders; it can also be impossibly demanding for the professional staff supporting them. Each scheme is normally run as a little co-op, with meetings, meetings, meetings – every smallest detail being decided

democratically. Walter Segal was a very libertarian individual and had endless patience – except for the issue of pitched roofs. He was a child of the 1930s, a modernist, and he insisted on flat roofs! Self-build schemes with intense tenant involvement can create huge satisfaction, but are a very slow method of producing houses and are only really viable as an outrider alongside a much bigger programme of more conventional social housing.[61]

Similarly, Segal's biographers suggest that the failure is largely because one thing the architect considered essential for the system's success never happened – that is, land nationalization, which would have meant, as in Lewisham, public authorities handing ordinary people land to build on for next to nothing. Without that interaction of the public state and the self-builder – an interaction between the clichéd opposing forces of the 'bottom-up' and 'top-down' – the Segal system remains one of socialist modernism's many tantalizingly unrealized utopias, though a particularly attractive one.

This sense that history – and the return since the 1980s of a capitalism red in tooth and claw – has caught up with some of the libertarian ideas that were mooted as a corrective to the big planner-state is also hard to avoid in reading some of the works of ideologists of smallness such as E. F. Schumacher and Leopold Kohr, for all their many humane and imaginative qualities. Kohr, an Anarchist philosopher and political scientist who was born in 1909 in Oberndorf, near Salzburg in the picturesque, Alpine corner of Austria – a long way from Vienna – was the first of the pair to decisively shift away from the big state in his arguments. Schumacher credited him with the basic idea of *Small is Beautiful*; Kohr was also responsible for coining the term 'the limits to growth', which became a popular one when it was taken up by the Club of Rome for their famous early 1970s study of impending ecological disaster. Kohr was both a ferocious critic of nationalism and planning at the level of the large-scale state, and an advocate for them at the level of the small state and micro-community. He was introduced and converted to Anarchist ideas in 1937, when working as a journalist during the Spanish Civil War, where he was able to witness them actually being put into practice in the communes and co-operatives of Catalonia. With the Anschluss the next year Kohr escaped to the United States, and from there taught in Puerto Rico, before making the perhaps unusual choice in the 1960s to emigrate again, this time to Wales. Back in Britain, he and Schumacher

became friends, based on Schumacher's enthusiasm for Kohr's work, seen at its most extensive in the 1957 study *The Breakdown of Nations*.

Written in 1953 in America but not published at first due to many rejections, eventually the manuscript reached England, where it found Herbert Read. It is hard in places to decide whether *The Breakdown of Nations* is or isn't a wind-up in the style of Jonathan Swift's *A Modest Proposal*. Writing at a time in which the gigantic, reforming, planning, corporate state – whether in its Soviet, US New Deal, French Gaullist or Third World developmentalist form – was at its height, Kohr argued that it would, much as Hayek suggested, end in disaster. Not because it wasn't capitalist enough; he stayed studiously agnostic as to the relative merits of capitalism or socialism – 'contrary to the tenets of the economic theory,' Kohr argued, 'a society's system of production has in itself very little to do with its social welfare'[62] – but because it was just too big. 'If the body of a people becomes diseased with the fever of aggression, brutality, collectivism, or massive idiocy,' he writes in his dense but wryly humorous tone, 'it is not because it has fallen victim to bad leadership or mental derangement. It is because human beings, so charming as individuals or in small aggregations, have been welded into overconcentrated social units such as mobs, unions, cartels, or great powers.'[63] The thing to do, then, is deconcentrate and disaggregate them.

Kohr argued that of course the first thing to happen should be the dissolution of the giant imperialist states (and their empires) – France, Italy, Germany, the United Kingdom, the United States and the Soviet Union – but this would only be part of the solution. Using a metaphor from physics, these particles would have to be broken down yet further:

> Spain, Yugoslavia, Czechoslovakia, Rumania, and Poland would loom disproportionately large in the new set-up of nations. This means that, if left intact, they would no longer be medium but large powers. Their sub-critical mass would have become critical . . . So these must be divided too, and as a result another crop of small states appears on our new map such as Aragon, Valencia, Catalonia, Castile, Galicia, Warsaw, Bohemia, Moravia, Slovakia, Ruthenia, Slavonia, Slovenia, Croatia, Serbia, Macedonia, Transylvania, Moldavia, Wallachia, Bessarabia, and so forth.[64]

Inviting us to be scandalized by this new map of Europe, Kohr then reminds us that this is exactly what the map of Europe looked like until

the modern era, with the creation of the new centralized nation states from the French Revolution onwards; this list, he avers, is Europe in its 'natural' state. Most of these places had their own nationalist movements, as did the Scots and the Welsh in the United Kingdom, and Kohr sees these as the wave of the future. Within this, he imagines some space for a very limited federalism, on the model of the Holy Roman Empire, or its partial successor, the Hapsburg Empire, for which he shows considerable nostalgia, claiming that 'no great power complex in history has ever been created peacefully (except, perhaps, the Austro-Hungarian Empire which grew by marriage)'.[65]

This all sounds very charming, and in some cases, the nationalism he speaks for is clearly harmless, and much more so than the large-country nationalism it resists. Aside from a few burnings of second homes on the fringes of the movement, the Welsh nationalism that Kohr came to passionately espouse has never been particularly right-wing, let alone genocidal. In the twenty-first century, the major imperialist powers are mostly still around and still at it, still cruel, self-important and ready to dispense horrific violence upon the smaller nations, whether it's the United States in the Middle East, Russia in Ukraine, the Caucasus and Syria, or France in Africa. But a lot of it is fatuous. 'A small-state Europe,' Kohr writes:

> would mean the end of the devastating and pathological proportions of national hostility which can only thrive on the collectivized power mentality of large nation-states. Germans, Frenchmen, and Italians, weighed down by the perverting influence of their history of blood and gore, will always hate each other. But no Bavarian ever hated a Basque, no Burgundian a Brunswicker, no Sicilian a Hessian, no Scot a Catalan. No insult mars the history of their loose and distant relations. There would still be rivalries and jealousies, but none of the consuming hatreds so characteristic of the perpetually humourless and mentally underdeveloped big.[66]

There is a little truth in this, and the transnational solidarity of small nations that Kohr as an Austrian Jew developed with the Welsh nationalists of Plaid Cymru, of which he became an active member, is a great example of it in practice. But some small nations live next to each other. The Croats and the Serbs, the Tutsis and the Hutus, the Georgians and

the Abkhaz, the Armenians and the Azerbaijanis. Their recent history is less cute.

Similarly, Kohr argues that:

> a small-state Europe would automatically dissolve a second source of constant conflict – the problem of *minorities*. Since from a political point of view there is no limit to how small a sovereign state can be, each minority ... could be the sovereign master of its own house, talk its own language when and where it pleased, and be happy in its own fashion. Switzerland, so wise in the science and practice of government, has shown how she solved the problems of minorities by means of creating minority *states* rather than minority *rights*.[67]

But what happens when, unlike in Switzerland, you have a territory where different populations live on top of each other? When Yugoslavia was divided in the 1990s back into the little units from which it had been formed, tiny, homogeneous and wealthy Slovenia did very well out of the split. Bosnia, where Muslims, Serbs and Croats lived side by side on the same streets in Sarajevo, did not. The Swiss-style arrangement of cantons introduced to end the horrific wars of the early 1990s paused the slaughter in that country, but entrenched sectarian divisions. Kohr's theory also has nothing to say to cities such as London, Manchester, Birmingham or Leicester, where large minorities share the same spaces; the only solution it seems to offer to the problems these groups face is each one should declare its own autonomous ghetto, presumably by setting up its own state in its own corner of Lewisham. Perhaps it is missing the point to take up these objections. The penultimate chapter of *The Breakdown of Nations*, 'But Will It Be Done?', consists of one word – 'No!'[68]

Kohr can be seen to have been vindicated by the generally civic, centre-left tenor of nationalist movements in large, wealthy states over the last few decades – Quebec, Wales, Scotland, Catalonia or the Basque Country – and in the economic success and social peace of tiny democracies like Iceland, Finland, Estonia or Eire, so much in contrast to the more dysfunctional recent example of the United States, the United Kingdom or the Russian Federation. But as generations of Hayekian neoliberals have argued, large states, with their parliaments, mass trade-union movements, and tendency towards an antagonistic politics, have

also stood in the way of free-market experiments. The ideal of the anti-planners of the right has been the enterprise zone, the tiny corner of a city where the planning laws are torn up, as happened in London's Docklands in the 1980s; in authoritarian city states like Singapore or Hong Kong; and in absolute monarchies like the United Arab Emirates and Qatar. Small these all are, but they are also quite radically undemocratic.[69] Kohr died in 1994, in Gloucester. As his admirer Neal Ascherson writes, this last move to Gloucester 'turned out to be a tragic error, through no fault of Kohr's or of the loyal friend who found him a place to live there. Gloucester lacked the warmth and solidarity Kohr expected from smallness. The police stood by as local English youths, taunting him for being old, infirm and a foreigner, repeatedly wrecked his home and then destroyed the papers for his last book, provoking his final and fatal heart attack in February 1994.'[70]

Kohr's comrade in smallness, Schumacher, remains better known today. Ernst Friedrich Schumacher was born into a middle-class gentile family in Bonn in 1911; his father was an economist, and his uncle was the great city architect of Hamburg, Fritz Schumacher. Ernst studied in the United States in the early 1930s, where he learned English, and returned to Germany in 1934, where he was both shocked by Nazism and the enthusiasm for it from some of his family. He emigrated to England in 1937, and worked in the City, before being interned in 1940. After his release, he briefly worked as a farm labourer, before he was recruited by Michał Kalecki to the 'circle of reds' working in economics at Oxford. When he came to work on the Beveridge Report, Schumacher's presence on the team was noted by the right-wing press, who described him as a 'totalitarian Prussian'. Nonetheless, Schumacher decided to stay in Britain after the war, and worked as economic advisor to the new publicly owned National Coal Board from 1949 to 1970. It is tough to find a connection between this work and the proto-hippy economics he is better known for – he seems to have encouraged rationalization and mechanization the same as any other planner at a nationalized industry, though the short life of Egon Riss's 'Superpit' projects in Scotland are a great example of the sort of overcentralized, short-termist follies Schumacher later inveighed against in *Small is Beautiful*. Nonetheless, he would justify nationalization on ethical rather than economic grounds, arguing in 1959 that its aim was 'not simply to out-capitalise the capitalists', but rather 'to evolve a more democratic and dignified system of industrial administration, a

more human employment of machinery, and a more intelligent utilisation of the fruits of human ingenuity and effort'.[71]

In the 1950s, Schumacher appears to have lived something of a double life, planning the efficient extraction of coal by day and studying yoga, Buddhism and the ideas of Gurdjieff by night. He was introduced to some of this esoteric thought by the London Buddhist Centre, which was run by the fellow émigré Edward Conze, a KPD activist who emigrated to Britain, where he became a socialist journalist – co-writing two books with the left-wing Labour politician Ellen Wilkinson – before he turned to Buddhism and reinvented himself as a 'Modern Gnostic'. Schumacher was also moved by a tenure working in Burma, where he became convinced that poorer nations needed an 'intermediate technology' – not the plough or the jet engine, but 'tools', responsive, easily produced, lightweight technologies that could be symbolized well by Smigielski's wind-power, or Segal's house-kits of B&Q matchsticks. He then outed himself in a series of lectures and papers in the late 1960s, which he collected and expanded into *Small is Beautiful*. One chapter in this study of 'economics as if people mattered', which Schumacher put together in Leopold Kohr's house in Aberystwyth, is titled 'Buddhist Economics'. A Buddhist looking at the capitalist system, he argues, would find that it '[stands] the truth on its head by considering goods as more important than people and consumption as more important than creative activity', and by 'shifting the emphasis from the worker to the product of work', it entails 'a surrender to the forces of evil'. Some of Buddhist economics, it transpires, sounds a little like the Beveridge Report, with full employment part of the programme: but it would also entail a reassertion of the traditional family (as indeed happened after the widespread employment of women in factories was curbed after the war). 'The large-scale employment of women in offices or factories would be considered a sign of serious economic failure. In particular, to let mothers of young children work in factories while the children run wild would be as uneconomic in the eyes of a Buddhist economist as the employment of a skilled worker as a soldier in the eyes of a modern economist.'[72] Not quite so progressive then.

What made *Small is Beautiful* famous was Schumacher's advocacy of renewable energy, and its opposition to mass production, particularly in the Third World. Citing Gandhi, he argues that 'the poor of the world cannot be helped by mass production, only by production by the

masses'. Now safely retired from the Coal Board, he could argue clearly that 'the technology of mass production is inherently violent, ecologically damaging, self-defeating in terms of non-renewable resources, and stultifying for the human person', but the use of 'tools' and renewable energies 'is conducive to decentralisation, compatible with the laws of ecology, gentle in its use of scarce resources, and designed to serve the human person instead of making him the servant of machines'. This is, on some level, an anti-capitalist argument, something lost on Schumacher's many followers in Silicon Valley: in particular, he argued that the fixation on prices, advocated by Hayek as the measure of all things, was profoundly ethically disfiguring:

> Taking various alternative fuels, like coal, oil, wood, or water-power: the only difference between them recognized by modern economics is relative cost per equivalent unit. The cheapest is automatically the one to be preferred, as to do otherwise would be irrational and 'uneconomic'. From a Buddhist point of view, of course, this will not do; the essential difference between non-renewable fuels like coal and oil on the one hand and renewable fuels like wood and water-power on the other cannot be simply overlooked. Non-renewable goods must be used only if they are indispensable, and then only with the greatest care and the most meticulous concern for conservation. To use them heedlessly or extravagantly is an act of violence.[73]

It is easy to see why this was popular in the 1970s, as just one year after the book's publication, the 'oil shock' hit the global economy, when the OPEC countries drastically raised oil prices in the aftermath of the Yom Kippur War, causing a crash in the rich economies and effectively singlehandedly ending the long Keynesian boom. But *Small is Beautiful* has, unlike many responses to that crisis, aged well in the twenty-first century. Its relevance remains strong to this day, as we observe the spectacular failure of the world's economy to free itself from fossil fuels; this despite the fact that renewable energies are much more efficient and productive than they were in Schumacher's day, and the prospect of a large industrial economy being run on wind and solar panels is much more plausible now than in 1973.

Schumacher still wrote as a socialist of sorts, as can be seen in the chapter in *Small is Beautiful* that he devotes to the subject. He is not

interested, there, in proving the efficiency or growth potential of socialist planning as against the capitalist 'spontaneous order' – quite the reverse, in fact. Arguing on the basis of his decades as an economist at a nationalized industry, Schumacher writes that 'socialism is of interest solely for its non-economic values and the possibility it creates for the overcoming of the religion of economics. A society ruled primarily by the idolatry of *enrichissez-vous*, which celebrates millionaires as its culture heroes, can gain nothing from socialisation that could not also be gained without it.' However:

> If the purpose of nationalisation is primarily to achieve faster economic growth, higher efficiency, better planning, and so forth, there is bound to be disappointment. The idea of conducting the entire economy on the basis of private greed, as Marx well recognised, has shown an extraordinary power to transform the world.

What nationalized industry offered was the possibility of doing things differently, outside the profit motive – that is, to run a large part of the economy ethically and holistically. The apparent problems of nationalized industry, then frequently discussed, as in the case of the famously dysfunctional publicly owned car manufacturer British Leyland, are a result of a failure to understand this, and instead running the socialized firms as if they were private businesses, forcing them to compete in market terms. Because of this misunderstanding, 'nationalisation will not fulfil its function unless [socialists] recover their vision'.[74]

The slogan 'Small is Beautiful' has been dangerous to any general, total changeover from fossil-fuel energy to renewables, and from generally carbon-intensive ways of living to less destructive approaches, because it strongly suggests the transition should all happen in a series of tiny exoduses from the metropolis, from 'the grid', dropping out into self-sufficient communities disconnected from an irreparably damaged wider world. This was not necessarily its author's intention. Schumacher's emphasis on the ethics rather than economics of planning, and the potential of renewable energies, brought something quite novel to the debate on planning. But many aspects of his thought were remarkably similar to the 'common sense' of a mid-twentieth-century planner.

Among these received ideas was a great distrust of the metropolis, which Schumacher imagined being broken up into smaller units. On

urbanism, *Small is Beautiful* is in the tradition of the Garden City, and Ebenezer Howard would not have been scandalized by any of it – not least its positing of 500,000 people as the upper limit for any city to be liveable. A Garden City planner would surely have nodded along with Schumacher's denunciation of 'places like London, or Tokyo or New York', where 'the millions do not add to the city's real value but merely create enormous problems and produce human degradation'.[75] This seems misjudged, given that these are among the cities with the lowest car ownership and the highest rates of people taking public transport and walking, and with larger percentages of individuals shopping in local businesses rather than chain stores and strip malls compared with smaller cities in the same countries. Alas, Schumacher failed to anticipate the 'Bristol Pound', or the English small-town high street of chains alternating with derelict units. The ways in which the large metropolis provides shelter and solidarity for minorities that they would not necessarily find in small towns was simply not of interest to Schumacher, who was really calling for newer, better, more ecological Stevenages. In that, he fit into a long tradition of British reforming writers who favoured what the émigré urbanist Ruth Glass described as the 'clichés of urban doom', the lurid pictures of the metropolis as a crime-ridden, teeming, insanitary, ungovernable hellhole that appear to endlessly fascinate people but have very little basis in reality.

The world described by the planners and the anti-planners is not our own. The failures of Hayekian economics are by now obvious to all but the truest believers. While we might admire the way in which the likes of Lubetkin, Goldfinger, Bor or Moro put their ideas at the service of wiping out the endemic misery left by the Great Depression and the nineteenth century, they used methods – widespread demolition of structurally sound buildings, lots and lots of concrete – that are wildly wasteful of resources. However, our problems are more similar to those of the 1930s than they are to those of the 1970s. The pre-1945 world of landlordism, poor housing and laissez-faire planning has triumphantly returned. In fact, thanks in large part to that great anti-planner Hayek, we now have building regulatory systems which ensure that the overcladding of an early 1970s GLC tower block is subject to market disciplines and the price mechanism, ensuring several competitive companies bid for different components of the job and creating 'best value'. What we do *not* have is a building regulatory system which ensures that

the cladding applied through this system does not spread fire from the top to the bottom of the tower.[76] It remains hard, however, to imagine a return to the world of the planners. Materials and energy are now seen in a much more Schumacherian light as scarce, precious resources whose use brings many unintended consequences. The planners and the anti-planners loved a prophecy, but very few of them have been fulfilled.

There is only one – broadly conceived – planner from the émigré generation whose work actually seems to describe the country we live in today, though prophecy was the least of her interests. Ruth Glass, in her interest in the effects of immigration from the former British Empire, in her studies of poverty and unemployment, in her curiosity for studying cities as they actually existed, in her critiques of the anti-modernist and anti-socialist hype of the 1980s, and most famously, in her coining of the term and introduction of the concept of 'gentrification', dissented entirely from the rather circumscribed world of mid-century planning discourse. In so doing, she inadvertently predicted the cities we actually live in, with their ethnic diversity, their overheated capitalist rental and property markets, and their pockets of invaluable twentieth-century affordable public housing. Glass worked in this vein quietly and diligently from the 1930s to the 1980s, and though she founded University College London's Centre for Urban Studies, she founded no 'school' of thought.[77] Although she wrote sometimes for *The Times*, the *Guardian* and *Tribune*, she published no Penguin book, she left no archive, and has no institution, think tank or street named after her. She was not an aesthete, and she founded no cult. Not a single one of Glass's books is in print, despite the thousands of citations of her 1964 introduction to the edited anthology *London: Aspects of Change*, always cited for her (often misunderstood) coinage of gentrification rather than anything else she had to say.

All this may be because, as one of her students remembered, 'Ruth was an ornery and ungovernable person, incapable of arse-licking'; in her friend Eric Hobsbawm's words, 'she was an all-purpose ball of fire, even though what she increasingly reduced to ashes was herself'.[78] She was born Ruth Lazarus in Berlin, in 1912, into a Jewish family, and studied at Humboldt University in her home city, before escaping with the rise of Nazism to Geneva, Prague, and finally, in 1935, to London, where she studied at the LSE. Aside from two years at Columbia University, New York, at the start of the war, she lived the rest of her life in London, where, in 1942, she married the sociologist David Glass.

As a very young journalist, Ruth Lazarus was a habitué of the avant-garde café culture of Weimar Berlin, and a regular at the Romanisches Café, a favourite of Brecht, Grosz, Toller, Alfred Kerr, Billy Wilder, Irmgard Keun and Joseph Roth; according to Hobsbawm, she proudly claimed to have lost her virginity there. The distinguishing thing about Glass's urban writing – her evident love of cities, which she by no means considered to conflict with her Marxist politics – was surely forged in the extraordinary environment of Berlin at the turn of the 1930s. Her earliest surviving study is of her home town, published in 1932, when she was twenty, a precocious piece of reportage on the 'Rejected Generation' of disaffected youth that was thrown up by the mass unemployment of the Great Depression; it begins by describing a demonstration by Communist schoolchildren through the streets of the proletarian district of Neukölln, and proceeds through a wild and terrifying demi-monde, of unemployed gangs drifting through the metropolis, an *M* world where bands of gangsters joined the SA and the Nazi Party en bloc, in which youths have essentially dropped out of society.[79]

Although the apocalyptic tone is something she would later disavow, the interest in and sympathy with demonized minorities is there from the start. However, Glass regarded as essentially foolish most of the other questions raised habitually by urban planning. Planning, she argued near the end of her life, was 'beset by 'the frequent recurrence and remarkable tenacity of false images, derived from mechanistic modes of thinking', meaning the endless repetition of 'various perennial questions, arising from a useless search for universally valid formulae', such as:

> What is the optimum size of cities? What rate of urbanisation is 'good'? And which one is 'bad'? What is the exact 'mix' of social classes in urban neighbourhoods that would bring about 'social harmony'? What percentage of ethnic minorities in the total population is too high? And so on.

Glass made it her life's work to fight against this sort of guff, 'at home or abroad, with different audiences – including students, colleagues and passengers on the Clapham omnibus'.[80]

In Britain, this meant moving away from the tradition of problem literature and the emphasis on returning the population to some earlier prelapsarian state, and to stop dreaming up societies 'subsisting on

a rural or crafts economy, broken up into a series of small-scale, self-contained, self-disciplined communities, where everyone stayed in their allotted place'.[81] Instead, urban studies should involve actually studying what existed and trying to understand it. Glass was enormously struck, as so many of her refugee contemporaries were, by the fact that 'in Britain, the most urbanised country in the world, we know so little about our contemporary towns – not least, it seems, because here they have not yet been accepted'.[82] The reason for this lack of acceptance, she argued, was the false image of dysfunction and horror that was shared by social reformers, the tabloid press and the upper classes – by 'picturing the city as a soul-less, frigid, menacing aggregate of people and buildings', 'the diversity of habitat and society hidden behind these images has rarely been explored'.[83] That is what Glass set out to do, with objects of her early studies ranging from the north-eastern steel and chemical town of Middlesbrough to a suburban estate in Hendon and the Lansbury Estate in Poplar; and she worked extensively on India and the Caribbean (her interest in post-imperial migration went both ways). But it is her work on the British inner city that is best known.

Her first major study was of Middlesbrough, the industrial boom town that emerged out of almost nothing in the late nineteenth century, but which by the 1940s was increasingly derelict. Glass found the town rather interesting, and writes about it with a Berliner's eye for urban and industrial spectacle, and for class conflict:

> Instead of growing around a castle or a cathedral, it has grown around coke-ovens and blast-furnaces. The founders of the great combines have been its Lords of the Manor. The scenery is marred by weird and giant industrial structures. The sky is obscured by the twin blasts of flame and smoke which emanate from industrial processes... its very bleakness and impetuousness has a vigorous beauty of its own. Battles have been and are fought here.[84]

She also noted that Middlesbrough was a town of immigrants, with its industrial workforce taken from Norfolk, Poland and the Baltic States, and with a large Catholic population. Although Glass was not, as was customary, appalled by 'Boro', she was not out to praise nineteenth-century capitalism through its example. Her book on the study, *The Social Background of a Plan*, is full of abundant evidence both that

industrial capitalism had made many people's lives in the town exceptionally miserable, and also that the scattered attempts to reform it, in the garden suburb-style council estates around the town, had improved ordinary people's health and their educational prospects markedly. For Glass, the problem with Middlesbrough's housing and planning was not that it was ugly or visually uncoordinated or stylistically retardataire – all this was irrelevant. She didn't believe the town needed 'neighbourhood units', a notion she dismissed as early as 1948 – what it needed was to be considered as a whole, not as a series of villages. The problem bequeathed by '19th century laissez faire', which she described as 'the one common cause' of Middlesbrough's ills, was in the way it reproduced the inequalities of class in space. The town was extremely divided by class, with an industrial north around the Tees and the railway, and a suburban south, where the town's small middle class lived.[85] The two classes were divided rather than unified by the city's Albert

Ruth Glass's maps: Middlesbrough.
Black spots show people wanting to be rehoused.

Park, the pride of its Victorian municipal improvers. If approached as a cosmetic, aesthetic exercise, rather than a social, democratic process, Glass argued, planning could separate as much as unify.

Although *The Social Background of a Plan* is by far the easiest book of Glass's to obtain, due to a 1998 reprint, the text that gets the citations is 'London: Aspects of Change', published in 1964 as her introduction to an edited anthology of the same name. It is one of the finest pieces of writing ever published on the city, with a rare attention to its sheer complexity and diversity, though without any sentimentality about any kind of 'ballet of the street'; unlike her much less interesting contemporary Jane Jacobs, Glass was highly attuned to class, race and capital, which is one reason her work is now considerably less dated. On one level Glass's study is, like Jacobs' *The Death and Life of Great American Cities*, very much a text of the 1960s, a vivid picture of the swinging city capturing its optimism, affluence and activity, but it sees way beyond this bubbling surface. First, Glass noted the failure of the New Towns to really decentralize – as opposed to depopulate – London. Its population had declined sharply after the war and was still in freefall at the time of writing, but jobs in Central London had increased over the same time, causing bottlenecks in public transport and traffic jams at rush hour. There was less ostentatious cultural difference and snobbery, and 'the new homes of working-class and lower-middle-class people', built by the local authorities, were 'frequently superior in design and appearance to the older "luxury flats"' (as indeed they are to the 'luxury flats' of recent years).[86] Glass noted that council housing had spread even to the affluent districts of the West End. But there had been no marked increase in real social mobility between classes, aside from some 're-shuffling of social groups' within the middle class.[87]

But then, given that the post-war rent controls and restrictions on speculation had been relaxed in the 1950s, 'laissez faire has played a part also', through the entirely unpredicted transformation of 'many of the working class quarters of London', which have 'been invaded by the middle classes'. Mews for horses and cottages for servants became expensive private houses, and Victorian houses that had degenerated into bedsits were upgraded into middle-class flats. This could be seen in 'the poorer enclaves of Hampstead and Chelsea', and in Islington, Paddington, Battersea – and even in 'the "shady" parts of Notting Hill', an area then best known outside London for the racist riots of 1958. 'Once

this process of "gentrification" starts in a district,' Glass the unwilling prophet insists, 'it goes on rapidly until all or most of the original working-class occupiers are displaced, and the whole social character of the district is changed.'[88] And beneath this affluent surface could be found still-extant old slums and 'tense zones of transition', dominated by unscrupulous landlords, housing:

> a motley collection of people – long-established Londoners and newcomers; Europeans and Asians; the Irish, the West Indians, the Poles; families of 'respectable' manual and clerical workers; students; delinquents and prostitutes. All of them have one thing in common: their housing needs are being exploited.

It was a world she encapsulated with a (self-translated) verse from Brecht's *Threepenny Opera*, about 'those who are in darkness' and those 'others in the light'. Much about post-war London is now deeply unfamiliar, but this is not. Then, as now, 'it is in such districts that the many sub-cultures of London come together', but they can now be found in Catford, Woolwich, Forest Gate, Wembley or Croydon rather than in the original 'inner city'.[89]

Migration, which Glass wrote about in her 1960 book *The Newcomers: The West Indian Migrants*, was something she regarded as a positive development, not 'a problem' – unsurprisingly so, as she herself was a migrant, a refugee. But she was fully aware that 'minorities have often been notoriously frigid to each other'. Noting that 'German middle-class Jews were super-Germans', and that 'middle class minorities have often been the most patriotic, the most loyal subjects of their parent society', Glass was unusual among her generation of Central European migrants in refusing to accept the status of being a 'Good Immigrant', standing instead in solidarity with the post-Windrush newcomers.[90] Glass knew that 'coloured' migration in Britain was by no means new. In a footnote to 'London: Aspects of Change', she reminded readers that the Notting Hill and Nottingham riots of 1958, directed at recently arrived Caribbean workers, were less violent than those that had been directed against the minorities of Cardiff and Liverpool in the aftermath of the First World War, which were reprised again in some areas after the Second. Glass's work on migration was just as concerned with dispelling clichés and myths as that on urbanism more generally.

She did not just focus on the most obvious aspects of racism – the slurs, the violent attacks in the street – but on the more polite, bourgeois versions of it, such as rejections for jobs and housing. In *The Newcomers*, she called this 'a profusion of benevolent prejudice which is so much taken for granted in English society that hardly anyone' – except the migrant – 'finds it objectionable at all'.[91]

The Newcomers, which was quickly republished in the United States (as *London's Newcomers*), combined patient statistical work with argument and anecdote to impressive effect. The book established that, no, most Caribbean immigrants were skilled workers, they preferred if possible to bring their families, they were not 'taking people's jobs' and, even less, their council housing, and they were not creating 'ghettos' or 'coloured quarters'. Although a lot of the detail is necessarily dated, it is still a powerful book. Glass's eye for the built landscape of London leads to a particularly vivid sense of the city's 'transition zones'. Areas like Notting Hill and Brixton were favoured by West Indian migrants

Ruth Glass's maps: London. West Indian settlement in London, 1960.

because they couldn't get 'good' housing in affluent or gentrifying areas, or in districts of East and South-East London dominated by council housing; what they could get was subdivided housing originally 'built mainly in the late 19th century for the large households of the middle-middle classes', which have 'been left to deteriorate also because they are so clumsy and ugly', with the oddly sized rooms and basements hard to convert into desirable luxury flats: though they could be rented out at brutally exploitative rates by the slum landlords who bought them up to let them to the 'newcomers'.[92]

Glass keeps her ear to the ground throughout, and it is things heard on the bus or the street that stay with you, comments and turns of phrase that reveal every bit as much as the patiently assembled statistics. After the 1958 riots, she spoke to a West Indian man in Notting Hill, who confidently asserted that he'd never been menaced by white people: 'at this, several West Indians standing nearby laughed derisively. One said: "He walks around with a placard saying 'I'm not to be touched by kind permission of the High Commissioner.'"'[93] On a bus in Paddington, Glass recounts a white office cleaner informing the (black and white) passengers and the (black) conductor that it isn't right that people beat up West Indian immigrants, treat them terribly and 'call them names'. 'And she then,' writes Glass, 'delivered her final line: "I know they ain't human, but we needn't be cruel to them."'[94]

Glass carried her analysis of the British capital further in 'The Mood of London' of 1973, in which she dismissed all the fears of what was happening to the capital at the time, abundantly attested in novels, studies and think-tank reports. 'Inner London', the feared 'inner city', she wrote:

> is not on the way to becoming 'Americanized': it is not on the way to becoming mainly a working-class city, a 'polarized' city, or a vast ghetto for a black proletariat. The real risk for inner London is that it might well be 'gentrified' with a vengeance, and be almost exclusively reserved for selected higher-class strata.

This she considered to be 'a patent social injustice', and one that would moreover mean a city 'not so paradoxically, seriously impoverished in many respects', a city 'deprived of the vigorous working class culture', with 'a very small component of children and old people', meaning that 'inner London [could] no longer claim to be the capital of Britain'.[95]

This – in her original list of Notting Hill and Battersea, Islington and Paddington, and now stretching even to the once ungentrifiable likes of Stoke Newington or the Elephant & Castle – is precisely what has happened, everywhere in Travelcard zones one and two except for the surviving enclaves of council housing. But at the time, it seems that while intellectuals clamoured around Leopold Kohr and E. F. Schumacher on the left or Friedrich Hayek on the right – with their visions of self-built windmill co-operatives or thriving spontaneous market utopias – nobody was listening to Ruth Glass.

It is unsurprising, then, that a tone of intense anger suffuses the introduction that Glass wrote to her work in 1989, as she put together an anthology that was published the year before she died. Social engineers have not disappeared, but they have moved on. 'No longer,' she notes, are they 'preoccupied with visions of the happy "mingling" of social classes in neat neighbourhood units, garden cities and new towns – the erstwhile pride of British planning.' Instead, they write tracts on the inevitable failure of all planned utopias, and celebrate the spectacular demolition of high-rise council housing. In the late 1980s:

> What is left of British land-use 'planning' [so-called] is mainly a series of demolition exercises. The dramatic assaults on the tower blocks are part of a general scheme to turn social objectives upside down in all fields of social policy, not least in housing. We are being brainwashed. A society that had been justifiably proud of the quantity and quality of its public housing sector was ordered to turn praise into condemnation almost overnight, and henceforth to embrace the official Thatcherite view that public housing was sickly, slummy, sinister: the work of the devil; peopled by the zombies of the welfare state.[96]

For sure, there were flaws in the long history of council housing – she points to the placing of young families in high-rises as an example – but 'bigness' was absolutely not one of them. In fact, it is one of the reasons why it worked in the first place. The sheer scale of council housing meant that, for the first time, affordable housing became a right, not a form of charity apportioned by the likes of the Peabody Trust. Moreover, it was 'a case where quality and quantity were intertwined'. When there was a local housing shortage or a rise in rents in the private market in an area of a city – as when an area came to be 'gentrified' – the local

authority could step in and build non-market housing. And because there was such a large quantity of council housing being built, 'tenants had the chance to move, and to exchange dwellings, when their domestic circumstances or their jobs changed', say from a childless couple's one-bedroom flat to a family house, from a family house to sheltered housing for the elderly, and so forth. 'By contrast, a small-scale public housing sector, consisting of the remnants of previous tenants who have not yet become owner-occupiers, is bound to be a pathetic cripple – a caricature of its former self',[97] and something far closer to the means-tested trickle of public housing available in the United States.

In 1989, Glass predicted that the memories of the actual successes of public housing policy 'might well be revived again when there has been more experience of the inevitable disappointments of privatisation'.[98] So it has proven, with the wave of public affection for the work of the likes of Goldfinger, Lubetkin and the LCC architects, with even Stevenage receiving a Historic England guidebook a couple of years ago so that, contra Smigielski, some people have now surely gone there for at least a day's holiday. But ultimately, Glass was pessimistic at the end. She hoped, as always, for a working-class revolt, but as she knew from seeing Berlin and London in the 1930s, the poverty caused by economic depressions – such as had been inflicted on industrial Britain in the 1980s – does not lead to revolution. On the contrary, it leads to despair, 'political indifference and apathy'.[99] Again, the world she describes is ours. Ruth Glass continued at UCL until 1988, but in smaller and smaller premises, with her Centre for Urban Studies frequently barged out by pushier departments. Michael Edwards recalls that, in 1970, it was Richard Llewelyn-Davies – the old partner of Peter Moro, and now the planner of Milton Keynes, with Walter Bor in the firm of Llewelyn-Davies, Weeks, Forestier-Walker and Bor – who took over the large room Glass had used for the Centre. He then 'converted it into his own office – with a white shaggy carpet, multiple layers of floor-to-ceiling white curtains and a room off for his secretary and the fridge for the smoked salmon, chablis and so on. Maybe a few Barcelona chairs. No books.'[100]

In this defeat, though, it is useful to remember that, in 1960, Ruth Glass had ended her study of *The Newcomers* with a note of optimism. Immigration into Britain was not, for her, a 'problem' to be anxious about and to try to 'solve', but could be something positive: a post-imperial experiment in expanding human possibility and solidarity. She

imagines a historian fifty years hence writing about the immigration into Britain from its former colonies during the 1950s and 1960s, and considers that they might actually find something much more positive than any observers at the time might have expected. This future historian might well write that the 'arrival and growth' of immigrants in the post-war years actually 'gave British society an opportunity of recognising its own blind spots, and also of looking beyond its own nose to a widening horizon of human integrity'.[101] Despite all the setbacks, violence and discrimination that have undoubtedly occurred, this is, broadly, what most British historians, and more importantly, most British people would conclude today, sixty-four years later. Only a minority would wish Britain to return to the overwhelmingly ethnically homogeneous country in which Ruth Glass arrived during the 1930s, in order to escape the 'master race' in the country where she was born.

Conclusion
Weimar-on-Thames

I sit by the roadside
The driver changes the wheel.
I do not like the place I have come from.
I do not like the place I am going to.
Why with impatience do I
Watch him changing the wheel?

>Bertolt Brecht, 'Changing the Wheel',
>from *Buckow Elegies* (1953),
>translated by Michael Hamburger[1]

29
Threepenny Operas

The fate of the Central European émigré artist or intellectual in Britain is tough to generalize about. Giants of modernism like Tschichold or Moholy-Nagy had very different experiences; abstractionists struggled, and figurative artists like Peri or Charoux briefly thrived before becoming desperately unfashionable. The syntheses of the knighted Gombrich and Pevsner; the eventual cult status of avant-gardists like Schwitters or Lubetkin; the disappointment and disillusion of Communists like Heartfield or Klopfleisch; the celebrated but questionable thought of Hayek or Kohr or the ignored but highly prescient ideas of Glass – these individuals may have all started in a similar place, but where they ended up was a matter of politics, time and location. Some of these émigrés successfully took a modernist gospel from Berlin, Vienna, Prague, Budapest or Warsaw to Britain and were listened to, taken seriously and followed; others adapted to London's more traditionalist scene, or weren't particularly experimental thinkers to start with. Any assessment of their legacies will shift according to the concerns of the time – the reputation of Goldfinger or Polanyi is much higher now than it could possibly have been in 1979, that of Hayek or Popper much lower. But there were more ways in which interwar modernist culture from Central Europe could become popular in Britain than through the model of the gospel coming to north-west London and Cornwall. An excursus into one particularly dramatic example can show how much the émigrés could actually be *peripheral* to the ways in which some of the more stringent forms of modernism spread into British life after 1945.

Today, most of the art, architecture, photography and film created in and around the Weimar Republic is much better known in Britain a hundred years later than it was at the time. Although the Polish, Hungarian, Czech and Slovak contribution is still poorly understood here,

a person with a few arts A-Levels, a regular cinema-or-gig-goer, will generally have some awareness of Dada, Brecht and the Bauhaus. They might well have seen *M*, *Metropolis* or *The Cabinet of Dr Caligari*. They might go to an exhibition of Kandinsky or Schwitters paintings at the Tate; they would recognize 'Mack the Knife' and maybe even 'What Keeps Mankind Alive' and 'Pirate Jenny' from *The Threepenny Opera*; and they might well go for a day trip to the De La Warr Pavilion, and recognize it as a German modernist building; they might recognize El Lissitzky's designs or Mondrian's abstractions as something much more than pattern-making. It is highly unlikely that someone comparably educated in Britain in 1935 would have known any of these things unless, like Auden, Spender and Isherwood, they had lived in Berlin or Vienna. How this expansion of knowledge happened, though, owes less to the émigrés themselves than we might assume.

Nowhere is this more obvious than in the writer who gives us the title of this book, surely the most influential Weimar figure in Britain who never settled here; someone arguably much more important in post-war British culture than most of those who did. That is, Bertolt Brecht. The story of Brecht himself in Britain can be told in just a few sentences. He lived in London twice after he fled Germany in 1933, staying for a few months on each occasion. In 1934, he stayed just off the Gray's Inn Road with the Marxist philosopher Karl Korsch; he returned in 1936, living in Abbey Road, not far from 'Finchleystrasse'. On the first visit, he pitched a film to Alexander Korda about a Hungarian scientist and was unceremoniously rejected; on the second, he worked on polishing dialogue for Karl Grune's film *Pagliacci*. In London he wrote two 'English Sonnets', one of them a great poem on the old Caledonian Market. But that's about it.[1] Brecht failed to gain work or a visa, and returned to the peripatetic life that brought him across Europe, from Berlin to Prague, to Denmark, Sweden, Finland, the Soviet Union, and then to Los Angeles. Brecht was spurned by British establishment culture during the 1930s and 1940s, whether staffed by émigrés or otherwise. And yet, he had an incalculably catalyzing effect on film, TV and pop music in the 1970s and 1980s. In Brecht's example, we can find how this cultural transfer from Weimar Berlin to Punk London worked not just in spite of, but in some cases actively *against*, the influence of the emigration.

This is perhaps logical, given that Brecht was the Weimar Republic's great Anglophile. He returned and returned to a set of – largely

pre-Victorian – English sources throughout his career. He adapted Shakespeare (*Coriolanus*) and Webster (*The Duchess of Malfi*); the musical drama that made his career, *The Threepenny Opera*, was a very loose adaptation of John Gay's *The Beggar's Opera*; his cynical, bone-dry early poetry, collected in tough little volumes like the 1926 *Handbook for City Dwellers*, was inspired above all by Rudyard Kipling's *Barrack-Room Ballads*. The writer's diaries reveal that in his exile Brecht was constantly to be found reading the English poetry and prose of the seventeenth, eighteenth and early nineteenth century: Boswell, Wordsworth, Shelley and, constantly, Shakespeare. In 1940, reading Macaulay's *Life and Writings of Addison*, Brecht wrote in his diary, written always in lower-case: 'the english are to be envied for their literature which has a real history and a real continuity, because a national life existed and the bourgeoisie came to power at an early stage', whereas 'the germans do not have any literature as yet, if one looks closely', the field dominated by 'one or two tall, spindly champions' like Goethe.[2] The same year, reading a debate between Matthew Arnold and the classical scholar F. W. Newman on translating Homer, he exclaims: 'again and again: what a literature these English have!'[3]

This comes somewhat from the particular kind of intellectual Brecht was – hard-scrabble, disciplined, blunt, populist but deeply theoretical. What Brecht loved in English literature was a combination of the intellectual and the brutish. The English writers Brecht admired were not 'politically sound' – particularly not his lifelong favourite, Kipling – but they all had an interest in political life, and worked in the marketplace, not in the university. The writers of the eighteenth and nineteenth century shared a distrust of high-flown theory, and lacked the grandiloquent bullshit that Brecht lamented in German literature. The great English writers combined philosophy, economics and physicality – their characters constantly, it seemed, debating, eating, fucking, shitting; they were exponents of what Brecht called *Plumpes Denken*, a term usually approximately translated as 'crude thinking'. Brecht was uninterested in originality, and his plays were practically all adaptations, as were Shakespeare's; he preferred to work in close collaboration with others, and believed Shakespeare did the same. It is unsurprising that in Brecht's Hollywood exile the one collaborator who he most respected was the great Yorkshireman and actor Charles Laughton, the star of Alexander Korda's *The Private Life of Henry VIII*; the second, American version

that Laughton and Brecht produced of *The Life of Galileo* was given by its author the respectful title of *Laughton's Galileo*. Laughton was exactly the kind of figure Brecht most admired, heavily physical and deeply intelligent, a massive embodiment of *Plumpes Denken*.

But right until the late 1950s, nobody much in Britain knew who Brecht was. Within a few years of its 1927 premiere, *The Threepenny Opera* travelled to Paris, Prague, Moscow, Shanghai and Tokyo, but was noticed only by *The Times'* Berlin correspondent as an eccentric and inaccurate adaptation of John Gay. While Auden and Isherwood privately acknowledged their debts to Brecht's plays and poetry, he was seldom translated in the 1930s and 1940s; if he was performed then, it was usually in German, in the events put on by the FDKB, the Free German League of Culture. Unsurprisingly, the first book on Brecht in English was by an émigré, the Budapest-born, Vienna-raised dramaturge and radio producer Martin Esslin, who fled Vienna with the Anschluss in 1938 and helped bring much of the modern drama that London had ignored with him, making him a highly influential critic during the 1950s. Esslin's *Brecht: A Choice of Evils* (1959) acknowledged Brecht's talents as a poet and playwright but took a firm, Cold War line on his political aesthetics. In Esslin's view, Brecht aimed to communicate with the workers but his work's ambiguities could only in the end appeal to intellectuals; his innovations didn't work insofar as audiences had emotional rather than intellectual reactions to the plays; and his politics were eventually absurd, rooted in the apparently ridiculous idea that capitalism was an inherently unstable system that would endlessly reproduce crisis and poverty. Esslin's assessment was probably shared with many other 'Finchleystrasse' émigrés – a good writer with silly politics, impossibly distant from the affluent, quiet life of post-war Britain. Although something like this remains middle-class common sense, as you can read in the broadsheet reviews of any new Brecht production, a lower-brow Brecht started to emerge beneath the surface of British culture.

In the 1950s a few young, largely Communist dramatists and actors became aware of the work of the Berliner Ensemble, the theatre company Brecht formed after returning to (East) Berlin. The enthusiasm of people like the theatre director Joan Littlewood and her former husband, the folk singer-songwriter and labour activist Ewan MacColl, eventually led to the Ensemble playing in London. Later in the same decade, this leftist influence fused with the global reach of Marc Blitzstein's

hugely successful Broadway production of *The Threepenny Opera*, in which Lotte Lenya reprised her role from twenty-five years earlier (via which Louis Armstrong heard and then jazzed up 'Mackie Messer', that is, 'Mack the Knife'). This brought a less politically improving, nastier, pop-culture Brecht into the mix. Through these influences, Brecht suddenly became one of the major sources of radical film and television in Britain. A mid-1960s BBC teleplay such as Dennis Potter's *Vote Vote Vote for Nigel Barton* was bursting full of Brechtian devices – third-wall-breaking, explicit politics, anti-naturalistic acting, characters commenting on their roles rather than inhabiting them. For New Wave directors bored with realism like Karel Reisz and Lindsay Anderson, Brecht offered a way out of the polarities of drawing room and kitchen sink, allowing them to make paradoxical, didactically political, picaresque and self-deconstructing films like Reisz's *Morgan* and *The French Lieutenant's Woman*, or Anderson's trilogy of *If . . .*, *O Lucky Man* and *Britannia Hospital*. For Anderson, Brecht's appeal was simple: in 1968, promoting *If . . .*, Anderson wrote as an explanation of its weird experiments with time, narrative and plausibility that 'Brecht said that realism didn't show what things really "look like", but how they really are'.[4] To show how things *really were* in 1968, artists and filmmakers had to break with the British documentary tradition as much as they did with the Expressionist tradition of dreamlike fantasy.

It was in the 1970s that Brecht's influence in Britain really came to the fore, aided by a set of crackling, venomous translations, many by émigrés like the poet Michael Hamburger, edited by John Willett and Ralph Manheim. These brought his plays and, for the first time, his brutally economical, often highly ambiguous and profound poems into the English language. The crucial art form now was not in the stage, nor even in the cinema, but rock music. Turn to, for instance, the Gang of Four's 1979 album *Entertainment!*, and you can find Brecht in practically every song. 'Not Great Men' is a straightforward rewrite of the poem 'Questions from a Worker Who Reads', with its clipped, percussive critique of a history consisting of 'the strong men who/have made the world/history lives on in/the books at home'.[5] Several songs, like 'I Found That Essence Rare' or '5.45', resemble the cut-up techniques of Brecht's *War Primer*, where war and atrocity – in Northern Ireland, Lebanon, Cambodia, Chile – constantly seep through the media into suburban living rooms. The Gang of Four used new technologies Brecht

wouldn't have recognized – electric guitars, echo machines, synthesized drums – but their work marked a certain catching-up with his ideas from the 1920s. Brecht loathed real opera almost as much as he loathed the declamatory, pompous styles of real theatre, and nearly as much as he loathed the abstract, atonal art music of Schoenberg. Instead, Brecht imagined a new, politicized music that was harsh, simple, rhythmic, sung by untutored voices and, above all, 'close to the people'. Well, here it was.

By the end of the 1970s, Brechtian 'Alienation Effects', *Verfremdungs-effekten*, or as Brecht called them, 'V-Effects', were everywhere, in the TV dramas of Alan Clarke and Dennis Potter, in the bursts of noise and commentary, argument and sloganeering that were thrown into three-minute pop songs by everyone from The Specials to Delta 5 to the Au Pairs to Scritti Politti. All these V-Effects were intended to be jarring, intent on 'waking up' listeners and viewers and stopping them from lying back and consuming the work as ordinary 'entertainment'; they were designed to make the audience think about their lives and their relation to political and economic processes. At least to an extent, it must have worked, because unlike in the interwar years, the people making this art tended to be from very ordinary backgrounds. These were in many cases the sons and daughters of the working-class people that the *Picture Post* photographers and the New Wave film directors pointed their cameras at and the architects devised modernist housing estates for. But throwing ideas like these around in a commercial art form like pop music can be a dangerous thing. The Gang of Four's Brecht was a scrupulous, well-thought-out tribute, and one that we can be fairly sure the man himself would have admired; the same might be said about some of the direct adaptations that came in the 1980s. In 1982, David Bowie performed in a TV version of Brecht's *Baal*, adapted for the BBC by Alan Clarke, and released a searing record of songs from the play. The recovering pop star Marianne Faithfull, herself from an aristocratic Austrian family, recorded a superb album of Brecht songs, as did the Australian theatre singer Robyn Archer, and the German art-rock chanteuse Dagmar Krause. Even the Pet Shop Boys released a synth-disco version of 'What Keeps Mankind Alive'. But not every adaptation of Weimar Culture in the 1970s was quite so thoughtful.

That 'Weimar' was in the air in the first place owed much to the apparent political and economic chaos of Britain in the 1970s. The homogeneous and stable, predictably class-bound society that the émigrés encountered

in the 1930s had become forty years later a violent, exciting, commercial, multicultural place of class mobility, ostentatious difference and political polarization. An economic crisis in the middle of the 1970s, mild as it was by the standards of the 2010s and 2020s, saw swings to the left – Tony Benn's socialist insurgency within the centrist Labour government, a rise in support for small left-wing groups like Militant and the Socialist Workers Party – and to the right, as the Neo-Nazi National Front rose to become, for a few years, the fourth largest political party in England. There was sharp inflation and mass unemployment. Accordingly, it became a ritual for commentators to compare Britain between around 1974 and 1982 to 'the Weimar Republic', as an exemplar of a fragile democracy roiled by economic crisis and the threats of fascism and communism, just ripe to be taken over by a 'strong leader'.[6] At this time, punk rockers borrowed from Weimar and from Third Reich aesthetics, without any concern as to which was which. Joy Division's first EP, *An Ideal for Living* (1978), featured a Nazi propaganda image of a Hitler Youth boy banging a drum on its cover; but Peter Saville's sleeve for their first album, *Unknown Pleasures* (1979), with its stark space, carefully kerned sans serifs and air of stern, hard modernity, was more like Jan Tschichold's work of the 1920s than anything the great typographer had actually created in his British exile during the 1940s. This was not accidental: Saville's first poster for Factory Records in 1978 was a straightforward rip-off of a graphic from Tschichold's 1928 book *Die Neue Typographie*.

Joy Division, and the heavily Germanophile Factory Records scene that grew up around them in Manchester, were only the most explicit case of Weimar fetishism. In 1979, Siouxsie and the Banshees, a group that had worn Nazi armbands and sung antisemitic lyrics in 1977, apologized and released a German translation of their song 'Metal Postcard' as a single, and put John Heartfield's montage 'Hurra, die butter is Alle!' on the cover, with an explanation on the back as to what it was. The sleeves of the anarcho-punk group Crass comprised a more creative dialogue with John Heartfield, with Gee Vaucher's photomontages as agitational and didactic as those of the German artist, but a general confusion was more common. In 1981, Orchestral Manoeuvres in the Dark released a hit album called *Architecture and Morality*, a title borrowed from David Watkin's conservative, neoclassical attack on the work of Nikolaus Pevsner, *Morality and Architecture*; its sleeve was another of Saville's tributes to the pre-classical work of Tschichold.

Siouxsie and the Banshees' tribute to John Heartfield ...

A Joy Division-influenced group from Northampton called themselves 'Bauhaus' and borrowed Oskar Schlemmer's logo for the school as their insignia, though as Simon Reynolds pointed out in his history of post-punk music, it was obvious that Expressionism, not Constructivism, was their real inspiration. Sometimes, the reference was even more direct. Brian Eno, who knew his art history well, actually sampled Kurt Schwitters reading the 'Ursonate' on the 1977 track 'Kurt's Rejoinder'.

The sources for all this did not lie solely in Weimar, of course. Some of it came from films and music that were more kitsch, like Bob Fosse's 1972 film *Cabaret*, a very approximate musical version of Isherwood's *Goodbye to Berlin*, or from Liliana Cavani's 1974 sexploitation film *The Night Porter*, much of which was filmed in 'Red Vienna's' Karl-Marx-Hof. A lot of inspiration also came from Bromley-to-Berlin traveller David Bowie's obsessions with Weimar – and Nazi – aesthetics,[7] from contemporary German rock bands such as Can or Neu!, from the explicit El Lissitzky tributes of Kraftwerk, or from the New German Cinema of Rainer

... And OMD and Peter Saville's homage to Jan Tschichold.

Werner Fassbinder and Wim Wenders. But in general, an imaginary Germany racked by conflict, decadence, seediness and hard-edged design became an obsession for thousands of provincial working-class and lower-middle-class youth in the late 1970s and early 1980s. Its political ambiguity led Chris Bohn – a writer at the *NME* from a German émigré family in the West Midlands, who wrote under the *Berlin Alexanderplatz*-inspired penname of 'Biba Kopf' – to write an entire article explaining Weimar Culture to the hundreds of thousands of young readers of this pop-music weekly, making clear to them that the culture they were so obsessed with, all late-night screenings of *M* and Brecht paperbacks and cabaret songs, was actually *anti*-fascist.[8]

Did any of this come directly from the legacy of the artistic emigration to Britain? Only very partially. There was no chance of Peter Saville making a tribute to Tschichold's English work on a record sleeve, for instance – too familiar, too ordinary, too conservative, lacking that alien frisson he found in the work of the 1920s. Perhaps one can root some

of this in some of the artistic legacies of the emigration, in some of the many exiles who taught in the art schools. We've seen how George Mayer-Marton taught some of The Beatles, and how others of his generation like Martin Bloch taught at the ordinary municipal art schools that were the alternative to manual labour for many mixed-up teenagers between the 1950s and 1970s. One could add to this that many of the most energetic, stylish photographs of The Beatles and other rock groups of the early 1960s were taken by Dezo Hoffmann, a Slovak émigré news photographer who had come to work mainly for the music press. Rock and Dada, meanwhile, had established tenuous links ever since the artist Gustav Metzger, a neo-Dadaist and *Kindertransport* refugee, taught Pete Townshend about 'auto-destructive' art in the early 1960s, inspiring him to smash up his guitars onstage.

But by the end of the 1970s, with the emigration long absorbed into the official culture of the time, there was little obvious connection between the Weimar-obsessed youth and the actual survivors of Weimar in Britain. Modernist architecture of the kind devised by Goldfinger or Lubetkin was a post-punk obsession, but mainly as a bleak, dystopian backdrop, not a utopian hope; after all, anyone could get a council flat in 1979. The band Bauhaus were surely unaware that Gropius's mentor Peter Behrens had designed a house in their home town, or that there was a German Expressionist collection in a gallery up the road in Leicester; tellingly perhaps, it was one of the nerdier, less critically admired bands of the time, The Police, who adapted an Arthur Koestler book (of the same title) into their 1981 album *Ghost in the Machine*. What could any of these intense young people find in Pevsner's guides to Victorian churches, in Popper's description of the virtues of a liberal order, or in Gombrich's history of art that stops just before things get really juicy?

It would almost seem as if the emigration was actually *irrelevant* to the rediscovery of Weimar Culture by pop culture; or at least, it might have seemed so to these art-school youths. They simply wouldn't have known that the black Thames & Hudson art books about Dada, Constructivism, Futurism and Photomontage, those paperbacks they stuffed into their pockets, pored over and plagiarized, were actually edited, designed and produced by almost anonymous Central European refugees who were old enough to be their grandparents, but who would have counted impossibly exotic cultural heroes like Kurt Schwitters, John Heartfield or Bertolt Brecht among their friends.

30
This Is What We Believe

The émigrés were often not so interested in merely importing something into their new home; many were much more inclined to take their 'Weimar' and remake it into something useful for a reformist, social-democratic or socialist reorganization of Britain. That a vision of 'Weimar' in Britain came into being that was hard, cruel and politicized had little to do with them. Some direct links can be found, though – one was Marlborough Fine Art, a gallery in Mayfair founded by Frank Lloyd and Harry Fischer, two Austrian art-dealers. Marlborough represented the most nihilistic and charismatic of post-war painters: Francis Bacon, and two Berliners who had arrived in Britain as refugees in the 1930s, Lucian Freud and Frank Auerbach. All three worked in a manner that was clearly in the tradition of the *Neue Sachlichkeit*, but stripped of all politics and utopianism, with all the energy transferred to an intense inward burrow into the problems of the psyche and the failings of the body. Marlborough mixed their exhibitions of these younger painters with the first London exhibitions (since those curated by Jack Bilbo, at any rate) of the likes of Schwitters, Beckmann and Moholy-Nagy. On the left, meanwhile, in the early 1970s the *New Left Review* and its book-publishing arm Verso made good on Perry Anderson's critique of the emigration by translating and publishing as much as they could of unadulterated interwar germanophone 'Western Marxism', putting out cheap paperbacks by Walter Benjamin, Theodor Adorno, Siegfried Kracauer, György Lukács. Verso books, and increasingly, Penguins, were jacketed in neo-Weimar designs by younger British graphic artists, whether neo-Constructivist (David King) or neo-Dada (Peter Kennard). In the process, the more affirmative *Picture Post* world, every bit as much a product of Weimar Culture as this more disruptive, revolutionary work, faded away into little more than dimly recalled 1940s

nostalgia. Nobody seemed to even remember that the people who made *Picture Post* were largely not British.

If in the popular modernism of the post-1968 era, Weimar became an intensifier, in the more rarefied world of architecture, where the influence of the emigration was most influential, the xenophobia of the 1920s and 1930s returned in a big way in the 1970s and 1980s. The Europeanness and Jewishness – with the appropriate euphemisms, like 'cosmopolitan' – of the likes of Pevsner, Goldfinger and Lubetkin were emphasized in the New Right critique of David Watkin's *Morality and Architecture*, in books like Alice Coleman's *Utopia on Trial*, and in the polemics of the then Prince Charles. The target for his intervention into British architecture in the 1980s was an extension to the National Gallery by the firm of Ahrends, Burton and Koralek (ABK), which was cancelled after he described it as a 'monstrous carbuncle on the face of a much-loved friend'. Two of the firm's named partners were from Central Europe, and emigrated as children or adolescents. Peter Ahrends had been born in Berlin, Paul Koralek in Vienna. Like Yorke Rosenberg Mardall, ABK worked in a strongly, unsentimentally modernist manner, and refused to shift to neoclassicism when it became fashionable in the 1970s; their career never fully recovered from Prince Charles's speech.[1] Another target was the only British building designed by Mies van der Rohe, the plans for which he completed shortly before his death, for a site by the Mansion House in the City of London. The building's construction was first delayed for two decades, and then finally cancelled in the mid-1980s after a campaign that often emphasized how 'alien' Mies's work was to British traditions. A few émigré institutions adapted. In the new era, Paul Elek, the émigré publisher who had once put out Walter Segal's guides to modernist rehousing, published a volume that described postwar reconstruction as *The Rape of Britain*. Thames & Hudson issued a book simply called *Has Modernism Failed?* (the answer: yes).[2] This was all rather undignified, but one man remembered his history: Berthold Lubetkin. In 1984, the retired architect wrote out a list of the various insults and epithets in Charles's 'carbuncle' speech, matching them with similar quotations from Stalin and Hitler, and sent it as a letter to the *Observer*. They did not publish it.[3]

You can find some émigré presence in the political polarization of the 1970s, if you look hard enough. Émigrés could be found on the right, in the neoliberal think tanks set up under the auspices of Friedrich Hayek,

and more picturesquely in the person of Robert Maxwell, a luxuriantly corrupt Czech entrepreneur and, for a time, Labour MP, who had links to secret services on each side of the Cold War, and found it in him to admire both Margaret Thatcher and Nicolae Ceaușescu. You could find the émigré presence more prominently on the left. The two major leaders of British Trotskyism, Militant's Ted Grant (born Isaac Blank) and the Socialist Workers Party's Tony Cliff (born Ygael Glückstein), were raised in a Central-Eastern European Marxist *Yiddishkeit* milieu, though neither had grown up in Europe, but rather in settler colonies of the British Empire, in South Africa and Mandate Palestine respectively. On the Bennite Labour left, a crucial organizer was the Slovak émigré Vladimir Derer, and a major intellectual inspiration was found in the Marxist sociologist Ralph Miliband, who was from a Polish Jewish family in Belgium that escaped just in time in 1940. But the continental influence was much more successful in actually gaining the ear of power in the case of that dedicated reader of Karl Popper and Friedrich Hayek, Margaret Thatcher. As noted earlier, it was Hayek's book *The Constitution of Liberty* that she once slammed down on the table and asserted to her colleagues 'this is what we believe'.

The cruelty that settled into British political culture during the 1970s was lamented by a few émigrés; neoliberal Britain meant, for them, the destruction of all they had come here to find in the first place. The Hungarian economist Nicholas Kaldor wrote a (highly vindicated) critique, *The Economic Consequences of Mrs Thatcher*; that great and slightly ridiculous polymath of 'Finchleystrasse' Elias Canetti registered the effects of Thatcherism in shocked, apocalyptic tones. After 1979, he wrote:

> England decided it would loot itself, and engaged an army of yuppies for that end. The hypocrisy, which was actually the mortar that held English society together, fell away ... it was shown – I say this with incredulity – that selfishness was every bit as much worth preaching as selflessness. Water, air, light, were turned into businesses, to flourish or fail; usually, they failed. I was permitted to live through this time, and see my best friends warped.[4]

That last clause is a reminder that Margaret Thatcher's constituency actually included within it the wealthier northern part of 'Finchleystrasse',

around Golders Green. Like any other upwardly mobile community, the Central European emigration and its children generally drifted rightwards.[5] In the twenty-first century, both major political parties have been led briefly and unsuccessfully by the children of Jewish émigrés – Ed Miliband, son of Ralph Miliband, for Labour, and in the Conservative Party, Michael Howard, son of Bernat Hecht, a Romanian-born businessman who took refuge in Wales in 1939. Both were depicted in mildly but clearly antisemitic terms by Britain's uniquely appalling tabloid press: Howard as a Transylvanian vampire, Miliband as a cosmopolitan who couldn't eat a bacon sandwich properly. Both made harsher controls on immigration into central parts of their respective party manifestos, but this didn't do them much good.

The Central European refugees from fascism can be seen as perhaps the first group of immigrants to have had a really decisive, transformative and positive effect on British culture, a precursor to the much better-known, more numerous and more completely transformative migrations between the 1940s and 1960s from the Caribbean, South Asia and West Africa. Some solidarities have been forged in this way, and indeed, in the 1930s, *Picture Post* photographers Felix H. Man and Kurt Hutton went looking for just this kind of multiculturalism as they took their cameras to Cardiff, Liverpool or to London's East End. But this has been complicated a little by the ways in which Britain has developed something similar to the American 'wages of whiteness'. Central European Jews were gradually considered part of the English national story in a way that has often been denied to darker-skinned migrants; naturally, with the gentile emigrants of the 1930s and 1940s this assimilation happened even faster.

This process has been put to some bizarre uses in British politics in recent years. It has not been uncommon to see any opposition to the unfolding genocide in Gaza, in the old British Mandate of Palestine, described as antisemitic by politicians and the press, even if – or sometimes, particularly if – the person objecting to it is Jewish;[6] but as the recent examples of Howard or Miliband indicate, the status of 'Englishness' can be suddenly withdrawn. Racist bigotry, an obsession with the dangers of immigration, and a fervent philosemitism are equally common in the media and in political life, and the results can be rather schizoid. During the five years in which Jeremy Corbyn was leader of the Labour Party, it was normal in the press to see the Labour

left criticized, sometimes on very tenuous grounds, for antisemitism, in the same breath as they were denounced for a 'North London' form of 'cosmopolitanism' that hated 'British values' – that is, using the exact same language once aimed at the continental Jews of 'Finchleystrasse'. The Colonel Blimp vainglory of Boris Johnson and the Brexit he 'delivered' is just one expression of how the moronic insularity of interwar British politics has returned in a big way in the twenty-first century, and how it has cut us off again from our nearest neighbours in favour of a fantasy of being 'world-beating'. In 1940, the British state dumped 'asylum seekers' in the open spaces of unfinished council estates, incarcerated them in disused cotton mills on the outskirts of Manchester and on the Isle of Man, and then deported them to Australia; the Conservative governments of the 2010s and 2020s stuck them in disused hotels, incarcerated them in the Yarl's Wood detention centre in Bedfordshire or the diseased corridors of the huge *Bibby Stockholm* barge, and attempted to fly them to Rwanda.

At the same time, outside of Britain, our émigré artists and intellectuals have an equally ambiguous status. In Hungary, a government that sees itself explicitly as continuing the tradition of Miklós Horthy's interwar dictatorship has no interest in celebrating the mainly Jewish and mainly left-wing artists, filmmakers, photographers and architects who were forced out of Budapest in 1919. In Poland, Czechia and Slovakia, the record is a little better, and a few figures like the Themersons, or the Bata empire, are celebrated by local publishers and institutions. The strangest example is perhaps Germany and Austria. By the 1960s, both East and West Germany had 'rehabilitated' their own interpretations of Weimar Culture, and welcomed a few re-emigrants; for a time in the 1970s, two germanophone states were led from the left by former émigrés, one of whom was Jewish: Willy Brandt in West Germany and Bruno Kreisky in Austria. After German reunification some of the major Weimar-era modernist monuments in Berlin, Frankfurt, Hamburg and Dessau were restored, and some, like the housing estates of Bruno Taut, even became UNESCO World Heritage sites. That the flower of germanophone modern culture was forced out of Berlin and Vienna was treated as a source of deep shame. But at the time of writing, in Germany, 'Never Again' has been redefined, to use David Rieff's phrase, as 'Never Again Will Germans Kill Jews in the 1940s in Europe'. The AfD (*Alternative für Deutschland*), a party that specifically stands against the notion of German guilt, and

explicitly rehabilitates the traditions of German nationalism and xenophobia, is the second most popular party in the country, and the most popular among the young; the same is true of the older but equally racist Freedom Party in Austria. Today, of course, the bigots who lead these parties don't talk about Jews as the enemy, or not publicly at least – instead they constantly praise the state of Israel, and direct their fire at Muslims, Africans, Roma – but their leaders will happily emit an antisemitic dog-whistle when it is necessary to do so.

Where all this leaves the memory of the emigration is unclear. In Britain, the society that the émigrés helped to build has been in large part destroyed. Yes, there are cult heroes; there's Powell and Pressburger and Lubetkin and Goldfinger. But the majority – by no means all, but a majority – of the people in this book were committed to a certain idea of public culture and public luxury. They believed in a serious popular press, which would report accurately from around the world and would stand against nationalism and parochialism. They believed in a public art, in putting sculptures, mosaics and murals in ordinary places like council estates, health centres, schools and hospitals. They believed in mass-market publishing as an educational endeavour, through which the public could encounter, understand and embrace ideas hitherto kept for an elite. They believed in a welfare state, whether left-liberal or socialist in hue, and they believed in the modern city, whether in a 'reformed' Garden City form or as the more realistic multicultural city favoured by somebody like Ruth Glass. It is incredible that so much of this still survives, after the forty-five years of assault on it by the British government and its closely linked media, but it survives as remnants – council estates just about clinging on, NHS hospitals with their modernist fountains switched off to save water and energy, and the orange and green and blue paperbacks that line the walls of your nearest second-hand bookshop.

I began this book with a work by one of the major global artists of the twentieth century, Naum Gabo, and a sculpture he designed in the heart of London, at the centre of British power. Gabo is the sort of modernist I find easiest to like – futuristic, unsentimental, abstract, pure, uncompromised, a real link from the October Revolution and Weimar Berlin to London (and St Ives). Not all artists of the time were like Gabo, and not all projects were so prestigious as St Thomas's Hospital, opposite the Houses of Parliament across the Thames. As I finished the

research that led me around this divided, sickly, unfair, unhappy island, the public artwork that stuck in my mind most was in a quite different place, and by a quite different artist. It was *The History of Newport*, a series of murals in the entrance hall to Newport Civic Centre, in South Wales, designed by Hans Feibusch and painted by him between 1961 and 1964 with his artistic partner Phyllis Bray.

If Feibusch isn't the right sort of artist, Newport is not the right sort of place. When writing about Feibusch, I've had to force myself to see in him some of the traces of the artists who the Nazis threw him together with in the 'Degenerate Art' exhibition – with Max Beckmann, Jankel Adler, Oskar Schlemmer, say – but I find the Christianity, the pastel colours, the beatific faces, all off-putting. I often feel as if I'm looking at the illustrations for some 1950s brochure trying to coax uninterested parishioners into the new church on the new estate. Look at them often enough, though, and you see it – you see the writhing intensity in his figures, the transfigured light of the backdrops, the Expressionistic tensions of the compositions. I could never have imagined any of the religious paintings bringing me to my knees, but in Newport, where Feibusch is preaching the civic gospel, they finally hit me, hard; I was thrilled by these murals, moved far more than I had expected. Perhaps one reason for this is because of the sort of place Newport is, and how Feibusch saw it.

Newport is a place with an important history – a Roman and medieval town, an industrial centre, a place where the Chartists launched an uprising against Victorian capitalism in 1839 and where numerous interesting rock bands and hip hop groups have formed. It should be thriving, and perhaps if we had an economic system based rather more on some of the plans published in Penguin Specials or *Picture Post* in the 1940s, it might be. It is instead one of many large towns and cities in Britain that have been left to rot in the last forty years, as a plurality of British voters have repeatedly endorsed a return to the inequality of the 1930s (though they haven't endorsed it in Newport, that's for sure – a Conservative MP hasn't been elected here for forty-one years). Its public buildings are often derelict or half-derelict. Many of the shops on the high street are empty. Despite the fact there's not much of a boom in house prices here, many clearly can't afford a roof over their head. Visibly ill people stagger around. Housing, whether Victorian inner-city terraces near the docks or the well-designed council housing built after

the war up on the hills, has been left to deteriorate. You could have taken Otto Dix or George Grosz here to paint it, and they would have understood it; you could have taken Edith Tudor-Hart or Bill Brandt here and they would have photographed it, and they might have hoped that might have made some difference. I live in London, and there, I can see every day extremes of poverty and wealth, but here in Newport, there was just the former: a grinding helplessness, a sense that nothing positive can happen, that nothing can or will change, that this sort of struggle is just normal and to be expected, that the best thing you can do in a place like this is get the hell out. And there, at the centre of it, is Feibusch.

The Civic Centre was begun in the 1930s, and abandoned with the war; the murals are part of a belated project to finally complete the building and open it up to the public. They tell the story of the city, in enormous painted panels – not just the sort of histories that usually get celebrated in Britain, the medieval monuments and the Roman remnants and the Victorian industrial triumphs, but the moments of dissent too, as in the panels depicting the Roundhead victory in the Civil War at nearby Raglan Castle, or of the Newport Rising of 1839, and the fight against fascism, in a panel depicting American soldiers on their way to D-Day.[7] The scale of these panels is so vast, reaching way above your head, the figures so gigantic, that you feel thrown into a film, into some sort of gigantic technicolour production, a hyper-realism that brings these events much more to vivid life than any straightforwardly accurate depiction ever could.

The murals take this town, which has been beaten down for a lifetime, and make it look heroic, important, resistant, writhing with all the fire that Feibusch teased into his religious paintings but without a hint of mysticism; through them, Newport becomes epic. If I began this book having my own way of seeing skewed and expanded by Gabo's abstraction at St Thomas's Hospital, here something rather different but equally important has happened. Here, it is Feibusch's eye, his way of seeing somewhere that he has approached wholly from the outside, that is transfiguring and exciting. Approaching Newport without preconceptions, he has represented it in the grandest, most thrilling terms, as a place of world-historical grandeur, something that is hard to believe in but which is a much truer vision of Newport and places like it than to see just another dying post-industrial town, just another 'shithole'.

Feibusch refuses to see it like this, and creates here a series of vast and pulsating scenes that put its history on the same level as the Bible.

Above all, this is a space that is a monument to public luxury, a tribute for everyone which anyone can walk into on a weekday and marvel at. What Feibusch has given here is an act of enormous *generosity*. It is not mean. It is not austere, and it stands very strangely in an age of punitive austerity. It probably cost a lot of money, *taxpayers' money*. It doesn't have to be here. It is superfluous, excessive. For me, it encapsulates, better than any other artwork by a Central European exile in this country, a precious reciprocal process of generosity and gratitude. For all our many flaws as a country, it was British people who saved this man's life from fascism. His work here responded to this generosity, and gives a gift back, not just to a few benefactors, but to the churches of a hundred council estates and here, to an entire large town. It is that gift, and the ethic behind it, which we most need to rediscover today, before it's too late.

The Sistine Chapel of Municipal Socialism.

Acknowledgements

The new photographs in the book are my own, and the ephemera is all from my collection; all images are intended, in John Berger's phrase, as 'simple memoranda' and nothing more.

This book has been a little bit of a departure for me, and took a while to reach its current form – it certainly would not have done so without considerable help. I owe a lot to various people I've spoken to about this book and related matters over the years – with apologies to anyone not listed here who should be. So thank you Anna Aslanyan, Marcus Barnett, Anindya Bhattacharyya, Sam Dolbear, Tom Gann, Pippa Goldfinger, Ievgeniia Gubkina, Frances Hatherley, Richard King, Michael Klein, Esther Leslie, Kate Macintosh, Douglas Murphy, Hannah Proctor, Agata Pyzik, Isaac Rose, Otto Saumarez Smith, Mark Sinker, Ioana Suliciu, Matthew Tempest, Troy Vettese, Christian Wertschulte, Thaddeus Zupancic, and to Peter Willis of BOOKS Peckham. Dorothea Schöne of Kunsthaus Dahlem in Berlin very kindly sent me a copy of her volume *New/Old Homeland: Re/emigration of Artists after 1945*, for which I'm especially grateful. A few people have commissioned essays, reviews or other writing in and around the issues in the book, so thank you to Ronan Burtenshaw and Fergal Kinney at *Tribune*, Fatema Ahmed at *Apollo*, Simon Hammond and Lola Seaton at *New Left Review/Sidecar*, Paul Myerscough at the *London Review of Books*, Bhaskar Sunkara at *Jacobin*, and Merlin Fulcher at Open City London.

Special thanks to Tom Wilkinson, Kirill Kobrin, Juliet Jacques and Daniel Trilling, all of whom read early drafts of the manuscript and offered many useful comments, suggestions and corrections. At Penguin, Tom Penn commissioned this book and took the chance as a proper historian that I might be able to write something like a history book. Thanks especially to Sam Fulton, who has been a joy to work

ACKNOWLEDGEMENTS

with as an editor, exacting but thoughtful, and to Richard Mason for his sharp-eyed copyediting and fact-checking. Much gratitude is also due to my agent, Nicola Barr, at the Bent Agency, who has been invaluable to have in my corner during what has at times been a tortuous road to completion.

Love to my companion on the desert island of Britland, Carla Whalen.

Camberwell, 2020–24

Notes

DEDICATION

1. Bertolt Brecht, *Refugee Conversations*, trans. Romy Fursland (Methuen, 2020), pp. 11–12.

INTRODUCTION

1. Letter reproduced in Andreas Schätzke, *German Architects in Great Britain: Planning and Building in Exile, 1933–1945*, trans. Ilze Mueller (Edition Axel Menges, 2013), p. 105.

Chapter 1

1. At the time of completing this book in mid-2024, both the revolving mechanism and the water are switched off.
2. On the firm's 'social-democratic', anti-star ethic, see Reyner Banham's Introduction to *The Architecture of Yorke Rosenberg Mardall 1944–1972* (Lund Humphries, 1972). On Czechoslovak modernisms in English, good starting points are the translation of the Marxist critic Karel Teige's *Modern Architecture in Czechoslovakia* (Getty, 2010), a guidebook, Ivan Margolius, *Prague: A Guide to Twentieth-Century Architecture* (Ellipsis, 1994), and again on the capital, Derek Sayer's panoramic study of modernism and surrealism, *Prague: Capital of the Twentieth Century* (Princeton, 2013).
3. Quoted in Martin Hammer and Christina Lodder, *Constructing Modernity: The Life and Career of Naum Gabo* (Yale University Press, 2009), p. 463.
4. Banham, *The Architecture of Yorke Rosenberg Mardall 1944–1972*, p. 7.

NOTES

Chapter 2

1. The literature on the Central European avant-garde is vast. The best sourcebooks and commentaries are MIT Press's two volumes by Timothy O. Benson and Éva Forgács, *Between Worlds: A Sourcebook on the Central European Avant-Gardes, 1910–1930* (MIT, 2002), and Timothy O. Benson, *Central European Avant-Gardes: Exchange and Transformation, 1910–1930* (MIT, 2002). Specifically on the 'little magazines' and print culture of the era, a great introduction is Stephen Bury, *Breaking the Rules: The Printed Face of the European Avant-Garde* (British Library, 2007); for the many manifestos, Stephen Bann (ed.), *The Tradition of Constructivism* (Da Capo, 1990). Not all 'Weimar Culture' was avant-garde, though: the best short introduction to its wider trends is still Peter Gay, *Weimar Culture: The Insider as Outsider* (Pelican, 1974). The book that has had by far the most influence on the one you are reading now is John Willett's rousing account of the radical edge of Weimar Culture, with its emphasis both on its socialism and its connections to the East and West: *The New Sobriety: Art and Politics in the Weimar Era* (Thames and Hudson, 1978). See also his excellent summary, originally published in an Italian Communist encyclopaedia in 1980, 'Art and Revolution', in English in *New Left Review* 112, July/August 2018. For a good recent history of the German Republic that roots the cultural changes strongly in the political process – and which roots the turn to Nazism very much in a right-wing counter-revolutionary culture war – see Eric D. Weitz, *Weimar Germany: Promise and Tragedy* (Princeton, 2019).
2. Stefan Themerson, *Kurt Schwitters in England, 1940–1948* (Gaberbocchus, 1958), pp. 14–15.
3. Imre Hofbauer, *George Grosz* (Nicholson and Watson, 1948), p. 12. I owe awareness of this book to Robert Waterhouse, *Their Safe Haven: Hungarian Artists in Britain from the 1930s* (Baquis Press, 2018).
4. Fred Uhlman, *The Making of an Englishman* (Gollancz, 1960), p. 121.
5. There has been some debate over this in recent years. In my view the received idea common in the middle of the century that the Nazis were implacably hostile to modern architecture should be nuanced, but I see no reason to discard it. The best book on how Nazi architecture rejected the aesthetics of modernism while keeping some of its organizational innovations is Barbara Miller Lane's unsurpassed *Architecture and Politics in Germany, 1918–1945* (Harvard University Press, 1968); if anything really resembles Third Reich architectural culture, with its fierce rejection of 'Judeo-Bolshevik' flat roofs, abstraction and angularity while embracing modernism in back-end structures such as factories and bunkers, it is not Weimar but the USA, where architects such as Albert Kahn built dramatically novel factories but remained deeply conservative in their public buildings and housing. Similarly, say, that Leni Riefenstahl was familiar with the work of Eisenstein; that in the early

days of Nazism Herbert Bayer designed some Nazi trade fairs in Bauhaus style; that the German Expressionist painter Emil Nolde was a passionate fascist; that Goebbels had once had some vague sympathies with Expressionism; and that favoured Nazi sculptors such as Arno Breker maintained an affection for Paris Purists such as Aristide Maillol, all these are interesting enough facts – but they are surely inadequate justification for downplaying the Nazi state's extremely public ridicule of Expressionism and Constructivism in its touring 'Degenerate Art' exhibition, and its persecution of those artists, who were denied work if they were lucky, murdered if they were not. The most intelligent study of 'Nazi Modernism', or surely, Nazi *modernity*, remains Jeffrey Herf, *Reactionary Modernism: Technology, Culture, and Politics in Weimar and the Third Reich* (Cambridge University Press, 2008). Similarly, on Stalin's USSR, some historians now stress that there were more continuities than was once believed between Constructivist architecture and Stalinist Socialist Realism, which were depicted as two utterly hostile 'cultures' as recently as Vladimir Paperny's 1980s classic *Architecture in the Age of Stalin: Culture Two* (Cambridge University Press, 2011). Arguments for continuity can be found in historical detail in Danilo Udovicki-Selb's *Soviet Architectural Avant-Gardes* (Bloomsbury, 2022), and famously in Boris Groys' provocative and prankish *The Total Art of Stalinism* (Verso, 2011). But again, the hostility to modern design and modern designers was very real and could be career-ending at best and lethal at worst, as outlined in Hugh D. Hudson's *Blueprints and Blood: The Stalinization of Soviet Architecture, 1917–1937* (Princeton University Press, 2019). The best introduction to this period in the USSR remains Catherine Cooke's exciting but wise *Russian Avant-Garde Theories of Art, Architecture, and the City* (Academy, 1995).

6. Uhlman, *The Making of an Englishman*, p. 201.
7. Ibid, p. 196.
8. For a version of this story that stresses this successful entry into the British establishment, see Daniel Snowman, *The Hitler Émigrés: The Cultural Impact on Britain of Refugees from Nazism* (Pimlico, 2012). For a focus on one city, see Bill Williams's *Jews and Other Foreigners: Manchester and the Rescue of the Victims of European Fascism, 1933–1940* (Manchester University Press, 2011).
9. Arthur Koestler, *The Invisible Writing* (Vintage, 2005), p. 519.
10. Ibid, p. 517.
11. Perry Anderson, *English Questions* (Verso, 1992), p. 61.
12. Ibid, p. 62.
13. Vienna's modernist culture is usually best known through the last years of the Hapsburg Empire – see Carl E. Schorske, *Fin-de-Siècle Vienna: Politics and Culture* (Vintage, 1981) – rather than through the socialist culture of the capital of the first Austrian republic. The major work is Helmut Gruber, *Red Vienna: Experiment in Working Class Culture* (Oxford University

Press, 1991), and for a more sympathetic revisionist account focusing on its housing programme there is Eve Blau, *The Architecture of Red Vienna, 1919–1934* (MIT Press, 1999).
14. Anderson, *English Questions*, p. 63.
15. Ibid, p. 65.
16. This shameful episode is described in David Caute's *Isaac and Isaiah: The Covert Punishment of a Cold War Heretic* (Yale University Press, 2015).
17. Anderson, *English Questions*, p. 84.
18. Ibid, p. 88.

Chapter 3

1. See, for instance, David Edgerton, *England and the Aeroplane: Militarism, Modernism and Machines* (Penguin, 2013), and *Britain's War Machine* (Penguin, 2011).
2. John Willett, 'The Emigration and the Arts', in Gerhard Hirschfeld (ed.), *Exile in Great Britain: Refugees from Hitler's Germany* (Berg, 1984), p. 205.
3. A recent example that has a good go at busting this 'myth' but eventually ties itself up in knots is Alan Powers, *Bauhaus Goes West* (Thames and Hudson, 2019); a more convincing account can be found in Powers' own *Britain: Modern Architectures in History* (Reaktion, 2007).
4. Willett, 'The Emigration and the Arts', p. 203.
5. Paul Cohen-Portheim, *The Spirit of London* (Batsford, 2021), p. 57. The book was first published in Batsford's British Heritage series, one of many self-congratulatory book series of the 1920s, 1930s and 1940s – some of which, we will see, were devised by exiles. The covers were designed in a very pleasant, mildly modernist style by Brian Cook, later a Tory MP.
6. Fiona McCarthy, *Walter Gropius: Visionary Founder of the Bauhaus* (Faber, 2019), p. 314.
7. Quoted in Christina Thomson, *Contextualising the Continental: The Work of German Émigré Architects in Britain, 1933–1945* (PhD thesis, University of Warwick, 1999).
8. Karel Čapek, *Letters from England* (Read Books, 2014), ebook, loc 91.
9. Ibid, loc 142.
10. Ibid, loc 150.
11. Ibid, loc 425.
12. Ibid, loc 302.
13. Ernst Schoen, 'Peace and War' (1943), from a series of 'London Elegies', quoted and translated by Sam Dolbear and Esther Leslie in their *Dissonant Waves: Ernst Schoen and Experimental Sound in the Twentieth Century* (Goldsmiths Press, 2023).

14. Elias Canetti, *The Tongue Set Free: Remembrance of a European Childhood*, trans. Joachim Neugroschel (Continuum, 1979), p. 44.
15. Hobsbawm, *Interesting Times* (Allen Lane, 2002), pp. 73–4.
16. Ibid, p. 88.
17. Ibid, p. 91.
18. Ibid, p. 93.
19. Hilde Spiel, *The Dark and the Bright: Memoirs, 1911–1989*, trans. Christine Shuttleworth (Ariadne, 2007), p. 101.
20. Ibid, p. 99.
21. Stefan Zweig, *The World of Yesterday* (Pushkin Press, 2011), trans. Anthea Bell, p. 399.
22. Charlotte Wolff, *Hindsight: An Autobiography* (Plunkett Lake Press, 2013), ebook, loc 2895.

Chapter 4

1. For more on this, see Jean-Michel Palmier's great *Weimar in Exile* (Verso, 2006), which mainly deals with the American, French and Czechoslovak emigration, with Britain relegated to a short chapter. There are many books on the American emigration, but one great one: Anthony Helibut's *Exiled in Paradise* (Viking, 1983).
2. Christopher Isherwood, *Christopher and His Kind* (Magnum, 1978), p. 10.
3. Stephen Spender, *The Temple* (Faber, 1988), p. 7.
4. With the exception of a peripheral member of that circle, the novelist and lifelong Marxist Edward Upward.
5. W. H. Auden, 'In Memory of Ernst Toller', in *Another Time* (Faber, 2019), p. 101.
6. Christopher Isherwood, *Prater Violet* (Penguin, 1961), p. 54.
7. Ibid, p. 99.

Chapter 5

1. Koestler, *The Invisible Writing*, pp. 229–30. Koestler, like most of his generation, reveals a blind spot for the British Empire's own concentration camps (in South Africa and Kenya), state-inflicted famines (in India) and genocides (in Australia and Canada), which of course all took place a long distance from the imperial centre itself.
2. Ibid, p. 465.
3. Judith Kerr, *Bombs on Aunt Dainty* (HarperCollins, 2017), pp. 133–4.
4. Quoted by Michael Seyfert, 'His Majesty's Most Loyal Internees', in Gerhard Hirschfeld (ed.), *Exile in Great Britain: Refugees from Hitler's Germany*

(Berg, 1984), p. 187. On Volkmann – who never wrote poetry before or after his internment – see the 'Dunera Stories' entry at https://www.dunerastories.monash.edu/mysteries/218-his-majesty-s-most-loyal-internee-the-mystery-of-oswald-volkmann.html

5. Sebastian Haffner, *Germany: Jekyll and Hyde* (Plunkett Lake Press, 2012), ebook, loc 3381.
6. Bernard Wasserstein, 'Intellectual Émigrés in Britain', in Jarrell C. Jackman and Carla M. Borden (eds.), *The Muses Flee Hitler: Cultural Transfer and Adaptation, 1930–1945* (Smithsonian Institution Press, 1983), p. 253.
7. The classic work on this failure is Louise London, *Whitehall and the Jews* (Cambridge University Press, 2000).
8. Chamberlain's broadcast is online at https://www.bbc.co.uk/archive/chamberlain-addresses-the-nation-on-his-negotiations-for-peace/zjrjgwx
9. Cited in Maya Goodfellow's excellent history of British immigration policy, *Hostile Environment: How Immigrants Became Scapegoats* (Verso, 2019), pp. 53–4.
10. David Cesarani, 'An Alien Concept?', in David Cesarani and Tony Kushner (eds.), *The Internment of Aliens in Twentieth-Century Britain* (Frank Cass, 1993), p. 29.
11. Francis L. Carsten, 'German Refugees in Great Britain 1933–1945: A Survey', in Hirschfeld (ed.), *Exile in Great Britain*, p. 12.
12. The debate is on the Hansard website at https://api.parliament.uk/historic-hansard/commons/1933/mar/09/aliens
13. Figures from 'German Refugees in Great Britain 1933–1945: A Survey', p. 13.
14. Reproduced in Waterhouse, *Their Safe Haven*, p. 74.
15. Ronald Stent, *A Bespattered Page? The Internment of His Majesty's Most Loyal Enemy Aliens* (André Deutsch, 1980), p. 56.
16. Stent, *A Bespattered Page?*, p. 47.
17. Seyfert, 'His Majesty's Most Loyal Internees', p. 168.
18. Tony Kushner, 'Clubland, Cricket Tests and Alien Internment', in *The Internment of Aliens in Twentieth-Century Britain*, is luridly fascinating on the malevolent Ball and his network.
19. Bernard Wasserstein, *Britain and the Jews of Europe, 1939–1945* (Oxford, 1988), p. 92.
20. Stent, *A Bespattered Page?*, p. 37.
21. Ibid, p. 34.
22. Ibid, p. 38.
23. Jessica Feather, *Art Behind Barbed Wire* (Liverpool Museums, 2004), p. 13.
24. Connery Chappell, *Island of Barbed Wire* (Robert Hale, 2017), ebook, loc 485.
25. Wasserstein, *Britain and the Jews of Europe, 1939–1945*, p. 91.
26. Daniel Snowman, *The Hitler Émigrés* (Chatto and Windus, 2002), p. 108.
27. Chappell, *Island of Barbed Wire*, loc 383.
28. Wasserstein, *Britain and the Jews of Europe, 1939–1945*, p. 97.

NOTES

29. F. Lafitte, *The Internment of Aliens* (Penguin, 1940), trenchantly trailed on its cover as 'a lamentable story of muddle and stupidity'.
30. Chappell, *Island of Barbed Wire*, loc 963.
31. Stent, *A Bespattered Page?*, p. 167.

Chapter 6

1. Quoted in Hammer and Lodder, *Constructing Modernity*, p. 284.
2. E. H. Gombrich, *A Lifelong Interest: Conversations with Didier Eribon* (Thames and Hudson, 1993), p. 14.
3. Isaac Deutscher, *The Non-Jewish Jew and Other Essays* (Oxford University Press, 1968), p. 27.
4. Ibid, p. 35.
5. Hobsbawm, *Interesting Times*, p. 24.
6. Marion Berghahn, *Continental Britons: German-Jewish Refugees from Nazi Germany* (Berghahn, 2011).
7. Deutscher, *The Non-Jewish Jew and Other Essays*, p. 58.
8. Ibid, p. 52.
9. Wolff, *Hindsight: An Autobiography*, loc 2769.
10. George Mikes, *How to Be an Alien: A Handbook for Beginners and Advanced Pupils* (Penguin, 1966), p. 50.
11. Ibid, p. 16.
12. Ibid, p. 36.
13. A good place to start here for those curious is *The Ambassador*, a mid-century modernist trade magazine for the British textile industry, run by the anti-fascist German émigré couple of editor Hans and photographer Elsbeth Juda, and with design by Trude Ettinger, aka 'Ett', a Czech refugee; see Christopher Breward and Claire Wilcox, *The Ambassador Magazine: Promoting Post-War British Textiles and Fashion* (Victoria and Albert Museum, 2012).
14. A major discoverer has been the Insiders-Outsiders project, launched for the Bauhaus centenary in 2019 by the scholar Monica Bohm-Duchen: I would have found this book much harder to write without their research and, particularly, their superlative YouTube channel of lectures, available online at https://www.youtube.com/channel/UCUpgH8wI9DOonxxMY3t_RoA. Similarly invaluable has been the website, collection and publications of the Ben Uri Gallery in London, set up in 1915, which has over time become an immense repository of the migrant, and especially Jewish, experience in British art.

NOTES

PART ONE

1. Tom Hopkinson, *Picture Post 1938–50* (Penguin, 1970), p. 21.

Chapter 7

1. Stefan Lorant, *I Was Hitler's Prisoner*, trans. James Clough (Penguin Special, 1939).
2. Quoted in Michael Hallett, *Stefan Lorant: Godfather of Photojournalism* (Scarecrow Press, 2006), p. 69.
3. Gavin Weightman, *Picture Post Britain* (Tiger Books, 1991), p. 7.
4. A good English-language digest of Weimar photojournalism can be found in Torsten Palmer and Henrik Neubauer, *The Weimar Republic Through the Lens of the Press* (Konemann, 2001).
5. Hallett, *Stefan Lorant*, p. 10.
6. Ibid, p. 11.
7. Ibid.
8. Ibid, p. 24.
9. Ibid, p. 35.
10. Lorant, *I Was Hitler's Prisoner*, p. 189.
11. Ibid, p. 18.
12. Hallett, *Stefan Lorant*, p. 56.
13. Michael Berkowitz, 'Émigré Photographers', in Monica Bohm-Duchen (ed.), *Insiders-Outsiders: Refugees from Nazi Europe and their Contribution to British Visual Culture* (Lund Humphries, 2019), p. 64.
14. Quoted in John Chillingworth and Colin Wilkinson (eds.), *Kurt Hutton: The Quiet Pioneer* (Bluecoat, 2018), p. 23.
15. Tom Hopkinson, *Of This Our Time: A Journalist's Story* (Hutchinson, 1982), p. 148.
16. Hallett, *Stefan Lorant*, p. 71.
17. The pages are included in Kaye Webb (ed.), *Lilliput Goes to War* (Hutchinson, 1985), pp. 15–16.
18. Hopkinson, *Of This Our Time*, p. 159.
19. Tom Hopkinson, *Picture Post 1938–1950* (Penguin, 1970), p. 9.
20. Hopkinson, *Of This Our Time*, p. 170.
21. Amanda Hopkinson, 'Strongly Political and Anti-Fascist', in Bohm-Duchen (ed.), *Insiders-Outsiders*, p. 132.
22. Hopkinson, *Picture Post 1938–1950*, p. 11.
23. Quoted in Brent Maddox, 'Finding Aid for the Stefan Lorant Collection', Online Archive of California, https://oac.cdlib.org/findaid/ark:/13030/tf6d 5nb1hh/entire_text
24. Hopkinson, *Of This Our Time*, p. 170.

NOTES

25. Ibid, p. 185.
26. Tom Wintringham, 'ARM THE CITIZENS!', *Picture Post*, 29 June 1940.
27. Hopkinson, *Picture Post 1938–1950*, p. 15.
28. Felix H. Man, *Man with Camera: Photographs from Seven Decades* (Secker and Warburg, 1983), unpaginated.
29. Ibid.
30. I owe both of these references to Chillingworth and Wilkinson (eds.), *Kurt Hutton: The Quiet Pioneer*.
31. For more on this aspect of *Picture Post*'s work, see Stuart Hall, David Hurn and Glen Jordan, *Down the Bay: Picture Post, Humanist Photography and Images of 1950s Cardiff* (Butetown History and Arts Centre, 2003).
32. Man, *Man with Camera*, unpaginated.
33. Amanda Hopkinson, 'Gerti Deutsch of Vienna', in Kurt Haindl (ed.), *Gerti Deutsch: Photographs 1935–1965* (Fotohof, 2011), p. 7.
34. Haindl (ed.), *Gerti Deutsch*, p. 136.
35. I owe this reference to the exhibition catalogue by Carla Mitchell and John March, *Another Eye: Women Refugee Photographers after 1933* (Four Corners, 2022).

Chapter 8

1. See Duncan Forbes' excellent *Edith Tudor-Hart: In the Shadow of Tyranny* (Hatje Cantz, 2013).
2. On Heartfield's terribly disappointing British work, see Jutta Vinzent, *Identity and Image: Refugee Artists from Nazi Germany in Britain* (Guernica Gesellschaft, 2006), pp. 128–35. Perhaps his only montage of note was for *Freedom Calling!*, an anonymous book on anti-fascist German radio, written by the Communist journalist Jurgen Kuczynski. It features Heartfield, behind Hitler, throwing an electric shock at him through the airwaves; it is the only depiction of Heartfield himself in one of his montages.
3. Paul Delany, *Bill Brandt: A Life* (Jonathan Cape, 2004), p. 10.
4. Ibid, p. 91.
5. Bill Brandt, *The English at Home* (Batsford, 1936), unpaginated.
6. Delany, *Bill Brandt*, p. 109.
7. Ibid, p. 179.
8. Alexandra Harris, *Romantic Moderns* (Thames and Hudson, 2010), p. 163.
9. Ibid, p. 247.
10. Bill Brandt and Norah Wilson, *Camera in London* (Focal Press, 1948), p. 7.
11. Ibid, p. 14.
12. Ibid, p. 19.
13. Ibid, p. 26.
14. Delany, *Bill Brandt*, p. 226.

NOTES

15. Bill Brandt, 'From Mud to Festival', *Picture Post*, 5 May 1951.
16. The story can be found in *The Bedside Lilliput* (Hulton Press, 1950), pp. 335–42.
17. See David Mellor, 'Brandt's Phantasms', in Mark Howarth-Booth (ed.), *Bill Brandt: Behind the Camera* (Aperture, 1985).

Chapter 9

1. Lucia Moholy, *A Hundred Years of Photography* (Pelican Special, 1939), p. 161.
2. Ibid, p. 166.
3. Ibid, p. 178.
4. Ibid, p. 16.
5. Ibid, p. 31.
6. Ibid, p. 38.
7. Ibid, p. 101.
8. Michael Berkowitz, 'Émigré Photographers', in Bohm-Duchen (ed.), *Insiders-Outsiders*, p. 65.
9. James Pope-Hennessy, 'Foreword', in Helmut Gernsheim, *Beautiful London* (Phaidon, 1950), p. 5.
10. Ibid, p. 6.
11. Helmut and Alison Gernsheim, *A Concise History of Photography* (Thames & Hudson, 1971), p. 214.
12. Quentin Bell, Alison Gernsheim and Helmut Gernsheim, *Those Impossible English* (Weidenfeld and Nicolson, 1952), p. 44.
13. Ibid, p. 7.
14. Ibid, p. 2.
15. Ibid, p. 53.
16. Ibid, p. 52.
17. Ibid, p. 63.
18. Ibid, p. 46.
19. Helmut and Alison Gernsheim, *Historic Events, 1839–1939* (Longmans, 1960), p. vii.
20. Ibid, p. 3.
21. Ibid, p. 21.
22. Andrew Sargent, *John Gay: England Observed* (English Heritage, 2009), p. 24.
23. Gavin Stamp, 'Introduction', in John Gay, *Cast Iron: Function and Fantasy* (John Murray, 1985), p. 16.
24. These photographs are all in Sargent, *John Gay*.
25. Hans Gohler, 'But One True Viewpoint', ibid, p. 319.
26. A rare and interesting recent account of the artistic cultures of this short-lived socialist republic is Bob Dent, *Painting the Town Red: Politics and the Arts during the 1919 Hungarian Soviet Republic* (Pluto Press, 2018).

27. But for well-argued contrary views, see Powers, *Bauhaus Goes West*, p. 147, and Valeria Carullo, *Moholy-Nagy in Britain, 1935–1937* (Lund Humphries, 2019).
28. L. Moholy-Nagy, *Street Markets of London* (Blom, 1972).
29. Though, as Powers points out in *Bauhaus Goes West*, Eton was one of the few British institutions to commission a building by a Bauhaus exile – a pair of masters' houses by Marcel Breuer with F. R. S. Yorke.

Chapter 10

1. Kiri Bloom Walden, *British Film Studios* (Shire, 2013), p. 34.
2. Graham Greene, 'The Marriage of Corbal', in *The Pleasure Dome: The Collected Film Criticism, 1935–1940* (Oxford University Press, 1980), pp. 78–80.
3. The major book on Weimar in Hollywood is John Russell Taylor, *Strangers in Paradise: The Hollywood Émigrés, 1933–1950* (Faber, 1983).
4. Kevin Brownlow, *The Parade's Gone By . . .* (Secker and Warburg, 1973), p. 591. For a bad-tempered Althusserian argument as to exactly why this was, see Roy Armes, *A Critical History of British Cinema* (Secker and Warburg, 1978).
5. Quoted in Kevin Gough-Yates, 'The British Feature Film as a European Concern: Britain and the Émigré Film-Maker, 1933–45', in Gunter Berghaus (ed.), *Theatre and Film in Exile* (Berg, 1989), p. 136.
6. Michael Korda, *Charmed Lives: A Family Romance* (Penguin, 1980), p. 62.
7. Mikes, *How to Be an Alien*, p. 61.
8. Korda, *Charmed Lives*, p. 101.
9. Ibid, p. 102.
10. The essay is reproduced in Scott Anthony's excellent *Public Relations and the Making of Modern Britain* (Manchester University Press, 2013).
11. Quoted in Gough-Yates, 'The British Feature Film as a European Concern', p. 150.
12. Quoted in the unpaginated booklet to the BFI's DVD *Lotte Reiniger: The Fairy Tale Films* (2008).
13. Nor was she the only major émigré animator. The pioneering Hungarian animator János Halász (John Halas) carved out an impressive career making first public-information films and then features, culminating in his classic 1954 film of Orwell's *Animal Farm*, one of several co-directed with Joy Batchelor. It was funded by the CIA.
14. Indeed, Powell credited some of the films – most notably *A Canterbury Tale* – as being almost wholly the work of Pressburger. Kevin Macdonald, *Emeric Pressburger: The Life and Death of a Screenwriter* (Faber, 1994), p. 381.

NOTES

15. Gough-Yates, 'The British Feature Film as a European Concern', p. 152. For a good short book on the film that stresses the émigré contribution, see Pam Cook, *I Know Where I'm Going!* (BFI, 2021).
16. In his filmed lecture *Made in England: The Films of Powell and Pressburger*, directed by David Hinton (2024).
17. Ian Christie, *A Matter of Life and Death* (BFI, 2021), pp. 56–7.
18. As revealed in Macdonald, *Emeric Pressburger*.

Chapter 11

1. Both events involved many of the same actors, from young intellectuals to the workers of Budapest's Csepel engineering works, but the political colours were reversed.
2. Notably, its vision of popular culture is much more sympathetic than Lindsay Anderson's misanthropic Free Cinema short *O Dreamland*, a peevishly nightmarish depiction of Margate.
3. Quoted in the unpaginated booklet to the BFI's box set *Free Cinema* (2006).
4. From a 1958 article in *Universities and Left Review*, the precursor to the *NLR*, quoted in Colin Gardner's thoughtful and dense *Karel Reisz* (Manchester University Press, 2006), p. 62. For a brilliantly, even eccentrically contrary account of 'the projection of England' from that of the Free Cinema group, see Raymond Durgnat's *A Mirror for England: British Movies from Austerity to Affluence* (Faber, 1970) – a *mostly* convincing critique from the left of what Isaac Deutscher described as the English intellectual's tendency to 'national nihilism'.
5. I owe this point to David Mellor, 'Brandt's Phantoms', in his *Bill Brandt: Behind the Camera* (Aperture, 2005).
6. Walter Lassally, 'Shooting *A Taste of Honey* on location', online at https://www.youtube.com/watch?v=56ENiXKHohU&ab_channel=WebofStories-LifeStoriesofRemarkablePeople. See also Lassally's garrulous but charming autobiography, *Itinerant Cameraman* (John Murray, 1987).
7. Quoted in Ronald Bergan, 'Sir Ken Adam Obituary', *Guardian*, 11 March 2016.

PART TWO

1. Jan Tschichold, 'Mass Producing the Classics', appendix to Richard B. Doubleday, *Jan Tschichold, Designer: The Penguin Years* (Lund Humphries, 2006), p. 151.

NOTES

CHAPTER 12

1. I am more or less describing here the bookshelves of my maternal grandfather and grandmother, Communist schoolteachers who lived in the outer suburbs of Southampton.
2. Outside the remit of this chapter are the other important German and Austrian émigré publishers in Britain, such as André Deutsch or Weidenfeld & Nicolson – important in their way, but not quite so decisive in bringing an entirely new way of reading and seeing to British eyes.

Chapter 13

1. Jerry Kelly, *The Officina Bodoni and the Stamperia Valdonega* (The Grolier Club, 1991), p. 7.
2. On these, see John Lewis, *The Left Book Club: An Historical Record* (Gollancz, 1970).
3. George Orwell, 'Arthur Koestler', in *As I Please: The Collected Essays, Journalism and Letters, Volume 3* (Penguin, 1978), pp. 271–2. Before one praises Orwell's apparent sympathy for the émigré, one should note his private opinions in his wartime diaries: 'what I do feel is that any Jew, i.e. European Jew, would prefer Hitler's kind of social system to ours, if it were not that he happens to persecute them. Ditto with almost any Central European, e.g. the refugees. They make use of England as a sanctuary, but they cannot help feeling the profoundest contempt for it. You can see this in their eyes, even when they don't say it outright.' 'War-Time Diary: 1940', in *My Country Right or Left: The Collected Essays, Journalism and Letters, Volume 2* (Penguin, 1978), p. 428.
4. Victor Gollancz, *Reminiscences of Affection* (Gollancz, 1968), pp. 100–1.
5. Michelle E. Troy, *Strange Bird: The Albatross Press and the Third Reich* (Yale University Press, 2017), p. 54.
6. For an insightful revisionist political history of the 'Specials' – which, however, totally ignores the international dimension – see Dean Blackburn, *Penguin Books and Political Change* (Manchester University Press, 2020).
7. Hans Schmoller, *The Paperback Revolution: An Essay* (Penguin Collectors Society, 2016), pp. 285–94.
8. Jeremy Lewis, *Penguin Special: The Life and Times of Allen Lane* (Viking, 2005), p. 79.
9. For some penetrating essays that set Tschichold in this context, see Robin Kinross, 'Jan Tschichold', 'Universal Faces, Ideal Characters' and 'The Bauhaus Again', in *Unjustified Texts: Perspectives on Typography* (Editions B42, 2020).
10. See the scathing account of Swiss meanness in Palmier, *Weimar in Exile*.

11. Ruari Maclean, 'Preface' to Jan Tschichold, *Asymmetric Typography* (Faber, 1967), trans. Ruari Maclean, p. 10.
12. W. E. Trevett, 'Introduction' to Tschichold, *Asymmetric Typography*, p. 11.
13. Tschichold, *Asymmetric Typography*, p. 19.
14. Ibid, p. 16.
15. Ibid, p. 36.
16. Ibid, p. 26.
17. Ibid, p. 20.
18. Ibid, p. 84.
19. Ibid, p. 93.
20. Ibid, p. 20.
21. Herbert Spencer, *Pioneers of Modern Typography* (Lund Humphries, 1969), p. 51.
22. Jan Tschichold, *The Form of the Book: Essays on the Morality of Good Design* (Lund Humphries, 1991), trans. Hajo Hadeler, p. 7.
23. Quoted in Robert Bringhurst, 'Introduction' to Tschichold, *The Form of the Book: Essays on the Morality of Good Design*, p. xv. In his book on Tschichold's Penguin years, Richard Doubleday suggests this was just as much an adaptation to market demands – in Switzerland, the New Typography was regarded with suspicion by many publishers, and deportations of Weimar refugees were common – and to a change in commissions towards new editions of the classics. Tschichold, a logical man, did not consider it appropriate to design Constructivist covers for Shakespeare. Doubleday, *Jan Tschichold, Designer*, p. 17.
24. Tschichold, *The Form of the Book*, p. 5.
25. Ibid, p. 6.
26. Ibid, p. 10.
27. Ibid, pp. 10–11.
28. Ibid, p. 123.
29. Ibid, p. 175.
30. Doubleday, *Jan Tschichold, Designer*, p. 29.
31. Quoted in ibid, p. 22.
32. Jan Tschichold, 'My Reform of Penguin Books', appendix to Doubleday, *Jan Tschichold, Designer*, p. 149.
33. Tschichold, 'My Reform of Penguin Books', pp. 143–4.
34. Ibid, p. 141.
35. 'Erik Ellergard Frederiksen in conversation with Colin Banks', appendix to Doubleday, *Jan Tschichold, Designer*, p. 173.
36. Ruari Maclean, *Jan Tschichold: A Life in Typography* (Princeton Architectural Press, 1997), p. 12.
37. 'Erik Ellergard Frederiksen in conversation with Colin Banks', appendix to Doubleday, *Jan Tschichold, Designer*, p. 174.
38. Doubleday, *Jan Tschichold, Designer*, p. 41.

39. Jan Tschichold, 'Mass Producing the Classics', appendix to Doubleday, *Jan Tschichold, Designer*, p. 151.

Chapter 14

1. Lewis, *Penguin Special*, p. 219.
2. Paula Rabinowitz, *American Pulp: How Paperbacks Brought Modernism to Main Street* (Princeton University Press, 2017), p. 4.
3. Gerald Cinamon, *Hans Schmoller, Typographer: His Life and Work* (The Monotype Recorder, 1987), p. 84.
4. Ibid, p. 1.
5. On Friedlander, see Billie Muraben, 'Elizabeth Friedlander: One of the First Women to Design a Typeface', in *It's Nice That*, 8 March 2018, online at https://www.itsnicethat.com/features/elizabethfriedlander-graphicdesign-internationalwomensday-080318
6. Phil Baines, *Penguin by Design* (Penguin, 2005), p. 70.
7. Cinamon, *Hans Schmoller, Typographer*, p. 24.
8. Phil Baines and Steve Hare (eds.), *Penguin by Designers* (Penguin Collectors Society, 2007), p. 19.
9. Quoted in Lewis, *Penguin Special*, p. 249.
10. Cinamon, *Hans Schmoller, Typographer*, p. 49.
11. For a very enjoyable sort of 'Pan by Design' with all the values reversed, see Colin Larkin, *Cover Me: The Vintage Art of Pan Books, 1950–1965* (Telos, 2022).
12. Naomi Games, *Abram Games and Penguin Books* (Penguin Collectors Society, 2013), p. 9.
13. Ibid, pp. 27–8.
14. Phil Baines, *Puffin by Design* (Penguin, 2010), p. 12.
15. Romek Marber, preface to Games, *Abram Games and Penguin Books*, p. 4.
16. Baines and Hare, *Penguin by Designers*, p. 67.
17. Ibid, p. 64.
18. Lewis, *Penguin Special*, p. 349.
19. Baines, *Penguin by Design*, p. 158.
20. Berthold Wolpe, *A Retrospective Survey* (Merrion Press, 2005), unpaginated.
21. Ibid.
22. John Bodley, 'Berthold Wolpe at Faber and Faber', in Wolpe, *A Retrospective Survey*, unpaginated.

Chapter 15

1. Lewis, *Penguin Special*, p. 144.
2. E. H. Gombrich and Ernst Kris, *Caricature* (Penguin, 1940). For a fascinating study of the original project, see Louis Rose, *Psychology, Art, and Antifascism: Ernst Kris, E. H. Gombrich and the Politics of Caricature* (Yale University Press, 2016).
3. Ibid, pp. 26–7.
4. Ibid, p. 4.
5. Ibid, p. 18.
6. Ibid, p. 13.
7. Doubleday, *Jan Tschichold, Designer*, p. 61.
8. L. D. Ettlinger, *Compliments of the Season* (Penguin, 1947), p. 7.
9. Ibid, p. 32.
10. Ibid, pp. 20–1.
11. Ibid, p. 28.
12. Ibid, p. 35.
13. Nikolaus Pevsner, *The Leaves of Southwell* (Penguin, 1945), p. 14.
14. Ibid, p. 35.
15. I owe this point to Susie Harries, *Nikolaus Pevsner: The Life* (Chatto & Windus, 2011), p. 323.
16. Pevsner, *The Leaves of Southwell*, p. 65.
17. Christopher S. Wood, *A History of Art History* (Princeton University Press, 2019), p. 329. For an interesting account of the politics of German art history before and during the Weimar era, see Frederic J. Schwartz, *Blind Spots: Critical Theory and the History of Art in Twentieth-Century Germany* (Yale University Press, 2005).
18. Wood, *A History of Art History*, p. 319.
19. Heinrich Wölfflin, *Renaissance and Baroque*, trans. Kathrin Simon (Fontana, 1979), p. 45.
20. Ibid, p. 51.
21. Ibid, pp. 64–5.
22. Ibid, p. 73.
23. Ibid, p. 79. Historians of footwear have, incidentally, debunked this one.
24. See here the Warburg Institute's interactive page on the map, at https://warburg.sas.ac.uk/archive/bilderatlas-mnemosyne
25. Edgar Wind, 'Warburg's Concept of *Kulturwissenschaft* and its Meaning for Aesthetics', in Donald Preziosi, *The Art of Art History: A Critical Anthology* (Oxford, 1998), p. 212.
26. Gay, *Weimar Culture*, p. 35.
27. Gombrich, *A Lifelong Interest*, p. 62. For a recent study of the Warburg's various homes, see Tim Anstey and Mari Lending, *Warburg Models: Buildings as Bilderfahrzeuge* (Hatje Cantz, 2023).

NOTES

28. On this, see Hans-Christian Hones, 'A Very Specialised Subject: Art History in Britain', in Bohm-Duchen (ed.), *Insiders-Outsiders*, pp. 100–1.
29. F. Saxl and R. Wittkower, *British Art and the Mediterranean* (Oxford University Press, 1969), unpaginated.
30. Ibid.
31. Quoted in Stephen Games, *Pevsner: The Early Life* (Continuum, 2010), p. 101.
32. Pinder shared this view; on his continued enthusiasm for modern architecture despite his Nazi politics, see Frederic J. Schwartz, *Blind Spots: Critical Theory and the History of Art in Twentieth-Century Germany* (Yale University Press, 2005).
33. Games, *Pevsner*, p. 215.
34. See Paul D. Lickiss, *Pelicans at Eighty: A Visual History* (Penguin Collectors Society, 2017), p. 43.
35. Harries, *Nikolaus Pevsner*, p. 562.
36. Geoffrey Scott, *The Architecture of Humanism* (Kindle, 2014), ebook, loc 331.
37. Ibid, loc 196.
38. Rudolf Wittkower, *Architectural Principles in the Age of Humanism* (Academy Editions, 1974), p. 21.
39. Ibid, p. 101.
40. Ibid, p. 27.
41. Ibid, p. v.
42. Rudolf Wittkower, *Art and Architecture in Italy, 1600–1750* (Penguin, 1982), p. 21.
43. Ibid, p. 141.
44. Peter Lasko, *Ars Sacra* (Yale University Press, 1994), p. x.

Chapter 16

1. Anna Nyburg, 'Émigré Art Publishers', in Bohm-Duchen (ed.), *Insiders-Outsiders*, p. 116.
2. Tom Rosenthal, 'Walter and Eva Neurath', in Richard Abel and Gordon Graham (eds.), *Immigrant Publishers: The Impact of Expatriate Publishers in Britain and America in the Twentieth Century* (Transaction, 2009), p. 111.
3. Anna Nyburg, *Émigrés: The Transformation of Art Publishing in Britain* (Phaidon, 2014), p. 20.
4. E. H. Gombrich, *A Little History of the World*, trans. Caroline Mustill (Yale University Press, 2008), pp. 245–6.
5. Abel and Graham (eds.), *Immigrant Publishers*, p. 111.
6. Nyburg, *Émigrés*, p. 156.
7. Francis Meynell, *English Printed Books* (Collins, 1946), p. 45.
8. Ibid, p. 10.

9. For a heavily illustrated study of these series, see Christopher Burke and Wim Jansen, *Soft Propaganda, Special Relationships and a New Democracy: Adprint and Isotype, 1942–1948* (Uitgeverij de Buitenkant, 2022).
10. See her own account in Marie Neurath and Robin Kinross, *The Transformer* (Hyphen Press, 2009); for a good synoptic book on Isotype, see Nader Vossoughian, *Otto Neurath and the Language of the Global Polis* (NAI, 2011).
11. Reproduced in Ursula Prokop, *Jacques and Jacqueline Groag, Architect and Designer: Two Hidden Figures of the Viennese Modern Movement*, trans. Laura McGuire and Jonee Tiedemann (DoppelHouse Press, 2019), p. 175.
12. Jacques Groag and Gordon Russell, *The Story of Furniture* (Pelican, 1946).
13. For a neat survey of their work, see Ruth Artmonsky, *Lewitt-Him: Design* (Antique Collectors Club, 2008).
14. Another vector for this was toy design, which had significant émigré presence through Ernő Goldfinger's work for Abbatt's Toys – see Alan Powers, *Abbatt's Toys: Modern Toys for Modern Children* (Design for Today, 2021).
15. E. H. Gombrich, *The Story of Art* (Phaidon, 1970), p. 5.
16. Ibid, p. 9.
17. Ibid, p. 17.
18. Ibid, p. 381.
19. Ibid, p. 48.
20. Carlo Ginzburg, 'From Aby Warburg to E. H. Gombrich: A Problem of Method', in *Clues, Myths and the Historical Method* (Johns Hopkins University Press, 2013), p. 41. But for an unadulterated blast of Warburg thought at its wildest, see Fritz Saxl's *A Heritage of Images* (Peregrine, 1970), edited and introduced by Gombrich, published – in paperback, in Penguins! – after Saxl's death. Certainly, one can't imagine Gombrich, midway through a 1936 lecture on astrology to classicists in Southampton, pausing to note 'we are today again at a stage where the pagan demons recur in some form or other' (p. 35).
21. Nyburg, *Émigrés*, p. 9.
22. Eva Neurath, *Recollections, 1908–1999*, edited by Stephen Feuchtwang (Thames and Hudson, 2016), ebook, loc 434.
23. Ibid, loc 482.
24. Ibid, loc 181.
25. Ibid, loc 662.
26. On Adams-Teltscher, see Powers, *Bauhaus Goes West*, p. 226.
27. Neurath, *Recollections, 1908–1999*, loc 826.
28. Abel and Graham, *Immigrant Publishers*, p. 111.
29. For good short studies of Antal, Hauser and Klingender, see the essays on each of them in Andrew Hemingway (ed.), *Marxism and the History of Art: From William Morris to the New Left* (Pluto Press, 2006).
30. On Hoffmann, see Lucy Watling's paper 'Émigré to Editor: Edith Hoffmann and the *Burlington Magazine*, 1938–1951', available online at the

NOTES

Tate website: https://www.tate.org.uk/about-us/projects/art-writers-britain/hodin-hoffman/emigre-editor
31. Anderson, *English Questions*, p. 85.
32. Miranda Carter, *Anthony Blunt: His Lives* (Macmillan, 2001), pp. 126–7.
33. Frederick Antal, *Classicism and Romanticism, with Other Studies in Art History* (Routledge and Kegan Paul, 1966), p. 147.
34. Ibid, p. 13.
35. Ibid, p. 41.
36. Francis Klingender, *Art and the Industrial Revolution* (Paladin, 1968), p. 4.
37. Ibid, p. 22.
38. Ibid, p. 75.
39. Ibid, pp. 145–6.

PART THREE

1. Hammer and Lodder, *Constructing Modernity*, p. 271.

Chapter 17

1. Quoted in Burcu Dogramaci, '20th Century German Art', *METROMOD Archive* (2021), online at https://archive.metromod.net/viewer.p/69/1470/object/5141-11260411
2. Bohm-Duchen, 'Accents in Art', in *Insiders-Outsiders*, p. 23.
3. Cited in Olaf Peters (ed.), *Degenerate Art: The Attack on Modern Art in Nazi Germany* (Neue Galerie, 2014), p. 25.
4. On the changes in Goebbels' artistic views – hailing the sculpture of Ernst Barlach in the 1920s and regarding it with horror and disgust in the 1930s – see Karsten Mueller, 'Violent Vomiting Over Me', in Peters (ed.), *Degenerate Art*. It is perhaps an error to ascribe any particular aesthetic sympathies to Goebbels – an authoritative recent biography portrays rather a media empire that alternated between the promotion of light entertainment and the instigation of pogroms. See Peter Longerich, *Goebbels: A Biography* (The Bodley Head, 2015).
5. Peters (ed.), *Degenerate Art*, p. 27.
6. Stephanie Barron (ed.), *Degenerate Art: The Fate of the Avant-Garde in Nazi Germany* (Los Angeles County Museum of Art, 1991), p. 19.
7. Mario-Andreas von Lüttichau, '*Entartete Kunst* in Munich – a Reconstruction', in ibid, p. 45.
8. Ibid.
9. Peters (ed.), *Degenerate Art*, p. 117.
10. Mario-Andreas von Lüttichau, 'Crazy at any Price', in Peters (ed.), *Degenerate Art*, p. 49.

11. Stephanie Barron, '1937: Art and Politics in Prewar Germany', in Barron (ed.), *Degenerate Art*, p. 9.
12. Herbert Read, *Art Now: An Introduction to the Theory of Modern Painting and Sculpture* (Faber, 1936), p. 11.
13. Ibid, pp. 12–13.
14. Ibid, p. 85.
15. Ibid, p. 93.
16. *Exhibition of Twentieth Century German Art* (New Burlington Galleries, 1938), pp. 6–7.
17. This argument is made by Keith Holz in *Modern German Art for Thirties Paris, Prague and London* (University of Michigan Press, 2004), p. 129.
18. All information here comes from Lucy Wasensteiner's exceptional research in *The Twentieth Century German Art Exhibition: Answering Degenerate Art in 1930s London* (Routledge, 2019).
19. *Exhibition of Twentieth Century German Art* (New Burlington Galleries, 1938), p. 5.
20. Holz, *Modern German Art for Thirties Paris, Prague and London*, p. 203.
21. Herbert Read, 'Introduction', in Peter Thoene, *Modern German Art* (Pelican Special, 1938), p. 7.
22. Ibid, p. 8.
23. Ibid, p. 15.
24. Ibid, p. 50.
25. Ibid, p. 61.
26. Ibid, pp. 78–80.
27. Ibid, p. 41.
28. Quoted in Wasensteiner, *The Twentieth Century German Art Exhibition*, ebook, loc 379.
29. Holz, *Modern German Art for Thirties Paris, Prague and London*, p. 219.
30. This spectacularly odd address is reproduced in full in Max Beckmann, 'On My Painting', in *Max Beckmann: A Small Loan Retrospective of Paintings, Centred Around His Visit to London in 1938* (Marlborough Fine Art, 1974).
31. Quoted in Wasensteiner, *The Twentieth Century German Art Exhibition*, ebook, loc 575.
32. Eric Newton, '"Degenerate Art" – Expressionism in London', in *Max Beckmann: A Small Loan Retrospective of Paintings, Centred Around His Visit to London in 1938*, p. 57.
33. *Max Beckmann: A Small Loan Retrospective of Paintings, Centred Around His Visit to London in 1938*, p. 58.
34. Cited in Dorothea Schoene, *New/Old Homeland: R/emigration of Artists after 1945* (Kunsthaus Dahlem, 2017), p. 81.
35. This and subsequent quotes from the reprint, *Mid-European Art: Exhibition Catalogue, 1944* (Leicester Museums and Galleries, 2009).

36. Quoted in Simon Lake's fascinating essay, 'A Short History of Leicester's Early Twentieth-Century German Art Collection', in Bohm-Duchen (ed.), *Insiders-Outsiders*, p. 138.
37. Barry Herbert and Alisdair Hinshelwood, *The Expressionist Revolution in German Art* (Leicester Museums, 1978), p. viii. For a useful account of how much Leicester was going against the grain, and just how impressive the collection is – far more so than the pre-1945 German collections in Tate Modern – see Christian Weikop, 'Assessment of the significance of the collection as a key asset in the understanding of German Expressionism within the United Kingdom', online at https://germanexpressionismleicester.org/leicesters-collection/academic-reports/academic-reports-on-the-collection/report-3-uk-significance-of-the-collection

Chapter 18

1. It lent its name to an exhibition and catalogue on German émigré artists – Sarah MacDougall (ed.), *Finchleystrasse: German Artists in Great Britain and Beyond* (Ben Uri, 2018).
2. Spiel, *The Dark and the Bright*, p. 127.
3. Ibid, p. 249.
4. Jeremy Adler, 'Introduction' to Elias Canetti, *Party in the Blitz*, trans. Michael Hofmann (Harvill, 2005).
5. Fred Uhlman, *The Making of an Englishman*, p. 123.
6. Ibid, p. 203.
7. Ibid, p. 196.
8. Canetti, *Party in the Blitz*, pp. 172–3.
9. Ibid, p. 185.
10. It is seldom remarked upon that Hampstead returned almost entirely Conservative MPs until the 1990s, and certainly did so from the 1930s through the 1950s; 'Hampstead Village' to this day has only Tory councillors, in the overwhelmingly Labour London Borough of Camden.
11. Uhlman, *The Making of an Englishman*, p. 215.
12. Keith Holz notes that this was 'the first and only exhibition of agitational political art' by the FDKB or any of its members; a Communist front it might have been, but the *Kulturbund* knew how to lie low in Britain's very different political culture. Holz argues convincingly that this absence was among many reasons for the Anglo-Saxon misunderstanding of the politicized, Marxist edge of Weimar art. See *Modern German Art for Thirties Paris, Prague and London*, p. 268.
13. Uhlman, *The Making of an Englishman*, p. 214.
14. Ibid.

15. Quoted in Edith Hoffmann, *Kokoschka: Life and Work* (Faber, 1947), p. 196. The painting, 'Vienna Seen from the Schloss Wilheminenberg', is sadly now in Vienna's Leopold Museum, not the Town Hall.
16. Ibid, p. 197.
17. Oskar Kokoschka, *My Life*, trans. David Britt (Thames and Hudson, 1974).
18. Canetti, *Party in the Blitz*, p. 186.
19. Kokoschka, *My Life*, pp. 165–6.
20. Hoffmann, *Kokoschka*, p. 72.
21. Ibid, pp. 186–7.
22. A few books that reveal some of these fabulous posters: Susannah Walker, *Home Front Posters of the Second World War* (Shire, 2012); Ruth Artmonsky's two books, *Jan LeWitt and George Him: Design* (Antique Collectors Club, 2008), and *F. H. K. Henrion: Design* (Antique Collectors Club, 2011); Pat Schleger, *'Zero': Hans Schleger, A Life in Design* (Lund Humphries, 2001); and David Bownes, *London Transport Posters: A Century of Art and Design* (Lund Humphries, 2011).
23. For the view from MI5, see David Burke, *The Lawn Road Flats: Spies, Writers, and Artists* (Boydell Press, 2014).
24. Quoted in Marty Bax, 'Climbing Colour Squares', in Cees W. de Jong (ed.), *Piet Mondrian: The Studios* (Thames and Hudson, 2013), p. 161.
25. Martin Hammer and Christina Lodder, *Constructing Modernity: The Art and Career of Naum Gabo* (Yale University Press, 2009), p. 231.
26. Ibid, p. 233.
27. J. L. Martin, Ben Nicholson and Naum Gabo (eds.), *Circle: International Survey of Constructive Art* (Praeger, 1971), p. v.
28. Gabo, 'On Constructive Art', in *Circle*, p. 1.
29. Ibid, p. 9.
30. Hammer and Lodder, *Constructing Modernity*, p. 271.
31. For a profile of the Cosmo, see Etan Smallman, 'From Berlin to Finchleystrasse', *Financial Times*, 8 November 2019, occasioned by Pamela Howard's play *The Ballad of the Cosmo Café*; it closed in 1998.
32. Nicola Baird, *Czech Routes to Britain* (Ben Uri, 2019), ebook, loc 993.
33. Quoted in Jill Lloyd, *The Undiscovered Expressionist: A Life of Marie-Louise von Motesiczky* (Yale University Press, 2007), p. 41.
34. Ibid, p. 102.
35. Ibid, p. 111.
36. Ibid, p. 139.
37. These intriguing works can be found in Monica Bohm-Duchen, *Art in Exile in Great Britain* (Camden Arts Centre, 1986).
38. It is available for free online at https://www.imre-hofbauer.com/the-other-london/j49i441w937q9yq496r59jaztxcz38
39. Christine Lindey, *Art for All: British Socially Committed Art* (Artery, 2018), p. 94.

40. These are all reproduced in Fran Lloyd, 'Ernst Eisenmayer, a Modern Babel', in Rachel Dickson and Sarah MacDougall (eds.), *Forced Journeys: Artists in Exile in Britain, c. 1933–45* (Lund Humphries, 2009).
41. Feliks Topolski and Peter Ford, 'Collage', in *Feliks Topolski: Panoramas* (Quartet, 1981), p. 52.
42. Ibid, p. 12.
43. The Duke of Edinburgh, 'Introduction', in ibid, p. 3.
44. Topolski and Ford, 'Collage', in *Feliks Topolski: Panoramas*, p. 22.
45. Ibid, p. 12.
46. Ibid, p. 56.
47. Baird, *Czech Routes to Britain*, loc 680.
48. Quoted in James Trollope, 'Käthe Strenitz: A Refugee's Vision of London', *Art UK*, 2021, online at https://artuk.org/discover/stories/kathe-strenitz-a-refugees-vision-of-london
49. See Beate Planskoy's short talk on her sister on the Insiders-Outsiders YouTube channel, 'Eva Frankfurther: A Stark Struggle', https://www.youtube.com/watch?v=cmCkvxGnCr0&ab_channel=InsidersOutsiders
50. Lindey, *Art for All*, p. 148.
51. Mervyn Levy, 'An Appreciation', in Eva Frankfurther, *People* (Gilchrist Studios, 1962), unpaginated.
52. A point made in Jutta Vinzent, 'The Other of the Other', in Dickson and MacDougall, *Forced Journeys*.

Chapter 19

1. On art in internment, see 'Four Internment Artists', in Dickson and MacDougall (eds.), *Forced Journeys*, and on Walter Nessler and Hugo Dachinger, see Jessica Feather, *Art Behind Barbed Wire* (National Museums Liverpool, 2004).
2. Dachinger (and Fritz Rosen)'s Jooss poster is reprinted in Feather, *Art Behind Barbed Wire*.
3. There is within this – but out of the remit of this book – one of the most fascinating and moving of all the refugee stories, the life of the French photographer Claude Cahun, who along with her partner Marcel Moore emigrated to Jersey in 1937, and took part in the resistance to the islands' Nazi occupation. See Jessie Williams, 'Claude Cahun, Jersey's Queer, Anti-Nazi Freedom Fighter', *Huck*, May 2020.
4. Uhlman, *The Making of an Englishman*, p. 230.
5. Michael Bird, *The St Ives Artists: A Biography of a Place and Time* (Lund Humphries, 2008), p. 26.
6. Charles Spencer, quoted in ibid, p. 11.
7. Kokoschka, *My Life*, p. 161.

8. Hoffmann, *Kokoschka*, p. 252.
9. Ibid, p. 253.
10. Hammer and Lodder, *Constructing Modernity*, p. 270.
11. Bird, *The St Ives Artists*, p. 57.
12. Hammer and Lodder, *Constructing Modernity*, p. 308.
13. Ibid, p. 309.
14. Ibid, p. 317.
15. On Feiler, see John Steer, *Paul Feiler: Paintings and Screenprints 1951–1980* (University of St Andrews, 1980). The turn to abstraction was apparently inspired initially by the space race; see https://www.paulfeiler.com/biography
16. This strange figure is profiled in Susan Soyinka, *Albert Reuss in Mousehole: The Artist as Refugee* (Sansom and Company, 2017).
17. Kokoschka, *My Life*, p. 167.
18. Politically, Adler was more Anarchist than Stalinist – see Herbert Read's heartfelt obituary in the Anarchist paper *Freedom*, in *A One-Man Manifesto and Other Writings* (Freedom, 1994).
19. A brief account of this time can be found in Richard Cork, *Jankel Adler: The British Years* (Goldmark, 2014).
20. Josef Herman, *Related Twilights: Notes from an Artist's Diary* (Robson Books, 1975), p. 70.
21. Ibid, p. 28.
22. Quoted in Lindey, *Art for All*, p. 24.
23. For a good recent account of these Polish modernists, see Martin Kohlrausch, *Brokers of Modernity: East Central Europe and the Rise of Modernist Architects, 1910–1950* (Cornell, 2019). Recent accounts of Polish art movements of the interwar years are rare in English, but there is one excellent book on the print cultures of the Polish Second Republic, namely Piotr Rypson, *Against All Odds: Polish Graphic Design, 1919–1949* (Karakter, 2011), and a very fine study of left-wing modernist literary culture, Marci Shore, *Caviar and Ashes: A Warsaw Generation's Life and Death in Marxism, 1918–1968* (Yale University Press, 2009).
24. Herman, *Related Twilights*, p. 46.
25. Quoted in Monica Bohm-Duchen, *The Art and Life of Josef Herman: 'In Labour My Spirit Finds Itself'* (Lund Humphries, 2009), p. 26.
26. Ibid, p. 29.
27. Herman, *Related Twilights*, p. 45.
28. Josef Herman, 'A Memory of Memories: Glasgow 1940–1943', in *The Early Years in Scotland and Wales* (Christopher Davies, 1984), p. 29.
29. Ibid, p. 30.
30. Quoted in Bohm-Duchen, *The Art and Life of Josef Herman*, p. 70.
31. Herman, *The Early Years in Scotland and Wales*, p. 15.
32. Simon Webb, quoted in Rachel Dickson and Sarah MacDougall, '"Driftwood Cast Upon a Foreign Shore": Jankel Adler in Britain 1940–49'

(2018), online at the Ben Uri Gallery's site, https://issuu.com/benurigallery/docs/jankel_adler_in_britain
33. H. Harvey Wood, 'Introduction', in Alexander Żyw, *Edinburgh as the Artist Sees It* (Machiner and Wallace, 1945), p. 3.
34. Ibid, p. 8.
35. Tommy Żyw, *Alexander Żyw: Before and After* (The Scottish Gallery, 2020), unpaginated.
36. Ibid.
37. Douglas Hall, *Art in Exile: Polish Painters in Post-War Britain* (Redcliffe Books, 2008), p. 85.
38. Quoted in Andrew Green, 'A Czech Refugee Artist in Mumbles', *Gwallter*, 2019, online at https://gwallter.com/books/a-czech-refugee-artist-in-mumbles.html
39. Herman, *Related Twilights*, p. 91.
40. Herman, 'A Welsh Mining Village: Ystradgynlais, 1944–1946', in idem, *The Early Years in Scotland and Wales*, p. 86.
41. Quoted in Lindey, *Art for All*, p. 59.
42. Herman, *The Early Years in Scotland and Wales*, pp. 85–6.
43. Ibid, pp. 88–9.

Chapter 20

1. On émigrés and the Festival, see Harriet Atkinson, 'Artists, Refugees and the Festival of Britain', in Bohm-Duchen (ed.), *Insiders-Outsiders*.
2. Lindey's *Art for All* grinds its axe extensively at how much her socialist and realist subjects were patronized or scorned as fashions shifted towards abstraction, then Pop, then Conceptualism; for a fairly recent example of this, Miranda Carter in *His Lives*, her biography of Anthony Blunt, evidently finds her subject's enthusiasm for the work of Peter Peri hilarious.
3. Caro had been taught sculpture by Siegfried Charoux.
4. Both quotes from Catherine Moriarty and Victoria Worsley, *Inside and Out: The Sculpture and Design of Bernard Schottlander* (Henry Moore Institute, 2009), unpaginated.
5. See Sarah MacDougall, '"A Vitalising Impulse": Sculptors Behind the Wire' (2010), Ben Uri Gallery, online at https://issuu.com/benurigallery/docs/01-sm-a_vitalising_impulse-sculptors_behind_the_wi
6. Siegfried Charoux, 'Building without Grace: An Aggressive Examination', *The Journal of the Royal Institute of British Architects*, January 1954.
7. According to Jonathan Blond, *Peter Peri, 1899–1967: Etchings* (Blond Fine Art, 1992), unpaginated.
8. John Kay, 'Sculpture, Schools and People', in Julia Collieu (ed.), *Peter Peri 1899–1967: A Retrospective Exhibition of Sculpture, Prints and Drawings* (Leicestershire Museum and Art Gallery, 1991), p. 10.

NOTES

9. Peter Peri, 'Peter Laszlo Peri: Biography' (2020), online at https://www.peterlaszloperi.org.uk/biography-of-peter-laszlo-peri
10. Quoted in Lindey, *Art for All*, p. 62.
11. Quoted in Kay, 'Sculpture, Schools and People', in Julia Collieu (ed.), *Peter Peri 1899–1967*, p. 7.
12. Baird, *Czech Routes to Britain*, loc 235.
13. David Nathan, 'Obituary: Franta Belsky', *Guardian*, 6 July 2000.
14. On the Primark opposite is a mosaic mural of workers and trades by Gyula Bajo and Endre Hevizi, Hungarian ceramic artists who worked principally for the Co-Operative Society. Their finest work is a fabulous, pulsating mosaic mural over the back entrance to Ipswich's Co-Operative Department Store, recently listed.
15. Vinzent, *Identity and Image*, p. 142.
16. Monica Bohm-Duchen and Zuleika Dobson (eds.), *Art in Exile in Great Britain, 1933–1945* (Camden Arts Centre, 1986), unpaginated.
17. There is a good, even-handed account of this conflict in Andy Beckett's study of the London Labour left, *The Searchers* (Allen Lane, 2024).
18. Marianne Colloms and Dick Weindling, 'The Sculptor Fred Kormis', *West Hampstead Life*, 7 August 2013.
19. For a good short account of Balden, see Burcu Dogramci, *Germany, a Foreign Homeland: The Return of Émigré Sculptors after 1945* (Kunsthaus Dahlem, 2015), pp. 54–6. On one city's quotient of Communist émigrés who had escaped to Britain via Prague, see the chapter on the Manchester branch of the KPD in Bill Williams, *Jews and Other Foreigners*; on refugee political organizations more generally, see the collection by Anthony Grenville and Andrea Reiter, *'I Didn't Want to Float; I Wanted to Belong to Something': Refugee Organisations in Britain, 1933–1945* (Editions Rodopi, 2008).
20. Quoted in Antony Penrose, 'Roland Penrose: "Changez la Vie"', in Bohm-Duchen (ed.), *Insiders-Outsiders*, p. 178.
21. Sonja Grossner, *Balancing Between Different Worlds: The Life and Work of Artist Margarethe Klopfleisch* (self-published, 2012), ebook, loc 176. On Klopfleisch's work and gender, see Burcu Dogramci, 'After Exile: Remigration or Artistic Return', in Schoene, *New/Old Homeland*, pp. 45–7.
22. Grossner, *Balancing Between Different Worlds*, loc 528.
23. Ibid, loc 25.

Chapter 21

1. Lucy Blake, 'Obituary: Naomi Blake', *Jewish Chronicle*, 22 November 2018.
2. From Peleg's moving lecture on her mother for the Insiders-Outsiders project, online at https://www.youtube.com/watch?v=Hzjd_SH7Vyw&ab_channel=

NOTES

InsidersOutsiders; see also her book, *Glimmer of Hope: The Story of Naomi Blake* (self-published, 2014).

3. 'An Introduction', in Dickson and MacDougall (eds.), *Forced Journeys*, p. 16.
4. Which did not, of course, rule out abstraction. For a good colour compendium, see Sharman Kadish, *Jewish Heritage in Britain and Ireland: An Architectural Guide* (Historic England, 2015).
5. Quoted in Jonathan Evens, 'Debt Owed to Jewish Refugee Art', *Church Times*, 11 June 2021.
6. Gavin Stamp, 'The Festival Site', in *Twentieth Century Architecture 5: The Festival of Britain* (Twentieth Century Society, 2001), p. 17. For a contrary view in the same publication, see Robert Drake, 'Thomas Ford and Hans Feibusch: A Unique Collaboration', in *Twentieth Century Architecture 15: Holy Houses* (Twentieth Century Society, 2023).
7. David Coke (ed.), *Hans Feibusch: The Heat of Vision* (Lund Humphries, 1995), p. 16.
8. Quoted in ibid, p. 30.
9. Hans Feibusch, *Mural Painting* (Adam and Charles Black, 1946), p. 17.
10. Ibid, p. 18.
11. Ibid, p. 24.
12. Ibid, p. 56.
13. Ibid, p. 39.
14. Ibid, p. 49.
15. Ibid, pp. 90–1.
16. Ibid, p. 92.
17. A useful slim book that concentrates on the Bell connection is Paul Foster (ed.), *Feibusch Murals: Chichester and Beyond* (Otter Memorial Papers, 1997).
18. Maike Bruhns, 'Bossanyi and Schumacher', in Jo Bossanyi and Sarah Brown (eds.), *Ervin Bossanyi: Vision, Art and Exile* (Spire Books, 2008), p. 112.
19. Rüdiger Joppien, 'A Flourishing Career: Germany 1919–1934', in Bossanyi and Brown (eds.), *Ervin Bossanyi*, p. 146.
20. Dagmar Hayes, *Ervin Bossanyi: The Splendour of Stained Glass* (Friends of Canterbury Cathedral, 1965), p. 30.
21. Ibid, p. 31.
22. Ibid, p. 32.
23. Ibid, p. 5.
24. Bossanyi and Brown (eds.), *Ervin Bossanyi*, p. 154.
25. Quoted in Jonathan Evens, 'Canterbury Cathedral', online at https://artway.eu/artway.php?id=578&lang=en&action=show
26. See the account on the website dedicated to Mayer-Marton's work, at http://www.mayer-marton.com/recollections.html
27. For a detailed description by someone more theologically aware of the resonances of the mosaic, see Clare A. P. Willsdon, 'Visionary Actions on

NOTES

a Ground of Viennese Modernism', in Robert Waterhouse (ed.), *George Mayer-Marton: Murals and Mosaics* (Baquis Press, 2021), p. 26.
28. In Waterhouse (ed.), *George Mayer-Marton*, Gordon Millar argues that the Liverpool Pentecost mosaic shows an affinity with the 'Rabbinical festival of Shavuot', with both festivals depicting 'the dramatic fulfilment of promises and contracts of faith', p. 21.
29. Karen Baxendale-Manning, *Ernst Blensdorf: Sculptor* (Mrs Jane Blensdorf, 1985), p. 59.
30. The description of the specifics here is owed to Jonathan Evens, 'St Andrew Bobola, Shepherd's Bush', online at https://www.artway.eu/content.php?id=1972&lang=en&action=show

Chapter 22

1. You can watch it online at https://www.britishpathe.com/video/jack-bilbo-sculptor
2. For an informative and entertaining symposium on Bilbo's career, see the Insiders-Outsiders festival's discussion in 2022, at https://www.youtube.com/watch?v=5290YB-4pWM&list=WL&index=25&ab_channel=InsidersOutsiders
3. Jack Bilbo, *I Can't Escape Adventure* (The Cresset Press, 1937), p. 13.
4. Ibid, p. 23.
5. Ibid, p. 131.
6. Uhlman, *The Making of an Englishman*, p. 233.
7. Quoted in *Kurt Schwitters in Exile: The Late Work* (Marlborough Fine Art, 1981), p. 38.
8. Jack Bilbo, *Reflections in an Art Gallery: In Celebration of the First Anniversary of the Modern Art Gallery* (Modern Art Gallery Ltd, 1942), unpaginated.
9. Ibid.
10. Jack Bilbo, *The Peace and Progress Plan: One World One People* (Modern Art Gallery Ltd, 1952), p. 1.
11. Ibid, p. 14.
12. Recently republished, along with two other children's books of the Themersons, by the Tate.
13. Anatol Stern and Miecyslaw Szczuka, *Europa* (Gaberbocchus, 1962), trans. Stefan and Franciszka Themerson, unpaginated.
14. Ibid.
15. Ibid.
16. This experience is obliquely referred to in *Bayamus*, Stefan's short 1944 Dada-novel about gender, language and racism: 'if somebody who was a Jew set himself against a baptized person engaged in the acquisition of knowledge at Warsaw University or engaged in a course of study at Warsaw

Polytechnic, then he got thrown out of trams. That was quite ordinary and quite normal.' Stefan Themerson, *Bayamus: A Novel* (Gaberbocchus, 1965), p. 22.
17. Franciszka Themerson, 'Bi-Abstract Pictures', in Nick Wadley, *Franciszka Themerson* (Themerson Estate, 2019), pp. 50–1.
18. Stefan Themerson, *Jankel Adler: An Artist Seen from One of Many Possible Angles* (Gaberbocchus, 1948), p. 9.
19. Ibid, p. 14.
20. Ibid, p. 24.
21. Ibid, p. 26.
22. Ibid, p. 28.
23. Stefan Themerson, *Critics and My Talking Dog* (Obscure Publications, 2001), p. 3.
24. Themerson, *Critics and My Talking Dog*, p. 21.
25. The literature on Schwitters is vast – a good, short and beautifully illustrated introduction is Isabel Schutz, *Kurt Schwitters: Merz Art* (Hirmer, 2020).
26. Hans Richter, *Dada: Art and Anti-Art* (Thames and Hudson, 1965), p. 138.
27. Ibid, p. 153.
28. Uhlman, *The Making of an Englishman*, p. 235.
29. Ann Blood, *Kurt Schwitters' Merzbarn* (CV Publications, 2013), p. 23.
30. Stefan Themerson, *Kurt Schwitters in England, 1940–1948* (Gaberbocchus, 1958), p. 29.
31. Ibid, p. 9.
32. Ibid, p. 15.
33. Ibid, p. 28.
34. Blood, *Kurt Schwitters' Merzbarn*, p. 6.
35. Emma Chambers, 'Schwitters and Britain', in Emma Chambers and Karin Orchard, *Schwitters in Britain* (Tate, 2013), p. 15.
36. Blood, *Kurt Schwitters' Merzbarn*, p. 30.
37. Themerson, *Kurt Schwitters in England, 1940–1948*, p. 28.
38. Blood, *Kurt Schwitters' Merzbarn*, p. 33.
39. It is, however, worth consulting the superb dedicated website on the Merzbarn about the details of this immensely complex undertaking – see for instance https://merzbarn.co.uk/what-we-dont-see
40. Karin Orchard, 'British-Made': The Late Collages of Kurt Schwitters', in Chambers and Orchard, *Schwitters in Britain*, p. 60.
41. Themerson, *Kurt Schwitters in England, 1940–1948*, p. 47.
42. Kurt Schwitters, *Three Stories*, edited by Jasia Reichardt (Tate, 2010), p. 15.
43. At art college in the late 1950s, the future Pop Artists Derek Boshier, Pauline Boty and Peter Blake used to pass between them a single dog-eared copy of a book of Schwitters montages. Sue Tate, *Pauline Boty: Pop Artist and Woman* (Wolverhampton Art Gallery, 2013), p. 20. This process has been

particularly cyclical in the case of Pop – the exiled Polish doctor and gallerist Mateusz Grabowski was the first to exhibit many of the Pop artists at the Grabowski Gallery in Chelsea, and when he donated his collection to the Muzeum Sztuki in Łódź in 1975 – a major modern art museum founded by Polish Constructivists – that city ended up with the finest collection of British Pop Art anywhere except, perhaps, the municipal gallery of Wolverhampton; certainly, better than the Tate. This collection has in turn, as Sue Tate points out, inspired the work of contemporary Polish painters such as Paulina Ołowska.
44. Schwitters, *Three Stories*, p. 17.

PART FOUR

1. Stefan Themerson, *Mr Rouse Builds His House* (Tate, 2013).

Chapter 23

1. I owe this reference to Alexandra Lazar, 'Arthur Korn: An Analytical and Utopian Architect', online at https://alexandralazar.com/art-archive/arthur-korn-an-analytical-and-utopian-architect
2. *The Studio*, November 1929.
3. Bruno Taut, 'The Nature and Aims of Architecture', *The Studio*, March 1929.
4. Bruno Taut, 'English Architecture as I See It', *The Studio*, November 1929.
5. Evelyn Waugh, *Decline and Fall* (Penguin, 1980), p. 119.
6. Ibid, p. 120.
7. See Schätzke, *German Architects in Great Britain: Planning and Building in Exile, 1933–1945*. In 1939, less than 1 per cent of practising architects in Britain were Central European refugees; by way of comparison, in Sweden the number was 18 per cent. See Jeremy Melvin, *FRS Yorke and the Evolution of English Modernism* (Wiley, 2003), p. 111.
8. Christina Thomson, *Contextualising the Continental: The Work of German Émigré Architects in Britain, 1933–1945* (PHD thesis, University of Warwick, 1999). Available online at http://wrap.warwick.ac.uk/34756/1/WRAP_THESIS_Thomson_1999.pdf
9. Reginald Blomfield, *Modernismus* (Macmillan, 1934), p. 82.
10. Quoted in Thomson, *Contextualising the Continental*.
11. Ibid.
12. Ibid.
13. The Bata 'Philosophy' is still something of a minor cult in the Czech Republic, and you can buy in Bata shoe shops books expounding it still: those who enjoy this sort of thing could start with Gabriela Koncitikova, *Inspired the*

Bata Way: How to be Stronger and Happier by Adopting Thomas Bata's Principles to Live By (Bata, 2022).
14. Malcolm McEwen, 'The Bata Story', in Ken Coates and Tony Topham (eds.), *Workers' Control* (Panther, 1970), p. 221.
15. Ibid, p. 222.
16. Jane Pavitt, 'The Bata Project: A Social and Industrial Experiment', in Alan Powers (ed.), *Industrial Architecture* (Twentieth Century Society, 1994), p. 43.
17. *A History of Dartington Hall in Twenty-Five Moments* (Dartington Hall Trust, 2017), p. 25.
18. Quoted in Fiona MacCarthy, *Walter Gropius: Visionary Founder of the Bauhaus* (Faber, 2009), p. 274.
19. Reproduced in Schätzke, *German Architects in Great Britain*, p. 105.
20. MacCarthy, *Walter Gropius*, p. 324.
21. Alan Powers, *Bauhaus Goes West* (Thames and Hudson, 2019), p. 111.
22. Frank Pick, 'Introduction', in Walter Gropius, *The New Architecture and the Bauhaus*, trans. P. Morton Shand (Faber, 1935), p. 8.
23. Ibid, p. 36.
24. Ibid, p. 37.
25. Ibid, p. 80.
26. Quoted in Powers, *Bauhaus Goes West*, p. 13.
27. Quoted in Schätzke, *German Architects in Great Britain*, p. 41.
28. Quoted in Charlotte Benton, *A Different World: Émigré Architects in Britain 1928–1958* (RIBA, 1995), p. 47.
29. Eric Mendelsohn, *Letters of an Architect*, trans. Geoffrey Strachan (Abelard-Schuman, 1967), p. 142.
30. Nikolaus Pevsner, 'Introduction', to Mendelsohn, *Letters of an Architect*, p. 19.
31. Ibid, p. 142.
32. Quoted in Alastair Fairley, *De La Warr Pavilion: The Modernist Masterpiece* (Merrell, 2006), p. 91.
33. Mendelsohn, *Letters of an Architect*, p. 140. Ironically, one of Mendelsohn's assistants, Ernst Sagebiel, would become one of the Third Reich's most prominent architects, fusing free, modernist internal planning and stern, humourless stripped classicism in the Air Force Ministry and Tempelhof Airport in Berlin.

Chapter 24

1. Thomson, *Contextualising the Continental*.
2. It is also hidden in extremely plain sight. I had visited the nearby Freud Museum several times, either passing or ignoring it, before being made aware of the house by Alan Powers' essay in Bohm-Duchen (ed.), *Insiders-Outsiders*.

3. Volker M. Welter, *Ernst L. Freud, Architect: The Case of the Modern Bourgeois Home* (Berghahn, 2012), p. 150.
4. Benton, *A Different World*, p. 198.
5. Quoted in Schätzke, *German Architects in Great Britain*, p. 41.
6. Quoted in Benton, *A Different World*, p. 21.
7. Ibid, p. 34.
8. Ibid, p. 93.

Chapter 25

1. Louise Kehoe recounts a bitter family argument over the Six Day War ending with her asking the strongly anti-Zionist Lubetkin if he had been 'reading the *Protocols of the Elders of Zion*', and him hitting her in response. Louise Kehoe, *In This Dark House* (Schocken, 1995), p. 219. She was also, she claims, led by her father to believe that his real father was a (presumably gentile) Tsarist officer called Makarov, until finding out the truth about his family from Mira Lubetkin, a cousin who survived the war in the USSR and emigrated to the USA in the 1970s. On visits to London, Lubetkin would collect *Challah* to bring back to the family home in Gloucestershire, and refer to it as 'Polish bread'. How one feels about all of this depends perhaps on attitudes to Jewish identity in general – that is, on whether it is considered as an absolute, unshakeable ontological fact that defines the entire being, or, as was common among secular Jews like Lubetkin and many of his contemporaries, as something that was quite unimportant until made so by the Nazis. Nonetheless, Kehoe provides plenty of evidence that Lubetkin could be a very cruel parent.
2. Quoted in John Allan, *Berthold Lubetkin: Architecture and the Tradition of Progress* (RIBA, 1992), p. 93.
3. Quoted in ibid, p. 111.
4. Peter Coe and Malcolm Reading, *Lubetkin and Tecton: An Architectural Study* (Triangle, 1992), p. 153.
5. Those curious about Lubetkin's Communism might enjoy my 'Lubetkin in Russia', in the *Architectural Review*, October 2014.
6. Quoted in Coe and Reading, *Lubetkin and Tecton: An Architectural Study*, pp. 91–2.
7. Carved figures holding up canopies or balconies were pretty common in nineteenth-century apartment buildings, but in her book on the building Deborah Lewittes writes that 'Kehoe consulted old phonebooks and determined with confidence that her grandparents' home was the source of the caryatids that had ingrained themselves in his consciousness and made their way to Highgate.' However, this by no means justifies Lewittes' own claim emerging from this: that 'Lubetkin's porte-cochère covered over his

NOTES

avant-garde fervour and his secret catastrophe, and was part of his strategy to keep quiet and bury the past.' In 1938, Lubetkin can have had no idea of what was about to befall his parents, and was in the not at all unusual position of being a young Jewish socialist from Eastern Europe estranged from a more politically conservative family (Deborah Lewittes, *Berthold Lubetkin's Highpoint II and the Jewish Contribution to Modern English Architecture* (Taylor & Francis, 2018), p. 65). In any case, it seems startlingly at variance with Lubetkin's intentions to try to find the 'real' source of something that is by its nature an ephemeral copy. For an account that emphasizes Lubetkin's own explanation – that the figures simply fit the canopy better than any other kind of construction – see John Allan's 2021 Docomomo lecture, at https://www.docomomo.org.uk/journal/berthold-lubetkin, and his recent short study, *Berthold Lubetkin* (Twentieth Century Society, 2023).

8. Berthold Lubetkin, 'Modern Architecture in England', reproduced in Coe and Reading, *Lubetkin and Tecton: An Architectural Study*, p. 135.
9. Ibid, p. 136.
10. According to John Allan, Lubetkin was never a CPGB member, or a 'joiner' at all, though Louise Kehoe claims both her father and Margaret Church were 'card-carrying' members and fanatical Stalinists, something that is hard to square with his very many sceptical comments on Soviet architecture in print from the 1930s until the 1980s, not to mention his condemnation of the Soviets for suppressing modern art; but at various times he was certainly a fellow traveller.
11. Allan, *Berthold Lubetkin*, p. 323.
12. Quoted in Peter Coe and Malcolm Reading, *Lubetkin and Tecton: Architecture and Social Commitment* (Arts Council of Great Britain, 1981), p. 52.
13. Ibid, p. 53.
14. Coe and Reading, *Lubetkin and Tecton: An Architectural Study*, p. 74.
15. The typeface is Thorne Shaded. See Paul Rennie, 'Fat Faces All Around', in *Twentieth Century Architecture 5: The Festival of Britain*, p. 112.
16. Berthold Lubetkin, 'The Origins of Russian Modern Art', an early 1970s lecture reproduced in Coe and Reading, *Lubetkin and Tecton: An Architectural Study*, p. 126. 'Rootless Cosmopolitan' was Stalinist code for 'Jew' in the Doctors Plot of 1951–3, and afterwards.
17. I owe this point on Hallfield to Lewittes, *Berthold Lubetkin's Highpoint II and the Jewish Contribution to Modern English Architecture*, p. 54.
18. Some biographies have it that the Lenin Memorial was buried in Percy Circus, but rumour has long held that it is actually buried, symbolically, directly below the staircase.
19. Berthold Lubetkin, 'Soviet Architecture: Notes on Development', *Architectural Association Journal*, no. 71 (1956).
20. Kehoe, *In this Dark House*, p. 61.
21. Lubetkin, 'Soviet Architecture'.

22. Berthold Lubetkin, 'Notes for a Commentary on Western Architecture', in Coe and Reading, *Lubetkin and Tecton: Architecture and Social Commitment*, p. 29.
23. See, for instance, James Meek's account of the Cranbrook Estate in his chapter on housing in *Private Island: Why Britain Now Belongs to Someone Else* (Verso, 2014).
24. Quoted in Allan, *Berthold Lubetkin*, p. 534.
25. Ibid, p. 553.
26. Berthold Lubetkin, 'Credo', in Coe and Reading, *Lubetkin and Tecton: An Architectural Study*, p. 141.
27. Ibid, p. 21.

Chapter 26

1. Allan, *Berthold Lubetkin*, p. 155.
2. Quoted in Benton, *A Different World*, p. 42.
3. Ibid, p. 50.
4. They are the centrepiece of Alistair Fair's useful book on the practice, *Peter Moro and Partners* (Twentieth Century Society, 2023). Moro's lead designer at the Theatre Royal, Andrzej Blonski, was born during the war in Tehran, to Polish parents who had been deported to the USSR and were by then serving in the 'Anders army'.
5. Nikolaus Pevsner, *Visual Planning and the Picturesque*, edited by Matthew Aitchison (Getty, 2010), p. 196.
6. Nikolaus Pevsner, *Pioneers of Modern Design* (Pelican, 1974), p. 27 – though note he qualifies this as 'English, not Scottish', in his analysis of the work of Charles Rennie Mackintosh. See also 'Nine Swallows, No Summer', in Nikolaus Pevsner and J. M. Richards, *The Anti-Rationalists: Art Nouveau Architecture and Design* (Architectural Press, 1973).
7. Nikolaus Pevsner, *An Inquiry into Industrial Art in England* (Cambridge University Press, 1937), p. 1.
8. Ibid, p. 8.
9. Ibid, p. 39.
10. Ibid, p. 204.
11. Ibid, p. 11.
12. Colin MacInnes, 'The Englishness of Dr Pevsner', in Simon Bradley and Bridget Cherry (eds.), *The Buildings of England: A Celebration* (Penguin Collectors Society, 2001), p. 41.
13. Ibid, p. 43.
14. See Harries, *Nikolaus Pevsner*, p. 486.
15. Quoted in Bradley and Cherry (eds.), *The Buildings of England: A Celebration*, p. 118.

16. Nikolaus Pevsner, *The Englishness of English Art* (Peregrine, 1964), pp. 174–5.
17. Pevsner, *Visual Planning and the Picturesque*, p. 51.
18. Pevsner, *The Englishness of English Art*, p. 181.
19. Ibid, p. 188.
20. Ibid, p. 191.

Chapter 27

1. Alan Colquhoun, 'A Note on Lyons Israel Ellis', in Alan Forsyth and David Gray (eds.), *Lyons Israel Ellis Gray: Buildings and Projects, 1932–83* (Architectural Association, 1988), p. 93.
2. See B. Szmidt, *The Polish School of Architecture* (University of Liverpool, 1945).
3. Biographical details from Kate Jordan 'Unfair Dismissal: The Legacy of Female Architects Working for London Councils', *Architectural Review*, March 2018. For a good recent interview with Borowiecka, see 'The Accidental Brutalist', *The Brixton Brewery* (2020), https://brixtonbrewery.com/blogs/brixton-news/the-accidental-brutalist-magda-borowiecka
4. I owe these quotes of the 1970s to the Colin Rowe centenary website, at https://colinrowecentenary.wordpress.com/2020/03/25/letter-to-girouard-29-nov-72
5. Arthur Korn, *Glass in Modern Architecture of the Bauhaus Period* (George Braziller, 1968), p. 7.
6. Jack Pritchard, 'Architecture in England during the 1930s', in Dennis Sharp (ed.), *Planning and Architecture: Essays Presented to Arthur Korn by the Architectural Association* (Barrie and Rockliff, 1967), p. 122.
7. Arthur Korn, 'Analytical and Utopian Architecture', in Sharp (ed.), *Planning and Architecture*, p. 162.
8. Hugh Morris and Andrew Derbyshire, 'Arthur Korn: Man and Teacher', in Sharp (ed.), *Planning and Architecture*, p. 125. Note also Rodney Gordon, the great LCC architect turned commercial Brutalist, recalling Korn as his 'tutor and mentor' in his entertaining essay on working for Owen Luder, 'Modern Architecture for the Masses', in Elain Harwood and Alan Powers (eds.), *The Sixties* (Twentieth Century Society, 2002).
9. Ibid, p. 176.
10. Ibid, p. 125.
11. Ibid, p. 176.
12. Peter Goldfinger, in *Passionate Rationalism: Recollections of Ernő Goldfinger* (British Library CD, 2004).
13. For instance, in Lewittes' *Berthold Lubetkin's Highpoint II and the Jewish Contribution to Modern English Architecture*.
14. Marianne Goldfinger, in *Passionate Rationalism*.

15. On Perret, see Peter Collins' *Concrete: The Vision of a New Architecture* (Faber, 1959), an important book in the post-war era.
16. This oft-told tale is disputed as an 'urban myth' in Elain Harwood and Alan Powers, *Ernő Goldfinger* (Twentieth Century Society, 2024), though the shaggy-dog story about golf they produce as an alternative is rather hard to understand.
17. Stephen Gardiner, 'Golden Eye', *The Times Magazine*, 16 November 1996.
18. James Dunnett and Gavin Stamp, *Ernő Goldfinger: Works 1* (Architectural Association, 1983), p. 9.
19. Ibid, p. 10.
20. Peter Goldfinger, in *Passionate Rationalism*.
21. Betty Cadbury-Brown, in *Passionate Rationalism*. For an excellent description of Willow Road, its contents and its complexities, see Harwood and Powers, *Ernő Goldfinger*.
22. Dunnett and Stamp, *Ernő Goldfinger*, p. 84.
23. Ernő Goldfinger, 'The Sensation of Space', in Sharp (ed.), *Planning and Architecture*, p. 97.
24. Barnabas Calder, *Raw Concrete: The Beauty of Brutalism* (Penguin, 2022), p. 69.
25. Calder, *Raw Concrete*, pp. 70–1.
26. Ibid, p. 63.
27. Gary A. Boyd, *Architecture and the Face of Coal* (Lund Humphries, 2022), p. 157.
28. Leyla Daybelge and Magnus Englund, *Isokon and the Bauhaus in Britain* (Batsford, 2019), pp. 159–61.
29. Boyd, *Architecture and the Face of Coal*, p. 258.
30. Ibid, p. 260.
31. On this process, see Otto Saumarez Smith's excellent *Boom Cities: Architect-Planners and the Politics of Radical Urban Renewal in 1960s Britain* (Oxford University Press, 2019).
32. Jelinek-Karl is only briefly mentioned in Benton, *A Different World*; my information here comes from Thomson, *Contextualising the Continental*.
33. See the website dedicated to the project, at https://anewwayoflivinginallesleyvillage.wordpress.com
34. Isi Metzstein, 'Life Before the War', at the oral history project *Gathering the Voices*, online at https://gatheringthevoices.com/isi-metzstein-life-before-the-war
35. Isi Metzstein, 'Immigration', https://gatheringthevoices.com/isi-metzstein-immigration
36. Gavin Stamp, 'Isi Metzstein: Obituary', *Guardian*, 22 January 2012.
37. Isi Metzstein, 'Reflection on Life', at https://gatheringthevoices.com/isi-metzstein-reflection-on-life
38. Quoted in Stamp, 'Isi Metzstein'.

NOTES

Chapter 28

1. E. J. Carter and Ernő Goldfinger, *The County of London Plan Explained* (Penguin, 1945), p. 5.
2. Ibid, p. 9.
3. Ibid, p. 17.
4. Ibid, p. 96.
5. Ibid, p. 31.
6. Ibid, p. 26.
7. I owe this information to Sarah Ossei's work on the Aylesbury Estate, summarized in 'Aylesbury Estate in Three Pieces', *GreyScape*, online at https://www.greyscape.com/aylesbury-estate-in-three-pieces. Heinrich Tischler died in 1938 as a result of being imprisoned in the Buchenwald concentration camp.
8. See Michael Romyn's superb revisionist history, *London's Aylesbury Estate* (Palgrave, 2020).
9. Quoted in Benton, *A Different World*, p. 53. Robertson would later design the Portland stone-clad high-rise Shell Centre on the site of the Festival of Britain, which can only be described as what a modernist building would look like if it were designed by somebody who hated modernist architecture.
10. Ian Nairn, *Nairn's London* (Penguin, 1988), p. 141.
11. This group and the secret-service reports on it are explored in Dolbear and Leslie, *Dissonant Waves*.
12. On the Shankland and Bor plan for Liverpool, see Saumarez Smith, *Boom Cities*.
13. Quoted in Benton, *A Different World*, p. 45.
14. Walter Bor, 'A Question of Urban Identity', in Sharp (ed.), *Planning and Architecture*, p. 16.
15. Ibid, p. 18.
16. See Saumarez Smith, *Boom Cities*, p. 60.
17. Simon Gunn, 'Between Modernism and Conservation: Konrad Smigielski and the Planning of Post-War Leicester', lecture online at https://www.youtube.com/watch?v=FUoNezaN8aA&t=214&ab_channel=EMOralHistory
18. Quoted in Saumarez Smith, *Boom Cities*, pp. 163–4.
19. K. Smigielski, *Leicester Traffic Plan* (Leicester Corporation, 1966), p. 17.
20. Ibid, p. 66.
21. Quoted in Gunn, 'Between Modernism and Conservation'.
22. Ibid.
23. Smigielski, *Leicester Traffic Plan*, p. 17.
24. Ibid, p. 28.
25. Quoted in Gunn, 'Between Modernism and Conservation'.
26. Konrad Smigielski, *Self-Supporting Co-Operative Village* (Building and Social Housing Foundation, 1978), p. 6.

27. Ibid, p. 47.
28. Ibid, p. 50.
29. Ibid, p. 6.
30. Ibid.
31. Ibid, p. 17.
32. E. A. Gutkind, *Revolution of Environment* (Kegan Paul, 1946), pp. 54–5.
33. Ibid, p. 2.
34. Ibid, p. 56.
35. Ibid, p. 4.
36. Ibid, p. 77.
37. Nader Vossoughian, *Otto Neurath: The Language of the Global Polis* (NAI, 2008), p. 18.
38. See Stuart Jeffries' recent revisiting of the Stowlawn Estate and the Neuraths' role in it, 'Bilston's Revival: The Pursuit of Happiness in a Black Country Town', *Guardian*, 2 August 2016.
39. On the poverty of the area at the time, see Frank Sharman's excellent history of the Stowlawn for the Black County Memories website, at https://www.blackcountrymemories.uk/stowlawn3.html
40. Quoted in *Black Country Memories*, https://www.blackcountrymemories.uk/stowlawn6.html. On the Bilston plan's resistance to anxieties about the dirty habits of slum dwellers, see Michelle Henning, 'The Pig in the Bath', *Radical Philosophy*, September/October 2007.
41. Karl Polanyi, 'Guild Socialism', in *The Hungarian Writings*, trans. Adam Fabry and edited by Gareth Dale (Manchester University Press, 2016), p. 119.
42. Polanyi, 'Guild Socialism', in *The Hungarian Writings*, p. 120.
43. Polanyi, 'The Constitution of Socialist Britain', in ibid, p. 110.
44. Karl Polanyi, *The Great Transformation: The Political and Economic Origins of Our Time* (Beacon Books, 2001), p. 45.
45. Ibid, p. 91.
46. Ibid, p. 147.
47. Robert Leonard, 'Between the Hand Loom and the Samson Stripper: Fritz Schumacher's Struggle for Alternative Technology', *Contemporary History Review*, no. 31, 2022. Thank you to Troy Vettese for the reference. The full Beveridge Report is available for free online, at http://pombo.free.fr/beveridge42.pdf
48. F. A. Hayek, 'History and Politics', in idem (ed.), *Capitalism and the Historians* (University of Chicago Press, 1963), p. 18.
49. Ibid.
50. Ibid, pp. 14–15.
51. Diego Pizano, 'A Conversation with Professor Friedrich A. Hayek' (1980), in *Conversations with Great Economists* (Jorge Pinto Books, 2009), ebook, loc 598.

52. Jonathan Ree, 'Opium of the Elite – Hayek in England', *London Review of Books*, 2 February 2023.
53. On Hayek, his disciples, and their dismantlement of what most people would recognize as 'democracy' – free elections, a wide choice of political options, mass participation in the political process, a free press, free trade unions – in the territories where they have had most success, see Quinn Slobodian, *Crack-Up Capitalism: Market Radicals and the Dream of a World Without Democracy* (Penguin, 2023). For an interesting contemporary review by an author predisposed to accept part of Hayek's political argument, but who found his economic argument highly unconvincing, see George Orwell, 'Review: *The Road to Serfdom* by F. A. Hayek', in *As I Please: The Collected Essays, Journalism and Letters, Volume 3* (Penguin, 1978).
54. Pizano, 'A Conversation with Professor Friedrich A. Hayek', loc 281.
55. Ibid, loc 267.
56. Walter Segal, 'Into the '20s', *Architectural Review*, January 1974.
57. Alice Grahame and John McKean, *Walter Segal: Self-Built Architect* (Lund Humphries, 2021), p. 73.
58. Quoted in ibid, p. 45.
59. Ibid, pp. 70–1.
60. Ibid, p. 109.
61. Magnus Wills, 'An Interview with Nicholas Taylor', in Owen Hatherley (ed.), *The Alternative Guide to the London Boroughs* (Open City, 2020), p. 148.
62. Leopold Kohr, *The Breakdown of Nations* (UIT Cambridge, 2016), p. 37.
63. Ibid, pp. 27–8.
64. Ibid, pp. 112–13.
65. Ibid, p. 110.
66. Ibid, p. 116.
67. Ibid, p. 115.
68. It makes interesting reading alongside what was by far the most intelligent book published on nationalism in Britain in the twentieth century – written by an émigré from Prague, Ernst Gellner – *Nations and Nationalism* (Blackwell, 1983), a book that is much more convincing than Kohr's, but much less plausibly utilized as a 'tool'.
69. On these, see, Slobodian *Crack-Up Capitalism*.
70. Neal Ascherson, 'Foreword' to Kohr, *The Breakdown of Nations*, p. 16.
71. Quoted in Leonard, 'Between the Hand Loom and the Samson Stripper: Fritz Schumacher's Struggle for Alternative Technology', *Contemporary History Review*, vol. 31, Special Issue 4, November 2022, pp. 525–52.
72. E. F. Schumacher, *Small is Beautiful: A Study of Economics as if People Mattered* (1973), online at https://www.ditext.com/schumacher/small/small.html
73. Ibid.
74. Ibid.
75. Ibid.

76. Peter Apps, *Show Me the Bodies: How We Let Grenfell Happen* (Oneworld, 2022).
77. But UCL do have a very useful collection of resources, available online at https://www.ucl.ac.uk/urban-lab/research-projects/2022/feb/remembering-ruth-glass
78. Michael Edwards, 'Ruth Glass at UCL' (2012), online at https://michaeledwards.org.uk/2012/03/29/ruth-glass-at-ucl
79. Ruth Glass, 'The Rejected Generation: Berlin 1932', in *Clichés of Urban Doom and Other Essays* (Basil Blackwell, 1989), p. 3.
80. Glass, 'Introduction' (1989), in ibid, p. ix.
81. Glass, 'The Mood of London' (1973), in ibid, p. 167.
82. Glass, 'Urban Sociology in Great Britain: A Trend Report' (1955), in ibid, p. 50.
83. Ibid.
84. Ruth Glass, *The Social Background of a Plan* (Routledge, 2013), p. 9.
85. Ibid, p. 187.
86. Glass, 'London: Aspects of Change' (1964), in *Clichés of Urban Doom*, p. 137.
87. Ibid, p. 136.
88. Ibid, p. 138.
89. Ibid, p. 142.
90. Glass, 'Insiders-Outsiders' (1962), in ibid, p. 230. On German-Jewish migrants to Britain and racism, see Berghahn, *Continental Britons*.
91. Glass, 'The Uncertainty of Immigrants' (1960), in *Clichés of Urban Doom*, p. 198.
92. Ruth Glass, *London's Newcomers: The West Indian Migrants* (Harvard University Press, 1961), p. 49.
93. Ibid, p. 71.
94. Ibid, p. 212.
95. Glass, 'The Mood of London', p. 178.
96. Glass, 'Introduction' (1989), p. x.
97. Ibid, p. xi.
98. Ibid, p. xiii.
99. Ibid, p. xix.
100. Edwards, 'Ruth Glass at UCL'.
101. Glass, *London's Newcomers*, p. 237.

CONCLUSION

1. Bertolt Brecht, *Poems: Part Three, 1938–1956* (Eyre Methuen, 1976), p. 439.

NOTES

Chapter 29

1. See Nicholas Jacobs and Prudence Ohlsen, *Bertolt Brecht in Britain* (National Theatre, 1977), pp. 29–31.
2. Bertolt Brecht, *Journals 1934–1955* (Methuen, 1993), trans. Hugh Rorrison, pp. 47–8.
3. Ibid, p. 97.
4. Lindsay Anderson, *The Diaries*, edited by Paul Sutton (Methuen, 2005), p. 194. For an excellent study of the film, and the extent to which it is and isn't 'Brechtian', see Mark Sinker, *If . . .* (BFI, 2004).
5. I owe this point to Simon Reynolds, *Rip It Up and Start Again: Postpunk 1978–1984* (Faber, 2005).
6. On the 'Weimar' motif in Britain in the second half of the 1970s, see Andy Beckett, *When the Lights Went Out* (Faber, 2009), and Jon Savage's *England's Dreaming* (Faber, 1991).
7. Bowie's German enthusiasms were often highly questionable, to put it mildly, but they were literally worn on the sleeve – the 'Berlin Period' album *"Heroes"* (1977) has a cover modelled on a painting by Erich Heckel of *Die Brücke*, as does the album he produced and co-wrote for Iggy Pop in the same year, *The Idiot*.
8. See Miloš Hroch's 2021 interview with Bohn, 'Eastern Bloc Rock', in *Tribune*, https://tribunemag.co.uk/2021/06/eastern-bloc-rock

Chapter 30

1. Peter Ahrends wrote a fascinating, fragmentary book on the firm, his family, and its roots in the socialist modernism of Weimar, *A3 Threads and Connections* (Right Angle, 2015).
2. But they also put out a much more sympathetic critique of modernism by Eric Hobsbawm, *Behind the Times* (Thames and Hudson, 1998), part of a series of Walter Neurath Memorial Lectures. Hobsbawm begins the book with a tribute to the Neuraths' educational efforts.
3. Allan, *Berthold Lubetkin*, p. 575.
4. Canetti, *Party in the Blitz*, p. 241.
5. See Berghahn, *Continental Britons*. For a sharp account of media 'philo-semitism', its close relation to antisemitism, and its political deployment, see Barnaby Raine, 'Jewophobia', *Salvage*, issue 6 (2018).
6. It is worth noting here that the left-wing pressure group Jewish Voice for Labour has estimated that Jews were six times more likely than gentiles to be expelled from the Labour Party for 'antisemitism', mostly in response to criticism of Israel; https://www.jewishvoiceforlabour.org.uk/statement/

the-ehrc-has-spoken-labour-is-no-place-for-left-wing-jews/. On Gaza and antisemitism, an intelligent statement is 'A Dangerous Conflation', *N+1*, October 2023, online at https://www.nplusonemag.com/online-only/online-only/a-dangerous-conflation

7. Newport Council gives out a useful short printed guide to the site, 'Newport City Council Civic Centre Murals', from which some of these details are taken.

Index

ABC tea shops 269, 272
Academic Assistance Council 40, 480
Academy Cinema, London 128–9, 138
Adam, Ken 144–6
Adams, George 228
Adler, Jankel 290–2
 'Degenerate Art' 246, 326
 Herman and 293, 295
 monograph on 350, 355–6
 Polish Army 289, 296
 Schwitters and 360
 Venus of Kirkcudbright 291–2
Adorno, Theodor W. 17, 20, 232
Adprint 188–9, 203, 212–14, 216–19, 224, 228–9, 473
Adriatica Building, Bucharest 399
AfD (*Alternative für Deutschland*) 527–8
Ahrends, Bruno 45, 424, 524
Ahrends, Burton and Koralek (ABK) 524
Aiton, Norah 372
Albatross Books 158–62, 172
Alberti, Leon Battista 207
Aleje Jerozolimskie, Warsaw 411–12
Aliens Act (1905) 38, 39
Allan, John 421
Allen and Unwin 150
Allen Lane 161, 167, 186, 189, 204, 205, 230
Allesley Village, Coventry 453
Alton Estate, Roehampton 431, 439
American Architect and Architecture 412
Amyes, Julian 135–6

Anders Army 340–1, 465
Anders, Władysław 340–1
Anderson, John 40
Anderson, Lindsay 139, 140, 517
Anderson, Perry 19–21, 234
Anrep, Boris 54
Antal, Frederick (Frigyes) 20–1, 232–5, 236, 311
Apollo 254
Arbeiter Illustrierte Zeitung (A-I-Z) 12, 13, 61, 68, 74–5, 262
Archers, The (production company) 130–5
Archipenko, Alexander 338
Architects and Technicians Organization (ATO) 413
Architectural Association (AA) 408, 409, 417, 438–9, 453, 485
Architectural Review 30, 105, 108, 410, 425, 426, 445, 485
Armstrong, Louis 517
Arntz, Gerd 127, 218, 219, 221–2
Arp, Hans 485
'Art Behind Barbed Wire' exhibition (1940) 283
Artists International Association 261, 300
Arts and Crafts movement 153, 426–7
Arup, Ove 24, 54, 411, 415
Ascherson, Neal 494
Association of Polish Architects (SARP) 434, 436
Atavism 103

INDEX

Atget, Eugène 89, 96
Atlantic Garden City, Berlin 398–9
Attenborough, F. L. 194
Auden, W. H. 31–3, 76, 516
Auerbach, Frank 18, 523
Aumonier, Eric 132–3
Auschwitz 139, 175, 182, 279, 324, 447, 461
Austin-Smith, Inette 107, 453
Austin-Smith, Mike 453
Austria 14, 16, 19–20, 39, 81, 82, 317, 527–8
Auteur Theory 113–15, 135
Avenue de Versailles, Paris 408
Aylesbury Estate, Walworth 461, 484, 488

Bach, J. S. 166
Bacon, Francis 335, 523
Baird, Nicola 272
Baker, Herbert 202
Balden, Theo 319–20, 389
Balfron Tower, Poplar 443–6, 447, 469
Ball, Joseph 41
Ballantine, Ian 172
Ballard, J. G. 275
Balogh, Thomas 71, 385, 476
Banham, Reyner 10, 422
Baranowska, Janina 341
Barlach, Ernst 13, 248, 325–6, 337, 338
Baroque style 197, 201, 203, 208, 233, 276, 342, 419–21
Barry, Charles 3, 10
Bartók, Béla 135
Bassett-Lowke, W. 29, 371
Bata Company 371, 381–4
Bato, Joseph 130
Battersea Park sculpture exhibition (1960) 306
Battleship Potemkin (1925 film) 118
Bauhaus Dessau 23, 82, 94, 152–3, 243, 388, 414
Bauhaus (pop group) 520, 522
Bauhaus school 12–13, 384–92
 designers 182, 250

 furniture 133, 179
 inspiration 195, 308
 major figures 17, 23, 123, 432
 students 82, 228, 319
 teachers 54, 108
 typography 76
Bauhausbucher series 29, 152, 152–3, 371, 388
Bauman, Zygmunt 54
Baumann, Hans 65
Bayer, Herbert 154, 162
Bayes, Gilbert 397
Beatles, The 522
Beckett, Marjorie 90
Beckett, Samuel 176
Beckmann, Max 243, 246, 248, 250, 253–4, 273–4, 275
Beerbohm, Max 191
Behrendt, Walter Curt 371, 396
Behrens, Peter 29, 157, 371, 522
Bell, George 44, 325, 326, 331
Bell, Quentin 100, 102
Bell, Vanessa 240
Belsize Square Synagogue 402
Bělský, Franta 305, 314–17
Belvedere Court, Hampstead 401
Benedetta, Mary 108
Benjamin, Elisabeth 377
Benjamin, Walter 28, 49, 96, 198
Bentley, Nicholas 120
Berg, Alban 73
Berger, John 235, 311, 344
Berger, Ludwig 116–17, 131
Berger, Otti 54, 389
Berghahn, Marion 49, 50
Berlin Dada 152, 243, 252, 358
Berlin, Sir Isaiah 20, 54
Berliner Ensemble 516
Berman, Mieczysław 293
Bernal, J. D. 270
Bernini, Gian Lorenzo 191, 208, 417
Bernstein, Sidney 30
Betjeman, John 30, 105–6, 109, 215, 235, 428

INDEX

Bevan, Aneurin 222, 415, 450, 486
Beveridge Report (1942) 480
Beveridge, William 40, 480
Bevin Court, Finsbury 406, 414, 417, 419
Bevin, Ernest 417
Beyer, Ralph 325
Big Ben 4, 5
Bihalji-Merin, Oto (Peter Thoene) 251–3
Bilbo, Jack 345–50, 356, 360, 523
Bilbo, Owo 346, 348, 350
Bilston, West Midlands 473–4, 476
Binder, Pearl 181
Bing, Gertrud 200–1, 202, 234
Bing, Rudolf 54, 296
Birdham, Chichester 424
Birdsall, Derek 175
Biro, Lajos 120
Biro, Val 179
Bishop's Avenue, Hampstead 402
Blacker, Jacob 446
Blackwell, Ursula 439, 441
Blake, Asher 324
Blake, Naomi 323–5, 326
Blake, William 202, 209
Blatchford, Robert 65
Blitzstein, Marc 516–17
Bloch, Martin 275, 283, 298, 300, 318, 522
Blomfield, Sir Reginald 377
Bloomsbury Group 31, 196, 240, 248
Blue Angel, The (1930 film) 64
Blue Books 203, 214–16
'Blue Rider' (*Der Blaue Reiter*) artists 239, 240, 245, 246, 252
Bluebeard's Castle (1963 film) 135
Blunt, Anthony 198–9, 205, 233, 254, 311, 344
Blyton, Enid 224
Board of Deputies of British Jews 41
Bodley Head, The 151, 161
Bohemia 38
Bohm, Dorothy 111
Bohn, Chris 521
Bolesławicz, Alina Zofia 435
Bomberg, David 341, 370

Bond film series 144–6
Bookchin, Murray 471
Bor, Walter 461–3, 462–3
Borenius, Tancred 54, 234
Borowiecka, Magda 435–6
Bossányi, Ervin 331–5
Boty, Pauline 364
Bowie, David 518, 520
Boyson, Alan 452
Brandt, Bill 86–93
 background 81
 documentary photography 51, 104, 105, 107, 141, 240, 460, 530
 Goldfinger and 469
Brandt, Ester 87, 88
Brandt, Rolf 87
Brandt, Willy 527
Bray, Phyllis 529
Brecht, Bertolt 14, 17, 20, 73, 118, 128, 346, 514–18
Breker, Arno 243, 244
Brendel, Otto 209
Brent Cross 451, 452
Breuer, Marcel 17, 110, 271, 377, 387–9, 391, 392, 433
Brick Expressionism 306, 338
Die Brücke ('The Bridge') 239, 245, 246, 248, 252, 254, 263, 276, 299
Briggs, Ella 474–5
Briggs, Walter 474
'Britain in Pictures' (ed. Turner) 213–17
British Leyland 497
British Union of Fascists (BUF) 41, 46, 417
Broome, Jon 488
Brown, Peter 229
Brownfield Estate, Poplar 443, 444, 446
Brownlow, Kevin 116
Bruce Plan, Glasgow 457
Brukalski, Barbara and Stanisław 293, 434
Brutalism 4, 434, 449
Buber, Martin 50
Bucherkreis, Der ('The Book Circle') 165
Bulatov, Erik 221
Burchard, Irmgard 250

579

Burlington Galleries 412–13
Burnett, Virgil 176
Buxton House, Huddersfield 452

Cabaret (1972 film) 520
Cadbury-Brown, Betty 443
Calder, Barnabas 445
Cambridge 430, 455
Camden Arts Centre 260
Cameron, James 72
Cameron, Julia Margaret 91
Canetti, Elias 17, 26, 31, 56, 261–2, 265, 272, 275
Canterbury Cathedral 333, 334
Čapek, Karel 24–5, 87
Caro, Anthony 307, 344
Carrington, Noel 181
Carroll, Lewis 345, 350, 354
Carter, Miranda 233
Cartier-Bresson, Henri 88
Caspari, Peter 404–5, 409
Cassirer, Ernst 199–200
Cavalcanti, Alberto 127
Cavani, Liliana 520
Cazalet, Victor 44
'Celtic fringe' 282–302
'Central Europe' (definition) 53–4
Cesarani, David 38–9
Chabrol, Claude 138
Chadwick, Lynn 306
Chagall, Marc 246, 291, 326
Chamberlain, Neville 11, 37, 44, 68, 70, 285
Chaplin, Charlie 116, 351
Charles, Prince 524
Charoux, Siegfried 303, 304, 305, 308–10
Chat, Elisabeth 78–80, 85, 86
Chelsea 386–7, 390
Cheltenham Estate, Ladbroke Grove 443
Chermayeff, Serge 377, 386
Chitty, Anthony 409
Church, Margaret 409
churches and cathedrals 325–43
Churchill, Winston 36, 75, 102, 315, 482

Cieślewicz, Roman 184
Cinamon, Gerry 175, 179, 211
Circle: International Survey of Constructive Art (1937) 269, 270–1, 424
Clarion, The 65
Clark, Kenneth 198–9, 207, 232, 295, 301, 344, 360
Clarke, Alan 518
Cleveland, John 236
Cliff, Tony 525
Clyde Young and Partners 452
Co-Operative Village, Loughborough 467–8
Coates, Well 30, 374, 450
Cohen House, Chelsea 386–7
Cohen-Portheim, Paul 23, 24, 25
Coia, Jack 454–5
Coke, David 329
Cole, G. D. H. 477
Cole, Henry 194
Coleman, Alice 524
Collins 188, 212
Colombus Haus, Hamburg 404
Colquhoun, Alan 434, 438
Communism 26, 63, 152, 157, 231, 243, 286, 413, 462
Conceptualism 226, 344
Congres International d'Architecture Moderne (CIAM) 370–1, 412, 440–1
Connell, Amyas 30, 371
Connell, Ward & Lucas 373–4, 401
Constructivism 109–10, 152–3, 245–6, 306–7
 abstraction 344
 buildings 371, 389
 commercial 267
 early 9, 30
 English 224, 268–71, 286–8
 German 108, 162, 243, 250, 270, 345
 Hungary 311
 ideas 12
 influence 82, 122, 173
 Italian 242

Lubetkin and 410, 416
mainstream 7
'maximum economy' 417–18
Polish 293–4
Soviet 163, 243, 358
Tschichold and 162, 165
'Contemporary Art' exhibition (1936) 257
Conze, Edward 495
Corbyn, Jeremy 527
Corgi 179
Cornwall 265, 268, 271, 284–6, 287–9
Cosman, Milein 275
Cosmo Restaurant, Finchley Road 272–3
Courbet, Gustave 251
Courtauld Institute of Art 30–1
Coward, Noel 46
Cranbrook estate, Bethnal green 418, 420–1, 446
Crawford's 29, 371
Crittall Windows, Essex 29, 405
Croft, Diana 261
Crosby, Theo 308
Cubism 240, 326, 336, 338, 461
Cullen, Gordon 408, 409, 414, 416, 460, 462
Cumbernauld College, Scotland 455
Curtis, Frederick 403
Curwen Press 153, 175, 235
Czechoslovakia 8, 14, 16, 23, 37, 38, 39, 323–4

Dachinger, Hugo 283, 284
Dada(ism) 12, 152, 153, 245–6, 250, 344–5, 411
Daily Express 239, 372
Daily Herald 65, 254
Daily Mail 34, 37, 40–2, 137, 239, 244
Daily Mirror 364
Daily Telegraph 254
Darley, Peter 280
Dartington Hall, Totnes 134, 384–6
Data Film Unit 127
Davis Estates 404, 405
De La Warr, Earl 393–4

De La Warr Pavilion, Bexhill-on-Sea 392, 393–5
de Mendelssohn, Peter 259
Deeping, Warwick 158
Defoe, Daniel 236
'Degenerate Art' 127, 209, 224, 241–2, 264
'Degenerate Art' exhibition (1933) 243
'Degenerate Art' exhibition (1937) 239, 241, 243–7, 252–3, 268, 291, 359, 529
Dekk, Dorrit 176–7
Delany, Paul 86, 91
Denham Studios 114, 120, 130, 390
Depero, Fortunato 152
Derbyshire, Andrew 438, 439
Derer, Vladimir 525
Deutsch, Gerti 75–8
Deutsche Werkbund 242, 378, 389
Deutscher, Isaac 20, 48–50, 296–7
Dietrich, Marlene 63
Dillon, Carmen 136
Dix, Otto 248, 321
Döblin, Alfred 31
Dollfuss, Engelbert 76, 264
Dollis Hill, London 318–19
Doran, Edward 39
Dorset estate, Bethnal green 418–19, 421, 446
Dovzhenko, Alexander 124
Drake, Lindsay 409, 414
Dresden Garden Suburb 379
Duchamp, Marcel 411
Duczyńska, Ilona 477
Dudley Zoo 406
Dudow, Slatan 117, 118, 128
Dunnett, James 444
Dupont, E. A. 29, 116, 131
Dürer, Albrecht 189, 276

Eames, Charles and Ray 307
East Tilbury, Essex 371, 381, 382–4
Edwards, Michael 508
Ehrlich, Bettina 317
Ehrlich, Georg 317–18

581

Einstein, Albert 262
Eisenmayer, Ernst 276–7
Eisenstein, Sergei 31, 118, 124, 143–4, 198, 227
Eisler, Hanns 14, 27
Elek, Paul 150–1, 298, 486, 487, 524
Elizabeth II, Queen 278
Elkan, Benno 325
Elmhirst, Leonard and Dorothy 384–5, 386
Emberton, Joseph 371, 423
Empire Exhibition, British (1924) 25–6
Empire Marketing Board (EMB) 124, 138, 139
Engel, Bernd (Bernard) 450, 451–2
Engel, Semmy 451–2
Engelman, Edmund 402
English Heritage 104
Eno, Brian 520
Enoch, Kurt 158, 172–3
Epstein, Jacob 370
Ernst, Max 345
Esslin, Martin 516
Etchells, Frederick 371
Ettlinger, Leopold 193–4
Europa (1931 film/book) 351
Everyman 64–5
Everyman's Library 149, 151
Expressionism 11–13, 29–30, 245–6, 251–2
 buildings 372
 English 22
 Expressionism Rescued 256
 German 242, 248, 263, 265–7, 276, 327, 338
 German film 127, 134
 humour in 274
 Polish 277
 pop culture and 520

Faber and Faber 150, 151, 187, 224, 266, 388
Fabian, Erwin 177, 180, 185
Facetti, Germano 151, 174–5, 181, 182, 184–5, 210

Factory Records 519
Faczyński, Jerzy 342, 434
Faithfull, Marianne 518
Fauvism 240, 245
Feibusch, Hans 327–31
 'Degenerate Art' 241, 246, 291
 muralist 297, 305, 326, 335
Feigl, Friedrich 272–3, 298
Feiler, Paul 288
Feininger, Lyonel 255, 257, 331
Fergusson, Bernard 109
Fergusson, J. D. 291
Festival of Britain (1951) 90–1, 303–5, 424–5
 buildings 98, 138
 Lansbury Estate 444
 pavilions 302, 403, 425
 St John's Church 327
 Topolski's murals 277, 279
Feuchtwang, Wilhelm 228
Feuchtwanger, Lion 67
Fifth Column 41, 46
'Finchleystrasse' 259–60, 265, 271–2, 275, 277, 319, 516, 525–7
Finsbury Health Centre 378, 391, 406, 413–14, 416
Finsbury Plan 413, 414, 423
Fischer, Harry 523
Fischinger, Oskar 124, 125
Fletcher, Richard 452
Focal Press 89, 104, 150, 151
Foges, Wolfgang 150–1, 188–9, 212–13, 215, 224
Foot, Michael 44
Forbát, Fred 457
Ford, Thomas J. 327, 328–9
Fordism 169, 381
Fosse, Bob 520
Foster, Norman 387
Fraenkel, Josef 49
Frampton, Kenneth 438
France 370
Franck, Carl Ludwig 283, 409, 423
Frank, Josef 397

Frankel, Rudolf 398–9
Frankfort, Henri 209–10
Frankfurt Institute for Social Research 14
Frankfurt School 17, 232
Frankfurther, Eva 280–1, 293
Frankl, Paul 209, 210
Frederiksen, Erik Ellergard 170
Free Cinema (NFT) 138–41
Free German League of Culture (FDKB) 259, 261–2, 272, 276, 299, 360, 516
Freeson, Reg 318
Freud, Anna 21, 402
Freud, Ernst 17, 400–2
Freud family 402
Freud, Lucian 17
Freud Museum 400
Freud, Sigmund 14, 17, 272, 273, 401
Freudianism 21
Freund, Gisèle 96
Freundlich, Otto 250
Frey, Dagobert 428–9
Fried, Erich 56
Fried, Grete 40, 335
Friedlaender, Walter 198, 234
Friedlander, Elizabeth 177, 214, 229
Frink, Elisabeth 421
Fry, Maxwell 31, 84, 267, 328, 377, 386, 390, 401, 429
Fry, Roger 30, 196, 247
Functionalism 7
Furtwängler, Wilhelm 73
Futurism 12, 103, 105, 152, 153, 242

Gaberbocchus Press 350–3, 354–6, 360
Gabo, Miriam 269, 287
Gabo, Naum 30, 268–71, 286–8
 background 9, 17, 53, 267
 on Hitler 47
 'Prepare for Design' 286
 Realistic Manifesto 9, 269–70
 Granite Carving 287
 Revolving Torsion 5–6, 51, 305, 306–7, 528

Spiral Theme 287
Gahura, František Lydie 381, 383
Galsworthy, John 157
Games, Abram 180, 183
Games, Naomi 181
Gang of Four (pop group) 517–18
Garden Cities 271, 287, 379–83, 398–9, 424, 471, 475, 498
Gaumont 117, 395
Gay, John 51, 104–7, 516
Gay, Marie 104
Gay, Peter 200
Gaza 526
Gellner, Ernest 18, 52
Geographical Magazine 83
Géricault, Théodore 235
'German Art Exhibition' (1937) 243–4
Germany 14, 22, 81, 527–8
Gernsheim, Alison 99, 100–2
Gernsheim, Helmut 45, 97–104, 105, 199, 202, 225
Gernsheim, Walter 97, 100, 101–4
Gerson, Horst 210
Gestetner, Sidonie 328
Get Carter (1971 film) 112–13, 115
Gibberd, Frederick 318
Giedion, Sigfried 105
Gill, Eric 154, 177, 185
Gillespie Kidd and Coia 454
Ginsberg, Jean 408, 450
Ginzburg, Carlo 227
Glasgow 291–2, 293–5, 456, 457
Glasgow School of Art 454, 456, 457
Glass, David 499
Glass, Ruth 498, 499–509
Glass, Stephen 78
Glass, Zoltan 66, 78
Gloag, John 193, 427
Godwin, Tony 174, 182
Goebbels, Joseph 242, 246
Goehr, Leila 91, 133
Goehr, Walter 133
Goethe, Johann Wolfgang von 157
Gohler, Hans 104

583

Goldfinger, Ernő 439–46
 'art' architect 450
 background 18, 21
 Brandt and 469
 Pevsner and 52
 popular culture depictions 145, 369
 Willow Road house 77, 312, 360
 The County of London Plan Explained 88, 459–61
 'The Sensation of Space' 445
Goldfinger, Marianne 440
Goldfinger, Peter 439–40, 443
Golding, Louis 186
Goldscheider, Ludwig 150, 224–5, 266
Gollancz 151, 155, 156–7, 160, 186
Gombrich, E. H. 47–8, 202–3
 Anderson on 20, 234
 background 52, 75, 275
 on Hauser 232
 peerage 11
 Caricature 191–2, 226, 233
 A Little History of the World 213, 225, 226
 The Story of Art 18, 150, 203, 225–7, 230
Gordine, Dora, *Mother and Child* 306
Gorky, Maxim 152
Górska, Adrienne 450
Gothic style 4, 5, 7
Gotlib, Henryk 275
Gowan, James 208
GPO Film Unit 124–7, 138, 139, 232, 351
'Graeco-Nordic' art 243, 247
Grahame, Alice 486
Gramsci, Antonio 381
Grant, Duncan 240
Grant, Ted 525
Gray, Allan 133
Gray, Camilla 229
Great Depression 15, 34, 82, 155, 298, 377, 412
'Great Russian Exhibition' (1922) 407
Greater London Council (GLC) 111, 435, 443, 498

Greene, Graham 114, 130, 168
Gregorovius, Ferdinand 225
Grenfell, David 299
Grenfell-Baines, George 403
Grierson, John 124, 232
Grisar, Erich 165–6
Groag, Jacques and Jacqueline 17, 181, 222–3, 425
Grohmann, Willi 255
Gropius, Ise 391
Gropius, Walter 386–93
 Bauhaus director 17, 23
 designs 123, 129, 312, 429, 457
 Englishness and 114, 394
 Fry and 328, 377, 429
 influence 144
 L. Moholy and 94, 97
 Moholy-Nagy and 108, 110
 Moro and 424
 Segal and 486
 International Architecture 371
 Monument to the March Dead 387
 The New Architecture and the Bauhaus 388–9
Grossner, Sonja 321
Grosz, George 15, 152, 243, 248, 252, 263–4, 345
Grune, Karl 114, 514
Guardian 41, 239
Guild Socialism 477
Gutkind, Erwin Anton 469–71, 470, 471
Guttman, Simon 73, 79

Haffner, Sebastian 36–7, 259
Hagen, Louis 125
Haller, Józef 290
Hallett, Michael 63
Hallfield Estate, Bayswater 414, 416
Halter, Roman 326
Hamburger, Michael 517
Hamilton, Richard 362, 364
Hampstead, London 259–62, 267–73, 275, 280, 299, 398–404, 441–2
Hapsburg Empire 75, 131, 273, 341, 492

Harding, Valentine 409
Hardy, Bert 72, 75, 90
Harrap 212
Harries, Susie 205
Harrison, Tom 76
Hartmann, Otto 78
Hastings, Hubert de Cronin 408–9, 426
Haus Goldstein, Berlin 436
Hauser, Arnold 232, 234
Hausmann, Raoul 345, 350
Havlíček, Josef 433
Hawkes, Jacquetta 228
Hawksmoor, Nicholas 201, 276, 462
Hayek, Friedrich 17, 20, 234, 479, 480–4, 496, 498, 524
 Capitalism and the Historians 480–2
 The Constitution of Liberty 482–3, 525
 The Road to Serfdom 476, 482
Haymarket Centre, Leicester 465–6, 467
Heartfield, John
 agitprop artist 93
 family 152
 FDKB member 262
 Grosz and 252
 A-I-Z work 12, 13
 influence 519, 520
 interned 45
 KPD member 83, 243, 345
 '*Kunstlump*' debate 263–4
 photomontages 17, 61, 68, 69, 95, 217
'Heath Drive', Gidea Park 410
Hecht, Bernat 526
Heckel, Erich 154
Heckroth, Hein 134, 135, 250
Heller, Otto 135
Hempel, Eberhard 210
Henrion, F. H. K. 185, 267
Hepworth, Barbara 31, 267, 268, 270, 271, 286, 287–8
Herman, Josef 289, 290, 292–6, 299–302, 303
Hermann, Frank 224
Heron, Patrick 288
Herrey-Zweigenthal, Hermann 399–400

Herzfelde, Wieland 152
Hess family 257
Hess, Hans 257–8
Heydenreich, Ludwig 210
High Cross House, Dartington 385
Highpoint, Highgate 406, 410, 411, 417
Highpoint II, Highgate 411–12, 413, 415, 417, 424
'Hillcrest', Hampstead 399
Hillier, Erwin 131
Him, George 181, 223, 267
Himmler, Heinrich 247
Hirschfeld-Mack, Ludwig 45
Hirschfeld, Magnus 32
Historic England 508
Historicism 105
Hitchcock, Alfred 88, 116
Hitler, Adolf 157, 243, 244, 246, 247, 265, 376
Hobsbawm, Eric 18, 26–7, 31, 48–9, 499, 500
Höch, Hannah 345
Hodges, Mike 112–13
Hodin, J. P. 272
Hoellering, Georg 128–9, 138
Hofbauer, Imre 15, 276, 280
Hoffman, Dezo 522
Hoffman, E. T. A. 134
Hoffmann, Edith 234, 249, 250, 266, 285, 289
Hoffmann, Josef 378
Hogarth Press 29
Hogarth, William 192, 233, 235
Hoggart, Richard 140
Holbein, Hans 178, 189, 276
Holden, Charles 199, 201, 332–3, 403
Hollamby, Ted 435
Hollis, Richard 175
Holocaust 318, 407, 415
Holroyd-Reece, John 158, 161, 379
Honzík, Karel 433
Hopkinson, Tom 70–2
 Hardy and 75, 90
 Hulton and 60
 Lorant and 65, 66, 68, 69

Hopkinson, Tom – *cont'd*
 Deutsch and 76, 78
 social improvement 88
Horovitz, Béla 150, 224–5
Horovitz, Michael 354
Horthy, Miklós 63, 119, 527
House for An Art Lover, Bellahouston Park 457–8
Houses of Parliament 10
Howard, Ebenezer 379–80, 465, 498
Howard, Michael 526
HPO (Heavenly Post Office) (1938 film) 125–6
Hübschmann, Kurt 65
Hugenberg, Alfred 64
Hughes, Kenneth 415–16
Hulton, Edward 60, 68, 72, 286
Hungary 14, 16, 63, 82, 108, 119, 324, 527
Hutton, Kurt 65, 68–9, 70, 72, 73–5, 141, 217, 526
Huxley, Aldous 158, 159
Huyton, Liverpool 43–4, 283

Illustrated London News 103
Impington Village College, Cambridge 390–1, 392, 429
Impressionism 251–2
Insel-Bücherei series 154, 157–8, 164, 177–8, 188–9, 189
Insel-Verlag 154, 162, 188, 190
International Style 242, 370–2, 409, 410–11, 441, 452, 453, 461
International Style, The 371, 393
internment camps 39, 40–6, 283–4, 347, 359
Isherwood, Christopher 31, 32–3, 117, 516, 520
Isle of Man 37, 42, 44–5, 282–4, 347
Isokon Building, Belsize Park 267, 374, 398, 438, 447–8
Isotype charts 20, 127, 216–22
Isotype Institute 218, 219, 224, 231, 473
Israel 49, 229, 280–1, 294, 528
Italy 16, 242

Jackson, Edgar 394
Jacobs, Jane 503
Jacoby, William 461
Jaretzki, Hans Sigmund 398
Jarrolds 228
Jarry, Alfred 350
Jelinek-Karl, Rudolf 450–1
Jennings, Humphrey 235
Jewish Chronicle 41
J. M. Dent 64, 151, 160
Johnson, Boris 527
Johnson, Hewlett 325, 333
Johnston, Edward 153–4
Jonas, Robert 173
Jonathan Cape 185
Jones, Inigo 202
Jones, Jennifer 134
Jooss, Kurt 134, 283, 385
Joy Division 519
Joyce, James 31, 158, 159, 185
Judith Kerr 17
Junge, Alfred 131, 132, 133
JW3 Jewish Community Centre, Finchley Road 260

Kabakov, Ilya and Emilia 221
Kafka, Franz 31, 92, 177, 272
Kaldor, Nicholas 476, 480, 484, 525
Kalecki, Michał 476, 494
Kalmein, Wend Graf 210
Kandinsky, Wassily 30, 124
Kapp Putsch 263, 387
Karfík, Vladimir 381, 383
Karl-Marx-Hof, Vienna 33, 84, 520
Kästner, Erich 67, 131
Katz, Bronek 425
Kauffer, Edward McKnight 153
Kaufman, Walter 45
Kaufman, Mikhail 118
Kaufmann, Eugene (Kent) 377, 380–1
Kee, Robert 69
Kehoe, Louise 406, 407, 411, 415, 418
Keller, Hans 275
Kennedy, Margaret 117

INDEX

Kerr, Alfred 17, 35
Kerr, Judith 17, 35
Khlebnikov, Velimir 416
Khrushchev, Nikita 314, 417
Kindertransport 37, 76–7, 139, 279, 280, 456, 522
King Penguins 151, 188–94, 199, 204–5, 212–14, 226, 233, 303, 325
Kingsley Court, Willesden 404–5
Kirchner, Ernst Ludwig 250, 252
Kirkcudbright, Scotland 291–2
Kitzinger, Ernst 45, 191, 203, 325
Klecki, Alexander 341
Klee, Paul 186, 243, 290, 338
Klein, Melanie 17, 21, 400
Klemperer, Otto 73
Klingender, Francis 231–3, 235–6, 262, 264–5, 311
Klopfleisch, Margarete 319, 320–2
Klopfleisch, Peter 321–2
Klutsis, Gustav 270
Koch, Rudolf 154, 175
Koestler, Arthur 18–19, 32, 34–5, 56, 67, 155–6, 522
Koffler, Camilla 'Ylla' 78
Kohr, Leopold 469, 490–4, 495
Kokoschka, Olda 262, 267, 284–5
Kokoschka, Oskar 262–7, 284–6, 288–9
 Eisenmayer and 276
 exhibitions 250–1, 255
 Feigl and 272
 Motesiczky and 274
 Strenitz and 279
 works 225, 246
Kołakowski, Leszek 54
Kolbe, Georg 250, 251
Kollwitz, Käthe 276, 293, 320
Komisarjevsky, Theodore 54
Koppel, Heinz 298
Korda, Alexander 114, 119–23, 129, 131, 134, 138, 514, 515
Korda, Michael 119, 120–1, 123, 129, 130
Korda, Vincent 119, 120, 123, 144
Korda, Zoltan 119, 120, 122, 123, 129

Kormis, Fred 318–19
Korn, Arthur 377, 433, 436–9, 437
Korn, Halina 279
Korsch, Karl 514
Kossowski, Adam 341–3, 434
KPD (German Communist Party) 94–5, 311–12
 Hobsbawm and 26
 members 68, 83, 243, 299, 321, 345, 376, 495
 Suschitzky and 82
 'Worker Photography' 75
Krasker, Bob 91
Krasna-Krausz, Andor 89, 104, 151
Krautheimer, Richard 209
Kreisky, Bruno 527
Kris, Ernst 191–2
Kristallnacht 16, 39, 69, 454
Kropotkin, Petr 270
Kuhle Wampe (1932 film) 144
Kulturwissenschaft 200, 204
Kun, Béla 63, 119, 232
'*Kunstlump*' debate 263–4
Kurz, Hilda 214, 215

La Casa Piccola, Switzerland 486
Lakeview estate, Bethnal Green 418
Lamprecht, Gerhard 117
Lancaster, Osbert 30, 109
Land of Promise (1946 film) 127, 218
Landauer, Fritz 403
Lane, Allen 151, 160, 162, 172, 173, 188
Lang, Fritz 13, 88, 115, 117, 131, 135
Lange, Oskar 476
Langewiesche, Karl Robert 214
Lansbury Estate, Poplar 444, 501
Lantos, Barbara 91
Lanyon, Peter 288
Lasdun, Denys 409, 414, 422, 423
Laski, Harold 151, 155
Lasko, Peter 205, 211
Lassally, Walter 140, 141–2, 143
Laughton, Charles 120–1, 122, 515–16
Lawrence, D. H. 159, 173

587

INDEX

Le Corbusier 286, 328, 370, 412, 432, 440, 462, 486
Le Witt, Jan 181, 223, 224, 267
Left Art 351
Left Book Club 30, 35, 149, 151, 155–7, 160, 161
Left Front for the Arts (LFF) 118
Leicester Museum and Art Gallery 255, 255–7, 272, 298, 321, 522
Leicester Traffic Plan 463–5
Lenica, Jan 184
Lenin, Vladimir Ilyich 417
Lenya, Lotte 517
Lescaze, William 385, 386
Lessing, Gotthold Ephraim 309
Lesy, Michael 103
Letchworth Garden City 379, 380, 381
Levy House, Chelsea 386–7, 390
Levy Mervyn 281
Lewis, Sinclair 158, 159
Lewis, Wyndham 30, 153
Lewisham Council 485, 488–9, 493
Lewishohn, Ludwig 173
Libeskind, Daniel 457
Lichtburg Cinema 399
Liebknecht, Karl 227, 389
Life and Death of Colonel Blimp, The (1943 film) 131–2
Lilliput 60–1, 66–8, 78, 86, 91–2, 104, 262
Lissitzky, El
 'Abstract Cabinet' 268, 358
 Bihalji-Merin on 252
 CIAM and 370
 designer 162, 163
 Gabo and 269, 270
 Herman on 293
 influence 407, 520
 'Proun Room' 358
 Schwitters and 358
 For The Voice 152
Listener, The 82, 83
Literary Britain 92–3
Little Friend (1934 film) 117
Littlewood, Joan 516

Litvinoff, Emmanuel 49
Liverpool Metropolitan Cathedral 336, 338
Llewelyn-Davies, Richard 424, 508
Llewelyn-Davies, Weeks, Forestier-Walker and Bor 508
Lloyd, Frank 523
Lom, Herbert 462
London 23–8, 259–81, 341
London County Council (LCC) 309–10, 312–13, 459–61
 estates 233, 315, 439, 451
 housing programme 397
 planning 424, 470
 schools 208, 443, 446
 sculptures 303, 304
London Film Society 29, 118–19
London Films 120, 129–30
London Plan 437, 459–61, 462
London School of Economics 476
London Transport 17, 29, 154, 181, 259, 267, 332, 388, 403
London Zoo 406, 440
Loos, Adolf 86, 222, 263, 378, 472
Lorant, Stefan 59–80, 102, 160, 242, 262
Lotz, Wolfgang 210
Low, David 160
Lubetkin, Berthold 406–22
 background 21
 'Credo' 422
 folk-hero image 369, 376
 Ginsburg and 450
 Goldfinger and 439–40, 446
 hard-line modernism 51
 Jewishness 49
 legacy 405, 524
 Peterlee plans 79
 works 18
Lukács, György 63, 119, 232, 235, 422, 477
Lunacharsky, Anatoly 119, 123–4
Lund Humphries 166
Lutyens, Edwin 196, 379
Luxemburg, Rosa 227–8, 389

588

INDEX

Lye, Len 125
Lynn, Jack 439
Lyons Corner Houses 113, 272, 280, 281

M (1931 film) 131, 135, 521
MA group 108, 311
McCarthyism 42, 174, 243, 270
MacColl, Ewan 516
MacInnes, Colin 428
McKean, John 486
Mackintosh, Charles Rennie 22, 29, 371, 378, 457–8
McLaren, Norman 125
McLuhan, Marshall 198
MacMillan, Andy 454–8
Macmurray, John 217
Macnaghten, Mary 311–12
Mahler, Alma 263
Mahler, Marian 193
Malevich, Kasimir 124, 269, 270
Malik-Verlag 152, 155
Maltby, John 83
Man, Felix H. 65–6, 70, 72–5, 526
Manchester Guardian 254
Manheim, Ralph 517
Mann, Erika 76
Manor House Drive, Brondesbury Park 452
Marber Grid 184–5, 211
Marber, Romek 151, 182–5
Marc, Franz 154, 257, 272
Mardall, Cyril 8, 54, 377, 433
Mardersteig, Hans (Giovanni) 154, 158, 159, 161, 162, 170, 447
Maresfield Gardens, Hampstead 399–402
Marks, Grete 250
Marlborough Fine Art, Mayfair 523
MARS Group 412, 437
Marshak, Samuil 181
Martin, Leslie 269, 424
Martin, Mary 344
Marx, Karl 14, 236, 440, 478
Masaryk, Jan 264
Matter of Life and Death, A (1946 film) 131, 132–3

Matthew, Robert 424, 461
Maufe, Edward 376
Maxwell, Robert 436, 525
May, Ernst 12, 175, 379, 380, 407, 486
Mayakovsky, Vladimir 152, 163
Mayer-Marton, George 40, 335–7, 522
Mayne, Ferdy 462
Mazzetti, Lorenza 139
Meades, Jonathan 425
media design 12, 13
Meidner, Ludwig 49, 246, 326
Melnikov, Konstantin 407, 440
Mendelsohn, Erich 49, 144, 232, 377, 386, 392–5, 404, 486
Mendelsohn, Louise 394
Menon, V. K. Krishna 160
Mentor 173–4
Merchant Ivory 143
Merseyside 434–5
Merseyway Centre, Stockport 452
MERZ art (Schwitters) 357–65
Metropolis (1927 film) 13, 64, 115, 144
Metzger, Gustav 522
Metzstein, Isi 454–8
Meyer, Hannes 243, 389, 391
Meynell, Francis 216
'Mid-European Art' exhibition (1944) 255–7, 259
Middlesbrough 501–3
Mies van der Rohe, Ludwig 17, 144, 385, 389, 432, 486, 524
migration 508–9
Mikes, George 38, 52, 120
Miles, John 179
Miliband, Ed 526
Miliband, Ralph 525
Miller, Lee 321
Milton Keynes 307, 508
mining industry 298–302, 448–50, 494
Ministry of Information 267
Miracle in Soho (1957 film) 135–7
Mises, Ludwig von 476, 479
Mnemosyne Atlas (Warburg Institute) 200, 201–2

INDEX

Modern Art Gallery, London 346, 347–9, 360
Modernism 196
Moffett, Noel 435
Moholy, Lucia 94–7, 389
Moholy-Nagy, László 108–10
 Balden and 319
 Bauhaus member 17, 162, 271, 389
 Bauhausbücher series 153, 217
 Englishness and 114
 Gropius and 387
 Kordas and 121, 123
 Lucia and 94
 'the New Vision' 55
 Peri and 311
 Segal and 485
 UFA-Magazin 64
 works 125, 267
Momma Don't Allow (1956 film) 140, 144
Mondrian, Piet 31, 124, 267, 268, 271, 287
Monktonhall Colliery, Scotland 449
Montagu, Ivor 30
Moore, Henry 31, 92, 215, 268, 287
Moravia 38
Morgan: A Suitable Case for Treatment (1966 film) 142, 143
Morgan, Guy 410
Morija Press 175, 176
Morison, Stanley 153, 155, 162, 164, 186, 193, 202
Moro, Peter 51, 409, 423–5
Morris, Henry 390, 391
Morris, Hugh 438, 439
Morris, William 153, 163, 426–7
Mortimer, Raymond 87, 239–40, 248, 252
Motesiczky, Marie-Louise von 273–5
Moya, Hildago 425
Muir, Edwin and Willa 31
Müller-Blensdorf, Ernst 337–9, 359
Müller, Theodor 210
Münchner Illustrierte Presse 64, 68, 75
Munich Agreement (1938) 37, 262
Münzenberg, Willi 35, 61, 118, 151

Murnau, F. W. 117
Museum of Modern Art, New York (MOMA) 360, 361, 370, 412
Muthesius, Hermann, *The English House* 378, 379

Nabokov, Vladimir 54
Nadar 96
Nairn, Ian 310, 426, 462
Nairn, Judy 205
Nansen, Fridtjof 338
Nash, Paul 370
National Film Theatre (NFT) 138
National Gallery 232, 275–6, 524
National Health Service 7, 8–9, 433, 480, 528
National Socialism 15, 64, 242
National Trust 369, 441–2
National Unemployed Workers' Movement (NUWM) 83, 84
Nazi Germany 16, 34, 37–8, 39, 82, 166, 201, 340, 359, 412
Nemon, Oscar 306
neo-Georgian style 207, 208
Nessler, Walter 42–3
Netherlands 41
Neubauer, Theodor 94
Neue Sachlichkeit (New Objectivity)
 Hutton and 69
 Motesiczky and 273–5
 Neuschul and 298
 Pressburger and 131
 realism of 65, 117, 165, 246, 256
 Sander and 290
 Willett on 22
Neues Bauen ('New Building') 203, 215, 370, 436
Neurath, Otto and Marie 20, 127, 214, 216, 218–19, 221, 472–6
Neurath, Walter and Eva 18, 150–1, 188–9, 212, 215, 224–5, 227–31, 275
Neuschul, Ernst 298–9
Neustift (New Foundations) 213
Neutra, Richard 385

INDEX

New American Library (NAL) 173–4
'New Architecture' 390, 403
New Brutalism 207–8, 344, 432, 436
New Empiricism 422
New Left Review 523
New Statesman 239
New Towns 379, 384, 430–1, 458, 463, 503
 Crawley 453
 Leyland 342–3, 434
 Malpas 434
 Nowa Huta 342, 465
 Peterlee 78–9, 406, 414, 422
 Scottish 455, 456
 Stevenage 102, 315–16, 467, 508
New Typography 163–6, 216
New Wave, British 139–45, 141, 517–18
New West End Synagogue 332
Newport Civic Centre, Wales 331, 528–31, 529
Newton, Eric 254
Nicholson & Watson 212
Nicholson, Ben 31, 267–8, 269, 271, 284, 286, 287–8, 360
Nicholson, Winifred 284
Night Porter, The (1974 film) 520
Nimptsch, Uli 306
Nolde, Emil 243, 248, 250, 257
Nordau, Max 241
Norrie, Ian 111
Norskaja, Niura 64
North-Western Reform Synagogue, Golders Green 260, 403
Norton, Noel 250
Novembergruppe 243, 299, 485
Novotný, Fritz 209
Novotný, Otakar 462
Nowa Huta, Kraków 342–3, 465

Oberon, Merle 399
Odeon 152, 395
Officina Bodoni 154, 164
Ohlsdorf Crematorium 332
Olden, Rudolf 45

Orchestral Manoeuvres in the Dark (pop group) 519, 521
Ortega y Gasset, José 198
Orwell, George 155–6, 173–5, 215
Oskar-Kokoschka-Bund 261, 319, 321
Ossulston Estate, London 397
Osten, Gert van der 210
Ott, Arisztid 119
Ovington Square, South Kensington 487
Oxford 430, 455

Pabst, G. W. 117
Palace of Pensions, Prague 6–8, 433
Palace of Westminster 2–4, 5
Paladin 235
Palestine 48, 50, 324, 394–5, 402, 526
Palladianism 411
Palladio, Andrea 201, 207, 411
Pan 179–80
Panofsky, Erwin 199–200, 210
Paolozzi, Eduardo 306, 364
Paris Expo (1925) 407–8
Pasmore, Victor 344
Pater, Walter 196
Paulick, Richard 400
Pechstein, Max 257
Peeping Tom (1960 film) 135
Peleg, Anita 324
Pelham, David 175
Pelican Books 7, 45, 170, 172–4, 185, 191, 216, 523
'Pelican History of Art' 149, 188, 204–5, 208–11, 228–9, 231, 233
Pelican Specials 94–5, 160–2, 251
Penguin Books 30, 40, 74, 88, 95, 149, 159–62, 167–71, 174–85, 187
Penguin Books USA 172–3
Penguin Classics 170, 171, 177, 185, 210, 225
Penguin Composition Rules 169, 175–6
Penguin Crime 183
Penguin furniture 447–8
Penguin Poets 177–8
Penguin Specials 151, 160, 161, 253, 325

591

Penrose, Roland 92, 321
People on Sunday (1930 film) 117–18, 144
Peri, Peter László 303–4, 305, 310–14, 316, 326
Pericrete 312–14
Perret, Auguste 407, 439, 439–40, 440, 445
Perspex 271, 287
Peterhans, Wolfgang 82
Peterlee, Co. Durham 78–9, 406, 414, 422
Peters, Olaf 245
Pevsner, Antoine 9, 269–70
Pevsner, Dieter 179, 181
Pevsner, Nikolaus 425–31
 background 51, 151
 Englishness and 432
 on Festival of Britain 425–6
 Goldfinger and 52
 on Mendelsohn 394
 peerage 11
 'Pelican History of Art' project 188, 203–5, 208–9, 211, 233
 'Pevsner' (noun) 369
 'The Buildings of England' 18, 177–8, 426, 430
 The Englishness of English Art 428–31
 An Enquiry into Industrial Art in England 427–8
 Industrial Art in England 430
 The Leaves of Southwell 194–5
 Outline of European Architecture 45
 Pioneers of the Modern Movement 426–7
 Visual Planning and the Picturesque 425–6, 428, 430
Phaidon 97–8, 150, 224–5, 266
Philby, Kim 83
Philip, Prince 278
Picasso, Pablo 348
Pick, Frank 29, 332, 388–9, 403, 427
Picture Post 60–1, 68–80, 85, 88–92
 Brandt and 87
 closure 224
 Heartfield and 262
 Hutton and 102
 'new world dream' 81, 106, 107, 127
 Suschitzky and 112, 113
 Tudor-Hart and 81, 84
 as useful source 361, 364
Picturesque style 425, 428, 429–30, 432, 453
Pilichowski, A. V. 409
Piłsudska, Jadwiga 435
Piłsudski, Józef 290, 293
Pinder, Wilhelm 198, 203, 210, 214, 428
Pinewood Studios 136, 144
Piper, John 215, 456
Piscator, Erwin 73
Pite, Beresford 376
Plaid Cymru 492
Plan for London (MARS) 412–13, 437
Plumstead, London 409
Pniewski, Bohdan 434
Poelzig, Hans 424
Poeschel, Carl Ernst 154
Poland 14, 38, 289–90, 340–1, 429
Polanyi, Karl 17, 476–9, 481
Police, The 522
Polish School of Architecture 376, 434–6
Pop Art 226, 344, 364
Pope-Hennessy, James 98
Popper, Karl 11, 20, 48, 226, 234, 482–3
Portmeirion 297–8, 328
Potter, Dennis 517, 518
Pound, Ezra 86
Powell, Michael 30, 49, 116–17, 130–1, 133–5, 137, 425
Prager, Theodor 217
Prague 16
Pressburger, Emeric 49, 130–7
Price, G. Ward 41
Priestley, J. B. 46, 216, 219, 220
Priory Green, Finsbury 414, 415–16, 417, 418
Pritchard, Jack 374, 438, 447, 448
Private Life of Henry VIII, The (1933 film) 120–1, 122, 515
Productivism 269–70, 270
'Projection of England' 124, 129, 134, 138
Prometheus Film 118

592

Proskauer, Albrecht 390
psychoanalysis 21, 29, 54–5, 86, 91
Pudovkin, Vsevolod 118, 124
Puffin Books 78, 149, 181–2, 222, 459
Pugin, Augustus Welby 3–4, 10

Querschnitt, Der 66–7

Rabinowitz, Paula 173
Rasmussen, Steen Eiler, 54
Ray, Man 86, 89
Read, Herbert 233–4, 247–51, 254–5,
 360–1
 art critic 30, 253, 258, 265, 357, 491
 Hampstead life 268, 270
 letter from Gabo 287–8
 Pevsner on 427
 Schwitters and 23
 Art Now: ... 247–8
Reclam 157, 161
'Red Engine' series (Ross) 223–4
'Red Vienna' 212–36, 396–7, 473–5
 British writers and 31
 culture of 18
 end of 16, 33, 76, 264
 housing schemes 29
 success of 489
Reed, Carol 30, 91, 130
Regent's Park Zoo 410
Reifenberg, Heinz J. 402–3, 425
Reilly, Charles 473
Reinhardt, Max 73
Reiniger, Lotte 124–5, 181
Reisz, Karel 138, 139–43, 517
Renaissance 153, 154, 164, 196–8,
 205–8, 326
Renier, Gustaaf Johannes 24
Renner, Paul 154, 218
Reuss, Albert 288
Reynolds, Simon 520
Rhodes, Cecil 315
Richards, J. M. 105, 418
Richardson, Tony 139, 140, 141
Richter, Hans 124, 125, 229, 358

Riefenstahl, Leni 63
Rieff, David 527
Reimann design school 434
Right Book Club 41, 160
Rilke, Rainer Maria 189
Riss, Egon 447–50
Robertson, Howard 370–1, 462
Robinson College, Cambridge 455–6
Robinson, Joan 480
Rodchenko, Aleksandr 74, 152, 162, 269,
 407, 417
Romania 14
Rosehill Court, London 450–1
Rosenauer, Michael 397–8, 472
Rosenberg, Alfred 246
Rosenberg, Eugene 8, 9, 51, 307, 377, 433
Rosenberg, Gerhard 423
Rosenberg, Jakob 209
Rosenthal, Tom 213
Ross, Colin 165
Ross, Diana 223–4
Rotha, Paul 126–7, 218, 473
Rothes Colliery, Scotland 448–50
Rothschild, Lady Emma Louisa 332
Routledge 232
Rowe, Colin 436
Rowlandson, Thomas 248
Royal Festival Hall 303, 424–5, 461
Royal Institute of British Architects
 (RIBA) 309, 377, 387, 394, 422,
 453, 458
Rubber Factory, Berlin 436–7
Rubens, Peter Paul 263
Rupert Street Car Park, Bristol 451
Ruskin, John 196
Russell, Gordon 181, 222–3
Russia 14, 16
Ruttman, Walter 32, 124, 125
Ryder, Gordon 423

Sachs, Rudolf Michael 179
Sagan, Leontine 117
St Andrew Bobola, Hammersmith 341
St Bride's, East Kilbride 455

St Clare's, Blackley 337
St Francis Secondary School, Glasgow 455
St Helier Estate, London 451
'St Ives Artists' 287–9, 344
St John's Church, Waterloo 327, 329
St Margaret's Church in King's Lynn 323
St Mary the Virgin, Bruton 339–40
St Mary's, Leyland 342–3, 434
St Thomas's Hospital 3, 4–6, 9, 10, 51, 306
Salisbury Cathedral 338
Saltzman, Harry 144
Salvisberg, Otto Rudolf 424
Samuel, Godfrey 408, 409
Samuely, Felix 395, 425
Sander, August 69, 290
Sangallo, Giuliano da 206, 207
Santa Maria delle Carceri, Prato 206
Sargent, Andrew 105
Saturday Night and Sunday Morning (1960 film) 141, 142, 144
Saville, Peter 519, 521
Saxl, Fritz 200–1, 202, 227
Sayers, Dorothy L. 183
Scharoun, Hans 457
Schindler, Rudolf 385
Schleger, Hans 'Zero' 185, 267
Schlemmer, Oskar 520
Schlesinger, John 141
Schmidt-Rottluff, Karl 154
Schmoller, Hans 175–82
 book designer/typographer 151, 161, 186, 204, 205
 Pelican Books tenure 170, 171, 173
 Penguin Modern Classics 185
Schoen, Ernst 26, 462
Schotten, Schalom 229
Schottlander, Bernard 305, 307–8
Schotz, Benno 291
Schroeder, Kurt 120
Schultze-Naumburg, Paul 241–2, 246, 376, 377
Schulze, Eberhard 181
Schumacher, E. F. 468–9, 476, 480, 484, 490–1, 494–8

Schumacher, Fritz 332–3, 494
Schütte-Lihotzky, Margarete 472
Schwarz, Hans 193
Schwarz, Heinrich 91
Schwitters, Ernst 362, 363–4, 365
Schwitters, Helma 358
Schwitters, Kurt 357–65
 artist 283, 345
 interned 45, 46, 348
 monograph on 350, 357, 360–1
 pop culture and 520
 Read and 23, 247
 uncelebrated 17, 241, 266
Scotland 126, 288–9, 291–5, 296, 448–50, 455, 457, 494
Scott, Betty 372
Scott, Elisabeth 372
Scott, Geoffrey 196, 205–6, 240
Scott, Giles Gilbert 372
Sedlmayr, Hans 198
Segal, Arthur 485
'Segal system' 488–90
Segal, Walter 18, 469, 485–90, 486, 495
Seifert, Richard 450
Senate House, London 333
Senior, Elizabeth 189, 191, 192
Serge, Victor 156
Shand, Philip Morton 388
Shankland, Graeme 462
Shchach, Max 120
Shub, Esfir 118
Siemenstadt, Berlin 457
Signet 173–4
Silkin, Lewis 316
Silone, Ignazio 156
Silver End, Essex 29, 371, 383
Simon, Oliver 153, 175, 235
Sinclair, Upton 152
Siodmak, Robert 115, 118
Siouxsie and the Banshees 519, 520
Sirk, Douglas 115
Sisson, Marshall 394
Sivill House, Bethnal Green 420
'Six Pillars', Dulwich 410

Skinner, Bailey and Lubetkin 414, 416, 422, 446
Skinner, Francis 409, 413, 417
Slutzky, Naum 389
Smigielski, Konrad 461, 463–9, 495
Smith, Ivor 439
Smithson, Alison and Peter 111, 207, 436, 438
Social Democratic Book Club 160
Social Democratic Party (SPD) 162, 260–1, 376
Socialist Realism 235, 276, 300, 309, 320, 418
Sonnenhof, Lichtenberg 470
Sophieneck residential complex, Hamburg 452
Soukop, Willi 385
South Bank, London 4, 98, 303–4, 305, 307
South Lambeth Estate, London 312–13
Southwyck House, Brixton 435–6
Soviet Union 15, 340, 412, 418, 437
Spa Green, Finsbury 406, 414, 415, 417
Spain 16
Spain, Alan 175, 210
Spectator, The 114, 254
Speller, Reg 102
Spence, Basil 297
Spencer, Herbert 164
Spencer, Stanley 261, 268
Spender, Stephen 31–3, 155, 216
Spiel, Hilde 17, 28, 259
squatters' movement, Vienna (1918–22) 472
Stalinism 155, 156–7, 235, 286, 322, 340, 406, 417
Stamp, Gavin 105, 106, 329, 454–5
Stent, Ronald 41, 44–5
Stern, Anatol 351, 353–4
Stern family 104
Stevenage 102, 315–16, 467, 508
Stirling, James 207, 208, 436
Stockholm Exhibition (1930) 425
Stowlawn Estate, Bilston 474–5
Strachey, John 151, 155

Strasser, Otto and Gregor 242–3
Strausfeld, Peter 127–9
Strenitz, Käthe 279–80
Strzemiński, Władysław 268
Studio, The 29, 372, 375
Sudetenland 37–8, 189
Sullivan, Louis 385
Summerson, John 205, 392
Sunday Times 254
Suprematism 124, 293
Surrealism 81, 89, 91, 134, 240, 345, 411
Suschitzky, Wolfgang 81, 104, 112–13, 127, 141, 217
Sutcliffe, Stuart 336
SVOMAS 407
Swansea 299
Swift, Jonathan 248, 491
synagogues 260, 326, 327, 331, 332, 398, 402–3, 454
Syrkus, Szymon and Helena 271, 293, 434
Szczuka, Mieczysław 351

Tabori, Peter 54
Tagore, Rabindranath 384–5
Tait, Thomas 29, 371
Tales of Hoffman (1951 film) 134–5
Tallents, Stephen 29, 124, 138
Taste of Honey, A (1961 film) 141–2, 144, 145
Tatlin, Vladimir 269, 270, 416
Tauchnitz 157, 158
Taut, Bruno 29, 372–5, 440, 470, 475, 485, 487, 527
Taylor, A. J. P. 229
Taylor, Nicholas 488, 489–90
Taylor, Stephen 217
Tecton (architectural group) 108, 405, 409, 410, 412, 413, 414
Teige, Karel 164
Tergit, Gabriele 56, 402
Thames & Hudson 99, 150, 213, 227, 228–9, 524
That Hamilton Woman (1941 film) 129
Thatcher, Margaret 449, 482, 525

Themerson, Stefan and Franciszka 14–15, 350–7, 360–1, 362, 363
Thief of Bagdad, The (1940 film) 117, 123, 129–30, 131
Things to Come (1936 film) 121, 123, 144, 146
Thomas, Edith, 'Wantee' 360, 361
Thomas, Trevor 258
Tisdall, Hans 185–6, 329
Toch, Ernst 117
Tocher, The (1938 film) 126
Toller, Ernst 33
Tolpuddle Martyrs 479
Topolski, Feliks 52, 277–9, 303, 305, 415
Townshend, Pete 522
Trellick Tower, Ladbroke Grove 443–4
Trenton Hans Peter 'Felix' 461, 484
Trevett, W. E. 163
Trier, Walter 67, 181
Truffaut, François 139
Tschichold, Jan 151, 162–71, 175–6, 177, 181, 192–3, 519, 521
Tudor-Hart, Edith 81, 82–6, 87, 213, 389, 460
Turner, W. J. 213, 215
Turnpike House, Clerkenwell 423
Tusa, Jan 383
Tuwim, Julian 223
'Twentieth Century German Art' exhibition (1938) 239, 240, 247, 248–51, 276, 360, 412–13
typefaces 153–5, 163–5, 171
Tzara, Tristan 359

UFA-Magazin 63–4
UFA (*Universum-Film Aktiengesellschaft*) 115, 120, 131, 135
Uhlman, Fred 260–3
 artist 298
 on Britain 16, 22, 240
 'fool's paradise' 15
 interned 283, 347, 423
 memoirs 265, 359

Ukraine 323–4
Ullapool, Scotland 289
Unger, Hans 180–1
Unity Theatre, Glasgow 294
Unwin, Raymond 379, 381
USSR In Construction 61
Uxbridge Station 332

van Gogh, Vincent 209, 224–5
Vas, Robert 139
Verso 523
Vertov, Dziga 32, 118, 124
Viertel, Berthold 33, 117
Vincent, Leonard 316
Vizinczey, Stephen 54
VKhUTEMAS 308, 407, 444
Vogel, Karel 306
Volkmann, Oswald 36
Volodko, Ivan 407
Vorticism 30, 153, 370, 371
Voysey, Charles 379

Wagner, Martin 311, 387–8
Wagner, Otto 397, 472
Walch, Hans-Joachim 178
Wales 297–302
Wallis, Alfred 284
Wanamaker, Sam 462
Warburg, Aby 199–200, 201, 205, 225, 227, 234
Warburg Institute 12–13, 97, 193, 199–206, 229, 233, 276, 434
Ward, Basil 30, 371
Warde, Beatrice 168
Warth Mills, Bury 43
Waterhouse, Keith 61
Waterloo Station, London 305, 310
Watkin, David 426, 519, 524
Watt, Harry 126
Waugh, Evelyn 30, 374–5
Webb, Kaye 78, 181–2
Webb, Sidney and Beatrice 156
Weekly Illustrated 60, 65, 66, 74

Wegener, Paul 272
Wegner, Max Christian 157–8
Weidenfeld & Nicolson 99–100
Weidenfeld, George 49, 99–100
Weidler, Charlotte 250
Weil, Simone 54
Weisenborn, Hellmuth 224, 276
Weitzmann, Siegfried 436
Weizmann, Chaim 49
Welles, Orson 91
Wells, H. G. 44, 121, 157
Welwyn Garden City 271, 287, 380–1, 424
Wertheim, Paul 250
West End Court, Hampstead 404
West Indian Migrants 504–6, 508–9
Weybridge, Surrey 346
'What We Are Fighting For' exhibition (1943) 265–6
Wiertz, Jupp 180
Wilczynski, Katarina 276
Wilde, Johannes 232
Wilder, Billy 115
Wilkinson, Ellen 155, 495
Willesden, London 403, 404
Willett, John 22–3, 517
Williams, A. V. 473
Williams, David Alexander 299
Williams-Ellis, Clough and Annabel 297–8, 328
Williams, Gertrude 218
Williams, Owen 371–2
Willow Road, Hampstead 360, 441–2, 442
Wilson, Norah 89
Wind, Edgar 196, 200
Winton, Nicholas and Grete 279
Wintringham, Tom 71–2
Wittgenstein, Ludwig 17, 18, 222, 482–3
Wittkower, Rudolf 201, 205–8, 209, 436
Wodehouse, P. G. 179
Wolff, Charlotte 28, 32, 50–1

Wölfflin, Heinrich 30, 197–8, 204, 205, 209, 210, 269
Wolpe, Berthold 151, 154, 177, 186–7, 204
Wood, Christopher S. 196
Wood, H. Harvey 296–7
Wood House, Kent 390
Woolf, Leonard and Virginia 29, 31, 159
Workers' Educational Association 325, 478
Workers' Illustrated Newspaper (WIN) 12, 61
'World of Art' series 229–30
Worswick, David 480
Wren, Christopher 201, 276
Wright, Basil 126

Yale University Press 188, 211
Yates, Peter 409, 423
Yiddish language 38, 45, 49, 289, 294–5, 324
Yorke, F. R. S. 8, 377, 433, 437
Yorke Rosenberg Mardall (YRM) 6, 8–9, 10, 305, 307, 377–8, 432–3
Young, Arthur 236
Young, Edward 162, 167, 169, 170, 181
Young, Michael 218, 385
Ystradgynlais, Wales 299–302
Yugoslavia 14

Zapf, Hermann 178–9
Żarnower, Teresa 354
Zeitgeist 197, 198, 204, 226
Ziegler, Adolf 243, 244
Zionism 318, 324, 394, 407
Zlín, Czechoslovakia 381–2, 384
Żuławski, Marek 300
Zulwski, Marek 279
Zweig, Ferdynand 476
Zweig, Stefan 28, 56
Żyw, Aleksander 289, 290, 296–7
Żyw, Tommy 297